Medieval Illuminators and
Their Methods of Work

W9-BYP-621

Medieval Illuminators and Their Methods of Work

Jonathan J.G. Alexander

Yale University Press
New Haven and London

For Marie and François Avril

Copyright © 1992 by Jonathan J.G. Alexander

9 8 7 6 5 4 3 2

All rights reserved. This book may not be reproduced in whole
or in part, in any form (beyond that copying permitted by
Sections 107 and 108 of the U.S. Copyright Law and except by
reviewers for the public press), without written permission from
the publishers.

Designed by John Nicoll
Set in Linotron Ehrhardt by Best-set Typesetter Ltd., Hong Kong
Printed in Hong Kong through World Print Ltd.

Library of Congress Cataloging-in-Publication Data
Alexander, J.J.G. (Jonathan James Graham)
 Medieval illuminators and their methods of work – Jonathan J.G.
 Alexander.
 p. cm.
 Includes bibliographical references and index.
 ISBN 0–300–05689–3 (cloth)
 ISBN 0–300–06073–4 (paper)
 1. Illumination of books and manuscripts. Medieval
2. Illumination of books and manuscripts – Technique. I. Title.
ND2920.A44 1992
745.6′7′0940902—dc20 92–5576
 CIP

Contents

List of Abbreviations vi

Photographic Acknowledgements viii

Preface 1

Chapter 1 The Medieval Illuminator:
Sources of Information 4

Chapter 2 Technical Aspects of the
Illumination of a Manuscript 35

Chapter 3 Programmes and
Instructions for Illuminators 52

Chapter 4 Illuminators at Work:
The Early Middle Ages 72

Chapter 5 Illuminators at Work:
The Twelfth and
Thirteenth Centuries 95

Chapter 6 Illuminators at Work:
The Fourteenth and
Fifteenth Centuries 121

Notes 150

Appendix 1 Contracts for Illumination 179

Appendix 2 Illuminators' Preliminary
Marginal Drawings 184

Bibliography 187

Index of Manuscripts Cited 204

Subject Index 209

Index of Names 211

List of Abbreviations

LIBRARIES

Bib. mun.	Bibliothèque municipale
Brussels, B.R.	Brussels, Bibliothèque royale Albert Ie.
Florence, Laur.	Florence, Biblioteca Medicea Laurenziana
London, B.L.	London, British Library
Munich, Bayer. Staatsbibl.	Munich, Bayerische Staatsbibliothek
New York, Morgan	New York, Pierpont Morgan Library
Oxford, Bodl.	Oxford, Bodleian Library
Paris, B.n.	Paris, Bibliothèque nationale
Vatican, B.A.V.	Vatican, Biblioteca Apostolica Vaticana
Vienna, O.N.B.	Vienna, Oesterreichische Nationalbibliothek

BIBLIOGRAPHY

Age of Chivalry — *Age of Chivalry. Art in Plantagenet England 1200–1400*, eds J.J.G. Alexander, P. Binski (Royal Academy of Arts, London, 1987).

Alexander, *Decorated Letter* — J.J.G. Alexander, *The Decorated Letter* (New York, London, 1978).

Alexander, *Insular Manuscripts* — J.J.G. Alexander, *Insular Manuscripts 6th to 9th Centuries* (A Survey of Manuscripts Illuminated in the British Isles, General editor J.J.G. Alexander, vol. 1) (London, 1978).

Alexander, *Scribes as Artists* — J.J.G. Alexander, 'Scribes as Artists: The Arabesque Initial in Twelfth-Century English Manuscripts', *Medieval Scribes, Manuscripts and Libraries. Essays Presented to N.R. Ker*, eds M.B. Parkes, A.G. Watson (London, 1978), pp. 87–116.

Alexander, Temple — J.J.G. Alexander, E. Temple, *Illuminated Manuscripts in Oxford College Libraries, the University Archives and the Taylor Institution* (Oxford, 1985).

Artistes, 1–3 — *Artistes, artisans et production artistique au Moyen Age. 1 Les hommes. 2 Commande et travail. 3 Fabrication et consommation de l'œuvre*, ed. X. Barral i Altet (Paris, 1986–90).

Bénédictins du Bouveret, 1–5 — Bénédictins du Bouveret, *Colophons de manuscrits occidentaux des origines au XVIe siècle* (Spicilegia Friburgensis Subsidia, 2–8), 7 vols (Fribourg, 1965–79).

Branner, *Manuscript Painting* — R. Branner, *Manuscript Painting in Paris during the Reign of Saint Louis. A Study of Styles* (Berkeley, Los Angeles, 1977).

Cahn, *Romanesque Bible* — W. Cahn, *Romanesque Bible Illumination* (Ithaca, 1982).

D'Ancona, Aeschlimann — P. D'Ancona, E. Aeschlimann, *Dictionnaire des miniaturistes du moyen âge et de la renaissance dans les différentes contrées de l'Europe* (Milan, 1949; repr. 1969).

Dix siècles — *Dix siècles de l'enluminure Italienne (VIe–XVIe siècles)*, catalogue by F. Avril *et al.* (Bibliothèque nationale, Paris, 1984).

Dutch Manuscript Painting — *The Golden Age of Dutch Manuscript Painting*, catalogue by J.H. Marrow *et al.* (New York, 1990).

Egbert, *Medieval Artist* — V.W. Egbert, *The Medieval Artist at Work* (Princeton, 1967).

English Romanesque Art — *English Romanesque Art 1066–1200*, catalogue by G. Zarnecki *et al.* (London, 1984).

Fastes du Gothique — *Les Fastes du Gothique. Le siècle de Charles V*, catalogue by F. Baron *et al.* (Paris, 1981).

Jackson, *Story*	D. Jackson, *The Story of Writing* (London, 1981).
Kauffmann, *Romanesque Manuscripts*	C.M. Kauffmann, *Romanesque Manuscripts 1066–1190* (A Survey of Manuscripts Illuminated in the British Isles, General editor J.J.G. Alexander, vol. 3) (London, 1975).
Lehmann-Brockhaus, 1–5	O. Lehmann-Brockhaus, *Lateinische Schriftquellen zur Kunst in England, Wales und Schottland vom Jahre 901 bis zum Jahre 1307*, 5 vols (Munich, 1955–60).
Le Livre	*Le Livre*, exhibition catalogue (Bibliothèque nationale, Paris, 1982).
M.G.H.	*Monumenta Germaniae Historica.*
Manuscrits à peintures (1954)	*Les manuscrits à peintures en France du VIIe au XII siècle* (J. Porcher, Bibliothèque nationale, Paris, 1954).
Manuscrits à peintures (1955)	*Les manuscrits à peintures en France du XIIIe au XVIe siècle* (J. Porcher, Bibliothèque nationale, Paris, 1955).
Meiss, *French Painting*, 1, 2, 3	M. Meiss, *French Painting in the Time of Jean de Berry. 1 The Late Fourteenth Century and the Patronage of the Duke* (London, 1967). *2 The Boucicaut Master* (London, 1968). *3 The Limbourgs and Their Contemporaries* (London, 1974).
Morgan, *Early Gothic Manuscripts (1), (2)*	N.J. Morgan, *Early Gothic Manuscripts (1) 1190–1250* (London, 1982). *Early Gothic Manuscripts (2) 1250–1285* (London, 1988) (A Survey of Manuscripts Illuminated in the British Isles, General editor J.J.G. Alexander, vol. 4).
Mostra storica	*Mostra storica nazionale della miniatura*, catalogue ed. G. Muzzioli (Rome, 1955).
Ornamenta Ecclesiae	*Ornamenta Ecclesiae. Kunst und Künstler der Romanik*, catalogue ed. A. Legner, 3 vols (Cologne, 1985).
Pächt, Alexander, 1, 2, 3	O. Pächt, J.J.G. Alexander, *Illuminated Manuscripts in the Bodleian Library, Oxford. 1 German, Dutch, Flemish, French and Spanish Schools* (Oxford, 1966). *2 Italian School* (Oxford, 1970). *3 British, Irish and Icelandic Schools* (Oxford, 1973).
Pen to Press	S. Hindman, J.D. Farquhar, *Pen to Press: Illustrated Manuscripts and Printed Books in the First Century of Printing* (University of Maryland, Johns Hopkins University, 1977).
Renaissance Painting in Manuscripts	*Renaissance Painting in Manuscripts. Treasures from the British Library*, catalogue ed. T. Kren (New York, London, 1983).
Sandler, *Gothic Manuscripts*	L.F. Sandler, *Gothic Manuscripts 1285–1385* (A Survey of Manuscripts Illuminated in the British Isles, General editor J.J.G. Alexander, vol. 5), 2 vols (London, 1986).
Scheller, *Model Books*	R.W. Scheller, *A Survey of Medieval Model Books* (Haarlem, 1963).
Schramm, Mütherich, *Denkmale*	P.E. Schramm, F. Mütherich, *Denkmale der deutschen Könige und Kaiser. Ein Beitrag zur Herrschergeschichte von Karl dem Grosse bis Friedrich II. 768–1250* (Munich, 1962; 2nd edn, 1983).
Scott, *Later Gothic Manuscripts*	K.L. Scott, *Later Gothic Manuscripts c. 1385–1490* (A Survey of Manuscripts Illuminated in the British Isles, General editor J.J.G. Alexander, vol. 1) (London, forthcoming).
Temple, *Anglo-Saxon Manuscripts*	E. Temple, *Anglo-Saxon Manuscripts 900–1066* (A Survey of Manuscripts Illuminated in the British Isles, General editor J.J.G. Alexander, vol. 2) (London, 1976).
von Euw, Plotzek, *Ludwig*	A. von Euw, J.H. Plotzek, *Die Handschriften der Sammlung Ludwig*, 4 vols (Cologne, 1979–85).
Warner, Gilson, *Royal mss.*	G.F. Warner, J.P. Gilson, *Catalogue of Western Manuscripts in the Old Royal and King's Collections*, 4 vols (British Museum, London, 1921).

Photographic Acknowledgements

Acknowledgment is made for permission to reproduce photographs to: Art Resource, New York. Figs 206, 235–6, 240. Bildarchiv Foto Marburg. Figs 20, 127, 128. Cliché Jean-Claude Stamm. Inventaire Générale (France)/ S.P.A.D.E.M. 1974. Fig. 28. Courtauld Institute of Art, University of London, Conway Library. Figs 131, 137–41, 155, 179, 180, 183, 185–6. Department of Printing and Graphic Arts, Houghton Library, Harvard University. Fig. 73. Master and Fellows of Corpus Christi College, Cambridge. Figs 26, 155, 179–80, 183, 185–6. Master and Fellows of St John's College, Cambridge. Figs 90, 156. Master and Fellows of Trinity College, Cambridge. Figs 166, 176. Master and Fellows of University College, Oxford. Figs 131, 137–40. President and Fellows of St John's College, Oxford. Fig. 56. Rheinisches Bildarchiv, Cologne. Fig. 16. St John's Abbey and University, Collegeville, Minnesota. Fig. 44. Society of Antiquaries of London. Fig. 208. Syndics of Cambridge University Library. Fig. 75. Syndics of the Fitzwilliam Museum, Cambridge. Figs 38, 110, 154, 226. The Medieval Institute, University of Notre Dame, Indiana. Fig. 46. Warburg Institute, University of London. Fig. 57. Warden and Fellows of New College, Oxford. Figs 85, 100–101. All other figures are reproduced by kind permission of the libraries and museums concerned.

Preface

This book is based on the James P.R. Lyell Lectures in Bibliography given at Oxford University in the summer of 1983. The Electors, whom I must thank for the honour of their invitation, require the Reader to deliver five one hour lectures. I have kept the main subject divisions of the lectures as given, but I have tried to alter my spoken text to a more acceptable written version, without entirely losing the looser framework of the lecture format. I have also enlarged and altered the text, especially the second lecture which has become Chapters 2 and 3, and, of course, I have added footnotes. The fact that this has taken me so long is due to interruptions caused by other projects, principally the Sandars Lectures given at Cambridge University in 1985 and my work on the exhibition of English Gothic art, 'Age of Chivalry', held at the Royal Academy of Arts, London, from November 1987 to March 1988. The initial work on the lectures could not have been done without a term's sabbatical leave from the University of Manchester where I was then teaching. The completion of the process of turning the lectures into a book has been made possible by the generous time allowed for research, and the excellent facilities provided by the Institute of Fine Arts of New York University where I have taught since 1988. There I also had the privilege of a semester's research leave in 1990. I express my gratitude to both the University of Manchester and New York University, and to my colleagues in both Institutions, as also to three research assistants at the Institute of Fine Arts, Diane Booton, Erik Inglis, and Maria Saffiotti, who helped me with this text in numerous ways.

I am very aware of the problems caused by the time gap between the original research for the lectures and their publication. Since I gave the lectures, interest in the illuminated manuscript book has continued to grow greatly, and the literature in equal measure. If it was possible then to be reasonably aware of the secondary literature, at least for certain periods and geographical areas, it is increasingly difficult to keep abreast of even restricted subject areas now. My aim was always to provide a general survey, however, and to trace patterns of continuity and of change over 'la longue durée'. This account was, even when it was originally undertaken, selective and therefore incomplete. The reader will notice, for example, the geographical imbalance in the concentration on Britain, France, the Netherlands and Italy, with comparatively little said about Spain, Germany, Eastern Europe or Scandinavia. Manuscript production in the Eastern Byzantine Empire is intentionally completely left out. For more extensive coverage of particular areas, particular periods or particular types of manuscript texts and production, the reader must go to more specialised literature, where also fuller bibliographical citation will be found than I have considered necessary or desirable.[1]

There is another point at which it has been more difficult to impose limits on my investigation, and that is the relation between text and illumination. My subject matter concerns the practical possibilities and constraints which influenced illuminators as they planned and executed their work. Thus the first chapter is concerned with surviving evidence as to who the illuminators were, in order to place them in their social and historical context. In the second and third chapters, in addition to some account of their materials, I have investigated the ways in which instructions as to subject matter or placement of illumination were received or transmitted. In the remaining three chapters, which are arranged chronologically, I have presented case studies and examples in an attempt to show their visual sources, and to demonstrate how these were adapted, copied or newly created in particular instances.

I have, in all this, only incidentally been concerned with the subject matter of their illumination – what is conventionally described as iconography. However, how illuminators illustrated or decorated their manuscripts obviously depended on the texts themselves, and inevitably there has been an overlap from the question of how it was done, to the question of what had to be represented. It has been impossible to draw the line between the two questions.

Since the late 1970s, much valuable work in the matter of text and illustration has been done by a number of

scholars, so that we have an account of that relationship in many more examples than when I prepared my lectures.[2] Moreover, a greater theoretical sophistication has led to an analysis of meaning on other levels than was earlier, for the most part, attempted. These analyses have been able to draw on theories of ideology in examining how particular interests were served in representation.[3] Also of great importance have been studies which can be broadly linked to 'reception theory', and which have led to a greater awareness of the audiences of the illuminated manuscript. There has been great interest in literacy and in the differences between an oral and a literary culture.[4]

Where an earlier approach might have taken account of a particular patron, both these newer approaches have led to a conception of meaning as generated in the interaction between a more broadly defined audience, and the images in a variety of texts. At the same time, meaning can no longer be thought of as closed, unvarying or static, as in earlier iconographic studies. Here the influence is apparent of semiology, the study of signs, as well as of currents which can be broadly characterised as structuralist and post-structuralist. These approaches, especially influential in literary studies, are now at last beginning to affect our studies too.

This book in one way has a more restricted subject, though in another it aims to range widely. I have tried to gather evidence, which seems to me relevant for my particular questions concerning illuminators' methods and decision processes, from examples taken from a wide area both geographically and temporally. As interest in book illumination has grown it has, no doubt, been inevitable that specialists have had to specialise more. But even apart from the initial confinement to a single one of the many media practised by medieval artists, to concentrate entirely on Europe north or south of the Alps, or to confine ourselves too rigidly to this or that century, has a tendency to make us myopic and unable to appreciate broader issues of artistic practice. So I have aimed to give an account which will serve, by its generality, to lift scholars' heads from what sometimes seems to me too narrow a focus. And this must be my justification for an account which is diachronic rather than synchronic, and which in the process inevitably sacrifices depth for breadth.

My first introduction to manuscript illumination was in a seminar on the Vienna Genesis held by Otto Pächt at Oxford University in 1959. I attended it as a nervous undergraduate with two other students, one of whom was Emmy Wellesz, whose book on the Vienna Genesis appeared the following year. Since then I have had the good fortune to be in personal contact with many of the scholars who have contributed so notably to the study of the illuminated book. This was first due to Pächt himself, through whom I came to know, for example, Francis Wormald, Carl Nordenfalk and Meyer Schapiro. Secondly, from my first post in the Department of Western Manuscripts, I encountered both the group of scholars interested in the manuscript book and resident in Oxford,

Tom Boase, Pierre Chaplais, A.B. Emden, Neil Ker, Roger Mynors, Graham Pollard, Beryl Smalley and, a little later, Bob Delaissé, as well as the many visitors from all over the world to the library, senior scholars like E.A. Lowe, Rosy Schilling, Bernard Bischoff and Millard Meiss, and the younger students just setting out having completed their doctorates like myself. Richard Hunt, the Keeper of Western Manuscripts, always liked to know what his readers were up to, and he actively encouraged us, his staff, both to share with and to acquire information from our visitors. In that way, Duke Humfrey's Library acted almost as a research institute in those far off days when there were few, if any, such places in existence. In this way, I became part of a wider community which continued to grow after my departure in 1971 to Manchester, through conferences, travels and correspondence. This community, sometimes referred to as the 'Tiberius C. VI Club',[5] which was then small enough to know personally a relatively large proportion of its members is still, even if it has so greatly expanded its membership, notable for its friendliness and sense of camaraderie in research.

In these circumstances I would find it impossible to recall, or to list all the many colleagues and friends from whom I have learnt, and who have shared information with me, whether by giving me references to sources or by communicating precious shelf-marks (this, of course, is the arcane lore with its weird vocabulary of our 'mystery', which gives our Club its title), or simply through shop-talk, described to me by Francis Wormald in our first meeting as 'the best talk in the world'. So I hope that all my friends and fellow-workers, in the same spirit of generosity, will accept my thanks as being no less grateful for being generally expressed. This must also apply to the very many librarians who over the years have given me access to objects in their care.

I wish nevertheless to make some exceptions. Michael Gullick not only read critically the first version of this text, but has continued since with a regular flow of letters and cards to draw my attention to valuable material I did not know. His comments as a practising scribe/illuminator with an intimate first-hand acquaintance with the medieval manuscript have been particularly valuable. Other friends and colleagues of long standing read all, or parts of my text, and contributed valuable corrections and suggestions. They were Richard and Mary Rouse, whose own Lyell Lectures on Parisian manuscript book production are eagerly awaited, and Walter Cahn, to whom I am grateful for reading in particular the material concerned with the earlier Middle Ages. They have improved my text in numerous ways, but are in no way responsible for such errors and omissions as still remain. I would also like to thank John Nicoll and Rosemary Amos at Yale University Press; the former for designing this book, the latter for her meticulous editorial work on the text. I also owe particular thanks to the Lyell Electors and to their Chairman, David Vaisey, for a generous financial subvention for the illustrations of this book.

Finally, in my dedication to Marie and François Avril, I recall one of my oldest manuscript friendships. My first meeting with François was in the Cabinet des Manuscrits at the Bibliothèque nationale in 1961, when our excited and increasingly noisy conversation finally provoked complaint from an irate reader, so that we had to leave and continue elsewhere the discussion of the Norman manuscripts on which we had both independently started to work for our theses. My debt to him is one shared by practically every member of the 'Club', who all at one time or another come to the Bibliothèque nationale to draw on his extraordinarily wide knowledge and experience of manuscripts, which are so generously and unfailingly shared. My own friendship with Marie and François has been cemented by constant meetings, hospitality and correspondence over almost thirty years now. Such are the precious rewards which come to us over and above the rich fulfilment we receive as scholars from our chosen areas of enquiry.

Jonathan J.G. Alexander
Institute of Fine Arts
New York University
1992

The Medieval Illuminator: Sources of Information

This first Chapter aims to review the sources of information available to us concerning medieval illuminators as to their identity and the social context in which they worked. In later Chapters, I shall look at the internal evidence found in their products as to their working methods and the kinds of decisions they had to make; but here I am concerned with two types of external evidence.

In the first place there are written sources. These may be literary texts, for example monastic chronicles, which mention such illuminators as Ervenius of Peterborough in the eleventh century[1] or Matthew Paris of St Albans in the thirteenth century.[2] There is also the famous reference by Dante in the *Divine Comedy* to the illuminators, Franco Bolognese and Oderisi of Gubbio.[3] Or they may be documents or archival records of various kinds, such as the Paris tax rolls of the 1290s, which record the names of illuminators and others in the book trade, their addresses and the tax they paid.[4] There are fairly numerous accounts of payments to illuminators working for royal and other aristocratic patrons,[5] as well as legal records of civil and religious cases and documents concerning matters such as property transfers or wills, in which illuminators are mentioned.[6] There is also a certain amount of documentary evidence contained in the manuscripts themselves, including signatures of artists or notes concerning payment, or instructions whether verbal or visual.[7]

Secondly, there are the pictorial representations of illuminators, most of which are self-portraits, from which we can gain some impression of their self-image and status.[8] This Chapter will also trace the history and development of these self-referential images.

In the classical world there is no evidence as to whether illustrations were executed by specialist illuminators or by professional painters.[9] Slaves or freedmen were regularly employed as scribes and one, Tiro, a freedman of Cicero, is credited with the invention of a form of shorthand.[10] Some of the simpler forms of illustration – diagrams in mathematical or astronomical texts, for example – perhaps were done by the scribes themselves.[11] However, trained painters would surely have been necessary to execute the author portraits described by Varro and Martial, or the considerable cycles of illustration to Greek and Roman literary texts such as Homer or Virgil, cycles whose existence has been hypothesised by Kurt Weitzmann.[12] In any case, the first known name attached to a specific book is that of Furius Dionysius Filocalus, who signed the copy of a Roman Calendar of 354 AD which does not survive, but is known to us from Renaissance and later copies.[13] He uses the word 'titulavit': in other words, he wrote the titles which display great calligraphic mastery. Whether he also executed the drawings in the manuscript is unknown.

Carl Nordenfalk has very plausibly suggested that the changeover from slave to free copyist is one factor which led to the development of the decorated letter from the later fourth century onwards.[14] The implication is that the scribe may also have been the artist, as was probably the case in the *Vergilius Augusteus*.[15] From the early fifth century the so-called Itala fragments of an illustrated Book of Kings have written directions to the artists who were working in Rome and these imply some form of workshop organisation (fig. 1).[16] Nevertheless at this date there are still no written references to illuminators which are known to me. Eusebius (*d.* 339/40 AD) refers to the copy of the Gospels which he gave to Carpianus containing the Canon Tables, a textual concordance, which he had composed, and also to the fifty copies of the Gospels sent to the Emperor Constantine in Constantinople in 331 AD.[17] Although he speaks of the school of scribes founded at Caesarea by Bishop Pamphilus, nothing at all is said of how, or by whom, the texts were decorated. Similarly, although there is a great deal of information about book production in Jerome's writings, no mention is made of either illustration or decoration.[18] His well-known condemnation in the letter to Eustochius, of luxury books written on purple parchment, suggests he would not have approved of any form of added embellishment.

It is surprising, considering the role monasteries came to play in the history of manuscript illumination, that the Rule of St Benedict has nothing to say about the making

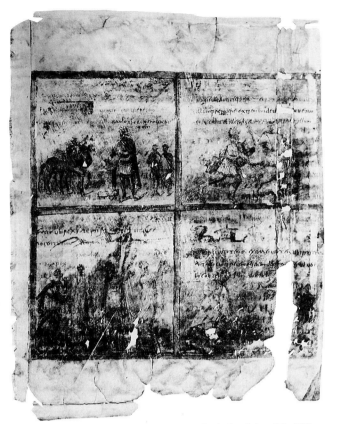

1. Berlin, Deutsche Staatsbibliothek, Cod. theol. lat. fol. 485, folio 2r. Itala fragments of Book of Kings. Instructions to the artist.

or decoration of books.[19] It does imply that books would be available not only for the services, where they would be essential, but also for meditative reading;[20] but it does not seem likely that the kind of texts recommended for study and meditation, such as Cassian's *Institutions*, would have been illustrated or decorated, or thought better for being so. Chapter LVII of the Rule, 'Concerning Craftsmen in the Monastery', may have had some importance later in connection with the general anonymity of monastic illuminators: 'if there are craftsmen (*artifices*) in the monastery they should pursue their crafts (*faciant ipsas artes*) with all humility after the abbot has given permission'.

The Gospels made at Zagba in Syria in 586 AD[21] are another example, from the early period, of the anonymity of artists as opposed to scribes. Though the manuscript is signed by the scribe Rabula, nothing is said of the artist, or artists, who were responsible for the four full-page miniatures and the highly decorated Canon Tables with figures. Scribal signatures become relatively frequent from this period onwards, but artists' signatures are always infrequent by comparison.[22]

The only literary references to specific illuminations which are known to me in this early Christian period are by Cassiodorus (*d.* 597 AD), in his Commentary on the Psalms, and in his Institutiones, where he refers to the illustrations of the Tabernacle and the Temple in Jerusalem which he had inserted in his larger one volume Bible (Pandect).[23] It has been argued that the illustrations in the *Codex Amiatinus* made at Wearmouth/Jarrow, Northumbria, in the early eighth century, are copies of Cassiodorus's pictures in his Pandect, and if that is so we have an indication of what the former were like.[24] Cassiodorus also refers to the patterns he kept for bindings, and a leaf surviving in a manuscript from the Abbey of Corbie in North France has been suggested by Carl Nordenfalk to be one of these patterns (fig. 2).[25] Yet again, there is no information as to who executed these book paintings, nor as to how they were trained.

Cassiodorus's illustrations, it seems, were fully painted, which would imply the work of a trained painter. The frontispiece illustration of an artist making a study of a plant, which is contained in the Vienna copy of Dioscorides's *Materia Medica*, a manuscript made in Constantinople in 512 AD, shows him working at an easel, apparently painting on a single sheet (fig. 3).[26] This would also imply that a trained painter was working on this particular manuscript. Another frontispiece in the book shows winged *putti* with writing instruments. Two small pieces of evidence of the existence of a book trade in this early period are contained in a sixth-century

2. Paris, Bibliothèque nationale, latin 12190, folio Av. Page of interlace patterns.

3. Vienna, Oesterreichische Nationalbibliothek, Cod. Med. Gr. 1, folio 5v. Dioscorides. *Materia Medica*. The artist painting a plant.

Orosius from Florence and in a tenth-century Gospels from Angers.[27] A colophon in the former states that it was made in the shop of Magister Viliaric, whilst in the latter a colophon seems to indicate that its model came from the shop of one Gaudiosus, 'librarius', located near San Pietro in Vinculo, Rome. There is no indication of date for the latter, but perhaps this was in the seventh century.

From the end of the seventh century onwards there is a larger sample of manuscripts with illustration or decoration. Still, there is little information as to who was responsible for it. The information, if any, is almost invariably concerned with the scribes. For example, upon looking at the list of illuminators' names prior to the year 900 AD given in the standard dictionary of miniaturists, almost all turn out, on closer inspection, to be scribes.[28] In some cases, certainly, it is highly possible that the scribe was also the illuminator. One such example is the Lindisfarne Gospels written by Bishop Eadfrith (*d*. 716 AD). The authors of the exemplary publication of this manuscript, T.J. Brown and R.L.S. Bruce-Mitford, argue convincingly from a detailed examination of the relationships between script and illumination, that he was also responsible for its very complex programme of decoration.[29] Nonetheless, only two certain signatures of illuminators survive from the whole of the Insular and Carolingian production of the eighth and ninth centuries.

The first is that of Macregol, Abbot of Birr, Co. Offaly, Ireland, whose colophon in a Gospels in the Bodleian Library, Oxford, reads: 'Macregol painted this Gospels. Whoever reads and understands its narrative, let him pray for Macregol the scribe'.[30] Macregol, who died

in 822 AD, is therefore both scribe and illuminator. The second signature is that of Adelricus who, in the miniature showing the players' masks prefacing a copy of Terence's plays made at Corvey on the Weser, *c*. 820–30 AD, writes: 'Have mercy on me O God according to your great mercy. Adelricus made me' (fig. 4).[31] L.W. Jones and C.R. Morey, in their study of the illustrated Terence manuscripts, call this 'the only authentic signature of a Carolingian miniaturist'. Even this might have been taken as a scribal signature, since the word 'fecit' is neutral, had not the scribe, Hrodegarius, also signed his name separately. According to Morey, Adelricus is one of three miniaturists working in the manuscript, but this is not to be taken as a signature to authenticate this particular miniature. As with Macregol, the inscription is a prayer, and significantly it is concealed so that it is almost invisible.

A few more names can be added with more or less certainty. The name 'David' occurs in two initials of the late eighth-century Sacramentary from Gellone and he may, therefore, be the artist responsible for the decoration of the manuscript (fig. 5).[32] The name 'Gedeon', inserted in one of the Canon Tables of an early ninth-century Gospels from Tours, may be the name of an illuminator and was accepted as such by Wilhelm Koehler (fig. 6).[33] Koehler also thought it possible that the three monks of St Martin at Tours, who are named in the dedicatory poem of the second or so-called Vivian Bible of the Emperor Charles the Bald, that is Amandus,

4. Vatican, Biblioteca Apostolica Vaticana, Vat. lat. 3868, folio 3. The masks for the actors of Terence's *Andria*. Signed by Adelricus in the pediment.

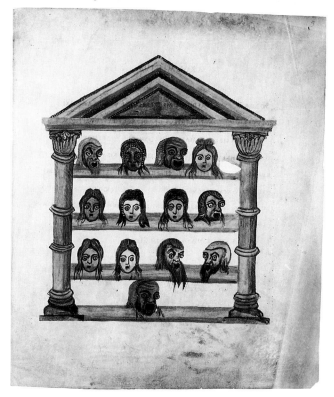

5. Paris, Bibliothèque nationale, latin 12048, folio 99. Gellone Sacramentary. Initial 'B' with the name 'David'.

6. London, British Library, Harley 2790, folio 23. Canon Table of Gospels. Signed by 'Gedeon' in the arch.

7. Darmstadt, Hessische Landes- und Hochschulbibliothek, Cod. 746, folio 14v. Canon Table of Gospels. Signed by 'Liuthardus' in Tironian notes.

Haregarius and Sigvaldus, are represented in the famous dedication picture placed at the end of the Bible, and were in fact also responsible for its illumination (fig. 8).[34]

Gedeon's signature, if it is one, may seem oddly placed, but it is interesting that another name appears in another Carolingian Canon Table, where the words 'Liuthardus ornavit' are written in Tironian notes at the end of the last Canon (fig. 7).[35] It is presumed that this is the same Liuthardus who wrote the Psalter of Charles the Bald in Paris, and collaborated with his brother, Berengar, to write the Golden Gospels of St Emmeram, Regensburg, now in Munich.[36] The colophons of the latter two manuscripts state that the two brothers were priests. Liuthardus's inscription in the Darmstadt Gospels is written in gold and, taken with the word 'ornavit', suggests the symbolic importance of gold as a material in such manuscripts.[37] This is also implied at St Gall where the Abbot, Salomon III, who died in 919 AD, is said to have himself executed the gold initials for the *Evangelium Longum* according to the eleventh-century chronicler, Ekkehard.[38] Though doubts have been expressed, there are other examples of highly placed churchmen apparently working as artisans, and that such claims could be even made is surely significant.[39] A number of painters and illuminators among the brethren at St Gall are mentioned, including Tuotilo, Notker

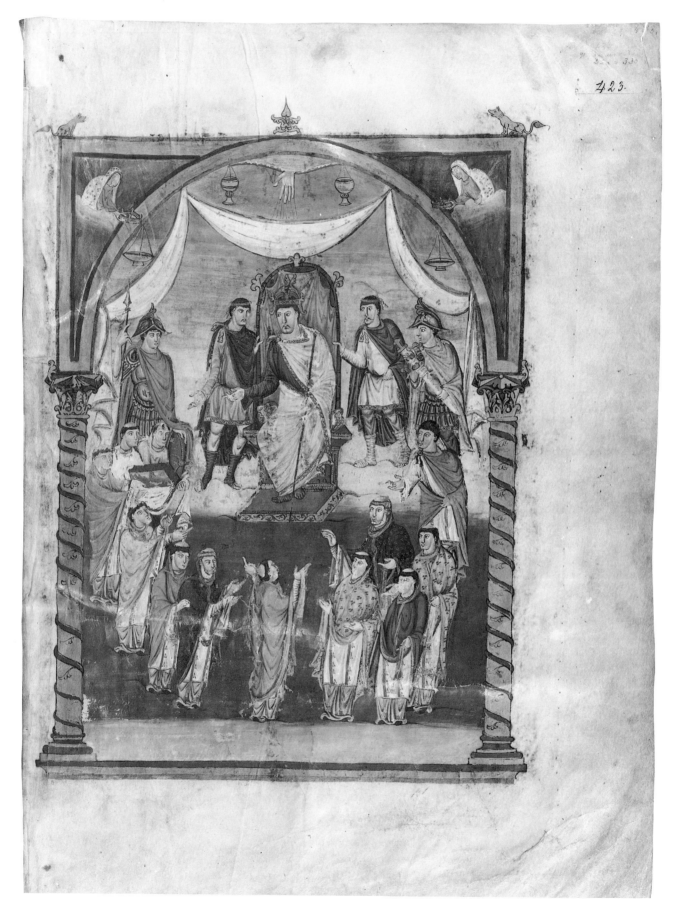

8. Paris, Bibliothèque nationale, latin 1, folio 423. Presentation of the Vivian Bible to Charles the Bald.

9. New York, Pierpont Morgan Library, M. 429, folio 183. Beatus, Commentary on the Apocalypse. The scriptorium at Tavara.

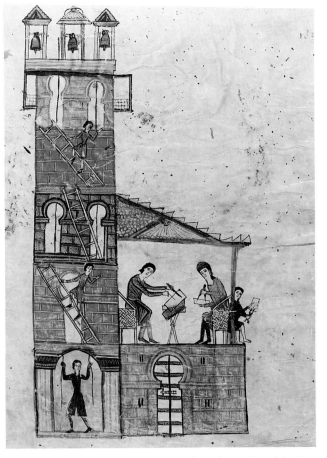

Medicinus and Chunibert, though their work is not certainly identifiable.[40] A group of monastic painters is also recorded at Fulda.[41] Finally, to these few names can be added that of Lantbertus, a priest in Reims, who in 798–800 AD wrote and illuminated a Sacramentary (which was unfortunately burnt in 1774), for a monk of Saint-Rémy, Godelgaudus. It contained five miniatures, including portraits of Saints Gregory and Remigius, and of the donor, and possibly also a self-portrait of Lantbertus himself.[42]

Looking beyond the ninth century to the succeeding two centuries, we can point to a few more documented illuminators, and we also have our first certain representations of illuminators as opposed to scribes. From Spain the names of a number both of scribes and illuminators are known; the latter include Oveco, Fructuosus 'pictor', Magius 'archipictor', Emeterius and Ende 'pinctrix'.[43] Many of these names occur in highly illuminated copies of the Commentary on the Apocalypse written c. 776 AD by the monk Beatus of Liebana. The representations, usually placed at the end of the manuscript, once again serve to ask readers of the manuscripts to remember the scribes or artists in their prayers, so that those named may reap their eternal reward at the Last Judgment. The opening of the Book of Life, in which the names of the faithful are recorded, is among the events described and illustrated in the preceding pages of these Apocalypse Commentaries. Thus Ende, presumably a nun, is named as collaborating with Emeterius on the Girona Apocalypse of 975 AD.[44] Emeterius left a self-portrait in a colophon miniature of the Madrid Apocalypse on which he collaborated with his master, Magius, and which he finished in 970 AD after the latter's death in 968 AD.[45] Emeterius shows himself sitting with his colleague the scribe, Senior, in a room beside the bell-tower at the monastery of Tavara. The figure to the right is cutting parchment. The miniature, which is now very worn, was copied later in another Apocalypse dated 1220, which is in itself interesting (fig. 9).[46] This is a salutary warning that all illuminators' self-portraits are to some extent conventional, and may even be, as here, copied from an earlier source.

The Apocalypse from Silos has a colophon with the name of the Prior, Petrus, which may, if taken literally, mean that he wrote and illuminated it; though again it may only mean that he ordered the work.[47] In any case, the mention of the illumination suggests that it is now seen as an important and integral part of the book, necessary to an understanding of the text, not a mere adjunct to the script. Thus the colophon of probably the earliest surviving Apocalypse, that in the Morgan Library

of the mid-tenth century, states that the artist, Magius, had painted the story of St John's vision as a warning to fear the judgement of Christ's Second Coming.[48] Secondly, and consequently, the art of illumination has come to have spiritual purposes as does the art of writing.

In addition to the examples of Eadfrith and Macregol quoted for the British Isles, St Dunstan, Abbot of Glastonbury (c. 943–57 AD), and Archbishop of Canterbury (961–88 AD), is described by his biographer, Osbern, as skilled in 'making a picture and forming letters'.[49] The two activities are clearly bracketed in the Latin. The famous drawing in the mid tenth-century *Glastonbury Classbook* with its first person inscription, again in the form of a prayer, is almost certainly written by Dunstan himself, and there is, therefore, a very strong, presupposition that he was responsible for one of the first of a series of outline drawings which were to become a special feature of Anglo-Saxon art of this period (fig. 10).[50] It is also, therefore, a self-portrait. Osmund, Bishop of Salisbury from 1078 to 1099, is described by William of Malmesbury as 'not ashamed to write and to bind books', to which a later source adds 'and to illuminate them'.[51] This, again, is an interesting comment in terms of the implied opposition between the status of bishop and the practice of work with the hands.[52] Mannius, Abbot of Evesham (1044–66), was described as an illuminator as well as a scribe and goldsmith,[53] and another abbot illuminator was Otbert of St Bertin near

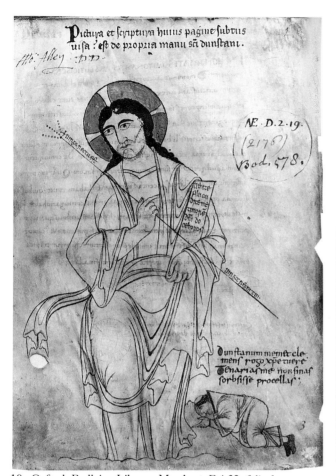

10. Oxford, Bodleian Library, Ms. Auct. F.4.32, folio 1.
Grammatical and other works. Self-portrait (?) of St Dunstan
worshipping Christ.

11. New York, Pierpont Morgan Library, M. 333, folio 51.
Gospels. Self-portrait of Abbot Otbert of St Bertin adoring
Christ at the Nativity.

Boulogne-sur-mer (*c.* 968–1007). A colophon at the
beginning of a Psalter says that Heriveus wrote it and
Otbert decorated it (decoravit).[54] The figure style of the
Psalter is recognisable in a Gospels, and in the tail of the
'Q' of St Luke's Gospel, a monk is shown in supplication
in a pose very similar to that of St Dunstan (fig. 11).[55]
This must therefore be Abbot Otbert's self-portrait.
Another Anglo-Saxon self-portrait is incorporated in
the initial 'B' to Psalm 1 of the Psalter from Bury St
Edmunds (fig. 12).[56] A damaged inscription reads 'pictor
hujus . . . mitis'. The painter is clearly represented as a
monk with the tonsure. And at Winchester two of the
brethren whose names are entered in the calendar of the
New Minster Book of Prayers for commemoration are
described as painters (pictor).[57]

The words 'pictor' and 'illuminator' are both used
of himself by Hugo, a Norman monk, probably from
Jumièges, working in the late eleventh century, in his
well-known self-portrait, which again is a colophon
portrait placed at the end of a manuscript of St Jerome's
Commentary on Isaiah (fig. 13).[58] Examples of both
words being used have been given earlier, and it is
uncertain if a distinction is intended. 'Illuminare', to light
up, might imply the use of gold or at least highlights, but

in fact Hugo does not use any gold in this particular
manuscript, and paints in a limited number of colours –
mainly green, red and blue applied in washes or stripes. It
is significant that he represented himself dipping a pen in
an inkwell and holding a knife in his other hand – that is,
as a scribe. This may be partly explained in terms of
the power of the scribal image so often shown in early
medieval art. It also again emphasises how the two ac-
tivities have now drawn together, are complementary, and
in practice are often done by the same person. A second
Norman example of a self-portrait is that of Robert
Benjamin, who shows himself kneeling at the feet of
William of St Calais, Bishop of Durham from 1081 to
1096 (fig. 14).[59] Here his subordinate position, referred
to in the inscription, is underlined by his position at the
base of the initial.[60]

The traditional view that monks were responsible for
much of the illumination in this early period can be
substantiated, therefore, even if the pictorial and literary
evidence is not very great. A number of illuminators at
this date will have been secular clergy like Liuthardus, or
even laymen, and it is impossible to quantify what pro-
portion of the total they formed.

The evidence quoted gives little indication of how a

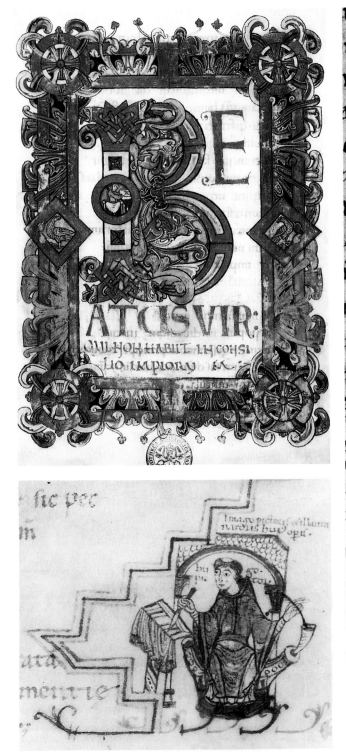

12. Vatican, Biblioteca Apostolica Vaticana, Reg. Lat. 12, folio 21. Psalter. Initial 'B' with illuminator portrait.

13. Oxford, Bodleian Library, Ms. Bodley 717, folio 287v. Jerome on Isaiah. Self-portrait of Hugo 'pictor'.

14. Durham, Dean and Chapter Library, Ms. B. II.13, folio 102. Augustine, Commentary on the Psalter, vol. 2. Initial 'I' with self-portrait of Robert Benjamin at the feet of Bishop William of St Calais.

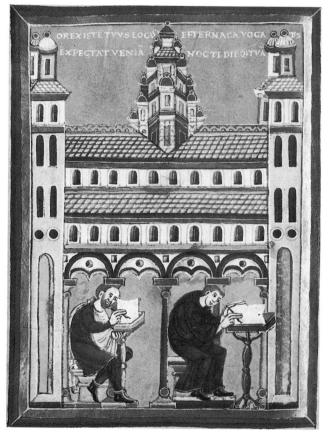

monastic illuminator was chosen and trained. Emeterius describes himself as 'nutritus' by Magius, which surely implies he was his pupil, as well as collaborator. The story told by William of Malmesbury concerning Wulfstan as a boy is significant here. Wulfstan had as his master, Ervenius, who was 'skilled at writing and working with colours'.[61] Ervenius executed a Sacramentary and a Psalter whose beauty Wulfstan greatly admired. Ervenius then gave the manuscripts to King Cnut (*d.* 1035 AD) and Queen Emma, to Wulfstan's sorrow, but years later they came back to Wulfstan. The story suggests how a young monk might attach himself to an older member of the community, watch him at work and gradually learn the craft. The need for practical instruction should be emphasised, for it does not seem that the technical manuals can ever have circulated very widely, nor could they by themselves (and they vary in degrees of practical usefulness) have sufficed to teach the craft.[62] This, then, is a sort of apprenticeship system at work within the monastery. A well-known early twelfth-century drawing prefacing a manuscript written at St Michael's, Bamberg, shows the self-sufficiency principle within a Benedictine community, since all the stages of book production from preparing the parchment to binding the completed book are being performed by the monks themselves (fig. 15).[63]

However, in the eleventh century and increasingly in the twelfth century, we begin to hear of lay illuminators who are professionals working directly for a stipend in cash or kind. An example is the career of the Lombard artist, Nivardus, working at Fleury in the early eleventh century,[64] which immediately shows how lay artists were more mobile and could import new styles from considerable distances. A typical situation seems to have been that of a master craftsman, able to execute work in different media, being called to a monastery and given board and lodging for as long as was necessary to execute whatever was required. The growth of the monetary economy and of international trade, as well as the increasing wealth of the monasteries, may also have been a factor. Examples of such lay artists were Fulk, a painter employed at St Aubin, Angers, in the late eleventh century,[65] and Master Hugo, metalworker and illuminator at Bury St Edmunds, *c.* 1135.[66] Sometimes such people were later given the privilege of acceptance into the community as monks. The collaboration between monk and layman is also represented at this period. Thus Felix, the lay painter in an initial 'P' in a Corbie manuscript of *c.* 1164, is balanced by Johannes, the one-eyed monastic scribe (fig. 17).[67] In the Echternach mid eleventh-century Pericope Book, now in Bremen, monk and layman work side-by-side in the same interior (fig. 16),[68] and in a

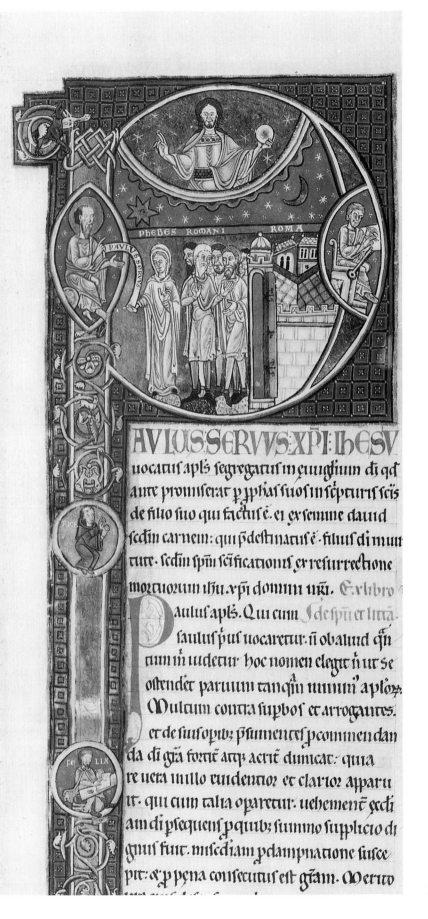

17. Paris, Bibliothèque nationale, latin 11575, folio 1. Florus on St Paul's Epistles. Initial 'P' with self-portrait of Felix.

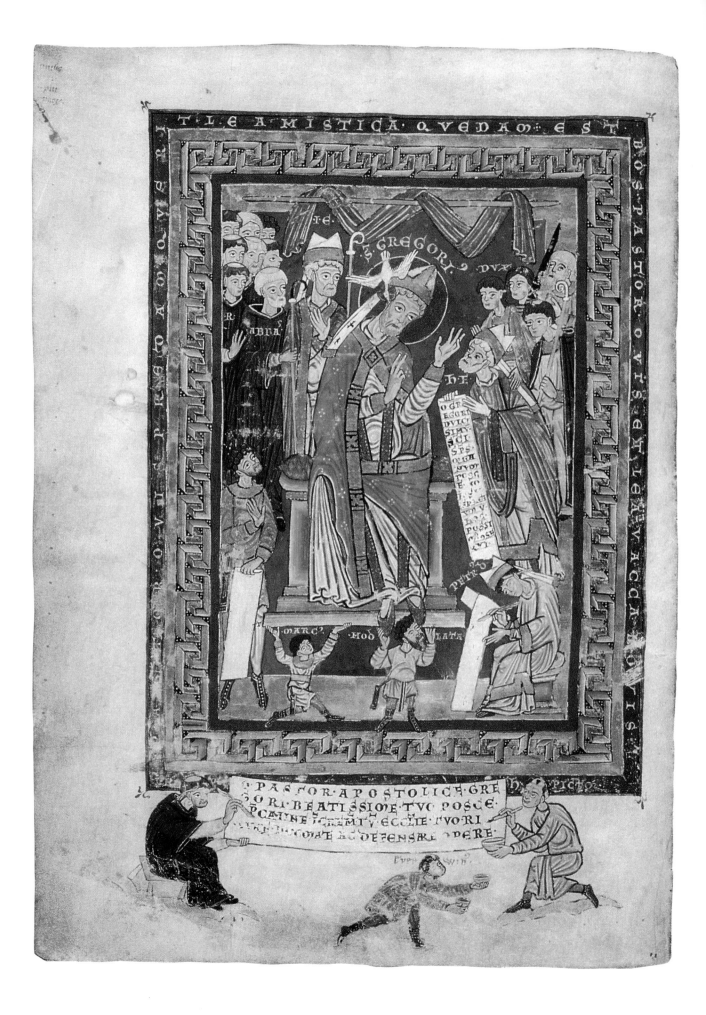

18. Stockholm, Kungliga Bibliotek, A. 144, folio 34. Sacramentary. St Gregory the Great with (below) self-portrait of Hildebertus with his assistant Everwinus and the scribe, 'R.'

19. Prague, Metropolitan Library, A. XXI/1, folio 153v. Augustine, *Civitas Dei*. Self-portrait of Hildebertus with his assistant Everwinus.

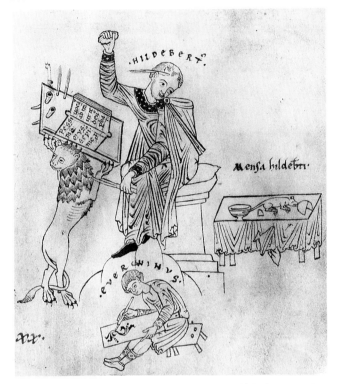

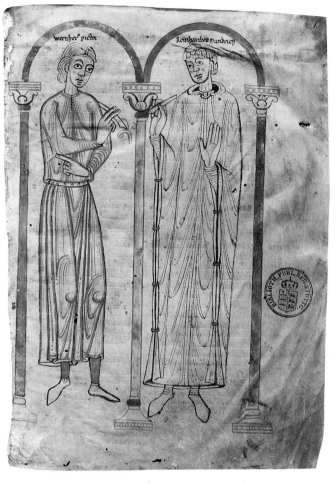

Bohemian Sacramentary of 1136, the monk 'R.' as copyist (scriptor) and the painter, Hildebertus (pictor), with his assistant, Everwinus, are all shown below the dedication miniature symbolically at work together at either end of an inscribed scroll (fig. 18).[69]

Everwinus is shown holding up the paint pots to his master, and this function of preparing and offering the paints will continue to be shown in many later depictions of artists and their assistants. In the other well-known self-portrait by Hildebertus in an Augustine, *Civitas Dei*, still in Prague, where he is interrupted by the 'wretched mouse' ('pessime mus') who tries to steal his lunch and knocks the roast chicken off the table, Everwinus is engaged in practising a flourish such as decorated second-grade initials in many manuscripts of the period (fig. 19).[70] Here, then, he learns his craft by executing the minor parts of the decoration. Hildebertus shows himself with a tonsure, though his dress appears to be secular, as is the short tunic of his assistant. Perhaps he was in minor orders. Clearly a secular painter, also apparently practising a similar decorative motif and using a pen, is Wernherus, who is placed in an arcade beside the monk, Reinhard von Munderkingen, also holding a pen (fig. 20). Reinhard was Abbot of Zwiefalten from 1232–4 and again in 1251–3.[71]

In the Prague Augustine Hildebertus still represents himself, as had the Norman monk Hugo, as a scribe in

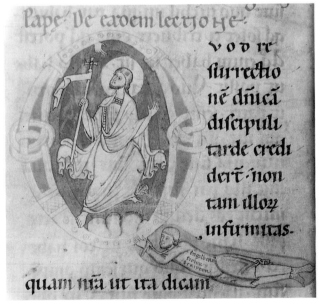

20. Stuttgart, Württembergische Landesbibliothek, Cod. hist. fol. 420, folio 1. Wernherus 'pictor' with the monk, Reinhard.

21. Trier, Stadtbibliothek, Cod. 261/1140 2°, folio 153v. Homiliary. Initial 'Q' with self-portrait of Engilbertus.

22. London, British Library, Harley 3011, folio 69v. Gregory the Great, Dialogues. Signature of Teodericus.

23. Douai, Bibliothèque municipale, Ms. 340, folio 9. Hrabanus Maurus, *De Laudibus Sanctae Crucis*. Initial 'O' with Rainaldus the scribe and Oliverus the painter.

24. Vatican, Biblioteca Apostolica Vaticana, Rossiana 181, folio 22v. Missal. Initial 'R' with self-portrait of the illuminator.

25. Geneva, Bibliotheca Bodmeriana, Cod. 127, folio 244. Legendary. Initial 'R' with self-portrait of Frater Rufillus of Weissenau.

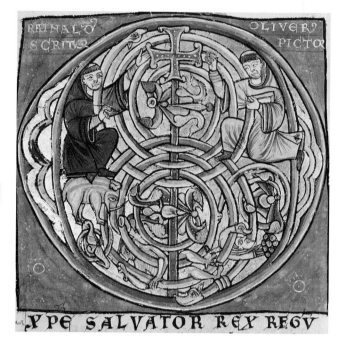

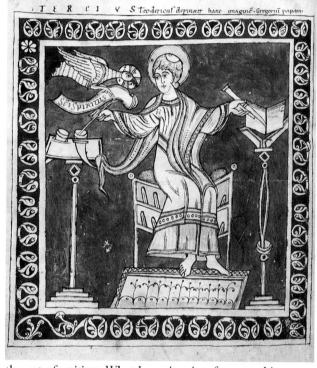

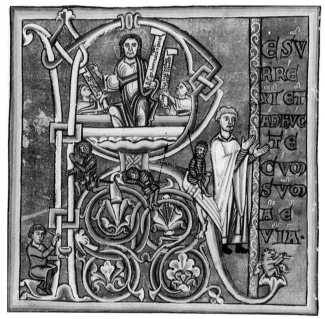

the act of writing. What he writes is, of course, his curse on the mouse, but he sits at a desk with a number of quill pens. Though the pen was certainly used for illumination as well as writing, this and other images suggest that the functions of scribe and artist are still here united, even when we see laymen at work. Another example is Engilbertus, a layman who calls himself 'pictor et scriptor', in his self-portrait in prayer to the Risen Christ in the tail of an initial 'Q' (fig. 21).[72] Teodericus, who, though he does not specify whether he was monk, secular clerk or layman, signed the portrait of Pope Gregory the Great in a copy of the Dialogues of the early twelfth century, can also be deduced to have been both scribe and artist (fig. 22).[73] In the later Middle Ages, it will become less common for lay illuminators to be scribes as well, though it is not entirely unknown, examples being Matteo di Ser Cambio of Perugia of the late fourteenth century,[74] and the prolific Gioacchino di Giovanni 'de Gigantibus', born in Rothenburg, Bavaria, but active in

Rome and Naples in the second half of the fifteenth century.[75]

In the twelfth century there are examples of most of the possible permutations between monks, secular clergy and lay persons, as scribes and illuminators. Another form of monastic collaboration is between a Benedictine scribe, Rainaldus, and a tonsured, perhaps Cistercian monk, Oliverus 'pictor' (fig. 23).[76] The Premonstratensian canon, Frater Rufillus, is shown painting the letter 'R' in a Passionale from Weissenau in the diocese of Constance to be dated *c.* 1170–1200 (fig. 25).[77] Here, as in the miniature of Wernherus (see fig. 20), and in another initial showing a tonsured, but non-monastic artist painting an initial 'R' in a Missal (fig. 24), the topos is to show the brush or pen in use, here as it were tracing

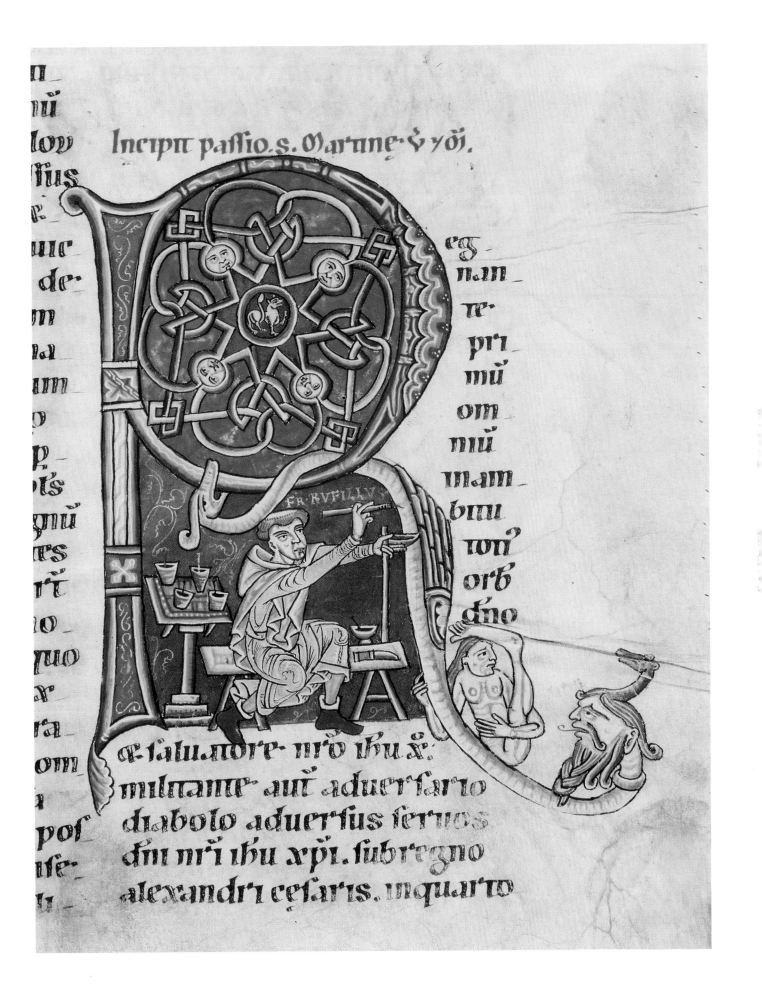

FR. RVFILLV

eg
nan
te
pri
mũ
om
nĩu
mam
biu
toñ
orb
dno

et saluatore nr̃o ihũ x̃.
militante aũt aduersario
diabolo aduersus seruos
dñi nr̃i ihu xp̃i. sub regno
alexandri cesaris. inquarto

26. Cambridge, Corpus Christi College, Ms. 4, folio 241v. Dover Bible. Initial 'N' with self-portrait of the illuminator and his assistant.

27. Padua, Biblioteca capitolare, s.n., folio 85v. Evangeliary. Self-portrait of Isidore.

28. Strasbourg, Bibliothèque du Grand Seminaire, Cod. 37, folio 4. Martyrology, necrology etc. Self-portrait of the priest Sintram with the scribe, the nun Guta.

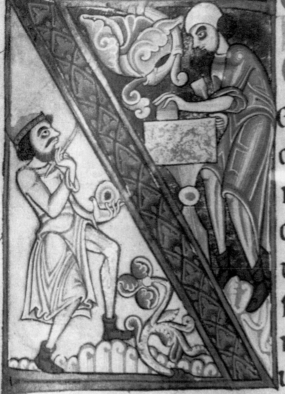

or colouring the self-same initial.[78] An anonymous lay illuminator is doing the same in an 'N' in the Dover Bible, made probably at Canterbury in the mid twelfth century, while his assistant is again represented preparing his colours (fig. 26).[79] Isidorus 'doctor bonus', who was probably a canon of the Cathedral of Padua, shows himself writing the inscription in which he says he executed the pictures in his Gospels (fig. 27).[80] His pen is once again on the letter 'x' of 'finxit', in a clever conceit which draws attention both to his making of the manuscript ('finxit' – he made it) and shows him as if in the process of actually writing it.

Two other representations reflect yet other possibilities at this time. A manuscript in Strasbourg dated 1154 shows the collaboration of the nun, Guta, as scribe and the priest, Sintram, as artist.[81] Guta was a nun in the convent of Schwarzenthann and Sintram a canon in the Augustinian house of Marbach, and Sintram shows them adoring the Virgin with long accompanying texts explaining their collaboration (fig. 28). A Homiliary in Frankfurt has a signed self-portrait of another Guta, describing herself as the sinner who had both written and painted ('pinxit') the book (fig. 29).[82] This demonstrates that nuns could work as illuminators. It seems unlikely to me, however, that in another initial, the 'Q' for Psalm 51

Suscipiam virgo memor huius pauperis et tu. — Dulcis amanda pia spes nostra beata Maria. Affectu matris nostri simul memor. — Per te fili Iesse quod dicor deprecor esse.

Presentiu utilitatz. ac animarum salutis buide sulere
uolens. Ego peccatrx z utina ultima mecu depascentis gregis
ouicula GVTA ut in libro uite scribi. ac in pascuis ui
rentib' depasci mererer. hunc libru famulante calamo manus.
summaq; deuotione suppeditante animi scribendo explicui.
Vt aut sanctissima di genitr MARIA ei qm obumbratio
ne sps sci digna cipere meruit. me misera. suoq; intuentu
indigna. in exitu egypti. ac indie iudicii offerre dignet. hunc
eunde librum spe salutis etne offero. meq; meliora de ipsa spe
rans. sue fidissime tuitioni committo. Committo itaq quam

29. Frankfurt, Stadt- und Universitätsbibliothek, Ms. Barth. 42, folio 110v. Homiliary. Initial 'D' with self-portrait of Guta.

30. Copenhagen, Kongelige Bibliotek, Ms. 4.2°, volume 1, folio 183. Bible. Initial 'D' with parchmenter.

31. Baltimore, Walters Art Gallery, W. 26, folio 64. Psalter. Initial 'Q' with Claricia.

in a twelfth-century Psalter, it is a female illuminator who is shown (fig. 31).[83] Her name is given as Claricia and as Dorothy Miner admitted, in her pioneering discussion of women illuminators, she is certainly secular, in fact ultra-fashionable with her long sleeves.[84] The text, very familiar in the Middle Ages, especially in a monastic context, reads: 'Why dost thou boast in malice ... thy tongue deviseth mischiefs like a sharp razor'. This seems to be more likely to be a negative comment on females as gossips, perhaps even with a specific Claricia in mind, rather than a self-portrait by a woman artist.

It would, of course, be a mistake to imply that religious, whether Benedictine monks, or members of other religious orders, or secular clergy, ceased to work as scribes and illuminators in the later Middle Ages. To mention only the best-known examples, the Carthusians continued to be active, particularly as scribes, and mainly copying texts for their own use,[85] while the Brethren and Sisters of the Common Life in the Netherlands in the fifteenth century helped to support themselves by their work as copyists and illuminators.[86] Nevertheless there is

a significant shift in the later Middle Ages. The changes taking place in the transitional period towards lay, paid, and in that sense professional artisans, are well-represented in a remarkable series of historiated initials in a three-volume Bible written in 1255 for the Dean of Hamburg Cathedral, Bertoldus, by a scribe Carolus.[87] They show, in contrast to the earlier exclusively monastic craftsmen at Bamberg (see fig. 15), secular and ecclesiastical craftsmen collaborating. In one initial, a secular parchmenter is shown providing the donor with a prepared animal skin (fig. 30). Another initial shows a scribe, presumably representing St Jerome since he is haloed and the initial introduces the prologue to Kings. Nevertheless this is a self-referential image of a scribe ruling his page for writing (fig. 32). A third initial shows an illuminator wearing a similar cap to the artist of the Dover Bible (see fig. 26), and thus secular, painting a human head, perhaps a self-portrait, with his paint dishes on his lectern beside him (fig. 33). It is significant that the illuminator places himself in the tail of the initial 'A' of the Apocalypse, once again underlining the connection between the

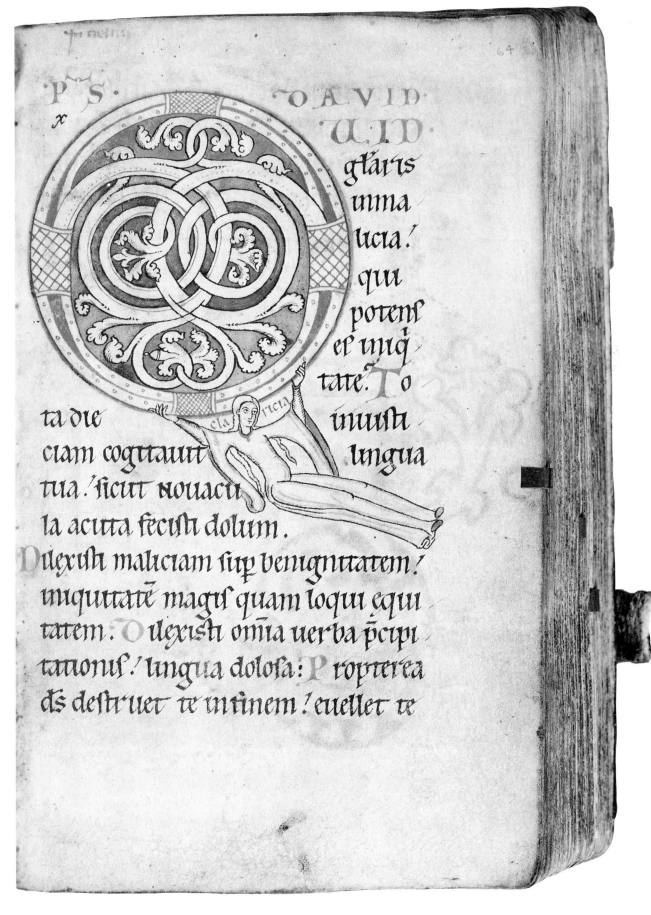

P̄S·
x

O̅ DAVID·
UID·

glaris
inma
licia·
qui
potens
es̅ iniq̅
tate. To
inuisti
lingua

ta die
ciam cogitauit
tua·sicut nouacu
la acuta fecisti dolum·
Dilexisti maliciam sup̄ benignitatem·
iniquitatē magis quam loqui equi
tatem· Dilexisti omīa uerba p̄cipi
tationis· lingua dolosa: Propterea
d̅s destruet te infinem· euellet te

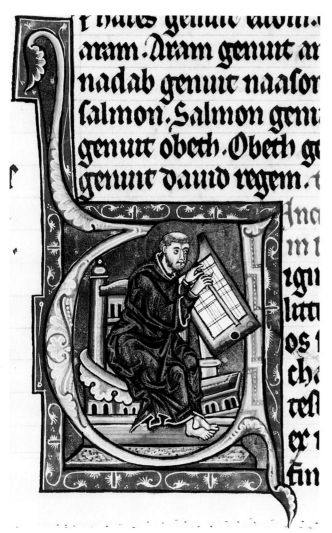

32. Copenhagen, Kongelige Bibliotek, Ms. 4.2°, volume 2, folio 137v. Bible. Initial 'V'. St Jerome as a scribe ruling parchment.

33. Copenhagen, Kongelige Bibliotek, Ms. 4.2°, volume 3, folio 208. Bible. Initial 'A' (detail) with self-portrait of illuminator painting a head.

signature or portrait and the prayer for salvation at the Last Judgment.

In the thirteenth century, the written sources on book production and illumination begin to increase very notably. The key factor is that the lay artists, who now begin to predominate, are property owners and thus they figure in legal documents, in accounts and in taxation lists. A whole new range of documentation opens up.

For example, the surviving production makes clear that Paris becomes a major centre of illumination in the thirteenth century, a fact to which Dante alludes in Purgatorio XI when he speaks 'of the art which in Paris they call illumination'.[88] The University was granted statutes by Pope Innocent III in 1215. The demand for books by masters and students had to be met by a greatly increased number of people to produce them and led to new methods of organisation and control.[89] The University needed to regulate, as far as it could, two matters. The first concerned the provision of good texts and thus the *exemplaria* were controlled and the 'pecia' system of

copying texts in sections evolved.[90] The second was the pricing of books whether new or secondhand. In both matters the *librarius*, fulfilling functions now assigned to publishers and booksellers separately, was the key figure who acted as middleman between the trade and the client.[91] The University appointed a limited number of accredited *librarii* who had to take an oath to abide by the University's regulations. There was considerable friction over these oaths and the University's attempts to control prices. In 1316, for example, a number of *librarii* refused to swear. The total swearing in 1323 and again in 1342 was twenty-eight.[92] The four 'grands libraires' had the overall supervision of the regulations and responsibility for valuations and prices which had to be clearly displayed in the shop. Regulations and statutes exist for 1275, 1316, 1323 and 1342, and these and other documents, such as the oaths of obedience sworn by the *librarii* (serments), are printed by Delalain.[93] In 1307, Philip IV exempted the *librarii* from taxes and his direction to the Prévôt of Paris survives, as do letters patent of Charles V of 1368

granting exemption from city guard duties.[94] These were valuable privileges and the University was now in a much stronger position to bargain with the *librarii*. Legal disputes were held before the Rector of the University or, if more serious, before the Bishop of Paris or later the Prévôt. It seems, however, that the theoretical monopoly which the *librarii* had in return for their oath of allegiance was often broken. Thus letters patent of Charles VI of 1411 repeat the prohibition forbidding any but the accredited *librarii* to keep a shop or to sell books for more than ten sous.[95] The document states that unauthorised persons were selling books in churches and secretly.

The regulations imposed by the University were only effective internally in dealings with members of the University, and it is important to stress that they did not affect outside dealings, which must often have been the most lucrative part of the trade when it involved luxury illuminated manuscripts.[96]

Illuminators are, of course, frequently mentioned in the documents.[97] The 1292 tax roll which lists taxes imposed on the citizens of Paris was published as early as 1837 by Géraud.[98] As Philip IV had not yet granted exemption, the document includes eight librarians (libraires), twenty-four scribes (escrivains), eleven writing masters (maistres d'ecole escrivains), one scrivener (escriturier), thirteen illuminators (enlumineurs), nineteen sellers of parchment (parcheminiers), one seller of ink (encrier) who was a woman, and seventeen binders (lieurs).[99] In each case we have addresses and details of the tax paid. Amongst the illuminators is Master Honoré, from whose shop in the rue Erembourc-de-Brie in Paris a copy of Gratian was bought for forty Paris livres in 1288, according to a partially legible note written in it by its owner.[100] Later tax rolls of 1296, 1297–9, 1300 and 1313 survive, some of which have been published.[101]

An interesting aspect of the rolls is the number of foreigners, including several Englishmen and one Irishman, involved as scribes and even librarians.[102] Paris, due to the University, housed an international community. The rolls also give us an opportunity to compare the wealth of people involved in the book trade relative to other trades people, though naturally there are problems of interpretation. Robert Branner has published relevant parts of lists for the burg of Ste Geneviève, the area around the University where many members of the book trade lived, for the years 1239–43 and 1247–59. Comparisons with a carpenter, a seal cutter and a glove maker show scribes and illuminators relatively well off, some owning two or even three houses.[103] In 1339, the University imposed an extraordinary tax and illuminators are mentioned.[104] In the Letter patent of 1368 there are fourteen librarians, eleven scribes, fifteen illuminators and six binders.[105] Of course, both scribes and illuminators could become librarians and continue their work as well. The names given include a number of women, for example, Jeanne, widow of Richard de Montbaston, who continued the business and was also an illuminator.[106]

It is noticeable how few of these thirteenth-century illuminators identified themselves in their works by signatures or added self-portraits, compared to their twelfth-century predecessors, and this may be explained by the changed circumstances in which they worked and their social situation and status relative to those for whom they worked. Exceptions are the Magister Alexander who signed a Bible, and Gautier Lebaube whose name occurs on a scroll held by a tonsured figure on the left and a cloaked, apparently lay figure on the right below a Tree of Consanguinity detached from a copy of Gratian's Decretum (fig. 34).[107] Branner took the tonsured figure to be the scribe, less probably Gratian, and the lay figure to be Gautier whom he believed to be the illuminator.[108] Undoubtedly a self-portrait, though anonymous, is the illuminator shown with a paint brush, half-length attached to a flower, at the tail of a 'P' in a Bible of *c.* 1300 (fig. 35).[109] He uses the same conceit, seen already in the twelfth century, of showing himself as if in the act of painting the initial. He also holds in his left hand a palette, perhaps the first representation of this object since antiquity.

Other University cities such as Oxford and Bologna provide comparable documentation on the book trade. At

34. New York, Pierpont Morgan Library, Glazier 37. Tree of Consanguinity. The illuminator Gautier Lebaube.

35. Reims, Bibliothèque municipale, Ms. 40, folio 83v. Bible. Initial 'P' with illuminator.

36. London, British Library, Royal 14 C. VII, folio 6. Chronicle. Self-portrait of Matthew Paris of St Albans praying to the Virgin.

37. London, British Library, Add. 49999, folio 43. Book of Hours. Initial 'C' with self-portrait of William de Brailes.

38. Cambridge, Fitzwilliam Museum, Ms. 330, leaf 3. Self-portrait of William de Brailes rescued by his guardian angel (halfroundel, lower right).

Oxford, members of the book trade similarly lived in the area near the University Church, St Mary's, and documents concerned with properties owned by William de Brailes in Catte Street beside the Church from *c.* 1230–60 have been published.[110] De Brailes is one of the few identifiable English illuminators of the period, since he left self-portraits in two of his manuscripts, signed respectively in Latin and French (figs 37–8).[111] He shows himself as tonsured but, since he was married, must have been in minor orders. The other English thirteenth-century illuminator to leave a self-portrait is Matthew Paris, a monk of St Albans who died in 1257. His image of himself kneeling before the Virgin, which prefaces the third volume of his Chronicle (fig. 36), may be a self-conscious reference to earlier images of mon-

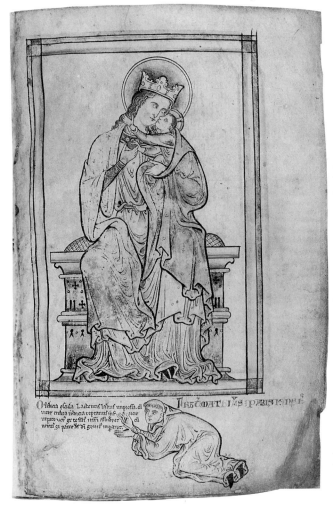

astic humility such as that of St Dunstan (see fig. 10), which he could even have known at first hand.[112]

Numerous documents on the book trade connected with the University of Bologna also exist.[113] These likewise show an international community, including a number of Englishmen and Scotsmen. Many of the documents are legal cases arising from brawls, and they give a vivid picture of a society in which arguments quickly turned to knife fights, often ending in murder. A Bible written in Bologna in the third quarter of the thirteenth century by an Englishman named Raulinus, who came from Fremington in Devon, contains some good quality Bolognese illumination.[114] Raulinus has left a series of extraordinary autobiographical notes in Latin and French in the manuscript, revealing that he spent two years studying the *artes* in Paris until he had spent all his money on prostitutes, and then came to Bologna to earn his living as a scribe. Once there, however, he continued to frequent the taverns and he also writes verses to Meldina, 'jewel of women'.[115] He ends with a colophon hoping for the Virgin's forgiveness for his sins. Other manuscripts written on parchment prepared in the Italian way by Bolognese scribes have both Italian and French style illumination, though it is not always easy to determine in such cases whether there were French illuminators at work in Bologna, whether Italian illuminators copied French styles, or whether, as also often happened, especially in law books, the illumination was completed when a patron returned home with his purchase.[116]

The Bologna documents include contracts for writing books, as well as information about the time taken to produce a book and as to payments made for writing and illumination. For example, in 1327, the Guild of Notaries pay Lorenzo di Stefano, notary and scribe, four lire for writing out their Statutes on four quires of paper, forty Bolognese soldi for illumination and rubrication, which is not described in detail, and ten soldi for the binding.[117] In 1277, a scribe is paid twenty-eight soldi a quire, and in 1287 another scribe thirteen soldi a quire.[118] In 1344, the Notaries pay ten lire to Jacopo, the miniaturist, and to

Petrus de Villola, for writing and illuminating a new preface to replace the old one in their matricola.[119] Jacopo painted the arms of 'our Lords (dominorum nostrorum)' and repaired or more likely replaced (reparavit) the miniatures (figuras), which is interesting as prefatory miniatures in Italian matricole are quite often re-used.[120] In 1286, Alberto di Ugolino da Firenze contracted to write a Decretals in eighteen months for thirty-eight lire.[121]

Much more work would be necessary in order to compare the valuations and prices of books to determine the proportion of payment for materials, for writing and illumination and for binding, and to compare these prices with those for other commodities and services.[122] There is a mass of relevant material surviving in accounts, inventories and wills. Sometimes notes of payment survive in the manuscripts themselves. Marks found in the margins in late twelfth- and early thirteenth-century manuscripts were inserted, it seems, for a variety of purposes during the process of illumination, which may have included counting initials in a quire so that they could be totalled and paid for, so much each.[123]

A good example of the process is in a Pontifical made at Avignon in the second quarter of the fourteenth century.[124] Its illumination was not completed, and when it came into the hands of the Anti-Pope, Benedict XIII (1394–1424), the task of completion was given to a Spanish illuminator, Sancius Gonter. On folio 4 verso, in the lower margin, a list estimates the number of plain gold initials on coloured grounds, of painted foliage initials and of historiated initials to be inserted (fig. 39).[125] On the same folio occur examples of the first two kinds of initials, and a note by each in the margin specifies what they cost: 'the price of the letters which are called "champide" 8d (*i.e.* denarii, pence) each'.[126] Such plain initials are referred to in both English and French documents as 'champs'. By another initial, above, which has foliage ornament is written: 'the price of the letters without figures 18d'.[127] On folio 4, beside what is now termed an 'historiated' initial, is written: 'the price of the

39. Paris, Bibliothèque nationale, latin 968, folio 4v. Pontifical. Notes of payment for 'champ' initials.

40. Paris, Bibliothèque nationale, latin 968, folio 4. Pontifical. Note of payment for an historiated initial.

41. Paris, Bibliothèque nationale, latin 11935, folio 642. Bible. Signature of the scribe, Robert de Billyng, with names of Jean Pucelle and his collaborators.

initials with figures one gros' (fig. 40).[128] At the end of the manuscript when all the work has finally been done the totals are recorded and the cost calculated and Sancius gives a receipt for the payment.[129] As is well-known, similar notes of payment occur in the Belleville Breviary, giving the names of Jean Pucelle and his colleagues,[130] and these same artists are listed in the colophon of the Bible written in Paris in 1327 by Robert de Billyng (fig. 41)[131] One of them, Jaquet Maci, now identified by François Avril as the artist responsible for the penwork decoration in these manuscripts, also signed his name with that of his apprentice, Laurentius, in the border of a copy of Augustine's Letters (fig. 42).[132]

In the fourteenth century we begin to hear of illumi-nators specifically employed in royal and other house-holds. One consequence, which may even have been a contributory factor, was to free them from the University and Guild regulations. Thus Jean le Bon of France's accounts show payments to Jean de Montmartre in 1352.[133] Philippa of Hainault, Queen of Edward III, had her own illuminator, Master Robert, at about the same time.[134] Payment to him is recorded along with other

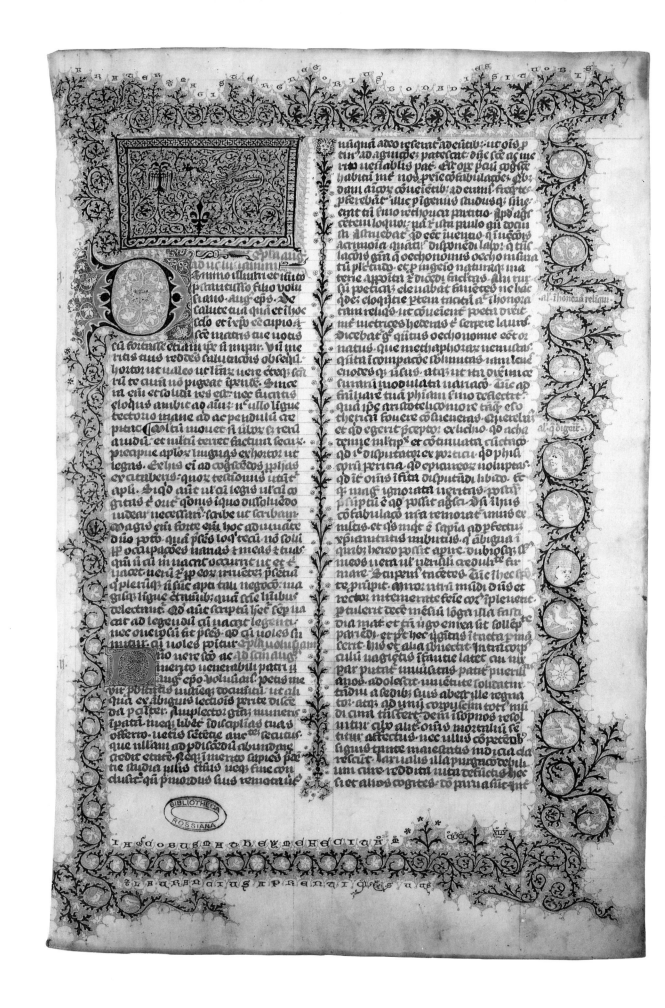

42. Vatican, Biblioteca Apostolica Vaticana, Rossiana Ms. 259, folio 1. Augustine, Letters. Signature of Jaquet Maci.

43. London, British Library, Cotton Nero D. I, folio 156. Matthew Paris, Lives of the Offas. Drawing of the Apocalyptic Christ by Fr William, O.F.M.

44. Bonn, Universitätsbibliothek, Cod. 384, folio 2v. Gradual. Self-portrait of Fr Johannes de Valkenburg, O.F.M.

45. London, British Library, Harley 7026, folio 4v. Lectionary. Self-portrait of Fr Johannes Siferwas, O.P., with the patron, Lord Lovell.

members of her household, her cook and her midwife. The artists employed by Jean de Berry and Philippe le Hardi, Duke of Burgundy, as household servants, 'valets de chambre', included Jacquemart d'Hesdin and the Limbourg brothers.[135] A Dominican illuminator, John Teye, was employed at Pleshey Castle by Humphrey de Bohun, Earl of Hereford, in the 1370s.[136]

It should be remarked that there seem to be quite a number of examples of mendicants working as illuminators. Matthew Paris preserved in his commonplace book a drawing of Christ by Brother William the Englishman (fig. 43).[137] Johannes de Valkenburg who signed and dated two Graduals in Cologne in 1299, shows himself in a Franciscan habit (fig. 44).[138] In the 1320s, Hugo the

illuminator, an Irish Franciscan, made a pilgrimage to the Holy Land.[139] John Siferwas, a Dominican, was evidently, to judge from the surviving works, one of the most important illuminators working in London in the early years of the fifteenth century. He left his self-portrait presenting the Lectionary made for Salisbury Cathedral to the patron, John, fifth Lord Lovell, who died in 1408 (fig. 45), as well as a number of self-portraits together with the scribe in the Sherborne Missal.[140] Frater Petrus de Pavia who signed his name in the stem of the initial 'M' containing his self-portrait may also have been a friar, Dominican or Augustinian (fig. 46).[141] Jacobus Muriolus of Salerno was certainly a Dominican. He tells us in an Antiphonal that he wrote, put in the musical notation and illuminated the manuscript.[142] He further tells us that it was his first work, though unfortunately he gives no indication of how he learnt to do it.

In conclusion, something should be said of the Guilds and Confraternities to which illuminators belonged in the later Middle Ages.[143] Though there still seem to be uncertainities and a need for further clarification, it seems that illuminators sometimes joined Guilds with scribes and sometimes with painters. The Paris Statutes of 1391 of the company of St Luke to which painters and sculptors belonged, do not mention illuminators.[144] The Statutes include regulations concerning the quality of materials and forbidding the import for sale of objects made outside France, that is in Germany or elsewhere. The Statutes also specify that a craftsman may only take one apprentice, though in the earlier *Livre des métiers* of

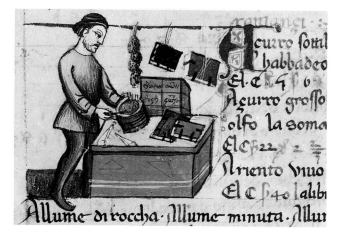

47. Florence, Biblioteca Riccardiana, Ms. 2526, folio 13v. *Stratto delle Porte. Libro di Gabelle fiorentine*. Books hanging up for sale.

Etienne Boileau, Prévôt of Paris, of *c.* 1268, no limit is specified.[145] The scribes' Confraternity had St John the Evangelist as its patron saint. The earliest known document is a letter patent of 1401 listing by name four scribes, one illuminator, one 'librairc' and three binders, with others unnamed of the same professions.[146] More work on other known centres of manuscript production in France needs to be done.[147]

In Florence illuminators like painters belonged to the Guild of the Medici e Speciali, whose members dealt also in the raw materials, that is especially the pigments, used by artists.[148] A toll list for the gates of Florence, written in the second half of the fourteenth century, shows a member of the Guild, a druggist, grinding powders whilst above him books are hanging up for sale (fig. 47).[149] When, in 1348, the painters formed a Confraternity dedicated to St Luke, illuminators also joined it.[150] Ciasca gives a breakdown of profession of the members of the Medici e Speciali with totals of painters and illuminators for the years 1320, eighteen and none respectively, 1353–86, fifty-eight and none, 1386–1409, thirty-four and three, 1409–44, forty-one and one. In the same four period divisions, the *cartolai*, the equivalent of the Paris *libraires*, number eleven, twenty-five, ten and sixteen.[151] Again, it is difficult to know how to interpret these figures, and how to account for the very small number of illuminators recorded. Is it that some are listed as painters, or is it that few, if any, qualified by wealth to be members of the Guild? In Perugia there was an Arte degli Miniatori from as early as 1310,[152] and similar Guilds can be found in most other comparable Italian cities in the fourteenth century.

Weale published some important documents concerning illuminators at Bruges and their Guild.[153] In 1426, the Painters' Guild complained of the importation by the text writers (ecrivains) of single leaf miniatures made in Utrecht, and this was duly prohibited.[154] In 1447, illuminators were prohibited from using any other colours than water colours. Oil paints and gold or silver

46. Milan, Biblioteca Ambrosiana, E.24 inf., folio 332. Pliny the Elder, Natural History. Initial 'M' with self-portrait of Fr Petrus de Pavia.

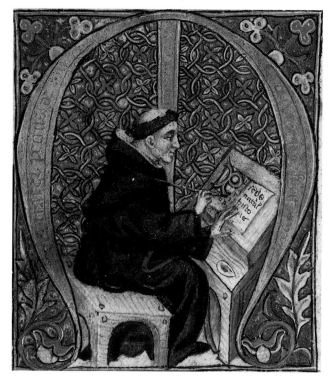

could only be used by members of the Painters' Guild.[155] In 1457, the profession of illuminator was declared to be one which could only be exercised by citizens.[156] In the same year, 1457, the members of the book trade, that is the text writers, the illuminators, the binders and the image makers in rolls, formed a Confraternity dedicated to St John.[157] The first account of the members' contributions shows there were forty-four men and six women members, the former including Willem Vrelant to whom a body of surviving work has been attributed.[158] Illuminators had to belong also to the Painters' Guild. The illuminator, Alexander Bening, was admitted to the Bruges Painters' Guild in 1486, having earlier become a member of that in Ghent in 1469, being sponsored for the latter by Hugo van der Goes and Justus van Ghent.[159]

In London the court-hand writers, text writers and lymners (illuminators) are exempted from Jury service in 1357, and this implies the existence of a Guild by this date.[160] The earliest surviving evidence of a separate Lymners' Guild is of 1389. In 1403, the lymners and the text writers amalgamated to form a single Guild and this, by the 1440s, was to be known as the Mistery of Stationers. Unfortunately, the early Guild records are lost. Links evidently existed between lymners and binders. For example, Sir John Oldcastle was charged, in 1413, with having left an heretical Lollard work in Paternoster Row to be illuminated and bound. Other English towns had similar Guild organisations, and the Statutes of the Guild of text writers in York of 1495 survive, for example.[161] There, the text writers had formed a company late in the reign of Edward III, and their laws were entered in the city archives in 1377, the first year of Richard II.[162] They included, according to Moran, 'limners', 'turnours' (drawers of initial letters and borders) and 'notours' (responsible for musical notation). In addition to banning outside competition from those who were not Freemen of the city, it is interesting to find that the Company wished to prevent lower ecclesiastics from exercising any of the crafts of writing or illumination, and from taking pupils. Priests with a competent salary, defined as eight marks a year, were prohibited from such work unless for their own use or for charity. In 1495, a priest named Richard Flint claimed exemption on the grounds that he had not 'towards his salary over four marks by the year'.

By the mid-fifteenth century, the book trade in general was highly organised and must have employed large numbers of people.[163] Very large numbers of manuscripts still survive from this century, and many of them are illuminated with large numbers of pictures. It was un-

48. London, British Library, Cotton Nero D. VII, folio 108. St Albans' Benefactors' Book. Self-portrait of Alan Strayler.

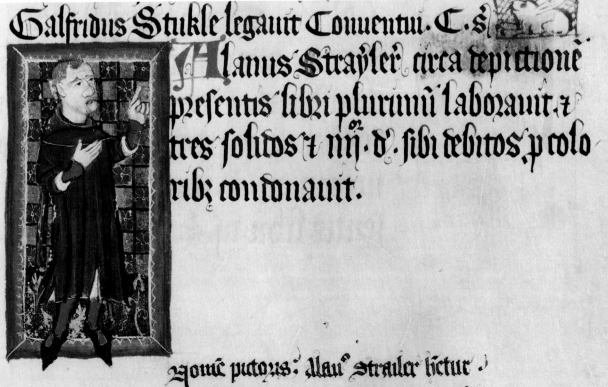

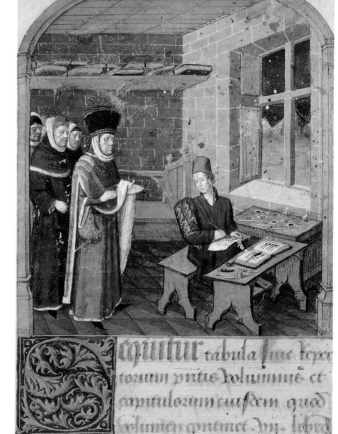

49. Paris, Bibliothèque nationale, latin 4915, folio 1. Giovanni Colonna, *Mare Historiarum*. Self-portrait of an anonymous illuminator receiving visitors.

50. Stuttgart, Württembergische Landesbibliothek, Cod. mus. I. fol. 65, folio 236ᵛ. Gradual. Self-portrait of Nicolaus Bertschi with his wife, Margaret.

doubtedly a major trade and by now, many of the illuminators must have been comparatively wealthy members of the community, especially those called regularly to work for great patrons such as Philip the Good of Burgundy or the Kings of Naples.

The way payment was calculated for miniatures, and for the very large numbers of small initials in three surviving manuscripts illuminated by Lieven van Lathem for Philip the Good, has been analysed by Anton de Schryver.[164] Some significant information also survives concerning payments to the painter and illuminator Simon Marmion.[165] Sandra Hindman observes that he was paid roughly the same amount for a single miniature as it cost him in 1463 to have the thatched roof of his house in Valenciennes replaced by a tiled roof – that is, just over four livres. Anne van Buren has deduced that three livres de Flandres was a normal payment for a miniature at this period in the Netherlands, and that to survive a miniaturist would need to paint some sixty a year.[166]

To conclude this Chapter, some representations of illuminators give a sense of their status and their self-image. One, of *c.* 1380 for example, is in the St Albans' Abbey Benefactors' Book.[167] It shows Alan Strayler, who is recorded in the manuscript as having worked hard at painting it, and as having donated three shillings and four

pence owed him for colours (fig. 48). Strayler thus appears in company with royal and ecclesiastical donors of exalted rank. A second representation is in a copy of Giovanni Colonna's *Mare Historiarum* of 1448–9.[168] It shows a powerful patron, Jean Jouvenel des Ursins, Chancellor of France, visiting an illuminator at work who, since he wears the Chancellor's emblem on his sleeve, must be in his personal employ (fig. 49). The illuminator remains seated in his presence, however, and the scene is modelled on others where patrons visit authors in their studies, which in itself implies a claim to exalted status. A third illuminator, Nicolaus Bertschi, shows himself at work on a lectern at a table with his wife, Margaret, beside him, apparently bringing him liquid refreshment![169] The scribe, Leonhard Wagner, sits at the desk opposite (fig. 50).

In the sixteenth century, the new genre of the portrait miniature develops and in its earlier stages has connections with the work of illuminators.[170] The two versions of a self-portrait made by Simon Bening of Bruges seem to be portrait miniatures, rather than self-portraits from a manuscript (fig. 51).[171] Bening must have been one of the most successful and highly rewarded illuminators of his period, in terms of the patronage he received. His clientele was international and included, for example, Cardinal Albrecht of Brandenburg and the Infante Dom

Ad summa missaz Sequn.
bn notkeri modu sanct

n q sibi laus est eterna. galli ppositoris sequinaz

Atus ante secula dei filius inuisi

bilis interimmus Per que

sit machma celi et terre maris et in hys degen

au Per que dies et hore labant et se iterum re

aprocant Que angeli in arce poli voce co

sona semp camit Hic corpus assumpserat

fragle sine labe originalis criminis de carne

marie virginis quo prinu parctus culpa cuictz

la sauma tergeret Hec presens dicuila loq

M·D·XII

Nicolaus Bertschy
Illuminista Auguste
vxor eius Margareta

Fernando, brother of King John III of Portugal.[172] The portraits make clear his status. He shows himself as elderly, by now, and needing glasses, but a grand bourgeois, as his costume indicates, and owner of a well-furnished house where he works at his desk by the window.

In a final example of an illuminator's self-portrait in the border of a Gradual illuminated as late as 1532, the artist, Bartolomeo Neroni of Siena, called il Riccio, also active as a painter and architect, still shows himself in conjunction with the scribe on the left and the Olivetan Abbot, his patron, in the centre (fig. 52).[173] The convention, which was already established in the twelfth century in the self-portraits by Felix or Hildebertus (figs 17, 18), still operates here, though the placement again implies that by now a more equal status exists between artist and patron.

51. London, Victoria and Albert Museum, P. 159-1910. Self-portrait of Simon Bening.

52. Genoa, Biblioteca Civica Berio, Cf. 3. 2, folio 1. Gradual. Self-portrait of Bartolomeo Neroni.

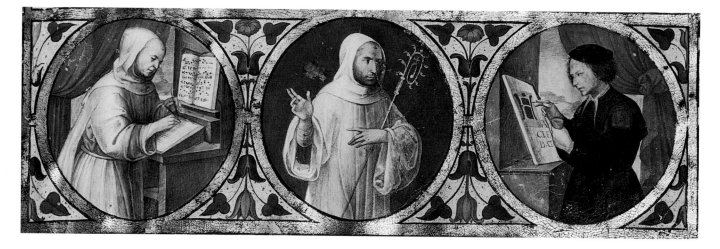

Chapter 2

Technical Aspects of the Illumination of a Manuscript

In this Chapter, the surviving evidence as to the materials and the technical processes of medieval illuminators will be briefly reviewed as a prelude to asking some more general questions about the planning of the illustration and decoration of a medieval manuscript, and the instructions given to illuminators.

There were three main materials on which the illuminator worked in the period under consideration. First, papyrus made from the Nile reed; second, and the most important for our purposes, parchment or vellum, that is prepared animal skin, usually of cow, goat or sheep, and lastly paper.[1] Papyrus was the main writing material of the ancient world. Sheets were glued together and rolled up into scrolls of varying length which were written in short columns and read horizontally. It was flexible but it can never have provided a very stable surface for paint. Weitzmann's theory is that, though illustration of all kinds of texts was executed on papyrus in ancient Greece, and earlier still in Egypt, it was the changeover under the Roman Empire in the second to fourth centuries AD from roll to codex that is to the type of book we are still familiar with, which revolutionised the art of book painting.[2] The artist was now provided with a surface which was both relatively stable and protected within the covers of the book, and which also by its shape invited comparison with a framed picture.[3] Some early *codices* continued to be made of papyrus, but parchment came to replace papyrus, in part for economic reasons as trade in the Mediterranean world contracted; in part, no doubt, for practicality; and perhaps, it has also been suggested, in connection with the spread of Christianity.[4]

A fourth type of writing surface was the wax tablet.[5] Though no example apparently survives of a wax tablet with a drawing incised on it, two early literary references show that they were in fact used in this way to convey information by graphic means. The first is the account by Adomnán of Iona (*d.* 704) of the Holy Places, in which he included representations of the Holy Sepulchre and other churches. He says that these were based on drawings on wax tablets furnished by the pilgrim Arculf.[6] The second is the account by Gerald of Wales (*d. c.* 1220) of the Gospels of St Bridget, a manuscript which from his description sounds as if it was very similar to the Book of Kells. Gerald says that an angel furnished designs ('figuras') for the pages on a wax tablet.[7] Since both of these accounts concern the early Middle Ages, it may be that wax tablets were used for drawings, at a period when writing materials were scarcer and more costly. In any event, wax tablets can only have been used for relatively impermanent and relatively simple or diagrammatic drawings.

Parchment, on the other hand, is an ideal material for illumination. Not only does it provide a very receptive surface for writing and illumination, but it can be manufactured from various animal skins to give different colour, weight and size, and then further prepared to control surface qualities.[8] It remained the preferred material for luxury books in the West, long after paper began to be commonly used in the thirteenth century; and even after the invention of printing, special copies (those required as presentation gifts for example), would still be printed on parchment.[9]

That the parchment surface was a matter of concern to illuminators is shown by the practice of sticking in parchment patches on which miniatures were then executed. One well-known example is in the Bible made for Bury St Edmunds at the order of Prior Talbot about 1135.[10] The Abbey Chronicle, in recounting this, says that the artist, Magister Hugo, sent for fine parchment 'in partibus Scottiae', that is Ireland. The parchment for the Bible of S. Isidoro, León, of 1162 was brought from France to Spain according to its colophon.[11] The three volumes were then written in six months and illuminated in a seventh.

Other examples of parchment patches being stuck in for the miniatures include the Carolingian Bible of San Paolo fuori le Mure of *c.* 870, the Lothian Bible from St Albans of the early thirteenth century, and the Lives of St Alban and Amphibalus illuminated by Matthew Paris of St Albans in the mid thirteenth century. The practice continued into the fifteenth century.[12] It has had unfortunate consequences in that many miniatures have either lifted or been peeled off and are now lost. This has happened in the Bury Bible, and another example is a late twelfth-century Life of St Cuthbert, made no doubt at Durham, where the outline of the miniature can be

53. London, British Library, Add. 39943, folio 9. Life of St Cuthbert. Space where a miniature on pasted-in parchment has been removed.

century miniature from St Michael's, Bamberg (see fig. 15), shows a monk scraping parchment on a frame.[18] In a Bible of 1255, a secular parchmenter is represented (see fig. 30), however, and a shop with parchment being prepared and displayed for sale is shown in a fourteenth-century Bolognese manuscript (fig. 54).[19] Even in the early Middle Ages it is likely that parchment was manufactured commercially, and not by the monks themselves, in most cases. In the later Middle Ages, major centres at least had specialist providers of parchment, and in Paris, for example, there were nineteen parchmenters listed on the 1292 tax roll.[20] Numerous records exist of the purchase of parchment for use by the English Royal Chancery.[21] The Norwich Cathedral Priory accounts rolls give details of the sums spent on parchment in the late thirteenth and early fourteenth century, as do those of Ely.[22] In Milan, in the late fourteenth century, parchment could be bought in three standard sizes and already arranged in gatherings.[23]

It would certainly be interesting to put together information on the cost of parchment, and to get an idea in this way of what percentage of the price of a book this basic raw material represented.[24] As noted in the previous Chapter, there is a great deal of information surviving in accounts and, more rarely, in notes in the manuscripts themselves.[25] An example of a still surviving Bible, in which both donations for the work and costs of its completion are noted at the end of the last volume, is that from Calci, which was begun as a gift to San Vito in Pisa in 1168. The contributions of various named donors are listed first, and then various payments are recorded for the materials and the work.[26] Another detailed costing is that for the still-existing luxury Missal made for Abbot Litlyngton of Westminster in 1383–7.[27] The initial payments of 1383–4 included £4 6s 8d for parchment, consisting of thirteen quires of twelve folios each. There was a further payment in 1386–7 of £1 1s for three further quires of twelve folios at 7s each. The scribe, Thomas Preston, was paid £4, but he also had board and lodging for at least twenty-six weeks of the two years it took him to write the Missal and also a Cloth of Livery worth 20s. The cost of the illumination included £22 0s 3d for the large letters ('grossae litterae') and 10s for the 'pictura', the whole-page miniature of the Crucifixion, both sums paid in the earlier account. In the later account £3 10s 11d was paid for illumination and binding to Thomas Rolf. £6 2s 7d had already been paid for binding expenses in the earlier account. The sums recorded as paid out for the Missal came to £34 14s 7d in 1383–4 and £4 16s 3d in 1386–7, making a total of £39 10s 10d.[28]

An even more complete break-down of the total expenses of producing a manuscript survives in connection with the gift, by the City of Amiens, of a copy of the

clearly seen, and also the overlap where the artist has painted a horse's tail extending on to the surface of the manuscript folio (fig. 53).[13]

Another aspect of the use of parchment, indicating how precious it was – particularly in the early Middle Ages – is the retention of folios with holes in them, caused by wounds or weakening of the animal's hide due to insect bites.[14] In certain early Insular manuscripts, the artist has decorated the flaws.[15]

In the later Middle Ages, it was a regular practice to paint miniatures on single leaves which could then be inserted into the regular gatherings of manuscripts, particularly Books of Hours. This was often done for commercial reasons, no doubt, facilitating a form of serial production or in order to avoid taxes or dues.[16] However, on occasion it may also have been a matter of economy in providing a finer prepared surface for the miniatures only, thus saving labour and expense.[17]

No general study exists of how parchment was obtained in the early Middle Ages. The early twelfth-

54. Bologna, Biblioteca Universitaria, Ms. 1465, folio 3. Villola, *Memorie*. Parchment-seller's shop.

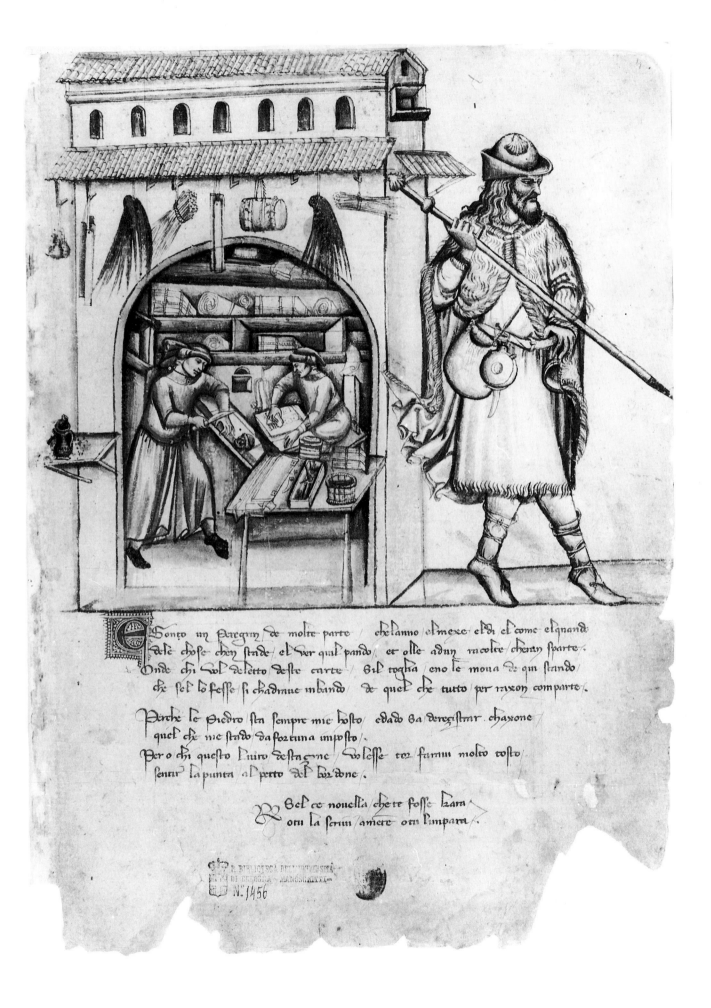

E sonto un peregrin de molte parte · chelanno el mexe el di el come el quand
de le chose chen stade · el per qual pando · et ose adun racolte chenin sparte ·
Onde chi vol delecto deste carte · sil toglia · eno le mona de qui stando ·
che sel lo fesse si chadrine inbando · de quel che tutto per raxon comparte ·

Perche le pedro sta sempre mie hosto · edad sa deregistrar chaxone
quel che mie stado da fortuna imposto ·
Pero chi questo l'niro destagne · volesse tor farmi molto tosto
sentir la punta a perto del burdone ·

Sel te nouella · che te fosse chara
otu la serim · amere · otu l'impara ·

R. BIBLIOTECA DELL'UNIVERSITÀ
DI BOLOGNA · MANOSCRITTI
N. 1456

55. Oxford, Wadham College, Ms. 2, folio 11. Gospels. Hardpoint drawing of St Matthew photographed by ultra-violet light.

56. Oxford, St John's College, Ms. 111, folio 19v. Glossed Gospel of St Mark. Graphite drawing of Christ on the Cross.

Chants royaux en l'honneur de la Vierge au Puy d'Amiens to Louise de Savoie in 1517–18. The price of the parchment was three livres fourteen sous. This is a relatively small sum in comparison to the payments to the scribe, the priest Jean de Beguines, of twelve livres; to Jacques Plastel, the artist who provided designs for the forty-eight miniatures ('tableaux'), of forty-five livres; to Jean Pinchon, the illuminator for the application of colours to these, of eighty livres; to Guy-le-Flameng for the initials ('grandes lettres'), of thirteen livres fourteen sous, and to Pierre Faveryn for the binding, of six livres. Other binding expenses totalled forty-four livres twelve sous. Jean Pinchon's 'ouvriers' were also paid fifty sous and there is a payment of twenty-four sous for the 'vin du marché' with the illuminator. Nicholas de la Motte 'rhetoricien' was paid forty sous for adding some ballades missing for several tableaux, and the expenses of the journey of the town's two representatives, who took the finished manuscript to Amboise, amounted to sixty-eight livres eight sous, calculated at one livre sixteen sous for thirty-six days. The total came to the enormous sum of three hundred and sixty-six livres.[29]

As to illuminators' tools we have various sources of information, the tools themselves which, where they survive, are usually difficult to date,[30] representations in

works of art, and descriptions in texts or inventories.[31] For drawing they could use either a hard point stylus of metal or bone, and such is recommended by Cennino Cennini in the late fourteenth century.[32] They also used graphite, what would nowadays be called a pencil, though it should be noted that both the English 'pencil' and the Latin 'penellum' were regularly used to mean brush, rather than pencil. The word 'plummet' is also used.[33] More research is needed into the nature of the graphite medium, and where and when it began to be used. Palaeographers have observed a change in ruling for the text, from the use of hard point to graphite, which occurs during the eleventh to twelfth century.[34] It may be that a similar change from the one instrument to the other for drawing took place at about the same time. If this could be established, could the two changes be connected and might the use of graphite for drawing have the primacy?[35]

Drawings in hard point or in graphite occur frequently throughout the Middle Ages in manuscripts which are unfinished.[36] They are often complex and of high aesthetic quality – anything but hasty sketches, even if incomplete. But they do not ever seem to have been regarded as finished products, as opposed to drawings in ink.[37] A striking example of hard-point drawing is a page from an Anglo-Saxon late eleventh-century Gospels

57. Winchester Cathedral Library. The Winchester Bible, folio 278v. Ecclesiastes. Initial 'U' with unfinished drawing in graphite strengthened with pen and gilt.

58. London, British Library, Harley 2798, folio 4v. Arnstein Bible. St Jerome. Graphite drawing with later pen strengthening.

which can only be seen clearly under ultra-violet light (fig. 55).[38] Sometimes graphite drawings were added on fly-leaves or in the margins with unknown purpose, perhaps as records or as studies, perhaps as meditations or even as 'doodles'. An example of high quality is the drawing of Christ crucified, added in the third quarter of the twelfth century to an English mid twelfth-century glossed Gospel of St Matthew (fig. 56).[39] Other graphite drawings, similarly placed and, apparently, without textual justification, occur in an Ottonian Gospels from Cologne of *c.* 1000.[40] More often the drawings are inked over, sometimes at the same date as, for example, in the Winchester Bible (fig. 57); sometimes, and often crudely, at a later date, as in the German Arnstein Bible of 1172 (fig. 58).[41]

Medieval illuminators also evolved a variety of techniques of finished drawings, using coloured inks in Anglo-Saxon manuscripts of the tenth and eleventh centuries, for example, as well as combinations of drawing and painting, ranging from light washes in English thirteenth-century Apocalypses (see figs 168–9), or fifteenth-century Flemish manuscripts, to *grisaille* with colour tinting in French fourteenth-century manuscripts (see figs 84, 107), to combinations of fully painted miniatures and drawings on the same page, or even in the

same miniature.[42]

There are various sources of information for the types of paints used by illuminators, though again there are many gaps, especially as to specific situations at specific times and places. A series of technical treatises starting in the ninth century with the *Mappae Clavicula*, which undoubtedly incorporates earlier practice, extends to the sixteenth century.[43] These give a great deal of information as to how colours were prepared and what materials were used, mineral or organic, natural or manufactured. Though some treatises must have circulated quite widely and survive in quite considerable numbers of manuscripts, usually together with other technical or scientific material, presumably expertise was mostly passed on verbally and through practical experience.[44]

Another source of information, examination of the pigments themselves, has been utilised relatively little for manuscripts as opposed to panel paintings and wall paintings. So far there has been a reluctance to take microsamples, and examination under high magnification and under special conditions of light reflection has been preferred.[45] Even this type of examination has been relatively little applied, and so far mainly to manuscripts of the earlier rather than the later Middle Ages. Of course, there are not the same problems of conservation of the

59. London, British Library, Royal 6 E. VI, folio 329. Encyclopedia of James le Palmer. Initial 'C' for 'Color'.

60. Vienna, Oesterreichische Nationalbibliothek, Cod. 2828, folio 2. Nikolaus of Dinkelsbühl. Unfinished initial 'D' with Moses receiving the Ten Commandments.

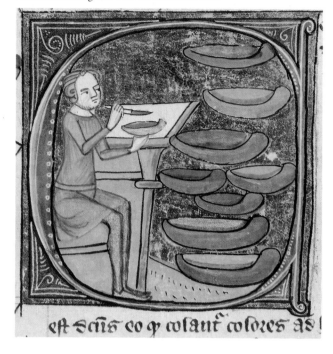

picture surface of illuminated manuscripts encountered in wall and panel paintings, and therefore not the same impetus to research.

Both for the earlier and the later period, we still have very little idea of how either the raw materials or the prepared paints were obtained.[46] Again, it is a matter of putting together scattered evidence, for example, customs levies or wills recording the contents of illuminators' shops.

It is well known that the best blue made from lapis lazuli was the most expensive colour, since the source of it was as far away as Afghanistan, and that the use of this and of metals, especially gold but also silver, denotes a luxury book.[47] These materials are often referred to in accounts, in contracts and in descriptions of works of art. But we are still imperfectly informed as to whether there were further hierarchies of colour.[48] In certain of the representations of illuminators already considered, pigments are shown in use (see figs 25, 33, 49). In the historiated initial for 'Color' in a fourteenth-century English encyclopedic compilation, the colours represented in the pans, as opposed to those discussed, are from the top down rose, yellow, green, orange, yellow, green, blue and pink (fig. 59).[49]

Minium, red sulphide of lead, used so commonly for minor initials and in simpler or plainer forms of decoration, particularly in earlier manuscripts, is the substance which gives its name to the whole activity of manuscript painting, 'miniare' to make a miniature. Only later by transference does the word come to mean 'small'.

The actual stages by which illuminators drew and painted their miniatures can be seen in the very numerous manuscripts whose illumination was never finished. In most manuscripts, though not necessarily in all, the text was written first.[50] In the majority of cases, therefore, the decision of *where*, with the implication it has on *how*, the illustration or decoration is placed and planned, had been made before the illuminators started their work. The extent to which alterations could be made was necessarily limited, though there are examples of insertion of extra leaves, and of deletion and recopying of text. The twelfth-century Winchester Bible is an example of radical changes of plan taking place with the addition of whole-page miniatures, whereas originally only historiated and other initials were intended. As a result, text had to be recopied.[51]

Before a scribe started to work, the page had to be ruled. It is the general, or at least by far the commonest practice throughout the Middle Ages, for this scribal ruling to dictate the format of the miniatures, borders, and initials; that is, for them at least to conform to the column of script in width and to the lines of script in height.[52] It has been shown that in Parisian illuminated manuscripts of the early fifteenth century, the page ruling might affect not just the format of a miniature, but its internal spatial organisation and objects represented, for instance the alignment of roof-lines or the doorposts of buildings.[53]

A late medieval manuscript which may stand for many to demonstrate this, contains a vernacular German commentary on the Ten Commandments by Nikolaus of Dinkelsbühl. This copy was written on paper at Brno in Czechoslavakia in 1464 and belonged to the Carthusians there.[54] The opening page has been ruled in two columns for writing, and then an exactly square space left at the top (fig. 60). Across this, diagonals have been taken to find the points for an inner square and for a centre point. From the latter, a circle with the diameter of the inner square has been drawn, and this forms the bowl of the letter 'D'. The other seven pages decorated with similarly historiated initials show various stages of illumination (fig. 61), and only one has been fully illuminated.

The artist thus started with a layout, a framing pattern which immediately related script and decoration on the page. The next stage was to make a design in hard point or, as in this example, in graphite. This is usually inked in as a second stage, in which the design is finalised, and both stages can be seen in this manuscript (fig. 60). Then came the colouring. If gold was to be used, it was put in at this stage, as can be seen both in the twelfth-century Winchester Bible (see fig. 57), and in the Douce Apocalypse illuminated also in England *c.* 1270 (fig. 62). The latter manuscript gives a particularly good idea of the different stages of the process.[55] Next came colour washes (fig. 63). It must be remembered that the book was not normally bound at this stage, but in sheets. It was

quite common, therefore, for an artist having mixed a quantity of a certain colour, to lay it on sequentially in a series of different miniatures. This has been observed in another unfinished manuscript, the Anglo-Saxon Hexateuch made at Canterbury in the early eleventh century (fig. 64).[56] It made practical sense and must have been done very often. In the penultimate stage, again clearly seen in the Douce Apocalypse (fig. 63), the washes

were overlaid with stronger or lighter tones to provide shadows and highlights. The last stage was reached when the artist outlined the forms where the gold leaf might be ragged at the edges, and also the contours of figures and the folds of garments.

Sometimes the colours to be used were specified. This practice has been noticed particularly in English and French manuscripts of the twelfth to fourteenth centuries,

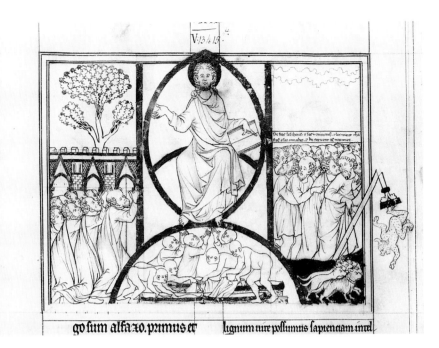

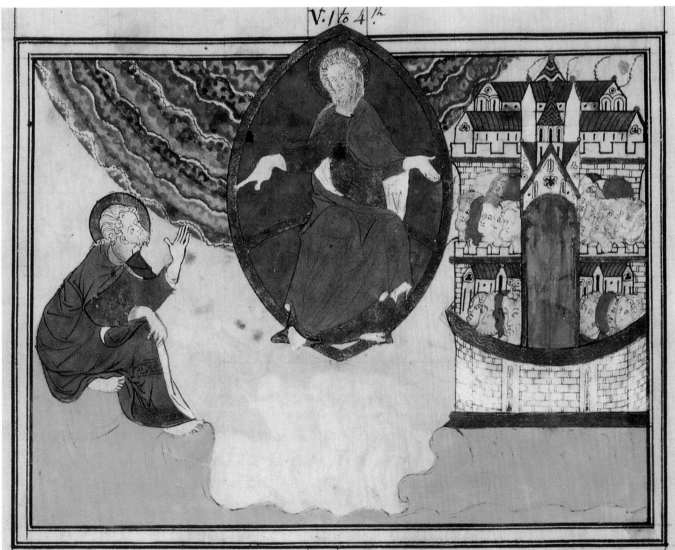

61. Vienna, Oesterreichische Nationalbibliothek, Cod. 2828, folio 51. Nikolaus of Dinkelsbühl. Initial 'D', partly painted, with Christ preaching.

62. Oxford, Bodleian Library, Ms. Douce 180, page 96. Apocalypse. Unfinished miniature. The Blessed wash their robes in the Blood of the Lamb.

63. Oxford, Bodleian Library, Ms. Douce 180, page 90. Apocalypse. Unfinished miniature. The New Jerusalem comes down to earth.

comon to ðam lande þe hit o lædde god. ðe he abrahame
beheꞇ ⁊ hir ofrpⱤince. Moyrer gⱦealde ðær folcer ma
nu ðⱤondam ꝑeꝛꞇne paꝛon accⱦꞇmede pigendⱱa mⱥnna.
ꝼꝛam tⱦⱤntⱦ pintⱤe. ⁊ ꝛⱱine tⱥc yldⱤan. ⁊ þⱥꝛi rod lıc ꝑⱥ
ꝛon ꝛix hund ðuꝛⱦnda. ⁊ ꝼⱦꝛꝑⱦꝛi ꝛcꝑⱦntⱦ ðuꝛⱦnda. ⁊ ꝛⱱ ꝼon
hund mⱥnna. ⁊ ðꝛⱦꝛtⱦ mⱥnna. hⱦⱱꝛa ꝼædeꝛⱥꝛ ꝼalle ꝼoꝛð
ꝼeꝛðon ondam ꝑeꝛꞇne. butⱦn caleph. ⁊ ıoꝛue. hıcⱦmon todam
lande. ⁊ nu ıꝛꝛa hela bꝛⱥꞇnum þone ꞇⱥꝛ ⱦ geꝛodon. ⁊ hın
betꝑynⱥn dældon ꝛꝑⱥꝛꝑⱥ hım dıhꞇⱦ ıo ꝛue :⁊

Moab ab uno filioꝛ loth. q̄ uocabaꞇ moab. urbſ arabıe q̄ nūc areopolıſ dr̄
ꝛc uocaꞇa. ē. Appellaꞇ. aū moab ex nomine urbıſ ⁊ regıo; porro ıpſa cıuıꞇaꞇ
ꝙ ıpꝛu uocabulū poꝛſıdeꞇ. rabbaꞇ moab. ıd ē grandıſ moab·

Petꝛa cıuıꞇaſ arabıe ın ꞇⱥa edom. q̄ cognominaꞇa ē ıeſⱥhel. ꝛab aꝛꝛırıſ rece dr̄
ꝛece hec ē peꞇ. cıuıꞇaſ arabıe. ın q̄ regnauıꞇ mam. quē ın̄ ꝛeceꝛunꞇ ꝛıbı ıſꝛl.
ꝛⱥ aū ıpꝛe rex qꝙ· madıan·

64. London, British Library, Cotton Claudius B. IV, folio 128.
Aelfric, Hexateuch. Unfinished miniature. Moses and the
Israelites.

65. Durham, Dean and Chapter Library, Ms. A.II.1, volume 4,
folio 133. The Puiset Bible. Thessalonians. Initial 'P' with a
note 'de auro'.

66. Malibu, California, J. Paul Getty Museum, Ms. Ludwig
XV.4, folio 91. Bestiary. The Whale. Miniature with colour
directions.

with the colour words, or abbreviations for them, either
written in the margins, or inserted on the preliminary
drawing and still visible beneath the paint.[57] The earliest
example known to me is for the constellation pictures in
an early ninth-century Aratea.[58] An English example is
the early thirteenth-century Bestiary in Aberdeen where
'a' for 'azur' or 'azureum' is written in the margin beside
initials painted blue, 'v' for 'vermeil' or 'vermiculum', that
is kermes, beside those painted in pink, and 'or' besides
those to be on a gilded ground.[59] Another example is the
Bible made for Bishop Puiset of Durham *c.* 1170–80,
where 'de auro' is written beside an initial (fig. 65).[60] A
Bestiary illuminated in North-West France, *c.* 1260, has
both colour letters ('R.', 'G.', 'a', etc.) and on folio 91v
the word 'wit' (fig. 66).[61]

A drawing of the end of the second quarter of the
fourteenth century, with the Crucifixion in an architec-
tural frame, may be either a reject leaf or, considering its

rather rough execution, more probably a maquette for a miniature, no doubt to be placed, as was common, opposite the Canon page of a Missal (fig. 67).[62] It has notes both of subject matter, for example 'Pilate lave', in the upper-left niche, and notes of colour 'azur', 'rose', 'vermeillon', 'blanc', 'or' and 'fausse rose'.

It has also been noted that in certain thirteenth-century Cistercian manuscripts, the small letters written by the scribe in the margin to show what initial should be put in (what are sometimes called 'lettres d'attent'), are marked with a minute blob of coloured paint, blue, red, green, which is then the colour of the initial.[63] Since the Cistercian twelfth-century statutes regulated that initials should be painted in a single colour, and these are very often alternated, it is obvious that such an indication would be a practical method of ensuring the right colour was used.[64] A later variation of this process is a Celsus illuminated in Naples in the late fifteenth century. Here, a system of ink dots is in operation to signal the grounds for the small three-line gold initials, one dot for a pink ground, two for green, three for purple and four for blue.[65]

The processes described here, with so many different stages, were clearly exceedingly time-consuming, and to some extent some stages were mechanical in that the final outlining in ink, for example, could follow the lines of the initial inking in, or the colour washes could be laid with no special expertise. This observation underlines the collaborative nature of much medieval art, especially late medieval art, as noted in the last Chapter. It also has a bearing on how the artist was trained. It is not difficult to see how different artists could work on different parts of an unbound book, and how different stages of the process could be assigned to different artists. The juniors could learn their art from executing the more mechanical parts and copying their master, as Everwinus was shown doing in the workshop of Hildebertus (see fig. 19). This is precisely what Cennini says the pupil should do: 'Take pains and pleasure in constantly copying the best things you can find done by the hand of great masters.'[66]

There are also, of course, a number of examples of unfinished manuscripts which were completed in a different style, and sometimes after a considerable interval. The initials and miniatures in the Winchester Bible were drawn by one set of artists and then painted over by another.[67] Here again, this has implications for attitudes of artists to their own and to others' work. In the example of the Winchester Bible, it seems to imply a respect for a laid-down subject matter which had to be retained. The style, however, could be updated. We see the same process in copies of earlier cycles of illustration made in the twelfth century, to be considered in Chapter 5.

Another well-known example of the later Middle Ages is the *Très Riches Heures* of Jean de Berry, left unfinished by the Limbourg brothers at their death in 1416.[68] The illumination was completed over sixty years later for the Duke of Savoy by Jean Colombe. This kind of later completion seems relatively rare, which is surprising.

67. Paris, Bibliothèque Ste Geneviève, Ms. 1624, folio 1. Drawing of the Crucifixion with directions to the illuminator for subject and colour.

68. Paris, Bibliothèque nationale, n. acq. fr. 24920, folio 41v. Guido de Columna, *Historia Troiana*. Unfinished miniature of the Trojan Horse.

Patrons were evidently often willing to own manuscripts with unfinished illustration or decoration, which it might have been relatively easy to have completed.[69] It is, perhaps, an indication of how much the *Très Riches Heures* was valued that an effort to complete it was made.

In spite of a great deal of scholarly comment on this famous manuscript, the process and the implications of this completion have not yet been fully unravelled.[70] An example of Colombe at work over his own drawings, and working like a painter from the top down, is in a Guido de Columna with unfinished miniatures (fig. 68).[71] No clear picture has yet emerged of what brief Colombe worked to in the *Très Riches Heures*, how far he followed earlier designs already sketched out, and how far he changed existing designs or invented new scenes himself. It seems rather likely that on many pages he followed Limbourg compositions and that may imply that he was instructed to do so.

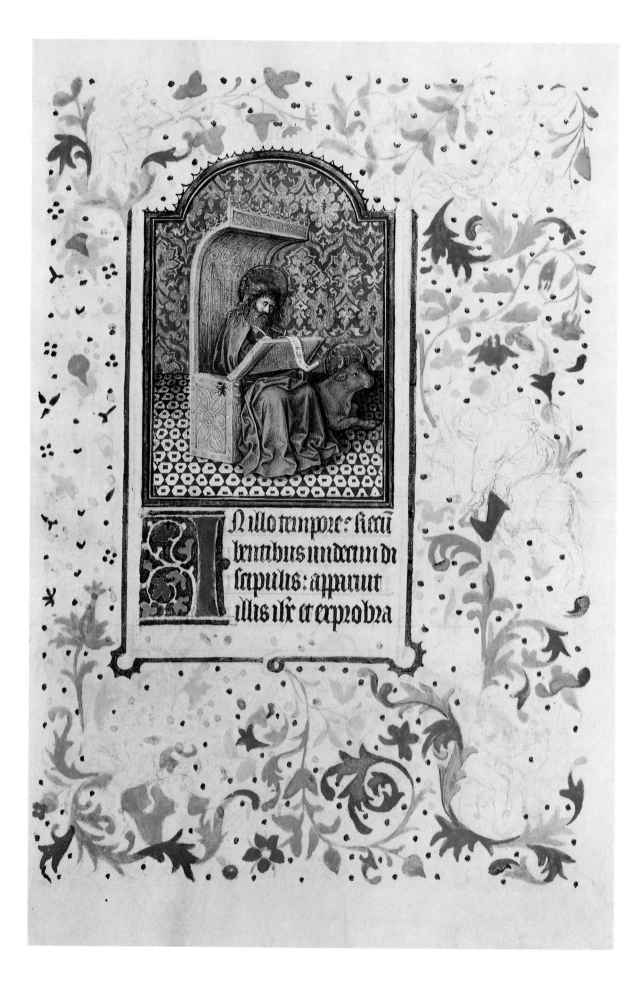

Sometimes it must have been necessary to restore manuscripts which were damaged. An early example may be the *Codex aureus* of St Emmeram, Regensburg, made for the Emperor Charles the Bald, *c.* 870, which according to an inscription was restored in the late tenth century by Aripo and Adalpertus on the order of Abbot Ramwold (979–1001).[72] Examples from the later Middle Ages which have been studied include a *Bible moralisée*, made originally for Jean le Bon of France, and a copy of the works of Christine de Pisan presented by the author to Queen Isabeau de Bavière.[73] Miniatures of the Annunciation and the Visitation of the early fifteenth century in a Book of Hours, which passed through the sale room in 1983, had been repainted and retouched *c.* 1470–80.[74] Presumably this was because they had somehow got damaged, rather than that they were being updated, though that is also possible.

It is relatively common to find the type of flourished penwork, often called 'fleuronée', which developed in the thirteenth and fourteenth centuries, added to plainer twelfth-century initials.[75] This must be due to a wish to update the decoration, the plain coloured initials of the early manuscripts being felt to be incomplete. In at least one instance, fleuronée initials were replaced with fully painted initials to make the manuscript more luxurious.[76] Initials were sometimes cut from an earlier manuscript and then re-used in a later one, an example being a Cistercian Collectarius written in Germany in the fifteenth century. Two earlier historiated initials have been pasted into the text and another plain initial re-used.[77] The practice may have been commoner than has so far been realised. A number of the late fifteenth- and early sixteenth-century manuscripts from the Bridgettine Abbey at Syon contain re-used initials.[78]

Concerning the stages of illumination and decoration, it should also be observed that in the later Middle Ages a hierarchy of activity evolved, where a leading illuminator might execute the most important miniatures, for example the first miniature in a book or a dedication page, and a less-gifted associate the rest. Also by the fifteenth century, the borders in most manuscripts were probably executed by an assistant or assistants. An ingenious method of saving time is often used, in that borders on recto and verso are identical, being traced through.[79] Even in the border, however, spaces could be left for figures and grotesques to be executed by the artists of the main miniatures. A particularly striking example is a Book of Hours with miniatures attributed to Enguerrand Quarton, a monumental painter working in the south of France in the mid fifteenth century, and a second artist, perhaps the Master of the Aix Annunciation.[80] In a number of unfinished borders, spaces have been left for figures and some of these have been filled with drawings by the artist of the main miniatures (fig. 69).[81] These figures are in various stages of completion.

The practice of pasting in parchment has been referred to earlier. In some Dutch manuscripts of the later fifteenth century woodcuts or prints are pasted in,

69. New York, Pierpont Morgan Library, M. 358, folio 19. Book of Hours. Unfinished page with drawings for marginal drolleries.

70. London, British Library, Add. 17524, folio 109v. Book of Hours. Silhouette of lost woodcut formerly pasted in.

coloured by hand and surrounded with gold backgrounds or with borders. A striking example is a Book of Hours from Arnhem where a figure of the standing Christ has lifted, leaving only a silhouette against the gold (fig. 70).[82] Here again the likely explanation seems to be in terms of specialisation and/or cost; a wish to save time combining, perhaps, with the lack of illuminators able to do figure work.

Collaboration between different illuminators, as in the example of Quarton and the Aix Master, was also very common, especially in the later Middle Ages.[83] It was facilitated by the fact that the manuscript was still unbound and so could be distributed for different artists to work on at the same time. There are a number of instances of notes where such a practice is actually referred to. Two come from manuscripts produced in the later fourteenth century in Paris where the book trade, as

71. Paris, Bibliothèque nationale, latin 12610, folio 40v. Life and Miracles of St Germain. St Germain.

72. Paris, Bibliothèque nationale, latin 11751, folio 59. Lectionary. St Germain with Sts Rusticus and Eleutherius.

73. Cambridge, Massachusetts, Harvard University, Houghton Library, Ms. Typ. 101, folio 10. Miniature of the Asp pricked for tracing.

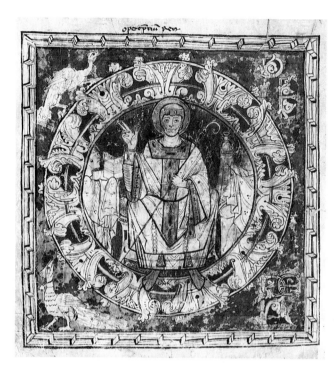

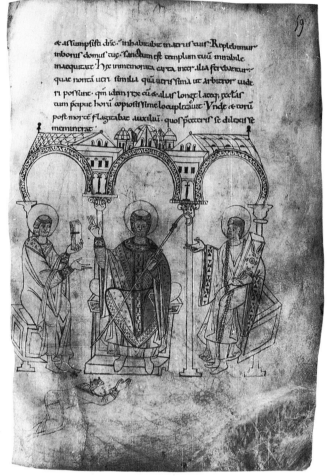

noted in the last Chapter, was by now highly organised. The first is in the Bible presented to King Charles V by his valet-de-chambre, Jean de Vaudetar. The scribe, Raoulet d'Orleans, speaks in a colophon of having to run hither and thither in the streets of Paris in the rain.[84] The second is a copy of the *Histoire ancienne jusqu'à César*.[85] Another example, this time from the Northern Netherlands, is a *Bible historiale* of 1431, where it is noted in Dutch on a fly-leaf that: 'Claes Brouwer has six and a half gatherings containing Judith, Esther, Job, Solomon's Parables, Ecclesiastes, Canticles and the Book of Wisdom'.[86]

How far tracing was used as a method of transferring designs for miniatures, as opposed to the border designs traced from recto to verso referred to above, is uncertain. Possible examples of tracing in a group of English early thirteenth-century Psalters and in Bruges Books of Hours of the mid fifteenth century have been examined with inconclusive results.[87] In the famous Ellesmere Chaucer, it has been observed that the outline of the horses is traced with a hard point for three of the portraits. However, here too this is not necessarily conclusive of tracing, since hard point, as said above, was a frequent tool for making the preliminary designs in manuscripts.[88] Another example is the early fifth-century Vatican Virgil, where it has been observed that figures of Achates, Aeneas and the Sybil have been traced. Since the Virgil was later at Tours and similar figures occur in the Vivian Bible made there *c.* 846, re-used in the miniature of St Paul addressing the Jews, it seems that the tracing was done by the Tours artists.[89]

The techniques of transferring a smaller design to a large wall were solved by monumental painters in various ways, some of which, for example pouncing, might also have been used by illuminators.[90] The earliest known surviving use of pouncing from pricked cartoons is of the 1340s in the Orcagnesque frescoes in Sta Maria Novella, Florence, but here, as in other early examples, the technique is used for the repetition of decorative forms, for example framing designs, not for the transfer of composition.[91] On folio 51 of the Nikolaus of Dinkelsbühl manuscript discussed earlier, the heads of the Apostles are outlined with little dots which may suggest a pricked pattern (see fig. 61). Some surviving pattern books are pricked.[92] Where actual miniatures are pricked, it is usually impossible to be sure when this was done, however.[93] A number of the known examples of pricked miniatures occur in Bestiaries, or are of animals in other contexts, and in many cases the pricking may have been done in the post-medieval period when the miniatures were less valued, since animal motifs were common in Tudor and Stuart embroidery, for example.[94] Animals

were, of course, also used in the Middle Ages as decorative adjuncts in many other media besides book illumination, in embroidery and textiles, in wall paintings, stained glass, and metalwork, for example. Some leaves of a late fourteenth-century pattern book, used probably in a Venetian silk-weaver's shop, survive and some of the drawings of animals there are pricked.[95]

Dorothy Miner considered a certain example of medieval use of the pouncing process to be two similar figures in manuscripts from St Germain-des-Prés of the later eleventh century, but this too is problematic, since the figure supposedly traced is not the same size as the pricked figure (figs 71–2).[96] An extensive example of pricked designs is the Harvard Aviary-Bestiary, a French thirteenth-century production (fig. 73). Even here it remains puzzling why only twenty-six of the Bestiary, and

fifteen of the Aviary subjects, out of the totals of respectively thirty-six and thirty-four miniatures, are pricked.[97]

Though much more could be said on illuminators' procedures, and a multiplicity of other unfinished manuscripts used to demonstrate different techniques and stages of completion, enough has been said to indicate some of the most important ways in which choices for the illuminator were circumscribed. In addition to the physical factors of materials, decisions were taken as to layout which, even if they were taken in conjunction with the illuminator, were already in most cases implemented by the scribe before the illuminator set to work. In the next Chapter, I will look at evidence, which is mainly taken from the later Middle Ages, as to the ways in which instructions were given to artists as to what to represent and where to place their illustrations and decorations.

Chapter 3

Programmes and Instructions for Illuminators

Turning now to look at factors which affected the planning of a programme of illumination or decoration, the patron's wishes and the artist's training and inclinations must have interrelated. Specific factors which will have affected the end product in varying degrees were the patron's ability to pay, the kind of message he or she wished the work of art to convey, the artist's training and ability to paint, the availability of materials, and the accessibility of models to copy. There were also the much more general patterns of expectation as to what was possible or acceptable in a particular illuminated text, which will have affected both the patron and the artist.

It is important to stress, with regard to the latter, how very important tradition was in the art of the Middle Ages, and how difficult a matter it could be to alter an accepted image or to apply illustration to a text which had not before received it.[1] In each case, specific historical explanations are needed to explain how and why such alterations or new departures could have been made. They were unlikely to be accidental, matters of whim or of hasty unthought-out decisions; though, of course, accidental factors may sometimes have influenced decisions.

One way of achieving insight into this process would be to examine surviving contracts. It is well-known that from the thirteenth century gradually increasing numbers of contracts survive for the execution of panel paintings and mural paintings – especially in Italy, but also in Northern Europe. The painting had to be guaranteed as satisfactory to the purchaser who spent money on it, whilst the producer equally had to be guaranteed a satisfactory return in market terms. Perhaps this treatment of a painting as the end-product of a process of manufacture was to be expected from a society which was precisely at the same time evolving the monetary skills of a growing capitalist economy (that is, more sophisticated banking and accounting systems), and also a legal system able to protect such activities and enforce obligation and contracts.

Contracts for illumination, however, appear to be much less common than those for monumental art. This is perhaps surprising, and certainly requires further investigation. Of upwards of twenty contracts for illumination known to me, four come from a study of the book trade at Avignon, and six from a study on the Dijon clergy, which certainly implies that many more await discovery.[2] However, a careful distinction must be made between contracts prior to the work being done, and documents recording payment after the completion of the work. The fact that large numbers of the latter exist and have been published perhaps indicates that preliminary written contracts were comparatively uncommon.[3]

The examples noted so far range only from the mid fourteenth century to the sixteenth century, which is perhaps also an indication that they were only felt to be necessary gradually and by analogy with other artistic projects. Hannelore Glasser's thorough study on monumental artists' contracts in Italy may indicate a solution to the problem.[4] There it is noted that in addition to contracts *per chartam*, that is written agreements, Roman Law also recognised verbal contracts by oath, and also a contract formed by the handing over of the materials to be worked on by the craftsperson. It may well be that the normal procedure in the later Middle Ages was for the patron to hand over the parchment for the scribe to work on, thus effecting an obligation; and once the manuscript was written, to give it and the materials (the gold and colours) to the illuminator, if he was a different person, thus effecting another obligation.

It may, of course, also be that book illumination had evolved a customary code of practice before such contracts became common; and thus it was only later that illuminators or scribes came to use contracts, partly because of their use elsewhere – especially by painters. Further study is also needed of the parties to the contracts. In some examples, the patron employs an intermediary who draws up the agreement, supervises the work, and is responsible for payment. In the University of Paris (as noted in the last Chapter), the *librarii* policed the system and presumably they, or in Italy their equivalents, the *cartolai*, commonly acted as intermediaries seeing to it that craftspersons were paid and ensuring that rewards

were fair in relation to prices which they also had the responsibility of fixing.

There is also the question of what protection was needed. Comparing the more frequent painters' contracts, it is clear that the patrons' anxieties were on two main counts; the use of good materials and the completion of the work to a specified time-scale. The problem for the scribe or illuminator was to get payment for the work at an agreed rate. An example will illustrate this. On the 20th March, 1448, Jean de Planis promises to illuminate a Missal for Jean Rolin, Bishop of Autun.[5] He has been shown an example of what the Bishop wants as to miniatures, he will execute them with pure gold, good blue and pink, and for each miniature he will receive fifteen gros, and for each hundred capital letters an ecu d'or. He will not interrupt work for any reason. He will be paid as work progresses, and according to need. The date of completion is often specified, though not here. In fact the Missal was received 'very well and completely illuminated' on 31st August, 1450.[6]

Other contracts specify the total payment and record that part of the total is to be paid either at the beginning or in instalments as work goes on, with a final balance on completion. In an immensely long and complicated contract between Attavante degli Attavanti and the Florentine merchant, Chimenti di Cipriano di Sernigi, of 1494, for the illumination of a Bible in seven volumes and a copy of the Sentences of Peter Lombard in one volume, the contract specifies that Chimenti will visit Attavante every week to check his progress and to pay him.[7] As Attavante was illuminating the leaves whilst the scribes finished them, there are complicated stipulations as to what was to happen if the scribes fell behind. Independent assessment and valuation by peers is a feature of scribal and illuminators' contracts, as it is for those of painters, and was provided for here. Another example is in a set of documents concerning the illuminating of Choir Books for a monastery in Bergamo by Jacopo da Balsemo.[8] These are taken from the chapter minutes. The documents here also give a good picture of the complex financial relationships between the artist and patron as regards various properties, debts, and other financial relations.

The contracts also give some indication of how patrons made their wishes known as to what illumination should be executed by the illuminator. In the document quoted concerning Jean Rolin's Missal, some form of specimen was produced on the Bishop's part for the artist to follow. In the Attavante contract, and also in that of the Bible of Duke Borso d'Este of Ferrara, a specimen quire had been produced which was to form the model. The contract for the illumination of Borso's Bible was drawn up on the 8th July, 1455, between his agent and the illuminators, Taddeo Crivelli and Franco dei Russi.[9] It states that the illumination is to be done in the same manner as the third gathering signed with the letter 'D', that is the gathering for the Book of Exodus. It continues 'for every book there is to be a magnificent opening worthy of such a Bible'.

Work is to be completed in six years, gatherings are to be paid for as completed (they were regularly shown to the Duke or his agent) and there are penalty clauses. In the event payments for binding begin in October, 1461, so the project was completed more or less on time. The final totals on completion are recorded in the Duke's accounts on 29th October, 1465.

One other contract which is also quite specific about the illumination is for a Book of Hours to be written and illuminated in Dijon in 1398 by Maistre Jean Demolin, clerc and writer, for a merchant of Dijon who furnished both the exemplar and also the parchment, gold and azur. Demolin is to execute twelve miniatures with borders, for the eight divisions of the Hours (which are listed), and also for the Seven Psalms, the Hours of the Cross and of the Holy Spirit, and for the Vigils of the Dead. There are also to be 'champis d'or et d'azur', and also six other images of saints for the suffrages 'such as Guillaume wishes and will specify'. The whole is to cost ten gold francs of which Demolin has already had seven.[10]

There is nothing in these, or any of the other contracts known to me, to specify exactly what was to be illustrated, though detailed programmes for subject matter are sometimes given in painters' contracts.[11] There must have been various possibilities and practices in the Middle Ages governing such a decision for the illuminator. First of all, the illuminator may have been set to copy a model exactly. In Italian painters' contracts where this is to be done, the phrase is often found 'secondo modo e forma', or in Latin 'secundum similitudinem et formam'.[12] Secondly, it may have been a matter of knowing of a traditional subject in a particular context. For example, the subject matter in Books of Hours is standardised beginning with the Annunciation for Matins, and there was no need for the Dijon merchant to specify it.[13] Similarly, the six days of creation are regularly shown in initials for the Book of Genesis at the beginning of thirteenth-century French and English Bibles. Thirdly, artists may themselves have made the decision. Sometimes only a general knowledge of the contents of a work was necessary. For example, texts of Augustine or Aristotle might be introduced by a small representation of the author writing or teaching. Sometimes artists may themselves have read a text, though often, it seems, only the first few words. Fourthly, there may have been a programme written for the illuminator, either by the patron or by an adviser appointed by him, or by the stationer, or even by the artist himself, if he had assistance or was subcontracting the work.

Such programmatic instructions survive in two ways. First, a few examples have been copied into the manuscript itself. Where this has happened they no doubt acted as well, or may even have been primarily intended, as explanatory text of the miniatures' subject matter. A well-known example is the complicated programme probably written by a Dominican theologian for the illustration of the Belleville Breviary which was illuminated in Paris by Jean Pucelle about 1325.[14] The programme, written in

74. Paris, Bibliothèque nationale, latin 10483, folio 6v. The Belleville Breviary. December. Building the New Church with bricks from the Old.

75. Cambridge, University Library, Ms. Ee.4.24, folio 32v. Psalter. Initial 'I' for Psalm 125, etc.

French and inserted at the beginning of the manuscript, describes how 'for each of the twelve months there is one of the twelve apostles and one of the twelve prophets represented in such a manner that the prophet gives to the apostle a veiled prophecy and the apostle uncovers it and makes of it an article. . . . For behind each prophet is a material synagogue from which he takes a stone . . . as you can see in the pictures' (fig. 74). Earlier, in two thirteenth-century Psalters, descriptions of the subjects of the historiated initials are included either as rubrics or as a prefatory text.[15] Some of these descriptions are long and detailed, others just a short sentence (fig. 75).[16] Other examples of surviving programmes include the mid fourteenth-century *Bible historiale* of Charles V,[17] Philippe de Mezières, *Le songe du vieux pèlerin*,[18] a fifteenth-century copy of the *Horloge de Sapience*,[19] and Olivier de la Marche's *Le Chevalier délibéré*.[20]

In these more complex programmes, the intervention of a learned adviser is implied.[21] Another example where this is documented is in a copy of Guillaume de

Deguileville's *Pèlerinage* written by the scribe, Raoulet d'Orleans. Raoulet added accounts of three miracles of the Virgin 'with the consent of two masters of theology (of Paris University), viz Master Estienne de Chaumont and Master Jehan Adam'. Though the consent primarily concerned the text, the miracles are duly illustrated so that the manuscript's iconographic programme was also affected either directly or indirectly, perhaps via the scribe himself.[22]

The value put on images, not only as devotional aids to prayer and meditation for the faithful, but as instruction in this period can be exemplified in two instances which also help to explain the increase (a veritable explosion) of illustration which takes place in the thirteenth century. When the Franciscan William of Rubruck went on embassy in 1253–4 from Louis IX to the Mongols, with the hope of converting them to Christianity and enlisting their aid for the Crusaders against Islam, he took with him an illuminated Psalter given to him by the Queen, and a Breviary and a Bible (both also illuminated), given him by the King. William reports showing these manuscripts to Mangu Khan in 1253, 'which he took a good look at' and 'he made a diligent enquiry as to the meaning of the pictures'. There can be no doubt that the King's gift was, partly at least, with that very purpose in mind.[23] The huge cycle of illustrations in the *Bibles moralisées* produced in Paris at this period have a similar teaching purpose, and in their prevalent anti-Jewish imagery, a similar ideological emphasis on conversion.[24] The theological adviser/author is actually represented in the colophon miniature of the Toledo copy where, above, the donors, presumably King Louis and either his mother, Queen Blanche, or his wife, Queen Margaret, are shown with, below, the author instructing the scribe who is engaged in laying out the complex page arrangement of roundels for the miniatures and ruling for the text (fig. 76).[25]

Another miniature where the religious adviser or explicator is shown is in the frontispiece to the Holkham Bible Picture Book, illuminated in England in the second quarter of the fourteenth century. A Dominican instructor represented with the painter tells the latter to do his work well since the pictures will be shown to rich people (fig. 77).[26]

Instructions were also often written in the margin of a manuscript with the intention of either erasing them or cutting them off in binding.[27] Such written instructions occur, as noted in the first Chapter, already in the 'Itala' fragments of the early fifth century, though there they were written in the space left for the miniatures, not in the margin (see fig. 1).[28] The marginal instructions must in many cases have been written out in a rough copy, or perhaps on the scribal exemplar, and then transferred from that. In one lucky case, such a maquette or model for text, layout of the illustration, and subject matter survives.[29] The text is Honoré Bouvet, *Somnium super materia schismatis* and for this instructions were written, probably by Jean Gerson in Paris, *c.* 1395. Spaces are left

Benefac domine: bonis et rectis corde.
Declinantes autem in obligationes ad
ducet dominus cum operantibus iniquitatem:
pax super israel.

In convertendo dominus captivitatem
syon: facti sumus sicut consolati.
Tunc repletum est gaudio os nos
trum: et lingua nostra exultatione. O
tunc dicent inter gentes: mag
nificavit dominus facere cum eis.
Magnificavit dominus facere nobiscum:
facti sumus letantes.
Converte domine captivitatem nos
tram: sicut torrens in austro.
Qui seminant in lacrimis: in ex
ultatione metent.
Euntes ibant et flebant: mittentes
semina sua.

Venientes autem venient cum exulta
tione portantes manipulos suos.

Nisi dominus edificaverit dom
um: in vanum laboraverunt
qui edificant eam.
Nisi dominus custodierit civi
tatem: frustra vigilat qui
custodit eam.
Vanum est vobis ante lucem surgere:
surgite postquam sederitis, qui manducatis
panem doloris.
Cum dederit dilectis suis somnum: ec
ce hereditas domini filii: merces fructus ventris.
Sicut sagitte in manu potentis: ita filii
excussorum.
Beatus vir qui implevit desiderium suum
ex ipsis: non confundetur cum loquetur
inimicis suis in porta.

Beati omnes qui timent
dominum: qui ambulant in
viis eius.
Labores manuum tua
rum quia manducabis:
beatus es et bene tibi erit.
Uxor tua sicut vitis abundans in late
ribus domus tue.
Filii tui sicut novelle olivarum: in cir
cuitu mense tue.
Ecce sic benedicetur homo: qui timet dominum.
Benedicat tibi dominus ex syon: et videas bona

ierusalem omnibus diebus vite tue.
Et videas filios filiorum tuorum: pacem super
israel.

Sepe expugnaverunt me a
iuventute mea: dicat nunc israel.
Sepe expugnaverunt me
a iuventute mea: et enim
non potuerunt michi.
Supra dorsum meum fa
bricaverunt peccatores: prolongaverunt ini
quitatem suam.
Dominus iustus concidet cervices peccatorum: con
fundantur et convertantur retrorsum omnes
qui oderunt syon.
Fiant sicut fenum tectorum: quod priusquam
evellatur exaruit.
De quo non implevit manum suam qui
metit: et sinum suum qui manipulos colliget.
Et non dixerunt qui preteribant benedictio
domini super vos: benediximus vobis in nomi
ne domini.

De profundis clamavi ad te
domine: domine exaudi vocem
meam.
Fiant aures tue inten
dentes: in vocem deprecatio
nis mee.
Si iniquitates observaveris domine: domine quis
sustinebit.
Quia apud te propitiatio est: et propter legem
tuam sustinui te domine.
Sustinuit anima mea in verbo eius: spe
ravit anima mea in domino.
A custodia matutina usque ad noctem: spe
ret israel in domino.
Quia apud dominum misericordia: et copiosa apud
eum redemptio.
Et ipse redimet israel: ex omnibus iniquita
tibus eius.

Domine non est exaltatum
cor meum: neque elati sunt
oculi mei.
Neque ambulavi in mag
nis: neque in mirabilibus
super me.
Si non humiliter sentiebam: sed exalta
vi animam meam.
Sicut ablactatus super matre sua: ita retri

76. New York, Pierpont Morgan Library, M. 240, folio 8. *Bible moralisée*. Colophon miniature with donors, author and scribe.

77. London, British Library, Add. 47682, folio 1. The Holkham Bible Picture Book. Dominican adviser with the illuminator.

78. Paris, Bibliothèque nationale, latin 14643, folio 270v. Maquette for Honoré Bouvet, *Somnium super materia schismatis*, with directions for the illuminator.

where little miniatures were to be placed, and for the initials, which are also specified. The directions for subject matter are written in smaller script in the margin (fig. 78). A typical direction reads: 'Here let the King of Scotland be painted and the figure as was said above'.[30] The necessity of such a model or dummy is shown by one note: 'This space has been left in error because nothing should be painted in it'.[31]

Possibly maquettes or dummies with layouts and/or drawings for miniatures were also sometimes made. The leaf in the Bibliothèque Ste Geneviève, already discussed, may be one such example (see fig. 67).[32] Another may be two leaves with drawings in an early fourteenth-century Sermologium from the area of Lake Constance.[33] They

79. Baltimore, Walters Art Gallery, W. 148, folio 24. Homiliary. Initials 'I' and 'M' with St Mark.

80. Baltimore, Walters Art Gallery, W. 148, folio 1. Homiliary. Sketch of initials 'I' and 'M' with St Mark.

81. Paris, Bibliothèque nationale, latin 11907, folio 232. Joinville, *Credo*. Scenes of Pentecost, baptism, marriage, etc.

copy compositions and page layout from illuminated folios in the manuscript into which they are now bound (see figs 79–80).

These drawings are rather unfinished in appearance. Those in two other sets of illustrations which have been thought to form some sort of pattern book are more finished, and their purpose remains unclear. These are the series of scenes in the thirteenth-century Vercelli Roll which, according to an inscription, record paintings of a church roof, perhaps prior to restoration,[34] and secondly, the scenes illustrating Joinville's *Credo* which also have been thought to have formed a record of or a model for wall paintings (fig. 81). Friedman has argued against that view, but the relationship of the drawings to a similar cycle of images in a Breviary in St Petersburg remains unclear.[35] The drawings may be either a record of an existing cycle, or a preparatory maquette, therefore.

The fullest and most detailed written programme to survive, together with the illustrative cycle it describes, is that composed by Jean Lebègue in Paris in the early fifteenth century for an illustrated Sallust.[36] Lebègue's

82. Geneva, Bibliothèque publique et universitaire, Ms. 54,
folio 1. Sallust, *Catalina*. Sallust as author writing the work.

83. Geneva, Bibliothèque publique et universitaire, Ms. 54,
folio 15ᵛ. Sallust, *Catalina*. The arrest of Vulturcius.

direction for the initial author portrait of Sallust reads: 'Make and portray a man with a forked beard and a white cap . . .'.[37] Lebègue also specifies that the horse on the left should be half concealed behind the building to signify that the author has been a knight (fig. 82). As J.D. Farquhar comments, this shows how the visual programme supplements the written text with complex symbolism.[38] The directions for the narrative scenes are mostly in two parts, as if one is to explain the scene to the reader and the other is for the illuminator. Thus the fourteenth miniature ('histoire') shows the arrest of Vulturcius on a bridge, as the first part of the direction explains, but the second part of the direction specifies that water should flow under the bridge and that no one should be shown as wounded (fig. 83).[39]

Perhaps another indication that such separate written programmes existed is the numbering of miniatures. This occurs, for example, in a Lydgate, Fall of Princes, illuminated in England in the fifteenth century,[40] and in a copy of Guillaume de Deguileville's *Pèlerinage* (fig. 84).[41] Since the former contains fifty-six and the latter two hundred and five miniatures, it is easy to see how numbering could have been helpful, though it is also possible that it was designed to facilitate payment.[42]

Whether it was necessary to write out the instructions on a separate sheet or sheets may have depended on how long and complicated they were. In a French thirteenth-century Bible, before Chronicles II, the marginal note reads 'Adam qui labore et Eve qui file' (fig. 85).[43] Whoever wrote this had done no more than read the first word of Chapter I, which starts with a genealogy 'Adam Seth Enos'. And he could have done the same all through the Bible. Directions are very often in the vernacular, in French or Anglo-Norman, as here, or in German or Dutch, which implies that they were to be read by the artists themselves and may sometimes have been composed and written by them. In a Dutch Bible of *c.* 1460, the vernacular direction reads: 'Here a man kills two lions and a man' (fig. 86).[44] This follows a mistranslation in the Dutch text. The Vulgate Latin text of II Samuel 23, vv. 20–21, says that Benaiah slew, not two lions, but two

84. Paris, Bibliothèque nationale, fr. 829, folio 39. Guillaume de Deguileville, *Pèlerinage*. Grace Dieu shows the pilgrim the armour of the Virtues. Miniature numbered xlii.

85. Oxford, New College, Ms. 7, folio 97. Bible. Chronicles II. Initial 'A' with Adam and Eve.

86. Vienna, Oesterreichische Nationalbibliothek, Cod. 2771, folio 188. Bible. Illustration of II Samuel, ch. 23, vv. 20–21. Men fight lions.

lion-like men! In other cases, the direction may have been followed by the designer who drew the miniature, but then ignored by the painter. An example is in a fourteenth-century, illustrated Alexander Romance where the written direction, followed by the still visible underdrawing, speaks of a combat with one-eyed Cyclops, but the painter, failing to understand the text and ignoring the drawing, has painted the figures with two eyes (fig. 87).[45]

Many examples of written marginal directions survive. They are found in Italian manuscripts as well, for instance, in Bolognese, fourteenth-century religious and secular texts. An example of the latter is a copy of the French text of Benôit de Saint Maur's *Roman de Troie*, illuminated no doubt at Bologna, and with directions in both Latin and French.[46] Some directions are very short, as in the Bible quoted, or in Books of Hours in which, as has been previously mentioned, the subject is standard. But other directions are long and very complex, as in a fourteenth-century *Roman de la Dame à la Licorne* (fig. 88).[47] In some cases, instructions may have been written in the margin of one manuscript but then, when it came in its turn to serve as exemplar, they were transferred from the margin of the exemplar to the text itself in the new manuscript in the form of a rubric. An example is the copy of a Latin translation from the Arabic made for Philip the Fair of France in 1313, known as *Calilah et Dimnah*, where a description of the subject matter starting 'figura . . .' is placed as a rubric above each miniature, for example, 'figure of an ox pulled out of the mud with ropes' (fig. 89).[48] It is easy to see how they would also have helped the reader, but in particular cases it can be difficult to decide whether one function had priority over the other. For example, the series of Passion scenes in a liturgical manuscript of the later thirteenth century used at St Augustine's Abbey, Canterbury, have quite long rubrics describing the scenes, whose primary function must have been to help meditation on the pictures. However, they begin with, or include, the word 'Comment', as do many of the instructions to artists, 'How Barabbas the robber was delivered from prison' (fig. 90).[49]

87. London, British Library, Royal 19 D. I, folio 38v. Alexander Romance. Alexander battles the Cyclops.

88. Paris, Bibliothèque nationale, fr. 12562, folio 26v. *Roman de la Dame à la Licorne.* Marginal instruction for a miniature of a Queen at table.

89. Paris, Bibliothèque nationale, latin 8504, folio 26. *Calilah et Dimnah.* An ox pulled out of the mud.

90. Cambridge, St John's College, Ms. 262 (K.21), folio 50v. Canticles, hymns etc. The Jews before Pilate and the release of Barabbas.

Coment pilate demanda as ieus si il uoleient ke il lur deluerast al iur de lur grant feste barraban ke fu enprisone pur homi cide e pur autres maus fez. ou Ihu crist. ke se fist Rois as ieus. e les ieus demande rent barraban le fort lere en deluere: e prierent ke il puissent cruchier Ihu crist.

Coment Barrabas li leres fu liuere hors de prison.

Coment ihs fu flaele e malement batu de uant pilate. e le liuera as

91. London, British Library, Harley 1527, folio 395. *Bible moralisée.* The Journey to Bethlehem.

92. Paris, Bibliothèque nationale, fr. 91, folio 178. Robert de Boron, *Histoire de Merlin.* Preliminary drawing with notes by Jean Colombe.

Sometimes notes are of other practical kinds. For example in a Deguilleville, *Pèlerinage de la vie humaine* of 1393, is written in French 'Remiet, do not put anything in here as I will do the miniature which should be there'.[50] Another note, in Latin in a Latin text with French illumination, reads 'This miniature is badly done'.[51] In the third volume of the copy of the *Bible moralisée* made in Paris *c.* 1230, now divided between London, Paris and Oxford, someone has taken the trouble to check all the hundreds of roundels with pictures and note mistakes. For example, the artist showed Joseph and Mary with the baby on a donkey as if for the Flight into Egypt, but for the scene of the Journey to Bethlehem before Christ's birth (fig. 91). The note, written in French, reads: 'Erase the baby whom the lady carries, she should not carry it here'![52] On another page the note reads: 'Give Jesus a white robe here'.[53] In fact his robe is purple, so here too the correction was never made (and consequently the note was not erased). There is also a long tradition of

scribal comments, prayers and imprecations of which the illuminators may have been aware.[54] In one manuscript Jean Colombe, the French fifteenth-century illuminator, has incorporated comments such as 'Time wasted for Colombe' into the actual miniatures.[55] He seems also to have himself written notes on his drawings, for example, 'feu, feu, feu' by a dragon (fig. 92).[56]

Another form of instruction is not written, but visual.[57] It seems that the two are related, since they often occur together and they also begin to appear at the same time, that is at the end of the twelfth century and the beginning of the thirteenth. An example of the two occurring together is an early fourteenth-century French *Legenda Aurea* where an instruction has been written over the drawing, 'Sanctus Egidius cum cerva' (fig. 94).[58] Both forms of instructions, written and pictorial, must be connected with the appearance of the professional illuminator and with the new forms of organisation of book production.

These visual directions were perhaps often placed where the miniature or historiated initial was to go and consequently covered over by the finished miniature so that they are now invisible. It is puzzling why this was not always done, but perhaps it would have been confusing to the illuminator and have spoilt the surface of the parchment, if erased. In one manuscript, a thirteenth-century glossed Bible, the drawing was executed in the space between the main text and the gloss, but since that was insufficient, it must have run over into the space left for the miniature. The finished miniature half covers the drawing, therefore (fig. 93).[59] At all events, preliminary marginal drawings are not as common as preliminary marginal written instructions. Of over seventy manuscripts

93. Paris, Bibliothèque nationale, latin 11545, folio 394v. Glossed Bible. Initial 'O' for Habakkuk with preliminary marginal drawing.

94. San Marino, California, Huntington Library, HM 3027, folio 118v. Jacobus de Voragine, *Legenda Aurea*. St Giles with the deer. Marginal drawing and instruction.

95. New York, Pierpont Morgan Library, M. 111, folio 170v. Bible. Initial 'P' for II Corinthians. St Paul escapes from Damascus.

96. Edinburgh, University Library, Ms. 19, folio 188v. *Bible historiale*. Banquet of King Ahasuerus.

97. Paris, Bibliothèque nationale, latin 108, folio 107. Psalter. Initial 'Q' for Psalm 51.

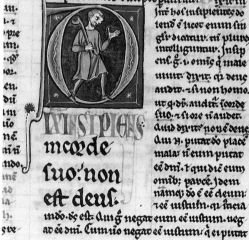

containing such drawings known to me, most are of the thirteenth and fourteenth centuries and French or English, with a smaller number of Netherlandish and German examples and only a single Italian example. Undoubtedly very many other examples exist still to be recorded and more manuscripts must have originally had both written and scribal directions which are now either erased or cut off in the binding process.

Preliminary marginal drawings, like written instructions, vary; some are very summary short-hand indications. For example, in the last volume of a French Bible of *c.* 1260, at the opening of II Corinthians, there is a circle with its lower half hatched placed in the margin.[60] This stands for the basket in which St Paul is lowered from the walls of Damascus in the historiated initial 'P' (fig. 95). Another similar example is a jug placed beside a miniature of the banquet of Ahasuerus in a French Bible of 1314 (fig. 96).[61] Other examples are in a thirteenth-century French Psalter where for the initial to Psalm 51, 'The fool hath said in his heart', only a rough sketch of his bauble was necessary as a cue to the artist (fig. 97);[62] a German Book of Hours of the second quarter of the

98. London, British Library, Add. 38122, folio 9v. Bible. The Creation.

99. Amiens, Bibliothèque municipale, Ms. 23, folio 143. Bible. Judith. Marginal drawings (very faint).

100. Oxford, New College, Ms. 20, folio 87v. Bible. Initial 'O' for the Song of Songs. Solomon and Ecclesia.

101. Oxford, New College, Ms. 20, folio 87v. Bible. Marginal sketch of Solomon and Ecclesia.

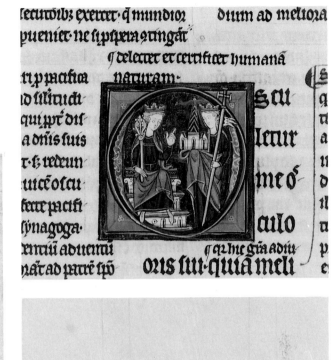

fifteenth century, where a hammer is enough to signify the miniature of Christ being nailed to the Cross;[63] and a fifteenth-century Dutch Bible where a star and some fish indicate a miniature of the Creation (fig. 98).[64]

Short-hand visual signs of this kind may, or may not, imply the existence of a pattern book to which the illuminator could make reference. In a Bible from Corbie of the early thirteenth century, figures constructed of triangles as in the pattern book of Villard d'Honnecourt are drawn in the margin of one folio (fig. 99).[65] Though they cannot be preliminary drawings since they do not relate to the preface initial for Judith, or to the historiated initial showing Judith beheading Holofernes on the same page, they show that Villard's method of constructing figures was indeed practised by other artists. It may be significant that the Bible comes from the same area of North-West France as Villard himself.

Sometimes, as in a French thirteenth-century Bible, the finished miniature is reversed from the sketch (figs 100–1).[66] It is quite common to find that the completed miniature differs significantly from the preliminary marginal drawing. For example, in a Bible attributable to a named Paris illuminator, Magister Alexander, working in the very early thirteenth century, a preliminary marginal drawing for Esdra II shows the prophet raising a lamb as an offering above the altar.[67] Behind the kneeling figure are three circles showing there were to be onlookers.

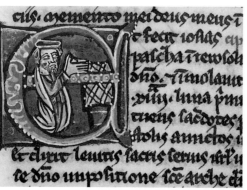

102. Liverpool, The National Museums and Galleries on Merseyside (Walker Art Gallery), Mayer 12038, folio 132v. Bible. Initial 'E' for Esdra II.

103. Liverpool, The National Museums and Galleries on Merseyside (Walker Art Gallery), Mayer 12038, folio 132v. Bible. Marginal sketch of Offering a ram.

104. Oxford, Balliol College, Ms. 2, folio 155v. Bible. Initial 'C' for II Chronicles. Offering a ram with marginal sketch.

105. Paris, Bibliothèque nationale, latin 17907, folio 62v. Petrus Riga, *Aurora*. Initial 'P'. Marginal drawing of grapes carried on a pole.

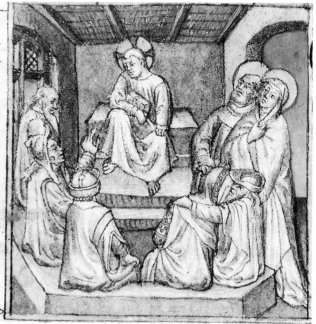

106. London, British Library, Royal 20 B. IV, folio 37v. *Meditationes Vitae Christi*. Christ teaching in the Temple.

107. London, British Library, Royal 20 B. IV, folio 40v. *Meditationes Vitae Christi*. Christ praying in the Temple with marginal drawing (lower margin) and a second marginal drawing of Christ teaching in the Temple (upper margin).

Neither these, nor the lamb, appear in the finished initial (figs 102–3). This seems to have been for negative reasons of lack of space, rather than for the positive reason of correcting the subject matter. This subject came to be very commonly used in later French Bibles in the initial 'C' for Chronicles II. An example, slightly later in date, also has a marginal sketch with similar iconography (fig. 104).[68] Robert Branner drew attention to an example of a short-hand preliminary marginal drawing for the Israelites carrying the grapes back from the Promised Land in a mid thirteenth-century Petrus Riga, *Aurora*, which was ignored or misunderstood, and a foliage initial inserted instead (fig. 105).[69]

In another example, a French text of the *Meditationes Vitae Christi* of the early fifteenth century, the preliminary marginal drawing for Christ teaching in the Temple was placed at the bottom of the wrong page, folio 40v, instead of on folio 37v (fig. 107).[70] This must have been noticed,

Le · xlb · chapitre · que fit Jhesus de puis son · xiij ·
an Jusques au commencement du · xxx · e

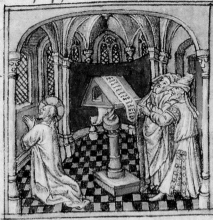

Jant Jhesus
fut retourne et
du temple de
Jherusalem a
uer ses parens en la cite
de nazareth. Il se tint de
subtret a eulx, et la habita
auec eulx, des ce temps
Jusques au commencement
de son · xxx · an, et ne trou
ue len point en escript que
tout ce temps il feist aucune chose, laquelle chose semble
bien merueilleuse. Que penserons nous que il feist,
fut le bon seigneur jhucrist oyseux par si grant temps,
tellement que il ne feist rien digne destre recite, ou destre
mise en escripture, ce semblerost du tout esbahissement
Toutesfois se tu consideres bien en ceste chose, tu seras pa
tient, et verras que en ne faisant rien il fist mueilles
Et nest aucun de ses fais qui soit hult de mistere. Car
ainsi come il parloit et faisoit ses oeuures vertueusement
aussy il se soubstrayoit, taisoit et reposoit vertueusement
Jhucrist doncques souuerain docteur et maistre qui par
aucun temps voulu enseigner les vertus, et la voie de
la vie eternelle, commenca des sa Joenesse a faire oeuures
vertueuses, mais maintenant il se teust et reposa par une
maniere merueilleuse magnifique et moure les teps
passes, cest assauoir en soy rendant deuant le monde
aussi come non saute inutile et reiete. Et en ceste

108. London, British Library, Harley 3487, folio 183v.
Aristotle. Initial 'N' with Moses and the Brazen Serpent.

109. London, British Library, Harley 3487, folio 183v.
Aristotle. Marginal sketch for Moses and the Brazen Serpent.

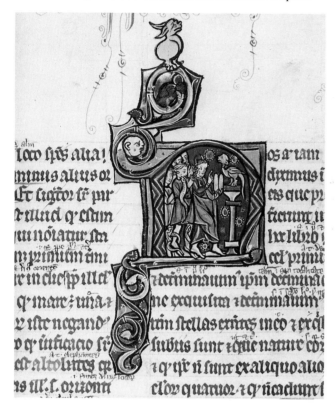

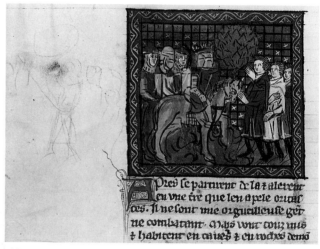

110. London, British Library, Royal 19 D. I, folio 28v.
Alexander Romance. Alexander on horseback. Miniature with
marginal drawing.

111. Cambridge, Fitzwilliam Museum, McClean Ms. 123, folio
40v. Bestiary. Unfinished drawing of the capture of the unicorn.

since the scene was inserted correctly on folio 37v (fig.
106) and a second drawing, this time for the correct
subject, Christ praying in the Temple, was placed in the
top margin to the left above on folio 40v (fig. 107).

In a few cases, artists drew the figures in their pre-
liminary sketches unclothed. Though this can hardly
indicate study from the life in the manner of later
Renaissance artists, it may suggest a preoccupation with
working out the composition, rather than with a strict
copying of a particular iconography. Striking examples
are in an Aristotle, *Libri naturales*[71] (figs 108–9) and
a Bestiary[72] (fig. 110), both English manuscripts of
the third quarter of the thirteenth century. In another
example, in the same French Alexander Romance of the
early fourteenth century mentioned earlier, the outline of
the nude figure is drawn with the drapery only summarily
indicated (fig. 111).[73]

Some later marginal drawings which are much more

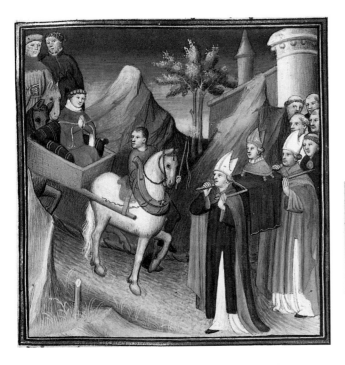

112. London, British Library, Cotton Nero E.II, volume 2, folio 4v. *Chroniques de France*. King Louis before the reliquary of St Denis.

113. London, British Library, Cotton Nero E.II, volume 2, folio 4v. *Chroniques de France*. Drawing for miniature of King Louis before the reliquary of St Denis.

114. London, British Library, Royal 20 B. IV, folio 61v. *Meditationes Vitae Christi*. Christ healing the Paralytic with marginal drawing.

complex, certainly have more the appearance of an artist working out the details of a composition. This is especially true of drawings in manuscripts illuminated by the Boucicaut Master, and Millard Meiss has observed that sometimes the drawings are both livelier and more adventurous in terms of settings or figure relationships than the finished miniature.[74] He cites a *Chroniques de France*, ascribed to the 'Boucicaut workshop', as an example of drawings less sophisticated than the finished miniatures (figs 112–13),[75] and the drawings in the same *Meditationes Vitae Christi*, discussed earlier, of the reverse (fig. 114).[76] In the latter manuscript, this may suggest that the head master executed the drawings for an assistant to follow.

In conclusion, the Avignon Pontifical mentioned in Chapter 1 is a particularly instructive example of the planning of a set of scenes.[77] The original campaign must have started *c.* 1330–40 and was left incomplete, as was said earlier, so that it was finished by Sancius Gonter for Benedict XIII (1394–1423). The scribe left spaces for initials of two sizes, either two lines high or four or five lines high. These follow textual divisions, though it is not clear how the scribe knew which size space to leave. He may have followed an exemplar, but if it had figure decoration, then it is difficult to see why such a full and complicated set of instructions should have been given.

The early artist had directions of two kinds. The first were written instructions in Latin, for example, on folio 62: 'A bishop with a mitre extending his hand over a kneeling nun' (fig. 115).[78] Sometimes these directions have been emended; 'standing' substituted for 'sitting', for example. There are also changes of plan. Sometimes, as on folio 83v, a direction is crossed out and instead of an historiated initial, a foliate initial is inserted. Or it can happen the other way round, as on folio 137: 'Here

nam in terram. 7 chorus cā
tet. ait. Summa igenu
itas ista ē. in qua seruitus
xpi comprobatur. Deinde
epē deposita mitra diat. do
mnus uobiscū. Et rū. Oremꝰ.
Espice qs do
mine sup hanc
famulā tuā. ꝓ
picius. ut uirgi
nitatis sanctæ ꝓpositū. qd
te inspirāte suscepit. te gu
bernante custodiat. P. Alia
Amulam tuā. oratio.
domine. tue custodia

115. Paris, Bibliothèque nationale, latin 968, folio 62. Pontifical. Initial 'R' with bishop blessing a nun.

116. Paris, Bibliothèque nationale, latin 968, folio 115v. Pontifical. Initial 'O' with bishop blessing.

117. Paris, Bibliothèque nationale, latin 968, folio 102v. Pontifical. Initial 'O' with bishop blessing a vestment.

should be a letter ('without figures' crossed out) with a priest baptising in the font (added)'.[79] Sometimes, the illuminator did not follow the direction, for example omitting a second figure for reasons of space, as on folio 115v in the lower initial (fig. 116).[80] The upper initial on this page is by the later artist, Sancius Gonter. On a number of pages, there are two directions. Sometimes they are more or less the same, sometimes one is fuller. The reason is not clear, but perhaps an original set was revised by a second programmer.

Not only are there these complex written directions, there are preliminary marginal drawings as well. On folio 115v, where the artist has omitted the second figure required in the written direction, he has also ignored the drawing which includes the second figure (fig. 116). On folio 102v, one direction reads 'Ad penellum' in darker ink, 'according to the drawing' that is, and then in lighter ink 'paint a stole' (fig. 117).[81] This is all in the left margin, but below in the lower margin is written a different instruction: 'A bishop pointing to sacerdotal vestments'.[82] The preliminary marginal drawing in the left margin shows a 'T' shaped garment, that is a 'vestis' similar to that shown on folio 166v, for example. The initial as finally executed, however, follows the written direction to paint a stole.

This manuscript thus shows a great deal of care being taken, even if the end product is quite a simple initial by a not particularly gifted artist. We have to consider each case individually, therefore, and beware of generalisation. But here the point was surely that the illustration had an important function for the Pope in the matter of ceremonial procedure. The manuscript gave him a text which told him what he must say for what purpose, that is blessing a stole or a nun or a bishop. But it did not tell him certain other things which he needed to know, such as whether to sit, or to stand, or to wear his mitre. So the pictures were an essential part of the manuscript, and in this example the directions to the artist were, passed on by the artist via his image. That was why so much trouble was taken and it is reasonable here to assume that the directions were written by someone both involved in, and knowledgeable about, papal ceremonial.

Chapter 4

Illuminators at Work: The Early Middle Ages

The importance of obedience to authority is one of the main messages of the Rule of St Benedict and, in the wider social context, a corollary of what Walter Ullmann called the descending theme of Government and Law – that is, authority imposed from on high.[1] In this Chapter, I want to look at the illuminator's function in the early Middle Ages from about 650 to about 1100, and to pose the question as to how far, in this early period, the task was seen as one of obedience to authority, in the sense of copying images from an exemplar. Thinking in terms of copy and exemplar, there is a good deal of evidence that in this period as opposed to later, the scribe was also often the illuminator, and since the task of the scribe is to faithfully transcribe the text before him, it might be expected that the same view might be taken of the illuminator's task.[2]

The notion that the task of the artist is to do something new is deeply embedded in twentieth-century cultural awareness, but this emphasis on originality is, of course, a legacy of the post-Renaissance period, and particularly of Romanticism.[3] In much of the evaluation of contemporary art, to be important is to do something new.[4] Such a view, however, whatever its implications for contemporary art practice, is inappropriate to medieval art. Therefore in considering medieval copies, we must beware of concealed value judgements such as those of Hans Swarzenski in a valuable paper on medieval copies.[5] Swarzenski is right to stress that, by comparing copy and exemplar, we can isolate changes in style. But surely it is a mistake to speak of 'creative copies', with the implication that they are superior or more interesting because they make alterations to the exemplar. The historian's project must be the examination of each specific instance to try to uncover reasons why, in one case a facsimile copy, in another a free variation of the exemplar, should have been made.

If we think in terms of more or less exact copies, then we may start with some examples of exact copies.[6] The portrait of Ezra in the *Codex Amiatinus* made *c.* 700 in Northumbria at the monasteries of Wearmouth/Jarrow under Abbot Ceolfrid for presentation to the shrine of St Peter in Rome, has been taken to be an exact copy of a portrait of Ezra made to preface a Bible made at the Vivarium Monastery in Southern Italy for Cassiodorus who died in 597 (fig. 118).[7] In the art-historical literature, a certain disquiet is apparent in the fact that at an earlier date, it was suggested that the miniature in the *Amiatinus* was not a copy, but actually part of the Cassiodoran Bible taken from its original volume and re-used. More recently, P.J. Nordhagen has suggested that the portrait was made at the same date as the rest of the *Amiatinus* but by an Italian painter, while K. Corsano has argued that the portrait is not an exact copy but a pastiche.[8] The difficulty, evidently, is to believe that an Anglo-Saxon illuminator could have copied his model so closely. And yet Bruce-Mitford showed absolutely convincingly, first that the Ezra miniature shows certain small but significant misunderstandings and mistakes only possible if it is a copy, and secondly that the technique is the same as the Majesty frontispiece to the Bible, which has never been thought to be an exact copy of a Cassiodoran model but always considered a pastiche, and therefore by an Anglo–Saxon artist.

Accepting Bruce-Mitford's conclusion, the Ezra portrait is an exact copy made around the year 700 of a miniature made between one hundred and one hundred and fifty years earlier, and we must therefore ask why this was done and how. Ceolfrid and his community were evidently quite conscious of what they were doing, and the gift to the shrine of St Peter only makes sense in the context of the struggle between the Roman and Celtic parties in the church of England after the Synod of Whitby of 664. An imported aesthetic corresponds to an imported cult. The gift, which Bede informs us was one of three identical Bibles, two of which were retained, affirms the commitment to Rome and is perceived as being in a style acceptable to the authorities in Rome, a suitable gift.

The Lindisfarne Gospels, made at about the same time in a monastery founded originally from Iona in 635 by St Aidan, depends on the same or a similar Cassiodoran model (fig. 119).[9] Here, however, the Mediterranean aesthetic seems to be challenged, in that even if the authority of the model is accepted to some extent in

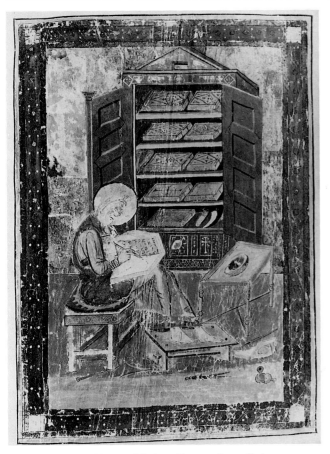

118. Florence, Biblioteca Medicea Laurenziana, *Codex Amiatinus* 1, folio V. Bible. The Prophet Ezra as Scribe.

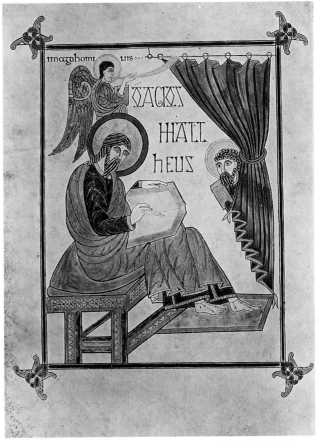

119. London, British Library, Cotton Nero D IV, folio 25v. The Lindisfarne Gospels. St Matthew.

pictorial form and content, nevertheless its appearance is totally transformed with an alternative space construction and colour composition. The Lindisfarne artist, probably Bishop Eadfrith, operated by means which can be claimed as the normal medieval way, that is by constructing his picture from pre-existent motifs and forms, combining these so that both authority and variation are present in the work.

This, in turn, serves to emphasise how exceptional the Ezra miniature is, and leads on to the question of how it was done. Here, the apparently very different range of pigments from those normally encountered in Insular manuscripts, is notable. Unfortunately H. Roosen-Runge, who wrote the authoritative account of the pigments used in the Book of Lindisfarne, did not examine the *Codex Amiatinus*. But the fact of the difference only serves further to emphasise the special nature of the endeavour.

Some three hundred years later, another well-known attempt was made at an exact copy. This is the copy made at Canterbury (it is not quite certain whether at the Cathedral Priory of Christ Church or at the Benedictine Monastery of St Augustine, but probably the former), of the Utrecht Psalter, a Carolingian manuscript made at Reims *c.* 820 (figs 120–21). The Utrecht Psalter, so named for its present home, is known to have been in the Cathedral library in the Middle Ages.[10] It is illustrated

with drawings in bistre for each Psalm, and for the Canticles and Creed at the end. The text is the version of Jerome's translation known as the Gallican and is written in rustic capitals, that is a form of script used in the late antique world and here self-consciously revived. The Canterbury scriptorium decided first to use a different Jerome text, that is the Roman, and secondly to write it in Caroline minuscule, though keeping the unusual three-column format of the Utrecht Psalter.[11] Both decisions surely imply that the book was not only intended as an exact copy but had also to be easily usable, that is legible. In fact, the project of illustration was never completed and goes through a number of interesting stages. The first group of drawings isolated by Wormald, who attributed them to four different artists, are in varying degrees careful copies of the Utrecht Psalter and moreover are very faithful to its style, so it is possible, as with the Ezra, to speak of an exact copy.[12]

Here again we can ask why and how such a copy should be attempted. It is not known for whom the manuscript was made, but if it was made for or at the order of the archbishop represented in the initial 'B' to Psalm I (fig. 121), it is most likely to have been Archbishop Aelheah (1005–1012), Archbishop Lyfing (1013–1020), or Archbishop Aethelnoth (1020–1038). The historical context of the tenth-century reformed Anglo-

EATUSUIR
QUINON
ABIIT
INCONSILI
OIMPIORU
ETINUIAPEC
CATORUMNONSTETIT
ETINCATHIDRAPESTI
LINTIAENONSEDIT
SEDINLEGEDNIUOLUN
TASEIUS ETINLEGEEIUS
MEDITABITURDIE

ACNOCTE
ETERITTAMQUAMLIG
NUM QUODPLANTA
TUMESTSECUSDECUR
SUSAQUARUM QUOD
FRUCTUMSUUMDA
BITINTEMPORESUO
ETFOLIUMEIUSNONDE
FLUET ETOMNIA
QUAECUMQUEFACIET
PROSPERABUNTUR
NONSICIMPIINONSIC

SEDTAMQUAMPUL
UISQUEMPROICIT
UENTUSAFACIETERRAE
IDEONONRESURGUNT
IMPIIINIUDICIO
NEQUEPECCATORES
INCONSILIOIUSTORU
QUONIAMNOUITDNS
UIAMIUSTORUM
ETITERIMPIORUM
PERIBIT

QUAREFREMUE
RUNTGENTES ETPO
PULIMEDITATISUNT
INANIA
DSTITERUNTREGESTER
RAE ETPRINCIPESCON
UENERUNTINUNUM
ADUERSUSDNM
ETADUERSUSXPMEIUS

DISRUMPAMUSUINCU
LAEORUM ETPROICI
AMUSANOBISIUGUM
IPSORUM
QUIHABITATINCAELIS
INRIDEBITEOS ETDNS
SUBSANNABITEOS
TUNCLOQUETURADEOS
INIRASUA ETINFURO

RESUOCONTURBABIT
EOS
EGOAUTEMCONSTITU
TUSSUMREXABEO SU
PERSIONMONTEMSCM
EIUS PRAEDICANS
PRAECEPTUMEIUS
DNSDIXITADMEFILIUS
MEUSESTU EGOHODIE

BEA
TVS
VIR QVI
NON HABIIT INCONSILIO IMPIO
rum. &inuia peccatorum
nonftetit. &incathedra
pefti lentiae nonfedit;

Sed inlege dni fuit uoluntas
eius. &inlege eius medita
bitur die ac nocte
Et erit tamquam lignum.
quod plantatum. e. fecus
decursus aquarum
Quod fructum suum dabit
intempore suo. &folium
eius non decidet. &omnia
quecumque fecerit pro
sperabuntur

Nonsic impii nonsic. sedtam
quam puluis quem proicit
uentus afacie terrae
Ideo nonresurgunt impii
iniudicio. neque pecca
tores inconsilio iustoru
Qm nouit dns uia iustoru
&iter impiorum per
ibit

PSALMVS DAVID
QVARE FREMUERUNT
gentes. &populi medi
tati sunt inania;
Adstiterunt reges terrę. &
principes conuenerunt
inunum. aduersus dnm &
aduersus xpm eius
Dirumpamus uincula eoru.

&proiciamus anobis iugu
ipsorum
Quihabitat incaelis irri
debit eos. &dns subsanna
bit eos
Tunc loquetur adeos inira
sua. &infurore suo contur
babit eos
Ego autem constitutus sum

rex abeo. super sion montem
scm eius. predicans pre
ceptum dni
Dns dixit adme. filius meus
estu. ego hodie genuite
Postula ame. &dabo tibi
gentes hereditatem tuam.
&possesionem tuam ter
minos terrae

120. Utrecht, Bibliotheek der Rijksuniversiteit, Ms. 32, folio 2. Psalter. Psalm I.

121. London, British Library, Harley 603, folio 2. Psalter. Psalm I.

Saxon church's indebtedness to the Frankish church must, at least, in part, explain the desire to copy the Psalter. It is not known how the Utrecht Psalter reached England. It might have been a royal gift, but it is also tempting to connect it with St Dunstan, Archbishop of Canterbury (957–988), who spent a period in exile on the Continent and might have brought it back as a gift, granted his own interest in art. Though there is no documentary evidence for such a speculation, in the image of the Archbishop in the Harley Psalter, there may well be an echo of Dunstan's self-portrait in his Class-book (see fig. 10), and this may signify, at the least, allegiance to Dunstan and to his ideals.[13] There is, therefore, a possible context to explain the wish to copy the Utrecht Psalter and this could have been further strengthened, if it had some connection with Dunstan who was already venerated as a saint, and thus could be considered to be in some sense a relic.

We can speculate upon another type of explanation if we turn to the question of how this was done. The Utrecht Psalter contains a number of marginal drawings in lead point (fig. 122). One explanation of these is to see them as the work, not of Carolingian, but of Anglo-Saxon

artists who were making preliminary copies.[14] It is useful to compare the practice particularly of early medieval scribes who made pen trials (*probationes pennae*) on fly-leaves or margins.[15] Such drawings on fly-leaves or margins are also important to bear in mind in relation to the problem of the early medieval use of pattern books, which will be discussed later in this Chapter.[16] Furthermore certain outlines in the Utrecht Psalter have been strengthened, and this may also have been done at the same period. The implication from this is perhaps that the Utrecht Psalter was copied for an interlocking series of reasons. It may have been valued, not just aesthetically and for its antiquity, but as venerable. On the other hand, it was both difficult to read and its text was *not* that required by the community. Finally it may be that the community were worried by the conservation problems of a venerable object whose ink was already fading. However, the range of possible explanation is further complicated by the fact that a second series of drawings in Harley 603 added some time later do not all faithfully copy the Utrecht illustrations.[17]

Other examples of exact copying occur in the early Middle Ages. Those of the early ninth century already

discussed, such as the Leiden Aratus or the Vatican Terence, signed by Adelricus (see fig. 4), again have to be seen as conscious efforts to copy exactly in a particular context, this time the Carolingian *Renovatio*.[18] Writing of these, C.R. Dodwell has pointed out that in such illuminated manuscripts to which he gives the title 'facsimile', the illustrations were 'retained for educational and scientific purposes' and that 'the classical pictures were copied with the same scrupulousness as the classical text' of which they were seen as an extension.[19]

Such exact or facsimile copies are, however, always exceptional and it is for this reason that in each case it is legitimate to look for exceptional reasons. It is much commoner either for the model to be copied as to content, but to be varied as to style or, as I believe to be the case with the Lindisfarne Gospels, for models of different kinds to be combined into a new whole. Thus many of the examples cited by Hans Swarzenski are of the former character, for example, the Gero Gospels written by the scribe Anno *c.* 950–70, which copies the Charlemagne Court School Gospels of *c.* 810 which was at Lorsch in the Middle Ages (figs 124–5).[20] Here, too, the wish to copy must connect with the ideological preoccupation of

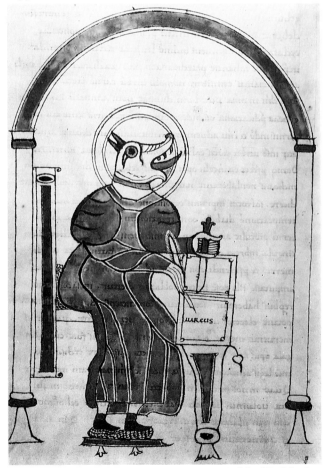

122. Utrecht, Bibliotheek der Rijksuniversiteit, Ms. 32, folio 8. Psalter. Marginal drawing below illustration for Psalm XV (16).

123. Oxford, Bodleian Library, Ms. Auct. D.2.16, folio 71v. The Leofric Gospels. St Mark.

Otto I in wishing to establish himself as the successor of Charlemagne. But in this case, significant stylistic alterations are made. These stylistic alterations respond to a different set of pressures or requirements, that is in favour of an emphasis on suprahuman, mystical symbols to bolster imperial aspiration, and these are in conflict with the other requirements to emulate the Carolingian origin. In other cases, the aesthetic aims of the copyist are more in tune with that of the work copied, as seems to be the case in England in the tenth and eleventh centuries where manuscripts of Prudentius' *Psychomachia* are copied, and probably approximate very closely to Carolingian manuscripts in the Rheims drawing style.[21] Another example is provided by the illustrated Terence manuscripts, of which some copies are both more accurate than others as to pictorial detail, and more consistent in their style with the classical visual language as transmitted via Carolingian intermediaries.[22]

Thus the copy may express some form of admiration or emulation for the original. In that case, it may be that refusal to copy may express some form of hostility or opposition. I have already suggested that the Lindisfarne Gospels may be a sort of manifesto for independence. An interesting example, which can be a way in to discussing some of these problems, is provided by two Gospel Books; one in the Bodleian Library, the other in Paris.

The former has an inscription stating that it was given to Exeter Cathedral by Leofric who was consecrated Bishop of Crediton in 1046, moved his see to Exeter in 1050 and died in 1072.[23] It contains Canon Tables and Evangelist portraits. The style and iconography of three of the portraits (those of Matthew, Mark and Luke), together with the book's script, suggest the Gospels is of Breton origin, and this is confirmed by the liturgical Gospel readings which indicate the manuscript was made at Landévennec in Brittany. The three surviving Breton Evangelist portraits (that of John is missing) are of the type known as 'beast-headed' in that those of Mark (fig. 123) and Luke are represented by human bodies with the heads of a Lion and a Calf respectively.[24] Matthew has a human head, but placed frontally in opposition to the body's profile position to signify that it too represents the head of his symbol, the Angel. The term 'beast-headed' is thus a misnomer in the case of Matthew. What we have here is a conflation of the human Evangelist portrait, which in the West is accompanied by, and identified by an appropriate symbol, with an alternative portrait tradition where the Evangelist is represented by his symbol. Both traditions existed in early Christian Mediterranean Gospel Books, and both were known in the British Isles in the seventh and eighth centuries. In the Book of Cerne, in fact, the Evangelist is represented in each case twice, once in human form, 'in humanitate', and once in symbolic form, for example 'in forma vituli'.[25] In the Breton Gospels, the two separate traditions are combined and this had already been done in the context of Canon Tables in two Insular Gospels, those from Maeseyck and the Barberini Gospels of the eighth century.[26] The

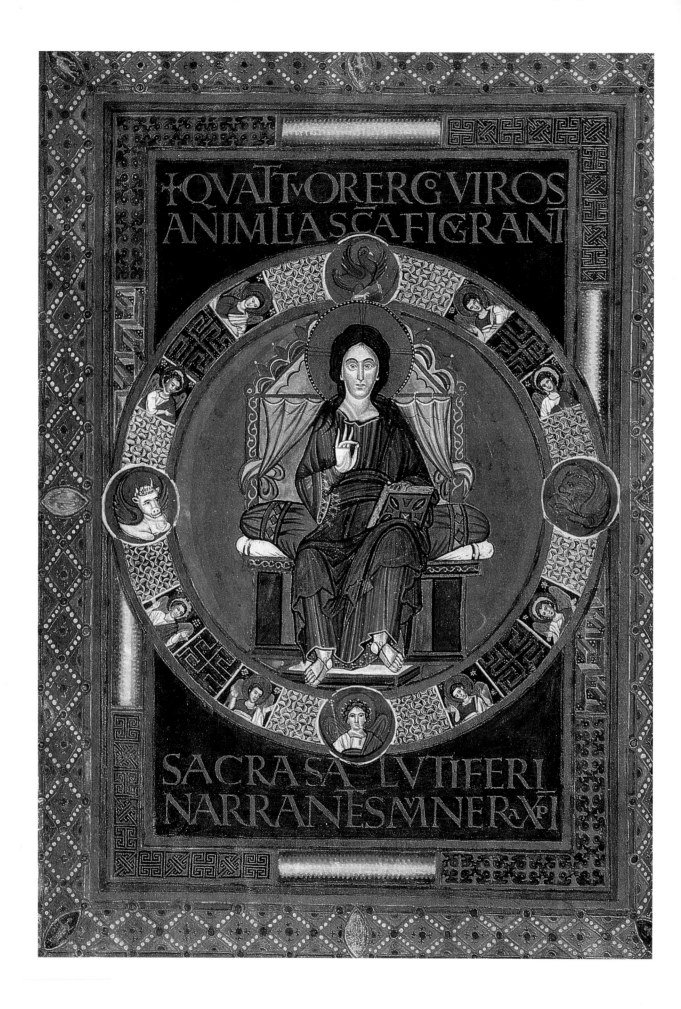

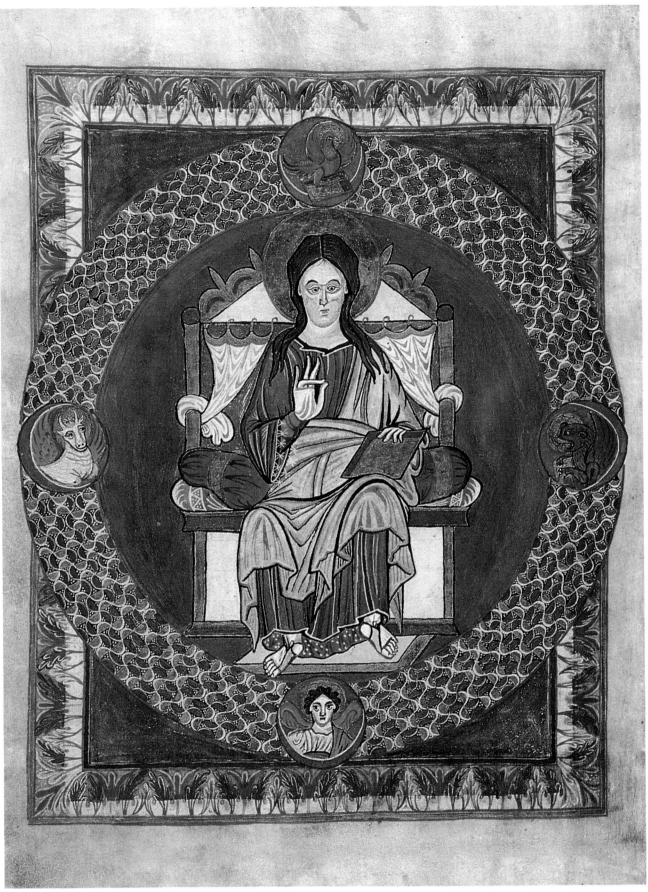

124. Alba Julia, Romania, Batthyaneum Library, *Codex aureus*, folio 36. The Lorsch Gospels. Christ in Majesty.

125. Darmstadt, Hessische Landes- und Hochschulbibliothek, Ms. 1948, folio 5v. The Gero Gospels. Christ in Majesty.

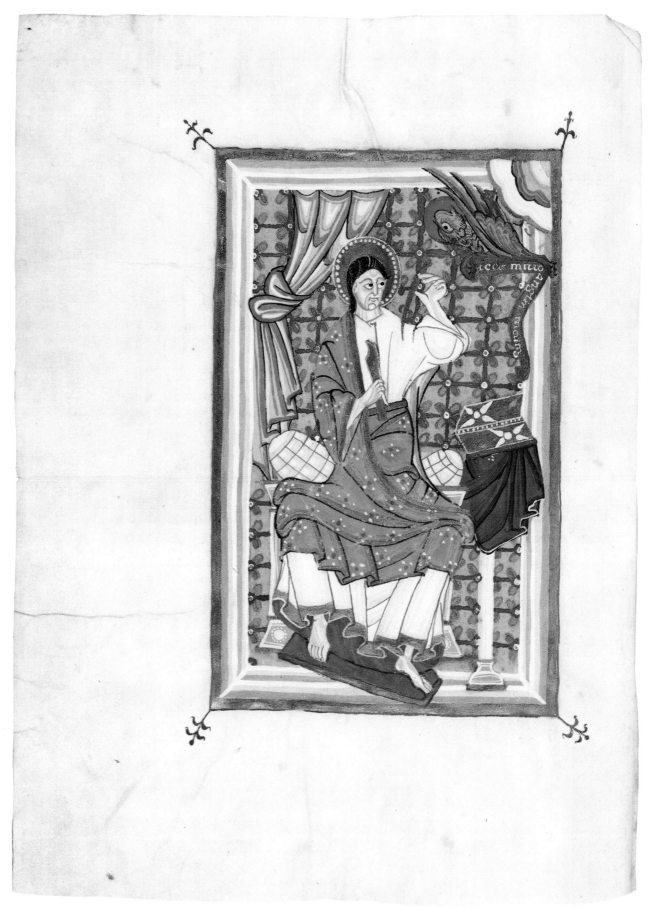

126. Oxford, Bodleian Library, Ms. Auct. D.2.16, folio 72v. The Leofric Gospels. St Mark.

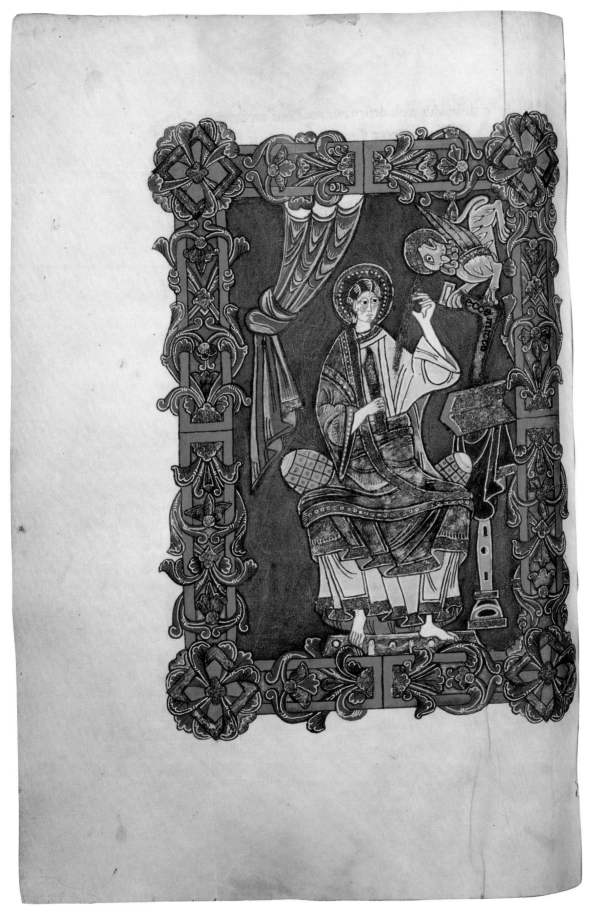

127. Paris, Bibliothèque nationale, latin 14782, folio 52v. Gospels. St Mark.

Landévennec illuminator may be thus drawing on an older tradition presumably reaching him via Celtic connections.

But the Gospel Book has two other portraits of St Mark (fig. 126) and St John. These are human Evangelist portraits accompanied by their symbols and are in a totally different style, one which can be placed in the context of North French and Flemish illumination of the mid or third quarter of the eleventh century.[27] In other words, these portraits are contemporary with Bishop Leofric and executed by an artist familiar with artistic styles obtaining in an area with which Leofric may have had personal connections, since he is said to have been educated in Lotharingia. Here, then, we can suppose that Leofric was in some way critical of the Breton portraits and decided to have more acceptable images inserted on single leaves. His criticism did not take him so far as to dispense with the Breton Gospel Book altogether or even to remove the leaves with the portraits.

The next stage is also interesting. The Paris Gospels contains four Evangelist portraits, and those of St Mark (fig. 127) and St John can be directly compared with the two Leofric additions in the Landévennec Gospels.[28] This suggests that the portraits of Matthew and Luke in the Paris Gospels copy pages originally present in the Bodleian Leofric Gospels and now lost; thus, that Leofric originally had a *complete* set of four Evangelist portraits added.

The artist of the Paris Gospels working in the late eleventh century makes his own contribution, most notably by surrounding the miniatures on the versos by Anglo-Saxon type rosette frames, and balancing them with initial pages similarly framed on the rectos. His copies, where they can be compared – that is of Mark and John – are exact as to pose and attributes, but he alters them both very radically in colouring and also in their overall spatial effect (figs 126–7). The North French or Flemish artist emphasises the Evangelist figure who is projected forward, since both he and his symbol overlap the frame. The Evangelist is also silhouetted by means of colour contrast and by emphasising the surface pattern of the background. Anglo-Saxon artists, by contrast, used their frames to contain the figures in the miniature and united, rather than separated the two, by using the same colours for both.

Leofric was one of the pre-Conquest bishops to survive the Norman Conquest, though not by long. He was succeeded by a Norman, Osbern Fitz Osbern (1072–1103), who imported Norman manuscripts such as the Jerome illustrated by Hugo Pictor, which was discussed in Chapter 1 (see fig. 13).[29] He was also, no doubt, responsible for the importation of other manuscripts probably made at the Norman Monastery of Lyre, which had been founded by his own family.[30] Nevertheless, the Paris Gospels, made very probably under his episcopacy, must be seen as a statement of devotion at Exeter to a past tradition, in this case, the native Anglo-Saxon tradition. The script is Anglo-Saxon, not Norman, in

style. Moreover the first leaf of its Canon Tables contains Evangelist portraits with symbol heads which connect with the Insular tradition as exemplified by the Barberini Gospels Canon Table.[31] Other Canon pages contain symbols in roundels according to another, also probably Insular, tradition.[32] The implication is that the Paris Gospels artist enriched his book from some separate source (or sources) which are most likely to have been made in England in the tenth century. But here, too, the power of the exemplar is shown in that the actual *text* of the Canons in the Paris Gospels copies that of the Landévennec Gospel Book, even though the latter is corrupt.

This is a complex story of transmission and alteration. Before leaving the Landévennec Gospels, I want to raise another point about medieval copying. I have tried to present the copy as a positive act having a special purpose, not aimless, due to lack of skill, inventive power or resources, though of course some copies may be due to any or all of these factors. Breton illumination of the ninth to the tenth century provides interesting evidence in this respect. In their attempts to remain independent of the Frankish Empire in the ninth century, Breton leaders allied themselves sometimes with the Viking invaders and sometimes with the Carolingian Frankish rulers. The latter sought to bring the Breton church under the control of Frankish bishops, which was resisted by the native clergy. Attempts at political domination as usual brought cultural infiltration. Gifts of manuscripts by Charles the Bald to the Breton leader, Salomon (857–874 AD), are recorded, and in this connection the Frankish church played its part in attempting to introduce conformity presented as reform. A group of Breton Gospel Books of this period are distinct from the so-called 'beast-headed' group in that their human portraits are related to types found in the Carolingian Tours and Rheims school (figs 128–9).[33] A model, or models, from these areas must have been available. At the same time the style is totally different from that of such Carolingian manuscripts. It is a simplified linear style in which vitality concentrates in interesting silhouettes and non-naturalistic shapes. The colours used are yellows, browns and oranges which were more easily available and therefore cheaper pigments. Such miniatures can be argued to be either impoverished provincial work of no intrinsic value (though possibly of some interest in so far as they aid the reconstruction of Carolingian 'great art'), or historical documents proving a cultural poverty in the area. But perhaps it can be argued more positively that they represent a conscious stand, a refusal of aesthetic values, in line with the resistance to both political and cultural domination. It seems that most art historians would take the former view, in that they are largely omitted from general accounts of the art of the period.[34]

The Gospels, being the fundamental Christian text, was so ubiquitous that a medieval illuminator in almost every case where illumination was planned, must have had a pictorial tradition of some kind available to him to

128. Berlin, Staatsbibliothek Preussischer Kulturbesitz, Ms. theol. lat. fol. 733, folio 22v. Tours Gospels. St Matthew.

129. Baltimore, Walters Art Gallery, W.1, folio 77v. Breton Gospels. St Luke.

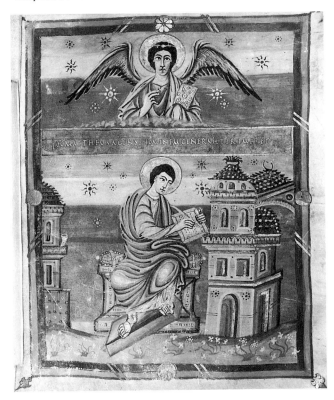

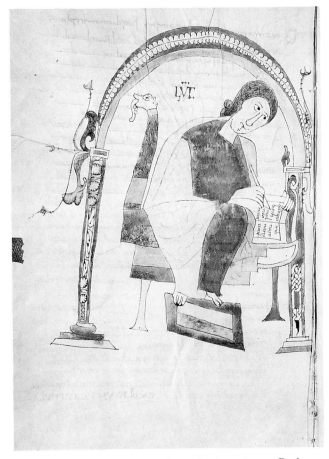

draw on. What happened when a new text was written and required illustration? First, it should be stressed that such an occurrence was relatively uncommon, that is to say very few *new* texts written in the period *c.* 700–1100 *were* required to be illustrated.

One example is the text *De Laudibus Sanctae Crucis* written by Hrabanus Maurus, Abbot of Fulda (822–42) and Archbishop of Mainz (847–56). The text was completed *c.* 810, and various dedication copies were sent out from Fulda over the next thirty years or so, for which Hrabanus wrote new prefaces.[35] Müller has shown that the Vatican manuscript made *c.* 810 remained at Fulda and was updated to include the new prefaces.[36] There are in total six ninth-century copies surviving, five from the tenth century and many from later centuries. The text contains poems and prose tracts in praise of the Cross and the poems take the form of *Carmina figurata*, that is the poems are written in capital letters and lines are drawn to outline shapes or figures. This complicated format was derived from the Roman poet of the time of Constantine, Porphyrius, thus typically it follows an earlier practice. Looking at the various representations of Christ on the Cross, of Louis the Pious, of the Cherubim and Seraphim, it is not difficult to see how here too the Fulda illuminator was able to draw on a pictorial tradition and to re-use existing images, though these were not necessarily available in the context of an illuminated manuscript, of course. The emperor representation, for

example, may depend on a Late Antique ivory. Perhaps the most interesting miniatures of the cycle are the two presentation scenes, the first showing Alcuin of Tours presenting Hrabanus to St Martin, and the second the presentation made *c.* 843 of a copy to Pope Gregory IV (827–44) (fig. 130). These images derive from a monumental presentation scene where in classical art tribute is brought to a ruler, or in Christian art martyrs carry their crowns to Christ. Peter Bloch has shown that the enfolding gesture of Alcuin appears in such monuments where (as at Sts Cosmas and Damian in Rome in an early sixth-century mosaic), a donor presents the church he has been responsible for building.[37] However, the book-presentation scene, and the other images, are not necessarily created at Fulda, since there may be North Italian intermediaries.[38] Nevertheless the image must have evolved in a monastic context, for as Bloch well remarks, the parallelism and equal importance implied between the dedication of the church as place of religious worship, and the presentation of a book containing a religious text, is specifically Benedictine. The image, once evolved, becomes widespread, and this is due both to its relevance in the context of monastic book production (a point we shall return to again), but also no doubt to the diffusion of copies of this specific text. One other thing worth stressing in connection with later copies of the text is Hrabanus's own comment that it will be easy to copy his text correctly if the letters are counted carefully and

130. Vatican, Biblioteca Apostolica Vaticana, Reg. Lat. 124, folio 3v. Hrabanus Maurus, *De Laudibus Sanctae Crucis*. The Presentation of the Book to Pope Gregory IV.

131. Oxford, University College, Ms. 165, page 163. Life of St Cuthbert. The ravens penitent before St Cuthbert.

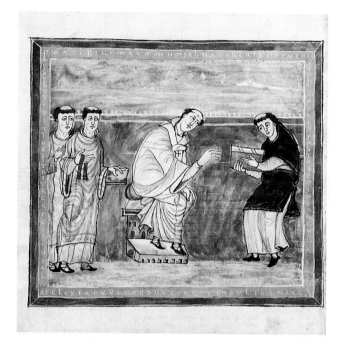

placed in their correct spaces.[39] Here, then, the pictures are seen as necessary adjuncts of the text.

Perhaps the most important class of text for which artists had to invent images in this period is the life of a saint.[40] Obviously devotion to Christian saints, martyrs, confessors, and virgins, is as old as the church itself, and their *acta* were recorded, in written form at least, from the second century AD. The cults found pictorial expression in various ways, in monumental mosaics and wall paintings, even cloth hangings in churches, and in smaller portable cult objects made of metal or ivory, such as reliquaries. The representation of scenes from the lives of Saints Romanus and Cassian in the Bern ninth-century copy of Prudentius' *Peristephaton*, a text written in the fifth century, strongly suggests an early Christian illustrative tradition also existed in manuscript form.[41] A Fulda manuscript of the later tenth century contains scenes of the lives of Saints Kylian of Würzburg and Margaret, which may be based in a general way on such Prudentius pictures.[42]

But it is not until the eleventh century that illustrated Lives begin to appear in numbers. In such Lives, a number of episodes may recur; for example, the saint preaching, baptising, healing the sick, and scenes of the saint's death or martyrdom. It is important to stress that the texts themselves betray knowledge of earlier saints' lives, and may model episodes more or less directly on

them. But also in each life there will be various individual episodes which differ.

Two papers by Barbara Abou-el-haj, one on the illustrated Lives of St Amand, the other on that of St Edmund of Bury, analyse the images in the light of a specific historical situation to show why certain episodes of the saints' lives were represented in certain ways.[43] She is able to link, for example, the representations of St Amand's consecration with the current late eleventh-century controversy over investiture, and in the Life of St Edmund, the struggle between the local bishop and the abbey is a factor in the choice of imagery. This gives a very important insight into the preliminary decision process in the making of such cycles of pictures, for it suggests that the artist must have been instructed in what to represent and sometimes even in how to represent it.

For St Amand we have a succession of copies of different dates of a saint's life, but even if they follow each other, at some point a cycle has had to be put together. We cannot hope to reconstruct fully and in detail the process of creation, growth and variation, because our surviving material – both in manuscripts and in other media, for example in wall paintings or, by the twelfth century, in stained glass – is too fragmentary. But we can, perhaps, suggest some of the ways in which the artist approached the task. First there are traditions of certain formats and arrangements. Sometimes the

miniatures are inserted into the text, often, as in the Prudentius, without any framing, which in itself conforms to an early form of relating text and picture. In other cases, as in the Life of St Aubin of Angers, miniatures are grouped before the text, as was beginning to be done in Psalters at the time.[44] This may perhaps signify a more liturgical aspect to the book. In the Lives of St Cuthbert and St Maur, the miniatures preface a chapter with a rubric heading narrating the substance of the chapter, for example, how a certain thing happened, or concerning someone born blind. This perhaps suggests rather a purpose of private reading and meditation. These chapter headings act both as a summary and as guide for the understanding of the miniature. In principle they might have acted as an instruction for the illuminator, but at least in some cases they are not detailed enough, and a close reading of the text was necessary as well. For example, as Malcolm Baker has pointed out, in the early twelfth-century Life of St Cuthbert made at Durham, one chapter title is 'How the ravens atoned for the injury which they had done to the man of God by their prayers and by a gift' (fig. 131).[45] The miniature is fuller, showing both the ravens stealing straw for the guesthouse roof, that is the injury they had done, and what their gift was, that is, a lump of lard, as well as one of the birds in contrition at Cuthbert's feet.

Such a picture must have been invented for this specific text, that is by the artist who, Baker argues, illustrated the exemplar made *c.* 1083–1090 at Durham and which he shows reason to believe was copied by the slightly later illuminator. Such an artist evidently had the ability to draw figures in action, animals, architecture, ships and implements of various kinds. But did he have models and if so of what kind?

Otto Pächt drew attention to the method of narrative in many of these scenes, which he called 'hinge compositions', in that two episodes are shown – a 'before' and an 'after', that is an action or crisis and its consequence or solution, with the saint often acting as a pivotal or 'hinge' figure.[46] Such an arrangement is also found in the Monte Cassino Lectionary of the eleventh century which contains scenes from the Lives of St Benedict and St Maur.[47] Pächt suggested that the resemblance could not be a mere coincidence and, since he wrote the identification of twelfth-century glass panels in York Minster as containing Benedict scenes, may add supportive evidence to his suggestion that a Benedict cycle was known in England at this time.[48]

Baker, however, has concluded 'that there seems to be too few agreements between the University College Manuscript and the Vatican Benedict Manuscript, in terms of specific details, to demonstrate that it was an illustrated Life of St Benedict, rather than a life of some other saint, illustrated in a similar manner, that served as a basis for the Cuthbert series'. Granted that some illustrated cycle of a saint's life, possibly St Benedict or possibly some other saint, may have been known to the Cuthbert life-illustrator, how then would he have

proceeded?

Did he have this in front of him, and then adapt compositions from it as he required them? Or might he have used a pattern book? Here we should draw attention to the distinction proposed by Ernst Kitzinger between motif books and iconographical guides.[49] By the former, Kitzinger meant that the artist would have recorded *details* of scenes not whole compositions – it might be figure poses or ornamental motifs, etc. – and such details could be used in different contexts. By the latter, he meant a record of a composition or even a cycle which, though probably simplified in say a linear form, nevertheless would record whole scenes in sufficient detail for an artist to transfer them from one place to another. In the former, a motif book, an artist has a repertoire of motifs which he can use to create new scenes or enrich old ones. In the latter, the iconographical guide, he has a model to follow exactly. It should be stressed that of the few surviving Western pattern books, most are 'motif books' and only a very small number can be argued to have been 'iconographical guides'.[50]

The problem of the pattern book is obviously of great importance in any study of creation and transmission, and will reappear in each of the remaining chapters. However, it is a particularly difficult problem in the early Middle Ages, since we have so few surviving examples.[51] It is not until the twelfth century that we have any sense of the surviving examples being coherent pattern books in which an artist has recorded motifs with a view to future use. Many drawings do occur on fly-leaves and in spaces in the text of both early and later medieval manuscripts, and examples have been collected for the early period by Bernhard Degenhart.[52] As hinted before, it is often useful to consider them as analogous to the medieval scribes' pen trials. They seem to be much more in the nature of experimental exercises or one-off records. Obviously such trial drawings can also be either intended as, or later used as, a model. But the point is that the *surviving* evidence suggests rather a haphazard process which can only have gradually developed into a more systematic collection of models, in the manner of Kitzinger's motif book. For example, the drawing on a single sheet of parchment, now in the J. Paul Getty Museum, shows a piece of border with leaf ornament and a standing male figure (fig. 132).[53] It has been dated either to the transition of the ninth century to early tenth century, or to the later tenth century. The context from which it comes is unknown, but it might very well have been a fly-leaf from a manuscript, rather than a part of a motif book. The ink drawings of Christ and a standing figure with a scroll and a female head in plummet added probably in the late ninth century to an earlier Astronomical Miscellany can be compared for example (fig. 133).[54] The same is true of three drawings of the mid eleventh century on two leaves in a Prudentius (fig. 134),[55] and of the bands of ornament drawn in a Gradual from Cluny also in the eleventh century (fig. 135).[56] They are either trials or records inserted on blank leaves in a

132. Malibu, California, J. Paul Getty Museum, Ludwig Folia 1. Single leaf with a figure and inhabited scroll.

133. (facing page, lower left) Kassel, Landesbibliothek, Ms. Astron. F.2. Inner pastedown. Added drawings.

134. (left) Paris, Bibliothèque nationale, latin 8318, folio 64v. Prudentius, *Psychomachia*. Patterns for ornament added on a fly-leaf.

135. (facing page, lower right) Paris, Bibliothèque nationale, latin 1087, folio 65v. Gradual. Drawing of ornament.

136. Leiden, Bibliotheek der Rijksuniversiteit, Voss. Lat. Oct. 15, folios 2v–3. Drawings by Adémar de Chabannes of the Deposition, etc.

manuscript. Drawings by Adémar de Chabannes, a monk of Limoges, who died in 1034, begin to be more in the nature of an iconographic guide, for instance, those which appear to record scenes from Carolingian ivories of the life of Christ (fig. 136).[57]

Returning to the Cuthbert manuscript, similar figures can be found repeated on different pages. For example, a falling figure is represented with knees bent so that the legs extend either to the right or the left. Such a figure occurs to the lower left in the miniature of the Angel appearing to Cuthbert as a boy in the playground (fig. 137), and to the right reversed in the miniature showing Cuthbert's vision of Hadwald's death by falling from a tree (fig. 138).[58] Another example is a figure swinging an implement or weapon, and turning in profile in the

opposite direction. It occurs in the same playground scene at the top right (fig. 137), and to the left in the scene of the Scottish army attacking Lindisfarne (fig. 139). These are the sorts of poses which a hypothetical motif book might have recorded. Another similar sort of motif figure, or 'modulus', is the sleeping shepherd shown in the scene of Cuthbert's vision of the soul of St Aidan being taken up to heaven (fig. 140).[59] Such a pose occurs in scenes of God drawing the rib from Adam's side to create Eve.

A more complicated motif is used in the same miniature (fig. 140). This is the motif of two angels carrying a soul represented as half-length in a napkin, which is not uncommon, especially in scenes of a saint's martyrdom. The motif occurs in various forms in the eleventh

137. Oxford, University College, Ms. 165, page 8. Life of St Cuthbert. Cuthbert playing as a boy rebuked by an Angel.

138. Oxford, University College, Ms. 165, page 94. Life of St Cuthbert. Cuthbert's vision of the death of Hadwald by falling from a tree.

139. Oxford, University College, Ms. 165, page 153. Life of St Cuthbert. The Scottish army attacking Lindisfarne.

140. Oxford, University College, Ms. 165, page 18. Life of St Cuthbert. St Cuthbert in a vision sees the soul of St Aidan received into Heaven.

141. Valenciennes, Bibliothèque municipale, Ms. 502, folio 30. Life of St Amand. The death of St Amand.

142. Solothurn, St Ursen Kathedrale, Domschatz, folio 7v. The Hornbach Sacramentary. The scribe Eburnant presents the book to Abbot Adalbert.

143. Solothurn, St Ursen Kathedrale, Domschatz, folio 8v. The Hornbach Sacramentary. Abbot Adalbert presents the book to St Pirmin.

144. Solothurn, St Ursen Kathedrale, Domschatz, folio 9v. The Hornbach Sacramentary. St Pirmin presents the book to St Peter.

145. Solothurn, St Ursen Kathedrale, Domschatz, folio 10v. The Hornbach Sacramentary. St Peter presents the book to Christ.

century, in the Monte Cassino Life of St Benedict, in the Troyes Life of St Maur, in the Sacramentary of Mont St Michel and in the Valenciennes Life of St Amand (fig. 141).[60] The latter is closest to the Cuthbert version. This, too, might be a recorded motif then. But in none of these examples does it seem absolutely necessary to believe in the existence of a motif book, even less of an iconographical guide. It remains only a possibility to indicate ways in which an artist learnt, practised and recorded useful poses. The point to be stressed is that whether the artist operated with mental or visual moduli, the cycle had to be newly put together; it is not a question of a more or less close adaptation of an existing cycle of another saint's life.

At the beginning of this Chapter, I referred to Ullmann's descending theme of government. In the monastery this came from the abbot, and was accompanied by a constant emphasis in the Rule on humility as a virtue. There is evidence in monastic customaries that the monastic scribe might only copy a text which was required, or at least sanctioned, by the abbot. Relevant passages from the Barnwell Customary state: 'Further, for those brethren who can write, he (the librarian [armarius]) shall provide in the Cloister everything that they require for writing books of general use to the community, but they must on no account do this without leave from the Prelate (viz Abbot)'; and 'Brethren must be careful never to write anything that they wish to keep to themselves as their own property; but, by favour of the Prelate, they may keep for their own use a book they have written, though they must not take it outside without consent of the Prelate'.[61] Such authorisations are reflected in scribal colophons stressing the abbot or bishop's role in commanding a book to be made.[62] It is also frequently visually portrayed in donor scenes showing the book travelling, as it were, up the chain of command. Thus in the Hornbach Sacramentary, an Ottonian manuscript of the later tenth century, there are no less than four presentation scenes. Eburnant, the scribe, presents the book to Abbot Adalbert who presents it to St Pirmin, who presents it to St Peter, who finally presents it to Christ himself (figs 142–5).[63] A Norman illuminator, Robert Benjamin, shows the same subservience even

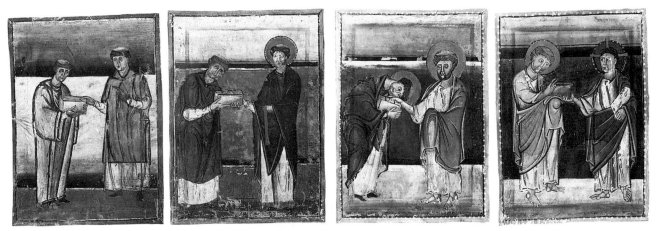

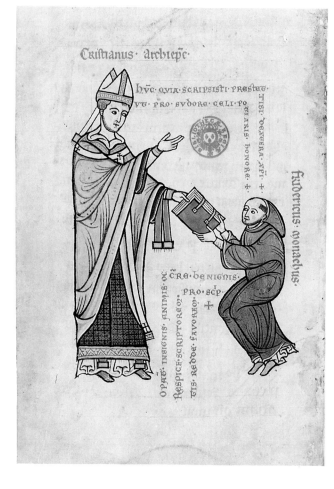

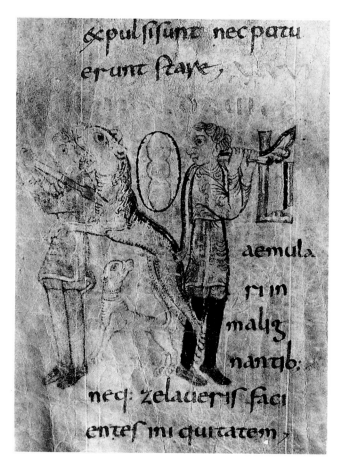

more graphically in the initial discussed in Chapter 1. He kneels below the feet of his Bishop/Abbot, William of St Calais, Bishop of Durham from 1081–1096 (see fig. 14).[64] In a Gospels from the Abbey of Saint-Vaast, the monk Guntfridus holds up his manuscript to Saint Vaast who prays to Christ above (fig. 153).[65] Examples could be multiplied and, in fact, a significant proportion of early scribe portraits show them kneeling before either their abbot, or the patron saint of their abbey, or both. Such representations are not, of course, confined to monks and monastic contexts, but occur also in secular religious contexts. Monks also wrote books as gifts for secular clergy. A good example is the monastic scribe, Fridericus, presenting his book to Archbishop Christian of Mainz (1167–83) (fig. 146).[66] The same constraints will certainly have applied to monastic artists as to the monastic scribes, especially when expensive materials were to be used for illumination, such as gold and lapis lazuli.

Another feature of monastic life may have in some ways strengthened, but also in some ways modified this situation of dependence on authority. This is the command of 'stabilitas loci', the prohibition on travel outside the monastery, which isolated the monk or nun from outside contacts. This would be expected to have an effect in the context of artistic influence, and artistic

training, and indeed it seems that early medieval book painting is characterised by much greater regional idiosyncracies than later production. In the eleventh century in France, different monastic houses have their own recognisable house styles as, for example, with the different monasteries in Normandy.[67] Influences, when they came, were likely to come from the import of books by gift, loan or perhaps purchase from elsewhere, and such sources were liable to be quite local. This needs to be qualified somewhat by saying that monks could travel on occasion to other centres for the specific purpose of copying texts.[68] An instructive example is a copy of Persius' Satires made by a monk of Mont St Michel, Hervardus, who must have gone to Corbie near Amiens (quite a considerable way), to copy this text around 1000 (fig. 148).[69] The Abbey of Mont St Michel had been founded quite recently, and was beginning to build up a library and establish a scriptorium. Whilst at Corbie, Hervardus must have admired a still surviving late eighth-century Psalter with a rich repertoire of letter designs and he (for he must have been both artist and scribe) used the design of an 'N' from the Psalter for the opening initial of his Persius text (fig. 147). A little later a Corbie artist, Ingelrannus, who was also a scribe, copied the same motif, but adapted now to an initial 'R' (fig. 149).[70]

Hervardus and Ingelrannus were making an aesthetic

146. Paris, Bibliothèque nationale, latin 946, folio 127v.
Pontifical. The Scribe Fridericus presents the book to Christian
I, Archbishop of Mainz.

147. Amiens, Bibliothèque municipale, Ms. 18, folio 31v.
Psalter. Initial 'N'.

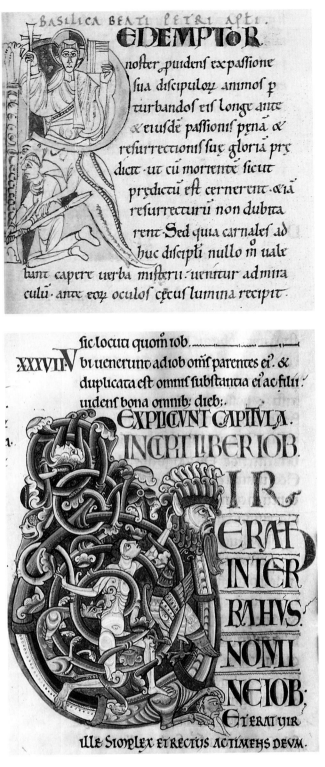

choice without any view of a specific meaning attaching to
the initial. It must have been above all in such areas of
decoration where aesthetic choices and preferences were
expressed in early medieval illumination. Meyer Schapiro
in a famous paper has emphasised the, as he calls it,
'aesthetic attitude' in Romanesque art.[71]

That is not to say that such motifs may not have
carried meanings for some of their creators and some of
their audience. Another example of such copying of a
motif from one context to another occurs in two manu-
scripts from St Maur-des-Fossés, Paris, a Sacramentary
and a Psalter.[72] In the Sacramentary, the stoning of St
Stephen is shown, and in the two top roundels figures
hold stones in their right hands and, incongruously,
shields in their left (fig. 151). The two roundels below
show pairs in conflict, however, with no ostensible bear-
ing on the martyrdom above. All four figures are repeated
on the Psalter page where they appear to have even less
relevance (fig. 152). However the motif of the beard
or hair pullers as found on Romanesque sculpture has
recently been traced and meaning within a social and
historical context sought for it.[73]

In regard to the possibilities of aesthetic choice,
Ullmann's 'practical thesis', which he opposes to the
descending theme, becomes relevant. This is the develop-
ment of the rights of the individual and Ullmann speaks
of a separation between the theory above and the way life
was actually lived below. Most monks and nuns were

148. Paris, Bibliothèque nationale, latin 8055, folio 141.
Persius, Satires. Initial 'N'.

149. Paris, Bibliothèque nationale, latin 13392, folio 43.
Passionary. Initial 'R'.

150. Oxford, Bodleian Library, Ms. Auct. E. inf. 1, folio 304.
Bible. Initial 'V'.

recruited from the upper levels of society, the landowning aristocratic classes and they were expected to bring financial resources to the monastery. It seems that in spite of their vows of poverty, they sometimes retained private wealth, and perhaps they were able to exercise control of the income they brought to the monastery. From this perspective, it seems that much monastic art reflects or expresses a tension and conflict between authority and independent status or individuality. There is a telling story of St Benedict reading the mind of a young monk set to wait on him at table, who in the pride of his heart, knowing himself to be of superior social status to the saint, resented the office.[74]

The illuminated letter, in particular, may be a metaphor of that tension (fig. 150).[75] It illustrates both the freedom to experiment which a decorative purpose as opposed to an illustrative purpose allowed, and also the restraint binding the early medieval illuminator even here. On the one hand, because the ornament is not necessarily tied to meaning, that is it does not have the function of relating, say, a Gospel story which must be recognisably represented and in accord with a particular dogma, experiment and variation have a far greater place. On the other hand, there can never have been a *carte blanche*, as it were, for the artists to do anything they liked. Restraints were first of all imposed by the context of the letter as part of the text which it introduced and which enclosed it, and by the necessity that the letter form remain legible. Secondly, a certain repertoire of pattern and ornament at any particular historical junction also acted, by its availability, as a form of restraint. The artist here too operated to a set of rules. Even in the great Insular carpet pages, which at first sight seem and must have been intended to seem exciting, precisely in their contrast of structure with variety, the patterns are built up from geometrical schemata. We can see these from the compass pricking holes on the pages.[76] In connection with this Insular ornament a number of bone trial pieces have been excavated more recently, which also show artists, presumably sculptors, metal or leather workers, rather than illuminators, experimenting and learning technically how to construct interlace and other patterns.[77]

In conclusion, therefore, the creative aspect of this tension which in the earlier period is socially and historically produced, should be stressed. It is just at the end of this period, in the early twelfth century, that Theophilus' treatise, *De diversis artibus*, was written by a Benedictine monk who may, or may not, have been Roger of Helmarshausen.[78] He justifies the labour of the monastic craftsperson as both 'a religious duty and a religious exercise'.[79] As monastic production is replaced by the lay professional, this tension with its variation, vigour and, as Schapiro is right to stress, individualism, is in certain ways released.

This might at first sight seem paradoxical, but the succeeding production is marked in some ways by greater standardisation and homogeneity. Even in the design of decorated letters and initials this is indicated by the

151. Paris, Bibliothèque nationale, latin 12054, folio 156v. Sacramentary. The stoning of St Stephen.

152. London, British Library, Add. 18297, folio 3. Psalter. Initial 'B' and border.

153. Boulogne-sur-mer, Bibliothèque municipale, Ms. 9, folio 1. St Vaast Gospels. The Scribe Guntfridus presents the book to St Vaast.

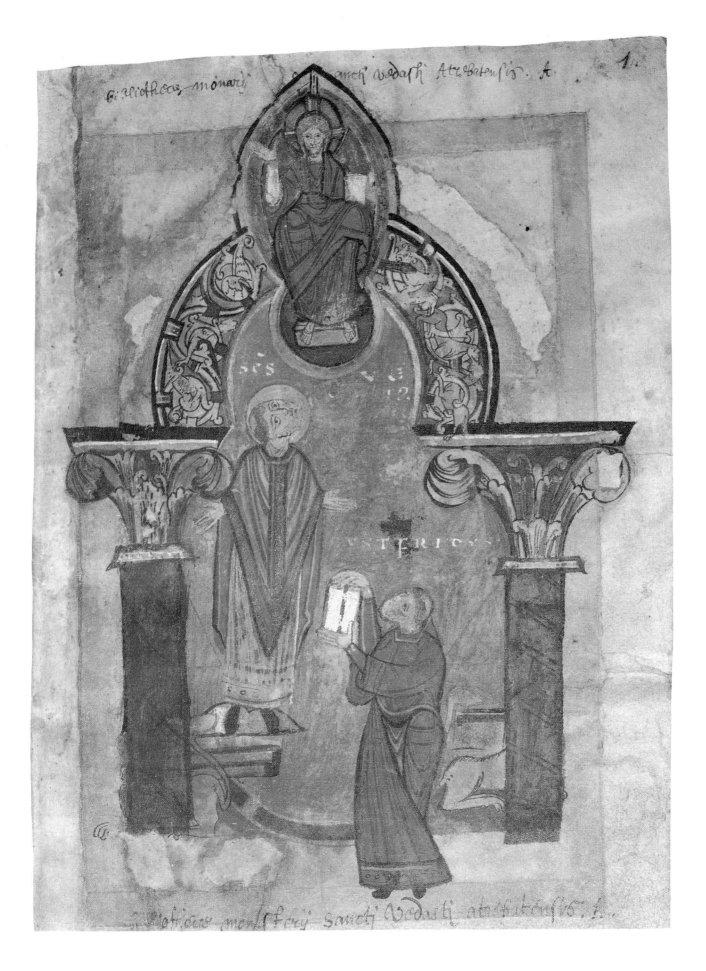

earliest known alphabet pattern book (fig. 154).[80] This was produced in Tuscany in the mid twelfth century, quite possibly by a lay illuminator, and is indicative of a new degree of professionalism and, with it, a greater degree of uniformity. In the later Middle Ages, however, there have also to be outlets for tensions, resistance and individual responses, which inevitably, since they have different contexts and causes, take new forms.

154. Cambridge, Fitzwilliam Museum, Ms. 83.1972, folio 1. Alphabet pattern book. Initials 'A' to 'D'.

Illuminators at Work: The Twelfth and Thirteenth Centuries

In this Chapter, I have chosen to consider the twelfth and thirteenth centuries together, in spite of the fact that this crosses the conventional stylistic division of Romanesque to Gothic illumination, usually placed around 1200. My reason is that this is, as we saw in Chapter 1, the transition period in which lay, professional illuminators begin to predominate over monastic craftspersons.

The twelfth century is notable for a series of magnificently illuminated manuscripts, many of which were evidently produced in monasteries and for monastic use. Two texts stand out particularly: Psalters and Bibles.[1] Both texts will also have been used in religious institutions other than the Benedictine monasteries, in secular cathedrals for example, and also on occasion by individuals. The Bibles were used in reading during meals in the monastic refectory and, in addition, become in the eleventh and twelfth centuries a necessary possession for the prestige of any wealthy Benedictine community. This coincides with the period of monastic reform, and is a time when the Order is at the height of its power and creativity as patron of the arts in general. When Henry II introduced the Carthusians to England he had, in addition to finding them a site and giving them land to live off, to put pressure on the monks of St Swithun's, Winchester, to part with a Bible which he could then give to St Hugh, the first prior.[2] In this instance, the newly founded community had neither the resources nor the skills to produce their own Bible themselves.

Some of the Psalters (and more frequently, probably, than the giant Bibles), are likely to have been made for individual owners; monastic, clerical and perhaps even lay. An example is the Psalter with a lengthy prefatory cycle of thirty-eight full-page miniatures, perhaps also made at Winchester Cathedral Priory. This has titles for the miniatures added in Anglo-Norman French, which may suggest that at least a later owner was a lay person.[3] Such manuscripts, though exceptional works, are of course not isolated but find their context in a very much larger production of texts for study. These, though simpler productions, are still finely designed, expertly written, and ornamented with decorated initials of extremely high quality.

For the Psalters and Bibles the significant point to stress in the present context is the way in which their pictorial matter is being enriched at this period, using a very wide number of sources. This means that not only are there considerable numbers of twelfth-century Psalters still surviving from all over Europe with miniatures, often in the form of lengthy prefatory cycles, but that there is notable variety in their pictures, so that they do not easily fall into family groups.[4] The same is true of the Bibles, and in both there is experimentation in format and layout.

Some of the evidence of the identity of artists at this period has already been considered, and it is clear that already in the twelfth century there were a number of lay artists employed in monasteries as illuminators. Examples are Hugo at Bury St Edmunds and the artist who showed himself painting an initial in the Dover Bible (see fig. 26). Another probable example is the artist named the Simon Master who illuminated manuscripts with a French provenance and also others made for St Albans under Abbot Simon (1167–83).[5] Sometimes, during this period, there are startling stylistic discrepancies in manuscripts produced at the same time in the same centre, or even in the same manuscript. For example, at St Albans, a second artist of much more limited skill and working in a less up-to-date style, copies the compositions of the Simon Master (figs 155–6).[6] Another example is the Laud Bible in the Bodleian, where the main artist uses a stylistic idiom which in general can be paralleled in other centres, for example, the later hands of the Winchester Bible, and shows Byzantine influence, though not necessarily experienced first-hand (fig. 157).[7] Then abruptly a quite different artist appears working in a much more old-fashioned style and with far less skill as a draftsman (fig. 158). One explanation for these examples would be that we have here a monastic craftsperson who executes some initials in a book whose main decoration is entrusted to a more skilled and up-to-date artist who would be a lay professional. The more conservative style would be that of the monastic illuminator.[8] Meyer Schapiro has written on the use of different stylistic modes, for example at both Silos and Cluny in the late eleventh to

155. Cambridge, Corpus Christi College, Ms. 48, folio 246v.
Bible. Initial 'A' with Apocalyptic Christ.

156. (right) Cambridge, St John's College, Ms. 183, folio 156v.
New Testament. Initial 'A' with Apocalyptic Christ.

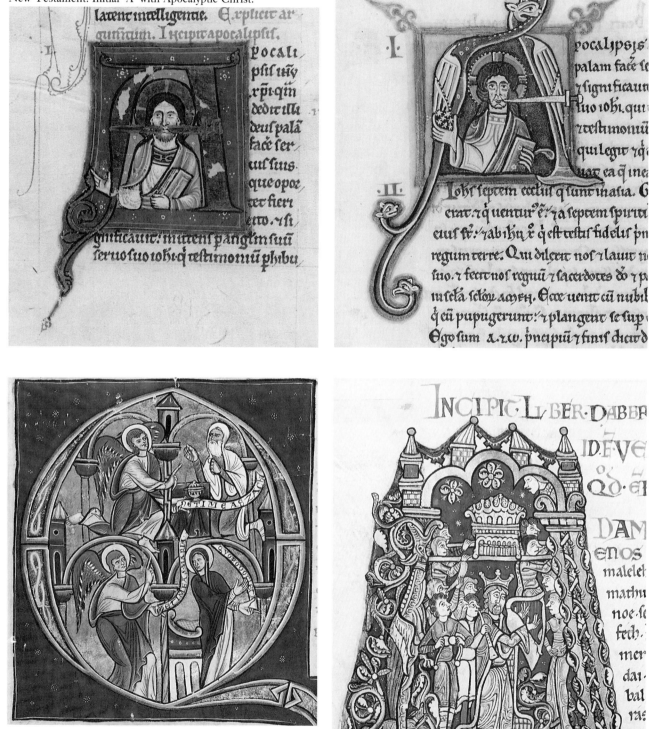

157. Oxford, Bodleian Library, Ms. Laud Misc. 752, folio 357.
Bible. Initial 'Q'. Annunication to Zacharias. Annunciation to
the Virgin.

158. Oxford, Bodleian Library, Ms. Laud Misc. 752, folio
279v. Bible. Initial 'A'. David and the Ark.

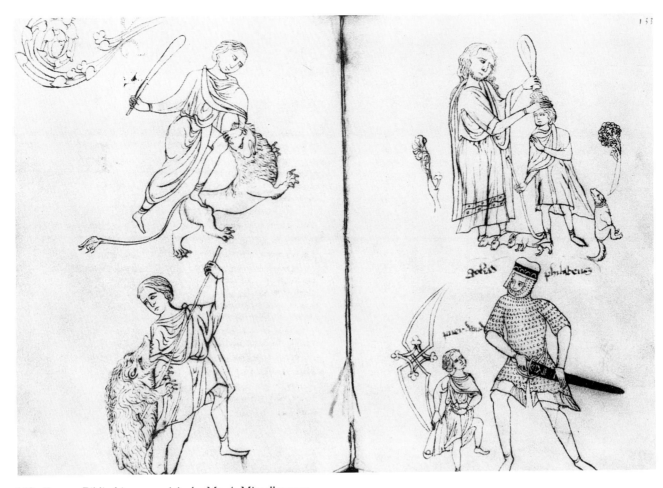

159. Evreux, Bibliothèque municipale, Ms. 4. Miscellaneous texts. Drawings for Psalm initials. Samuel anoints David. David and Goliath.

early twelfth century, but this appears to be rather a matter of geographical origins and regional styles than of professional status.[9]

Whether this is so or not, the enrichment of the pictorial material at this period may already be connected in part to the greater activity of lay artists. An indication of the interest in this process of enrichment is the early twelfth-century description of the pictorial cycles in two Psalters described as those of Sigbertus and Leobertus. The pictures in these are described in considerable detail.[10] A series of late twelfth-century drawings for historiated initials to be inserted at the liturgical Psalter divisions, found in a manuscript from the Abbey of Lyre in Normandy, are a further indication of how such enriched iconographies circulated at this time, and are also probably an indication of the participation of lay professionals (fig. 159).[11]

A feature of twelfth-century illumination which has received much attention is its debts to Byzantine art.[12] The crucial determinants were new contacts with the Eastern Empire fostered by the Crusades, and the political ambitions of the Norman Kings of Sicily, Roger II (1130–54), William I (1154–66) and William II (1166–89), which led to the commissioning of strongly

Byzantinising mosaic cycles, especially those in the Cappella Palatina and at Monreale, Palermo. The impact of Byzantine and Byzantinising art can be clearly seen in the West, and yet we have little surviving evidence, and even fewer surviving examples of Byzantine pictorial works of art, manuscripts or icons, being imported at this time; though rather more evidence of ivory and metalwork. The implication may be, therefore, that some artists gained their knowledge of Byzantine art at first hand by travelling in Italy, Sicily, or as far afield as Constantinople or Palestine. This may or may not mean that such artists were secular clergy or lay persons rather than monks. But it would surely have been easier for the former to travel freely.

At all events the admiration of Byzantine art and the increase in the numbers of lay artists in this period, seem to work together towards certain consequences in book illumination and these are, on the one hand, a greater stylistic homogeneity, and on the other, a standardisation in layout, decoration and to some extent, subject matter.

The standardisation, in that it is a response to quite different needs, is not, for example, a matter of taking over literally and exactly Byzantine modes of representation or Byzantine subject matter. But artists may have

160. Freiburg i. Br., Augustinermuseum, Inv. Nr. G 23/1a. Single leaf. Christ and Zacchaeus. Two saints.

161. Wolfenbüttel, Herzog August Bibliothek, Cod. Guelf. 61.2 Aug. 8°, folio 89. Pattern book. Figure studies.

perceived an authority, an organisation and a discipline in Byzantine art, beside which their own traditions may have looked more *ad hoc* and unskilled. Thus it may well be that artists begin to use pattern books in a more systematic way from now on, because of such general perceptions of Byzantine art; that is, that there is a 'right', a 'fitting way' to represent certain scenes or figures.[13]

It is also likely that they actually came across pattern books in use by Byzantine or Italo-Byzantine craftspersons. Kitzinger has argued, for example, that such pattern books of the variety he calls 'iconographical guides', would have been essential tools of the mosaicists at Monreale, granted the similarities there to the earlier mosaics of the Cappella Palatina.[14] A single leaf, datable *c.* 1200, clearly copies Byzantine models, and has been argued to be a copy by a German artist of such a Byzantine pattern book (fig. 160).[15] The pattern book of the early thirteenth century, now preserved in Wolfenbüttel, has been studied by Hugo Buchthal who concludes that it is 'a selective copy, an incomplete and utterly disorganised second-hand reflection of a collection of Byzantine and Byzantinising formulas'.[16] Whether his hypothetical

Byzantine pattern book existed and if so, whether it was better organised, are questions perhaps still open to doubt; but in any case, the significance of the pattern book's survival in the Western context is precisely its richness in imagery – especially in complex figure poses and groupings (fig. 161).

A bifolium rather similarly inserted in a late twelfth-century manuscript of Orosius has mainly single figure drawings of Old Testament prophets, though Job in a narrative scene with his comforters is included with them, and also Doctors of the Church. D.J.A. Ross has argued that this too is an artist's pattern sheet with ultimately Byzantine sources, originating probably also in Germany in the late twelfth century.[17]

It would be a mistake, however, to over-emphasise the influence of Byzantine art. Not only was there the great weight of a past Western visual tradition, going back to the early Christian and Carolingian periods as well as to more recent and more localised sources, but there were also quite different historically specific factors operating in the West. Two which may have been especially important for book illumination should be mentioned.

162. Vienna, Oesterreichische Nationalbibliothek, Cod. 507, folio 3v. The Rein Pattern Book. Bestiary subjects.

163. Heiligenkreuz, Stiftsbibliothek, Cod. 226, folio 149v. Hugo de Folieto, *De rota verae religionis*. Wheel of the Bad Monk.

164. Oxford, Bodleian Library, Ms. Bodley 188, folio 120v. Hugo de Folieto, *De rota verae religionis*. Wheel of the Bad Monk.

The first concerns the reformed Benedictine Order of Cîteaux. Both St Bernard's attack in the letter to William of St Thierry of *c.* 1125/6 on certain forms of Romanesque art (especially sculpture with non-religious subject matter in the Cloister), and the justification of art in the religious context included by Abbot Suger of St Denis in his accounts of his administration, have been much commented on.[18] In the present context, however, it is not only Bernard's criticism of an over-luxurious monastic art, on which too much money was to be spent, that is important. It is also the emphasis on *uniformity* in the Cistercian community. Glass is to be of only one colour, that is grey, and initial letters in manuscripts are to be of a single colour, not multicoloured.[19] In twelfth-century manuscripts from English Cistercian houses, not only is a certain uniform type of punctuation employed, but also there seem to have been similar initial styles in use.[20] One of the earlier surviving Western pattern books is that from Rein, a Cistercian house in Austria of the early thirteenth century, and it has been suggested that such a pattern book is also significant in the context of Cistercian organisational conformity (fig. 162).[21] It

165. Malibu, California, J. Paul Getty Museum, Ms. Ludwig XIV.2. Gratian, *Decretum*. Initial 'H'.

166. Cambridge, Trinity College, Ms. R.17.1, folio 33v. Eadwine Psalter. Psalm XIX (20).

167. Paris, Bibliothèque nationale, latin 8846, folio 33v. Psalter. Psalm XIX (20).

happens that the Wolfenbüttel pattern book also belonged to a Cistercian house, Marienthal, near Helmstedt.

In this connection, it is interesting to find a number of illuminated manuscripts of works by Hugo de Folieto coming from Cistercian Abbeys – Clairvaux, Aulne, Heiligenkreuz, and Zwettl, for example.[22] Some of these manuscripts are admittedly of the thirteenth century, when there may have been some relaxation of rules. But, evidently, here was an acceptable text with regularised illustrations which are an essential part of the book. A number of the illustrations are diagrams to which figures are added; for instance, the 'Wheels of Good and Bad Monks' (figs 163–4).[23] It is also interesting that Hugo, an Augustinian Canon who died in 1174, may himself have been responsible for the original illustrations of his texts. He says, for instance, several times, that he himself painted them.[24]

The second point concerns changes in education with consequent increase in literacy, and demand for books. With the growth of the schools, and the establishment of

such major Universities as Paris and Bologna, literate people were drawn from different areas to a single centre and the consequence was the imposition of some sort of uniformity. In the context of manuscript production, we see this happening with the development of the glossed books of the Bible, and of Peter Lombard's Sentences and his Commentary on St Paul, and of Law Books.[25] A specific form of decoration, the so-called 'white-lion' style, becomes extremely prevalent, especially in such texts (fig. 165).[26] The question of the origins of this style, which may lie in England, is different from the question of its diffusion, which is most likely to have been from Paris as a centre of study and book production. Whatever its origins, this was clearly an easily copied style which may have made it attractive to the newly developing class of lay illuminators. Scholars came to Paris, bought their glossed texts and took them home, where in turn, they acted as exemplars.

The ways in which the book trade in Paris was regulated and controlled by the University were discussed in the first Chapter. The same process of standardisation can be seen in the thirteenth-century production of small format Bibles, where matters like the order of books, the series of prefaces to them, and their texts, are gradually made uniform during the thirteenth century.[27] At the same time, a form of decoration and illustration by means of historiated, painted and penwork initials evolves, and a whole series of specialised, mainly lay, craftspersons grow up to do the work.[28] There is nothing to compare with

this in the twelfth century or earlier, and even at the same time in the thirteenth century there is not the same uniformity of text or illustration in Bibles made in England.[29]

I want now to consider, as I did in the last Chapter, first the question of copies; then some examples of modification and alteration of scenes; and lastly areas where new illustrations are required, or new forms of figural or decorative illumination evolve.

Facsimile copies, that is the copying of both the subject matter and of the style of an earlier period, appear to be very rare in the Romanesque and Gothic periods. The facsimile copies of the earlier Middle Ages discussed in the last Chapter, and also those of the fifteenth century, to be discussed in the next Chapter, aim to reproduce classical style as well as content. It seems that this particular historicising impulse did not exist in the twelfth and thirteenth centuries. This is not to say, of course, that illustrative cycles were not copied. On the contrary, examples are numerous. For example, the two copies made in England in the twelfth century of the Utrecht Psalter both copy the illustrative cycle, though with some alterations or modifications (figs 166–7).[30] But unlike the early eleventh-century copy, discussed in the last Chapter (see fig. 121), they do not attempt to copy the style. The same is true of twelfth-century English copies of Prudentius and Terence,[31] or of a French late twelfth-century copy of Hrabanus Maurus.[32] Many other examples could be given.

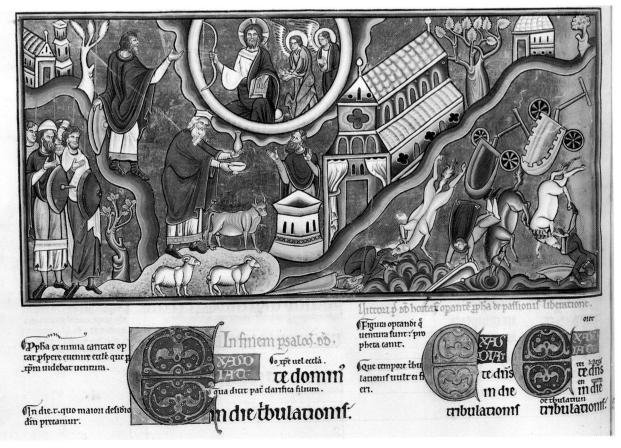

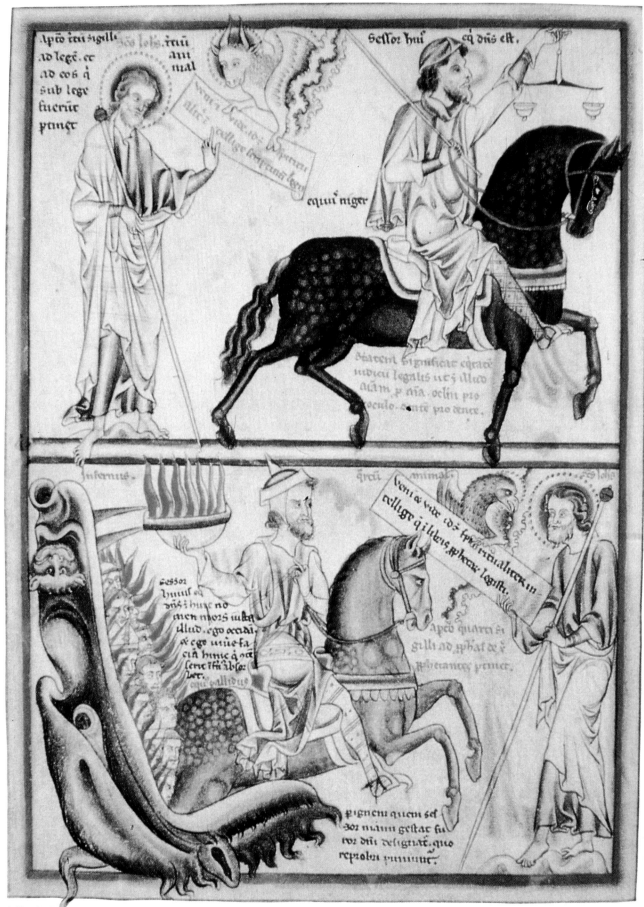

168. Oxford, Bodleian Library, Ms. Auct. D. 4.17, folio 4v. Apocalypse. The third and fourth riders on the black and the pale horses.

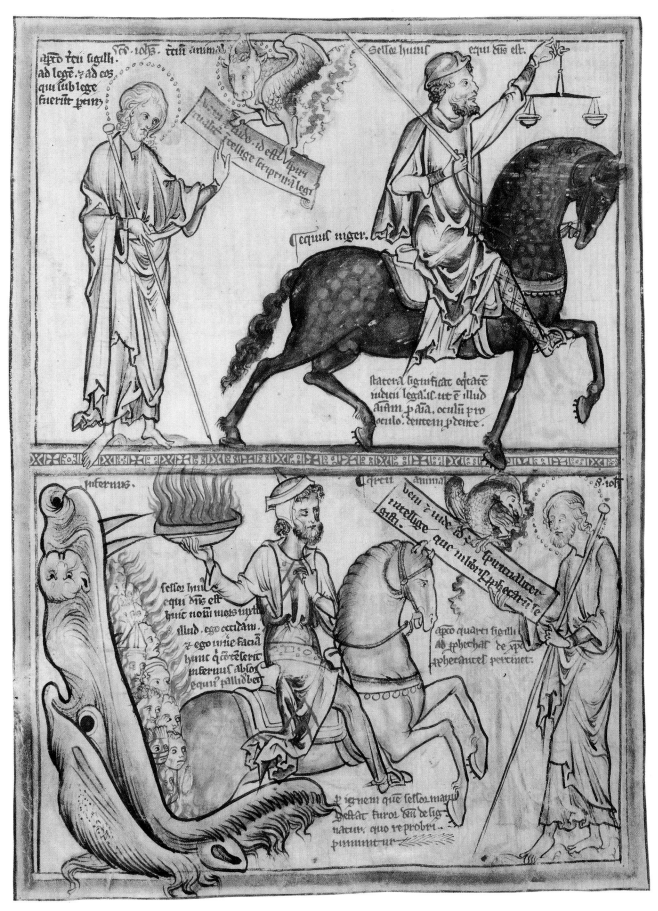

169. New York, Pierpont Morgan Library, M. 524, folio 2v. Apocalypse. The third and fourth riders on the black and the pale horses.

170. Oxford, Bodleian Library, Ms. Auct. D.2.1., folio 147v. Gilbert de la Porée, Commentary on Psalms. Initial 'D' with Christ.

171. Oxford, Trinity College, Ms. 58, folio 180. Gilbert de la Porée, Commentary on Psalms. Initial 'D' with Christ.

173. (below) Oxford, Bodleian Library, Ms. Ashmole 1511, folio 7. Bestiary. Creation of Eve.

172. Aberdeen, University Library, Ms. 24, folio 3. Bestiary. Creation of Eve.

174. (facing page, left) Aberdeen, University Library, Ms. 24, folio 93v. Bestiary. The fiery stones.

An example of two very similar initials in two late twelfth-century glossed Psalters is difficult to interpret (figs 170–71).[33] It may be that one is intended as a reproduction of the other, but it may also be that the two were produced together as a pair for some specific reason. It seems that this happened quite often in the thirteenth century. For example, among the large number of illustrated Apocalypses produced in England in the thirteenth century, there are two pairs of manuscripts which seem to be 'twins' (figs 168–9).[34] Similarly, several Bestiaries are twinned; one example being the Aberdeen and Ashmole Bestiaries (figs 172–3).[35]

In such examples it seems more likely that for some special reason, two identical or nearly identical manuscripts were made at the same time, or perhaps after a very short interval, rather than that one manuscript aimed to copy another exactly after a longer interval. In the later Middle Ages there are examples of a new text or newly translated text being made in two or even multiple copies. For instance, both Marino Sanudo and Paolino Veneto in the early fourteenth century had more or less identical multiple copies made of the texts they had written to urge a new Crusade.[36]

The relationship of the Aberdeen and Ashmole Bestiaries is interesting, but in some ways still puzzling.[37] The former contains both marginal drawings and colour notes, and in addition some of the miniatures have been pricked. On folio 3 in the scene of the Creation of Eve (fig. 172), the figures of Adam and Eve, but not of the Creator, are pricked, and animals and birds on a number of other pages are also pricked.[38] Colour notes are visible at various places and there are other notes, probably also concerning colours, which are harder both to read and to

interpret.[39] Finally on folios 32v and 93v (fig. 174), marginal drawings are clearly visible and on a few other pages there seem to be faintly visible traces of such drawings.[40] On the whole, the style of the Aberdeen manuscript looks earlier than that of the Ashmole manuscript and it is accordingly stated to be the earlier by Nigel Morgan. The possibility that Aberdeen copies Ashmole should not be ruled out, however, for the following reasons. The marginal drawing of the man and woman for the fiery stones on folio 93v in Aberdeen, resembles Ashmole (fig. 175) more than it does the completed miniature in Aberdeen (fig. 174), as can be seen by comparing the position of the arms of the couple below. This may suggest that a sketch was made copying Ashmole in the margin in Aberdeen, but that finally the Aberdeen artist, as so often happened, did not choose to follow it. If Ashmole, on the contrary, copies Aberdeen, it is more difficult to see why the Ashmole artist should follow the marginal drawing in Aberdeen rather than the finished miniature. Xenia Muratova suggests the drawings were actually made by the headmaster of an atelier responsible for both manuscripts.

Bestiary illustration can be traced through a series of surviving manuscripts as far back as the early ninth-century Bern *Physiologus*, probably made at Rheims. The classicising style of its illustrations suggests that it copies a model of the fourth or fifth century.[41] It is a typical case of the gradual alteration and accretion of a picture cycle. For example, in the Bestiaries just discussed, named by M.R. James the 'Second Family', scenes of the Creation of the World are prefixed, which probably are transferred from a text of Ambrose's *Hexameron*.[42]

175. Oxford, Bodleian Library, Ms. Ashmole 1511, folio 103v. Bestiary. The fiery stones.

Ekaunt il aueit ouert le secunt seel. Jo oi la secun de beste disaunt. Venez e veer. E un autre cheual sor issi, e il est dune a celu ke seet sur lu, ke il preist la pei de la tere, e ke il se entreoaisent, e il li est dune une graunt espee. o oi la secund best disaunt. Venez e veer.

Le sor cheual signefie les eslitz deuaunt la lai. Le sor nostre seignur. Le esper les ewes del deluue e la destructiun de sodome. Il i ad bone peis e male. Les fitz deu aueient male peis od les fitz del houme. Kaunt il pisterent lur filez, e donerent lur filez a euls, iceste pei su pf p les ewes del deluue. Qui auer sout ke les bons uiet les maue, ele maue le bons.

Epus ke il ouert le teir sel. Jo oi la teirte beste dire Venez e veez. E jo vi un neir cheual, e celu ki seet sur lu auer une balaunce en sa main. E jo oi ausi un une vois en mi les quatre bestes ke disent. Deus huueis de for

ree uirgine marie est signefiee la quele le sauer del pe purunt a reposer enz sun fiz, en la quele il pist char, e porta tutes nos enfermeetz for sul ignoraunce e petche. P le arzil. la uirginte de la benuit marie. P le peis ke gard le uin, sa humilitre gardeine desau tres uertues. Dunt ole dist, pur ço ke il regardar la humilitre de sa

The Apocalypses, which are likewise a speciality of English thirteenth-century illumination, are even more complex regarding the origins and interrelationships of their cycles.[43] As with the Bestiary, present research is helping to clarify our understanding.[44] But here, though three Carolingian illustrated Apocalypses survive, and there are also the numerous Spanish illustrated copies of the text with the commentary of Beatus of Liebana of the tenth to the twelfth century,[45] there seems to be a fundamental break between these and the thirteenth-century copies which the twelfth-century cycles, such as that in the *Liber Floridus*, do not fill. The question is whether a radical replanning of the illustrations took place at a particular time, from which the thirteenth-century copies all derive, or whether different experiments in illustrating the text took place, possibly using the same sources but

nevertheless evolving independently. This is an example which suggests the dangers of assuming that creation and transmission will operate in a certain way. In the general arrangement of their pictures, there are three different methods. In one, the pictures are placed at irregular intervals and take up varying space as, for example, in the Trinity College Apocalypse (fig. 176).[46] In another, the pictures are arranged two to a page with a small amount of text incorporated on scrolls, as in the Bodleian and New York Apocalypses discussed above (see figs 168–9). In the third, each page has a picture at the top with the text written below as in the Douce Apocalypse (see figs 62–3).

Various scholars in the past have tried to argue that one, or other, of these arrangements represents an archetypal cycle from which others depend. But it may be a mistake to treat picture cycles as always analogous to written texts for which the philologist seeks to establish a stemma. This method has been applied with great rigour and considerable success for the early Middle Ages by K. Weitzmann, a period of contraction in general terms of pictorial cycles, though even there it is perhaps more problematic than Weitzmann suggests.[47] The thirteenth century, however, is on the contrary a time of major experiment and expansion in book illustration, and different methods are therefore necessary to its study.

Though it may be an error to think always in terms of an archetypal cycle of illustrations, it remains essential for the art historian to work together with the philologist. In this period, we begin to have numerous new texts or new translations of texts, for which cycles of illumination had to be created or adapted. A great deal of significant work has been done in the last few years in this direction, and this has interestingly shown that the philologist often also has need of the art historian's expertise – especially in the matter of dating and localising manuscripts. An example concerns the manuscripts of the French fourteenth-century poet, Guillaume Machaut, where art historical

analysis has shown that a manuscript, once dated by the philologists to the fifteenth century, is in fact of the mid fourteenth century and thus of considerable textual importance.[48]

These remarks are very applicable to the study of the work of Matthew Paris. Matthew was professed as a monk at St Albans in 1217, and so must have been born around 1200, and he died in 1259. More is known about him than about any other English medieval illuminator, though this, of course, is because he was not just an illuminator, but official chronicler of his Abbey. He himself refers to his activity as an artist, and is described as such in the later chronicles of the Abbey. The problems of attribution have been most recently discussed by Nigel Morgan and Suzanne Lewis, and their more inclusive view in opposition to some earlier scholarship is surely right.[49] The arguments are founded, above all, on palaeographical, codicological, and textual considerations. A quite considerable body of material thus survives for study and we can ask questions about how Matthew learnt his craft, what were the sources of his images, and what choices he made in his representations. Matthew himself tells us nothing of his training as an artist or of his sources, though he does mention various works of art at St Albans, mainly works in precious metals and paintings for the altars of the Abbey church. He does not mention in his chronicle any work he may have done himself for the Abbey.

It is generally agreed that the earliest work by him is the sequence of illustrations of the Lives of St Alban and St Amphibalus in Dublin, executed perhaps about 1240.[50] The text is a translation in Anglo-Norman verse, made by Matthew and written in his own handwriting, of a Latin Life written by William of St Albans, c. 1155–68. A strange feature of Matthew's illustrations is certain contorted mask-like faces, for instance, that of the torturer on folio 35 (fig. 177). These mask-like faces recall the illustrations in a mid twelfth-century manu-

176. Cambridge, Trinity College, Ms. R.16.2, folio 6. Apocalypse. The second and third riders on the red and the black horses.

177. Dublin, Trinity College, Ms. 177 (E.1.40), folio 35. Life of St Alban. The scourging of St Alban.

178. Oxford, Bodleian Library, Ms. Auct. F.2.13, folio 16. Terence. Scene from the *Andria*.

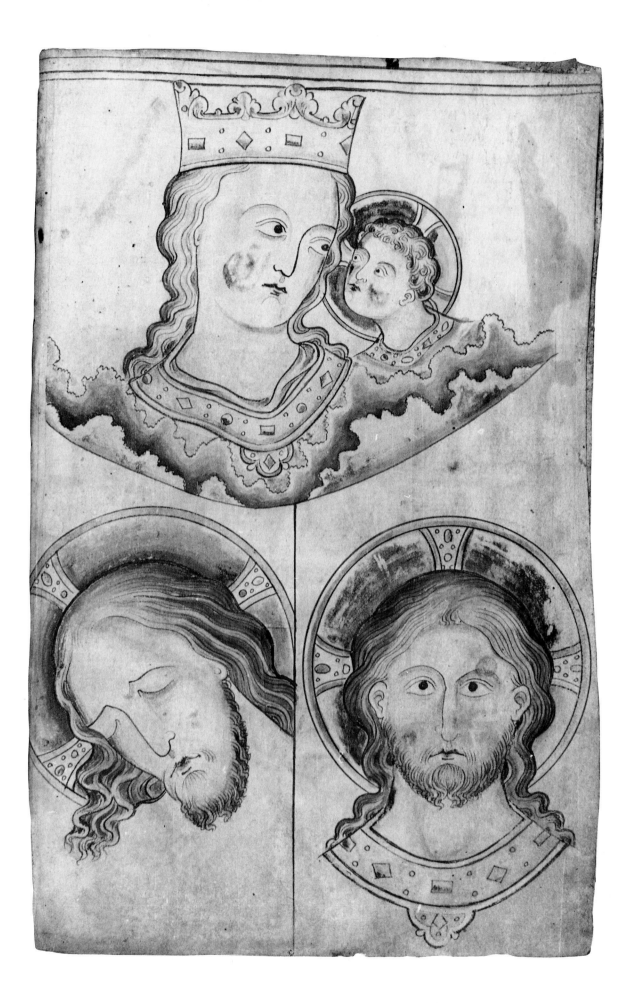

script of Terence with a St Albans' thirteenth-century ownership inscription (fig. 178).[51] These types of masks appear in the Terence since the figures, dependent ultimately on a late antique pictorial tradition, are shown wearing the masks of the classical stage. It seems likely to me that the twelfth-century Latin Life of St Alban was illustrated by the same artist, or artists, as were responsible for the Terence illustrations, and that these illustrations served as a model for Matthew, just as the Latin text did for his translation. He may have copied his model rather exactly, both in composition, and in such aspects as architecture and landscape.

One strand, therefore, of Matthew's training, according to this argument, would be the traditional medieval one of copying. It has been observed that his use of the coloured outline technique in itself shows that he knew Anglo-Saxon manuscripts of the late tenth and eleventh centuries, which use this technique, and there seem to be other indications that he knew and copied earlier works of art. His own self-portrait (see fig. 36), prefacing the third volume of his Chronicle, may even be a reference specifically to the Dunstan Classbook image discussed earlier (see fig. 10); or it may be that he had another similar example in mind of this image of monastic humility.[52] His representation, though updated by the use of a new type of Virgin and Child, also reflects Matthew's conservatism and fierce devotion to his order, therefore. As a monastic craftsman, one may observe that he is already something of an anachronism, but at the same time, unlike many monks, he had exceptional opportunities for travel and outside contact. A leaf inserted in the Chronicle is perhaps a worked-up record of monumental representations he had seen (fig. 179).[53] He also owned,

and valued highly, a drawing by another artist, the Franciscan Brother William (see fig. 43).[54]

Matthew's most remarkable achievements, however, are his Chronicle illustrations. Some precedents exist in the historical and legal manuscripts of this period.[55] Contemporary events or activities are beginning to be illustrated in Italian and other law books at this time.[56] The germ of the idea of inserting drawings in his Chronicle may have come to Matthew from some such source, therefore. But it should also be pointed out that the marginal drawing has a very ancient tradition in Psalters, where a word serves as it were to trigger an image, and that Anglo-Saxon examples survive; so that it is not impossible that once again Matthew was looking back to what was, for him, a glorious past.[57]

If this is the context into which the drawings fit, we can go on to look at how in practice Matthew operated. Most of the scenes in the Chronicle must have been invented, though a few, such as those of the Nativity, the Crucifixion, as well as a figure threshing corn (fig. 180), are no doubt copies (either direct, or from memory) of representations known to Matthew. The Crucifixion can be compared, for instance, to wall paintings of this subject still surviving in the nave of St Albans. The threshing figure, inserted beside an account of a riot during a food shortage, is significant, because here the image of peasant labour so frequently replicated in the period after 1100, in both monumental contexts and in calendars in manuscripts (fig. 181),[58] has proved more powerful than the text's description of events.[59] Matthew wrote: 'they emptied the greater part of the granaries and sold the corn on good terms for the benefit of the whole district and had also given a portion of it in charity to the poor'.

179. Cambridge, Corpus Christi College, Ms. 26, page 283. Chronicle. Pattern sheet with heads of the Virgin and Child and of Christ.

180. Cambridge, Corpus Christi College, Ms. 16, folio 79. Chronicle. Peasant threshing corn.

181. Oxford, Bodleian Library, Ms. Ashmole 1525, folio 4. Psalter. Calendar scene for September: Threshing Corn.

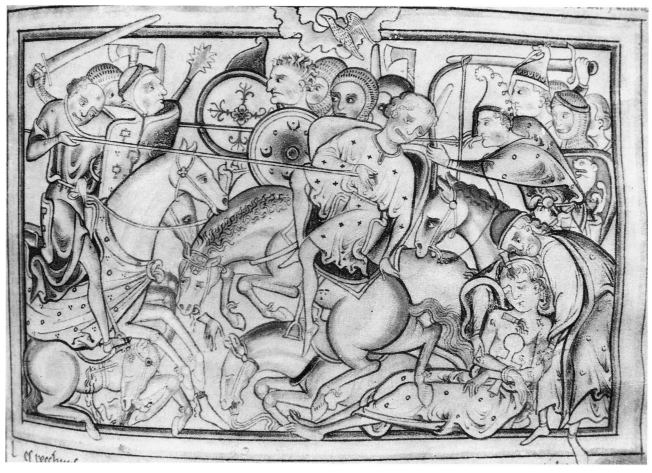

182. Dublin, Trinity College, Ms. 177 (E.1.40), folio 48. Life of St Alban. Battle between pagans and Christians.

183. Cambridge, Corpus Christi College, Ms. 16, folio 54v. Chronicle. Battle of Damietta.

184. London, British Library, Cotton Nero D.1, folio 3v. Lives of the Offas. Battle scene.

185. Cambridge, Corpus Christi College, Ms. 16, folio 169. Chronicle. Griffin falling from the Tower of London.

186. Cambridge, Corpus Christi College, Ms. 16, folio 144. Chronicle. Victims of a Tartar horseman.

The revolutionary threat of the uprising, which required the intervention of the King's sheriff before it was suppressed, is thus ignored in favour of an image with positive connotations of the peasant at work.[60]

Looking at the invented scenes, we find that Matthew operates with a number of conventional motifs or moduli, which he can deploy for figures on horseback, for men and women standing or sitting, for architectural and landscape features, for arms and armour, etc. Such stock patterns do not, of course, imply study from life, in the sense that a Renaissance artist might have studied particular poses. Either the figures are held in the memory, or perhaps they formed part of a stock of models in a pattern book of the kind called a 'motif' book by Kitzinger, and of which instances in the early twelfth-century Life of St Cuthbert were discussed earlier.[61] Examples are the falling horse which is used three times in different manuscripts, once in the Life of St Alban, in the centre of the scene of pagans and Christians fighting (fig. 182); then again to the right, in a representation of the Battle of Damietta in 1218 in the Chronicle (fig. 183); and thirdly, also at the right, in a drawing in the Lives of the Offas (fig. 184). Another figure which seems to be a pattern-book motif is the one which Matthew uses for people falling, for example Griffin falling from the Tower of London, or the victim of a Tartar horseman (figs 185–6).[62]

187. Paris, Bibliothèque nationale, fr. 19093, folio 3v. Villard d'Honnecourt's Pattern book. Figure of Pride.

Certain similarities have been noted by Betty Kurth between Matthew, and Villard d'Honnecourt, who was compiling his pattern book probably in the 1230s.[63] She did not wish to suggest any direct link. The important point is that Villard is seeking to do two things in his pattern book, which Matthew is also doing in these illustrations. One is to supply models (motifs) which can be copied and re-used in different contexts, like the falling figure or the falling horse used by Matthew, and recorded also by Villard (fig. 187). The second is to supply instruction, to teach a method of drawing, which can then be applied in different pictures as necessary.[64] Here, then, we begin to have an impression of an artist's method of constructing pictures, of using a pictorial vocabulary to build up scenes. This continues what was said in the last Chapter about the Life of St Cuthbert. Since Matthew was also the scribe and the author, there was no problem for him as to what was to be illustrated. He made the choice himself, and his intimate knowledge of his text and particular point-of-view must explain his choice.

Two other examples where the artist had to follow outside instructions may now be examined. The first is an example of a widely circulated type of text at this period, an Arthurian Romance, now in Manchester.[65] The manuscript, now bound in two volumes, contains the second half of the Arthurian cycle; that is, 'Lancelot', 'Queste du Saint Graal' and 'Mort d'Artu'. The first half, 'Estoire del Saint Graal' and 'Merlin', has been separated from it.[66] There are fifty-five small miniatures set in the text of the Manchester manuscript, which is to be dated on stylistic grounds c. 1300. At the beginning of 'Queste' and 'Artu' there are more elaborately decorated pages with marginal scenes. The beginning of 'Lancelot' is missing and there are other leaves missing throughout the

text, some of which survive in a Bodleian manuscript.[67] In the early fifteenth century, nineteen miniatures were added in the margins. The language of the text enabled C.E. Pickford to attribute the manuscript to the Picard region.

Accompanying each miniature is a rubric which describes the event shown. For example, on folio 109v: 'How the knights of the round table sat at dinner and a knight sat in the perilous seat and fire and lightning fell on him and burnt him and the King and Queen sat at another table.'[68] The miniature (fig. 188) duly shows the presumptuous Knight being struck by fire and lightning and the King and Queen seated at a separate table. Pickford observed that some of the rubrics overlap the miniature or there is not room for them, for example, on folio 188v, so that they must have been written in last. They could not, therefore, have acted as a direction to the artist for his picture, though they seem to describe the event so well.

He then perspicaciously spotted erased writing in the lower margin and was able, with the aid of an ultra-violet lamp, to decipher parts of some of the inscription. This made clear the procedure followed. The scribe, in transcribing the text, left the necessary space for rubric and miniature, as on folio 109v, 'The Siege Perilous'. Then in the lower margin, a direction in French was written in small script beginning with such phrases as 'Si com' or

188. Manchester, John Rylands University Library, French 1, folio 109v. Arthurian Romance. The siege perilous.

189. Manchester, John Rylands University Library, French 1, folio 24v. Arthurian Romance. A joust.

'Ensi que' and occasionally 'Chi endroit'; that is, 'How' or 'Here follows'. These directions are sometimes longer and more detailed than the rubrics. There is, in fact, a second larger script detectable in the margin (a clumsy book hand, Pickford calls it), which is also erased but which contains a condensed version of the other inscription, and it was these inscriptions which acted as directions for the rubricator.

Unfortunately, there is no means of knowing who was responsible for the directions. Was it an adviser, someone appointed by the patron perhaps, a family chaplain, for example? Or was it a *libraire*, or even perhaps the main illuminator ? One cannot say for sure, but the miniature on folio 24v might give some clue (fig. 189). Here the

rubric is: 'A joust before a fountain and the trees on which the shields of arms hang'. The part of the directions which Pickford could decipher reads: 'Letters written'.[69] In the miniature, the names Gauvain, Agravain and Lancelot, are written on the bridge below their shields, but so far as Pickford was able to read them, the directions do not specify these names. This may, perhaps, suggest that the person who wrote the direction was still available, either himself to write in the names on the miniature, or at least to supply them to a scribe after it was executed. The conclusion would be, therefore, that the author of the directions was connected with either the artist's atelier, or with a *libraire*, rather than with a patron.

We may now look at some examples of how the illuminator responded to the instructions he was given. On folio 16v the rubric reads: 'How Lancelot met a young maiden in a forest who was crying and lamenting very strongly'. The marginal direction is fuller, in that it specifies that the woman should be on horseback.[70] The artist, however, has constructed his picture (fig. 190) according to a formula with which he must have been familiar, and which occurs not only in numerous scenes in manuscripts, but also on Gothic secular ivories, small jewellery chests or mirror backs (fig. 191).[71] It is not strictly suitable, since such a scene represents not a meeting, but rather two lovers accompanying each other and conversing. A visual schema or modulus has thus been applied, and has proved more powerful than the written instruction. On folio 46v, three women are shown crowning Lancelot and, as they do so, a statue falls and breaks (fig. 192). The instruction here is not legible, but the text specifies neither what sort of statue fell, nor that it was a nude figure. Again, the artist has taken a representation with which he was familiar, that is the pagan idols which,

190. Manchester, John Rylands University Library, French 1, folio 16v. Arthurian Romance. Lancelot with the maiden in the forest.

191. London, British Museum, Department of Medieval and Later Antiquities, 56, 6–23, 103. Ivory mirror back. Lovers on horseback.

192. Manchester, John Rylands University Library, French 1, folio 46v. Arthurian Romance. Lancelot crowned by three women.

193. Manchester, John Rylands University Library, French 1, folio 84v. Arthurian Romance. Lancelot kills Belyas the Black.

according to the Apocrypal Gospels, fell as the Holy Family passed by on the Flight into Egypt, and which are always shown as nude.[72] On folio 84v, Lancelot is shown having killed Belyas the Black (fig. 193). In this miniature, the artist is using moduli to give variation to his picture. Thus, both the fallen figure and the fore-shortened horses appear over and over again in such contexts. The latter is another motif included by Villard in his pattern book.[73]

In this instance, it is not necessary, therefore, to suppose that the artist was copying another Arthurian Romance which he had before him. He inserted his pictures, as necessary, from the instructions, using moduli which he kept either in his head, or some of which he may have recorded in a pattern book.[74]

The main conclusion of more recent work on the Arthurian cycles is that illustration takes place on a much more *ad hoc* basis than was earlier assumed. There is not a single illustrative tradition to which manuscripts more or less conform. It cannot be reconstructed, and there is really no reason to suppose that it ever existed. Texts are illustrated usually very simply at first, often by the most direct way of connecting text and picture, that is by historiated initials. In so far as larger cycles occur, they seem to be built up by a process of accretion, and that accretion is not necessarily a matter of copying images; rather, that there is an expectation on the part of patrons of the amount of illumination, and this expectation increases as time goes on.[75]

Thus, in general, the Arthurian picture cycles do not relate closely. R.S. and L.H. Loomis, however, connected two other prose Lancelots to the Rylands manuscript in both text and style, and these are both now in the British Library.[76] The second has a date of 1316 inserted in a miniature on folio 55v. Pickford states that: 'if one compares the miniatures in the three manuscripts there is seen to be an indisputable connection between them'. He compares the illustration of the Divine Stag, on folio 90 of French 1, to the same scene in the other two manuscripts. They are quite similar, certainly, though the stag is reversed in French 1. Another comparison is of the scene where the Lady of Shalott reaches Camelot in her boat. Here, however, different moments are shown: in French 1, folio 226, King Arthur looks out from the window (fig. 194), but in the other two manuscripts the court has already come down to the riverside (figs 195–6). Comparing other scenes, the differences seem to me more striking than the similarities; for example, Gawain trying to draw the sword,[77] or Lancelot striking the shield.[78] And equally important, there are a great many scenes in Royal and Additional which are not to be found in French 1. Thus, whilst the stylistic connection is indisputable, the pictorial connection seems to be less close. There are, in fact, marginal directions in both the British Library manuscripts, though they cannot be read by the naked eye and very few are recoverable even with ultra-violet light.[79] However, it seems to me this must suggest that the artists did not have a visual model, that

they were not copying French 1 or some other intermediary cycle, nor did they have a pattern book in the form of an iconographical guide. Either a new set of instructions was drawn up or, as seems an even stronger possibility, the set of instructions for French 1 had been kept. That set may either have been amplified for a new, even more luxurious commission, or may have been a very full set of instructions which had existed when French 1 was illustrated but from which, for that commission, only a selection was made. If this is the correct hypothesis, then it would suggest that the instructions were kept by either the artist or the *libraire*; probably the latter. It would then be quite simple for the patron, when ordering a manuscript, to specify how many illustrations he or she was willing to pay for, and they could be executed accordingly. As was demonstrated earlier, there is good evidence for payments to artists being calculated in this way.[80] If the instructions were only, or mainly, verbal not pictorial, that would account for variations in the miniatures in this and other examples.

Another important example, where it is certain that a programme was followed, is the *Somme le Roi*, a treatise on the virtues and vices, composed by the Dominican, Frère Lorens, for Philip III of France in 1279. Though no surviving manuscript can be considered the dedication copy, it is reasonably certain that the text was illustrated from the first and that the full cycle of fifteen pictures, which is preserved in many of the later copies, was present in the original dedication manuscript. Four manuscripts are datable before 1300, and of these, perhaps the finest in quality is that now in the British Library.[81] A thorough study of this manuscript, and of the other illustrated copies of the *Somme* by Ellen Kosmer, discusses the cycle of illustrations and also the problems of dating and attribution.[82] She shows that the four surviving thirteenth-century manuscripts divide into a 'Parisian' pair and a 'North French' pair.[83] These two pairs contain

194. Manchester, John Rylands University Library, French 1, folio 226. Arthurian Romance. The Lady of Shalott.

195. London, British Library, Royal 14 E. III, folio 153v. Arthurian Romance. The Lady of Shalott.

196. London, British Library, Add. 10294, folio 65v. Arthurian Romance. The Lady of Shalott.

y doit estre premierement listoire comment
nře͂ donna les dix commandemens de la loy
entables de pierre a moyse qui estoit au pie
de une montaigne et les recepuoit de la main
nře͂ a genoulx et a grant deuocion Ainsi comme rec͂ueroit
chose si dicte et si tres precieuse Soyons doncques bien
diligens en lire et oir cest liure pour tous vices hors
ecter et vertuz en nous planter

197. Paris, Bibliothèque nationale, fr. 958, folio 1. *Somme le Roi*. Moses receives the Ten Commandments.

198. Paris, Bibliothèque nationale, fr. 938, folio 2v. *Somme le Roi*. Moses receives the Ten Commandments.

199. London, British Library, Add. 54180, folio 5v. *Somme le Roi*. Moses receives the Ten Commandments.

broadly similar scenes, but with certain variants. Kosmer argues that the 'Parisian' pair preserves the original iconography of the dedication copy, from which the 'North French' pair diverge.

Two matters call for attention in the present context. The first concerns the programme of illustrations. The second concerns the way in which the artists came to illustrate their copies. A careful examination of the *Somme* text and the images has led Kosmer to conclude that the images very often depart from the text, or include things not referred to in it. Seven manuscripts contain additional texts descriptive of the miniatures, inserted by them in the form of rubrics.[84] None of the four thirteenth-century manuscripts include these descriptions, however; and none of the seven manuscripts which have them, have a full set of descriptions for all fifteen scenes. The description of the first scene in a manuscript of 1464 (fig. 197), reads: 'Here should be put first the story of how our Lord gave the Ten Commandments of the law on tablets of stone to Moses, who was at the foot of the mountain and received them from the hand of our Lord on his knees

and with great devotion, as he should receive something so worthy and precious. Be diligent then to read and hear this book and to reject all vices and enplant the virtues.'[85] The scene can be compared to that in one of the two thirteenth-century manuscripts described by Kosmer as 'North French' variants (fig. 198),[86] and in the Millar *Somme* (fig. 199). In the former, as in the 1464 manuscript, there are three trumpeters, but in the Millar *Somme* there are only two. On the other hand, a group of kneeling Israelites not found in the 'North French' variant is included in the other two manuscripts (figs 197, 199). In the same scene in a copy dated 1311, the lower register is closer to the 'Parisian' version of the Millar *Somme* (fig. 199), but instead of Moses breaking the tablets, the Synagogue does so (fig. 200).[87] Lastly, for the purposes of this discussion, in a manuscript dated 1373, which has descriptions of the last ten scenes of the cycle inserted as rubrics, the Sacrifice of Isaac is added below, and Moses breaking the tablets omitted (fig. 201).[88] Thus, there are changes and variations made of greater or lesser significance.

The descriptions of the miniatures, since they start
'Here should be' or 'Here should be painted', must have
been intended originally as instructions for the artist; even
if later they may have been found useful as guides for
the reader as to what is represented. Interestingly, their
usefulness as guides in this respect is limited, since they
do not always name figures but, for example, describe
David and Goliath as 'a large man' and 'a little child'. It is
not known if Frère Lorens compiled them himself, but it
would seem quite likely that he did. The fact that they
do not occur in the four early manuscripts would be
explained if they were written in the margin, as in the
Rylands 'Lancelot', or on a separate leaf or leaves,
like some of the programmes discussed earlier.[89] At a
later stage of the transmission, these directions contain
elements of both the 'Parisian' and the 'North French'
iconographies, and it seems likely that variations or simple
errors must have been introduced.

Supposing that the original artist in the lost dedication
copy had a similar set of instructions, they are sufficiently
detailed for him to make up his pictures using moduli and
in certain cases incorporating familiar images, such as
that of David and Goliath. The latter scene in the Millar
Somme is shown very similarly in the Breviary of Philippe
le Bel, illuminated by the same artist, for example (figs
202–203).[90]

For the twelfth scene, on the top left, the Virtue is
Prowess (fig. 202). The surviving direction only describes
her as holding a lion. Beside her, the figure of Sloth is
described as a man who sleeps and neglects his plough.
The sleeping figure is a straightforward modulus type,
but the form of the plough is sufficiently complex to sug-
gest the artist's personal familiarity with such an object;
and in any event, this is a less common image than the
figure sowing below (Labeur), who commonly appears in
calendar cycles.[91]

Kosmer comments on the relative fidelity of later
copies of the *Somme* to the original cycle once created.
The main changes are in format, as in the manuscript of
1373, for example, where the miniature is inserted as a
small square into a two-column script layout (fig. 201).
This is one of the manuscripts which contains the
instructions for the last ten scenes, numbers six to fifteen.
But it is interesting that the final scene of Moses trying to
separate the two fighting Egyptians is misunderstood,
though clearly described. It looks more like a Christ
figure being tortured after his arrest. This underlines an
important point made by Kosmer; that familiar scenes are
those most likely to be altered. For example, the biblical
episode of Joseph and Potiphar's wife is shown differently
in later manuscripts which, on the other hand, keep the
scenes unique to the *Somme*, such as the Virtues watering
trees, unchanged. Besides changes of format, the other
main alteration is the setting, whether of interiors or
landscapes (figs 197, 201).

In the *Somme*, therefore, unlike the secular Lancelot
manuscript, the pictorial cycle with its more didactic and
religious purpose is perceived as having a special auth-

200. Paris, Bibliothèque de l'Arsenal, Ms. 6329, folio 7v.
Somme le Roi. Moses receives the Ten Commandments.

201. Paris, Bibliothèque nationale, fr. 14939, folio 5. *Somme le
Roi*. Moses receives the Ten Commandments.

ority, because it is closely related to the understanding of
the text. Alterations are made to update it, but only within
relatively strict limits.

In conclusion, it should be stressed that, as in the
earlier period, there are opportunities for illuminators
to evade or even challenge the authority of the pre-
existing cycle and the constraints of the text. In the
twelfth century, such opportunity continues in the
decorative vocabulary used for frames and above all for
initials, as was discussed in Chapter 4. In the thirteenth
century, a new space becomes available, the borders
of the page. The marginal or *bas-de-page* scenes with
grotesques, drolleries, and a variety of scenes from
secular and religious texts, as well as many without
identifiable textual underpinning, have rightly received a
great deal of attention.[92] Here fantasy, jokes, riddles,
natural observations, satire, social comment, all mix.
Though even here copying and adaptation sometimes
took place, and motifs can be seen to have migrated, the
important thing is the great variety and the possibility of
innovation. This material still requires more analysis,
especially as to how it was perceived by its audiences and
what were its multiple meanings.[93] As an example, a

de creatures qlez quelles soient.
Contre ce comandemeut pecheut
cil qui trop aimeut leur treso
oz. ou autres chos terienes z
qui en ces cops trespassables niet
teut leur cuer et leur esperance
q̃ il en oublieut leur createur. et
laissent quito ces bus le app
tes. Et pour ce le deusser seur z
mercier et sur tous amer et hono
rer. Si come ce puier comande
uit no euseigue. le secoud. ii.

Le secous comandemeut est
tu ne preudras mie le no
de dieu eu vain. cest adire tu ne
uueras mie pour noient z sans
boue cause. Et meismes desseut
niet eu leuuaugille. q̃ on ne uue
ne puet ne par tre. ne p autre cre
ature. mais en toute cause puet
on uuer sans pechie. come en
iugemeut ou le demaude keiuent
de uerite. Ou hors de iugeut eu
autres boues causes z hõnestes z
pfitables. En autre mãie ne
iort on mie uuer. Et p ce qui
uure sans raison le no de meb
et pour noient. fil uure fault
a son eusieut il se puure. Et fi
fuit coutre ce comandemeut et
peche moztelmb. Car il uure cõ
tre sa conscieuce et est a enteu

Ci comeuce le miraour
du moude. Et pmiermeut
des x. comaudemeus de la loy
tout les trois premiers no
ordeneut a dieu. Et les au
tres .vii. a uos prosmes
Le puier comandement.

Le premier coma
deuit que dieu cõ
mauda si est tel.
Tu nauras mie
dius diex. cest a
dire tu nauras dieu q̃ moy. Ne
aoureras ne seruiras. Et ne met
tras tou esperance fors en moy.
Car cil qui met sesperauce priua
palmit en creature peche mortel
meut et fait coutre ce comau
deuit. Tielz sout eulz q̃ aou
reut les ydoles et fout loz dieu

202. London, British Library, Add. 54180, folio 121v. *Somme le Roi*. David and Goliath.

203. Paris, Bibliothèque nationale, latin 1023, folio 7v. Breviary. David and Goliath.

marginal scene of this genre, quite unrelated to the text in which it appears, the *Roman de la Rose*, is quite likely to have been unique. It shows the copying and decoration of such a manuscript around 1300, by a man and a woman at work in an interior with the leaves of parchment, written or illuminated, hanging up to dry (fig. 204).[94] This unique self-referential image is in significant contrast, in its unassuming, unframed design, to the official donor portraits in which noble or ecclesiastical patrons so frequently had themselves commemorated (see fig. 18).

204. Paris, Bibliothèque nationale, fr. 25526, folio 77v. *Roman de la Rose*. Copying and illuminating the folios of a manuscript.

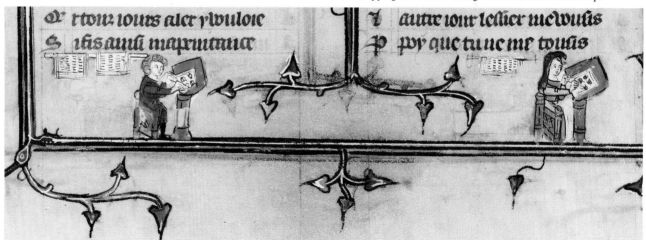

Illuminators at Work:
The Fourteenth and Fifteenth
Centuries

Already, early in the fourteenth century, we are made aware of a new situation for the book illuminator in relation to other practitioners of the pictorial arts. I refer to the development and spread of panel painting, a development which takes place in Italy especially and which, gathering momentum in the thirteenth century, becomes widespread throughout Europe in the fourteenth century. It may be that if larger amounts of wall painting survived from the earlier Middle Ages, more relationships between book illumination and monumental painting in the West in the period before *c.* 1300 would become apparent than at present. There are some well-known examples, such as the paintings of the Apocalypse, brought back from Italy to Wearmouth/Jarrow by Benedict Biscop, which may be reflected in a ninth-century Carolingian Apocalypse, thought to be a copy of a lost Insular manuscript.[1] But this case is extremely problematic as to the reconstruction of the paintings, and in that it is typical of our difficulties in the non-survival of monumental material. In the late twelfth century, the same group of artists worked on the illumination of the Winchester Bible and on wall paintings in the Cathedral, and at Sigena in North Spain, and this overlap may have been quite common.[2] We simply cannot judge this from the surviving material. The problems of the relation of miniatures to monumental cycles have been studied in the Byzantine context, the best known example being the relationship of the Cotton Genesis cycle to the mosaics of the atrium in San Marco, Venice, of the early thirteenth century.[3] That, however, is an example of miniatures which acted as models for a monumental work; not the other way round. Similar general studies of this problem in the West have not been attempted. In the present state of our knowledge, however, it seems that much, if not most, early medieval illumination depends on its own pictorial tradition, rather than relating to monumental art. To give another example, the links between the mosaics of Old Testament scenes in Santa Maria Maggiore in Rome of *c.* 430, and the illustrations of the Vatican Virgil, have been clearly demonstrated.[4] The same craftsmen may have been involved, or the same pattern books may have been used. We do not have to suppose a monumental

cycle of Virgil illustrations existed as wall paintings or mosaics which were copied in the manuscripts. The links are in style and in the use of motifs, not in the invention of the whole cycle, even if a monumental representation of a particular episode may have influenced a particular representation in the manuscript, the Laocoon scene, for example.

Examples of monumental painting, whether wall or panel painting, influencing manuscript illuminators, however, become increasingly numerous from the fourteenth century onwards. For example, a Psalter from Peterborough Abbey, datable *c.* 1300–18, has a long series of Old and New Testament subjects arranged as types and anti-types. These share subjects and inscriptions with those recorded in a series of paintings formerly in the choir stalls, executed for the Abbey between 1235 and 1245. While the inspiration for the manuscript's cycle was, no doubt, the monumental cycle, recent study has tended to stress the independence of the illuminators and their likely use of their own pictorial models.[5]

A clearer example are the historiated initials in the six choir books at Padua Cathedral, for which documents exist showing that debts were outstanding in 1306. Payments were made to Gerarduccius, priest and *custos* of the Cathedral as scribe-illuminator.[6] A number of the historiated initials in these vast choir books quite clearly copy Giotto's compositions in the Arena Chapel, and they have been used as a means of dating the completion of those paintings. An example is the scene of the Lamentation (figs 205–6). The style of the initials is that known from Bolognese manuscripts of the time, and Bolognese illuminators are documented in Padua. What part Gerarduccius himself played is uncertain.

These initials are significant evidence that Giotto's contemporaries perceived his compositions as innovatory in terms, above all, of their space compositions and the psychological relationships between figures, and copied them for that reason. The Padua initials are not always faithful in the spirit or the letter, however. They simplify or omit some of the essential subtleties of Giotto's compositions. For example, in the Betrayal, Christ's head is three-quarter frontal, thereby losing the dramatic

205. Padua, Biblioteca capitolare, A. 15, folio 159. Choir book. Initial 'S' with the Lamentation.

206. Padua, Scrovegni Chapel. Giotto. The Lamentation.

confrontation of profiles in Giotto's fresco. In that the copy is local, taking place in the same town, there is no very great problem of transmission, though perhaps even here the illuminators may have made visual records, that is iconographic guides, of the scenes in the Chapel.

Some twenty years later a French artist, Jean Pucelle, as is well known, copied compositions from Duccio's High Altar for Siena Cathedral in the Hours of Jeanne d'Evreux between 1325 and 1328.[7] Duccio's altarpiece had been completed in 1312, and there is a very strong presupposition that Pucelle travelled to Italy and made his own pattern book drawings; though it is perhaps just conceivable that knowledge of Duccio's compositions reached Paris in some other way. At any rate, from now on borrowings by illuminators from monumental art are frequent. Italian artists work in France and panel paintings are increasingly exported from Italy, especially via Avignon, so Northern artists do not even have themselves to travel to Italy, though many continue to do so – the Limbourg brothers and Jean Fouquet being the most famous. As the Netherlandish school of panel painting is established in the fifteenth century, there too close relationships between illuminators and monumental painters grow up. Another example, this time in English art, is the frontispiece portrait to a manuscript containing the Life of the Black Prince made c. 1390 where the figure of the Black Prince kneeling below the Trinity was copied from that painted at the west end of St Stephen's Chapel, Westminster, c. 1350–63 (figs 208–9).[8]

A fairly lengthy list of monumental painters who occasionally executed miniatures in manuscripts, can be drawn up. In many cases, some special reason for this existed as, for example, Simone Martini's execution of a prefatory miniature in Petrarch's Virgil, as a result of a friendship developing between the two men in Avignon in the early 1340s.[9] Dürer similarly executed illustrations for printed books owned by his friend, Willibald Pirckheimer.[10] In other examples, a powerful patron was perhaps able to put pressure on an artist, Dürer again being an example in his work, done in collaboration with other artists including Lucas Cranach, for the Emperor Maximilian I.[11] The Venetian condottiere, Jacopo Marcello, probably was able to put pressure on the young Mantegna, who later said he did not like working on a small scale, if the illumination of the special copy of the Life of St Maurice, which Marcello wanted to send to King René of Anjou in 1453, is indeed by Mantegna himself.[12]

There is perhaps more of an overlap in Italy where figures like Pacino da Bonaguida and Lippo Vanni in the fourteenth century, and Michelino da Besozzo, Girolamo da Cremona, Marco Zoppo, Monte and Gherardo del Fora, and Cristoforo di Predis in the fifteenth century, to name only a few of the most famous, all worked as both miniaturists and painters.[13] In the North, Fouquet and Marmion are the main examples of such an overlap of roles. As we have seen, illuminators and painters often belonged to the same guild and in 1469, for example, Alexander Bening was sponsored when he was admitted to the Guild of Painters in Ghent by Hugo van der Goes and Justus van Ghent.[14]

207. New York, Pierpont Morgan Library, M. 346, folio 1v. Pattern book. Virgin and Child.

208. Copy of destroyed paintings at the east end of St Stephen's Chapel, Westminster. Edward III and his family kneeling below the Adoration of the Magi.

209. London, University of London Library, Ms. 1, folio 3v. Life of the Black Prince. The Black Prince adoring the Trinity.

210. Liverpool, The National Museums and Galleries on Merseyside (Walker Art Gallery), Ms. Mayer 12023, page 26. Book of Hours. The Annunciation.

211. Washington, D.C., National Gallery of Art, Rosenwald Collection. Martin Schongauer. Engraving of the Annunciation.

The relationship to monumental artists may have had some other consequences for the status of illuminators. Though their social position does not radically alter, as it does in the twelfth to thirteenth centuries, in general they may have achieved something of a higher status, as did other artists, and also they may have become more prosperous and better organised as a profession. Some may have been very successful indeed as businessmen, judging by the number and splendour of their commissions, for example, Simon Bening in Bruges and Attavante degli Attavanti in Florence.[15]

A self-consciousness on the part of illuminators about their own skills may also be exemplified in some of the later pattern books which are so finely finished that they can no longer be considered simply as motif books for the workshop. It seems likely that they could have been used rather as advertisements, and as demonstrations of skill, in order to show to potential clients the artist's capabilities. Examples are the pattern book which has been attributed to Jacquemart d'Hesdin in the Pierpont Morgan Library (fig. 207), and the Bohemian pattern book in Vienna.[16]

On the other hand, as the status of the monumental artist increased, especially in Italy, the book illuminator might remain by implication a craftsman working in a less important field of art. Vasari, though he mentions a number of illuminators, only writes the life of one, Don Giulio Clovio, and his description of him 'as the Michelangelo of small works' and 'far surpassing others in this exercise' is significant.[17]

The mobility of illuminators is also increasingly evident in this period. Paris, in the late fourteenth and early fifteenth centuries, draws illuminators from all over France and Flanders, and many of these settled for a period to work.[18] Zebo da Firenze, an Italian, is at work there at the same time.[19] They are not just visitors, as were Pucelle or the Limbourgs to Italy. In England, a German or Fleming, Herman Scheerre, works during the first decade of the fifteenth century in London and is probably the same individual mentioned earlier in documents in Dijon and later in Paris.[20] He may have been a panel painter, as well as an illuminator. Gerard Horenbout of Ghent probably moved to England with his family in the mid 1520s and both his son, Lucas, and daughter, Suzanne, worked there as painters of portrait miniatures. Lucas is documented as working in England

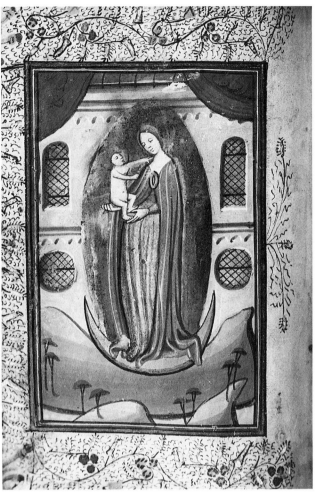

212. Formerly Upholland College, Lancashire, Ms. 106, folio 20v. Book of Hours. The Virgin and Child on the Crescent Moon.

213. Liverpool, The National Museums and Galleries on Merseyside (Walker Art Gallery), Ms. Mayer 12009, page 116 (?). Book of Hours. The Virgin and Child on the Crescent Moon.

for the King in 1528.[21] Italian illuminators travel widely in the peninsula for commissions, Girolamo da Cremona being a good example as he started in Lombardy, then went to Mantua, then to Siena and Florence, and then to Venice, where he probably ended his career.[22]

Illuminated manuscripts continued to circulate widely, whether as scholars' books brought back from foreign study and travel, by humanists in Italy, for example, or as gifts exchanged between rulers as diplomatic presents. There are also some signs of specialised export markets being developed, such as the Books of Hours for Sarum Use, which were written and illuminated by Flemish scribes and artists for the English market in the fifteenth century.[23]

As regards the transmission of compositions by monumental painters, the dissemination of woodcuts and engravings in the fifteenth century had a notable effect, especially on late fifteenth-century illumination. The number of copies of Dürer prints in manuscripts from every part of Europe must be huge.[24] But other earlier artists' works were also copied as studies of the use of motifs by the so-called Master of the Playing Cards

as border decoration have shown.[25] An example of an artist of limited talent enriching his repertoire is the Annunciation in a Dutch late fifteenth-century Book of Hours at Liverpool copied from a print by Schongauer (figs 210–11).[26] After the invention of printing there were other possibilities of manuscript illuminators working with or even as woodcut illustrators.[27]

Other important factors in the development of fourteenth- and fifteenth-century illumination result from changes in patronage, from the requirement to illustrate different, especially secular texts, and from changes in attitude to religious imagery and its purpose and function. These should be borne in mind again in discussing, as in preceding Chapters, examples of direct copying, of change and adaptation, and of new invention.

In the matter of copying, some new developments take place in the fifteenth century, where, for example, more or less identical miniatures appear in Books of Hours. An example is the representation of the Virgin and Child on the Crescent Moon in two early fifteenth-century Dutch Hours (figs 212–13).[28] Here, and in many other examples, the miniatures are single leaves bound in,

214. Paris, Ecole des Beaux-Arts, Ms. Masson 98. Alphabe
pattern book. Initial 'D'.

ation. One example is the Göttingen pattern book, which may originally have been part of the same manual as a fragment in Berlin, and which was apparently in use in Mainz in the mid fifteenth century.[31] Another is the pattern book of Stephan Schriber, working in the area of Stuttgart in the late fifteenth century.[32]

The provision of models for decorated letters which strike the modern viewer, as no doubt they were intended to strike contemporary viewers, not as copies, but as endlessly varied and creative, is something of a paradox. A number of the earlier pattern books contained alphabets of decorated letters in addition to figural motifs, and this remains true of some of the later examples.[33] The very exceptional Italian alphabet pattern book of the mid twelfth century in the Fitzwilliam Museum was mentioned earlier (see fig. 154). From the fifteenth and sixteenth centuries, a number of alphabet pattern books from England, the Netherlands, France, and Italy are known.[34] An example of the early sixteenth century, with a complete alphabet of decorated letters is possibly Spanish (fig. 214).[35] A flyleaf inserted in a collection of miscellaneous theological texts, which contains designs of the initials 'V', 'Y' and 'Z' as well as penwork initials 'A' to 'D', is also likely to be part of a complete alphabet pattern book (figs 215–16).[36] From its style, it must be English of the mid fifteenth century. It cannot be certain in this case that the whole alphabet was once included, and even where the alphabets are complete, they could also once have been part of a more extensive pattern book. However, it does seem likely that some of the later surviving examples, at least, were intended to be complete as alphabet books.

Some of the scribes' pattern books and advertisement sheets which survive from this period also contain examples of decorated letters, usually for the more simple penwork letters which scribes executed themselves, but sometimes for more ambitious painted and decorated initials.[37] Clearly in these, as in the pattern books, the various functions of teaching manuals, of advertisements of available skills, or of exemplars for assistants or apprentices, could coexist or overlap, and any or all be fulfilled by a particular example.

The existence of independent alphabet pattern books may imply a greater specialisation of roles in this period. There is also evidence in the manuscripts themselves for the necessity of new methods of production to keep up with demand. Division of labour is increasingly apparent, as is the use of short cuts such as stencilling and tracing. An example of borders being executed with space left for human figures to be inserted, implying that an assistant executed the more mechanical parts and a more important artist finished off the work, was discussed earlier (see fig. 69).[38] It becomes extremely frequent for borders to be traced from recto to verso which avoided bleed-through on fine parchment, and must also have saved time, and yet meant that each opening appears different.[39] Small ornaments or grotesques are very often repeated in such borders. Even in the main miniatures

not part of the original quiring of the manuscript. The importance, in this context, of a document of 1426 forbidding the importation to Bruges of single leaf miniatures from Utrecht, has already been mentioned.[29] Further, the Guild Regulations in Bruges legislate that illuminators must stamp their miniatures with a personal mark, and a number of examples have now been found.[30] In the Upholland miniature, the stamp is visible at the bottom right of the frame, a '*b*' reversed white on red, and in the Liverpool miniature the stamp is at the top right of the frame. Taken together, then, we can see on the one hand a system developing of copies produced presumably in series and portable for export, and on the other hand, an attempt to keep out imports and to control the market. The stamps are a form of verification that the regulations have been complied with, rather than a signature, therefore.

This is one sign of a growing market for illuminated books, especially for Books of Hours, having to be met by new techniques to facilitate production and to keep down prices. Another is the appearance of a different kind of pattern book, in addition to those mentioned above, which aimed to advertise an illuminator's capabilities and skills. These pattern books provided written instruction as well as models for the execution of the more mechanical parts of the illuminator's craft, the initials and border decor-

215. Vienna, Oesterreichische Nationalbibliothek, Cod. 4943, folio I. Flyleaf with initial 'V' and penwork initials.

216. Vienna, Oesterreichische Nationalbibliothek, Cod. 4943, folio Iv. Flyleaf with initials 'Y' and 'Z' and penwork initials.

there may have been collaboration and the different stages of the process of illumination discussed earlier made this easily possible.[40] The question has also been raised as to whether tracings were used, where (as, for example, in manuscripts associated with Vrelant in Bruges in the mid fifteenth century), the same compositions, almost identical in size as well as in outline, exist in different manuscripts.[41]

The nature of the illuminator's workshop or atelier in this later period remains problematic, and still has not been the subject of sufficient detailed study.[42] The implication to be drawn, for example, in Millard Meiss's major studies of French illumination in the time of Jean de Berry, is that the personel of the workshops of certain successful illuminators, such as the Bedford or Boucicaut Masters, must have been very considerable to handle so much work. However, this may not, in fact, be the legitimate deduction from the large numbers of manuscripts which can be grouped around such artistic personalities. Meiss himself is properly cautious: 'From the evidence of the codices we infer that the Boucicaut Master was an entrepreneur who produced manuscripts for the market and who accepted commissions that were to be executed mostly by associates.'[43] But what is meant

by 'associates', or 'workshop', or 'school', or 'atelier' – terms which are so often used? Deriving from evidence of the later practices of monumental artists in the Renaissance, they are not necessarily applicable to medieval illuminators' practices, and more recently scepticism has grown as to their appropriateness. Are the 'assistants' actual apprentices, or past apprentices? Or is it a question of journeymen so often employed by painters? Some of the Painters' Guild regulations stated that not more than one apprentice should be taken at a time, though the existence of such a regulation may, as with medieval sumptuary laws, merely prove that it was or had been flouted. It did not, it seems, apply to children of a painter or even, perhaps, to close relatives. However, if such regulations were taken seriously, and the apprenticeship was to last three years, at the least, then an artist would only have been able to train a maximum of seven apprentices over a period of twenty years. A well-documented example of a major project undertaken by collaborating artists, Taddeo Crivelli and Franco dei Russi, with the help of both apprentices and assistants, is the Bible of Borso d'Este.[44]

Two points should therefore be made. First, perhaps some of the divisions commonly made on grounds of

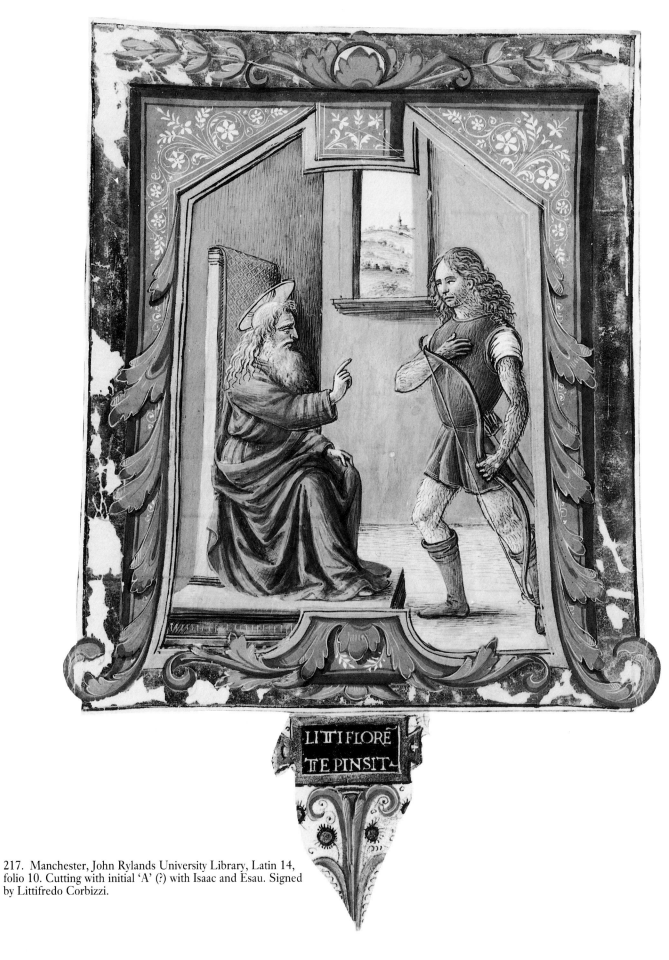

LI'TI FLORÉ
TE PINSIT

217. Manchester, John Rylands University Library, Latin 14,
folio 10. Cutting with initial 'A' (?) with Isaac and Esau. Signed
by Littifredo Corbizzi.

218. Blackburn Museum and Art Gallery, Lancashire, Hart Ms. 20865, folio 29. Book of Hours. The Annunciation.

219. Formerly Upholland College, near Wigan, Ms. 105, folio 19. Book of Hours. The Annunication.

quality, for example, Meiss's ascriptions to the Boucicaut Master's own hand and to 'associates' of the Boucicaut Master, might be interpreted rather as differences caused by more or less haste, more or less care, or more or less money available from the patron to pay for materials and time. Secondly, taking an Italian example, where Italian illumination is often better documented and more signed work survives, two signed works exist by Littifredo Corbizzi, for whom we have archival documentation that he was born in Florence in 1465, and was still living in Siena in 1515 (fig. 217).[45] His style is really very close indeed to that of the much more famous Attavante degli Attavanti, who was born in Florence in 1452 and died between 1520 and 1525. If it were not for the signatures and the documents, Littifredo might well appear in the literature as 'associate of Attavante', though there is, in fact, no present evidence at all to link them, other than by style; and Littifredo, in his later years at least, is working in Siena. It is therefore questionable as to whether the 'Boucicaut style' is one of a possible number of widely practised styles in Paris at this time or whether, on the

contrary, it is directly dependent on the Master himself, though spreading out from him via collaboration or association.

The problem with the Boucicaut Master, however, is not only one of stylistic kinship. It is also a problem of how compositions were circulating. For example, Meiss reproduces the scene of the Annunciation from seventeen different manuscripts, in which it is very similarly shown.[46] He ascribed *three* of these miniatures to the 'Boucicaut Master' himself, *two* of them to the 'Boucicaut Master and Workshop', *ten* of them to the 'Boucicaut Workshop', *one* of them to 'a Boucicaut Associate', and one of them to a 'follower of the Boucicaut Master'. More examples could be added for good measure, for example, two Books of Hours, one in Blackburn, the other formerly at Upholland College (figs 218–19).[47] The Blackburn Hours is clearly a more expensive job in quality of materials, gold and expensive pigments, as well as in detailed workmanship seen, for example, in the borders. At *some* point, the chain must be broken, and it can no longer be possible to consider the Boucicaut Master as

220. Berlin, Staatsbibliothek Preussischer Kulturbesitz, Ms. A.74, folio iv b. Pattern book. St Luke. The Annunication.

221. Stonyhurst College, Lancashire, Ms. 33, folio 26. Book of Hours. The Annunciation.

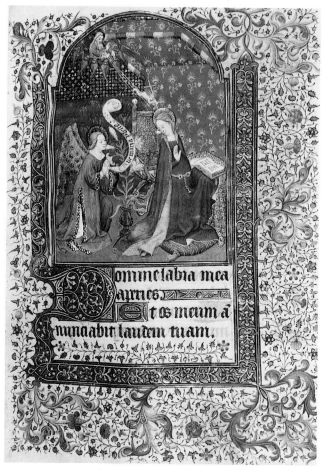

having anything to do with the miniature, even in the most general supervisory capacity. Clearly manuscripts which are privately owned, and not on public display, are less accessible to an illuminator to copy than wall paintings or altarpieces in a church. Special arrangements have to be made. Artists at this time were already jealously guarding their pattern books, as we know from John of Holland's complaint that Jacquemart d'Hesdin had stolen colours and patterns from his strong box at Poitiers in 1398.[48] The incident implies that artists were beginning to think of their inventions as private property.

So the question becomes how did a workshop keep a record of compositions, and what kind of record was it? Here the pattern book of Jacques Daliwe, now in Berlin, can be used as evidence, since on one page the Annunciation is represented with the Virgin in the kneeling position, seen in so many of the examples associated with the Boucicaut Master (fig. 220).[49] Though many details are dissimilar, the main divergence is in the setting. This, too, is the main point of divergence in the 'Boucicaut' renderings. We can, therefore, imagine a pattern book of the motif-book variety retained by the Boucicaut Master for use by himself or his apprentice or even perhaps lent to a collaborator.

Artists continued regularly to collaborate, and the Boucicaut Master himself commonly joins the so-called Egerton, Bedford and Harvard Hannibal Masters on commissions. The same Annunciation composition is used by the last named of these three illuminators, for example, in an Hours now at Stonyhurst College (fig. 221).[50] In this way also, other artists could see a new composition and then record it in their own pattern books with their own variants. This process is not confined to the North, as two examples in Books of Hours from Florence of the late fifteenth century demonstrate, where scenes of David praying in Books of Hours show the same kind of general similarity and divergent detail (figs 222–3).[51]

To these kinds of copies, which can be more or less close, but appear to emanate from one artist, one workshop or one wider association, operating in a single centre, a very different kind of copy may be contrasted. In 1436, Pietro Donato, Bishop of Padua, was present at the Council of Constance, and whilst there, he managed to borrow a venerable manuscript from the Chapter Library at Speyer. This contained the text on the military organisation of the late Roman Empire known as the *Notitia Dignitatum*, a compilation made, probably, in the early fifth century. Donato had this manuscript copied with its considerable number of illustrations, and his copy is now in the Bodleian.[52] The probability is that the Speyer manuscript was a late ninth or early tenth-century copy of an early fifth-century manuscript, and that this copy was not entirely faithful to the style of the original

but had already modified it in being generally less classical. The problem relevant here is the faithfulness of the illustration in Donato's copy, made in 1436. The artist can be identified as Peronet Lamy from stylistic comparison with manuscripts for which payment was made to him by Amadeus, Duke of Savoy, later Antipope as Felix V. It seems that Lamy aimed to provide Bishop Donato with an accurate copy, though he made involuntary errors; that is, his own stylistic idiom took over and distorted his copy. In some cases, however, he consciously made additions. For example, he inserted representations of classical coins of the Emperors Tiberius, Nero and Domitian, which cannot have been in the model since they are too early in date (fig. 224). Probably the reason was that the Speyer manuscript was defective at that point. Lamy's copies are of quite genuine Imperial coins, and these are likely to have been provided as models by Bishop Donato. The decision to 'improve' the copy at this point was therefore probably the patron's, not the artist's.

Nevertheless, it does seem that Lamy's copy is more accurate than another slightly earlier copy made in 1427, which is probably to be connected with Cardinal Giordano Orsini, who was Papal legate in Germany in 1426.[53] This can be seen from the miniature of the province of Palestine, where the Orsini copy inserts fleur-de-lys behind the crowned figure – an anachronism

222. London, British Library, Add. 19417, folio 167v. Book of Hours. King David in prayer.

223. London, British Library, Add. 35254, cutting R. Single leaf with King David in prayer.

224. Oxford, Bodleian Library, Ms. Canon. Misc. 378, folio 70. *Notitia Dignitatum*. Coins.

225. Oxford, Bodleian Library, Ms. Canon. Misc. 378, folio 128v. *Notitia Dignitatum*. The Province of Palestine.

226. Cambridge, Fitzwilliam Museum, Ms. 86.1972, folio 2. *Notitia Dignitatum*. The Province of Palestine.

apparently prompted by the Angevin claim to the king-doms of Naples and Jerusalem (figs 225–6).

The wider context in which both these copies must be set is the beginning of antiquarianism in Italy, particularly in Padua. The text was of interest for the reconstruction of the past, and the illuminations are perceived as integral to that antiquarian reconstruction. The Donato copy was required to be accurate, not only as to the content of the text and to the content of the illustration, but also as to the style of illumination, for even if Lamy did not succeed everywhere in suppressing details of Gothic form and ornament familiar to him, it is nevertheless notably different from his other works in its 'purity'.

This, then, distinguishes it both from the Boucicaut workshop patterns which are more or less contemporary with each other, and also from the copies made of earlier cycles of illustration, which continue to be made with more or less modification in the fourteenth and fifteenth centuries, as they had been earlier.[54] Thus illustrated manuscripts of the Apocalypse continue to be made and one, in the Rylands Library, copies a cycle similar to that in the two thirteenth-century Apocalypses referred to earlier in Chapter 5 (figs 168–9, 227).[55] The style, however, is that of the later fourteenth century, even if content and layout are retained fairly faithfully from the earlier exemplar.

Such copies may show a whole range of degrees of accuracy, as to content, layout, and stylistic alteration. In each particular case, specific circumstances will have dictated the degree of modification; circumstances which we may only be able to guess at. For example, in the very late thirteenth century, a translation was made into French of the treatise on falconry, the *Liber de Avibus*, by the Emperor Frederick II (*d.* 1250). The famous manu-script, now surviving in the Vatican, seems to be a copy of Frederick's original text made for his son, Manfred, after 1258.[56] This, in turn, is thought to have served as exemplar for a French translator working for Jean II, seigneur de Dampierre (*d.* 1308), and it may therefore have reached France in the late thirteenth century, perhaps because the Anjou branch of the French royal family were by now installed in Naples. A manuscript of this French translation, datable *c.* 1300, has very exact copies of the pictures in the Vatican manuscript (figs 228–9).[57] It is also interesting that the illuminator's name is given in the colophon, 'Simon d'Orleans'.

A second example of a French copy of a Neapolitan original is the late fourteenth-century manuscript of the historical compilation known as the *Histoire Ancienne jusqu'à César* made for Jean de Berry.[58] This copies a mid fourteenth-century exemplar being especially faithful in the frontispiece miniatures (figs 230–31).[59] In the first of these two examples, the scientific technical nature of the text must explain the necessity of the close copying of the pictures. In the other, it may be rather a question of Berry's interest in a particular text combining with his admiration for Italian art.

A third example is in a manuscript of Friedrich

227. Manchester, John Rylands University Library, Latin 19, folio 4v. Apocalypse. The black and the pale horse.

228. Vatican, Biblioteca Apostolica Vaticana, Pal. lat. 1071, folio 69. Frederick II, *Liber de Avibus*. Figure Swimming.

229. Paris, Bibliothèque nationale, fr. 12400, folio 115v. Frederick II, *Liber de Avibus*. Figure Swimming.

Schavard's *Collatio super urbis recommendatione*, a col-lection of materials on the city of Trier put together *c.* 1402 by a provost of St Paulinus, Trier.[60] This includes a copy of the city's twelfth-century seal (fig. 232), a rep-resentation of a silver plaque sculpted with the 'Xp' monogram found on the breast of St Paulinus in his tomb, and even historicising copies of tenth-century initials of the type found in the *Codex Egberti* of Arch-bishop Egbert of Trier.

A rather similar, and almost contemporary, interest in the early history of his own institution, St Augustine's Abbey, Canterbury, is seen in Thomas of Elmham's manuscript of his History completed in 1418.[61] This contains copies of early charters and Papal bulls which attempt to copy the type of script of the originals. Perhaps a similar loyalty explains the illustrations in a fourteenth-

230. Paris, Bibliothèque nationale, fr. 301, folio 25. *Histoire ancienne jusqu' à César.* The city of Troy.

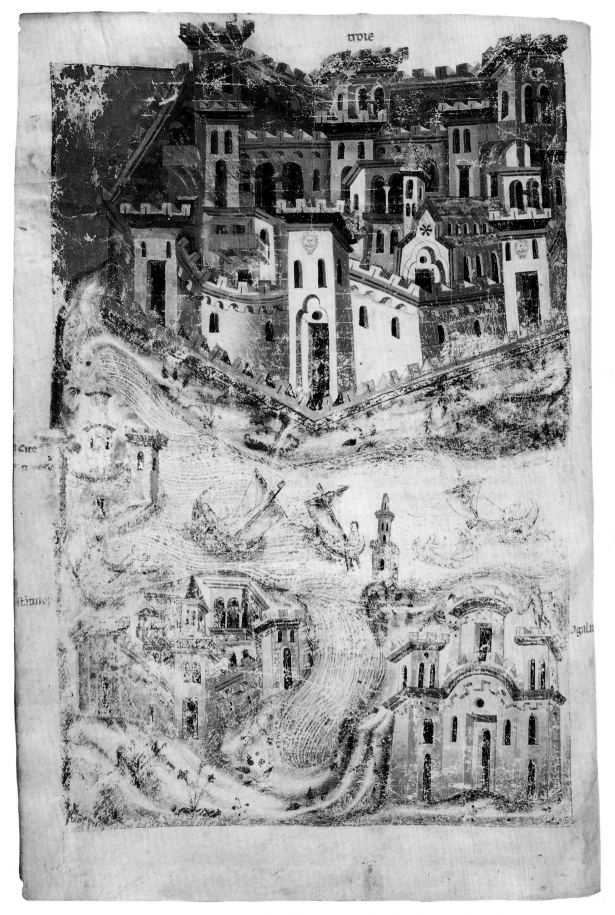

231. London, British Library, Royal 20 D.1, folio 26v. *Histoire ancienne jusqu' à César.* The city of Troy.

232. (right) Paris, Bibliothèque nationale, latin 10157, folio 13. Friedrich Schavard, *Collatio super urbis recommendatione*. Seal of the city of Trier.

233. (below) London, Victoria and Albert Museum, Ms. L. 101-1947, folio 9v. Frontispiece to Petrarch's *Rime*.

234. Madrid, Biblioteca nacional, Ms. 611, folio Iv. Frontispiece to Petrarch's *Rime*.

century manuscript of the text known as the *Pseudo-Callixtinus* or the Pilgrim Guide to the Shrine of St James at Compostella. They seem to be intentionally close copies of the twelfth-century exemplar.[62] In any case, these kind of copies are getting closer to the antiquarian objectives of Bishop Donato.

Given the conspicuous consumption by rival aristocratic bibliophiles in early fifteenth-century Paris, twin or multiple copies may have been relatively common.[63] Examples are the Duke of Burgundy's purchase of three copies of Hayton's *Fleur des Histoires* from the Italian merchant from Lucca, Jacques Raponde (Rapondi), in Paris in 1403;[64] or the copies, in vernacular French translation, of Boccaccio's *Des cleres et nobles femmes*, given respectively to the Dukes of Burgundy and Berry;[65] or the copies of Terence,[66] or of Gaston Phébus' Hunting Book,[67] or of Christine de Pisan's Works.[68]

Such instances of twin manuscripts are rarer, it seems, in Italy. But an example is a pair of manuscripts containing Petrarch's *Rime* and *Trionfi* made in Padua or Venice *c.* 1470. Though one, now in Madrid, is smaller in size than the other, its frontispiece to the *Rime* (fig. 234), the first of the *Trionfi*, and for the poem on the 'Death of Laura', appear to be contemporary replicas of those in the second manuscript, now in London (fig. 233).[69] Both manuscripts are written by the same scribe, Bartolomeo Sanvito of Padua.[70] The miniatures of the London Petrarch are by a gifted, but so far anonymous, artist who there worked in collaboration with Franco dei Russi. The authorship of the Madrid miniatures requires further study, but they may be by the artist known as the Master of the Vatican Homer.[71] If so, he would here be in a significant pupil relationship to the senior artist.

An intermediate position as to copy or invention, that is a matter of adaptation and change of imagery, is filled by many, perhaps the majority, of manuscripts of the period. The alterations made could be small, as in the

Boucicaut Master's compositions – a matter of altering the position of the hands, the placing of a vase or a candlestick; or they could extend to changing the setting, though leaving the figures unchanged; or they could encompass introducing an entirely new composition. No better example of all these processes can be found than one of the most famous of all later medieval illuminated manuscripts, the *Très Riches Heures* of Jean de Berry.[72] This is identifiable in the inventory made at the Duke's death in 1416. The description reads: 'item en une layette plusieurs cayers d'unes tres riches Heures, que faisoient Pol et ses frères très richement historiez et enluminez'.[73] Thus we know the artists' names, Paul's brothers being Jean and Hermann who appear in other documents. The scribe's name on the other hand is not recorded; and by now, in the late Middle Ages, though undoubtedly the names of scribes recorded in signatures and documents still far outnumber the names of illuminators, the balance as here is sometimes redressed.

In spite of the considerable research on the *Très Riches Heures* since its acquisition by the Duc D'Aumale in 1855, and the identification of it in Berry's inventory by Léopold Delisle in 1884, research which culminated in Millard Meiss's two volume monograph of 1974, there still remain many uncertainties.[74] Of these, not least is the implication of the phrase 'Pol et ses frères'; in other words, as to the nature of the artistic collaboration. The collaborative nature of medieval illumination has been stressed in this book, but a phrase of Otto Pächt's, in connection with the Limbourg problem, should be recalled: 'collective execution is possible, but not collective invention'.[75] Meiss, in fact, proposed a division of hands in the manuscript, ascribing the miniatures he considered the best (on the whole those that seemed to him most forward-looking), to Paul who was both the eldest and, it seems, the best paid of the brothers. To Jean, Meiss ascribed miniatures he considered to have certain qualities of elegance and refinement; and this left Hermann with those miniatures which did not seem to fulfil the criteria defining the other two brothers' work. The possibility of collaboration on a single miniature is not, in this case, entertained, though hypothesised in other contexts by Meiss.

Meiss's attributions may or may not be accepted in general or in detail. But other hypotheses as to the nature of the collaboration are possible in the context of illuminators' working practices, as demonstrated above. In any case, a different point needs emphasising, and that is the stylistic homogeneity of these miniatures. It is a situation of 'Boucicaut Master and Associates', and were it not for the documents, is likely to have been so described. It is probable, therefore, that there was a conscious *intention* to make the illumination in the manuscript as stylistically homogeneous as possible, and this has been commented on in other contexts in other manuscripts.

It should be stressed that the description of more than one artist's involvement is not an isolated case in Jean de Berry's inventories. His Psalter is described in French in the 1402 inventory as a 'Psalter written in Latin and French, very richly illuminated with a number of miniatures at the beginning by the hand of Master André Beauneveu'.[76] This implies that other miniatures later in the book are not by Beauneveu. An entry in the inventory of 1413, again in French, describes the *Grandes Heures* as 'a very large and very beautiful and rich Hours, very notably illuminated with large miniatures by the hand of Jacquemart D'Hesdin and other craftsmen of Monseigneur'.[77] Thus, in both these manuscripts too, there is documented collaboration. But this collaboration is taken for granted. It is neither a virtue nor a defect in the book. A great part of scholars' energies, not only in Meiss's volumes, have been devoted, not just in the *Très Riches Heures*, but in all the manuscripts, to prising apart this collaboration by dividing up the miniatures and even the border decoration, according to the names available and where none exist coining them, the Master of this and the

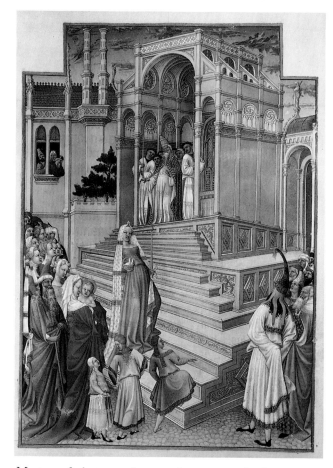

235. Chantilly, Musée Condé. The *Très Riches Heures* of Jean de Berry, folio 54v. The Presentation of Jesus in the Temple.

236. Florence, Sta Croce. Taddeo Gaddi. Fresco in the Baroncelli Chapel. The Presentation of the Virgin in the Temple.

237. Paris, Musée du Louvre, Inv. 1222. Drawing by Taddeo Gaddi. The Presentation of the Virgin in the Temple.

238. London, British Library, Add. 16997, folio 72v. Book of Hours. The Presentation of Jesus in the Temple.

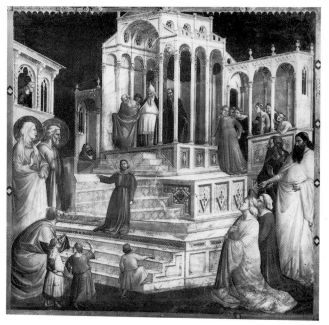

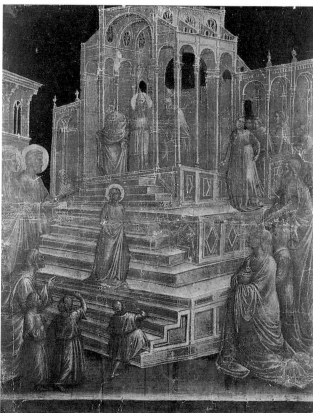

Master of that, so that we have not only Jacquemart d'Hesdin, who is documented, but also Pseudo-Jacquemart. This project seems to be connected with the values ascribed in our present Western society to individualism, and consequently with the need to ascribe achievement to a single, individual talent. It does not reflect contemporary, that is late medieval, preoccupations.

However, this is a moment of transition, accurately described by the inventories which speak of Paul and his brothers, Jacquemart, and several craftsmen of the Duke; that is, individuals and collectives. Some fifty years later in Italy, in the contract for the Bible of Borso d'Este, the five illuminators to do the work are each named and all are relatively easily distinguishable.[78]

Turning then to the question of the planning and design of the miniatures, through the multiplication of Books of Hours (one of the commonest of all illuminated texts by this date), a typical pattern of expectation as to what subjects will be appropriate at what points in the text and how they will be shown, had evolved by this date.[79] The Limbourgs broadly fulfil these expectations, but they also modify them in two main ways; first by adding scenes which are not usually found in a Book of Hours, or in some cases even appear to be unique, and secondly by variations or alterations to ways of showing the standard scenes. Thus, to take the former case, they insert miniatures of the Zodiacal man after the calendar, of the Procession of Gregory the Great in the Litany and of the

map of Rome before the Hours of the Passion. Such additions must have been at the least intended to please the patron and may well have been specifically requested by him or perhaps an adviser appointed by him. The intention was to make the book special and exceptional, and this is further indicated by the fact that various alterations and additions were made during the making of the manuscript.[80]

Such additional scenes are not, of course, necessarily inventions of the Limbourgs themselves, and sources for all the examples just mentioned can, in fact, be found. The Map of Rome is probably copied fairly literally.[81] The Procession of St Gregory, on the other hand, probably modifies its model considerably.[82] The process of modification is demonstrated quite clearly in the more standard scenes, though it can take different forms. Thus the expectation in the series of scenes for the Hours of the Virgin is fulfilled in that the standard sequence in French Books of Hours of the period is followed, starting with the Annunciation for Matins and ending with the Coronation of the Virgin for Compline. But the expectation is also modified in various ways. First there are additions, both of many smaller miniatures inserted in the text of the Hours and of one full-page miniature showing an unusual scene, the meeting of the Magi coming from the three Continents before they arrive at Bethlehem to worship the child, which is added on folio 51v, before the usual scene of the Nativity on folio 52. Secondly, though

the first two scenes, the Annunciation and the Visitation, follow rather standard compositions which could be found similarly in numerous contemporary works, the third scene, the Presentation in the Temple, shows a dramatic change from the normal representation (fig. 235). As is well known, the Limbourgs here take over the composition with the steeply rising steps in perspective that Taddeo Gaddi used for the different scene of the Presentation of the Virgin in the Temple, which he painted c. 1330 in the Baroncelli Chapel of Santa Croce, Florence (fig. 236). They might also have seen a finished drawing of this composition which may have been executed by Taddeo as a preliminary demonstration of skill for the patron (fig. 237).[83] Of course, this source is now familiar to modern students of the Très Riches Heures, but to see how forcibly the Limbourgs' miniature would have struck a contemporary, it is necessary to compare rather contemporary miniatures with the standard, centralised composition of the Virgin and Simeon on either side of the altar, such as those painted by the Boucicaut and Bedford Masters (fig. 238).[84] This places the Limbourgs' miniature in context as a dramatic intervention.

The calendar scenes in the Très Riches Heures again demonstrate an expectation modified. The occupations shown are on the whole the standard expected ones, but to show them as full-page miniatures was a new departure. For certain of them expectation is again dramatically denied, for example, in the December scene which normally should show the pig being killed for Christmas by the butcher and instead shows the climax of a boar hunt in the Forest of Vincennes. Again, as is well known, the source is an Italian composition recorded in the pattern book of Giovanni dei Grassi.[85]

Each miniature in the Hours can be analysed in this way in terms of expectation, modification, source of expectation, source of modification. As a more complex example of this process, the miniature placed at the introduction of the Hours of the Passion may be examined in more detail. First, it should be noted that the Hours of the Passion are not always included in Books of Hours. Where they are included, they are not always illustrated by a full sequence of illustrations and this was probably a decision which came late in the manuscript's execution. If there is a sequence of the Passion, it will normally begin either with the Agony in the Garden or with Judas's Betrayal and the Arrest of Christ. Neither of these common scenes occur in the Très Riches Heures. Instead, the sequence begins with a much rarer scene which is only narrated in St John's Gospel. Jesus asks the soldiers whom they are looking for. They answer: 'Jesus of Nazareth'; and he answers: 'I am he'; that is in the Vulgate Latin, 'Ego sum'.

This relatively rare scene is illustrated in two main contexts in the Middle Ages.[86] The first, appearing in the earlier Middle Ages, is as a marginal illustration in Byzantine Psalters illustrating the words of Psalm 35 verse 13: 'There are the workers of iniquity fallen. They

239. (below) Munich, Bayerische Staatsbibliothek, Clm 146, folio 19v. *Speculum Humanae Salvationis*. The soldiers fall before Christ in the Garden of Gethsemane.

240. (right) Chantilly, Musée Condé. The *Très Riches Heures* of Jean de Berry, folio 142. The soldiers fall before Christ in the Garden of Gethsemane.

241. London, The Wallace Collection, M.348. Cutting. The soldiers fall before Christ in the Garden of Gethsemane.

242. New York, Metropolitan Museum of Art at the Cloisters. *Belles Heures* of Jean de Berry, folio 66v. King David intercedes for the Plague to cease.

are cast down and shall not be able to rise'. The second is in the *Speculum Humanae Salvationis*, a devotional text with illustrations written in the late thirteenth or early fourteenth century (fig. 239).[87]

The compositional modification in the *Très Riches Heures* is to place Christ spatially in the midst of a jumbled pile of fallen figures that radiate out around him (fig. 240). This new composition was not the Limbourgs' own invention, however, but had already been used by a Lombard illuminator of the late fourteenth century, as is shown by a manuscript cutting in the Wallace Collection, London (fig. 241).[88] Unfortunately, the text of the cutting has not been identified, but it is certainly not from a *Speculum*. Some of the figures in the Wallace cutting recur in the 'Ego sum' miniature literally, especially one in the centre with head pointing out towards us as spectators. Others, for instance a figure in foreshortening with feet towards us and head tipped back, are not found in the cutting. They also are probably derived from Italian models and are typical pattern-book motifs. It is also typical that the same figure is used twice on the same page, but is reversed to give variety, and that it occurs in other Limbourg miniatures (fig. 242).

The 'Ego sum' miniature, though it is unique both in this context and as shown in this way, can thus be seen nevertheless to be a modification of an existing image, a

modification using other pictorial sources which are combined and fused to alter the existing imagery.

Again, as with the other additions and unusual subjects in the *Très Riches Heures*, we have to seek for a reason. In this example, it is possible to suggest that the image takes on meaning in the context of the Passion cycle as a whole and that that meaning can be understood in the context of a theological debate concerning the interpretation of the events of Christ's Passion. The point being demonstrated is that Christ is on the one hand all powerful, but on the other chooses to place himself helplessly in the power of his adversaries. Meiss has, for other reasons, supposed that Jean Gerson, Chancellor of Paris University and known to Berry, might have taken some part in devising the programme for the *Très Riches Heures*, and a sermon preached by him in 1403 makes these very points about the events of the Passion.[89] Thus the 'Ego sum' miniature, at the beginning of the sequence, is there to demonstrate the power of Christ at whose feet the soldiers are shown stunned.

The foreshortened pose, as seen here, when it occurs in later Italian art is very often used to show figures either

dying, or dead; and since it is used by the Limbourgs in other miniatures in such a context, either for plague victims or for executioners struck down by heavenly fire, it is likely that the Limbourgs were conscious of this meaning.[90] This further strengthens the interpretation of the image as one of Christ all powerful, which then should be contrasted with the scenes of his torture and humiliation that follow, for instance, on folio 146v, where he is shown to the people naked.

The question of how an image such as this was created then inevitably begins, as its meaning becomes apparent, to merge in with the question of why it was created; and as with the saints' lives, discussed earlier in Chapter 3, it is necessary to examine the whole historical context of the making of the image to answer the latter question. Another example in the *Très Riches Heures* are the opening two miniatures. In the first, for January, the Duke is represented feasting with his courtiers gathered around him, and in the second, for February, two women and a man warm themselves at a fire. Here, too, a pictorial ancestry can be traced in calendar and season representations. But to understand further meanings, it is necessary to ask questions about the social status of these people and what attitudes to them are being constructed by patron and by artist. In another context, I have argued that the nudity of the peasants in the February scene must be seen in a context of negative imagery of peasants, and is a sign of their boorishness.[91]

The ways in which images in manuscripts could be used for ideological and propaganda purposes has also been investigated in relation to the patronage of Berry's brother, Charles V.[92] After the catastrophe of the defeat at Poitiers in 1356, followed by the rebellion of the Jacquerie and the revolt of Etienne Marcel in Paris, Charles had to rebuild the prestige of the French crown. In this objective, artistic patronage was crucial, and in the context of book illumination this links with Charles's patronage of the men of learning of the University of Paris, whom he commissioned to translate texts chosen specifically for their view of monarchical power, and of royal prerogatives and functions. The King is constantly portrayed and this is, on such a scale, something new. He is shown under various guises, but above all as 'le roi sage'. In the opening illustration of a dedication copy of Bartholomaeus Anglicus' *De Proprietatibus Rerum*, translated into French by Jean Corbechon for Charles V, formal parallels are drawn in the dedication portraits where the King is placed in relation to God himself, so that the King's role on earth parallels that of God above, a source of wisdom and justice benefitting his people (fig. 243).[93] Here it seems likely that the artist was instructed not only on what to paint, but also on how to paint it.[94]

In considering newly created images in the later Middle Ages, a new development must be taken into account in the fifteenth century. Artists come increasingly to incorporate their own direct visual observation of the world, and objects in it, into their representations. Again, this is not entirely new in medieval illumination or art

243. London, British Library, Add. 11612, folio 10.
Bartholomaeus Anglicus, *De Proprietatibus Rerum*. God creating
the World. The book presented to Charles V of France.

244. Vienna, Oesterreichische Nationalbibliothek, Cod. 2597,
folio 47v. René of Anjou, *Le Livre du Coeur d'Amour Epris*. Cuer
and Esperance at the hermit's chapel.

generally. Even in the early Middle Ages, artists might
introduce their lived experience into their representations.
This is particularly noticeable in the representation of
such objects of use as tools, weapons or musical instru-
ments. Thus, in the eleventh century, the illustrations of
both the Anglo-Saxon Aelfric Hexateuch and the Harley
Psalter are realistic in that they show tools in use, and
archaeologists and musicologists are now finding that
pictorial representation, even in periods in which, in other

respects, art seems almost totally abstract, can give
information on the appearance and functioning of such
objects as swords or harps.[95] In other words illuminators,
in detail at least, responded to their experience and
altered or modified their models even where they appear
most closely to copy them.

In the fifteenth century, such recourse to observation
becomes much more widespread.[96] Once again, it is
clearly mirrored in the pattern books; most strikingly in

the nature studies of Giovanni dei Grassi in the Bergamo pattern book.[97] Ulrike Jenni, in a study of the Uffizi pattern book of the early fifteenth century, has emphasised a related phenomenon by introducing the term 'sketch book' (Skizzenbuch) in distinction from 'motif book' (Musterbuch).[98] The copying of motifs continues, and this particular artist, as she has shown, travelled widely to record them. But side-by-side, and overlapping this function of the pattern book, is the artist's experimentation and creation of new compositions. The same transition could be observed in some of the marginal drawings discussed earlier.[99]

In relation to a newly created cycle, another manuscript which has become famous like the *Très Riches Heures*, provides significant understanding of both these phenomena. This is the Romance entitled *Le Livre du Coeur d'Amour Epris* written in 1457 by René of Anjou (1409–80), unsuccessful claimant to the kingdom of Naples.[100] In general, the illustrations of the *Coeur* manuscript fall into a context of a very large production of manuscripts with secular texts in the fifteenth century, particularly in France and the Netherlands. They may contain classical texts, such as Livy, or compilations or adaptations of classical history, mythology and legend, such as the *Ovide moralisé* or Alexander Romances or Troy material. They may be more recent history, Froissart, the *Chroniques de France*, the *Chroniques d'Hainault*, or they may be medieval romance, Arthurian material, or Boccaccio's *Decameron*. Many are translations

into the vernacular. Such texts, written in large folios and illuminated with many (sometimes hundreds) of miniatures, were made for royal and aristocratic patrons of whom Philippe Le Bon, Duke of Burgundy, may stand as typical in one sense, exceptional though he was in his resources and thus in the numbers of such books that he owned.[101] Such books were probably mainly read aloud to the patrons, rather than read physically by them, and the pictures had a function within this process.

Delaissé introduced the concept of publication by editors to describe the way such books were produced in different centres in the Netherlands at this period.[102] In Florence, the *cartolai*, of whom Vespasiano da Bisticci is the best known, acted similarly as intermediaries between patron, scribe and illuminator to produce a manuscript.[103] A parallel process has been analysed in England with regard to the production of copies of Lydgate in the 1460s, including two manuscripts with long, almost identical cycles of illustration of the Lives of Sts Edmund and Fremund of Bury St Edmunds.[104]

The methods of the illuminators to illustrate these texts seem, in general, to be similar to those used by the thirteenth- and fourteenth-century illuminators, as seen for example in the Arthurian manuscripts examined earlier. There must have been instructions of some sort as to where the picture should be put, and what should be represented, and the artist then constructed his or her miniatures, either extracting or modifying an earlier cycle or using moduli. The latter can be so sophisticated and

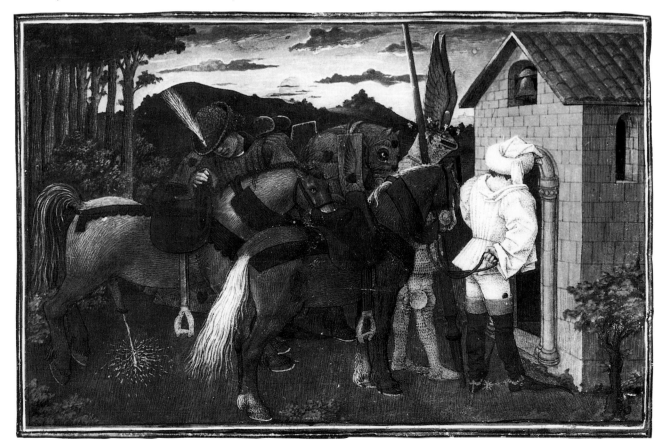

M·VALERII·MAR
TIALIS·EPIGRAM
MATON·LIBI

PERO·ME·SECV
TVRVM·IN·LI
BELLIS·MEISTA
LE·TEMPERA

245. Genoa, Biblioteca Durazzo
Giustiniani, Ms. 22 (A.III.3),
folio 2. Martial. Frontispiece.

246. Paris, Bibliothèque
nationale, latin 10532, folio 198.
Hours of Frederick III of Aragon.
The Deposition.

247. Oxford, Bodleian Library, Ms. Douce 219, folio 115. Hours of Engelbert of Nassau. The Holy Family refused admittance at the Inn.

varied as to the actors, figures, animals, and so on, that the process is often less noticeable. The artist was also able to place his actors in a greatly increased repertoire of settings, interiors, townscapes, landscapes, with a vastly increased range of properties, such as furniture, weapons or clothes.[105]

In specific cases, questions need to be asked as to the degree of relationship to the text; in particular, what knowledge of the text on the part of the illuminator is implied. As we have seen earlier, in many if not most cases, the answer is probably that it was not very great.[106]

It is the extraordinarily close relationship of picture to text which makes the *Livre du Coeur* remarkable; so close is it, indeed, that Otto Pächt has concluded that there is only one possible deduction, and that is that the author was also himself the illustrator.[107] This conclusion is bolstered first by historical evidence that René was a painter, and secondly by the observation that the itinerary of the *Coeur* artist, as shown by works attributable to him,

is exactly that of René himself, as well as on arguments of style which, according to Pächt's analysis, is French not Netherlandish. The conclusion is not accepted everywhere, but in the present context it is the deep sympathy for, and intimate knowledge of, the text which should be stressed.[108]

The artist, whether René himself or not, can be seen to have created his images by using stock modules for knights in armed combat, for figures sleeping, for buildings and tents, for boats and bridges, and for trees and rocks. Simultaneously, however, he incorporated his personal observation of natural phenomena, for example, in showing times of day, sunrise, sunset, and night time.

In one miniature in the *Coeur* manuscript, the realism includes a horse pissing on the ground (fig. 244), and in another miniature by the same artist in a copy of Boccaccio, *La Teseida*, the bird droppings are shown beneath a swallow's nest.[109] The natural observation in the North is often, in fact, connected with the humorous,

the unexpected, and the grotesque, and one of the most creative areas of later medieval illumination is the marginal or secondary illumination in borders or initials. The most varied and imaginative examples occur in English and Flemish manuscripts of the late thirteenth to mid fourteenth century, alluded to briefly in the previous Chapter, but they continue into the fifteenth century. This, however, is too large and complex a topic to be explored further here.

It is significant of a different situation in Italy, that if we speak of the incorporation of observation of real objects by illuminators into their imagery there, it is not still life, flowers, insects or birds as in the North which come to mind, but classical remains and antiquities. The probability of Peronet Lamy copying classical coins from the collection of Bishop Donato was referred to earlier. In the copying of classical antiquities, there are separate and specific problems of transmission, and there is evidence that this took place often by means of single sheet drawings which circulated amongst antiquarians. Such are mentioned in the Diary of the Paduan scribe and antiquary, Bartolomeo Sanvito.[110] An example is the frontispiece of a Martial illuminated *c.* 1470–80 by a Paduan artist, who often worked on manuscripts written by Sanvito and who has even been thought to be Sanvito himself (fig. 245).[111] Below is an image of the Colosseum in Rome, and to either side are basket-bearing figures of Pan which allude to the famous pair of classical statues discovered in Rome in the Theatre of Pompey at this period, and first recorded in the della Valle Collection in 1490.[112] This learned allusion is a product of that kind of recording of antiquity described in the well-known account of a day's picnic on Lake Garda, when the painter, Andrea Mantegna, the physician and antiquarian Giovanni Marcanova, and the scribe Felice Feliciano went to look for classical remains.[113]

At the beginning of this Chapter, I referred to the necessity of illuminators having to respond to the practice of monumental artists working all around them on wall and panel paintings. This was in relation to the question of the influence of monumental painting on miniatures, and of the status of painters as opposed to miniaturists. I want to end with a different point. By the late fifteenth century, many miniatures have come to resemble minute panel paintings, and some are actually shown framed as if they hang on a wall, or are placed above altars as if altarpieces (fig. 246).[114] Otto Pächt analysed the consequences of this in the context of the manuscript book, and the problem of relating the imaginary picture space with the physical surface of the page, and with the script written on it.[115] He showed how the Flemish illuminator known as the Master of Mary of Burgundy, in particular, introduced novel solutions to this problem in the period around 1480.

In the context of pictorial creation, however, there is another way in which in the work of this illuminator there comes to be a division of picture and text; not so much a physical division, as a division of purpose. The Master of Mary of Burgundy, in taking again the standard scenes for the Book of Hours, recreated them in his imagination as dramatisations of a lived, psychological experience with which he was able to empathise.[116] Thus, as well as showing the Annunciation, the Visitation and the Nativity, the standard scenes, he included a miniature to show *why* the baby was born in the stable, that is because the pregnant mother was refused a room in the inn even when there was snow on the ground. He thus reconstructed imaginatively the cruelty on the one side, and the suffering on the other (fig. 247).

There is a textual basis here, certainly, but that is not quite the point. It is not the text which has necessitated the image; nor here does it seem likely, though it is possible, that it was a requirement of Engelbert of Nassau, the aristocratic patron, or his adviser.[117] They may have required a more lavishly illustrated manuscript, but it is more likely to have been the artist himself who decided on the nature of the new images, and in doing so, he liberated the pictures from the book since they no longer depended directly on the book, its particular text, and the conventions dictating their placing within that text. Instead the miniatures depended on his imagination.

This point of artistic individuality should not be overstressed, because such a response must also be seen in the context of religious experience at the time; that is, the new movement known as the *Devotio Moderna* in the Netherlands. But nevertheless the artist is now free in a new way, and in taking into account all the reasons why book illumination fades gradually away after the invention of printing, except in certain exceptional cases, this too has to be borne in mind. The book and its text put a restraint on artistic individuality, not only in its mode of production, which was primarily collective, but in its function as requiring the artist to submit to an exterior authority, that of the pictorial purpose defined in the text itself. As artistic individuality is more and more stressed, the activity of book illumination, with its processes of creation by transmission and in collaboration with others, becomes more and more marginalised.

Notes

PREFACE

[1] In addition to the older general account by D. Diringer, *The Illuminated Book: Its History and Production* (2nd edn, London, 1967), and the more recent general surveys by J. Backhouse, *The Illuminated Manuscript* (Oxford, 1979); R.G. Calkins, *Illuminated Books of the Middle Ages* (Ithaca, New York, London, 1983); C.F.R. de Hamel, *A History of Illuminated Manuscripts* (Oxford, 1986); O. Pächt, *Book Illumination in the Middle Ages: An Introduction* (London, 1986) (for a review of Backhouse, de Hamel and Pächt, see L.F. Sandler, *Art Bulletin*, 70, 1989, 521–3); J. Glénisson, ed., *Le livre au Moyen Age* (Turnhout, 1988), the following works concerned more particularly with the subject matter of my own book should be cited: S. Hindman, J.D. Farquhar, *Pen to Press: Illustrated Manuscripts and Printed Books in the First Century of Printing* (College Park, Maryland, 1977). R.G. Calkins, *Programs of Medieval Illumination* (Franklin D. Murphy Lectures, V) (Helen Foresman Spencer Museum of Art, University of Texas, 1984). *Text and Image*, Acta, vol. X, ed. D.W. Burchmore (Center for Medieval and Early Renaissance Studies, State University of New York at Binghamton, 1986), especially S. Hindman, 'The Roles of Author and Artist in the Procedure of Illustrating Late Medieval Texts', pp. 27–62. S. Hindman, 'The Illustrated Book: An Addendum to the State of Research in Northern European Art', *Art Bulletin*, 68 (1986), 536–42. C. de Hamel, *Medieval Craftsman. Scribes and Illuminators* (London, 1992).

[2] S.D. Smith, *Illustrations of Raoul de Praelles' translation of St Augustine's City of God between 1375 and 1420*, Ph.D. (Institute of Fine Arts, New York University, 1974). See also her 'New Themes for the *City of God* Around 1400: The Illustrations of Raoul de Presles' translation', *Scriptorium*, 36 (1982), 68–82. V.G. Porter, *The West Looks at the East in the Late Middle Ages: the 'Livre des merveilles du monde'*, Ph.D. (Johns Hopkins University, 1977). C. Lacaze, *The Vie de St Denis Manuscript (Paris, Bibliothèque nationale fr. 2090–92)*, Ph.D. (Institute of Fine Arts, New York University, 1978). D. Byrne, *The Illustrations to the Early Manuscripts of Jean Corbechon's French Translation of Bartholomaeus Anglicus*, Ph.D. (Cambridge University, 1981). A.D. Hedeman, *The Illustrations of the Grandes Chroniques de France from 1274 to 1422*, Ph.D. (Johns Hopkins University, 1984). M. Camille, *The Illustrated Manuscripts of Guillaume de Deguilleville's Pèlerinage 1330–1426*, Ph.D. (Cambridge University, 1985). D. Oltrogge, *Die Illustrationszyklen zur 'Histoire ancienne jusqu'à César' 1250–1400* (Europäische Hochschulschriften, Ser. XXVIII, No. 94) (Frankfurt a.m., etc., 1987). See also *Texte et Image* (Actes du colloque international de Chantilly, 13 au 15 octobre 1982) (Paris, 1984). S.L. Hindman, *Christine de Pizan's 'Epistre d'Othéa'. Painting and Politics at the Court of Charles VI* (Toronto, 1986). L.E. Stamm-Saurma, 'Zuht und wicze: zum Bildgehalt spätmittelalterlicher Epenhandschriften', *Zeitschrift des deutschen Vereins für Kunstwissenschaft*, 41 (1987), 42–70. For recent work on the illustrated Saints' Lives, see pp. 84–9, nn. 40–47. Of earlier studies, the following should also be mentioned: J.V. Fleming, *The 'Roman de la Rose'. A Study in Allegory and Iconography* (Princeton, 1969); I. Zacher, *Die Livius-Illustration in der Pariser Buchmalerei (1370–1420)* (unpubl. diss, Free University of Berlin, 1971); K. Laske-Fix, *Der Bildzyklus des Breviari d'Amor* (Munich, Zürich, 1973); H. Frühmorgen-Voss, *Text und Illustration im Mittelalter. Aufsätze zu den Wechselbeziehungen zwischen Literatur und bildender Kunst*, ed. with introd. N.H. Ott (Munich, 1975); *Text und Bild. Aspekte des Zusammenwirkens zweier Künste in Mittelalter und früher Neuzeit*, eds C. Meier, U. Ruberg (Wiesbaden, 1980).

[3] For pioneer works in this respect concerned with Charles V see C.R. Sherman and D. Byrne, p. 143, n. 92, and also V. Porter (as in n. 2). Also particularly significant are the papers by B. Abou-el-Haj, cited p. 168, n. 40, and the recent book by M. Camille, *The Gothic Idol. Ideology and Image-Making in Medieval Art* (Cambridge, 1989).

[4] F.H. Bäuml, 'Varieties and Consequences of Medieval Literacy and Illiteracy', *Speculum*, 55 (1980), 237–65. B. Stock, *The Implications of Literacy: Written Language and Models of Interpretation in the Eleventh and Twelfth Centuries* (Princeton, 1983). M. Clanchy, *From Memory to Written Record. England 1066–1307* (London, 1979). M. Camille, 'Seeing and Reading: Some Visual Implications of Medieval Literacy and Illiteracy', *Art History*, 8 (1985), 26–49; id., 'The Book of Signs: Writing and Visual Difference in Gothic Manuscript Illumination', *Word and Image*, 1 (1985), 133–48; id., 'Visual Signs of the Sacred Page: Books in the *Bible moralisée*', *Word and Image*, 5 (1989), 111–30.

[5] In reference to the shelf-mark of an eleventh-century Anglo-Saxon Psalter in the British Library! Temple, *Anglo-Saxon Manuscripts*, cat. 98. My friend, Michael Kauffmann, is the first person I am conscious of having heard using this phrase.

CHAPTER 1

[1] Lehmann-Brockhaus, 3, nos 5929–30.

[2] Lehmann-Brockhaus, 3, no. 5344. R. Vaughan, *Matthew Paris* (Cambridge, 1958). S. Lewis, *The Art of Matthew Paris in the Chronica Majora*, (California Studies in the History of Art, XXI), (Berkeley, 1987).

[3] Dante, *Purgatorio*, XI, vv. 79–81. Oderisi 'l'onor di quell arte ch' alluminar chiamata e in Parisi.'

[4] See nn. 98, 101.

[5] For example, the Valois brothers in the later fourteenth and early fifteenth century. For Charles V of France, see L. Delisle, *Recherches sur la librairie de Charles V* (Paris, 1907). For Jean de Berry, see Meiss, *French Painting*. For Philip the Bold,

Duke of Burgundy, see P. de Winter, *La bibliothèque de Philippe le Hardi, duc de Bourgogne (1364–1404). Étude sur les manuscrits à peintures d'une collection princière à l'époque du 'Style gothique international'* (Paris, 1985). For later major princely collections, see G. Doutrepont, *Inventaire de la 'librairie' de Philippe le Bon (1420)* (Brussels, 1906); *La librairie de Philippe le Bon*, cat. by G. Dogaer, M. Debae (Brussels, Bibliothèque royale, 1967). E. Pellegrin, *La bibliothèque des Visconti et des Sforza, ducs de Milan, au XVe siècle* (Paris, 1955). T. de Marinis, *La Biblioteca napoletana dei re d'Aragona* (Milan, 4 vols, 1947, 1952; *Supplemento*, 2 vols, Verona, 1969).

[6] See n. 110.

[7] See, for example, p. 27, and figs 41–2.

[8] Medieval illuminators' self-portraits have not been systematically listed. Mr Michael Gullick has for some time been collecting examples of portraits of scribes and illuminators, and I am grateful to him for sharing his list with me. F. de Mély, *Les primitifs et leurs signatures. Les miniaturistes* (Paris, 1913), is a pioneer work, but must be used with caution. For the earlier period, see Alexander, *Scribes as Artists*. For representations of medieval artists generally, including some illuminators, see V.W. Egbert, *The Mediaeval Artist at Work* (Princeton, 1967); A. Martindale, *The Rise of the Artist in the Middle Ages and Early Renaissance* (London, 1972); A. Legner, 'Illustres manus', *Ornamenta Ecclesiae*, 1, pp. 187–230, and in general the section of the catalogue entitled 'Fabrica'; P. Binski, *Medieval Craftsmen. Painters* (Toronto, London, 1991). For known illuminators' names, see P. D'Ancona, E. Aeschlimann, *Dictionnaire des miniaturistes du Moyen Age et de la renaissance dans les différentes contrées de l'Europe* (Milan, 1949; repr. Nendeln, 1969). For debates on the role and status of the artist in the Middle Ages more generally, see J. Jahn, 'Die Stellung des Künstlers im Mittelalters', *Festgabe für Friedrich Bülow*, ed. O. Stamner (Berlin, 1960), pp. 151–68. M. Schapiro, 'On the Relation of Patron and Artist. Comments on a Proposed Model for the Scientist', *The American Journal of Sociology*, 70 (1964–5), 363–9. H. Klotz, 'Formen der Anonymität und des Individualismus des Mittelalters und der Renaissance', *Gesta*, 15 (1976), 303–12. R. Hausherr, '*Arte nulli secundus*. Eine notiz zum Künstlerlob im Mittelalter', *Ars auro prior. Studia Joanni Bialostocki sexagenario dicata* (Warsaw, 1981), pp. 43–7. See also the three volumes of *Artistes, artisans, et production artistique au Moyen Age. 1 Les Hommes. 2 Commande et travail. 3 Fabrication et consommation de l'œuvre*, ed. X. Barral i Altet (Paris, 1986, 1987, 1990), and especially X. Muratova, '*Vir quidem fallax et falsidicus, sed artifex praeelectus*', 1, pp. 53–72. For monks, see R.E. Swartout, *The Monastic Craftsman* (Cambridge, 1932), and for the transition to secular production, F. Masai, 'De la condition des enlumineurs et de l'enluminure à l'époque romane', *Bulletino dell'archivio paleografico italiano*, 2–3 (1956–7), 135–44, making the interesting suggestion that the monk's reward was spiritual and that he therefore only signed his work if it was *not* done at the abbot's command.

[9] The fullest account of ancient book illumination, K. Weitzmann, *Illustrations in Roll and Codex. A Study of the Origin and Method of Text Illustration* (2nd edn, Princeton, 1970), contains no mention of a named illuminator and has no reference to the question of who did this work. See also K. Weitzmann, *Ancient Book Illumination* (Cambridge, Mass., 1959). The nature of the decoration (*kosmesis*) applied to a book by the Presbiter Aurelius Heraclius living in Egypt in the fourth or fifth century is uncertain. See the publication of the Yale papyrus, in which this is referred to, by G.M. Parassoglou, 'A Book Illuminator in Byzantine Egypt', *Byzantion*, 44 (1974), 362–6. Note also his warnings about Weitzmann's theories. For an overview of what is known about artists in general in the classical period, see A. Burford, *Craftsmen in Greek and Roman Society* (London, 1972). Also J.M.C. Toynbee, 'Some Notes on Artists in the Roman World', *Collection Latomus*, 6 (1951).

[10] *Der kleine Pauly. Lexicon der Antike*. ed. K. Ziegler *et al.*, 5 (Munich, 1975), pp. 862–3. For further literature, see L.E.

Boyle, *Medieval Latin Palaeography. A Bibliographical Introduction* (Toronto, 1984), nos 1804–1812.

[11] Examples of mathematical and astronomical diagrams in Weitzmann, *Ancient Book Illumination*, figs 1–2.

[12] As in nn. 9, 16.

[13] H. Stern, *Le calendrier de 354. Étude de son texte et ses illustrations* (Paris, 1953).

[14] C. Nordenfalk, *Die spätantiken Zierbuchstaben* (Stockholm, 1970).

[15] Vatican, B.A.V., Vat. lat. 3256 and Berlin, Staatsbibliothek Preussischer Kulturbesitz, Cod. lat. fol. 416. C. Nordenfalk, Kommentarband to *Vergilius Augusteus* (Codices Selecti, LVI) (Graz, 1976).

[16] Berlin, Staatsbibliothek Preussischer Kulturbesitz, Cod. theol. lat. fol. 485. I. Levin, *The Quedlinburg Itala. The Oldest Illustrated Biblical Manuscript* (Leiden, 1985), especially pp. 18–19, 39, 46, 55–6, 63–6. C. Davis Weyer, *Early Medieval Art 300–1150* (Sources and Documents in the History of Art, ed. H.W. Janson) (Englewood Cliffs, New Jersey, 1971), pp. 23–5, some of the notes in translation. See also K. Weitzmann, *Late Antique and Early Christian Book Illumination* (New York, 1977), pl. 5, where the notes are clearly visible.

[17] C. Nordenfalk, *Die spätantiken Kanontafeln* (Göteborg, 1938), 1, pp. 46–51.

[18] E. Arns, *La technique du livre d'après Saint Jérôme* (Paris, 1953).

[19] E.C. Butler, *Sancti Benedicti Regula monachorum* (3rd edn, Freiburg-i-Breisgau, 1935). For an overview of the role of reading and copying manuscripts in the Benedictine Order, see J. Leclercq, *The Love of Learning and the Desire for God. A Study of Monastic Culture* (2nd revised edn, London, 1978).

[20] *Op. cit.*, chs XLVIII.1, LIII.

[21] Florence, Laur., plut. 1, 56. C. Cecchelli, G. Furlani, M. Salmi, *The Rabbula Gospels* (Olten and Lausanne, 1959).

[22] Named scribes are listed in Bénédictins du Bouveret.

[23] Comm. on Ps. 14, 86. *Institutiones*, V.2. G.L. Houghton, *Cassiodorus and Manuscript Illustration at Vivarium*, Ph.D. (State University of New York, Binghamton, 1975).

[24] Florence, Laur., Amiatinus 1. Alexander, *Insular Manuscripts*, cat. 7, gives literature, among which see especially: R.L.S. Bruce-Mitford, 'The Art of the *Codex Amiatinus*', *Journal of the British Archaeological Association*, 32 (1969), 1–25. See also Ch. 4, pp. 72–3.

[25] Paris, B.n., latin 12190. C. Nordenfalk, 'Corbie and Cassiodorus', *Pantheon*, 32 (1974), 225–231. See, however, K. Bierbrauer, *Die Ornamentik frühkarolingischer Handschriften aus Bayern* (Munich, 1979), p. 73.

[26] Vienna, O.N.B., Cod. Med. Gr.1. H. Gerstinger Kommentarband to *Dioscorides (Codex Vindobonensis Med gr.1)* (Codices Selecti, XII), (Graz, 1970). Weitzmann, *Late Antique* (as in n. 16), pl. 17.

[27] Florence, Laur., plut. 56, 1, Orosius. 'Confectus codex in statione magistri Viliaric antiquarii, ora pro me scriptore sic dnm habeas protectorem'. It seems to be generally assumed that Viliaric was the scribe, but that does not necessarily follow. E.A. Lowe, *Codices latini antiquiores, III. Italy. Ancona–Novara* (Oxford, 1938), no. 298. Angers, Bib. mun., Ms. 24. Gospels. *Manuscrits à peintures* (1954), no. 212. For both notes, see B. Bischoff, 'Scriptoria e manoscritti mediatori di Civiltà', *Settimane di studio del Centro italiano di studi sull' alto medioevo. II. Centri e vie di irradiazione della civiltà nell' alto medioevo* (Spoleto, 1963), 479–504, reprinted *Mittelalterliche Studien. Ausgewählte Aufsätze zur Schrifikunde und Literaturgeschichte*, II (Stuttgart, 1967), p. 316.

[28] See D'Ancona, Aeschlimann (as in n. 8), p. 221.

[29] London, B.L., Cotton Nero D.IV. T.D. Kendrick, T.J. Brown, R.L.S. Bruce-Mitford, H. Roosen-Runge, A.S.C. Ross, E.G. Stanley, A.E.A. Werner, *Evangeliorum Quattuor Codex Lindisfarnensis*, vol. I, complete facsimile, vol. II commentary (Olten and Lausanne, 1956, 1960). Alexander, *Insular manuscripts*, cat. 9.

[30] Oxford, Bodl., Ms. Auct. D.2.19. 'Macregol dipinxit hoc Evangelium. Quicumque legerit vel intellegerit istam narrationem orat pro macreguil scriptori'. Alexander, *Insular manuscripts*, cat. 54.

[31] Vatican, B.A.V., Vat. lat. 3868, folio 3, in the gable to the left. 'Miserere mei deus se(cundum magnam misericordiam tuam, Ps. 50). Adelricus me fecit'. L.W. Jones, C.R. Morey, *The Miniatures of the Manuscripts of Terence Prior to the Thirteenth Century*, 2 vols (Princeton, 1931), p. 33. W. Kœhler, F. Mütherich, *Die karolingischen Miniaturen, IV. Die Hofschule Kaiser Lothars. Einzelhandschriften aus Lotharingien* (Berlin, 1971), 85–100, Taf. 30. For this, and other instances of both scribes and artists at this period and later, with a good discussion of the issues, see H. Hoffmann, *Buchkunst und Königtum im ottonischen und frühsalischen Reich* (M.G.H. Schriften, Bd. 30/1–2) (Stuttgart, 1986), espec. Ch. 2, 'Schreiber, Buchmaler, Stifter'.

[32] Paris, B.n., latin 12048, folios 99, 254v. Noted by E.A. Lowe, *Codices Latini Antiquiores, V. France, Paris* (Oxford, 1950), no. 618. B. Teyssèdre, *Le sacramentaire de Gellone* (Toulouse, 1959), unfortunately does not reproduce them.

[33] London, B.L., Harley 2790, folio 23. W. Koehler, *Die karolingischen Miniaturen, I,1. Die Schule von Tours* (Berlin, 1930; repr. 1963), p. 39.

[34] Paris, B.n., latin 1, folio 423. Koehler, I,1, pp. 398–9 (gives the text of the colophon), I,2, pp. 220–231.

[35] Darmstadt, Hessische Landesbibl., Cod. 746, folio 14v. Schramm, Mütherich, *Denkmale*, p. 131. W. Koehler, F. Mütherich, *Die karolingischen Miniaturen, V. Die Hofschule Karls des Kahlen* (Berlin, 1982), pp. 11, 88–99.

[36] Paris, B.n., latin 1152. Munich, Bayer. Staatsbibl., Clm 14000. Koehler, Mütherich (as in n. 35), pp. 132–43, 175–98. Schramm, Mütherich, *Denkmale*, nos 44, 52. On p. 131, the authors describe Liuthard as: 'wohl der Hauptkünstler der Hofschule Karls der Kahlen'.

[37] The symbolic importance of gold, especially in the early Middle Ages, has been stressed by C.R. Dodwell, *Anglo-Saxon Art. A New Perspective* (Manchester, 1982). See also the colophon of the Dagulf Psalter, given by Charlemagne to Pope Hadrian I (772–95), Vienna, O.N.B., Cod. 1861, folio 4v:

Aurea Daviticos en pingit litera cantus.

Ornari decuit tam bene tale melos.

Aurea verba sonant, promittunt aurea regna.

M.G.H., Poetae Latini, 1, p. 92. W. Koehler, *Die karolingischen Miniaturen, II. Die Hofschule Karls des Grossen* (Berlin, 1958), pp. 11ff, 42ff. Schramm, Mütherich, *Denkmale*, no. 11.

[38] St Gall, Stiftsbibl., Cod. 53. A. Merton, *Die Buchmalerei in St. Gallen vom 9. bis 11. Jahrhundert* (Leipzig, 1912; 2nd edn 1923), pp. 49ff.

[39] Adolf Merton, however, refused credence to the chronicler and C.R. Dodwell also warns of the dangers of accepting such ascriptions uncritically, *op. cit*, pp. 48–50. Abbot Ellinger of Tegernsee (*d.* 1056) signed a number of manuscripts as scribe. E.F. Bange, *Eine Bayerische Malerschule des XI. und XII. Jahrhunderts* (Munich, 1923), took him also to have been their illuminator and was followed by O. Pächt, 'Two Manuscripts of Ellinger, Abbot of Tegernsee', *Bodleian Library Record*, 2 (1947), 184–5. However, this seems untenable on grounds of a revised chronology. See C. Eder, *Die Schule des Klosters Tegernsee im frühen Mittelalter im Spiegel der Tegernseer Handschriften* (Munich, 1972).

[40] F. Landsberger, *Der St. Galler Folchart Psalter* (St Gall, 1912), pp. 30, 33. C. Eggenberger, *Psalterium aureum Sancti Galli. Mittelalterliche Psalterillustration im Kloster St. Gallen* (Sigmaringen, 1987). It is significant that it is from the early ninth century that the most crucial piece of evidence for the organisation of the monastic scriptorium comes, that is the Plan of St Gall. See W. Horn, E. Born, 'The Medieval Monastery as a Setting for the Production of Manuscripts', *Journal of the Walters Art Gallery*, 44 (1986), 16–47.

[41] J. von Schlosser, 'Eine Fuldaer Miniaturhandschrift der K.K. Hofbibliothek', *Jahrbuch der kunsthistorischen Sammlungen der Allerhochsten Kaiserhauses*, 13 (1892), 30–36. See pp. 84–5.

[42] U. Chevalier, *Sacramentaire et martyrologe de l'abbaye de Saint Remy* (Bibl. Liturg., VIII), 1900, p. vii. F. Mütherich, 'Das Godelgaudus-Sakramentar, ein verlorenes Denkmal aus der Zeit Karls des Grossen', *Festschrift Wolfgang Braunfels*, eds F. Piel, J. Traeger (Tübingen, 1977), pp. 267–74, Abb. 1–3. The three miniatures of the two standing saints and of the donor were reproduced in the seventeenth century, but not the other two images which occurred before the scribe's colophon which was unfortunately not transcribed. Lantbertus is described in the donor inscription as 'sacerdos vitam solitariam degens'.

[43] J. Williams, *Early Spanish Manuscript Illumination* (New York, 1977). M. Mentré, 'L'enlumineur et son travail selon les manuscrits hispaniques du Haut Moyen Age', *Artistes*, 1, 295–309. For the long career of the scribe Florentius, who is shown with his disciple, Sanctius, on the colophon page of the Bible of San Isidoro, León, Cod. 2, see J. Williams, 'A Contribution to the History of the Castilian Monastery of Valerancia and the Scribe Florentius', *Madrider Mitteilungen*, 11 (1970), 231–248, and Williams, *Early Spanish*, pl. 11.

[44] J. Camón Aznar, *et al.*, *Beati in Apocalipsin Libri Duodecim: Codex Gerundensis* (Madrid, 1975) (facsimile). See Mentré, p. 298, for the suggestion that the Gerona colophon may read 'En depintrix', however.

[45] Madrid, Archivio historico nacional, 1097B. For colour plate, see C. Nordenfalk, 'Book Illumination' in *Early Medieval Painting* (with A. Grabar), (Skira, 1957), p. 173. Also Williams, frontispiece, and Mentré, fig. 4 (both line reconstructions since the folio is damaged).

[46] New York, Morgan, M. 429. From Las Huelgas, Burgos. *Los Beatos* (exhibition catalogue, Europalia '85. España) (Brussels, Royal Library, 1985), no. 20, with bibliography.

[47] London, B.L., Add. 11695. 'Prior Petrus . . . complevit et complendo ab integro illuminabit'. Mentré, pp. 298–9. Nordenfalk, *Early Medieval Painting*, p. 168, gives a translation of the colophon with its still pertinent admonition: 'so gentle reader, turn these pages carefully and keep your fingers far from the text. For just as hail plays havoc with the fruits of Spring, so a careless reader is a bane to books and writing'; and, one might add, to illumination!

[48] New York, Morgan, M. 644. 'Storiarum verba mirifica per seriem depinxi, ut scientibus terreant judicii futuri eventus'. Mentré, p. 300.

[49] Lehmann-Brockhaus, 3, no. 5160: 'facere picturam, litteras formare'. Alexander, *Scribes as Artists*, p. 88.

[50] Oxford, Bodl., Ms. Auct. F. 4.32. R.W. Hunt, *Saint Dunstan's Classbook from Glastonbury* (Umbrae Codicum Occidentalium, IV) (Amsterdam, 1961). Temple, *Anglo-Saxon Manuscripts*, cat. 11, pl. 14.

[51] *Willelmi Malmesbiriensis monachi, De gestis pontificum Anglorum* (Rolls Series, 52), ed. N.E.S.A. Hamilton (London 1870), p. 184. See N.R. Ker, 'The Beginnings of Salisbury Cathedral Library', *Medieval Learning and Literature. Essays Presented to Richard William Hunt*, ed. J.J.G. Alexander, M. Gibson (Oxford, 1976), pp. 23–49. Ker discusses the formation of the library and the surviving manuscripts of the period, in which there is, however, very little illumination. For the later, fifteenth-century source, see Dodwell, *Anglo-Saxon Art* (as in n. 37), p. 47 and Lehmann-Brockhaus, 3, no. 5933.

[52] For the opposition, see J. van Engen, 'Theophilus presbiter and Rupert of Deutz: the manual arts and Benedictine theology in the early twelfth century', *Viator*, 11 (1980), 147–63.

[53] Lehmann-Brockhaus, 1, no. 1610. Dodwell, *Anglo-Saxon Art*, p. 65.

[54] Boulogne-sur-mer, Bib. mun., Ms. 20. V. Leroquais, *Les Psautiers manuscrits des bibliothèques publiques de France*, 1 (Macon, 1940–41), pp. 94–101. R. Kahsnitz, 'Der Christologische Zyklus im Otbert Psalter', *Zeitschrift für Kunstgeschichte*, 51 (1988), 33–125.

[55] New York, Morgan, M. 333, folio 51. Alexander, *Decorated Letter*, pl. 21.

[56] Vatican, B.A.V., Reg. lat. 12, folio 21. Temple, *Anglo-Saxon Manuscripts*, cat. 84. The portrait was first noticed by R. Kahsnitz, *Der Werdener Psalter in Berlin* (Düsseldorf, 1979), p. 220.

[57] London, B.L., Cotton Titus D. XXVII, Obits of Aethericus, 19 May, and Wulfricus, 3 July. Temple, *Anglo-Saxon Manuscripts*, cat. 77.

[58] Oxford, Bodl., Ms. Bodley 717, folio 287v. O. Pächt, 'Hugo Pictor', *Bodleian Library Record*, 3 (1950), 96–103. Alexander, *Scribes as Artists*, p. 107, pl. 19.

[59] Durham, Dean and Chapter Library, Ms. B.II.13, folio 102. R.A.B. Mynors, *Durham Cathedral Manuscripts to the End of the Twelfth Century* (Durham, 1939) pp. 34–5 (no. 31), pl. 20. Robert also is described as 'pictor', cf. Bénédictins du Bouveret, 5, pp. 243–4, no. 16672 for the colophon in full.

[60] As is also implied in a 'D' in a German Psalter of the second half of the twelfth century, Vienna, O.N.B., Cod. 1226, folio 60. In the stem of the letter Christ is above, then a full-length prelate and below him in a roundel a half-length figure, apparently untonsured, with an ink horn. A second roundel in the bowl of the letter shows a tonsured figure with a pair of dividers. He was thought to be the illuminator by H.J. Hermann, *Die deutschen Romanischen Handschriften* (Beschreibendes Verzeichnis der illuminierten Handschriften in Oesterreich, VIII. Band, II. Teil) (Leipzig, 1926), pp. 90–93, fig. 47.

[61] In scribendo et quodlibet coloribus effingendo peritum'. See note 1. Also Dodwell, *Anglo-Saxon Art* (as in n. 37), p. 55.

[62] See Ch. 2, p. 39, n. 43–4.

[63] Bamberg, Staatsbibl., Msc. Patr. 5, folio 1v. F. Dressler, *Scriptorum opus. Schreiber-Mönche am Werk. Prof. Dr. Otto Meyer zum 65. Geburtstag* (Wiesbaden, 1971). Egbert, *Medieval Artist*, p. 28, pl. IV. Jackson, *Story*, pls pp. 68–9. *Ornamenta Ecclesiae*, 1, p. 219.

[64] C. Nordenfalk, 'A Travelling Milanese Artist in France at the Beginning of the XI. Century', *Arte del Primo Millenio* (Atti del Convegno di Pavia, 1950) (ed. E. Arslan, 1954), pp. 374–80. C. Nordenfalk, 'Miniature ottonienne et ateliers capétiens', *Arts de France*, 4 (1964), 47–55. The ex-Dyson Perrins Sacramentary thought to be illuminated by Nivardus is now J. Paul Getty Museum, Malibu, Ludwig V.1, von Euw, Plotzek, *Ludwig*, 1, pp. 219–22, Taf., Abb. 137–41.

[65] P. Marchegay, 'Documents du XIe siècle sur les peintures de l'abbaye de Saint-Aubin', *Bulletin de la Société industrielle d'Angers*, 17 (1846), 218–23. It has been suggested without any firm evidence that Fulk was responsible for the miniatures of Paris, B.n., n. acq. lat. 1390, illustrated Life of Saint Aubin. J. Porcher, *French Miniatures from Illuminated Manuscripts*, transl. J. Brown (London, 1960), p. 30. M. Carrasco, 'Spirituality and Historicity in Pictorial Hagiography: Two Miracles of St Albinus of Angers', *Art History*, 12 (1989), p. 4 (and see p. 168, n. 40).

[66] Lehmann-Brockhaus, 1, no. 495. Kauffmann, *Romanesque Manuscripts*, cat. 56. See also Ch. 2, p. 35 and n. 10.

[67] Paris, B.n., latin 11575, Florus, Commentary on St Paul's Epistles. C. de Mérindol, *La production des livres peints à l'abbaye de Corbie au XIIe siècle. Etude historique et archéologique* (Lille, 1976), II, pp. 834–8, pl. A. Alexander, *Decorated Letter*, pl. 24. Alexander, *Scribes as Artists*, pp. 112, 116, pls 25, 27. *Ornamenta Ecclesiae*, 1, p. 239 (B 40). C. de Mérindol, 'Les peintres de l'abbaye de Corbie au XIIe siècle', *Artistes*, 1, pp. 311–26, fig. 9. Nevelo was another Corbie monk who was both scribe and artist, see de Mérindol, p. 311, fig. 3.

[68] Bremen, Universitätsbibl. Cod. b. 21, folio 124v. C. Nordenfalk, *Codex Caesareus Upsaliensis. An Echternach Gospel-Book of the Eleventh Century* (Stockholm, 1971), p. 115, fig. 65. C.R. Dodwell in a review in the *Times Literary Supplement* (19 November 1976), pp. 1463–4, suggested that the lay figure might be holding a burnishing tool not a pen, but this seems improbable from its curved shape.

[69] Stockholm, Kungliga Biblioteket, Cod. A. 144, folio 34. C. Nordenfalk, 'Book Illumination' in *Romanesque Painting* (Skira, 1958), colour pl. p. 204. Alexander, *Scribes as Artists*, pp. 109, 112. *Ornamenta Ecclesiae*, 1, B. 48, colour plate.

[70] Prague, Metropolitan Library, A XXI/1. Egbert, *Medieval Artist*, p. 30, pl. V. Alexander, *Scribes as Artists*, pp. 111–12, pl. 22.

[71] Stuttgart, Württembergische Landesbibliothek, Cod. hist. fol. 420, folio 1. K. Löffler, *Schwäbische Buchmalerei in Romanescher Zeit* (Augsburg, 1928), pp. 72–6, Taf. 44.

[72] Trier, Stadtbibliothek, Cod. 261/1140 2°. Homiliary from Springiersbach, c. 1160–70. *Schatzkunst Trier. Kunst und Kultur in der Diözese Trier*, exh. cat. by F.J. Ronig (Trier, 1984), no. 63.

[73] London, B.L., Harley 3011, folio 69v. 'Teodericus depinxit hanc imaginem Gregorium papam'. The script of the inscription is clearly that of the main text. D'Ancona, Aeschlimann, p. 203, pl. CXXXV.

[74] He signed the Matricola of the Cambio, Perugia, Collegio del Cambio, Ms. 1, folio 3, in 1377 in gold: 'Io Matteo di ser Cambio orfo (goldsmith) che qui col sesto mano me fegurai quisto libro scrisse, dipinse et miniai' and portrayed himself on the same page in a letter 'A' holding a pair of dividers. D'Ancona, Aeschlimann, p. 147, pl. XC.

[75] de Marinis, *Biblioteca napoletana* (as in n. 5), I, pp. 149–50, II, pp. 8, 23–4, 28–9, 34, 40, 112, 132, 147. J.J.G. Alexander, A.C. de la Mare, *The Italian Manuscripts in the Library of Major J.R. Abbey* (London, 1969), pp. xxiii, xxviii, 80–81. J. Ruysschaert, 'Miniaturistes "Romains" sous Pie II', *Enea Silvio Piccolomini-Papa Pio II* (Atti del convegno per il quinto centenario della morte) (Siena, 1968), pp. 248, 254, 267–82.

[76] Douai, Bib. mun., Ms. 340. A. Boutemy, 'Enluminures d'Anchin au temps de l'abbé Gossuin (1131/3 à 1165)', *Scriptorium*, 11 (1957), 234–48, espec. p. 236 and pl. 18b.

[77] Geneva, Bib. Bodmeriana, Cod. 127. E. Pellegrin, *Manuscrits Latins de la Bodmeriana* (Cologny-Genève, 1982), pp. 265–6, colour frontispiece. Egbert, *Medieval Artist*, 32, pl. VI. Alexander, *Scribes as Artists*, p. 111 n. 59, pl. 23. The copyist is also represented on folio 2. S. Michon, *Le Grand Passionaire enluminé de Weissenau et son scriptorium autour de 1200* (Geneva, 1990), especially pp. 105–8, 134–5, pls 139, 142.

[78] Vatican, B.A.V., Rossiana 181, folio 22v. c. 1200–50, Padderborn. H. Tietze, *Die illuminierten Handschriften der Rossiana in Wien-Lainz* (Beschreibendes Verzeichnis der illuminierten Handschriften in Oesterreich, V) (Leipzig, 1911), p. 8, fig. 10. For other examples of the topos, see Trento, Biblioteca Comunale, Ms. 3568, p. 270. Gratian, Decretum. German (?), c. 1200. Initial 'I' with standing lay figure with paint pot in left hand and pen on the succeeding letter 'N' of the rubric. M. Bernasconi, L. dal Poz, *Codici miniati della Biblioteca Comunale di Trento* (Florence, 1985), p. 48, fig. 7. Munich, Bayer. Staatsbibl. Clm 9511, Alexander, *Scribes as Artists*, pl. 24. Also the Chronicle of St Pantaleon at Cologne, Wolfenbüttel, Herzog August Bibliothek, Cod. Guelf. 74.3 Aug. 2°, twelfth to thirteenth century, and the wall painting at Sankt Johann in Taufers (Tubre) of similar date. Both illustrated *Ornamenta Ecclesiae*, 1, pp. 187, 230. The latter shows the painter's brush particularly well.

[79] Cambridge, Corpus Christi College, Ms. 4, folio 241v. Egbert, *Medieval Artist*, p. 34, pl. VII. Kauffmann, *Romanesque Manuscripts*, cat. 69.

[80] Padua, Biblioteca capitolare, s.n. A. Barzon, *Codici Miniati. Biblioteca Capitolare della Cattedrale di Padua* (Padua, 1950), pp. 6–8, tav. VIIb. Alexander, *Scribes as Artists*, p. 107, pl. 20.

[81] Strasbourg, Bibliothèque du Grand Séminaire, Cod. 37, folio 4. *Le Codex Guta-Sintram* (facsimile) (Luzern, Strasbourg, 1982); with commentary volume by B. Weis, P. Bachoffner, *et al.* (1983). *Ornamenta Ecclesiae*, 1, B.44 with further literature.

[82] Frankfurt a.M., Stadt- und Universitätsbibl., Ms. Barth 42, folio 110v: 'Guda peccatrix mulier scripsit et pinxit hoc librum'. Homiliary, second half twelfth century, Middle Rhine. G. Powitz, H. Buck, *Die Handschriften des Bartholomaeusstifts und des Karmeliterklosters in Frankfurt am Main* (Frankfurt, 1974), pp. 84–8, assume that Guda is a nun. Alexander, *Scribes as Artists*, p. 109, pl. 21. *Ornamenta Ecclesiae*, 1, B.43 (colour).

[83] Baltimore, Walters Art Gallery, W. 26, folio 64. D. Miner, *Anastaise and Her Sisters. Women Artists of the Middle Ages* (Baltimore, Walters Art Gallery, 1974), pp. 11–12, fig. 2.

[84] Cf. J. Harris, '"Thieves, Harlots and Stinking Goats": Fashionable Dress and Aesthetic Attitudes in Romanesque Art', *Costume*, 21 (1987), 4–15.

[85] See, for example, the documents on the Chartreuse de Champmol, founded by Philip the Bold of Burgundy, printed by C. Monget, *La Chartreuse de Dijon d'après les documents des archives de Bourgogne*, 1 (1898), pp. 184ff., 409–19, especially 'Pièces justificatives', 31, the accounts of Dom Thiébaut de Besançon who was in charge of book provision for the abbey.

[86] P. Gumbert, *The Dutch and their Books in the Manuscript Age* (Panizzi Lectures, 1989) (London, British Library, 1990), Ch. 3.

[87] Copenhagen, Kongelige Bibliotek, Ms. 4. 2°. A.A. Björnbo, 'Ein Beitrag zum Werdegang der mittelalterlichen Pergamenthandschriften', *Zeitschrift für Bücherfreunde*, 11 (1907), 329–335, and espec. Abb. 1, 5, 8. *Gyllene Böcker. Illuminerade medeltida handskrifter i dansk och svensk ägo* (Nationalmuseum, Stockholm, 1952), no. 32. Jackson, *Story*, colour pls p. 79.

[88] 'di quell'arte ch' alluminar chiamata e in Parisi'. See note 3. For the gradual development of a secular book trade in Paris independent from the religious houses, see F. Avril, 'A quand remontent les premiers ateliers d'enlumineurs laïcs à Paris?' *Les Dossiers de l'Archéologie*, 16 (1976), 36–44. C.F.R. de Hamel, *Glossed Books of the Bible and the Origins of the Paris Booktrade* (Woodbridge, 1984). P. Stirnemann, 'Quelques bibliothèques princières et la production hors scriptorium au XIIe siècle', *Bulletin archéologique*, n.s. 17–8A (1984), 7–38. J.P. Turcheck, 'A Neglected Manuscript of Peter Lombard's *Liber Sententiarum* and Parisian Illumination of the Late Twelfth Century', *Journal of the Walters Art Gallery*, 44 (1986), 48–69.

[89] For an up-to-date and authoritative survey of University book production in Paris, see R.H. and M.A. Rouse, 'The Book Trade at the University of Paris, *c*. 1250–*c*. 1350', *La production du livre Universitaire au Moyen Age. Exemplar et pecia* (Actes du Symposium tenu au Collegio San Bonaventura de Grottaferrata en Mai 1983), eds L.J. Bataillon, B.G. Guyot, R.H. Rouse (Paris, 1988), 41–123. This supersedes P. Delalain, *Étude sur le libraire parisien du XIIIe au XVe siècle d'après les documents publiés dans le cartulaire d'Université de Paris* (Paris, 1891). See also, especially for the documents, H. Denifle, A. Chatelain, *Chartularium Universitatis Parisiensis, 1. 1200–1286. 2, 1286–1350* (Paris, 1889, 1891). *Robert Goulet, Compendium on the Magnificence, Dignity and Excellence of the University of Paris in the Year of Grace 1517*, lately done into English by Robert Belle Burke (Philadelphia, London, 1928). P. Chauvet, *Les ouvriers du livre en France des origines à la Révolution de 1789* (Paris, 1959).

[90] J. Destrez, *La Pecia dans les manuscrits universitaires du XIIIe et du XIVe siècle* (Paris, 1935). R.H. and M.A. Rouse, as in note 89, have shown that the system evolved more slowly and later than was thought earlier.

[91] See R.H. and M.A. Rouse, pp. 41–3 for the term and for the distinction between *librarius* and stationer (*stationarius*): 'the sole distinguishing factor is that those *librarii* who were stationers rented out peciae and those *librarii* who were not stationers did not'.

[92] R.H. and M.A. Rouse, pp. 66–71. 'The total number of *librarii* (including stationers) was quite modest'. They suggest the number twenty-eight may have formed a quota. The number was still the same in 1488 when printers were admitted.

Chauvet, p. 7. For the confirmation of the privileges of the University of Paris by Charles VIII in 1488, and also the Ordinance of Louis XII of 1513, see *Le Livre*, no. 462.

[93] Delalain (as in n. 89), pp. 59–70. R.H. and M.A. Rouse, Appendix 2, '*Librarii* and *stationarii* at Paris 1292–1354', is a fuller and revised list of names.

[94] Delalain, Documents III and XI.

[95] Delalain, pp. xl, 55–58, Document XVII.

[96] R.H. and M.A. Rouse, p. 48, emphasise this point.

[97] See R.H. and M.A. Rouse (in addition to their full list of recorded names) for a discussion, pp. 52–6, of three *librarii* of the first half of the fourteenth century involved in producing expensive illuminated manuscripts, some of which survive. They are Geoffroy de St-Léger, Thomas de Maubeuge and Richard de Montbaston. See further J. Diamond, 'Manufacture and Market in Parisian Book Illumination around 1300', *Europäische Kunst um 1300* (Akten des XXV. internationalen Kongresses für Kunstgeschichte, 6.6) (Vienna, 1986), pp. 101–10 and R.H. and M.A. Rouse, 'The Commercial Production of Manuscript Books in Late-Thirteenth-Century and Early-Fourteenth-Century Paris', *Medieval Book Production. Assessing the Evidence*, ed. L.L. Brownrigg (Los Altos Hills, California, 1990), pp. 103–15. The latter gives a detailed picture of the geographical distribution and the collaborative working methods of the book trade in Paris.

[98] P.H. Géraud, *Paris sous Phillippe le Bel d'après des documents originaux, et notamment d'après un manuscrit contenant le rôle de la taille imposée sur les habitans de Paris en 1292* (Documents inédits sur l'histoire de France) (Paris, 1837).

[99] Bookbinders, however, are usually specified as 'lieur de livres' or 'relieur'. I thank Mary Rouse for this point.

[100] Tours, Bib. Mun., Ms. 558, folio ii. 'Anno domini MCCLXXX octavo emi presens Decretum ab Honorato illuminatore morante Parisius in vico Herenboc de Bria precio quadraginta librarum Parisiensium, etc [partly erased]'. *Catalogue général des bibliothèques publiques de France. Départements, t. xxxvii, Tours*, par M. Collon (Paris, 1900), pp. 450–51. Fuller transcription and reproduction in de Mély (as in n. 8), p. 39, fig. 38. See also E.G. Millar, *The Parisian Miniaturist Honoré* (London, 1959), p. 11, pl. I, and Ch. 5, pp. 115–18.

[101] K. Michaëlsson, 'Le Livre de la taille de Paris, l'an 1296', *Göteborg Universitets Årsskrift*, 44 (1958), no. 4; 'Le Livre de la taille de Paris, l'an 1297', *ibid.*, 67 (1961), no. 3; 'Le Livre de la taille de Paris, l'an de grâce 1313', *Göteborgs Högskolas Årsskrift*, 57 (1951), no. 3. The rolls have also been excerpted by F. Baron, 'Enlumineurs, peintres et sculpteurs parisiens des XIIIe et XIVe siècles d'après les rôles de la taille', *Bulletin archéologique du Comité des travaux historiques et scientifiques*, n.s. 4 (1969), 37–121. See also F. Baron, 'Enlumineurs, peintres et sculpteurs parisiens des XIV et XV siècles, d'après les archives de l'hôpital Saint-Jacques aux Pèlerins', *ibid.*, n.s. 6 (1970–71), 77–115. For a data base of records of the Paris book trade which is being compiled at the Institut de Recherche et d'Histoire des Textes in Paris, see K. Fianu, 'L'histoire des métiers du livre Parisien aux XIVe et XVe siècles: presentation des sources', *Gazette du livre médiéval*, 15 (1989), 1–4.

[102] An example is Thomas of Wymondswold (Norfolk) who wrote a Gratian in Paris in 1314, now Paris, B.n., latin 3893. This has mainly French illumination, though some miniatures may be by an English artist. See F. Avril, P. Stirnemann, *Manuscrits enluminés d'origine Insulaire VIIe–XXe siècle* (Paris, 1987), cat. 172. Princeton University Library, Ms. 83/1, Durandus, Commentary on the Sentences in two volumes, was written in 1336 in Paris by an English scribe, William of Kirkeby, for Fr. Symon Comitis of Naples, O.P.

[103] R. Branner, 'Manuscript-Makers in Mid-Thirteenth Century Paris', *Art Bulletin*, 48 (1966), 65–7. A fuller study is L.E. Sullivan, *The Burgh of Ste Geneviève: Development of the*

University Quarter of Paris in the Thirteenth and Fourteenth Centuries, Ph.D. (Johns Hopkins University, 1975). For the geographical location in Paris of members of the book trade, see also R. and M.A. Rouse, 1990 (as in 97).

[104] Delalain, Document VIII.

[105] Delalain, Document XI.

[106] 'libraria et illuminatrix'. Delalain, pp. 38–42. Also R.H. and M.A. Rouse (1988), p. 54; (1990) p. 110, and especially their forthcoming Lyell lectures. For a fifteenth-century Hours, Use of Besançon, copied by a scribe, Alanus, and illuminated by his wife, see V. Leroquais, *Les Livres d'Heures manuscrits de la Bibliothèque nationale*, 1 (Paris 1927), pp. 96–7 and *Le Livre*, no. 431. It is Paris, B.n., latin 1169, signed on folio 84v: 'Alanus scripsit has horas et uxor ejus illuminavit eas'. C.F.R. de Hamel, *A History of Illuminated Manuscripts* (Oxford, 1986), ill. 168. For the identification of work of two female illuminators in Bruges in the late fifteenth and early sixteenth centuries, Margriete Sceppers, and Cornelie van Wulfschkercke, the latter a sister of the Syon monastery in the city, see A. Arnould, *The Art Historical Context of the Library of Raphael de Mercatellis*, Ph.D. (University of Ghent, 1992), pp. 132–44.

[107] Paris, B.n., latin 11930–1. 'Magister Alexander me fecit' on the Genesis page, p. 5. Branner, *Manuscript Painting*, 31, 202 Avril (1976) (as in n. 88), pl. p. 44. New York, Morgan, Glazier 37. 'Gautier. Lebaube Fit Larbre'. Branner, pp. 6, 72–5, 87, 138, 213, figs 144–5.

[108] The name 'Galterus illuminator' occurs, Branner noted, in the Ste Geneviève parish tax list of 1243 (for which see n. 103).

[109] Reims, Bib. mun., Ms. 40, folio 83v. *Le Livre*, no. 250.

[110] G. Pollard, 'William de Brailes', *Bodleian Library Record*, 5 (1954–6), 202–209. *Id.*, 'The University and the Book Trade in Medieval Oxford', *Miscellanea Mediaevalia* (Beiträge zum Berufsbewusstein des mittelalterlichen Menschen, ed. P. Wilpert), 3 (1964), 336–44. C. Donovan, *The de Brailes Hours. Shaping the Book of Hours in Thirteenth-century Oxford* (London 1991). More research is needed to identify illumination done in Oxford and Cambridge. See Morgan, *Early Gothic Manuscripts (2)*, pp. 33–4, and for the fourteenth century M. Michael, 'Oxford, Cambridge and London: Towards a Theory for "Grouping" Gothic Manuscripts', *Burlington Magazine*, 130 (1988), 107–15.

[111] Cambridge, Fitzwilliam Museum, Ms. 330, leaf 3. 'W. de Brail' me fecit'. London, B.L., Add. 49999, folio 43. 'W. de Brail' q. me depeint'. Respectively Morgan, *Early Gothic Manuscripts (1)*, cat. 72, ill. 238, and cat. 73.

[112] For Matthew Paris, see Ch. 5, pp. 107–12.

[113] The abundant Bolognese records have been calendared by F. Filippini, G. Zucchini, *Miniatori e Pittori a Bologna. Documenti dei secoli XIII e XIV* (Raccolta di Fonti per la storia d'arte, dir. M. Salmi, VI) (Florence, 1947). See also G. Orlandelli, *Il libro a Bologna dal 1300 al 1330. Documenti con uno studio su il contratto di scrittura nella dottrina notarile Bolognese* (Studi e ricerche di storia e scienze ausiliarie, I) (Bologna, 1959), which is concerned above all with the scribes, and F.P.W. Soetermeer, 'La terminologie de la librairie à Bologne aux XIIIe et XIVe siècles', *Actes du Colloque Terminologie de la vie intellectuelle au moyen âge. Leyde/La Haye 20–21 Septembre 1985*, ed. O. Weijers (Turnhout, 1988), pp. 88–95. Also F.P.W. Soetermeer, *De 'pecia' in juridische Handschriften* (Utrecht, 1990).

[114] Recently acquired by the Bibliothèque nationale, Paris, n. acq. lat. 3189. *Dix siècles*, no. 30, pl. F. Avril, M.-T. Gousset, C. Rabel, *Manuscrits enluminés d'origine italienne, 2. XIIIe siècle* (Paris, Bibliothèque nationale, 1984), no. 118 bis, pls E, LVII. The sale catalogue, Vente Andrieux, Paris, 20 March 1933, lot 59, transcribes Raulinus' notes.

[115] Fol. 347: 'Surge Rauline vade ad tabernam'. Meldina 'gemma feminarum'.

[116] Another thirteenth-century example with both French

and Italian illumination is a Bible, Oxford, Balliol College, Ms. 2. Alexander, Temple, nos 700 and 895, pls XLI and LXIII.

[117] Filippini, Zucchini, p. 162.

[118] Filippini, Zucchini, pp. 165 (Marchesino da Verona), 132 (Jacopo di Bombologno).

[119] Filippini, Zucchini, p. 129.

[120] See, for example, the Perugian matricole. J.J.G. Alexander, 'Italian Renaissance Illumination in British Collections', *Miniatura Italiana tra Gotico e Rinascimento* (Atti del II Congresso di Storia della Miniatura, Cortona, September, 1982), ed. E. Sesti (Florence, 1985), 107–10.

[121] Filippini, Zucchini, p. 4.

[122] See pp. 32 and Ch. 2, pp. 36, 38.

[123] R. Branner, 'The Manerius Signatures', *Art Bulletin*, 50 (1968), 183–4, drew attention to such marks, but mistakenly interpreted them as artists' identification signs. See especially P. Stirnemann, 'Nouvelles pratiques en matière d'enluminure au temps de Philippe Auguste', *La France de Phippe Auguste. Le temps des mutations* (Colloques internationaux du Centre Nationale de recherche scientifique, 1980, no. 602), ed. R.-H. Bautier (Paris, 1982), pp. 955–980. Also Avril, Stirnemann (as in n. 102) and P. Stirnemann, 'Réflexions sur des instructions non iconographiques dans les manuscrits gothiques', *Artistes*, 3, pp. 351–55, enjoining caution in the interpretation of these marks which had various functions in the process of illumination and were not always or solely for payment. See also p. 166, n. 62.

[124] Paris, B.n., latin 968. L. Delisle, *Le cabinet des manuscrits de la bibliothèque impériale (nationale)*, I (Paris, 1868), p. 491. P. Stirnemann, M.-T. Gousset, 'Marques, mots, pratiques: leur signification et leurs liens dans le travail des enlumineurs', *Vocabulaire du livre et de l'écriture au moyen âge. Actes de la table ronde Paris 24–25 septembre 1987*, ed. O. Weijers, (Turnhout, 1989), p. 37, fig. 3.

[125] This is certainly not an isolated example. See, for instance, the Dutch History Bible dated 1431, Brussels, B.R. 9018–9, volume 2, and B.R. 9020–23, volume 3. On a flyleaf of volume 2 is a note in Dutch: 'In this book there are ninety-nine miniatures of which forty-nine have been finished leaving fifty still to be done. There are also thirteen initials of which three have been completed...'. For the text of this and other notes in the Bible, see J.A.A.M. Biemans, *Middelnederlandse Bijbelhandschriften: Verzameling van middelnederlandse bijbelteksten; catalogus* (Leiden, 1984), p. 258. It is pointed out in *Dutch Manuscript Painting*, no. 39, that the totals are in fact mistaken as there are ninety-six miniatures and fourteen initials. For the Bible see also Ch. 2, n. 86.

[126] 'Pretium literarum que dicuntur champide VIIId pro pecia'.

[127] 'Pretium literarum sine figuris XVIIId'.

[128] 'Pretium literarum cum figuris 1 gross'.

[129] Folio 186v: 'Ego frater Sancius Gonterii habui pro illuminatura hujus libri a Johanne Reginaldi XVII florinos VII solidos'.

[130] Paris, B.n., latin 10483–4. K. Morand, *Jean Pucelle* (Oxford, 1962), p. 31 (Document IV).

[131] Paris, B.n., latin 11935. Morand, p. 31 (Document V). de Mély (as in n. 8). p. 60, fig. 64.

[132] Vatican, B.A.V., Rossiana 259, folio 1. A greeting to the patron in the upper margin reads: 'Frater et magister Gregorius, bona dies sit vobis'. Below, in the lower margin the signature reads: 'Jacobus Mathey me fecit anno D. mcccxlv° et Laurancius apprentici(us) suus'. F. Avril, 'Un enlumineur ornementiste parisien de la première moitié du XIVe siècle: Jacobus Mathey (Jaquet Maci?)', *Bulletin Monumental*, 129 (1971), 249–64. *id.*, 'Autour du Bréviaire de Poissy (Chantilly, Musée Condé, ms. 804)', *Le Musée Condé*, 7 (1974), 1–6.

[133] See F. Avril, 'Un chef-d'oeuvre de l'enluminure sous le règne de Jean le Bon: la Bible Moralisée manuscrit français 167

de la Bibliothèque nationale', *Monuments et Mémoires. Fondation Eugène Piot*, 58 (1973), 120–3.

[134] M. Michael, 'A Manuscript Wedding Gift from Philippa of Hainault to Edward III', *Burlington Magazine*, 127 (1985), 589 n. 31.

[135] Meiss, *French Painting*, 1, 30. P. Cockshaw, 'Mentions d'auteurs, de copistes, d'enlumineurs et de libraires dans les comptes généraux de l'Etat bourguignon (1384–1419)', *Scriptorium*, 23 (1969), 122–44. P. de Winter, as in n. 5; *id.*, 'Copistes, éditeurs et enlumineurs de la fin du XIVe siècle. La production à Paris de manuscrits à miniatures', *Actes du 100e Congrès national des Sociétés savantes (1975)* (Paris, 1978), 173–98; *id.* 'Manuscrits à peintures produits pour le mécénat Lillois sous les règnes de Jean sans Peur et de Philippe le Bon', *Actes du 101e Congrès national des Sociétés savantes (1976)* (Paris, 1978), 233–56.

[136] L.F. Sandler, 'A Note on the Illuminators of the Bohun Manuscripts', *Speculum*, 60 (1985), 364–72.

[137] London, B.L., Cotton Nero D.1, folio 156. Morgan, *Early Gothic Manuscripts (1)*, cat. 87b, ill. 297. A.G. Little, *Franciscan History and Legend in English Medieval Art* (Manchester, 1937), pp. 37–8. Little, pp. 38–9, records a payment by Elizabeth de Burgh in 1351 to the Friars in Cambridge for illumination.

[138] Bonn, Universitätsbibl., Cod. 384, folio 2v. Cologne, Erzbischöfliche Diözesanbibl., Hs. 1b, folio 1v. H. Knaus, 'Johann von Valkenburg und seine Nachfolger', *Archiv für Geschichte des Buchwesens*, 3 (1961), 57–76. J. Oliver, 'The Mosan Origins of Johannes von Valkenburg', *Wallraf-Richartz-Jahrbuch*, 40 (1978), 23–37. For the Cologne manuscript, see also the exhibition catalogue *Vor Stefan Lochner. Die Kölner Maler von 1300 bis 1430* (Wallraf-Richartz-Museum, Cologne, 1974), no. 69. Johannes wrote, noted and illuminated the two manuscripts.

[139] He went with Fr. Simon Simeonis. See the itinerary in Cambridge, Corpus Christi College, Ms. 407. M. Esposito, ed., *Itinerarium Symonis Simeonis ab Hybernia ad Terram Sanctam* (Scriptores Latini Hiberniae, 4) (Dublin, 1960).

[140] London, B.L., Harley 7026, folio 4v. The Sherborne Missal from Alnwick Castle and signed by Siferwas has been deposited by the Duke of Northumberland at the British Library. See Scott, *Later Gothic Illumination*, cat. 8. T. Tolley, *The Sherborne Missal*, Ph.D. (University of East Anglia, 1985).

[141] Milan, Ambrosiana, Ms. E.24 inf., folio 332. Pliny, Natural History dated 1389. Egbert, *Medieval Artist*, pl. XXX. *Miniature Lombarde. Codici miniati dall' VIII al XIV secolo* (introd. M.L. Gengaro, testo di L. Cogliati Arano, Milan, 1970), p. 415, fig. 277. The portrait occurs in Book 35 where Pliny speaks of painters and where they are quite often represented in later copies. See L. Armstrong, 'The Illustration of Pliny's *Historia Naturalis* in Venetian Manuscripts and Early Printed Books', *Manuscripts in the Fifty Years After the Invention of Printing* (Papers read at a colloquium at the Warburg Institute 12–13 March 1982), ed. J.B. Trapp (London, 1983), 97–106, fig. 49.

[142] 'Ego Jacobellus dictus muriolus de Salerno hunc librum scripsi, notavi et miniavi. Fuit primum opus manuum mearum'. J. Paul Getty Museum, Malibu, Ludwig VI.1. von Euw, Plotzek, *Ludwig*, 1, pp. 262–5, Abb. VI.1, Taf.170–73. Two other volumes of a set of Choir Books are in Stockholm, Nationalmuseum, B.1578. and Chicago, Art Institute, no. 2.142 B. For the former see C. Nordenfalk, *Bokmålningar från Medeltid och Renässans i Nationalmusei Samlingar* (Stockholm, 1979), no. 18, pl. IX. A fourth volume has been broken up. Two leaves are in the Museum of Fine Arts, Boston. Another appeared at Sotheby's, 22 June 1982, lot 12, 'S' with St Paul falling from horse (later Ellin Mitchell, New York).
Ludovicus de Gaçis of Cremona also states that he wrote, noted and illuminated, in 1489, a Gradual formerly in the Mark Lansburgh Collection, subsequently dismembered. See Sotheby's, 5 December 1978, lot 15. For a leaf in the Rosenwald Collection, Library of Congress, Washington, D.C.,

see *Medieval and Renaissance Miniatures from the National Gallery of Art*, C. Nordenfalk, G. Vikan *et al.* (Washington, 1975), no. 24.

[143] For the Guilds in general, see A. Black, *Guilds and Civil Society in European Political Thought from the Twelfth Century to the Present* (London, 1984).

[144] J. Guiffrey, 'La communauté des peintres et sculpteurs parisiens, dite Académie de Saint-Luc (1391–1776)', *Journal des Savants*, 13 (1915), 145–56.

[145] R. de Lespinasse, F. Bonnardot, *Les métiers et corporations de ville de Paris. XIIIe siècle, le livre des métiers d'Étienne Boileau* (Histoire générale de Paris. Les métiers et corporations de la ville de Paris) (Paris, 1879).

[146] 'Et plusieurs autres desdicts metiers'. Chauvet (as in n. 89), p. 8. In fifteenth-century Books of Hours St John is commonly represented writing on the Island of Patmos, while the Devil creeps up behind him to steal his ink pot and penner. I suspect this image has some connection with devotional panels commissioned for the Guild Chapels. See, for example, the painting by Memlinc discussed by J. van Gelder, 'Der Teufel stiehlt das Tintenfass', *Kunsthistorische Forschungen Otto Pächt zu ehren*, eds A. Rosenauer, G. Weber (Salzburg, 1972), 173–89.

[147] For Dijon and Avignon, see Pansier and Simonnet as in Ch. 3, n. 2. For the book trade in Rouen, see documents in E. de Beaurepaire, *Nouveaux mélanges historiques et archéologiques* (Rouen, 1904), pp. 360–66, and *id.*, *Derniers mélanges historiques…concernant le département de la Seine-Inférieure* (Rouen, 1909), pp. 226–36, quoted with a valuable overview by R. Watson, *The Playfair Hours. A Late Fifteenth-Century Illuminated Manuscript from Rouen (V. and A. L.475–1918)* (London, 1984), pp. 19–34. Other important centres were Lyons and Tours.

[148] R. Ciasca, *L'Arte dei medici e speziali nella storia e nel commercio Fiorentino dal secolo XII al XV* (Florence, 1927). J.E. Staley, *The Guilds of Florence* (London, 1906).

[149] Florence, Bibl. Riccardiana, Ms. 2526, folio 13v. Stratto delle Porte. Libro di Gabelle fiorentine. 'Dell'arte delli Ispeziali e Libri e Dicretali e di Ramanzi' is the rubric beside the miniature. S. Partsch, *Profane Buchmalerei der bürgerlichen Gesellschaft im spätmittelalterlichen Florenz* (Worms, 1981), 98–100, Kat. nr. 32 with literature, Abb. 182.

[150] Ciasca, pp. 88ff.

[151] Ciasca, pp. 695ff. The profession of many members of the Guild is not specified. For an informative discussion of members of the book trade in Florence with an emphasis on their perceived malpractices, see R.H. and M.A. Rouse, 'St Antoninus of Florence on manuscript production', *Litterae Medii Aevi. Festschrift für Johanne Autenrieth* eds M. Borgolte, H. Spilling (Sigmaringen, 1988), 255–63. The comments are in Antoninus' *Summa Theologica*, written from *c.* 1444, to shortly before his death in 1459. See also C. Gilbert, 'The Archbishop on the Painters of Florence', *Art Bulletin*, 41 (1959), 75–87. Certain very specific iconographical representations, for example of the Trinity with three heads, or of the Child descending from Heaven in Annunciation scenes, are condemned.

[152] A. Briganti, *Le Corporazioni delle Arti nel Comune di Perugia (sec. XII–XIV)* (Perugia, 1910). D. Gordon, *Art in Umbria c. 1250–1350*, Ph.D. (University of London, 1979), especially Ch. 6.

[153] W.H.J. Weale, 'Documents inédits sur les enlumineurs de Bruges', *Le Beffroi*, 2 (1864–5), 298–319; *ibid.*, 4 (1872), 111–19, 238–337. A. Vandewalle, 'Het librariërsgild te Brugge in zijn vroege periode', *Vlaamse Kunst op Perkament* (Gruuthusemuseum, Bruges, 1981), pp. 39–43.

[154] Weale, 1872, pp. 238–44. The importance of this document was stressed by L.M.J. Delaissé, *A Century of Dutch Manuscript Illumination* (Berkeley, 1968), pp. 70–71. See also pp. 125–6.

[155] Weale, 1872, pp. 244–5.

[156] Weale, 1872, pp. 246–51.

[157] Weale, 1872, pp. 251–3.

[158] J.D. Farquhar, *Creation and Imitation. The Work of a Fifteenth-Century Manuscript Illuminator* (Fort Lauderdale, 1976), reviews the evidence. Though he enjoins caution concerning the identification, it has continued to be generally accepted.

[159] Weale, *Le Beffroi*, 2 (1864–5), 306–19. A discussion of the documentary evidence concerning painters and their Guilds in the Netherlands is L. Campbell, 'The Early Netherlandish Painters and Their Workshops', *Le Dessin sous-jacent dans la peinture. Colloque III, 6–8 septembre 1979. Le problème Mâitre de Flémalle-van der Weyden*, eds D. Hollanders-Favart, R. van Schoute (Louvain, 1981), pp. 43–61. For Gerard David, admitted to the Painters' Guild in Bruges in 1484 and also active as a miniaturist, see D.G. Scillia, *Gerard David and Manuscript Illumination in the Low Countries, 1480–1509*, Case Western Reserve University, Ph.D. (1975). H.J. van Migroet, *Gerard David* (Antwerp, 1989). The Guild of the Book Trade in Bruges was amalgamated with the Painters' Guild in 1501, van Migroet, p. 124. For illuminators' marks registered with the Painters' Guild, see p. 126. Further on relations between panel painters and illuminators in the Netherlands, see A.H. van Buren, 'Thoughts, Old and New, on the Sources of Early Netherlandish Painting', *Simiolus*, 16 (1986), 93–112, especially 102–3.

[160] G. Pollard, 'The Company of Stationers before 1557', *The Library*, 4th series, 18 (1937), 1–38. C.P. Christianson, 'A Century of the Manuscript-book Trade in Late Medieval London', *Medievalia et Humanistica*, ns 12 (1984), 143–65. *Id.*, 'Early London Bookbinders and Parchmeners', *The Book Collector*, 34 (1985), 41–54. *Id.*, *Memorials of the Book Trade in Medieval London: The Archives of Old London Bridge* (Woodbridge, 1987). *Id.*, 'Evidence for the Study of London's Late Medieval Manuscript Book Trade', *Book Production and Publishing in Britain 1375–1475*, eds J. Griffiths, D. Pearsall (Cambridge, 1989), pp. 87–108. C.P. Christianson, *A Directory of the London Stationers and Book Artisans 1300–1500* (New York, 1990).

[161] T.F. Simmons, ed., 'The Layfolks' Mass Book', *Early English Text Society*, 71 (1879), 400–401.

[162] J. Moran, 'Stationers' Companies of the British Isles', *Gutenberg-Jahrbuch* (1962), 533–40, espec. p. 534.

[163] Chauvet (as in n. 89), p. 4, gives a figure of six-thousand illuminators, copyists and writers in Paris, *c.* 1470, for which he does not cite evidence, however, and which seems scarcely credible.

[164] A. de Schryver, 'Prix de l'enluminure et codicologie. Le point comme unité de calcul de l'enlumineur dans "Le Songe du viel pellerin" et "Les faictz et gestes d'Alexandre" (Paris, B.n., fr. 9200–9201 et fr. 22547)', *Miscellanea Codicologica F. Masai dicata MCMLXXIX*, eds P. Cockshaw, M.-C. Garrand, P. Jodogne, 2 (Ghent, 1979), pp. 469–79. He shows that the price of initials was calculated by 'points', that is their height in terms of numbers of lines of script, one, two, etc.

[165] S. Hindman, 'The Case of Simon Marmion: Attributions and Documents', *Zeitschrift für Kunstgeschichte*, 40 (1977), 185–204, espec. pp. 198, 202.

[166] van Buren 'Jean Wauquelin' (as in Ch. 6, n. 102), p. 62.

[167] London, B.L., Cotton Nero D.VII, folio 108. Sandler, *Gothic Manuscripts*, cat. 158, ill. 419.

[168] Paris, B.n., latin 4915, folio 1. E. König, *Französische Buchmalerei um 1450* (Berlin, 1982), pp. 213–20, Abb. 198. Though the object in his right hand is curved and therefore looks more like a pen than a brush, the pans of colour on the bench beside him, green, red, blue and purple, and the two flasks, perhaps for glair, surely indicate he is an illuminator. F. Avril pointed out the emblem on his sleeve to me.

[169] Stuttgart, Württembergische Landesbibl., Cod. mus. I fol. 65, Gradual for the Benedictine Abbey of Lorsch dated 1512. *Stuttgarter Zimelien*, catalogue by W. Irtenkauf (Stuttgart, Württembergische Landesbibliothek, 1985), no. 34, colour plate. D'Ancona, Aeschlimann, p. 31. Bertschi who died at Augsburg in 1541 also worked at St Gall.

[170] J. Backhouse, 'Illuminated Manuscripts and the Early Development of the Portrait Miniature', *Early Tudor England* (Proceedings of the 1987 Harlaxton Symposium), ed. D.T. Williams (Woodbridge, 1989), 1–17. The well-known self-portrait roundel by Jean Fouquet was apparently inserted in the frame of the Melun Diptych. *Jean Fouquet (Les dossiers du département des peintures)*, cat. by N. Reynaud (Paris, 1981), no. 6.

[171] The portraits are in the Victoria and Albert Museum, London, P159–1910 (4677) and the Robert Lehman Collection, M. 191, Metropolitan Museum of Art, New York. For the former, see W.H.J. Weale, 'Simon Binnink Miniaturist', *Burlington Magazine*, 8 (1905–6), 355–6, fig. and D'Ancona, Aeschlimann, pl. x. For the latter, see de Hamel (as in n. 106), fig. 164, and the catalogue forthcoming by Professor Sandra Hindman. The inscription reads: 'Simo' Binnick Alexandri f. seipsum pi'gebat an'o aetatis 75. 1558'. Benning shows himself still in the tradition of portraits of St Luke as if working on a drawing of the Virgin and Child.

[172] Malibu, J. Paul Getty Museum, Ludwig IX.19. Hours of Albrecht of Brandenburg. Von Euw, Plotzek, *Ludwig*, 2, pp. 286–313. London, B.L., Add. 12531. Genealogical roll of House of Portugal. *Renaissance Painting in Manuscripts*, no. 9.

[173] Genoa, Biblioteca Civica Berio, Cf. 3.2. *Mostra storica*, no. 544, Tav. LXXXIII b. P. Torriti, *Le miniature degli antiphonari di Finalpia* (Genoa, 1953).

CHAPTER 2

[1] See L.E. Boyle, *Medieval Latin Palaeography. A Bibliographical Introduction* (Toronto, 1984), pp. 234–45 for bibliography. For the earlier Middle Ages, see J. Vezin, 'La réalisation matérielle des manuscrits latins pendant le haut Moyen Age', *Codicologica, 2. Eléments pour une codicologie comparée*, ed. A. Gruys (Leiden, 1978), pp. 15–51.

[2] Weitzmann, as in Ch. 1, n. 9.

[3] K. Weitzmann, 'Book Illustration in the Fourth Century: Tradition and Innovation', *Studies in Classical and Byzantine Illumination*, ed. H.L. Kessler (Chicago, London, 1971), pp. 96–125. A. Blanchard, *Les débuts du codex. Actes de la journée d'étude organisée à Paris les 3 et 4 Juillet 1985* (Paris, 1989).

[4] C.H. Roberts, T.C. Skeat, *The Birth of the Codex* (London, British Academy, 1983). E.G. Turner, *The Typology of the Early Codex* (Philadelphia, 1977).

[5] R.H. and M.A. Rouse, 'Wax Tablets', *Language and Communication*, 9 (1989), 175–91. R.H. and M.A. Rouse, 'The Vocabulary of Wax Tablets', *Vocabulaire du livre et de l'écriture au moyen âge* (Actes de la table ronde Paris 24–26 septembre 1987), ed. O. Weijers (Turnhout, 1989), pp. 220–30.

[6] Adomnán, *De locis sanctis*, ed. D. Meehan (Dublin, 1958), pp. 46–7. 'has ... figuras ... juxta exemplar quod mihi ... sanctus Arculfus in paginola figuravit cerata depinximus ...'.

[7] *Giraldi Cambrensis Opera 5. Topographia Hibernica* (Rolls Series, 21), ed. J.F. Dimock (London, 1867), pp. 123–4. The angel showed the scribe 'Figuram quandam tabulae quam manu praeferebat impressam'. And later 'Eandem figuram aliasque multas'. For an English translation, see J.J. O'Meara, *Giraldus Cambrensis. The History and Topography of Ireland* (Portlaoise, 1982), p. 84.

[8] H. Saxl, 'Histology of Parchment', *Technical Studies*, 8 (1939–40), 3–9. R. Reed, *Ancient Skins, Parchments and Leathers* (London, New York, 1972). M. Gullick, 'From Parchmenter to Scribe: Some Observations on the Manufacture and Preparation of Medieval Parchment Based Upon the Literary Evidence', *Pergament: Geschichte, Struktur, Restaurierung, Herstellung heute*, ed. P. Rück (*Marburger Kolloquium für Historische Hilfswissenschaften*, 2) (Sigmaringen, 1991), pp. 145–57.

[9] See pp. 125, 174n. 27. Two of the earliest known Western manuscripts written on paper are datable to the eleventh century, and come from Spain. *Le Livre*, p. 28 and no. 96, Paris, B.n., n. acq. lat. 1297, Glossary from S. Domingo, Silos. Paper

was made at Fabriano, which continued to be one of the main centres in Italy, by 1276 and in Troyes by 1348.

[10] Cambridge, Corpus Christi College, Ms. 2. Kauffmann, *Romanesque Manuscripts*, cat. 56. It is not clear if the parchment he sent for was for the main text or for the miniatures. Perhaps it was the latter, which is why it was remarked on.

[11] León, Colegiata San Isidoro, Cod. I.3. *Bénédictins de Bouveret*, 4, p. 197 (no. 13645). 'Pergamena ex gallicis partibus itineris labore nimio ac maris asperrimo navigio... quodque maxime mireris in sex mensium spatio scriptus septimoque colorum pulchritudine iste fuit liber compositus'. T. Ayuso Marazuela, 'Un scriptorium español desconocido', *Scriptorium*, 2 (1948), 9. Cahn, *Romanesque Bible*, p. 290.

[12] Rome, San Paolo fuori le Mure. Schramm, Mütherich, *Denkmale*, no. 56. New York, Morgan, M. 791. Dublin, Trinity College Library, Ms. 177. Morgan, *Early Gothic Manuscripts (1)*, cats 32, 85. Other manuscripts with miniatures or initials on stuck-in parchment are: Paris, B.n., latin 15176, 'Odilo' Bible, eleventh century, miniatures of Evangelists stuck over initials in late twelfth century. Cahn, *Romanesque Bible*, pp. 242, 278. Valenciennes, Bib. mun., Ms. 500. Life of S. Amand, c. 1170–85. N. Garborini, *Der Miniator Sawalo* (Cologne, 1978), pp. 223–4. Oxford, Magdalen College, lat. 100. Psalter. English. c. 1220–30. Morgan, *Early Gothic Manuscripts (1)*, cat. 49. Oxford, New College, Ms. 322. Psalter by William de Brailes. c. 1240–50. Morgan, *Early Gothic Manuscripts (1)*, cat. 74. Cambridge, Corpus Christi College, Ms. 16. Matthew Paris, Chronica Majora. Mid thirteenth century. Miniature of Facies Christi stuck in on folio 53v. Morgan, *Early Gothic Manuscripts (1)*, cat. 88. New York, Public Library, Spencer Ms. 26. Tickhill Psalter. English. c. 1303–14 (?). D.D. Egbert, *The Tickhill Psalter and Related Manuscripts* (New York, 1940), p. 15. Paris, B.n., latin 8504, Calilah et Dimnah, early fourteenth century, for which see Ch. 3, n. 48. New York, Morgan, M. 90, Hours, Use of Verdun, c. 1375. London, B.L., Royal 2 A. XVIII. Book of Hours. Early fifteenth century. Miniatures by the Master of the Beaufort Saints stuck in. Scott, *Later Gothic Manuscripts*, cat. 37. Cambridge, Fitzwilliam Museum Ms. 3–1954 with Brussels, B.R., 11035–7. Hours of Philip the Bold of Burgundy. Late fourteenth century. This was revamped for his grandson, Philip the Good, in the mid fifteenth century with a number of stuck-in miniatures by Dreux Jean and others. F. Wormald, P.M. Giles *A Descriptive Catalogue of the Additional Illuminated Manuscripts in the Fitzwilliam Museum*, 2 (Cambridge, 1982), pp. 479–499. It is presently the object of study by Dr Anne van Buren who also drew my attention to the same practice in the Alexander, Paris, B.n. fr. 9342, for which Jean Wauquelin was paid by Philip the Good in 1448. See van Buren, 1983 (as in Ch. 6, n. 102). Paris, B.n., latin 10532, Hours of Frederick III of Aragon. Miniatures by Bourdichon have been stuck on separate pieces of parchment within frames already painted (perhaps by an Italian artist). For this manuscript, see Ch. 6, p. 149, fig. 246. Michael Gullick comments to me on the great difficulty of controlling parchment when it is damp, and consequently on the technical skill needed to insert such pieces of parchment. Similarly they may have lifted when manuscripts were exposed to damp and their loss may be due to this rather than vandalism.

[13] London, B.L., Add. 39943, folio 9. Morgan, *Early Gothic Manuscripts (1)*, cat. 12a.

[14] See further on parchment W. Wattenbach, *Die Schriftwesen in Mittelalter* (Leipzig, 1896), pp. 113–39 ('Pergament').

[15] E.g., the Gospel Book, Durham, Dean and Chapter Library, A.II.17, folios 9, 74, 80, 80*, seventh-eighth century. Alexander, *Insular Manuscripts*, cat. 10. C.D. Verey, T.J. Brown, E. Coatsworth, *The Durham Gospels* (Early English Manuscripts in Facsimile, 20) (Copenhagen, 1980), p. 40. For Insular parchment, see T.J. Brown, 'The Distribution and Significance of Membrane Prepared in the Insular Manner', *La paléographie hébraïque médiévale* (Colloques internationaux du Centre national

de la recherche scientifique 547) (Paris, 1974), pp. 127–35. A spectacular later example of repair to holes with silk threads is the Berthold Missal from Weingarten, c. 1200–32, New York, Morgan, M. 710.

[16] For the Bruges ordinance forbidding the importation of single leaves, see Ch. 1, note 154 and Ch. 6, pp. 125–6.

[17] This may also have been done earlier for the same reason. Michael Gullick draws my attention to the singleton frontispiece of Oxford, Bodl., Ms. Laud Misc. 409, Hugh of St Victor, late twelfth century. Pächt, Alexander, 3, no. 255.

[18] Ch. 1, note 98.

[19] See p. 20 for the Hamburg Bible. For Bologna, Bibl. Universitaria, Ms. 1465 see Jackson, *Story*, p. 94 in colour. For a detailed description of the manufacture of parchment 'after the Bolognese fashion' see D.V. Thompson, 'Medieval Parchment Making', *The Library*, 4th series 16 (1935), 113–17. Italian parchment is easily distinguished by its smooth surface from that used in the North.

[20] Ch. 1, note 98.

[21] T.F. Tout, *Chapters in the Administrative History of Mediaeval England*, vol. 6 (Manchester, 1933), see *index* s.v. 'Parchment'.

[22] N.R. Ker, 'Medieval Manuscripts from Norwich Cathedral Priory', *Transactions of the Cambridge Bibliographical Society*, 1 (1949–53), 23ff., reprinted *Books, Collectors and Libraries: Studies in the Medieval Heritage*, ed. A.G. Watson (London, 1985), pp. 243–72. M. Gullick, *Extracts from the Precentor's Accounts Concerning Books and Bookmaking of Ely Cathedral Priory* (Hitchin, 1985).

[23] K. Sutton, 'The Master of the "Modena Hours", Tomasino da Vimercate, and the Ambrosianae of Milan Cathedral', *Burlington Magazine*, 133 (1991), 87–90, with further references to costs of materials, script and illumination. For Florence in the fifteenth century, see A.C. de la Mare in A. Garzelli, *Miniatura fiorentina del Rinascimento 1440–1525. Un primo censimento* (Florence, 1985), pp. 408–10. G.S. Martini, 'La bottega di un cartolaio fiorentino della seconda meta del Quattrocento. Nuovi contributi biografici intorno al Gherardo e Monte di Giovanni', *La Bibliofilia*, 58 (1956), supplemento, 1–82. Prices also varied according to whether the parchment was already ruled or not.

[24] H.E. Bell, 'The Price of Books in Medieval England', *The Library*, 17 (1936–7), 312–32, concludes that the number of variables makes this very difficult to determine. See also p. 52.

[25] See Ch. 1, pp. 22, 26, 32.

[26] Certosa di Calci, Cod. Four volumes measuring 560 × 380 mm. The donations recorded total 16l. 12s. and the costs recorded total 32l. 1s. 8d. The parchment cost 8l. 2d. See K. Berg, *Studies in Tuscan Twelfth-Century Illumination* (Oslo, 1968), pp. 151–55, 224–27 for the problems of interpretation. See also Cahn, *Romanesque Bible*, pp. 224–6, 283, with some comparative prices of grain and building works, demonstrating the huge expense of the Bible.

[27] London, Westminster Abbey. *Age of Chivalry*, no. 714, the Missal, and no. 715, the account. J.A. Robinson, M.R. James, *The Manuscripts of Westminster Abbey* (Cambridge, 1909), pp. 7–8, print the accounts. N.R. Ker, *Medieval Manuscripts in British Libraries, 1. London* (Oxford, 1969), p. 410 n., suggests convincingly that the accounts printed from the Abbot's Treasurer's roll of 1383–4 and from the Infirmarer's Roll of 1386–7 are for the same Missal. Michael Gullick, however, points out to me that the parchment bought, sixteen quires of twelve folios, i.e. one hundred and ninety-two folios, is insufficient for the Missal which has three hundred and forty-one folios. The account is still incomplete, therefore.

[28] This can be compared with the total cost of £118 7s 0d for the two volumes of the Great Cowcher Book of the Duchy of Lancaster, still extant in the Public Record Office. From this total £74 was paid to the scribe, Richard Frampton, at 13s 4d a quire, over a period of six years. These totals, but not the complete accounts which are extant, are given by R. Somerville,

'The Cowcher Books of the Duchy of Lancaster', *English Historical Review*, 51 (1936), 598–600. There is only modest illumination, two historiated initials and borders, probably by Hermann Scheerre, for whom see Ch. 6, p. 124.

[29] The manuscript is now Paris, B.n., fr. 145. The payments are printed by A.P. Paris, *Les manuscrits françois de la bibliothèque du roi*, I (Paris, 1836), pp. 302–3. See also Y. Pinson, 'Les "Puys d'Amiens" 1518–1525. Problèmes d'attribution et d'évolution de la loi du genre', *Gazette des Beaux-Arts*, 6e sér. 109 (1987), 47–61.

[30] See the sections in *Ornamenta Ecclesiae*, 1, 'Fabrica' and in *Age of Chivalry*, section XII, 'Medieval Artists and Their Techniques'.

[31] Scribal tools are included in Vocabularies by Alexander Neckham (*d.* 1217) and John of Garland, *c.* 1220. For the former, see A. Scheler, *Lexicographie Latine du XIIe et XIIIe siècle* (Leipzig, 1867), pp. 112–15. For the John of Garland, Paris, B.n. latin 11282, folios 17v–18, see *Le Livre*, no. 81. For a later list, see K. Gould, 'Terms for Book Production in a Fifteenth-Century Latin-English Nominale (Harvard Law School Library Ms. 43)', *The Papers of the Bibliographical Society of America*, 79 (1985), 75–99. They are also mentioned in inventories and wills. See, for instance, the stock of a bookseller who had died in Paris in 1475. C. Couderc, 'Fragments relatifs a André le Mustier, libraire-juré de l'Université de Paris', *Bulletin de la société de l'histoire de Paris et de l'Ile de France*, 45 (1918), 90–107.

[32] *Il libro d'Arte. The Craftsman's Handbook. Cennino d'Andrea Cennini*, ed. D.V. Thompson, 2 vols (New Haven, 1932–3).

[33] H. Petroski, *The Pencil: A History of Design and Circumstance* (Boston, London, 1989). Cennini gives a recipe. See M. Gullick, *Working Alphabet of Initial Letters from Twelfth-Century Tuscany. A Facsimile of Cambridge, Fitzwilliam Museum Ms. 83.1972* (Hitchin, 1979), p. 6 n. 2 with further references. For modern terms in general, see D. Muzerelle, *Vocabulaire codicologique. Répertoire méthodique des termes français relatifs aux manuscrits* (edns CEMI, Paris, 1985). As useful as it is to be clear about modern descriptive terms, it would also be highly desirable to do the same listing methodically for medieval usage. A start is made for some aspects of manuscript production, though not for illumination, in *Vocabulaire du livre et de l'écriture au moyen âge* (Actes du table ronde Paris 24–26 septembre 1987), ed. O. Weijers (Turnhout, 1989).

[34] N.R. Ker, *English Manuscripts in the Century After the Norman Conquest* (Oxford, 1960), p. 41. B. Bischoff, 'Über Einritzungen in Handschriften des frühen Mittelalters', *Zentralblatt für Bibliothekwesen*, 54 (1937), 173–77, reprinted 'erweitert' in *Mittelalterliche Studien. Ausgewählte Aufsätze zur Schriftskunde und Literaturgeschichte*, I (Stuttgart, 1966), 88–92.

[35] C. Hahn (as in Ch. 4, n. 41), p. 82 n.10, notes a stylus was used for the drawings in the ninth-century Prudentius, Bern, Burgerbibliothek, Cod. 264. She also notes that in the Gospels, Paris, B.n., latin 323, early ninth century, from folios 14–19v the Canon Tables were drawn with a stylus which thus conveniently traces the outline on both rectos and versos. I do not know what is the earliest recorded drawing in graphite. For an Ottonian example, see p. 39, and n. 40.

[36] For a general discussion of medieval drawings, see R.W. Scheller, 'Towards a Typology of Medieval Drawings', *Drawings Defined*, eds W. Strauss, T. Felker (New York, 1987), pp. 13–33.

[37] For the Anglo-Saxon speciality of coloured ink drawings, see F. Wormald, *English Drawings of the Tenth and Eleventh Centuries* (London, 1952).

[38] Oxford, Wadham College, Ms. 2, folio 13. St Matthew. J.J.G. Alexander, *Anglo-Saxon Illumination in Oxford Libraries* (Oxford, 1970), pl. 32. The page was photographed by ultra-violet light to make the drawing show up.

[39] Oxford, St John's College, Ms. 111. Alexander, Temple, no. 90, pl. VI.

[40] Cologne, Historisches Archiv, Ms. W. 312, folios 139v and 140. R. Green, 'Marginal Drawings in an Ottonian Manuscript', *Gatherings in Honor of Dorothy E. Miner*, eds U. McCracken, L.M.C. Randall, R.H. Randall (Baltimore, 1974), pp. 129–38. For independent drawings in manuscripts, see also Ch. 4, pp. 85, 87, and especially B. Degenhart as in p. 168n. 52.

[41] London, B.L., Harley 2798, folio 4v. Cahn, *Romanesque Bible*, p. 253, cat. 8. For the Winchester Bible, see nn. 51, 67.

[42] Anglo-Saxon artists were particularly creative and experimental. See Wormald, as in n. 37 above. For an anthology of medieval drawings, many from manuscripts, see M.W. Evans, *Medieval Drawings* (London, 1969).

[43] For medieval and early Renaissance artists' pigments, see D.V. Thompson, *The Materials and Techniques of Medieval Painting* (London, 1936; repr. New York, 1956). For an overview of the treatises, see M. Gullick ed., *The Arte of Limming. A Reproduction of the 1573 Edition Newly Imprinted* (London, 1979). M. Gullick, *List of Mediaeval Painting Treatises* (1979; additions 1983), an unpublished manuscript bibliography with extremely useful short summaries and comments, is kept in the Palaeography Reading Room, London University Library. See also F. Avril, *La technique de l'enluminure d'après les textes médiévaux. Essai de bibliographie* (Réunion du Comité de l'Icom pour les laboratoires de Musées et du Souscomité d'Icom pour le traitement des peintures), 1967 (typescript), including pp. 14–28 'Liste de manuscrits contenant des renseignements sur la technique de l'enluminure'. Also for technical treatises, in general, in the early Middle Ages, B. Bischoff, 'Die Überlieferung der technischen Literatur', *Artigianato e tecnica nella società dell' alto medioevo occidentale* (Settimane di Studio del Centro Italiano di Studi sull' alto medioevo, XVIII) (Spoleto, 1971), pp. 267–96, reprinted in *Mittelalterliche Studien* (as in n. 34 above), III (Stuttgart, 1981), pp. 277–97.

A number of the treatises were published already by M.P. Merrifield, *Original Treatises Dating from the XIIth to the XVIIIth Centuries on the Arts of Painting* (London, 1849; reprinted New York, 2 vols, 1967). For more modern editions of particular treatises: C.S. Smith, J.G. Hawthorne, 'Mappae clavicula: A Little Key to the World of Medieval Techniques', *Transactions of the American Philosophical Society*, n.s. 64 part 4 (1974), 1–128. D.V. Thompson, ed. and transl., 'The De Clarea of the so-called Anonymus Bernensis', *Technical Studies in the Field of the Fine Arts*, 1 (1932), 8–19, 70–81. R.E. Straub, 'Der Traktat "De clarea" in der Burgerbibliothek Bern. Eine Anleitung für Buchmalerei aus dem Hochmittelalter', *Schweizerisches Institut für Kunstwissenschaft. Jahresbericht, 1964* (Zürich, 1965), pp. 89–114. H. Silvestre, 'Le Ms. Bruxellensis 10147–58 (s. XII-XIII) et son compendium artis picturae', *Bulletin de la Commission Royale d'Histoire*, 119 (1954), 95–140. D.V. Thompson, 'Liber Magistri Petri de Sancto Audemaro De coloribus faciendis', *Technical Studies in the Field of the Fine Arts*, 4 (1935–6), 28–33. L. van Acker ed., *Petri Pictoris carmina necnon Petri de Sancto Audemaro Librum de coloribus faciendis* (Corpus Christianorum continuatio mediaevalis, XXV) (Turnhout, 1972). D.V. Thompson, ed. and transl., 'Liber de coloribus illuminatorum sive pictorum from Sloane Ms. no. 1754', *Speculum*, 1 (1926), 280–307, 448–50. D.V. Thompson, 'More Medieval Color Making. *Tractatus de coloribus* from Munich Staatsbibliothek Ms. Lat. 444', *Isis*, 24 (1937), 382–96. D.V. Thompson, '*De coloribus naturalia exscripta et collecta* from Erfurt, Stadtbücherei, Ms. Amplonianus Quarto 189 (XIII–XIV century)', *Technical Studies in the Field of the Fine Arts*, 3 (1934–5), 133–45. D.V. Thompson, G.H. Hamilton, ed. and transl., *An Anonymous Fourteenth-century Treatise De Arte Illuminandi. The Technique of Manuscript Illumination Translated From the Latin of Naples Ms. XII. E.27* (New Haven, 1933). F. Brunello, ed. and transl., '*De arte illuminandi*' e altri trattati sulla tecnica della miniatura medievale (Venice, 1975). D. Bommarito, 'Il ms. 25 della Newberry Library: la tradizione dei ricettari e trattati sui colori nel Medioevo e Rinascimento veneto e toscano', *La Bibliofilia*, 87 (1985), 1–38. *The Strassburg Manuscript*, transl. V. and R. Borrodaile (London, 1966). For the treatises by Theophilus and by Cennini, see n. 32 and Ch. 4, n. 78.

[44] Michael Gullick, as a practising calligrapher, has remarked that in many works too much is left unsaid to be of practical as opposed to general or literary interest, but that the two compilations, the *Compendium artis picturae* of the late twelfth century and the *De clarea* of shortly before 1100, ring so true that the work of other compilers seems like hearsay in comparison. See Jackson, *Story*, p. 81.

[45] For the latter technique, see H. Roosen-Runge, A.E.A. Werner, 'The Pictorial Technique of the Lindisfarne Gospels', *Codex Lindisfarnensis* (as in Ch. 1, n. 29), II, pp. 261–277. H. Roosen-Runge, *Farbgebung und Technik frühmittelalterlicher Buchmalerei*, 2 vols (Berlin, 1967). H. Roosen-Runge, 'Zum Erhaltungszustand der Farben im Evangelistar Heinrichs III. der Universitätsbibliothek Bremen, Ms. 21b', *Von Farbe und Farben. Albert Knœpfli zum 70 Geburtstag*, ed. M. Hering-Mitgau (Zurich, 1980), pp. 13–20. H. Roosen-Runge, 'Neue Wege zur Erforschung von illuminierten Handschriften und Drucken der Gutenberg-Zeit', *Gutenberg-Jahrbuch* (1983), 89–104. A. Cains, 'The Pigment and Organic Colours', *The Book of Kells Ms. 58 Trinity College Library, Dublin. Commentary* ed. P. Fox (Luzern, 1990), pp. 211–31. V. Trost, 'Tinte und Farben. Zum Erhaltungszustand der Manesseschen Liederhandschrift' *Codex Manesse. Die grosse Heidelberger Liederhandschrift. Texte. Bilder. Sachen*, eds E. Mittler, W. Werner (Heidelberg, 1988), pp. 440–445.

For the technique of analysis of micro-samples in Armenian manuscripts, see D.E. Cabelli, M.V. Orna, T.F. Mathews, 'Analysis of Medieval Pigments from Cilician Armenia', *Archaeological Chemistry*, 3 (1984), 243–54. M.V. Orna, T.F. Mathews, 'Uncovering the Secrets of Medieval Artists', *Analytical Chemistry*, 60 (1988), 47A–50A. Also B. Guineau, 'Microanalysis of Painted Manuscripts and of Coloured Archaeological Materials by Raman Lasar Microprobe', *Journal of Forensic Sciences*, 29 (1984), 471–85 and 'Analyse non-destructive des pigments par microsand Raman laser: exemples de l'azurite et de la malachite', *Studies in Conservation*, 29 (1984), 35–41 (analysis of a fragment of border from a fifteenth-century Hours). Also Guineau *et al.* (as in n. 47). The examination of illuminations by infra-red reflectography, so successful for certain panel-paintings, has not yet, so far as I know, been widely tried. The technique, of course, only works for underdrawing with a carbon component. My own limited experience of the technique has not so far yielded results.

[46] B. Guérard, *Polyptyche de l'abbé Irminon . . . ou denombrement des manses, des serfs et des revenus de l'abbé de Saint-Germain des Près sous la règne de Charlemagne* (Paris, 2, 1844), p. 336, prints a list of spices, drugs and pigments to be bought at Cambrai for Corbie Abbey, including ten pounds of minium and three pounds each of orpiment, dragonsblood and indigo. I owe the reference to Michael Gullick. L.J.V. Dunlop, *The Use of Colour in Parisian Manuscript Illumination c. 1320–c. 1420 with Special Reference to the Availability of Pigments and Their Commerce at That Period*, unpublished Ph.D. (University of Manchester, 1988), studies the problem of availability and price of pigments for a specific area and time in the later Middle Ages. The fourteenth-century manual of the Florentine merchant, Francesco Pegolotti, is a prime source. See A. Evans, *Francesco Balducci Pegolotti. La pratica della mercatura* (Cambridge, Mass., 1936).

[47] For types of blue, see M.V. Orna, M.J.D. Low, N.S. Baer, 'Synthetic Blue Pigments: Ninth to Sixteenth Centuries.1. Literature', *Studies in Conservation*, 25 (1980), 53–63. B. Guineau, C. Coupry, M.T. Gousset, J.P. Forgerit, J. Vezin, 'Identification de bleu de lapis-lazuli dans six manuscrits à peintures du XIIe siècle provenant de l'abbaye be Corbie', *Scriptorium*, 40 (1986), 157–71. B. Guineau, J. Vezin, 'Nouvelles méthodes d'analyse des pigments et des colorants employés pour la décoration des livres manuscrits; l'exemple des pigments bleus utilisés entre le IXe siècle et la fin du XIIe siècle, notamment à Corbie', *Actas del VIII Coloquio del Comité internacional de paleografía latina*, ed. M.C. Díaz y Díaz (Madrid,

1990), pp. 83–94. For the use of metals, see S.M. Alexander, *Treatises Concerning the Use of Gold, Silver and Tin in Medieval Manuscripts*, unpublished M.A. thesis (Institute of Fine Arts, New York University, 1963). Also S.M. Alexander, 'Medieval Recipes Describing the Use of Metals in Manuscripts', *Marsyas*, 12 (1964–5), 34–51.

[48] For a useful 'Table of Pigment Prices', see *Art in the Making. Italian Painting Before 1400* (National Gallery of Art, London, 1990), Appx. IV, pp. 201–4.

[49] London, B.L., Royal 6.E. VI, f. 329. Sandler, *Gothic Manuscripts*, cat. 124. The colour terms in the text are: albedo, glaucus, pallidus, rubeus, croceus, minius (sic), viridis, lividus, umetus. The source used by James le Palmer, the compiler, is Bartholomaeus Anglicus, Liber de proprietatibus rerum. I am grateful to Professor Sandler who is engaged on a full study of this manuscript, for this information. See also her '*Omne bonum*: *compilatio* and *ordinatio* in an English Illustrated Encyclopedia of the Fourteenth Century', *Medieval Book Production. Assessing the Evidence*, ed. L.L. Brownrigg (Los Altos Hills, 1990), 183–200. The twelfth-century illuminator Felix and the fifteenth-century anonymous French illuminator (figs 17, 49), also have colour pans, probably oyster shells, beside them, see Ch. 1, pp. 12, 32, and such pans are also sometimes represented with scribes. An example is Avranches, Bib. mun., Ms. 159, Robert de Torigni, Chronicle, mid twelfth century, where eight such pans, in addition to an ink horn on the lectern, stand on three shelves behind the scribe and abbot shown in an initial 'D', folio 70. *Ornamenta Ecclesiae*, 1, B35.

[50] For example, in the sixth-century Genesis, Vienna, O.N.B., Cod. Th. gr. 31, the Greek text may have been written after the miniatures were painted. E. Wellesz, *The Vienna Genesis* (London, 1960), p. 6.

[51] W. Oakeshott, *Two Winchester Bibles*, as in Ch. 5, n. 2.

[52] Palaeographers and codicologists have been very much concerned with methods of ruling and with ruling patterns. See, for example, L. Gilissen, 'Un élément codicologique trop peu exploité: la réglure', *Scriptorium*, 23 (1969), 150–62. L. Gilissen, *Prolégomènes à la codicologie. Recherches sur la construction des cahiers et la mise en page des manuscrits médiévaux* (Ghent, 1977). A. Derolez, *Codicologie des manuscrits en écriture humanistique sur parchemin*, 2 vols (Turnhout, 1984). Gumbert (as in Ch. 1, n. 86), pp. 27–8. But the ways in which this affected the planning, the placing and the designs of miniatures, has been less studied. See now H. Toubert, 'Illustration et mise en page', *Mise en page et mise en texte du livre manuscrit*, eds H.-J. Martin, J. Vezin (Paris, 1990), pp. 355–420. It seems that usually no allowance was made for miniatures, which were executed over the pre-existing ruling, for instance, but this also merits further study. It may have been another advantage to the use of inserted single leaves, for which see pp. 35–6. Aspects of page layout and illumination in English fourteenth- and fifteenth-century manuscripts are discussed in the Introductions to Sandler, *Gothic Manuscripts* and Scott, *Later Gothic Manuscripts*.

[53] D. Byrne, 'Manuscript Ruling and Pictorial Design in the Work of the Limbourgs, the Bedford Master, and the Boucicaut Master', *Art Bulletin*, 66 (1984), 118–36.

[54] Vienna, O.N.B., Cod. 2828, folio 2. F. Unterkircher, *Inventar der illuminierten Handschriften, Inkunabeln und Frühdrucke der Oesterreichischen Nationalbibliothek*, 1 (Vienna, 1957), p. 86.

[55] Oxford, Bodl., Ms. Douce 180. A colour facsimile is *Apokalypse (Bodleian Library, Oxford, Ms. Douce 180)* (Codices Selecti, LXII) (Graz, 1981). A selection of pages in colour were reproduced by A.G. and W.O. Hassall, *The Douce Apocalypse* (London, 1961). See also p. 107.

[56] London, B.L., Cotton Claudius B.IV. Temple, *Anglo-Saxon Manuscripts*, cat. 86. C.R. Dodwell, 'Techniques of Manuscript Painting in Anglo-Saxon Manuscripts', *Settimane di studio del Centro italiano di studi sull'alto mediœvo, 18 (1970)* (Spoleto, 1971), 643–662, 675–83.

[57] For English examples, see A. Petzold, 'Colour Notes in

English Romanesque Manuscripts', *British Library Journal*, 16 (1990), 16–25. For French examples, see P. Stirnemann, 'Nouvelles pratiques en matière d'enluminure au temps de Philippe Auguste', *La France de Philippe Auguste. Le temps des mutations* (Actes du colloque international organisé par le C.N.R.S. 1980), ed. R.-H. Bautier (Paris, 1982), 955–80. A tenth-century Spanish example is Madrid, Real Academia de la Historia, Ms. 8, see *ibid.*, p. 980, 'compte rendu de la discussion'. See also M.-T. Gousset, P. Stirnemann, 'Indications de couleur dans les manuscrits médiévaux', *Pigments et colorants de l'Antiquité et du Moyen Age* (Colloque international du C.N.R.S., Orléans, 1988) (Paris, 1990), pp. 189–98. Most of the examples included there belong to the twelfth and thirteenth centuries, but P. Stirnemann, M.-T. Gousset, 'Marques, mots, pratiques: leur signification et leurs liens dans le travail des enlumineurs', *Vocabulaire du livre et de l'écriture au moyen âge*, ed. O. Weijers (Turnhout, 1989), 42–50, add examples of the fourteenth century. London, B.L., Royal 19 D. II, Bible of Jean le Bon, mid fourteenth century, for example, has colour letters, written instructions for the illuminators and also numbers for the miniatures (for which see Ch. 3, n. 41). The Grandes Chroniques de France, Paris, B.n., fr. 2813, made for Charles V before 1380, has colour notes for the backgrounds of the miniatures. See Hedeman (as in Chapter 6, n. 92), pp. 109 n. 59, 110–15.

[58] Cologne, Dombibliothek, Cod. 82 II. B. Bischoff in *Mittelalterliche Studien*, I, (Stuttgart, 1966) (as in n. 34), p. 88 n.1. The notes in red chalk as recorded by Bischoff are 'vir' (viridis, green), 'ocra', 'nicri' (black) and 'brunus'. Bischoff, 'Die Uberlieferung' (as in n. 43), pp. 290–93, Abb. 6–8, has also read colour notes on the drawings of mid eleventh-century date on fly-leaves of Paris, B.n., latin 8318 and Vatican, B.A.V., Reg. lat. 596, 'laz' and 've' (vermiculum). For these drawings, see also p. 85.

[59] Aberdeen, University Library, Ms. 24. Morgan, *Early Gothic Manuscripts (1)*, cat. 17. See also Ch. 5, p. 105.

[60] Durham, Dean and Chapter Library, Ms. A.II.1. vol. 4, folio 133. Kauffmann, *Romanesque Manuscripts*, cat. 98. Mynors, *Durham* (as in Ch. 1, n. 59), p. 85, records the note.

[61] Malibu, J. Paul Getty Museum, Ludwig Ms. XV. 4, folios 67–102v. von Euw, Plotzek, *Ludwig*, 4, p. 186. A. Stones, 'Indications écrites et modèles picturaux, guides aux peintres des manuscrits enluminés aux environs de 1300', *Artistes*, 3, pp. 321–50, especially pp. 329–30, fig. 15.

[62] Paris, Bibliothèque Ste Geneviève, Ms. 1624, folio 1. Measures 275 × 188 mm. It is bound in with a thirteenth-century manuscript of Johannes Faventinus, Summa super decretum Gratiani. The manuscript was in Normandy in the later Middle Ages. See L.-M. Michon, 'Un dessin inédit du XIV siècle', *Mélanges en homage à la mémoire de Fr. Martroye* (Paris, 1940), pp. 319–23. I owe the reference to Michael Gullick.

[63] L. Gilissen, 'Un élément codicologique méconnu: l'indication des couleurs des lettrines joint aux "lettres d'attent"', *Paläographie 1981* (Münchener Beiträge zur Mediävistik und Renaissance-Forschung, 32), ed. G. Silagi (Munich, 1982), pp. 185–91. Other examples are noted by P. Stirnemann, 'Quelques bibliothèques princières et la production hors scriptorium au XIIe siècle', *Bulletin archéologique du comité des travaux historiques et scientifiques*, ns. 17–18 (1984), p. 30.

[64] Alexander, *Scribes as Artists*, p. 106. J.M. Canivez, *Statuta capitulorum ordinis Cisterciensis*, I (Louvain, 1933): 1131, Stat. LXXX, De literis et vitreis. 'Litterae unius coloris fiant et non depictae'. See also Ch. 5, p. 99.

[65] Munich, Bayer. Staatsbibl., Clm 10261. Arms of Cardinal Domenico della Rovere, d. 1501. The manuscript was among those exhibited at the library during a palaeographical conference organised by Professor J. Autenrieth at the Historisches Kolleg in Munich in April, 1986, and the dots were noticed by Professor J.P. Gumbert.

[66] Cennini, Ch. 27 (as in note 32).

[67] As W. Oakeshott showed in a famous demonstration where he had them photographed lit from behind. *The Artists of the Winchester Bible* (London, 1945), pl. 41. See also Ch. 5, p. 95.

[68] Chantilly, Musée Condé. See Ch. 6, pp. 139–43.

[69] Paris, B.n., latin 8846, the third English copy of the Utrecht Psalter, was left incomplete in the late twelfth century and miniatures were added in Catalonia in the fourteenth century. For the English illumination see Morgan, *Early Gothic manuscripts (1)*, cat. 1. For the Catalan illumination, see M. Meiss, 'Italian Style in Catalonia and a Fourteenth-century Catalan Workshop', *Journal of the Walters Art Gallery*, 4 (1941), 73–7, and F. Avril *et al.*, *Manuscrits enluminés d'origine ibérique* (Paris, Bibliothèque nationale, 1983), cat. 108. See also Ch. 5, p. 101.

[70] R. Cazelles, 'Les étapes d'élaboration des Très Riches Heures du duc de Berry', *Revue française d'histoire du livre*, 10 (1976), 1–30, and further literature cited below, Ch. 6, pp. 139–43.

[71] Paris, B.n., n. acq. fr. 24920. M. Thomas, *Le manuscrit de parchemin* (Faits de Civilization, no. 2) (Paris, 1967), pl. X. *Histoire de la Destruction de Troye le Grant. Reproduction du manuscrit Bibliothèque nationale nouvelles acquisitions françaises 24920*, introd. M. Thomas (Paris, 1973).

[72] Munich, Bayer. Staatsbibl., Clm 14000. Schramm, Mütherich, *Denkmale*, pp. 134–5, no. 52. *Regensburger Buchmalerei. Von frühkarolingischer Zeit bis zum Ausgang des Mittelalters*, F. Mütherich, K. Dachs, eds (Munich, 1987), no. 13, Taf. 91. Two inscriptions, folios 1 and 126v, record the restoration: 'Hunc librum Karolus Quondam perfecit honorus. Quem nunc Hemrammo Ramvold renoverat almo' and 'Domini abbatis Ramvoldi jussione hunc librum Aripo et Adalpertus renovaverunt'. This may be rather a case of retouching or of additions, than of restoration proper, however. Another instance which seems to be of collaboration rather than restoration, are the Byzantinising heads of Christ and the Virgin which along with other details are thought to have been the contribution of a visiting, presumably Greek, artist in the Golden Gospels made for Henry III at Echternach, c. 1045 for presentation to Speyer cathedral, Escorial, Real Biblioteca, Cod. Vitr. 17. A. Boeckler, *Das Goldene Evangelienbuch Heinrichs III* (Berlin, 1933).

[73] Paris, B.n., fr. 167. F. Avril, 'Un chef-d'oeuvre de l'enluminure sous le règne de Jean le Bon: La Bible moralisée manuscrit français 167 de la Bibliothèque nationale', *Fondation Eugène Piot. Monuments et mémoires publiés par l'Académie des Inscriptions et Belles Lettres*, 58 (1973), 91–125. London, B.L., Harley 4431. S. Hindman, 'The Composition of the Manuscript of Christine de Pizan's Collected Works in the British Library: A Reassessment', *British Library Journal*, 9 (1983), 112.

[74] Sotheby's, 25 April 1983, lot 99. Of later date are the background architecture of the Annunciation and gold on the Virgin's robe, and in the Visitation the figures of Joseph and the Virgin are retouched. Walter Cahn has drawn my attention to Paris, Bibliothèque Ste Geneviève, Ms. 1273, a French thirteenth-century Psalter, where in a miniature of Pentecost the heads of Sts Peter and Paul have been repainted in the fourteenth century. A parallel to this might be the repainting of heads of earlier Sienese Madonnas in the fourteenth century.

[75] E.g. Oxford, Lincoln College, Lat. 26. Alexander, Temple, no. 347. For 'fleuronnée' initials or 'initiales à filigranes', see S. Scott-Fleming, *Pen-Flourishing in Thirteenth-Century Manuscripts* (Literae textuales) (Leiden, 1989), and P. Stirnemann, 'Fils de la Vierge: l'initiale à filigranes parisienne: 1140–1314', *Revue de l'Art*, 90 (1990), 58–73.

[76] New Haven, Yale University, Beinecke Library, Ms. 425. French Missal, c. 1470–80, drawn to my attention by Walter Cahn. W. Cahn, J. Marrow, 'Medieval and Renaissance Manuscripts at Yale: A Selection', *The Yale University Library Gazette*, 52 (1978), pp. 252–4.

[77] London, Victoria and Albert Museum, Reid Ms. 51 (AL. 1682–1902), folios 50v, 102v, 157. On folio 157 the original

figure of St Paul has been turned into a St Andrew by painting his sword blue and adding a cross-bar. I am grateful to Dr Rowan Watson for knowledge of this manuscript. In a Commentary on the Mass in German of *c*. 1596, Sotheby's, 29 November 1990, lot 126, cut-out initials of thirteenth and fifteenth-century date have been reused. Walter Cahn also draws my attention to the Ratman Missal written in 1159 but then rewritten *c*. 1400 over erasure, Trier, Domschatz, Ms. 37. The miniatures and historiated initials and where feasible the painted initials too were preserved. M. Stahli, ed. H. Hartel, *Die Handschriften im Domschatz zu Hildesheim* (Wiesbaden, 1984), pp. 117–23.

[78] Examples are London, B.L., Add. 5208 and Royal 2 A. XIV. Oxford, Bodl., Ms. Rawl. C. 781 has missing initials which may have been excised for the purpose. Three other Syon manuscripts have woodcuts or engravings inserted, London, St Paul's Cathedral, Ms. 5, Oxford, St John's College, Ms. 167 and Oxford, Bodl., Ms. Rawl. D.403, for which practice cf. the Dutch mss cited in n. 82. I am grateful to Dr C.F.R. de Hamel for allowing me to read his account of the Syon manuscripts which is to be published by the Roxburghe Club.

[79] D.J.A. Ross, 'An Illuminator's Labour-saving Device', *Scriptorium*, 16 (1962), 94–5. Professor Richard Rouse suggests to me that a more likely reason was to avoid bleed-through from the other side of the leaf.

[80] New York, Morgan, M. 358. F. Avril, 'Pour l'enluminure provençale. Enguerrand Quarton peintre de manuscrits?', *Revue de l'Art*, 35 (1977), 9–40.

[81] R.G. Calkins, 'Stages of Execution: Procedures of Illumination as Revealed in an Unfinished Book of Hours', *Gesta*, 17 (1978), 61–70. See also for analysis of collaborative work on another manuscript, R.G. Calkins, 'Distribution of Labor: The Illuminators of the Hours of Catherine of Cleves and Their Workshop', *Transactions of the American Philosophical Society*, 69 (1979), 3–83.

[82] London, B.L., Add. 17524, folio 109v. Gumbert (as in Ch. 1, n. 86), p. 76, pl. VIII. It is not clear if this image of Christ was removed by an iconoclast or not. Images have also been lost on folios 59v and 87v, but others of the Sacrifice of Abraham and the Death of the Virgin, folios 137v, 157v, also woodcuts, remain. For use of woodcuts in other manuscripts from the same area, see *Dutch Manuscript Painting*, nos 88–9.

[83] See, for example, Ch. 1, pp. 127–30, 139–40, R.H. and M.A. Rouse, 1990, and further their forthcoming Lyell Lectures which will also deal with the question of working spaces, the 'workshop'.

[84] Hague, Rilksmuseum Meermanno-Westreenianum, Ms. B.10.23. 'Pluseurs alées et venues/Soir et matin parmi les rues/Et mainte pluye sus son chief/Ains [avant] qu'il en soit venu a chef'. *Fastes du Gothique*, no. 285, Bénédictins du Bouveret, 5, no. 16290 (not in full, but giving other colophons of this same scribe).

[85] London, B.L., Royal 20 D.I, folio 8v, below the catchword at the end of the quire: 'Cy faut le secont cahier que maistre Renait doit avoir que fu baillie a Perrin Remiet pour faire enlumineure de l'autre cayer'. See also Ch. 2, p. 50 and Ch. 6, p. 135. Notes for the subjects of many miniatures survive at the bottom of the folios, e.g. folio 323v: 'Comme (*sic*, often 'comment') Cartage fu restoree'. In Oxford, Balliol College, Ms. 2, Bible, third quarter of the thirteenth century, French script with French and Italian illumination, there is a note on folio 177v: 'Post istum quaternum incepit illuminator parvarum literarum et capitulorum et habet x sest. Inde reddidit mihi tres. Postea dedi unum sest. sequentem et duos sest. interpretationum et unum xx foliorum'. R.A.B. Mynors, *Catalogue of the Manuscripts of Balliol College, Oxford* (Oxford, 1963), p. 2. Alexander, Temple, nos 700, 895. For the marginal drawings in this manuscript, see Ch. 3, p. 66.

[86] Brussels, B.R., 9018–19, volume 2 of a three volume Bible Historiale. Biemans (as in Ch. 1, n. 125), p. 258, gives the note. I thank James Marrow for the reference. *Dutch Manuscript*

Painting, no. 39, identifies the second illuminator assisting Claes Brouwer as the 'Alexander Master'. Still other illuminators worked on volume 3, Brussels, B.R., 9020–23. Gumbert (as in Ch. 1, n. 86), p. 72, doubts that London, B.L., Add. 10043 is, as has been thought, volume 1 of the set. The latter, by an overlapping set of scribes and artists, is, he argues, evidence for serial production. For the proximity of illuminators' dwellings as facilitating this sort of collaboration, see R.H. and M.A. Rouse as in Ch. 1, n. 97. A particularly well-documented example of artistic collaboration with the help of assistants is the Bible of Borso d'Este which was also illuminated quire by quire. See Ch. 3, p. 53.

[87] J.S. Golob, *The Glossed Psalter of Robert de Lindsey and Related Manuscripts*, Ph.D. (Cambridge University, 1981), for the Psalters, Cambridge, St John's College, Ms. D.6, Berlin, Kupferstichkabinett, Ms. 78 A.8 and London, B.L., Lansdowne 420. Morgan, *Early Gothic Manuscripts (1)*, cats 35, 36 and 37. J.D. Farquhar, *Creation and Imitation. The Work of a Fifteenth-Century Manuscript Illuminator* (Fort Lauderdale, 1976), for miniatures in the 'Vrelant' style. Farquhar reviews the evidence for the existence of oiled tracing paper. For evidence of tracing in Dutch fifteenth-century manuscripts, see *Dutch Manuscript Painting*, pp. 185, 187–8.

[88] San Marino, California, Huntington Library, Ms. 26 C 9. H.C. Schulz, *The Ellesmere Ms. of Chaucer's 'Canterbury Tales'* (San Marino, 1966), pp. 4–6. Scott, *Later Gothic Manuscripts*, cat. 42.

[89] Vatican, B.A.V., Vat. Lat. 3225, folio 45v. Paris, B.n., latin l, folio 386v. D.H. Wright, Kommentarband to *Vergilius Vaticanus (Codex Vaticanus lat. 3225)* (Codices Selecti, LXXI) (Graz, 1984), p. 17 and n. 4. Tracings also occur in the (?) seventh-century Ashburnham Pentateuch, which was also later at Tours, Paris, B.n., n. acq. lat. 2334. See A. Grabar, 'Fresques romanes copiées sur les miniatures du Pentateuque de Tours', *Cahiers archéologiques*, 9 (1957), 329–41. A.S. Cahn, 'A Note: The Missing Model of the Saint-Julien de Tours Frescoes and the *Ashburnham Pentateuch* Miniatures', *ibid*., 16 (1966), 203–207. See also Ch. 6, pp. 121–2.

[90] C.B. Cappel, *The Tradition of Pouncing Drawings in the Italian Renaissance Workshop: Innovation and Derivation*, Ph.D. (Yale University, 1988). She emphasises, p. 202, that: 'the early evidence of pouncing in painting occurs in decorative details, never in the main scenes, attesting to the selective use of the technique in minor parts of compositions'. In origin this seems to be a labour-saving device, not a means of transferring designs, therefore.

[91] E. Borsook, *The Mural Painters of Tuscany from Cimabue to Andrea del Sarto* (2nd rev. edn, Oxford, 1980).

[92] Scheller, *Model Books*, cats 19, 21, the Bergamo pattern book of Giovanni dei Grassi (*d*. 1398) and a fifteenth-century Icelandic pattern book.

[93] Cappel addresses the question of whether pricking was used in medieval manuscripts as a method of copying, pp. 193–202. Her conclusions are largely negative. Only one instance seems to withstand scrutiny, the Alphabet of Mary of Burgundy which was pricked to make a later copy, see p. 175 n. 34.

[94] Pricked subjects occur in the following Bestiaries: Cambridge, Fitzwilliam Museum, Ms. 379, Bestiary, England, *c*. 1300; London, B.L., Add. 11283, Bestiary, England, early twelfth century; Brussels, B.R., 8340, Bestiary, fourteenth century. Also in the Aberdeen and Ashmole Bestiaries for which, see Ch. 5, p. 105. Other examples of pricking I have noted are: London, B.L., Add. 38119, folio 22, Speculum, Cologne, mid fifteenth century; London, B.L., Harley 6563, Hours and Psalter, folios 52 and 86, England, *c*. 1330; Paris, Bibliothèque de l'Arsenal, Ms. 588, folio 153v (rabbit), Bible, French, early fourteenth century; New York, Morgan, M.736, folios 27, 74, 77, 95, Life of St Edmund, England, twelfth century; Manchester, John Rylands University Library, Latin 8, folios 3v (Lion of St Mark), 5v (Eagle of St John), 49v (bear),

149v ('bestia ascendit de terra'), Apocalypse, Spain (?), thirteenth century; Paris, B.n., latin 6069 G, folio 1ᵛ, Petrarch, de viris illustribus. Padua, *c.* 1380. Lion in allegorical miniature of struggle between Venice and Padua. F. Avril, *Dix siècles d'enluminure italienne (VIᵉ–XVIᵉ siècles)* (Paris, Bibliothèque nationale, 1984), cat. 75. I would suspect most, if not all, of these examples to be post-medieval. A few additional examples are listed by Lehmann-Haupt (as in n. 97) and by Cappel. Munich, Bayer. Staatsbibl., Cgm 254, Ulrich von Pottenstein, Buch der natürlichen Wahrheit, Regensburg (?), *c.* 1430, is exceptional in the number of its pricked subjects. See Cappel and *Regensburger Buchmalerei* (as in n. 72), no. 84, Taf. 60–61. This manuscript also contains colour notes.

[95] Some of the leaves were incorporated in Jacopo Bellini's pattern book, now in the Louvre. Others are scattered in various collections. See B. Degenhart, A. Schmidt, *Corpus der Italienischen Zeichnungen 1300–1450. Teil II. Venedig. Addenda zu Süd- und Mittelitalien* (Berlin, 1980), pp. 136–77 (Kat. 652–663), Taf. 69–78, Abb. 248–9, 254–5, 268–70, 279, 294–5.

[96] Paris, B.n., latin 12610, folio 40v, figure of St Germain, and latin 11751, folio 59. D. Miner review of Ives, Lehmann-Haupt (as in note 97), *Art Bulletin*, 25 (1943), 88–9 and 'More about Medieval Pouncing', *Homage to a Bookman. Essays on Manuscripts, Books and Printing Written for Hans P. Kraus on His Sixtieth Birthday*, ed. H. Lehmann-Haupt (Berlin, 1967), pp. 87–107. Cappel discusses this instance, pp. 186–7, with similar conclusions based on the observations of Dr Patricia Stirnemann.

[97] Cambridge, Massachusetts, Harvard University, Houghton Library, Ms. Typ. 101. S.A. Ives, H. Lehmann-Haupt, *An English Thirteenth-Century Bestiary* (New York, 1942). Scheller, *Model Books*, cat. 13. W.B. Clark, 'The Aviary-Bestiary at the Houghton Library, Harvard', *Beasts and Birds of the Middle Ages. The Bestiary and Its Legacy*, eds W.B. Clark, M.T. McMunn (Philadelphia, 1989), pp. 26–51, discusses the relationship of the pattern book leaves with the Bestiary in St Petersburg, Public Library, Ms. lat. Q.v.III.1.

CHAPTER 3

[1] Compare Dante, Purgatorio, XXXII, 67: 'Come pittor che con esemplo pinga...'. And see J.J.G. Alexander, 'Facsimiles, Copies and Variations; the Relationship to the Model in Medieval and Renaissance European Illuminated Manuscripts', *Retaining the Original. Multiple Originals, Copies and Reproductions (Studies in the History of Art, volume 20)* ed. K. Preciado (National Gallery of Art, Washington, 1989), pp. 61–72.

[2] For the former, see P. Pansier, *Histoire du Livre et de l'imprimerie à Avignon du XIVe au XVe siècle* (3 vols, Avignon, 1922). For the latter, kindly brought to my attention by Michael Gullick, see J. Simonnet, *Documents inédits pour servir à l'histoire des institutions et de la vie privée en Bourgogne* (Dijon, 1867). More are likely to await discovery in other local archives and, of course, it is only too likely that others may be published but unknown to me. For transcriptions of some examples, see Appendix 1.

[3] Thus in Filippini, Zucchini's book on the Bologna book trade (see Ch. 1, n. 113) documents are not given in full and the type of record is not always therefore clear. The same applies to documents referred to by C. Monget, *La Chartreuse de Dijon d'après les documents des Archives de Bourgogne* (Montreuil-sur-mer, 1, 1898), pp. 409–19.

[4] H. Glasser, *Artists' Contracts of the Early Renaissance*, Ph.D. (Columbia University, 1965) (Garland Outstanding Dissertations in the Fine Arts, 1977).

[5] Pansier (as in n. 2), pp. 40–41. See pp. 180–81, Appendix 1.

[6] Missals with Rolin's arms survive at Autun, Bib. mun., Mss. 114A and 108A, and at Lyon, Bib. mun., Ms. 517. See *Le Livre au siècle des Rolin* (Autun, 1985), especially p. 14, where the conclusion is reached that none of these can be certainly identified with Jean de Planis' Missal. De Mély (as in Ch. 1 n. 8), pp. 250–51, pls XIV, XV, observed that the cardinal's hat on folio 1 of the Lyons Missal is inscribed 'Benigne Guyot' and concluded that this was the artist's name. It seems a most unlikely place for a signature! A detached leaf from a Missal with Jean Rolin's arms is London, Victoria and Albert Museum, 8122.

[7] G. Milanesi, *Nuovi documenti*, pp. 164–66, no. 185 (as on pp. 181–2, Appendix 1). The Bible and the Sentences are now in Lisbon. Similarly Jean Duvart, physician, received money to dispense in payment to the Limbourg Brothers for the illumination of the *Bible moralisée*, Paris, B.n., fr. 166, for Philip the Bold, Duke of Burgundy. He also was to supervise the work. The document of payment to Duvart of 1402 refers to an agreement between the Duke and the illuminators made the preceding year, 1401. Apparently then the latter was a contract which does not, however, survive. See Meiss, *French Painting*, 3, pp. 72–3 for the payment document.

[8] L. Cortesi, G. Mandel, *Jacopo da Balsemo miniatore (c. 1425–c. 1503)* (Monumenta Bergomensia, XXXIII) (Bergamo, 1972).

[9] The Bible is now Modena, Biblioteca Estense, VG. 12. *La Bibbia di Borso d'Este*, complete facsimile (ed. A. Venturi, 2 vols, Milan, 1937). For the contract, see H.J. Hermann, 'Zur Geschichte der Miniaturmalerei am Hofe der Este in Ferrara', *Jahrbuch der kunsthistorischen Sammlungen des Allerhochsten Kaiserhauses*, 21 (1900), 249–50 and G. Bertoni, *Il maggior miniatore della Bibbia di Borso d'Este, Taddeo Crivelli*, Modena, 1925. Bertoni includes further documentation on costs and materials in Ferrara at this period and in particular publishes in an Appendix extracts from Taddeo's Comto di dibituri e crededuri. For a much fuller account see C. Rosenberg, *The Politics of the Book. Este Patronage of Manuscripts and Manuscript Production in Fifteenth-Century Ferrara*, forthcoming. I am grateful to Professor Rosenberg for allowing me to read this in typescript. The contract for Crivelli to illuminate the Choir Books of San Petronio in Bologna in 1478 also survives. See L. Frati, *I corali della Basilica di S. Petronio in Bologna* (Bologna, 1896), 84–6. C. Gilbert, *Italian Art 1400–1500* (Sources and Documents in the History of Art Series, ed. H.W. Janson) (Englewood Cliffs, 1980), pp. 36–8.

[10] Simonnet (as in n. 2), pp. 354–5. 'telx qu'il plaira audit Guillaume ordonner'. See p. 180, Appendix 1.

[11] For example, the contract for Enguerrand de Quarton's painting of the Coronation of the Virgin at Villeneuve-les-Avignon is very specific and detailed as to what should be represented. W. Stechow, *Northern Renaissance Art 1400–1600* (Sources and Documents in the History of Art Series, ed. H.W. Janson) (Englewood Cliffs, 1966), pp. 141–5.

[12] See E. Castelnuovo, C. Ginzburg, 'Centro e periferia', *Storia dell'arte Italiana. Parte Prima. Materiali e problemi. Volume 1, Questioni e metodi* (Turin, 1979), p. 317, for a contract specifying a copy of a painting to be made 'ad speciem et similitudinem' of the original.

[13] This is proved by instructions to the artist surviving in Books of Hours which consist merely of the name of the Hour, for example, Paris, Bibl. Mazarine, Ms. 473, folio 98, 'Histoire a sext' ('nones' crossed out!) and similar notes throughout. The manuscript is unfinished, which is no doubt why the notes were not erased, and is an excellent example of the stages of execution. *Manuscrits à peintures* (1955), no. 250. Other fifteenth-century Books of Hours with similar notes are Paris, B.n., latin 1160 and Edinburgh, University Library, Ms. 44, folio 30, 'In laudibus' for the Visitation.

[14] Paris, B.n., latin 10483–4. L.F. Sandler, 'Jean Pucelle and the Lost Miniatures of the Belleville Breviary', *Art Bulletin*, 66 (1984), 73–96 (text and translation of the programme, pp. 94–6).

[15] Manchester, John Rylands University Library, Latin 22, *c.* 1220–25, and Cambridge, University Library, Ms. Ee. IV. 24, *c.* 1280. The rubrics in the latter are in French, apparently

deriving from those in Latin in the former. The French rubrics have been published by M.R. James, 'On a Manuscript Psalter in the University Library Cambridge (Ee. IV. 24)', *Proceedings of the Cambridge Antiquarian Society*, 8/2 (1894), 146–67. See also M.R. James, *A Descriptive Catalogue of the Latin Manuscripts in the John Rylands University Library* (London, 1921; repr. with introduction and notes by F. Taylor, Munich, 1980), pp. 68–70. S. Berger, 'Les manuels pour l'illustration du Psautier au XIIIe siècle', *Mémoires de la Société nationale des Antiquaires de France*, 57 (1898), 95–134, adds a third manuscript, also of the thirteenth century, with the same set of notes but this time in Picard dialect, Paris, B.n., latin 10435, *c.* 1290–97. He prints these notes in full, pp. 128–34. The rubrics also occur in Latin in the text in Philadelphia, Free Library, J.F. Lewis Collection, European Ms. 185, a Psalter of *c.* 1225–30, as noted by E.A. Peterson, 'Accidents and Adaptations in Transmission Among Fully-Illustrated French Psalters in the Thirteenth Century', *Zeitschrift für Kunstgeschichte*, 50 (1987), 375–84, who discusses the iconography of the initials in these and related Psalters. The relation of imagery to rubrics needs further study, but Dr Peterson's observation 'that the formal script of the rubrics argues against their having served as notes for the illuminator' seems to me unjustified, even if, as she and James also have shown, there are mistakes made. For an earlier, less complex list of Psalter illustrations, see Wormald cited in Ch. 5, p. 97.

[16] In the Rylands Psalter, the notes accompany each Psalm. In the Cambridge Psalter, the descriptions are written together on folios 4v, 5, 5v. For Psalm 68 in the latter, the description is: 'En la lettre sera larche nostre seigneur sus .i. char qe diec bof meneront et david harpera par devant larche et sera vestu dun rochiet blanc. E par dessus sera michol la fame david qui esgardera david par dessus une fenestre e fera une contenance quele le despise'. For the historiated initials of Psalms 125–130 which occur on folio 32v (fig. 75), however, the descriptions are much shorter, e.g. Psalm 125, 'Uns home porte a joie les bles', or Psalm 129, 'De profundis', 'Jonas ist del ventre del poisson'.

[17] Hamburg, Kunsthalle, Ms. Fr. 1, volume 2 and Paris, Bibliothèque de l'Arsenal, Ms. 5212, volume 1. F. Avril, 'Une Bible historiale de Charles V', *Jahrbuch der Hamburger Kunstsammlungen*, 14–15 (1970), 45–76, espec. pp. 74–5. A lost set of directions was in the *Bible moralisée*, Paris, B.n., fr. 166, described in the inventory of the French Royal Library taken at Blois in 1518: '. . . avec deux cayés de papier ou sont contenus la forme de fair les dictz histoires'. A. de Laborde, *Étude sur la Bible moralisée illustrée*, 5 (Paris, 1927), p. 104. Another set is referred to by Robert Gaguin in his letter of 1473 to Charles de Gaucort concerning an Augustine, *Cité de Dieu*, to be illuminated by Maître François: 'Lineamenta picturarum et imaginum rationes, quas libris "de Civitate Dei" prepingendas jussisti a nobis, accepit egregius pictor Franciscus'. The two volume set survives as Paris, B.n., fr. 18–19. See A. de Laborde, *Les manuscrits à peintures de la Cité de Dieu de Saint Augustin*, 2 (Paris, 1909), p. 399. I am grateful to Dr Rowan Watson for this reference.

[18] The text of this was written *c.* 1389. Instructions survive in a late fifteenth-century manuscript, Paris, B.n., fr. 22542. They have not been printed in full, unfortunately, but see M. Prinet, 'Un manuscrit armorié du "Songe du vieux pèlerin"', *Bibliographe moderne* (Besançon, 1907), 32–8. I owe the reference to François Avril. The directions of the author also specify that the miniatures should be protected by pieces of silk sewn to the parchment, such as survive in many medieval manuscripts.

[19] Brussels, B.R., IV. 111. E. Spencer, 'L'Horloge de Sapience (Bruxelles, Bibliothéque royale, ms. IV. 111)', *Scriptorium*, 17 (1963), 277–99. P.R. Monks, 'Reading Fifteenth-Century Miniatures: The Experience of the "Horloge de Sapience" in Brussels, B.R. IV.iii', *Scriptorium*, 40 (1986), 242–8. P.R. Monks, *The Brussels 'Horloge de sapience'. Iconography and Text of Brussels, Bibliothèque Royale, Ms. IV. 111* (Leiden, 1990).

[20] F. Lippmann, *Le Chevalier délibéré by Olivier de la Marche. The Illustrations of the Edition of Schiedam Reproduced with a Preface. . .* (London, Bibliographical Society, 1898). The illustrations reproduced there are in the edition printed at Gouda in 1486. The directions are clearly by Olivier de la Marche himself, but the pictorial tradition in the manuscripts has not been studied. See also S. Hindman, *Pen to Press*, p. 172.

[21] Cf. S.D. Smith, 'New Themes for the *City of God* around 1400: the Illustrations of Raoul de Presles' Translation', *Scriptorium*, 36 (1982), 68–82. Concerning the cycle of illustrations by the 'Virgil Master' of *c.* 1405–12 she writes, p. 79: 'The most likely hypothesis is that a scholar furnished the program to a book dealer who in turn lent it to those workshops from which he commissioned *City of God* manuscripts'. For Christine de Pisan's involvement with the illustrated copies of her own works, see S.L. Hindman, *Christine de Pizan's 'Epistre d'Othéa'. Painting and Politics at the Court of Charles VI* (Toronto, 1986).

[22] Paris, B.n., fr. 12465. M. Camille, *The Illustrated Manuscripts of Guillaume de Deguileville's 'Pèlerinages' 1330–1426*, Ph.D. (Cambridge University, 1985), pp. 118–19.

[23] *The Mongol Mission (Narratives and Letters of the Franciscan Missionaries in Mongolia and China in the Thirteenth and Fourteenth Centuries)*, translated by a nun of Stanbrook Abbey, ed. C. Dawson (London, 1955), pp. 118, 162, 209. William had to leave the Psalter behind 'since it greatly pleased Sartach (another Mongol ruler)'. I owe the references to Dr H. Evans, Institute of Fine Arts, New York.

[24] M. Camille, *The Gothic Idol. Ideology and Image-Making in Medieval Art* (Cambridge, 1989), Ch. 4. M. Camille, 'Visual Signs of the Sacred Page: Books in the *Bible moralisée*', *Word and Image*, 5 (1989), 111–30.

[25] New York, Morgan, M. 240. This is a fragment of eight leaves detached from the end of the *Bible moralisée*, now in Toledo Cathedral. See de Laborde, as in n. 17.

[26] London, B.L., Add. 47682. Sandler, *Gothic Manuscripts*, cat. 97. W.O. Hassall, *The Holkham Bible Picture Book* (London, 1954), pp. 53–5, pl. 1. The Dominican's scroll reads: 'Ore feres bien e nettement/car mustre serra a riche gent' to which the illuminator replies that if God grant him long enough life you will never see such another book: 'Nonkes ne veyses un autretel livre'. Hassall considers the Dominican to be the patron, which I doubt.

[27] S. Berger, *La Bible française au Moyen Age* (Paris, 1884; repr. 1967), pp. 287ff. S. Berger, P. Durrieu, 'Les notes pour l'enlumineur dans les manuscrits du Moyen Age', *Mémoires de la Société nationale des Antiquaires de France*, 53 (1893), 1–30. F. Avril, 'Un manuscrit d'auteurs classiques et ses illustrations', *The Year 1200: A Symposium* (Metropolitan Museum of Art, New York), ed. J. Hoffeld (New York, 1975), pp. 261–82. A. Stones, 'Indications écrites', *Artistes*, 3, pp. 321–49. P. Stirnemann, 'Réflexions sur des instructions non iconographiques dans les manuscrits gothiques', *Artistes*, 3, pp. 351–6. L.F. Sandler, 'Notes For the Illuminator: The Case of the *Omne Bonum*', *Art Bulletin*, 71 (1989), 551–64. And see Ch. 5, pp. 112–18.

[28] See p. 4. Another early example may be the World Chronicle, the so-called Scaliger Barbarus, Paris, B.n., latin 4884, a Carolingian copy thought to be of an archetype from Alexandria of the early fifth century. A. Bauer, J. Strzygowski, 'Eine Alexandrinische Weltchronik', *Denkschriften der Kaiserlichen Akademie der Wissenschaften in Wien*, 51 (1905), 132–43. In the spaces left for miniatures, words are written on a number of folios in neat capitals; e.g. on folio 15v, 'Vox domini', 'Abraham', 'Isaac', 'Altarium' are written, but apparently not in such a way as they relate spatially to some hypothetical miniature of the Sacrifice of Isaac, i.e. the word 'Isaac' is written below and to the left of the word 'altarium', whereas one would assume Isaac would be represented *on* the altar. On another folio, folio 17, the sentence 'Populus ebreorum transeuntes Iordanem' is written on the last line of the page with twelve lines

left blank above. This seems more like a *titulus* for the scene of the Israelites crossing the Red Sea than an instruction. Further study might determine if the inscriptions are a first stage of the making of miniatures to be copied from an exemplar, or rather instructions for a cycle to be inserted.

[29] Paris, B.n., latin 14643, folios 269–83v. G. Ouy, 'Une maquette de manuscrit à peintures', *Mélanges offerts à Frantz Calot* (Paris, 1960), 43–51. No illustrated copy of this text is known, so the illustrations may never have been executed, though two bibliophiles, Pope Benedict XIII and Jean de Berry, owned copies which do not survive.

[30] Folio 270v: 'Hic depingatur rex Scocie et actor ut supra dicitur'.

[31] Folio 272: 'Frustra dimissum fuit hoc spatium quia nichil in eo debet depingi'.

[32] See Ch. 2, pp. 45–7.

[33] Baltimore, Walters Art Gallery, W. 148, folios 1–2. D. Miner, 'Preparatory Sketches by the Master of Bodleian Douce Ms. 185', *Kunsthistorische Forschungen Otto Pächt zu ehren*, eds A. Rosenauer, G. Weber (Vienna, 1972), pp. 118–28 and *Anastaise and Her Sisters. Women Artists of the Middle Ages* (Baltimore, 1974), pp. 14–18. Dorothy Miner pointed out that the drawings are probably by the same artist as Oxford, Bodl. Ms. Douce 185, *Sermologium*, second quarter of the fourteenth century, from the same region. Pächt, Alexander, 1, no. 136. Perhaps they were a maquette for a companion volume, therefore.

[34] Vercelli, Biblioteca Capitolare. Early thirteenth century. Scheller, *Model Books*, no. 11. Part of the inscription reads:
Hoc notat exemplum media testudine templum
Ut renovet novitas, quod dolet longa vetustas.
Hic est descripta media testudine pictum
Ecclesiae signans ibi que sunt atque figuras.

[35] Paris, B.n., latin 11907. French, later thirteenth century. Scheller, *Model Books*, no. 12. L.J. Friedman, *Text and Iconography for Joinville's Credo* (Cambridge, Mass., 1958). Review by H. Bober, *Speculum*, 35 (1960), 601–3. See also Ch. 4, p. 85.

[36] J. Porcher, *Jean Lebègue, Les histoires que l'on peut raisonablement faire sur les livres de Salluste* (Paris, 1962). D. Byrne, 'An Early French Humanist and Sallust: Jean Lebègue and the Iconographical Programme for the *Catiline* and *Jugurtha*', *Journal of the Warburg and Courtauld Institutes*, 49 (1986), 41–65. The guide survives in Oxford, Bodl., Ms. D'Orville 141, unillustrated, on paper. Manuscripts of the translation are Geneva, Bibliothèque publique et universitaire, Fr. 54, *c*. 1420, with the full cycle of illustrations (reproduced by Porcher); Paris, B.n., latin 9684 with arms of Louis d'Orléans, *d*. 1407, and latin 5762, French Royal arms, *c*. 1405, each with only a frontispiece miniature.

[37] 'On puet deviser la première histoire en ceste forme: Première histoire. Soyt fait et pourtrait ung homme à grant barbe fourchue qui aura en sa teste une coiffe blanche comme l'en souloit porter . . .'.

[38] *Pen to Press*, p. 82.

[39] 'xiiiie histoire. Illec comment deux parlemens romains viennent de nuit au pont que devoient les Gaules passer que conduisoit Vulturcius et comment il fut prins et se rendi. *Vulturcius primo cohortatus* (45,4, i.e. the passage where the miniature is to be inserted). Soit portrait ung pont de pierre et l'eaue passant par dessoubz. Et en la haute partie dud. pont seront fait gens d'armes qui feront semblant de eux combatre et aultres gens qui venront du bas du pont pour cuider passer par force et se mectront en defense, maiz n'y aura personne blecié ne sang respendu, maiz leur capitaine sera pris.'

[40] San Marino, California, Huntington Library, HM. 268. C.W. Dutschke, *Guide to Medieval and Renaissance Manuscripts in the Huntington Library*, 1 (Berkeley, 1989), pp. 230–2. Scott, *Later Gothic Manuscripts*, cat. 79(a). I am grateful to Dr Jeremy Griffiths for bringing this to my attention and supplying details. The Lydgate also has marginal drawings as instructions for the illuminator.

[41] Paris, B.n., fr. 829. Camille (as in note 22), figs 127–8. The numbering begins with XXXIII and XXXIV on folio 25. The preceding frontispiece and thirty-one miniatures are unnumbered. The miniatures in another *Pèlerinage*, Baltimore, Walters Art Gallery, W. 141 are numbered alphabetically. Camille, fig. 59, and Randall, *Medieval and Renaissance Manuscripts* (as in Appendix 2, p. 184), pp. 192–3, cat. 72. Other manuscripts with numbered miniatures are London, B.L., Add. 15248, *Bible moralisée*, Flemish, Vrelant style, mid fifteenth century; London, B.L., Royal 19 D. II, Warner, Gilson, *Royal mss.*, 2, pp. 341–2 and Ch. 2, n. 57; Paris, B.n., latin 8504, see n. 48; Paris, B.n., latin 18014, 'Petites Heures' of Jean de Berry. F. Avril, L. Dunlop, B. Yapp, *Les Petites Heures de Jean, duc de Berry. Introduction au manuscrit lat. 18014 de la Bibliothèque nationale, Paris* (Luzern, 1989), p. 62; and Rouen, Bib. mun., Ms. 1044, Chrétien Legouais, *Ovide moralisé*, Paris, *c*. 1315–20, *Fastes du Gothique*, no. 230. This last also has colour directions under its miniatures. Douglas Farquhar has also noted numbered miniatures in New York, Morgan M. 672, Golden Legend, and in Paris, B.n., fr. 308–10, *Miroir historiale*. For the latter, see *Pen to Press*, p. 83, fig. 10. For the former, see A. van Buren, 'The Model Roll of the Golden Fleece', *Art Bulletin*, 61 (1979), 367 and n. 37. Numerals also occur under the drawings in the roll she discusses, which is now Berlin, Kupferstichkabinett, Inv. 14721, while alphabetical letters are used in volume 1 of the Chroniques d'Hainaut, Brussels, B.R., 9242, discussed by A. van Buren, *Scriptorium* (as in Ch. 6, n. 102), 1972, p. 254 and 1973, p. 318.

[42] Manuscripts sometimes contain notes on the ordering of the miniatures. In a Vaticinia Pontificum, Cologne, *c*. 1420, Paris, B.n., latin 10834, a long note concerns the order of the 'figurae' in relation to the prophecies. See L.V. Wilckens, 'Die Prophetien über die Päpste in deutschen Handschriften. Zu Illustrationen aus der Pariser Handschrift Lat. 10834 und aus anderen Manuskripten der ersten Hälfte des 15. Jahrhunderts', *Wiener Jahrbuch für Kunstgeschichte*, 28 (1975), 171–80, especially p. 173.

[43] Oxford, New College, Ms. 7, folio 97. Alexander, Temple, no. 173, pl. IX. From folio 1–97 there are written instructions and after that marginal drawings. There are also marks 'X' and 'O' which may signify initials with and without figures respectively. I have noticed similar marks in other manuscripts, but a more systematic checking is needed of a variety of marks which may relate to illumination, but may on the contrary relate to the text. On the difficuties of interpretation, see Stirnemann as in n. 27 above.

[44] Vienna, O.N.B., Cod. 2771, folio 188. 'Hier slact een man twe leewen doot en ene' mann'. O. Pächt, U. Jenni, *Holländische Schule (Fortsetzung des Beschreibenden Verzeichnisses der illuminierten Handschriften der Nationalbibliothek in Wien)* (Vienna, 1975), p. 53, Abb. 104.

[45] London, B.L., Royal 19 D.I, folio 38v. This and other mistakes were noted by D.J.A. Ross, 'Methods of Book-Production in a XIVth Century French Miscellany' *Scriptorium*, 6 (1952), 63–75. The manuscript has visual as well as written directions, see p. 68, fig. 111.

[46] Vienna, O.N.B., Cod. 2571. H.J. Hermann, *Beschreibendes Verzeichnis der illuminierten Handschriften in Oesterreich. Neue Folge: Die illuminierten Handschriften und Inkunabeln der Nationalbibliothek in Wien, Band 5/2. Die italienischen Handschriften des Dugento und Trecento. Oberitalienische Handschriften der zweiten Hälfte des XIV. Jahrhunderts* (Leipzig, 1929), pp. 136–52, Taf. LII–LXI.

[47] Paris, B.n., fr. 12562. On folio 26v, the direction reads: 'Faites une royne seant a table et .iii. dames avech et .ii. compagnons mengons sur .i. bachm (?) devant la table et tiens li .i. un boire a qui il boit et li autre tourne le teste en regardant la royne (which he does)'.

[48] Paris, B.n., latin 8504, folio 26. The translation was made by Raymond de Bèziers. Notes on a flyleaf seem to concern

payment for miniatures. Marginal notes number the miniatures, e.g. folio 10 'ii figura' in red. Another example of instructions apparently becoming rubrics is in Paris, B.n., fr. 25532, Miracle of the Virgin and Bishop of Clermont. See also Ch. 5, pp. 112–18, the discussions of the Rylands Arthurian manuscript and of the *Somme le Roi* cycle.

[49] Cambridge, St. John's College, Ms. 262 (K.21), folio 50v. Above right: 'Comment Barrabas li leres fu livere hors de prison'. Sandler, *Gothic Manuscripts*, cat. 8, figs 18–20. *Age of Chivalry*, cat. 42, pl. Other common phrases in the instructions are 'Soit . . .' or 'Faites . . .'.

[50] Paris, B.n., fr. 823, folio 18v. de Mély (as in Ch. 1, n. 8), figs 75–6. *Fastes du Gothique*, no. 294. 'Remiet ne faites rien cy, car je y ferai une figure qui doit y estre'. It has generally been assumed that the note is from the head illuminator to his 'assistant', Remiet, e.g. Avril 'Trois manuscrits' (as in Ch. 6, n. 58), pp. 307–8; *Fastes du Gothique*, no. 294; H. Toubert, 'Fabrication d'un manuscrit: l'intervention de l'enlumineur', *Mise en page et mise en texte du livre manuscrit*, eds H.-J. Martin, J. Vezin (Paris, 1990), pp. 417–20, fig. 404. Camille (as in n. 22), pp. 11, 107, argues, however, as did Durrieu, 1892, p. 122, 1894, pp. 173–4, that the note is written by the scribe, Oudin de Cavarnay, since a diagram including the word 'Pax' should be inserted on this page. But if so, why did Oudin not insert it straight away?

[51] Paris, B.n., latin 8504. See n. 48. Folio 96v: 'Ista figura male est facta'. On folio iiv three miniatures are on parchment stuck in. See Ch. 2, pp. 35–6. Do they perhaps cover other miniatures considered unsatisfactory or were they an afterthought? In a French Bible of the early fifteenth century, London, B.L., Royal 19 D. VI, folio 59, beginning of Exodus, an instruction, quoted by Berger, Durrieu (as in n. 27), reads: 'Querez la facon du candelabre apres les faits des apostres en la fin du livre'. There is no candelabra in the two miniatures on this page and no miniature or drawing at the end of Acts. The note is in a different script from that of other instructions to the illuminator in the Bible; possibly it refers to a text rather than to an image. Warner, Gilson, *Royal mss.*, 2, pp. 346–7. An earlier note of text and miniature misplaced is in the eleventh-century Roda Bible, Paris, B.n., latin 6, vol. 3, folio 97: 'Istas figuras [Esther scenes] nec iste liber non est in suo loco'. Cahn, *Romanesque Bible*, p. 77, pl.

[52] London, B.L., Harley 1527, folio 9: '[L'e]nfant qu la da[me] porte deffaciez. [El]le ne doit point porter ici' (the manuscript is tightly bound and the letters in brackets are concealed in the gutter). de Laborde (as in n. 17), pp. 39–40. Other notes, folio 35: 'Deffaciez les corones qe ce sont paiens ki se convertissent'; and on folio 86v: 'De sein Pol ki esta fetes notre seigneur et de ceci ki gist fetes sein Pol'. In the latter roundel St Paul stands to address a man lying in bed.

[53] Folio 56: 'Fetes a Jhesu robe blanche ici'.

[54] For the well-known Irish examples, see C. Plummer, 'On the Colophons and Marginalia of Irish Scribes', *Proceedings of the British Academy*, 12 (1926), 11–44. For Raulinus of Fremington, a vociferous English scribe of the thirteenth century, see Ch. 1, p. 26.

[55] Paris, B.n., n. acq. fr. 24920, *Histoire de Troye le Grant*, folio 7: 'Or ai ge bein mon temps perdu pour leaument servir'. On folio 11 the name of his grandson, François Colombe, occurs. See M. Thomas (1973) (as in Ch. 2, n. 71), pls 10, 17, and C. Schaefer, 'Un Livre d'Heures illustré par Jean Colombe à la Bibliothèque Laurentienne à Florence', *Gazette des Beaux-Arts*, 82 (1973), 288, for these and other similar notes by Colombe.

[56] Paris, B.n., fr. 91. Robert de Boron, *Histoire de Merlin*, c. 1482–9. *Manuscrits à peintures*, 1955, no. 300. This is another unfinished manuscript given, like the *Très Riches Heures*, to Colombe to complete. In this case he failed to finish his work.

[57] H. Martin, 'Les esquisses des miniatures', *Revue archéologique*, 4 (1904), 17–45 was the pioneering article. Many of his examples were manuscripts in the Bibliothèque de

l'Arsenal of which he was Conservateur. Others were added by Branner, *Manuscript Painting*, p. 15; Meiss, *French Painting*, 1, Ch. 1; and especially P. Stirnemann, 'Nouvelles pratiques en matière d'enluminure au temps de Philippe d'Auguste', *La France de Philippe Auguste. Le Temps des Mutations* (Colloques Internationaux du Centre nationale de la recherche scientifique, 1980, no. 602) (Paris, 1982), pp. 955–80. See also Stones (as in Ch. 2, n. 61), and my 'Preliminary Marginal Drawings in Medieval Manuscripts', *Artistes*, 3, pp. 307–19. For a consolidated list of manuscripts with such drawings at present known to me, see Appendix 2.

[58] San Marino, Huntington Library, HM 3027, folio 118v. Alexander, *Artistes*, 3, pp. 308–9, fig. 2. Dutschke (as in Appendix 2, p. 185), 2, pp. 590–94.

[59] Paris, B.n., latin 11545, folio 394v. *Le Livre*, no. 257. Alexander, *Artistes*, 3, p. 312, fig. 10.

[60] New York, Morgan, M. 111, folio 170v. Alexander, *Artistes*, 3, p. 309.

[61] Edinburgh, University Library, Ms. 19, folio 188v. Dated 1314. Alexander, *Artistes*, 3, p. 309, fig. 3. J. Diamond, 'Manufacture', as in Ch. 1, n. 97, p. 103, as by the 'Royal Master'.

[62] Paris, B.n., latin 108. Stirnemann (as in n. 57), pl. 1. In the margin can also be seen a colour note 'a' = azure, and two strokes which perhaps are to be connected with payment to the artist. See Ch. 1, p. 26, Ch. 2, p. 45.

[63] Formerly Private Collection, Germany. Alexander, *Artistes*, 3, p. 309, fig. 4. Professor James Marrow tells me he considers this manuscript German rather than Dutch as I earlier supposed.

[64] London, B.L., Add. 38122. Alexander, *Artistes*, 3, p. 309, fig. 5.

[65] Amiens, Bib. mun., Ms. 23, Bible, volume 2. *Manuscrits à peintures* (1955), no. 53, does not mention the drawings which occur on folio 143. For Villard's pattern book, see p. 112. Other very faint marginal drawings, which do relate to the historiated initials on the same folios, occur on folios 109, 110.

[66] Oxford, New College, Ms. 20. Alexander, Temple, no. 205, pl. X.

[67] Liverpool, The National Museums and Galleries on Merseyside (Walker Art Gallery), Mayer 12038/2. Alexander, *Artistes*, 3, p. 308, fig. 1. For Magister Alexander, see Ch. 1, p. 23.

[68] Oxford, Balliol College, Ms. 2. Alexander, Temple, no. 700, pl. XLI.

[69] Paris, B.n., latin 17907, folio 62v. Branner, *Manuscript Painting*, p. 15, fig. 8.

[70] London, B.L., Royal 20 B.IV. Warner, Gilson, *Royal mss.*, 2, pp. 360–61, pl. 114 (folio 61v). Meiss, *French Painting*, 1, pp. 10–13, fig. 316. Alexander, *Artistes*, 3, pp. 309–10.

[71] London, B.L., Harley 3487. M. Camille, 'Illustrations in Harley Ms. 3487 and the perception of Aristotle's *Libri naturales* in thirteenth-century England', *England in the Thirteenth Century* (Proceedings of the 1984 Harlaxton Symposium), ed. W.M. Ormrod (Harlaxton, 1985), pp. 31–44, figs 1–18. Alexander, *Artistes*, 3, pp. 311–12, figs 7–8. Morgan, *Early Gothic Manuscripts (1)*, cat. 145. An Averroes, Commentary on Aristotle's Metaphysics, of similar date and style, and also with marginal sketches for its historiated initials, is Oxford, Merton College, Ms. 269 (F.1.4). Alexander, Temple, no. 241, pl. XIV. Morgan, cat. 146(b).

[72] Cambridge, Fitzwilliam, Ms. McClean 123. M.R. James, *A Descriptive Catalogue of the McClean Collection of Manuscripts in the Fitzwilliam Museum, Cambridge* (Cambridge, 1912), pp. 262–69, pl. LXXX. This drawing is not marginal but in the space of the miniature.

[73] London, B.L., Royal 19 D.I, folio 28v. Alexander Romance, etc. Warner, Gilson, *Royal mss.*, 2, pp. 339–41. Ross (as in n. 45). Alexander, *Artistes*, 3, p. 312, fig. 9.

[74] Meiss, *French Painting*, 1, pp. 11–12, figs 304–11, 314–15.

[75] London, B.L., Cotton Nero E.II, folio 4v. *Ibid.*, figs 308–9.

[76] London, B.L., Royal 20 B.IV, folio 61v. *Ibid.*, fig. 316. And see pp. 66, 68.

[77] Paris, B.n., latin 968. See Ch. 1, pp. 426–7.

[78] 'Episcopus mitratus extendens manum super monialem genuflexam'. For another example, see M. Thomas, *Le manuscrit de parchemin* (Faits de civilisation, 2) (Paris, 1967) pl. XI. 'Hic pingatur papa genuflexus' with marginal drawing.

[79] 'hic fiat litera (sine figuris crossed out) cum sacerdote baptisante in fonte (added)'.

[80] There is a sketch in the left margin with 'ad penellum' written beside it. In the lower margin is: 'Hic ponantur episcopus stans cum mitra benedicens et diaconus stans cum vasculo ante eum'.

[81] 'Pingatur stola'.

[82] 'Episcopus signans vestes sacerdotales'.

CHAPTER 4

[1] E.C. Butler, as in Ch. 1, n. 19. Convenient translation, L. J. Doyle, *St Benedict's Rule for Monasteries* (Collegeville, MN, 1948). W. Ullmann, *The Individual and Society in the Middle Ages* (Baltimore, London, 1966).

[2] For the overlap of roles, see Ch. 1, pp. 6–20, and Alexander, *Scribes as Artists*. A striking image of the priority of the scribal task in terms of its heavenly reward is in Munich, Bayer. Staatsbibl., Clm 13031, Isidore, *Etymologiae*, from Prüfening, *c.* 1160, a miniature showing angels weighing the book written by the dead scribe. *Ornamenta Ecclesiae*, 1, B.39. The story of a scribe whose sins were weighed against the letters he had copied is told earlier in the twelfth century by Ordericus Vitalis, monk of S. Evroul in Normandy. M. Chibnall, *The Ecclesiastical History of Ordericus Vitalis*, II (Oxford, 1969), p. 51.

[3] J.J.G. Alexander, 'Facsimiles, Copies and Variations. The Relationship to the Model in Medieval and Renaissance European Illuminated Manuscripts', *Retaining the Original*, (Studies in the History of Art, 20) (National Gallery of Art, Washington, 1989), pp. 61–72.

[4] Eg. Robert Hughes's significantly titled book, *The Shock of the New* (London, 1980).

[5] H. Swarzenski, 'The Role of Copies in the Formation of the Styles of the Eleventh Century', *Romanesque and Gothic Art: Studies in Western Art. Acts of the Twentieth International Congress of the History of Art*, I, ed. M. Meiss *et al.* (Princeton, 1963), pp. 7–18.

[6] We speak of copies sometimes as faithful and at other times as slavish, according to our perception of their function. I hope 'exact' will be more neutral in its connotations, even though it remains problematic, as to what is considered an 'exact' copy.

[7] Florence, Laur., Amiatinus 1. R.L.S. Bruce-Mitford, 'The Art of the *Codex Amiatinus*', *Journal of the British Archaeological Association*, 32 (1969), 1–25 (Jarrow Lecture, 1968). For other literature, see Alexander, *Insular Manuscripts*, cat. 7.

[8] P.J. Nordhagen, 'An Italo-Byzantine Painter at the Scriptorium of Coelfrith', *Studia Romana in honorem Petri Krarup septuagenarii* (Odense, 1976), 138–45. K. Corsano, 'The First Quire of the Codex Amiatinus and the *Institutiones* of Cassiodorus', *Scriptorium*, 41 (1987), 3–34. J. Merten, 'Die Esra-Miniatur des Codex Amiatinus. Zu Autorenbild und Schreibgerät', *Trierer Zeitschrift*, 50 (1987), 301–19 reaffirms the arguments for the Cassiodoran model.

[9] London, B.L., Cotton Nero D.IV. Alexander, *Insular Manuscripts*, cat. 9. See Ch. 1, p. 6.

[10] Utrecht, Bibliotheek der Rijksuniversiteit, Ms. 32 (Script. eccl. 484). E.T. Dewald, *The Illustrations of the Utrecht Psalter* (Princeton, n.d., 1932). K. van der Horst, J.H.A. Engelbregt, Kommentarband to *Utrecht-Psalter* (Codices Selecti, LXXV) (Graz, 1984).

[11] London, B.L., Harley 603. Temple, *Anglo-Saxon Manuscripts*, cat. 64. Kauffmann, *Romanesque Manuscripts*, cat. 67.

[12] F. Wormald, *English Drawings of the Tenth and Eleventh Centuries* (London, 1952), pp. 69–70. J. Backhouse, 'The Making of the Harley Psalter', *British Library Journal*, 10 (1984), 79–113. R. Gameson, 'The Anglo-Saxon Artists of the Harley 603 Psalter', *Journal of the British Archaeological Association*, 143 (1990), 29–48, looks in greater detail at the various artists' alterations of the model.

[13] See Ch. 1, n. 50 for the self-portrait of Dunstan in the Bodleian Classbook. The kneeling figure motif is taken from the similarly posed figure of Hrabanus Maurus adoring the Cross. See Cambridge, Trinity College, Ms. B. 16.3, folio 30v, a manuscript of this text copied in England, perhaps at Glastonbury, in the mid tenth century. J. Higgitt, 'Glastonbury, Dunstan, Monasticism and Manuscripts', *Art History*, 2 (1979), 275–90, figs 1, 2.

[14] Examples are on folios 8, 10v, 11, 14, 14v, 24, 46v, and 90. On folios 22, 23 and 82 are drawings in ink which are certainly Anglo-Saxon and probably of the late eleventh century. Dr A. Heimann pointed to the significance of these drawings in a lecture on Harley 603. Her work unfortunately has remained unpublished. Though faint, the drawings are nonetheless visible in Dewald, and even more clearly in the superb quality facsimile made over one hundred years ago for the Palaeographical Society, *Latin Psalter in the University Library of Utrecht (formerly Cotton Ms. Claudius C. vii) Photographed and Produced in Facsimile by the Permanent Autotype Process of Spencer, Sawyer, Bird and Co*, London, n.d. [1875]. For the later English copies of the Utrecht Psalter, Cambridge, Trinity College, Ms. R. 17.1 ('Eadwine' Psalter) and Paris, B.n., latin 8846, see Ch. 5, n. 30.

[15] B. Bischoff, 'Elementarunterricht und "Probationes pennae" in der ersten Hälfte des Mittelalters', *Mittelalterliche Studien* (as in Ch. 2, n. 34), pp. 74–87.

[16] See pp. 85–7.

[17] See J.E. Duffey, *The Inventive Group of Illustrations in the Harley Psalter (British Museum Ms. Harley 603)*, Ph.D. (Berkeley, 1977). R. Hasler, 'Zu zwei Darstellungen aus der ältesten Kopie des Utrecht-Psalters, British Library Codex Harleianus 603', *Zeitschrift für Kunstgeschichte*, 44 (1981), 317–339, argues that the second campaign took place under Archbishop Aethelnoth (1020–38), in order to present the manuscript either to King Cnut or to Queen Emma. See also Gameson (as in n. 12), for alterations to the Utrecht Psalter images.

[18] Leiden, Bibliotheek der Rijksuniversiteit, Ms. Voss. Lat. Q. 79. Aratea. Facsimile and commentary, *Aratea. Kommentar zum Aratus des Germanicus Ms. Voss. Lat. Q. 79 Bibliotheek der Rijksuniversiteit Leiden*, B. Bischoff, B. Eastwood, T.A.-P. Klein, F. Mütherich, P.F.J. Hobbema (Luzern, 1989).

[19] C.R. Dodwell, *Painting in Europe 800–1200* (Pelican History of Art) (Harmondsworth, 1971), pp. 22–23.

[20] The Lorsch Gospels is divided between Vatican, B.A.V., Pal. Lat 50 and Batthyaneum Library, Alba Julia, Romania. For partial facsimile, see W. Braunfels, *The Lorsch Gospels* (New York, 1967). The Gospels written for *custos* Gero is Darmstadt, Hessische Landesbibliothek, Cod. 1948. The two manuscripts were exhibited together, *Karl der Grosse. Werk und Wirkung* (10th Council of Europe exhibition) (Aachen, 1965), nos 418 and 473, pls 58, 76.

[21] Temple, *Anglo-Saxon Manuscripts*, cats 48, 49, 50, 51.

[22] L.W. Jones, C.R. Morey, *The Miniatures of the Manuscripts of Terence Prior to the Thirteenth Century*, 2 vols (Princeton, 1931).

[23] Ms. Auct. D. 2.16. Pächt, Alexander, 1, no. 427. C.R. Morey, E.K. Rand, C.H. Kraeling, 'The Gospel-Book of Landévennec (the Harkness Gospels) in the New York Public Library', *Art Studies*, 8.2 (1931), 225–86, discussed the Harkness Gospels in the New York Public Library, Ms. 115, also from Landévennec. See also M. Huglo, 'Les Évangiles de Landévennec', *Landévennec et le monachisme Breton dans le haut*

Moyen Age. Actes du colloque du XVe centenaire de l'abbaye de Landévennec 25–27 avril 1985, ed. M. Simon (Landévennec, 1985), 245–51. More generally, see J.J.G. Alexander, 'La résistance à la domination culturelle carolingienne dans l'art Breton du IXe siècle: le témoignage de l'enluminure des manuscrits', *ibid.*, 269–80, and F. Wormald, *An Early Breton Gospel Book, a Ninth-Century Manuscript from the Collection of H.L. Bradfer-Lawrence*, ed. with 'Note on the Breton Gospel Books' by J.J.G. Alexander (Roxburghe Club, 1977).

[24] This type has been most recently discussed by M. Werner, 'On the Origin of Zoanthropomorphic Evangelist Symbols: The Early Christian Background', *Studies in Iconography*, 10 (1984–6), 1–35.

[25] Cambridge, University Library, Ms. L1.1.10. Alexander, *Insular Manuscripts*, cat. 66.

[26] Maeseyck, Church of St Catherine, Trésor, Gospels. Alexander, *Insular Manuscripts*, cat. 23. Vatican, B.A.V., Barberini lat. 570. Alexander, *Insular Manuscripts*, cat. 36.

[27] They are folios 72v and 146 respectively. Pächt, Alexander, 1, no. 433. R. Schilling, 'Two Unknown Flemish Miniatures of the Eleventh Century', *Burlington Magazine*, 90 (1948), 312–17, pls. *English Romanesque Art*, cat. 8.

[28] Paris, B.n., latin 14782. J.J.G. Alexander, 'A Little-Known Gospel Book of the Later Eleventh Century from Exeter', *Burlington Magazine*, 108 (1966), 6–16. Kauffmann, *Romanesque Manuscripts*, cat. 2. *English Romanesque Art*, cat. 9.

[29] See p. 10.

[30] E.g. Oxford, Bodl., Ms. Bodley 147. Pächt, Alexander, 1, no. 447, pl. XXXVII.

[31] Vatican, B.A.V., Barberini lat. 570. Alexander, *Insular Manuscripts*, cat. 36, fig. 173.

[32] Maeseyck, Church of St Catherine, Trésor, Gospels. Alexander, *Insular Manuscripts*, cat. 23, figs 104–7.

[33] Wormald, Alexander, as in note 23. Alexander, as in note 23.

[34] The Leofric Gospels is not the only example of Celtic images being supplemented; this also happens in an eighth- to ninth-century Irish Pocket Gospels, London, B.L., Add. 40618, to which an Anglo-Saxon artist added portaits in the mid tenth century. Alexander, *Insular Manuscripts*, cat. 46. Temple, *Anglo-Saxon Manuscripts*, cat. 15.

[35] H.G. Müller, *Hrabanus Maurus, de laudibus sanctae crucis* (Beiheft der Mittellateinischen Jahrbuch, 11), 1973. The text with its images continued to be copied for the rest of the Middle Ages and was also printed with woodcuts. See, for example, note 13, and for an overview, J. Adler, U. Ernst, *Text als Figur. Visuelle Poesie von der Antike bis zur Moderne*, exhibition catalogue (Wolfenbüttel, 1988).

[36] Vatican, B.A.V., Reg. lat. 124. The Vienna copy has been reproduced in facsimile. K. Holter, Kommentarband to *Hrabanus Maurus, de laudibus sanctae crucis (Codex Vindobonensis 652)* (Codices Selecti, XXXIII) (Graz, 1972). See also E. Sears, 'Louis the Pious as *Miles Christi*. The Dedicatory Image in Hrabanus Maurus's *De laudibus sanctae crucis*', *Charlemagne's Heir: New Perspectives on the Reign of Louis the Pious (814–840)*, eds P. Godman, R. Collins (Oxford, 1990), pp. 605–28.

[37] P. Bloch, 'Zum Dedikationsbild im Lob des Kreuzes des Hrabanus Maurus', *Das erste Jahrtausend. Kultur und Kunst im werdenden Abendland an Rhein und Ruhr*, Textband I, ed. V.H. Elbern (Düsseldorf, 1962), 471–94.

[38] Such as the Vercelli Codex, Bib. Cap., Cod. 148. Bloch, Abb. 16–17.

[39] 'Ille quidem facile rectitudinem in eo servare poterit quo linearum numerum caute rimatur et literarum dispositionem in eis diligentius custodit', *M.G.H. Ep. V*, 382, 5–7. In a later twelfth-century copy, Douai, Bib. mun., Ms. 340, the scribe, Rainaldus, excuses himself for making rectangular instead of square frames and, if anyone copies his manuscript, for this and any other mistakes. *Manuscrits à peintures* (1954), no. 153. See also Ch. 1, p. 16 and fig. 23.

[40] F. Wormald, 'Some Illustrated Manuscripts of the Lives of the Saints', *Bulletin of the John Rylands Library*, 35 (1952), 248–66, reprinted *Collected Writings, II*, eds J.J.G. Alexander, T.J. Brown, J. Gibbs (London, 1988), pp. 43–56, first drew attention to the number of illustrated lives produced in the eleventh and twelfth centuries. Recently they have been the subject of considerable scholarly interest. See M. Baker, 'Medieval Illustrations of Bede's Life of St Cuthbert', *Journal of the Warburg and Courtauld Institutes*, 41 (1978), 16–49. B. Abou-el-Haj, 'Consecration and Investiture in the Life of St Amand, Valenciennes Bibl. Mun. Ms. 502', *Art Bulletin*, 61 (1979), 342–58. B. Abou-el-Haj, 'Bury St Edmunds Abbey between 1070 and 1124: A History of Property, Privilege, and Monastic Art Production', *Art History*, 6 (1983), 1–29. M. Carrasco, 'Notes on the Iconography of the Romanesque Illustrated Manuscript of the Life of St Albinus of Angers', *Zeitschrift für Kunstgeschichte*, 47 (1984), 333–48. M. Carrasco, 'An Early Illustrated MS of the Passion of St Agatha (Paris Bib. Nat. Lat. 5594)', *Gesta*, 24 (1985), 19–32. M. Carrasco, 'Spirituality and Historicity in Pictorial Hagiography: Two Miracles by Saint Albinus of Angers', *Art History*, 12 (1989), 1–21. M. Carrasco, 'Spirituality in Context: The Romanesque Illustrated Life of St Radegund of Poitiers (Poitiers, Bibl. Mun., Ms. 250)', *Art Bulletin*, 72 (1990), 414–35. C. Hahn, 'Purification, Sacred Action, and the Vision of God: Viewing Medieval Narratives', *Word and Image*, 5 (1989), 71–84. C. Hahn, 'Picturing the Text: Narrative in the *Life* of the Saints', *Art History*, 13 (1990), 1–33. H. Kessler, 'Pictorial Narrative and Church Mission in Sixth-Century Gaul', *Studies in the History of Art* (National Gallery of Art, Washington DC), 16 (1985), 75–91.

[41] Bern, Burgerbibliothek, Cod. 264. O. Homburger, *Die illustrierten Handschriften der Burgerbibliothek Bern. Die vorkarolingischen und Karolingischen Handschriften* (Bern, 1962), pp. 136–58.

[42] C. Hahn, Kommentarband to *Kilians und Margaretenvita. Passio Kiliani, Ps. Theotimus, Passio Margaretae, Orationes (Hannover, Niedersächsische Landesbibliothek, Ms. I 189)* (Codices Selecti, LXXXIII) (Graz, 1988). C. Hahn, 1989 (as in n. 40).

[43] Abou-el-Haj, 1979 and 1983 (as in n. 40).

[44] M. Carrasco, 1984, 1989 (as in n. 40).

[45] Oxford, University College, Ms. 165, p. 63. Baker (as in n. 40), 1978.

[46] O. Pächt, *The Rise of Pictorial Narrative in Twelfth-Century England* (Oxford, 1962), pp. 14ff. Hahn, 1988, 1989 (as in n. 40) discusses this as a *topos* which demonstrates change effected by divine power, rather than as a means to a temporal narrative.

[47] Vatican, B.A.V., Vat. lat. 1202. *The Codex Benedictus: An Eleventh-Century Lectionary from Monte Cassino* (facsimile), (ed. P. Meyvaert, New York, 1982), especially pp. 33–57 'Art Historical Introduction to the Codex Benedictus' by P. Mayo.

[48] D.E. O'Connor, J. Haselock, 'The Stained and Painted Glass' in G.E. Aylmer, R. Cant, *A History of York Minster* (Oxford, 1977), 321–22, pl. 87.

[49] E. Kitzinger, 'Norman Sicily as a Source of Byzantine Influence on Western Art in the Twelfth Century', *Byzantine Art: An European Art* (Lectures given on the occasion of the Ninth Council of Europe Exhibition) ed. M. Chatzidakis, (Athens, 1966) 139–41.

[50] See Chs 2 and 3, pp. 51, 57, for the Harvard Aviary-Bestiary, the Vercelli Roll and the Joinville Credo. These, together with other surviving pattern books, are catalogued by R.W. Scheller, *A Survey of Medieval Model Books* (Haarlem, 1963), cats 11, 12, 13.

[51] Scheller's thirty-one entries start with two examples from Egypt, respectively of the first century BC and the fourth-sixth centuries AD. There is then a gap until the tenth century.

[52] B. Degenhart, 'Autonome Zeichnungen bei mittelalterlichen Künstlern', *Münchner Jahrbuch der bildenden Kunst*, 3 Folge 1 (1950), 93–158. Drawings of David anointed by Samuel and killing Goliath inserted by an Insular artist in the

eighth or ninth century on a flyleaf of a manuscript of Paulinus of Nola, St Petersburg, State and Public Library, Ms. Q.v.XIV.1 were published by O. Kurz, 'Ein Insulares Musterbuchblatt und die byzantinische Psalterillustration', *Byzantinisch-neugriechische Jahrbücher*, 14 (1938), 84–93, arguing they were intended as a record of a Byzantine David cycle. Alexander, *Insular Manuscripts*, cat. 42.

The practice continued in the later Middle Ages. See, for example, M. Michael, 'Some Early Fourteenth-Century English Drawings at Christ's College, Cambridge', *Burlington Magazine*, 124 (1982), 230–32 for fly-leaf drawings in Cambridge, Christ's College, Ms. 1. Also included in *Age of Chivalry*, no. 467. Or the St Christopher on a leaf in the Woodner Collection, *Master Drawings* (as in Ch. 6, n. 10), no. 38, as Austrian or Bohemian (?), *c.* 1340.

53 Malibu, J. Paul Getty Museum, Ms. Ludwig Folia 1. Formerly in the von Hirsch collection, then Ludwig, not included by Scheller, *Model Books*. Von Euw, Plotzek, *Ludwig*, 1, 15–18.

54 Kassel, Landesbibliothek, Ms. Astron. F.2. A. Boeckler, *Der Codex Wittekindeus* (Leipzig, 1938), p. 23, Taf. XXXIIIc.

55 The manuscript is now divided between Paris, B.n., latin 8318 and Vatican, B.A.V., Reg. lat. 596. Foliage designs and drawings of the *Sepulchrum domini*, folio 64v of Paris and folios 27 r,v of Vatican. Scheller, *Model Books*, cat. 3, as France (Loire region?). Bischoff, 'Die Uberlieferung' (as in Ch. 2, n. 43), pp. 290–3, Abb. 6–8, corrects the date. E. Vergnolle, 'Un carnet de modèles de l'an mil originaire de Saint-Benôit-sur-Loire (Paris, B.N. lat. 8318 + Rome, Vat. Reg. lat. 596)', *Arte Medievale*, 2 (1984), 23–56. For the colour notes, see also Petzold (as in Ch. 2, n. 57).

56 Paris, B.N., latin 1087, folio 65v. The ornament is inserted after the text on the lower blank three-quarters of the folio. M. Schapiro, *The Parma Ildefonsus. A Romanesque Illuminated Manuscript from Cluny and Related Works* (New York, 1964), 3, 5, 33, fig. 43.

57 Leiden, Bibliotheek der Rijkuniversiteit, Voss. Lat. Oct.15. Scheller, *Model Books*, cat. 4. D. Gaborit Chopin, 'Les dessins d'Adémar de Chabannes', *Bulletin Archéologique*, n.s. 3 (1967), 163–226.

58 Also pp. 115, 163.

59 The term 'modulus' was used by F. Deuchler, *Der Ingeborgpsalter* (Berlin, 1965), passim and especially pp. 125–7, for figures re-used in this way in different contexts (and often reversed) in the Ingeborg Psalter, Chantilly, Musée Condé, Ms. 1695, North France or Paris, early thirteenth century.

60 Vatican, B.A.V., Vat. lat. 1202. Troyes, Bib. mun., Ms. 2273, from S. Maur-des-Fossés, Paris. New York, Morgan, M. 641. Valenciennes, Bib. mun., Ms. 502. J.J.G. Alexander, *Norman Illumination at Mont St Michel 966–c.1100* (Oxford, 1970), pp. 138–42, pls 34 a, b, c, d, f.

61 J.W. Clark, ed., transl., *The Observances in Use at the Augustinian Priory of St Giles and St Andrew at Barnwell, Cambridgeshire* (Cambridge, 1897) (edn of B.L. Harley 3601 dated 1295–6). For the duties of the librarian ('armarius'), see pp. 63–9. Though most of the Customaries are late in date, they probably codify earlier practice. Clark, pp. xxxviii–xlvii, points out that the Barnwell library regulations are similar, though fuller, to those of S.-Victor at Paris, which he prints in parallel, pp. xlii–xlvi. Useful information on the organisation of the libraries and the procurement of books in the English secular cathedrals is contained in K. Edwards, *The English Secular Cathedrals in the Middle Ages; A Constitutional Study With Special Reference to the Fourteenth Century* (Manchester, 1949), (2nd edn, Manchester, New York, 1967), pp. 210–14.

62 F. Wormald, 'The Monastic Library', *The English Library Before 1700*, eds F. Wormald, C.E. Wright (London, 1958), pp. 15–31 (reprinted *Gatherings in Honor of Dorothy Miner*, eds U. McCracken, L.M.C. Randall, R.H. Randall, Baltimore, 1974, 93–9). A good example of such a colophon is that of Ingelardus, monk of St Germain-des-Prés, who works as illuminator at the order of Prior Siguinus and Abbot Adraldus (*c.* 1030–1060) in Paris, B.n., latin 11751, folio 145v.

> Abbatis domni nutu, probitate decori,
> Adraldi, monachus quidam prior, arte modestus,
> Libris intentus, horum preparator amenus,
> Siguinus librum scribi preceperat istum.
> Quem si quis tulerit maledictus fine peribit.
> Hunc Ingelardus decoravit scriptor honestus.

See Y. Deslandres, 'Les manuscrits décorés au XIe siècle à Saint-Germain-des-Prés par Ingelard', *Scriptorium*, 9 (1955), 3. Unlike Deslandres, I take this to mean that Ingelardus was also a scribe. See also M.B. Parkes, *The Scriptorium of Wearmouth-Jarrow* (Jarrow Lecture, 1982), p. 22: 'The basis of the scribal discipline was monastic discipline'.

63 Solothurn, St Ursenkathedrale, Domschatz. P. Bloch, *Das Hornbacher Sakramentar und seine Stellung innerhalb der frühen Reichenauer Buchmalerei* (Basel, 1956), Taf. 1–4. *Ornamenta Ecclesiae*, 1, p. 150 and colour pls on pp. 140–41. See also Bloch as in n. 37, J. Prochno, *Das Schreiber- und Dedikationsbild in der deutschen Buchmalerei, 1 Teil. 800–1000* (Leipzig and Berlin, 1929), and M. Schapiro, *The Parma Ildefonsus. A Romanesque Illuminated Manuscript from Cluny and Related Works* (New York, 1964), pp. 38–40. Such scenes perfectly illustrate what L.K. Little, *Religious Poverty and the Profit Economy in Medieval Europe* (London, 1978), terms the 'gift economy'.

64 Durham, Dean and Chapter Library, Ms. B.II.13. See Ch. 1, n. 59.

65 Boulogne-sur-mer, Bib. mun., Ms. 9, folio 1. S. Schulten, 'Die Buchmalerei des 11. Jahrhunderts im Kloster St Vaast in Arras', *Münchner Jahrbuch der bildenden Kunst*, 3 Folge 7 (1956), 83–4, Taf. 52.

66 Paris, B.n., latin 946. V. Leroquais, *Les Pontificaux manuscrits des bibliothèques publiques de France*, 2 (Paris, 1937), pp. 21–6, pl. XVIII.

67 *Manuscrits Normands XIe–XIIe* siècles, catalogue by F. Avril (Bibliothèque municipale de Rouen, 1975).

68 For the travels in the early eleventh century to nearby monasteries in Bavaria to copy manuscripts of Ellinger, monk and later Abbot of Tegernsee, see E.F. Bange, as in Ch. 1, n. 39, pp. 8–9.

69 J.J.G. Alexander, 'A Romanesque Copy from Mont St Michel of an Initial in the Corbie Psalter', *Millénaire monastique du Mont Saint-Michel*, 2, ed. R. Foreville (Paris, 1967), 241–4. Alexander, as in n. 60, p. 53, pl. 53c,d.

70 Paris, B.n., latin 13392, folio 43. Passionary. First quarter twelfth century. C. de Mérindol, *La production des livres peints à l'abbaye de Corbie au XIIe siècle. Etude historique et archéologique*, 1 (Université de Lille, 1976), pp. 393–404, fig. 41. *Id.*, 'Les peintres de l'abbaye de Corbie au XII siècle', *Artistes*, 1, 311–37.

71 M. Schapiro, 'On the Aesthetic Attitude in Romanesque Art', *Art and Thought: Issued in Honor of Dr Ananda Coomaraswamy on the Occasion of his 70th birthday* (ed. K. Bharatha Iyer, 1947), pp. 130–50. Reprinted *Romanesque Art. Selected Papers* (New York, 1977), pp. 1–27. Schapiro perhaps goes too far in claiming almost an 'art for art's sake' attitude in the twelfth century. See also his less well-known paper 'Diderot on the Artist and Society', *Diderot Studies*, 5 (1964), 5–11. And further, in addition to works cited in Ch. 1, n. 8, J. Guilmain, 'The Forgotten Early Medieval Artist', *Art Journal*, 25 (1965), 33–42 and W. Cahn, 'The Artist As Outlaw and Apparatchik: Freedom and Constraint in the Interpretation of Medieval Art', *The Renaissance of the Twelfth-century*, ed. S. Scher (Providence, 1969), 10–14.

72 Paris, B.n., latin 12054, folio 156v. *Manuscrits à peintures* (1954), no. 241. London, B.L., Add. 18297, folio 3, apparently unpublished.

73 Z. Jacoby, 'The Beard Pullers in Romanesque Art: An Islamic Motif and Its Evolution in the West', *Arte Medievale*, 1 (1987), 65–85. F.M. Besson, '"A armes égales": une

représentation de la violence en France et en Espagne au XII siècle', *Gesta*, 26/2 (1987), 113–26.

[74] See H. Mayr-Harting, *The Venerable Bede, the Rule of St Benedict and Social Class* (Jarrow Lecture, 1976), pp. 2–3.

[75] Oxford, Bodl., Ms. Auct. E. inf. 1, folio 304. Kauffmann, *Romanesque Manuscripts*, cat. 82. For Romanesque initials more generally, see Alexander, *Decorated Letter*.

[76] A number of recent studies have aimed to show how this was done. See, most recently, R.D. Stevick, 'The 4 × 3 crosses in the Lindisfarne and Lichfield Gospels', *Gesta*, 25/2 (1986), 171–84 and 'The Shapes of the Book of Durrow Evangelist-Symbol Pages', *Art Bulletin*, 68 (1986), 182–94 with references to earlier literature.

[77] U. O'Meadhra, *Early Christian, Viking and Romanesque Art: Motif-Pieces From Ireland* (Stockholm, 1979) with volume 2, *A Discussion* (Stockholm 1987). Also 'Irish, Insular and Scandinavian Elements in the Motif-Pieces from Ireland', *Ireland and Insular Art A.D. 500–1200*, ed. M. Ryan (Dublin, 1987), pp. 159–65. These again can be compared to the *probationes pennae* referred to p. 76.

[78] *Theophilus, On Divers Arts*, ed., transl. C.R. Dodwell (London, 1961; 2nd edn Oxford, 1986).

[79] See the important article from which this quote is taken (p. 151) by J. van Engen, 'Theophilus Presbyter and Rupert of Deutz: The Manual Arts and Benedictine Theology in the Early Twelfth Century', *Viator*, 11 (1980), 147–63. Van Engen draws attention to the writings of the theologian, Rupert of Deutz (*c*. 1075–1129), as providing a theoretical underpinning for this enhanced view of the value of manual labour.

[80] Cambridge, Fitzwilliam Museum, Ms. 83.1972. M. Gullick, *A Working Alphabet of Initial Letters From Twelfth-Century Tuscany. A Facsimile of Cambridge, Fitzwilliam Museum, Ms. 83.1972* (Hitchin, 1979). For a second alphabet, contained on two folios of Philadelphia, Free Library, Ms. Lewis 22, see M. Gullick, *Working Alphabet of Initial Letters from Twelfth-Century Spain* (Hitchin, 1987).

CHAPTER 5

[1] For the Bibles, see Cahn, *Romanesque Bible*. Chapter vii, 'The Artists and Their Patrons', is devoted to an account of the methods of production of these manuscripts. For a detailed description of the making of a single Romanesque Bible, see A. Cohen-Mushlin, *The Making of a Manuscript. The Worms Bible of 1148 (British Library, Harley 2803–4)* (Wiesbaden, 1983) (review by S. Hindman, *Zeitschrift für Kunstgeschichte*, 48 (1985), 562–6). No up-to-date overview of the Psalters exists. For the thirteenth century, see G. Haseloff, *Die Psalterillustration im 13. Jahrhundert. Studien zur Geschichte der Buchmalerei in England, Frankreich und den Niederländen* (Kiel, 1938).

[2] For the story, see W. Oakeshott, *The Two Winchester Bibles* (Oxford, 1981). For the Latin text, Lehmann-Brockhaus, 2, nos 4828–9. Oakeshott argued that the Bible given was Oxford, Bodl., Ms. Auct. E. inf. 1–2, not the even more magnificent Bible still at Winchester Cathedral. Henry also gave Hugh money to buy books. For further literature on the two Bibles, see Kauffmann, *Romanesque Manuscripts*, cats 82, 83 and 84, and *English Romanesque Art 1066–1200*, cats 63, 64, 65. See also pp. 39, 40.

[3] London, B.L., Cotton Nero C.IV. F. Wormald, *The Winchester Psalter* (London 1973). K.E. Haney, *The Winchester Psalter: An Iconographic Study* (Leicester, 1986). Kauffmann, *Romanesque Manuscripts*, cat. 78. For arguments against it having been made for Henry of Blois, Bishop of Winchester, see T.A. Heslop, 'Romanesque Painting and Social Distinction: The Magi and the Shepherds', *England in the Twelfth Century (Proceedings of the 1988 Harlaxton Symposium)* ed. D. Williams (Woodbridge, 1990), pp. 150–1, n. 32.

[4] See Kauffmann for an overview of the overlaps and dissimilarities among the English twelfth-century surviving Psalter cycles.

[5] W. Cahn, 'St Albans and the Channel Style in England', *The Year 1200. A Symposium* introd. J. Hoffeld (Metropolitan Museum, New York, 1975), pp. 187–230.

[6] The Simon Master works in the Bible, Cambridge, Corpus Christi College, Ms. 48, and the other artist in a New Testament with Abbot Simon's donor inscription, Cambridge, St John's College, Ms. 183. See Cahn (as in note 5), pp. 192–3, figs 16–19, describing the other artist as 'a secondary figure of the workshop' and as 'archaising in a pedestrian Romanesque vein'.

[7] Oxford, Bodl., Ms. Laud Misc. 752. J.M. Shepperd, 'Notes on the Origin and Provenance of a French Romanesque Bible in the Bodleian', *Bodleian Library Record*, 11/5 (1984), 284–99.

[8] For the self-portraits of Godfroi, Canon of Saint-Victor, in Paris, Bibliothèque Mazarine, Ms. 1002, see F. Gasparri, 'Godefroid de Saint-Victor: une personnalité peu connue du monde intellectuel et artistique Parisien au XIIe siècle' *Scriptorium*, 39 (1985), 57–69, pl. 9. They show a very modest artistic ability.

[9] M. Schapiro, 'From Mozarabic to Romanesque in Silos', *Art Bulletin*, 21 (1939), 312–74. Reprinted *Selected Papers. Romanesque Art* (New York, 1977), pp. 28–101. M. Schapiro, *The Parma Ildefonsus* (New York, 1964). T.A. Heslop (as in n. 3) has pointed out how stylistic variation can also be used as a signifier, of social status for example.

[10] F. Wormald, 'A Medieval Description of Two Illuminated Psalters', *Scriptorium*, 6 (1952), 18–25. For example, for the second miniature in the Psalters, the text reads: 'Sequitur Nativitas. Maria in lecto, puer in presepio et bos et asinus. Joseph ad pedes, lampas desuper, in Sigardi (psalterio); sed in Leoberti psalterio appositi sunt duo angeli super lampadem'. For each miniature, a Latin couplet is also transcribed. For thirteenth-century programmes of Psalter illustration, see also Ch. 3, p. 54.

[11] I. Ragusa, 'An Illustrated Psalter from Lyre Abbey', *Speculum*, 46 (1971), 267–81. L.M. Ayres, 'Problems of Sources for the Iconography of the Lyre Drawings', *Speculum*, 49 (1974), 61–8.

[12] O. Demus, *Byzantine Art and the West* (New York, 1970).

[13] There is, however, no Western equivalent of the Painter's Manual laying down exact directions for the representation of Christian scenes which are as it were here codified and can be followed in surviving works of art. P. Hetherington, *The 'Painter's Manual' of Dionysius of Fourna* (London, 1974). Even if some attempts were made in the West, for example, in the *Pictor in Carmine*, a Cistercian text, perhaps written by Adam of Dore (fl. 1200), they never achieved widespread authority. M.R. James, 'Pictor in Carmine', *Archaeologia*, 94 (1951), 141–66. Edn by K.-A. Wirth, *Pictor in Carmine. Ein Handbuch der Typologie aus dem 12. Jahrhundert. Nach der Handschrift des Corpus Christi College in Cambridge, Ms. 300* (Berlin, 1989).

[14] See Ch. 4, pp. 85–7, 168n. 49.

[15] Freiburg i. Br., Augustinermuseum, Inv. Nr. G 23/1a and Scheller, *Model Books*, cat. 7. *Ornamenta Ecclesiae*, I, p. 316 (B. 89).

[16] Wolfenbüttel, Biblioteca Augusta, Cod. 61.2 Aug. 8⁰. Scheller, *Model Books*, cat. 8. H. Buchthal, *The 'Musterbuch' of Wolfenbüttel and Its Position in the Art of the Thirteenth Century* (Vienna, 1979). The drawings are on twelve folios incorporated in a thirteenth-century manuscript, folios 78r,v, 89r,v, 90r,v, 91r,v, 92r,v, 93r,v. Slightly later a text of William of St Thierry, *Epistola ad fratres de Monte Dei*, was copied over the drawings. Only folio 89 remained untouched.

[17] Vatican, B.A.V., Vat. lat. 1976, folios I–II. D.J.A. Ross, 'A Later Twelfth-Century Artist's Pattern-sheet', *Journal of the Warburg and Courtauld Institutes*, 25 (1962), 119–28.

[18] E. Panofsky, *Abbot Suger on the Abbey Church of St.-Denis and Its Art Treasures*, 2nd edn by G. Panofsky-Soergel, (Princeton, 1979). *Abbot Suger and Saint-Denis. A Symposium* ed. P.L. Gerson (Metropolitan Museum of Art, New York,

1986). C. Rudolph, *Artistic Change at St-Denis: Abbot Suger's Program and the Early Twelfth-century Controversy Over Art* (Princeton, 1990); *The 'Things of Greater Importance'. Bernard of Clairvaux's Apologia and the Medieval Attitude Toward Art* (Philadelphia, 1990).

[19] For the Statutes, see C. Holdsworth, 'The Chronology and Character of Early Cistercian Legislation on Art and Architecture', *Cistercian Art and Architecture in the British Isles*, eds C. Norton, D. Park (Cambridge, 1986), pp. 40–55. See also C.H. Talbot, 'The Cistercian Attitude Towards Art: The Literary Evidence', *ibid.*, pp. 56–64. For the distinction between theory and practice, especially in the French context, however, see W. Cahn, 'The *Rule* and the Book. Cistercian Book Illumination in Burgundy and Champagne', *Monasticism and the Arts*, ed. T.G. Verdon (Syracuse, 1984), pp. 139–72. For 'Pictor in Carmine' see n. 13.

[20] See Alexander, *Scribes as Artists*, pp. 106–7; A. Lawrence, 'English Cistercian Manuscripts of the Twelfth Century', *Cistercian Art* (as in n. 19), pp. 284–98, pls 178–89.

[21] Vienna, O.N.B., Cod. 507. Scheller, *Model Books*, cat. 9. F. Unterkircher, *Reiner Musterbuch*, Faksimile-ausgabe, Graz, Codices Selecti, LXIV, LXIV*, 1979. E. Frodl-Kraft, 'Das "Flechtwerk" der frühen Zisterzienserfenster', *Wiener Jahrbuch für Kunstgeschichte*, 20 (1965), 10, has similarly observed of Cistercian stained glass that local traditions are less important than the tradition of the Order.

[22] *Saint Bernard et l'art des Cisterciens* (exhibition catalogue, Dijon, 1953), nos 104–7.

[23] Heiligenkreuz, Stiftsbibliothek, Cod. 226, folio 149v, *c.* 1200. F. Walliser, *Cistercienser Buchkunst. Heiligenkreuzer Skriptorium in seinem ersten Jarhrhundert 1133–1230* (Heiligenkreuz, Vienna, 1969), pp. 2, 4–5, 41–2, Abb. 93–6. Oxford, Bodl., Ms. Bodley 188, mid thirteenth-century. It has a fifteenth-century ownership mark of the Augustinian Priory of Haughmond, Shropshire. Pächt, Alexander, 3, no. 423, pl. XXXV. An Italian copy of *c.* 1300 is Oxford, Bodl., Ms. Lyell 71. Pächt, Alexander, 2, cat. 144, pl. XIV, and for a detailed description referring to other manuscripts with the cycle of illustrations, see A.C. de la Mare, *Catalogue of the Collection of Medieval Manuscripts Bequeathed to the Bodleian Library, Oxford, by James P.R. Lyell* (Oxford, 1971), pp. 211–16. These 'Rotae verae religionis' were obviously based on the Wheel of Fortune iconography.

[24] C. de Clercq, 'Le rôle de l'image dans un manuscrit médiéval (Bodleian, Lyell 71)', *Gutenberg-Jahrbuch* (1962) 23–30. *Id.*, 'Hugues de Fouilloy, imagier des ses propres oeuvres', *Revue du Nord*, 45 (1963), 31–41. See also W.B. Clark, 'The Illustrated Medieval Aviary and the Lay-Brotherhood', *Gesta*, 21 (1982), 63–74. W.B. Clark, 'Three Manuscripts for Clairmarais; A Cistercian Contribution to Early Gothic Figure Style', *Studies in Cistercian Art and Architecture. III*, ed. M.P. Lillich (Kalamazoo: Cistercian Publications, 1987), 97–110. Two further thirteenth-century manuscripts of the text, neither with certain provenance, are now in the J. Paul Getty Museum, Malibu, Ludwig XV. 3 and XV. 4. See von Euw, Plotzek, *Ludwig*, 4, pp. 172–206, Abb. 66–97.

[25] C.F.R. de Hamel, *Glossed Books of the Bible and the Origins of the Paris Booktrade* (Woodbridge, 1984).

[26] Malibu, J. Paul Getty Museum, Ms. Ludwig XIV. 2. Gratian, Decretum. See von Euw, Plotzek, *Ludwig*, 4, pp. 41–8, for a judicious summary of the state of research on the origins of the style. For discussions of illumination in Paris in the early thirteenth century, see also Ch. 1, n. 88. Much uncertainty remains, however, as to where and how illuminated manuscripts were made in the early period in Paris.

[27] L. Light, 'Versions et révisions du texte biblique', *Bible de tous les temps, 4. Le Moyen Age et la Bible*, ed. P. Riché. G. Lobrichon (Paris, 1978), pp. 55–93.

[28] See Branner, *Manuscript Painting*, and Ch. 1, pp. 22–3, 154, n. 89.

[29] Morgan, *Early Gothic Manuscripts (1)*, pp. 22–3. L. Eleen, *The Illustration of the Pauline Epistles in French and English Bibles*

of the Twelfth and Thirteenth Centuries (Oxford, 1982).

[30] Cambridge, Trinity College, Ms. R. 17.1 Kauffmann, *Romanesque Manuscripts*, cat. 68. Paris, B.n., latin 8846. Morgan, *Early Gothic Manuscripts (1)*, cat. 1. C.R. Dodwell, 'The Final Copy of the Utrecht Psalter and Its Relationship with the Utrecht and Eadwine Psalters', *Scriptorium*, 44 (1990), 21–53.

[31] London, B.L., Cotton Titus D. XVI, Prudentius. Kauffmann, *Romanesque Manuscripts*, cat. 30. Oxford, Bodl., Ms. Auct. F. 2.13. *Ibid.*, cat. 73.

[32] Oxford, Bodl. Ms. Douce 192. Pächt, Alexander, 1, no. 485. See Ch. 4. pp. 83–4.

[33] Oxford, Bodl., Ms. Auct, D. 2.1. Psalter with commentary of Gilbert de la Porée, probably from Llanthony Abbey. Pächt, Alexander, 3, no. 226, pl. XXII. Oxford, Trinity College, Ms. 58, same text, no early provenance. Alexander, Temple, no. 88, pl. VI.

[34] The first pair are New York, Morgan, M. 524 and Oxford, Bodl., Ms. Auct. D. 4.17. Morgan, *Early Gothic Manuscripts (1)*, cats 122, 131. The second pair are Oxford, Bodl., Ms. Douce 180 and Paris, B.n., latin 10474. *Ibid.*, cats 153, 154.

[35] Aberdeen, University Library, Ms. 24. Oxford, Bodl., Ms. Ashmole 1511. Morgan, *Early Gothic Manuscripts (1)*, cats 17, 19. X. Muratova, 'Etude du Manuscrit', *Bestiarium* (Paris, Club du livre, 1984), 13–55. Also n. 37.

[36] B. Degenhart, A. Schmitt, 'Marino Sanudo und Paolino Veneto. Zwei Literaten des 14. Jahrhunderts in ihrer Wirkung auf Buchillustrierung und Kartographie in Venedig, Avignon und Neapel', *Römisches Jahrbuch für Kunstgeschichte*, 14 (1973), 3–137. For other multiple copies, see Ch. 6, p. 138.

[37] X. Muratova, 'Workshop Methods in English Late Twelfth-century Illumination and the Production of Luxury Bestiaries', *Beasts and Birds of the Middle Ages. The Bestiary and Its Legacy*, eds W.B. Clark, M.T. McMunn (Philadelphia, 1989), pp. 53–68, figs 3.2–3.4. Dr Muratova's other studies of Bestiary illustration are conveniently listed there. See also, in the present context, especially 'Les manuscrits frères: un aspect particulier de la production des Bestiaires enluminés en Angleterre à la fin du XIIe et au début du XIIIe siècle', *Artistes*, 3, 69–92, discussing the Bestiaries in St Petersburg, Public Library, Ms. Q.v.V.1 and New York, Morgan, M. 81. My own observations on the relationships of the Aberdeen and Ashmole Bestiaries were made independently, and I am therefore glad to find myself substantially in agreement with Dr Muratova's conclusions. I also had the opportunity to read a study of the Aberdeen Bestiary kept in typescript in the University Library: S.G. Forest, *The Aberdeen Bestiary* (1978–9).

[38] Folios 11, Man in scene with Hyena, 12v Monkeys, 37 Archer in the scene with the Magpie, 36v Hoopoo, 59 Ducks, 66v Viper, 68v Amphisbaena. Cf. Muratova, 1989, n. 25 and Ch. 2, n. 94, for pricked miniatures.

[39] See Chapter 2, pp. 42–6. There are also colour notes in Ashmole, for example, folios 50v, 63v and possibly 70v 'a' and on folio 69v and 71 'R'.

[40] Folios 44v, 68v. Muratova, 1989, pp. 55–6.

[41] Bern, Burgerbibliothek, Cod. 318. O. Homburger, *Die illustrierten Handschriften der Burgerbibliothek Bern* (Bern, 1962), pp. 101–17. For Bestiary illustration, see M.R. James, *The Bestiary being a Reproduction in Full of the Manuscript Ms. Ii. 4.26 in the University Library, Cambridge* (Roxburghe Club, 1928). F. McCulloch, *Medieval Latin and French Bestiaries* Chapel Hill, 1962). X. Muratova as in n. 37 and especially 'Problèmes de l'origine et des sources des cycles d'illustrations des manuscrits des Bestiaires', *Epopée animale, fable, fabliau. Actes du IVe Colloque de la Société Internationale Renardienne (Evreux, 1981)*, eds G. Bianciotto, M. Salvat (Paris, 1984).

[42] Morgan, *Early Gothic Manuscripts (1)*, p. 23.

[43] M.R. James, *The Apocalypse in Art* (London, 1931).

[44] See important studies by P. Klein, *Endzeiterwartung und Ritterideologie. Die englische Bilderapokalypsen der Frühgotik und MS Douce 180* (Graz, 1983). S. Lewis, 'Giles de Bridport and

the Abingdon Apocalypse', *England in the Thirteenth Century* (Proceedings of the 1984 Harlaxton Symposium), ed. W.M. Ormrod (Harlaxton, 1985), 107–119, and *'Tractatus adversus Judaeos* in the Gulbenkian Apocalypse', *Art Bulletin*, 68 (1986), 543–66. Morgan, *Early Gothic Manuscripts (2)*, pp. 16–19. N. Morgan, M. Brown, *The Lambeth Apocalypse Ms. 209 in the Collection of the Archbishop of Canterbury at Lambeth Palace* (facsimile) (London, 1990).

[45] A *corpus* publication is in preparation by John Williams. Until it appears, see his *Early Spanish Manuscript Illumination* (New York, 1977) and W. Neuss, *Die Apokalypse des Hl. Johannes in der altspanischen und altchristlichen Bibel-Illustration* 2 vols (Münster in Westfalen, 1931).

[46] Cambridge, Trinity College, Ms. R. 16.2. P.H. Brieger, *The Trinity Apocalypse* (colour facsimile) (London, 1967). Morgan, *Early Gothic manuscripts (2)*, cat. 110.

[47] K. Weitzmann, *Illustrations in Roll and Codex: A Study of the Origin and Method of Text Illustration* (Princeton, 1947), rev. edn 1970. Also papers collected in *Studies in Classical and Byzantine Manuscript Illumination*, ed. H.L. Kessler (Chicago, London, 1971).

[48] F. Avril, 'Les manuscrits enluminés de Guillaume de Machaut. Essai de chronologie', *Guillaume de Machaut. Colloque. Table Ronde organisé par l'Université de Reims* (Paris, 1982), pp. 117–33. Also on the necessity of the art historian and the philologist working together, see G. Pinkernell, 'Die Handschrift B.N. fr. 331 von Raoul Lefèvre's "Histoire de Jason" und das Wirken des Miniaturisten Lievin van Lathem in Brügge', *Scriptorium*, 27 (1973), 295–301.

[49] Morgan, *Early Gothic Manuscripts (1)*, pp. 30–31 and cats 85, 87, 89, 91, 92, 93. S. Lewis, *The Art of Matthew Paris in the 'Chronica Majora'* (Berkeley, 1987). R. Vaughan, *Matthew Paris* (Cambridge 1958; repr. 1979) argued the more inclusive view against M. Rickert, *Painting in Britain. The Middle Ages* (2nd edn, Harmondsworth, 1965), pp. 108–10.

[50] Dublin, Trinity College, Ms. 177 (E.i. 40). Morgan, *Early Gothic Manuscripts (1)*, cat. 85. W.R.L. Lowe, E.F. Jacob, M.R. James, *Illustrations to the Life of St Alban in Trin. Coll. Dublin MS. E.I.40* (Oxford, 1924) (black-and-white reproduction of all miniatures).

[51] Oxford, Bodl., Ms. Auct. F.2.13. The Terence's illustrations are reproduced by L.W. Jones, C.R. Morey, *The Miniatures of the Manuscripts of Terence Prior to the Thirteenth Century*, 2 vols (Princeton, 1931).

[52] See Ch. 1, p. 9.

[53] Cambridge, Corpus Christi College, Ms. 26, p. 283. Lewis, pp. 471–2, argues that this and other leaves served as a pattern book. Rickert (as in n. 49) had already suggested that these subjects copied monumental paintings with a suggestive comparison to the wall paintings surviving at Winchester Cathedral, pp. 114–15, pls 112–13.

[54] London, B.L., Cotton Nero D.1, folio 156. Morgan, *Early Gothic Manuscripts (1)*, cat. 87b, fig. 297.

[55] E.g. in topographical works of Giraldus Cambrensis, in a twelfth-century copy of Florence of Worcester, in the roll Chronicles of Peter of Poitiers and in a copy of Henry of Huntingdon. See Morgan, *Early Gothic Manuscripts (1)*, pp. 24–5 and Lewis, *passim*.

[56] A. Melnikas, *The Corpus of the Miniatures in the Manuscripts of Decretum Gratiani*, 3 vols (Rome, 1975). F. Ebel, A. Fijal, G. Kocher, *Römisches Rechtsleben im Mittelalter. Miniaturen aus den Handschriften des Corpus juris civilis* (Heidelberg, 1988).

[57] Paris, B.n., latin 8824. Psalter, second quarter eleventh century. Temple, *Anglo-Saxon Manuscripts*, cat. 83, ills 208–9.

[58] Oxford, Bodl., Ms. Ashmole 1525. Pächt, Alexander, 3, no. 355, an early thirteenth-century Psalter from St Augustine's, Canterbury.

[59] Lewis, pp. 246–7.

[60] J.J.G. Alexander, '*Labeur* and *Paresse*: Ideological Images of Medieval Peasant Labour', *Art Bulletin*, 72 (1990), 437–8.

[61] See Ch. 4, pp. 85–9.

[62] Cambridge, Corpus Christi College, Ms. 16, folios 169 and 144. James, pls XV, XVII. Lewis, figs 133, 179. This differs from the other falling figure used in volume 3 of the Chronicle for the same scene of Griffin falling, London, B.L., Royal 14 C. VII, folio 136, James, pl. XX, Lewis, fig. 134, which is essentially the same as that used in the Life of St Cuthbert (figs 137–38).

[63] B. Kurth, 'Matthew Paris and Villard d'Honnecourt', *Burlington Magazine*, 81 (1942), 227–8. Villard's model book is Paris, B.n., fr. 19093. H.R. Hahnloser, *Villard de Honnecourt. Kritische Gesamtausgabe des Bauhüttenbuches ms. fr. 19093 der Pariser Nationalbibliothek* (2nd rev. edn, Graz, 1972). Scheller, *Model Books*, cat. 10.

[64] See Ch. 3, p. 65, for Villard's geometric schemata for human figures.

[65] Manchester, John Rylands University Library, French 1. C.E. Pickford, 'An Arthurian Manuscript in the John Rylands Library', *Bulletin of the John Rylands Library*, 31 (1948), 318–44. R.S. and L.H. Loomis, *Arthurian Legends in Medieval Art* (New York, 1938), pp. 97–8, pls 237–8, 240.

[66] Amsterdam, Biblioteca Philosophica Hermetica (J.R. Ritman library), BPH 1 (3 vols). Sold by H.P. Kraus, New York, *Cimelia. Catalogue 165* (New York, 1983), no. 3. See A. Stones, 'Indications', as in Ch. 2, n. 61, p. 323, n. 10, and *Illuminated Manuscripts in Dutch Collections. Preliminary Precursor. Part I* (A. Korteweg *et al.*, Koninklijke Bibliotheek, The Hague, 1989), pp. 7–9. One volume contains the Estoire del Saint-Graal (formerly Phillipps 1047) and two others (formerly Phillipps 3630) contain Merlin and parts of Lancelot. For the Estoire, see E. Remak-Honnef, *Text and Image in the 'Estoire del Saint Graal'. A Study of London British Library Ms. Royal 14 E. iii* (University of North Carolina at Chapel Hill, unpublished Ph.D., 1987), passim and especially pp. 184–95.

[67] Oxford, Bodl., Ms. Douce. 215. Pächt, Alexander, 1, no. 571, pl. XLIII. A. Stones, 'Short Note on Manuscripts Rylands French 1 and Douce 215', *Scriptorium*, 22 (1968), 42–5. A. Stones, 'Another Short Note on Rylands French 1', *Romanesque and Gothic: Essays for George Zarnecki*, ed. N. Stratford (Woodbridge, 1987), 185–92. Some leaves of 'Lancelot' are included in one of the Ritman manuscripts.

[68] Pickford, p. 18: 'ensi que li chevalier de la table reonde se sieent au disner et uns chevaliers sest assis ou siege perilleus et foudres et fus est chaus sour lui et la tout ars et li rois et la royne sieent a une autre table'.

[69] Pickford, p. 20, rubric: 'Chi jouste estoit du mares devant la fontaine et les arbres ou li hyaumes pendent'; Instruction, four lines of only partly legible script: 'attaint che ... lettres escrites ... vont ... chaust(?) ...'.

[70] Pickford, p. 20, gives the rubric: 'Ensi que lancelos encon [tra] une damoisele en une forest qui plouroit et dementoit mout fort'; and direction (only partly legible): '... lancelot encontra ... a ... le qui chevauchoit'.

[71] R. Koechlin, *Les ivoires gothiques français*, 2 (Paris, 1924), pp. 375–81, nos 1020, 1026, 1027, 1028, 1034, pls CLXXVII-IX. For the ivory illustrated, Koechlin no. 1026, British Museum, Department of Medieval and Later Antiquities, 56, 6–23, 103, see also O.M. Dalton, *Catalogue of the Ivory Carvings of the Christian Era ... of the British Museum* (London, 1909), no. 377, pl. LXXXVIII.

[72] E.g. Blackburn Museum and Art Gallery, Hart 29060, folio 3v. French, second quarter thirteenth century. For this and other examples, see M. Camille, *The Gothic Idol. Ideology and Image-Making in Medieval Art* (Cambridge, 1989), ill. 1, etc.

[73] Hahnloser (as in n. 63), Taf. 46.

[74] Stones 'Indications' (as in Ch. 2, n. 61) traces the use of another motif, the hermit in the tree, pp. 323–5, pls 7–9.

[75] M.A. Stones, *The Illustration of the French Prose Lancelot in Flanders, Belgium and Paris, 1250–1340*, Ph.D. (London University, 1970), first demonstrated this. See also her later papers, 'Secular Manuscript Illustration in France', *Medieval*

Manuscripts and Textual Criticism, ed. C. Kleinherz (Chapel Hill, 1976), pp. 83–102. 'Sacred and Profane Art: Secular and Liturgical Book-Illumination in the Thirteenth Century', *The Epic in Medieval Society. Aesthetic and Moral Values*, ed. H. Scholler (Tübingen, 1977), pp. 100–112. 'Manuscripts, Arthurian Illuminated', *The Arthurian Encyclopedia*, ed. N.J. Lacy (New York, 1986), pp. 359–74. A. Stones, 'Arthurian Art since Loomis', *Arturus Rex, II* (Acta Conventus Lovaniensis 1987), eds W. van Hoecke, G. Tournoy, W. Verbeke (Leuven, 1991), 21–55.

[76] London, B.L., Royal 14 E. III, 'Lancelot', 'Queste', 'Mort Artu', and Add. 10292–4, complete cycle. R.S. and L.H. Loomis, as in n. 65, pp. 97–8, pls 241–9. E.M. Remak-Honnef, as in n. 66, is a detailed investigation of the illustrations of 'Queste' in surviving manuscripts and especially in these two manuscripts and in the Kraus/Amsterdam manuscript. See also Stones, 'Indications', p. 325.

[77] French 1, folio 182 and Royal 14 E. III, folio 91.

[78] French 1, folio 172v and Add. 10292–4, folio 378v.

[79] Missed by both Pickford and R.H. and L.S. Loomis, Remak-Honnef, pp. 95–8, has noted their existence, and transcribed a few of those that can be read, especially in Add. 10292.

[80] Ch. 1, p. 33, Ch. 2, pp. 37–8.

[81] London, B.L., Add. 54180, formerly owned by Eric Millar. See E. Millar, *An Illuminated Manuscript of La Somme le Roy, Attributed to the Parisian Miniaturist Honoré* (Roxburghe Club, 1953), E.G. Millar, *The Parisian Miniaturist Honoré* (London, 1959). D.H. Turner, 'The Development of Maître Honoré', *The Eric George Millar Bequest of Manuscripts and Drawings, 1967. A Commemorative Volume* (London, 1968), pp. 53–65.

[82] E.V. Kosmer, *A Study of the Style and Iconography of a Thirteenth-Century Somme le Roi (British Museum, Ms. Add. 54180) With a Consideration of Other Illustrated Somme Manuscripts of the Thirteenth, Fourteenth and Fifteenth Centuries*, Ph.D. (Yale University, 1973). On the problems of identification, I need only say that Kosmer does not accept the identification of the London *Somme* illuminator as Honoré proposed earlier by Millar, and that she dates it *c.* 1285. E. Kosmer, 'Master Honoré: a Reconsideration of the Documents', *Gesta*, 14/1 (1975), 63–8.

[83] The 'Parisian' pair are the Millar *Somme* and Paris, Bibliothèque Mazarine, Ms. 870, the 'North French' pair are London, B.L., Add. 28162 and Paris, B.n., fr. 938.

[84] These have been printed by H. Martin, 'La Somme le Roi, Bibliothèque Mazarine, no. 870', *Trésors des Bibliothèques de France*, 1 (1926), 43–57 and by Millar (1953), pp. 49–51 (from Paris, B.n., fr. 958 and 14939). See also Kosmer's thesis, Appx. B for a discussion of them.

[85] Paris, B.n., fr. 958, folio 1. 'Cy doit estre premierement l'estoire comment . . .'. This is, in fact, an incomplete text. The full version is contained in a manuscript in Hanover, which also describes Moses breaking the tablets and the Israelites worshipping the Golden Calf.

[86] Paris, B.n., fr. 938, folio 2v.

[87] Paris, Bibliothèque de l'Arsenal, Ms. 6329, folio 7v.

[88] Paris, B.n., fr. 14939, folio 5.

[89] Ch. 3, pp. 53–9.

[90] London, B.L., Add. 54180, folio 121v. Millar, 1953, pl. X. Paris, B.n., latin 1023, folio 7v. Millar, 1953, pl. XV.

[91] J.J.G. Alexander, '*Labeur* and *Paresse*' (as in n. 60), 437–8.

[92] L.M.C. Randall, *Images in the Margins of Gothic Manuscripts* (Berkeley, 1966).

[93] See M. Camille, 'Labouring for the Lord: The Ploughman and the Social Order in the Luttrell Psalter', *Art History*, 10 (1987), 423–54; and now his *Image on the Edge. The Margins of Medieval Art* (London, Cambridge, Mass., 1992).

[94] Paris, B.n., fr. 25526. Randall, pp. 32, 212 (s.v. 'scribes'). *Le Livre*, no. 250.

CHAPTER 6

[1] Valenciennes, Bib. Mun., Ms. 99. Alexander, *Insular Manuscripts*, cat. 64. P. Meyvaert, 'Bede and the Church Paintings at Wearmouth Jarrow', *Anglo-Saxon England*, 8 (1979), 63–77.

[2] W. Oakeshott, *Sigena: Romanesque Paintings in Spain and the Winchester Bible Artists* (London, 1972). D. Park, 'The Wall-Paintings of the Holy Sepulchre Chapel', *Medieval Art and Architecture at Winchester* (British Archaeological Association, 1983), 38–62.

[3] W. Loerke, 'The Monumental Miniature', *The Place of Book Illumination in Byzantine Art* (Princeton, 1975), pp. 61–97. E. Kitzinger, 'The Role of Miniature Painting in Mural Decoration', *ibid.*, pp. 99–142. For the Cotton Genesis, see K. Weitzmann, H.L. Kessler, *The Cotton Genesis British Library Codex Otho B.VI* (Princeton, 1986). For San Marco, see O. Demus, *The Mosaics of San Marco in Venice*, 2 vols (Chicago, 1984).

[4] Vatican, B.A.V., Vat. lat. 3225. H. Buchthal review of J. de Wit, *Die Miniaturen des Vergilius Vaticanus* (Amsterdam, 1959) in *Art Bulletin*, 45 (1963), 372–5. Kitzinger (as in note 3), pp. 122ff. T.B. Stevenson, *Miniature Decoration in the Vatican Virgil. A Study in Late Antique Iconography* (Tübingen, 1983). See also Ch. 2, p. 50.

[5] Brussels, B.R., 9961–62. Sandler, *Gothic Manuscripts*, cat. 40. M.R. James, 'On the Paintings Formerly in the Choir at Peterborough', *Proceedings of the Cambridge Antiquarian Society*, 9/2 (1897), 178–94. L.F. Sandler, 'Peterborough Abbey and the Peterborough Psalter in Brussels', *Journal of the British Archaeological Association*, 33 (1970), 36–49.

[6] Padua, Biblioteca Capitolare, A.15. C. Bellinati, 'La cappella di Giotto all'Arena e le miniature dell'Antifonario Giottesco della cattedrale (1306)', *Da Giotto al Mantegna*, exhibition at the Palazzo della Ragione, Padua, 9 June–4 November 1974 (Milan, 1974), pp. 23–30. Barzon (as in Ch. 1, n. 80), pp. 16–21, tav. XVI–XXII.

[7] The Hours is now in New York, The Cloisters Museum. See K. Morand, *Jean Pucelle* (Oxford, 1962).

[8] University of London Library, Ms. 1. The paintings were destroyed in the fire of 1834, but fortunately copied before that. J.J.G. Alexander, 'Painting and Manuscript Illumination for Royal Patrons in the Later Middle Ages', *English Court Culture in the Later Middle Ages*, eds V.J. Scattergood, J.W. Sherborne (London, 1983), p. 145, pl. 5. *Age of Chivalry*, nos 623, 681.

[9] Milan, Ambrosiana, Ms. A. 79 inf. (Sp. 10/27). A. Martindale, *Simone Martini* (Oxford, 1988), pp. 191–2, pls XV, 113–14. B.S. Tosatti, 'Le techniche pittoriche di Simone nell' "Allegoria Virgiliana"', *Simone Martini. Atti del Convegno, Siena, 27–29 Marzo 1985*, ed. L. Bellosi (Florence, 1988), pp. 131–8. An illumination in Paris, B.n., latin 5931, Jacopo Stefaneschi, *De miraculo gloriose Dei genetricis Virginis Mariae in civitate Avinionensi facto* has also been attributed to Simone by B. Degenhart, 'Das Marienwunder von Avignon. Simone Martini's Miniaturen für Kardinal Stefaneschi und Petrarca', *Pantheon*, 33 (1975), 191–203. See also *L'art gothique Siennois. Enluminure, peinture, orfèvrerie, sculpture* (Avignon, Musée du Petit Palais, 26 June–2 October 1983) (Florence, 1983), no. 41.

[10] See the Theocritus printed by Aldus in Venice in 1495/6. *Master Drawings. The Woodner Collection* (Royal Academy of Arts, London, 1987), no. 47, colour plate, with earlier literature, especially E. Rosenthal, 'Dürer's Buchmalereien für Pirckheimers Bibliothek', *Jahrbuch der Preussischen Kunstsammlungen*, 49 (1928), *Beiheft*, 1–54 and *ibid.*, 51 (1930), 175–8.

[11] Munich, Bayer. Staatsbibl., 2° L. impr. membr. 64. E. Panofsky, *The Life and Art of Albrecht Dürer* (Princeton, 1955), pp. 182–90, ills 234–8. *The Book of Hours of the Emperor Maximilian the First*, ed. W.L. Strauss (New York, 1974).

[12] Paris, Bibliothèque de l'Arsenal, Ms. 940. The attribution by M. Meiss, *Andrea Mantegna as Illuminator* (Hamburg, 1957), has been contested and other names suggested. See R.

Lightbown, *Mantegna* (Oxford, 1986), appendix 'Mantegna and Book-Illumination', pp. 494–5.

[13] See also J.J.G. Alexander, 'Constraints on Pictorial Invention in Renaissance Illumination. The Role of Copying North and South of the Alps in the Fifteenth and Early Sixteenth Centuries', *Miniatura*, 1 (1988), 123–35.

[14] See Ch. 1, p. 31.

[15] See Ch. 1, p. 32, Ch. 3, p. 53.

[16] New York, Morgan, M. 346. Scheller, *Model Books*, no. 14. W. Voeckle, 'Two New Drawings for the Boxwood Sketchbook in the Pierpont Morgan Library', *Gesta*, 20/1 (1981), 243–5. Vienna, Kunsthistorisches Museum, Inv. no. 5003–4. Both are on boxwood and the Vienna pattern book has a stamped leather satchel to contain it. Scheller, *Model Books*, cat. 18. *Die Parler und der schöne Stil 1350–1400*, ed. A. Legner, vol. 3 (Cologne, 1978), p. 146.

[17] G. Vasari, *Le vite de' piu eccellenti pittori, scultori ed architettori*, ed. G. Milanesi, vol. 7 (Florence, 1881), pp. 557–69.

[18] E. Panofsky, *Early Netherlandish Painting. Its Origins and Character* (Cambridge, Mass., 1953), especially chs I and II. Meiss, *French Painting*, 1–3, passim.

[19] Meiss, *French Painting*, 1, pp. 229–41, does not accept the reading of the signature in the Cleveland Museum Hours of Charles le Noble, and prefers to call the illuminator the 'Master of the Brussels initials'. That his style is Italian is undoubted and he appears to have returned to Italy. See also R.G. Calkins, 'The Brussels Hours Re-evaluated', *Scriptorium*, 24 (1970), 3–26, and 'An Italian in Paris: the Master of the Brussels Initials and His Participation in the French Book Industry', *Gesta*, 20/1 (1981), 223–32.

[20] Some of the documents are collected by M. Rickert, *The Reconstructed Carmelite Missal* (London, 1952), Appendix B. For the considerable literature, for the signed manuscrpits and for a critique of attributions, see now Scott, *Later Gothic Manuscripts*, cats 21–30.

[21] H. Paget, 'Gerard and Lucas Hornebolt in England', *Burlington Magazine*, 101 (1959), 396–402. *Renaissance Painting in Manuscripts*, p. 118. J. Murdoch, J. Murrell, P.J. Noon, R. Strong, *The English Miniature* (New Haven, 1981). J. Backhouse, (as in Ch. 1, n. 170). L. Campbell, S. Foister, 'Gerard, Lucas and Susanna Horenbout', *Burlington Magazine*, 128 (1986), 719–27.

[22] G. Mariani Canova, *La miniatura Veneta del Rinascimento 1450–1500* (Venice, 1969), especially pp. 117–21. For other illuminators known to have moved around the peninsula, see L. Armstrong, '*Opus Petri*: Renaissance Illuminated Books From Venice and Rome', *Viator*, 21 (1990), 385–412, especially pp. 408–9. J.J.G. Alexander, 'Illuminations by Matteo da Milano in the Fitzwilliam Museum, Cambridge', *Burlington Magazine*, 133 (1991), 686–90.

[23] N.J. Rogers, *Books of Hours Produced in the Low Countries for the English Market in the Fifteenth Century*, M. Litt. (Cambridge University, 1982) J.J.G. Alexander, 'Katherine Bray's Flemish Book of Hours', *The Ricardian*, 8 (1989), 308–17. C.F.R. de Hamel, 'Reflexions on the Trade in Books of Hours at Ghent and Bruges', *Manuscripts in the Fifty Years after the Invention of Printing* (as in Ch. 1, n. 141), pp. 29–33. For Edward IV's purchases in Bruges, see J. Backhouse, 'Founders of the Royal Library. Edward IV and Henry VII as Collectors of Illuminated Manuscripts', *England in the Fifteenth Century* (Proceedings of the 1986 Harlaxton Symposium), ed. D. Williams (Woodbridge, 1987), pp. 23–41.

[24] E.g. C.M. Rosenberg, 'The Influence of Northern Graphics on Painting in Renaissance Ferrara: Matteo da Milano', *Musei Ferraresi. Bollettino Annuale*, 15 (1985–7), 61–74.

[25] H. Lehmann-Haupt, 'Gutenberg und der Meister des Spielkarten', *Gutenberg-Jahrbuch* (1962), 360–79. H. Lehmann-Haupt, *Gutenberg and the Master of the Playing Cards* (New Haven, London, 1966). A. van Buren, S. Edmunds, 'Playing Cards and Manuscripts: Some Widely Disseminated Fifteenth-Century Model Sheets', *Art Bulletin*, 56 (1971), 12–30. S. Edmunds, 'The Kennicott Bible and the Use of Prints in Hebrew Manuscripts', *Atti del XXIV Congresso Internazionale di Storia dell'Arte* (Bologna 10–18 September 1979), 8 (Bologna, 1983), pp. 23–9. M. Wolff, 'Some Manuscript Sources for the Playing-Card Master's Number Cards', *Art Bulletin*, 64 (1982), 587–600 shows that this is a two-way process.

[26] Liverpool, The National Museums and Galleries on Merseyside (Walker Art Gallery), Mayer 12023. Alexander, 'Facsimiles' (as in Ch. 4, n. 3), figs 10–11. For the interconnections in the North between prints and miniatures and their artists there is now a considerable literature. See, for example, J. Marrow, 'A Book of Hours from the Circle of the Master of the Berlin Passion: Notes on the Relationship Between Fifteenth-Century Manuscript Illumination and Printmaking in the Rhenish Lowlands', *Art Bulletin*, 60 (1978), 589–616. D.G. Scillia, 'The Master of the London Passional: Johann Veldener's "Utrecht Cutter"', *The Early Illustrated Book: Essays in Honor of Lessing J. Rosenwald* (ed. S. Hindman, Washington, 1982), pp. 23–40. D.G. Scillia, 'The Jason Master and the Woodcut Designers in Holland 1480–5', *Dutch Crossing*, 39 (1989), 5–44. *Dutch Manuscript Painting*, pp. 14–15, 286, 297 (cat. 105).

[27] For Italy and the effect of printing on manuscript illuminators, see L. Armstrong, 'Il Maestro di Pico: un miniatore veneziano del quattrocento', *Saggi e memorie di Storia del Arte*, 17 (1990), 7–39, ills 1–44 and 'The Impact of Printing on Miniaturists in Venice After 1469', *Printing the Written Word: the Social History of Books ca. 1450–1520*, ed. S.L. Hindman (Ithaca, 1991), pp. 174–202.

[28] Liverpool, The National Museums and Galleries on Merseyside (Walker Art Gallery), Mayer 12009 and formerly Upholland College, Lancashire, Ms. 106 (sold Christie's, London, 2 December 1987, lot 36). Alexander, 'Facsimiles' (as in Ch. 4, n. 3), figs 6–7.

[29] Ch. 1, pp. 30–31.

[30] Weale, *Le Beffroi*, 2 (as in Ch. 1, n. 153). dé Mely (as in Ch. 1, n. 8), p. 292, fig. 254. J.D. Farquhar, 'Identity in an Anonymous Age: Bruges Manuscript Illuminators and Their Signs', *Viator*, 11 (1980), 371–84. *Id.*, 'Manuscript Production and Evidence for Localizing and Dating Fifteenth-Century Books of Hours: Walter Ms. 239', *Journal of the Walters Art Gallery*, 45 (1987), 44–57. Though most stamped marks occur on single inserted leaves, in two cases, one being Baltimore, Walters Art Gallery, Ms. 239, the leaves on which they occur are integral to the manuscript. Now that Farquhar has drawn attention to them a number of further examples have been noticed, for example, in manuscripts sold at Sotheby's, 21 June 1982, lot 15 (now Hague, Koninklijke Bibliotheek, Ms. 135 K.45), 22 June 1982, lot 82, 23 June 1987, lot 121, 20 June 1989, lot 67, and 18 June 1991, lot 33 (now Cambridge, Fitzwilliam Museum, Ms. 27.1991). See also a Book of Hours at University College, London, Ms. 509 (sold Sotheby's, 7 December 1953 lot 42). Farquhar has totalled twenty-seven manuscripts and detached leaves with fourteen different marks, 'Manuscript Production', p. 54, n. 4. Examples are also listed and the significance of the documents further discussed by M. Smeyers, H. Cardon, 'Merktekens in de Brugse miniatuurkunst', *Merken opmerken. Typologie en methode*, ed. C. Van Vlierden, M. Smeyers (Leuven, 1990), pp. 45–70. The marks used resemble those of contemporary goldsmiths. See J.M. Fritz, *Goldschmiedekunst der Gotik in Mitteleuropa* (Munich, 1982), Abb. 6, the table of marks of the Ghent Goldsmiths, 1454–81.

[31] Göttingen, Niedersächsische Staats- und Landesbibliothek, Cod. Uffenbach 51. 11ff. c. 15.8 × 10.5 cm. H. Lehmann-Haupt, *The Göttingen Model Book* (rev. edn, Columbia, 1978). The Berlin fragment is Kupferstichkabinett, Ms. 78 A.22. 18ff. 15.8 × 10.4 cm. *Zimelien. Abendländische Handschriften des Mittelalters aus den Sammlungen der Stiftung Preussischer Kulturbesitz Berlin* (Berlin, 1975–6), no. 115.

[32] Munich, Bayer. Staatsbibl., Cod. icon. 420. M. and H. Roosen-Runge, *Das spätgotische Musterbuch des Stephan Schriber in der Bayerischen Staatsbibliothek München, Cod. icon. 420*, 3 vols (Wiesbaden, 1981).

[33] See Ch. 5, pp. 99–100, for the thirteenth-century Rein pattern book. Later examples are the Bergamo pattern book of Giovanni dei Grassi, *d.* 1398, the early fifteenth-century pattern book in the Uffizi, Florence, the pattern book from Iceland, Copenhagen, Arnamagnean Institute, ms. AM. 673a, 4°, the Lombard pattern book of the first quarter of the fifteenth century, Rome Gabinetto nazionale delle Stampe, Inv. 3727–56, and the Codex Vallardi in the Louvre with drawings by Pisanello. See nn. 97, 98 and Scheller, *Model Books*, cats 19, 21, 24, 22 and 26. The last two of these contain 'banderolles alphabets', letters made up as it were of ribbons, as does the dei Grassi pattern book. The latter also contains, as does the Uffizi pattern book, a 'figure alphabet', that is, letters composed of human figures. For the figure alphabets and their relation to the engraved figure alphabet of Master E.S. and the Dutch woodblock figure alphabet of 1464, see U. Jenni, *Das Skizzenbuch der internationalen Gotik in der Uffizien. Der Übergang vom Musterbuch zum Skizzenbuch* (Vienna, 1976), Ch. 7. Figure alphabets also occur in two pattern books produced in England in the late fifteenth and early sixteenth centuries, Oxford, Bodl., Ms. Ashmole 1504 and Paul Mellon Collection, Upperville, Virginia. N. Barker, *Two East Anglian Picture Books. A Facsimile of the Helmingham Herbal and Bestiary and Bodleian Ms. Ashmole 1504* (Roxburghe Club, 1988).

[34] In addition to the Fitzwilliam Museum alphabet pattern book, for which see Ch. 4, p. 94, other examples are: London, B.L., Sloane 1448A. English. Mid fifteenth century. This also contains a figure alphabet. J. Backhouse, 'An Illuminator's Sketchbook', *British Library Journal*, 1 (1975), 3–14. Lilly Library, Bloomington, Indiana, Ms. Ricketts 240. Sample alphabet book of Guinifortus de Vicomerchato (Milan, 1450). *Two Thousand Years of Calligraphy* (Walters Art Gallery, Baltimore Museum of Art, Peabody Institute, Baltimore, 1965, repr. 1976), no. 38. Vatican, B.A.V., Vat. lat. 6852. Alphabet book (designs for Roman capitals) of Felice Feliciano, Verona, *c.* 1460. *Felice Feliciano. Alphabetum Romanum Vat. lat. 6852 aus der Biblioteca Apostolica Vaticana*, facsimile, text by G. Mardersteig (Zürich, 1985). Louvre, Cabinet des dessins and Brussels, B.R., II.845. So-called alphabet of Mary of Burgundy, *c.* 1480, with copy of *c.* 1550. P. Dumon, *L'alphabet Gothique dit de Marie de Bourgogne. Reproduction du codex Bruxellensis II. 845* (Brussels, 1972). Alexander, *Decorated Letter*, fig. XXIX. Baltimore, Walters Art Gallery, W. 200. French, *c.* 1500. Oxford, Bodl., Ms. Douce f. 2. French. Early sixteenth century. Pächt, *Alexander*, 1, no. 839. Glasgow, University Library and Hunterian Museum, SM 1161. Netherlands, *c.* 1529. *The Glory of the Page. Medieval and Renaissance Manuscripts from Glasgow University Library*, catalogue by N. Thorp (London, 1987), no. 129. London, B.L., Add. 31845. Alphabet book by (or owned by ?) Fr. Johannes Holtmann. German (?). *c.* 1529 (?). M. Gullick, *Calligraphy* (London, 1990), pls 25–6.

[35] Paris, Ecole des Beaux-Arts, Ms. Masson 98. Apparently unpublished. I owe knowledge of this to M. François Avril who suggested to me that it is Spanish.

[36] Vienna, O.N.B., Cod. 4943, folio I. F. Unterkircher, *Inventar der illuminierten Handschriften, Inkunabeln und Frühdrucke der Oesterreichischen Nationalbibliothek*, 1, Vienna, 1957, p. 102. Ascribed to Cologne. See also Jenni (as in n. 33), p. 65 n. 301, correctly as English. It may be significant that here and in the Fitzwilliam alphabet the initials are mainly drawings and only a few, as if demonstration pieces, are painted.

[37] For example, the advertisement sheet of Hermann Strepel, 1447, Hague, Koninklijke Bibliotheek, Ms. 76 D. 45, IVA. B. Bischoff, transl. D. Ó Cróinín, D. Ganz, *Latin Palaeography. Antiquity and the Middle Ages* (Cambridge, 1990), p. 132, pl. 18, with further references. Also Basel, Öffentliche Bibliothek der Universität, Ms. 16 Nr. M. Steinmann, 'Ein mittelalterliches Schriftmusterblatt', *Archiv für Diplomatik*, 21 (1975), 450–58, pl.; and Berlin, Staatsbibliothek, Cod. lat. fol. 384. Johannes Hagen. Lower Saxony. Early fifteenth century. Gullick, *Calligraphy* (as in n. 34), pl. 20. Paris, B.n., latin 8685 is a fifteenth-century writing book of a clerk of the diocese of Nantes with calligraphic initials. *Le Livre*, no. 159. New Haven, Yale University, Beinecke Library, Ms. 439 is a scribal specimen book with a variety of alphabets by Gregorius Bock (Swabia, *c.* 1517). W. Cahn, J. Marrow, 'Medieval and Renaissance Manuscripts at Yale: A Selection', *The Yale University Library Gazette*, 52 (1978), 267–8. Another, dated 1520, is by Lawrence Autenrieth. Stuttgart, Württembergische Landesbibliothek, Cod. Mus. fol. I.63, apparently depending on the Bok book. J.C. John, 'A Note on the Origin of the Calligraphy Book of Lawrence Autenrieth', *Litterae Medii Aevi. Festschrift für Johanne Autenrieth zu ihren 65 Geburtstag*, eds M. Borgholte, H. Spilling (Sigmaringen, 1988), pp. 309–14. For the initial designs of a writing master active in Norwich in the late sixteenth century, see J. Backhouse, *John Scottowe's Alphabet Books* (Roxburghe Club, 1974) (London, B.L., Harley 3885 and Chicago, Newberry Library, Wing Ms. 7). For the Italian writing-master's alphabets, printed as well as manuscript, see *Two Thousand Years of Calligraphy* (as in n. 34), A.S. Osley, *Luminario: An Introduction to the Italian Writing Books of the Sixteenth and Seventeenth Centuries* (Nieuwkoop, 1972) and S. Morison, ed. N. Barker, *Early Italian Writing Books: Renaissance to Baroque* (London, 1990). A manuscript example is the writing book of Giovanbattista Palatino, after 1541, with very highly ornamental letter designs, Oxford, Bodl., Ms. Canon. Ital. 196. Pächt, *Alexander*, 2, no. 1010, pl. LXXXIII. Vienna, O.N.B., Cod. 2368, the school book of Maximilian I, written by Wolfgang Spitzweg, *c.* 1465, also contains decorated alphabets. H. Fichtenau, *Die Lehrbücher Maximilans I und die Anfänge der Frakturschrift* (Hamburg, 1961).

[38] Ch. 2, p. 49.

[39] See also Ch. 2, p. 50.

[40] See Ch. 2, pp. 40–42. For the hypothesis of collaboration on the same miniature, see Meiss, *Painting in France*, 1, p. 9.

[41] See Ch. 2, pp. 50–51. J.D. Farquhar, *Creation and Imitation. The Work of a Fifteenth-Century Manuscript Illuminator* (Fort Lauderdale, 1976). Also *Dutch Manuscript Painting*, where tracing is hypothesised for the so-called 'Delft grisailles'.

[42] 'Workshop' or 'shop' is used in the literature sometimes literally of a space, sometimes by transfer of the personel working in it. Some information on the house properties owned by illuminators, especially as to their location, can be gained from the records, but it is more difficult to deduce evidence as to their size and what spaces in them might be available as 'shops'. See R.H. and M.A. Rouse and C.P. Christianson, as in Ch. 1, nn. 97, 160.

[43] Meiss, *French Painting*, 2, p. 69. See also his Ch. 2, 'The Master Among His Associates'. For warnings concerning the loose use of the word 'atelier', see also P. Stirnemann and M.-T Gousset, 1989, as in Ch. 2, n. 57.

[44] See Ch. 1, pp. 30–31, for the Guilds, and Ch. 3, n. 9, for the Borso Bible.

[45] Siena, Biblioteca Comunale, Ms. X.V.3. Signed and dated 1494. P. D'Ancona, *La miniatura fiorentina (secoli XI–XVI)*, 1 (Florence, 1914), p. 69, tav. LXXIX, 2, pp. 647–8. *Mostra storica*, no. 530. D'Ancona, Aeschlimann, pl. XXX. Manchester, John Ryland's University Library, Latin 14, folio 10. M.R. James, *A Descriptive Catalogue of the Latin Manuscripts in the John Rylands Library at Manchester* (Manchester, etc., 1921), repr. with introduction and additional notes by F. Taylor (Munich, 1980), p. 38, pl. 35.

[46] Meiss, *French Painting*, 2, pp. 27–30, figs 29, 118–34, 246, 263.

[47] Blackburn, Lancashire, Museum and Art Gallery, Hart Ms. 20865. Formerly Upholland College, Ms. 105, sold Christie's, London, 2 December 1987, lot 35. *Medieval and Early Renaissance Treasures in the North West*, catalogue by J.J.G.

Alexander, B.P. Crossley *et al.* (Whitworth Art Gallery, Manchester, 1976), nos 28, 29.

[48] Meiss, *French Painting*, 1, pp. 226 and nn. 99, 278. 'Certaines couleurs et patrons'.

[49] Berlin, Staatsbibliothek, Liber picturatus, A.74. H. Kreuter-Eggemann, *Das Skizzenbuch des 'Jaques Daliwe'* (Munich, 1964). U. Jenni, U. Winter, *Das Skizzenbuch des Jaques Daliwe. Kommentar zur Faksimileausgabe des Liber picturatus der Deutschen Staatsbibliothek, Berlin DDR* (Berlin 1987).

[50] Stonyhurst College, Lancs, Ms. 33. *Treasures in the North West* (as in n. 47), no. 31. Meiss, *French Painting*, 3, p. 392. For evidence of the circulation of patterns by illuminators working in Ghent and Bruges in the late fifteenth century, see J.J.G. Alexander, as in n. 23, B. Brinkmann, 'The Hastings Hours and the Master of 1499', *British Library Journal*, 14 (1988), 90–106 and F. Steenbock, 'Münzen, Blüten und Mannargen. Eine Motivstudie', *Festschrift für Peter Bloch zum 11. Juli 1990*, eds H. Krohm, C. Theuerkauff (Mainz, 1990), pp. 135–42.

[51] Alexander, 'Constraints' (as in n. 13), 125, figs 8–9. Dr Mark Evans has pointed out to me that both miniatures follow the composition by Francesco Rosselli found in Munich, Bayer. Staatsbibl., Clm 23639, folio 155v, Book of Hours made for the marriage of Lucrezia Medici to Jacopo Salviati in 1488. M.L. Evans, 'Die Miniaturen des Münchner Medici-Gebetbuchs um 23639 und verwandte Handschriften', *Das Gebetbuch Lorenzos de' Medici Clm 23639 der Bayerischen Staatsbibliothek München* (facsimile) (Frankfurt am Main, 1991), pp. 242–5.

[52] Oxford, Bodl., Ms. Canon. Misc. 378. For the other fifteenth- and sixteenth-century copies, including the tracing made in 1550 of the *Spirensis* for the Count Palatine Ottheinrich, Munich, Bayer. Staatsbibl., Clm 10291, and for the complicated arguments as to their interrelationships and also as to the date of the *Spirensis*, see J.J.G. Alexander, 'The Illustrated Manuscripts of the "Notitia Dignitatum"', *Aspects of the Notitia Dignitatum*, ed. R. Goodburn, P. Bartholomew (British Archaeological Reports. Supplementary Series, 15) (Oxford, 1976), 11–25.

[53] This only survives as a fragment, Cambridge, Fitzwilliam Museum, Ms. 86. 1972. Alexander, 'Illustrated Manuscripts' (as in n. 52), pls IV–V.

[54] For example, the *Somme le roi*, copies for which see Ch. 5, pp. 115–18.

[55] Manchester, John Rylands University Library, Ms. Latin 19. James (as in note 45), pp. 57–8. For the earlier Apocalypses, see Ch. 5, pp. 105–7.

[56] Vatican, B.A.V., Pal. lat. 1071. C.A. Willemsen, Kommentarband to *Fredericus II, De arte venandi cum avibus. Ms. Pal. Lat. 1071* (Codices Selecti, XXXI) (Graz, 1969). *Das Falkenbuch Kaiser Friedrichs II nach der Prachthandschrift in der Vatikanischen Bibliothek*, Einführung und Erläuterung von C.A. Willemsen (Die bibliophilen Taschenbücher, Nr. 152) (Dortmund, 1980), is a more accessible version, though reduced in size.

[57] Paris, B.n., fr. 12400. *Manuscrits à peintures*, 1955, no. 97. Willemsen, 1969, Taf. I, II, IX–XI. For the French text, see G. Tilander, 'Etude sur les traductions en vieux français du traité de fauconnerie de l'empereur Frédéric II', *Zeitschrift für Romanische Philologie*, 46 (1926), 211–90. Tilander, pp. 212–13, says he was unable to see the date 1310 which E. Charavay, *Etude sur la chasse à l'oiseau au moyen âge* (Paris, 1873), had claimed to decipher in the partly erased colophon. The illuminator's name, however, can be read, folio 186: 'Simon d'Orliens, anlumineur d'or, anlumina se livre si'.

[58] Paris, B.n., fr. 301. F. Avril, 'Trois manuscrits napolitains des collections de Charles V et de Jean de Berry', *Bibliothèque de l'école de chartes*, 127 (1969), 291–328. See also D. Oltrogge (as in Preface, n. 2).

[59] London, B.L., Royal 20 D.1. Warner, Gilson, *Royal mss*, 2, pp. 375–77, pl. 118.

[60] Paris, B.n., latin 10157. *Schatzkunst Trier. Kunst und Kultur in der Diözese Trier*, catalogue by F.J. Ronig (Trier, 1984), no. 100 with further literature. The 'Xp' is on folio 10v and the initial on folio 17v. An interesting miniature later in the manuscript shows a nun finding a *Liber ymnorum* 'vetustissimus scottice scriptus' in a bookcase as a result of a dream, folio 29.

[61] Cambridge, Trinity Hall, Ms. 1. *Historia monasterii S. Augustini Cantuariensis by Thomas of Elmham* (Rolls Series 8), ed. C. Hardwick (London 1858). M.R. James, *A Descriptive Catalogue of the Manuscripts in the Library of Trinity Hall* (Cambridge, 1907), pp. 1–4.

[62] Vatican, B.A.V., Arch. S. Pietro C.128. A. Stones, 'Four Illustrated Jacobus Manuscripts', *The Vanishing Past. Studies of Medieval Art, Liturgy and Metrology Presented to Christopher Hohler* (British Archeological Reports, International Series, 111 eds A. Borg, A. Martindale) (1981), 197–222, pls 14, 1–4, 6–8, 11–13, 15–16.

[63] For the earlier, thirteenth-century examples, see Ch. 5, p. 105.

[64] Paris, B.n., fr. 12201 survives. *Manuscrits à peintures* (1955), no. 156. Meiss, *French Painting*, 3, p. 345. For Rapondi, see B. Buettner, 'Jacques Raponde "marchand de manuscrits enluminés"', *Langue, texte, histoire médiévales (La culture sur le marché)*, 14 (1988), 23–32.

[65] Paris, B.n., fr. 12420, *Manuscrits à peintures* (1955), no. 157, and fr. 598, *ibid.*, no. 158. Meiss, *French Painting*, 2, pp. 47–52.

[66] Paris, Bibliothèque de l'Arsenal, Ms. 664. *Manuscrits à peintures* (1955), no. 165. Paris, B.n., latin 7907A, *ibid.*, no. 166, and latin 8193. Meiss, *French Painting*, 3, pp. 41–54.

[67] Paris, B.n., fr. 616, *Manuscrits à peintures* (1955), no. 212; fr. 619, thought by Meiss to be the earliest copy, and New York, Morgan, M.1044 (gift of Mrs Clara Peck). Meiss, *French Painting*, 3, pp. 60–61, figs 253–60. C. Nordenfalk, 'Hatred, Hunting, Love: Three Themes Relative to Some Manuscripts of Jean Sans Peur', *Studies in Late Medieval and Renaissance Painting in Honor of Millard Meiss*, eds I. Lavin, J. Plummer (New York, 1978), pp. 330–35. Nordenfalk also discusses multiple copies of the text of the 'Justification' of Jean Sans Peur's murder of the Duke of Anjou, ibid., pp. 323–30.

[68] S.L. Hindman, *Christine de Pizan's "Epistre d'Othéa". Painting and Politics at the Court of Charles VI* (Toronto, 1986).

[69] London, Victoria and Albert Museum, L.101–1947. J.J.G. Alexander, 'A Manuscript of Petrarch's Rime and Trionfi', *Victoria and Albert Museum Yearbook*, 2 (1970), 27–40. Madrid, B.n., Ms. 611. The latter was brought to my attention by M. François Avril. It was included in the exhibition catalogue, *La corona de Aragón en el Mediterraneo, legado commún para Italia y Espana 1282–1492* (Barcelona, 1988), no. 304 (entry by T. Mesquita Mesa to whom I am indebted for showing me the reference).

[70] For whom, see pp. 149, 178, n. 110.

[71] Vatican, B.A.V., Vat. gr. 1626. See p. 178, n.111.

[72] Chantilly, Musée Condé. Convenient colour plates are in J. Longnon, R. Cazelles, *The Très Riches Heures of Jean, Duke of Berry* (London, 1969). A full colour facsimile is *Les Très Riches Heures du Duc de Berry* (Luzern, 1984) (commentary volume by R. Cazelles). Most recently, see R. Cazelles, *Illuminations of Heaven and Earth: The Glories of the* Très Riches Heures (New York, 1988).

[73] J. Guiffrey, *Inventaires de Jean duc de Berry (1401–1416)*, vol. 2 (Paris, 1894–6), p. 280 (no. 1164).

[74] L. Delisle, 'Les Livres d'Heures du duc de Berry', *Gazette des Beaux-Arts*, 2e pér. 29 (1884), 97–110, 281–92, 391–405. Meiss, *French Painting*, 3, *passim*.

[75] O. Pächt, 'The Limbourgs and Pisanello', *Gazette des Beaux-Arts*, 6e pér. 62 (1963), 121 n. 1.

[76] Paris, B.n., fr. 13091. Meiss, *French Painting*, 1, p. 331.

[77] Paris, B.n., latin 919. Meiss, *French Painting*, 1, p. 332.

[78] See Ch. 3, p. 53.

[79] See L.M.J. Delaissé, 'The Importance of Books of Hours for the History of the Medieval Book', *Gatherings in Honor of Dorothy E. Miner*, ed. U. McCracken, L.M.C. Randall, R.H. Randall Jr (Baltimore, 1974), pp. 203–25 and R. Wieck with

L.R. Poos, V. Reinburg, J. Plummer, *Time Sanctified. The Book of Hours in Medieval Art and Life* (Walters Art Gallery, Baltimore, 1988). The latter provides a valuable overview of the texts and their illustration. For the way they were used and read, see P. Saenger, 'Books of Hours and the Reading Habits of the Later Middle Ages', *The Culture of Print: Power and the Uses of Print in Early Modern Europe*, ed. R. Chartier (Cambridge, 1989), pp. 141–73.

[80] Meiss, *French Painting*, 3, pp. 144ff.

[81] Meiss, *French Painting*, 3, pp. 209ff.

[82] Meiss, *French Painting*, 3, pp. 119ff.

[83] B. Degenhart, A. Schmitt, *Corpus der Italienischen Zeichnungen. Teil 1. Süd und Mittelitalien. 1 Band. Katalog 1–167* (Berlin, 1968), pp. 60–65 (Kat. 22), *3 Band*, Taf. 47.

[84] Meiss, *French Painting*, 2, figs 34, 266, 287, 318, 320.

[85] See n. 97. Meiss, *French Painting*, 3, pp. 197, 214–16. J.J.G. Alexander, '*Labeur* and *Paresse*; Ideological Representations of Medieval Peasant Labour', *Art Bulletin*, 72 (1990), 436–52.

[86] J.J.G. Alexander, 'The Limbourg Brothers and Italian Art: A New Source', *Zeitschrift für Kunstgeschichte*, 46 (1983), 425–35.

[87] E. Silber, 'The Reconstructed Toledo *Speculum humanae salvationis*: the Italian Connection in the Early Fourteenth Century', *Journal of the Warburg and Courtauld Institutes*, 43 (1980), 32–51. For a convenient facsimile of a fourteenth-century German *Speculum*, now Darmstadt, Hessische Landesbibliothek, Cod. 2505, see *Heilsspiegel. Die Bilder des mittelalterlichen Erbauungsbuches 'Speculum humanae salvationis'*, mit Nachwort und Erläuterungen von Horst Appuhn (Die bibliophilen Taschenbücher, Nr. 267) (Dortmund, 1981).

[88] M. 348. J.J.G. Alexander, *Wallace Collection. Catalogue of Illuminated Manuscript Cuttings* (London, 1980), pp. 35–6.

[89] Jean Gerson, *Le Passion de Nostre Seigneur*, ed. G. Frénaud (Paris, 1947), espec. pp. 20–28.

[90] For this foreshortened figure of which Mantegna's 'Lamentation', known as the *Christus in scorto* in the Brera, Milan, is a famous example, see K. Rathe, *Die Ausdrucksfunction extrem verkürzter Figuren* (Studies of the Warburg Institute, 8) (London, 1938, repr. 1968).

[91] Alexander, '*Labeur* and *Paresse*', as in n. 85.

[92] C.R. Sherman, *The Portraits of Charles V of France (1338–80)* (New York, 1969). C.R. Sherman, 'Representations of Charles V of France (1338–1380) as a Wise Ruler', *Medievalia et Humanistica*, n.s. 2 (1971), 83–96. C.R. Sherman, 'Some Visual Definitions in the Illustrations of Aristotle's *Nicomachean Ethics* and *Politics* in the French Translations of Nicole Oresme', *Art Bulletin*, 59 (1977), 320–35. D. Byrne, '*Rex imago Dei*: Charles V of France and the *Livre des propriétés des choses*', *Journal of Medieval History*, 7 (1981), 97–113. A. Hedeman, 'Valois Legitimacy: Editorial Changes in Charles V's *Grandes Chroniques de France*', *Art Bulletin*, 66 (1984), 97–117. A.D. Hedeman, *The Royal Image. Illustrations of the Grandes Chroniques de France 1274–1422* (Berkeley, 1991).

[93] London, B.L., Add. 11612, folio 10. Byrne (as in note 92).

[94] See Ch. 3, p. 53ff., on written programmes and instructions.

[95] For the Hexateuch, London, B.L., Cotton Claudius B. IV, see C.R. Dodwell in P. Clemoes, C.R. Dodwell, *The Old English Illustrated Hexateuch. British Museum Cotton Claudius B.IV* (Early English Manuscripts in Facsimile, 18) (Copenhagen, 1974). For the Psalter, London, B.L., Harley 603, see M. Carver, 'Contemporary Artefacts Illustrated in Late Saxon Manuscripts', *Archaeologia*, 108 (1986), 117–45. A striking example in regard to a musical instrument is the revised reconstruction of the harp found in the excavation at Sutton Hoo. R.L.S. and M. Bruce-Mitford, 'The Musical Instrument' in *The Sutton Hoo Ship-burial, Volume 3*, ed. A.C. Evans (London, 1983) pp. 611–731, a reconstruction founded on a representation of King David as harpist in the early Anglo-

Saxon Psalter, London, B.L., Cotton Vespasian A.1. For costume realistically represented and therefore recognisable as a social signifier, see T.A. Heslop as in Ch. 5, n. 3, pp. 142–3 (trousers, shaggy cloaks) and J. Harris as in Ch. 1, n. 84, *passim* (long sleeves, hair).

[96] Otto Pächt, in charting developments in realism, has emphasised the particular difficulties this causes for the art historian concerned with creation and transmission. O. Pächt, 'Early Italian Nature Studies and the Early Calendar Landscape', *Journal of the Warburg and Courtauld Institutes*, 13 (1950), 13–47.

[97] Bergamo, Biblioteca Civica, cod. VII.14. Scheller, *Model Books*, cat. 21. A facsimile is *Giovannino de Grassi, Taccuino di disegni (Monumenta Bergomensia, V)* (Bergamo, 1961). Another pattern book with naturalistic bird studies, though it is not certain that it was for use by an illuminator, is Cambridge, Magdalene College, Pepys Ms. 1916. Scheller, *Model Books*, cat. 16. *Age of Chivalry*, no. 466. Scott, *Later Gothic Manuscripts*, cat. 8.

[98] Florence, Uffizi, Gabinetto delle Stampe. Scheller, *Model Books*, cat. 24. U. Jenni, *Das Skizzenbuch* (as in n. 33) and 'Von mittelalterlichen Musterbuch zum Skizzenbuch der Neuzeit', *Die Parler und der schöne Stil 1350–1400*, 3, ed. A. Legner (Cologne, 1978), pp. 139–50.

[99] Ch. 3, pp. 68–9.

[100] Vienna, O.N.B., Cod. 2597. It is also, like the *Très Riches Heures*, now available in a widely circulated publication, F. Unterkircher, *King René's Book of Love* (New York, 1975).

[101] L.M.J. Delaissé, *Le siècle d'or de la miniature flamande. Le mécenat de Philippe le Bon* (Brussels, Paris, Amsterdam, 1959).

[102] For more recent work refining his hypothesis and demonstrating different procedures, see A. van Buren, 'New Evidence for Jean Wauquelin's Activity in the Chroniques de Hainaut and for the Date of the Miniatures', *Scriptorium*, 26 (1972), 249–68 and 27 (1973), 318, and 'Jean Wauquelin de Mons et la production du livre aux Pays-Bas', *Publication du centre Européen d'études Burgundo-Médianes* (Rencontres de Mons, 24–6 September 1982), 23 (1983), pp. 53–66.

[103] See A.C. de la Mare, 'New Research on Humanistic Scribes in Florence' in A. Garzelli, A.C. de la Mare, *Miniatura fiorentina del rinascimento 1440–1525* (Florence, 1985), pp. 395–600. A.C. de la Mare, 'The Shop of a Florentine "Cartolaio" in 1426', *Studi offerti a Roberto Ridolfi* (Florence, 1973), pp. 237–48. *Id.*, 'Bartolomeo Scala's Dealings with Booksellers, Scribes and Illuminators, 1459–63', *Journal of the Warburg and Courtauld Institutes*, 39 (1976), 237–45. M.A., R.H. Rouse, *Cartolai, Illuminators and Printers in Fifteenth-Century Italy: The Evidence of the Ripoli Press* (University of California, Los Angeles, 1988).

[104] London, B.L., Yates Thompson 47. Arundel Castle, Library of Duke of Norfolk. K.L. Scott, 'Lydgate's Lives of Saints Edmund and Fremund: A Newly-Located Manuscript in Arundel Castle', *Viator*, 13 (1982), 335–366. For England in the fifteenth century, see further K.L. Scott, 'A mid Fifteenth-Century English Illuminating Shop and Its Customers', *Journal of the Warburg and Courtauld Institutes*, 31 (1968), 170–96, and '*Caveat lector*: Ownership and Standardization in the Illustration of Fifteenth-Century English Manuscripts', *English Manuscript Studies*, 1 (1989), 19–63. Also the volume *Book Production and Publishing in Britain 1375–1475*, eds J. Griffiths, D. Pearsall (Cambridge, 1989), especially K.L. Scott, 'Design, Decoration and Illustration', pp. 31–64, and K. Harris, 'Patrons, Buyers and Owners: the Evidence for Ownership and the Rôle of Book Owners in Book Production and the Book Trade', pp. 163–99.

[105] See van Buren, 1983 (as in n. 102), fig. 3, for a hypothetical reconstruction of a pattern book page with such moduli. Another instructive example is the Lydgate, Troy Book, Manchester, John Rylands University Library, Ms. English 1. See L. Lawton, 'The Illustration of Late Medieval Secular Texts with Special Reference to Lydgate's "Troy Book"', *Manuscripts and Readers in Fifteenth-Century England: The Literary*

Implications of Manuscript Study (Essays from the 1981 Conference at the University of York), ed. D. Pearsall (Cambridge, 1983), pp. 41–69. Scott, *Later Gothic Manuscripts*, cat. 93.

[106] See Ch. 3, pp. 59–60. Particularly instructive is the analysis, referred to there, by D.J.A. Ross, of illustrations where an artist read only the rubrics and was misled by them. D.J.A. Ross, 'Methods of Book-Production in a XIVth Century French Miscellany', *Scriptorium*, 6 (1952), 63–75.

[107] O. Pächt, 'René d'Anjou Studien. 1, 2', *Jahrbuch der kunsthistorischen Sammlungen in Wien*, 69 (1973), 85–126, and 73 (1977), 7–106.

[108] See, for example, F. Avril, 'Manuscrits à peintures d'origine française à la Bibliothèque nationale de Vienne', *Bulletin Monumental*, 134 (1976), 335–8. F. Avril, *Le livre des Tournois du Roi René de la Bibliothèque nationale (ms. français 2695)* (Paris, 1986), pp. 7, 16–17. It may be that certain twentieth-century assumptions, once again concerning the artist as genius, stand in the way of such acceptance of a king being a painter. A history of the amateur artist needs to be written.

[109] Vienna, Ö.N.B., Cod. 2597, folio 47v. and Cod. 2617, folio 102. O. Pächt, D. Thoss, *Französische Schule I (Fortsetzung des Beschreibenden Verzeichnisses der illuminierten Handschriften der Nationalbibliothek in Wien)* (Vienna, 1974), pp. 37–48, and 32–37, and Pächt (as in n. 107) (1977), Taf. 31, 52, 95–6.

[110] S. de Kunert, 'Un padovano ignoto ed un suo memoriale de' primi anni del cinquecento (1505–1511)', *Bollettino del Museo Civico di Padova*, 10 (1907), 1ff, 64ff. J. Wardrop, *The Script of Humanism. Some Aspects of Humanistic Script 1460–1560* (Oxford, 1963), pp. 26–7.

[111] Genoa, Biblioteca Durazzo Giustiniani, 22 (A.III.3). D. Puncuh, *I manoscritti della raccolta Durazzo* (Genoa, 1979), p. 92, figs 1, 2, 52. For this artist (whom I still prefer to call the 'Master of the Vatican Homer'), see J.J.G. Alexander, A.C. de la Mare, *The Italian Manuscripts in the Library of Major J.R. Abbey* (London, 1969), pp. 104–10. U. Bauer-Eberhardt, 'Lauro Padovano und Leonardo Bellini als Maler, Miniatoren und Zeichner', *Pantheon*, 47 (1989), 49–82.

[112] P.B. Bober, R.O. Rubinstein, *Renaissance Artists and Antique Sculpture. A Handbook of Sources* (London, 1986), pp. 109–111, pl. 75. The Pans are painted again by the same artist in another manuscript written by Sanvito, a Juvenal in Florence,

Laur., plut. 53, 2. *Mostra storica*, no. 611. M. Salmi, *Italian Miniatures* (London, 1957), pl. LXVII. Wardrop, p. 30, n. 3., pl. 27.

[113] Known as the *Jubilatio*. For the context of this artistic antiquarianism, see P. Kristeller, *Andrea Mantegna* (Berlin, 1901, 2nd edn, 1902). Meiss, *Mantegna* (as in n. 12). B. Ashmole, 'Cyriaco of Ancona', *Proceedings of the British Academy*, 45 (1959), 25–41.

[114] For an example of the former, see the late fifteenth-century French Book of Hours, formerly in the Chester Beatty Collection, Western Ms. 85, sold Sotheby's, 24 June 1969, lot 71, pl. 43, where on folio 155v a small panel with the Virgin is shown as if hanging from a nail (cf. Sotheby's, 11 December 1979, lot 62, for another version of this Virgin icon); and of the latter, the miniatures added by Bourdichon to the Hours of Frederick III of Aragon, Paris, B.n., latin 10532. de Marinis (as in Ch. 1, n. 5), tav. 175–9. *Dix siècles*, no. 158, pl., where the scene is unveiled by angels as if a panel above an altar. For the use of parchment patches for the added miniatures see Ch. 2, n. 12.

[115] O. Pächt, *The Master of Mary of Burgundy* (London, 1948). See also his *Book Illumination in the Middle Ages* (London, 1986), Ch. VII.

[116] Oxford, Bodl., Ms. Douce 219–220. J.J.G. Alexander, *The Master of Mary of Burgundy. A Book of Hours for Engelbert of Nassau* (New York, 1970). For earlier examples of this psychological empathy in Dutch illumination, see Delaissé (as in Ch. 1, n. 154), pp. 23–4, fig. 23, the scene of Joseph and the Angel in New York, Morgan, M. 87, folio 99v, the Egmond Breviary, *c.* 1435–40, for which see also *Dutch Manuscript Painting*, no. 36. There are written instructions for the artist in this manuscript in both Dutch and Latin.

[117] It is not certain that Engelbert of Nassau was the original owner, in any case. There appear to be other arms in the manuscript. Some of the hair-spray borders were painted over with trompe-l'oeil borders which might have been occasioned by the intervention of a new patron, that is Engelbert. See Alexander (as in n. 116) and A. van Buren, 'The Master of Mary of Burgundy and His Colleagues: the State of Research and Questions of Method', *Zeitschrift für Kunstgeschichte*, 38 (1975), 286–309.

Contracts for Illumination

A selection of contracts for illuminators is reprinted here from older sources which are in most cases not very accessible. I have put them in date order. The last document (no. 8) is one of a number of contracts of apprenticeship included by Pansier in his book. In addition to the sources from which these contracts are taken, the following refer to, and in some cases print in full, contracts with scribes and/or illuminators: H.J. Hermann, 'Zur Geschichte der Miniaturmalerei am Hofe der Este in Ferrara', *Jahrbuch der kunsthistorischen Sammlungen der allerhöchsten Kaiserhauses*, 21 (1900), 247–71, see Docs 2, 31 (Borso Bible), 89, 97, 121, 122 (the last four are contracts with Taddeo Crivelli), 192, 246. L. Frati, *I corali della Basilica di S. Petronio in Bologna* (Bologna, 1896), 84–86 (contract for Choir Books for S. Petronio with Crivelli, *cf.* C. Gilbert, as in Ch. 3, n. 9). F. Filippini, G. Zucchini, *Miniatori e pittori a Bologna. Documenti dei secoli XIII e XIV* (Florence, 1947), see especially pp. 100, 174, 224, 238 for illumination, documents not given in full. F. Gasparri, 'Un contrat de copiste à Orange au XVe siècle' *Scriptorium*, 28 (1974), 285–6. G. de Carné, 'Contrat pour la copie d'un Missel au XVe siècle', *Artistes, artisans et production artistique en Bretagne au Moyen Age*, ed. X Barral i Altet *et al*; 1983, p. 127. C.P. Christianson, *A Directory of London Stationers and Book Artisans 1300–1500* (New York, 1990), p. 66.

1. On 26 August 1346, Robert Brekeling, scribe, contracts with John Forbor to write a Psalter with Calendar including also a Hymnary and Collectarium, etc. He will be paid 5s. 6d. for writing the Psalter and 4s. 3d. for the additional texts. He is also to illuminate it with letters in gold and colours. Large letters for the Nocturns are to be five lines in height and those for *Beatus vir* (Psalm 1) and *Dixit Dominus* (Psalm 109) six or seven lines. He will receive 5s. 6d. for the illumination, 18d. for the gold and 2s. for items of clothing, and also further items of clothing and bedding.

August 26, 1346. Comparuit Robertus Brekeling, scriptor, et juravit se observare condicionem factam inter ipsum et dominum Johannem Forbor, viz.,

quod idem Robertus scribet unum psalterium cum kalendario ad opus dicti domini Johannis pro 5s. et 6d.: et in eodem psalterio, de eadem litera, unum placebo et dirige cum ympnario et collectario pro 4s. 3d. Et idem Robertus luminabit omnes psalmos de grossis literis aureis positis in coloribus, et omnes grossas literas de ympnario et collectario luminabit de auro et vermilione praeter grossas literas duplicium festorum, quae erunt sicut grossae litterae aureae sunt in psalterio. Et omnes literae in principiis versuum erunt luminatae de azuro et vermilione bonis, et omnes literae in inceptione nocturnorum erunt grossae literae unciales (?) continentes v lineas, set *beatus vir, et dixit Dominus*, continebunt vj vel vij lineas; et pro luminatione predicta dabit 5s. 6d., et ad colores, dabit pro auro 18d., et 2s. pro una cloca et furura. Item in unam robam et unum chalonem et unum linthiamen et unum auriculare (*sic*).

J. Raine, 'The York Fabric Rolls', *Surtees Society*, 35 (1858), pp. 165–66, doc. XX (*cf.* T.F. Simmons, ed., 'The Lay Folks Mass Book', *Early English Text Society*, 71 (1879), 401 n.3). [Indentura pro scriptura et luminatio cujusdam libri. Acta Capit. 1343–68, f.30].

2. On Monday after the Fourth Sunday in Lent, 1347, Master Robert, scribe, living in Dijon, contracts to write, illuminate and bind an Antiphonary of ten quires, or more if necessary. He will be paid six livres of which he has had 60s. The book is to be illuminated with azure and vermilion and the large letters will be flourished. It will be completed by St John Baptist's day next (24 June).

Maistre Robert, scriptor, Divione commorans, confesse que, pour VI livres, monnoie courant maintenant, desquelx il hay ehu et recehu de Mons. Biete, etc., LX s. et L(d ?) à la nativitey S. Jehan Baptiste, yeils Robert doit parfaire entenerement hun antiffonay ou quel il faut environ X queurs (peaux de parchemin) et plus, se plus il falloit, tant d'escripture, de enluminure, de reloihure comme de autres chouses quelx quelles soient, liquelx doit estre enluminez d'asur et de vermoillon, et les grosses lettres fleuretées, et lequel il

doit rendre parfait dans la nativ. S.J. Bapt. prochaine-
ment venant, etc. Die lune post Laetare.

J. Simonnet, *Documents inédits pour servir à l'histoire des institutions et de la vie privée en Bourgogne* (Dijon, 1867), p. 351. [1347, *Protocole* of Domin le Cultiler, no. 19.]

3. In March 1398, Master Jehan Demolin, clerc and scribe, living at Dijon, promises to make an Hours of the Virgin for Guillaume le Chamois, bourgeois of Dijon. It will be copied from an exemplar furnished by Guillaume. The Hours will have twelve miniatures with borders, that is for the eight Hours, the Seven Penitential Psalms, the Hours of the Cross, the Hours of the Holy Spirit, and the Vigils of the Dead, and champs of gold and blue. Guillaume is to provide the parchment which Jehan already has, and gold and azure. The work is to be finished on St John the Baptist's day next (24 June). There are to be six other images of saints for suffrages as Guillaume wishes and will specify. The price will be ten gold francs. Guillaume has already paid seven francs and eight gros. Guillaume will also pay the debt of sixteen and a half gros of Jehan's and retrieve for him an Hours left as surety.

Maistre Jehan Demolin, clere et escripvain, demeurant à Dijon, doit et promet, par marchié fait, faire à Guillaume le Chamois, bourgeois de Dijon, présent, etc., unes heures de Nostre Dame, contenans en escriptures autant que font celles que lidis Guillaumes lui baille en et pour exemple.

Et fera es dites heures douze ystoires à vignettes, c'est assavoir à matines, laudes, prime, tierce, midi, none, vespres, complies, sept seaulmes, houres de la croix, houres du saint esprit et vigiles de mois [sic in Simonnet, but presumably mors], telle qu'il appartien à chascune houre, lesquelles ystories montent en somme à douze ystories, et le remenant champis d'or et d'azur.

Item fera es dites heures six aultres ymaiges de sains pour suffrages, telx qu'il plaira audit Guillaume ordonner, tout pour le prix et somme de dix frans d'or.

Et lidiz Guillaumes doit administrer le parchemin, deux trézeaux de fin azur et ung quarteron de fin our pour convertir oudit ouvraige, dont lidiz maistres Jehan a jà receu le parchemin. Et doit rendre les dites heures toutes finies et accomplies dans la nativité saint Jehan Baptiste prochainement venant; promet, oblige, etc.

Sur laquelle somme de (dix) frans lidiz escripvain a receu sept frans d'or, huit gros vies. Et parmy ce, lidis Guillaumes doit acquittier ledit maistre Jehan de seze gros et demi qu'il doit en papier au dit fu Jehan de Beaulne, et parmi ledit acquis, unes houres de Nostre Dame, enluminées d'or et d'azur à vignette qui sont chées ledit fu Jehan sont acquittées et les li fera rendre franches et quittes.

J. Simonnet, *Documents inédits pour servir à l'histoire des institutions et de la vie privée en Bourgogne* (Dijon, 1867), pp. 354–5. [March, 1398, *Protocole*, no. 102]

4. On Thursday after Quasimodo (Low Sunday), 1399, Jean Demolin, scribe, living in Dijon, promises to make a Missal for Philippe Juliot, merchant of Dijon. It is to be in the same script and of the same length as Master Jehan has made before, and of parchment similar to that on which he has already started work. He will insert a calendar and also miniatures of Christ in Majesty and the Crucifixion. The large initials will be ornamented with azure and vermilion, and the large letters for the major feasts will be in gold with flourishing. The work is to be done in a way satisfactory to those who know about such things. The Missal is to be bound in red stamped leather and finished by the Assumption of the Virgin next (15 August) for the price of 16 gold francs and a vat (meul) of wine. Ten francs worth of wine has been paid already and the rest will be paid on completion.

Maistre Jehan Demolin, escripvain de forme, demorant à Dijon, fait marchief et convenances à honorable homme Philippe Juliot, bourgeois de Dijon, de faire et parfaire ung messaul qu'il sera au moins de requise que faire se pourra, à l'avis de gens en ce aient cognoissance, et sera de telle lettre et de tel longuour comme ce qui est jà fait par devers ledit maistre Jehan, en son parchemin, tel comme est encommencié; et fera en icellui ung kalendrier, aussi une majesté et ung crucifil qui seront de colour, et seront les grosses lettres tournées d'azour et de vermillon, et devront estre les grosses lettres des bonnes fêtes d'or floretées; et le devra rendre tout assovis et parfait bien et con-venablement, à l'avis de gens aians en ce cognoissance, et sera couvert de roige cuer emprainte, dedans la feste de Nostre Dame la mi aoust prochainement venant, pour le prix de seze frans d'our et d'ung meul de vin. A lui baillié dix frans de vin. Et le demorant le sera baillié quant il lui rendra ledit messaul. Die jovis post Quasimodo.

J. Simonnet, *Documents inédits pour servir à l'histoire des institutions et de la vie privée en Bourgogne* (Dijon, 1867), pp. 355–6. [1399, *Protocol* of Jean le Bon, no 101.]

5. On 20 March 1448, Johannes de Planis, illuminator, contracts to illuminate a Missal written for Jean Rolin, Bishop of Autun, by Dominique Cousserii, Celestine monk. It is to have suitable miniatures and initials for the capitula of pure gold with particoloured grounds of blue and rose [cum jetons ? means]. Each miniature is to be well drawn and with gold, blue and pink similar in form and figures to a specimen shown him on the Bishop's part. The price of the miniatures is fifteen gros and of one hundred initials one gold écu. The work is to be done as quickly as possible without fraud, and is not to be interrupted for any reason whatever. Henricus Tegrini, citizen of Avignon, the Bishop's representative, guaran-tees payment on receiving the Missal which Johannes will guard faithfully and restore to the Bishop.

Pro reverendo in christo patre domino episcopo Eduensi. Pactum de illuminando unum missale.

1448 et die vicesima marcii magister Johannes de Planis, de Ucecia, illuminator librorum, pactum fecit et promissio[nem] dicto domino episcopo absenti, ac nobili Henrico Tegrini, campsori, civi Avin. presenti, ac pro eodem domino episcopo stipulanti, de illuminando unum missale ipsius domini episcopi, quod scribi fecit per Dominicum Cousserii, celestinum, cum historiis opportunis ac litteris capitularibus de auro puro et fino in campo diversificato et pertito de lazulo d'Acre et rosa et cum jetons (*sic*), bene fideliter et decenter ac honeste sine quacumque fraude seu sophisticacione, et facere quamlibet historiam bene pertractam et cum auro puro, lazuloque et rosa similibus secundum formam et personagia debita prout ex parte dicti domini episcopi sibi fuerit munstratum, et precio quamlibet historiam quindecim grossorum, et quodlibet centenarium litterarum capitalium predictarum precio unius scuti auri; et dictum opus bene et diligenter ac fideliter, prout melius et brevius poterit, expedire sine fraude quacumque; et dictum opus pro alio non intermittere neque interrumpere pro quacumque causa.

Et ibidem nobilis Henricus Tegrini, campsor et civis Avinionensis, responsorio nomine dicti domini episcopi, et suum debitum proprium faciendo, dicto Johanni promisit stipulanti et recipienti sibi solvere dictum precium pro rata operis seu laboris sui, ac prout peccuniis indigebit; et dictus Johannes promisit facere dictum opus in presente civitate Avinionensi, et dictum librum sive missale bene et fideliter custodire et illum sic illuminatum et perfecte completum eidem domino Eduensi restituere et consignare....

Actum Avinione in domo habitacionis seu banca cambii ipsius Henrici....

P. Pansier, *Histoire du livre et de l'imprimerie à Avignon du xiv^e au xv^e siècle* (Avignon, 1922) pp. 40–41. [Doc. 17. Arch. de Vaucluse, notaires, fonds Martin, brèves de Jhs. Morelli, fol 105. 20 March 1448]. Pansier, pp. 46–7, also prints the document of receipt of the Missal on 31 August by Dominique Cousserii and Petrus Chalmelli, Celestines of the Avignon Convent, 'bene sufficienter et complete illuminatum', for the Bishop's Chapel. [Doc. 23. Arch. de Vaucluse, notaires, fonds Martin, brèves de Jhs. Morelli, fol. 190].

6. On 23 April 1494, the Florentine illuminator, Attavante contracts with Chimenti di Cipriano di Sernigi, citizen and merchant of Florence, for the illumination of a Bible with commentary of Nicholas de Lyra in seven volumes with, in addition, a copy of Peter Lombard on the Sentences. Forms of decoration are laid down in accordance with a specimen quire and rates of payment are stipulated for different parts of the illumination, for instance twenty-five gold ducats for the 'principio' of each volume (one of these is to be finished every two months), etc. Chimenti will pay Attavante twenty-five gold ducats a month and pro rata week by week, with fines if the work is not completed to Chimenti's satisfaction or on time. If the scribes fall behind in providing the quires as promised each month and Attavante cannot work, then Chimenti can withhold the payments. Chimenti will inspect the work personally, or by intermediary, every day. At completion Attavante wishes at least a hundred gold ducats to be owing to him, and Chimenti is to pay the final balance due all together. (The Bible and the Sentences are now in Lisbon, Arquivo Nacional da Torre do Tombo. See P. D'Ancona, 'Nuove ricerche sulla Bibbia dos Jeronymos e dei suoi illustratori', *La Bibliofilia*, 15 (1913), 205–12. M. Levi D'Ancona, *Miniatura e miniatori a Firenze dal XIV al XVI secolo. Documenti per la storia della miniatura* (Florence, 1962), pp. 256–7).

1494 die xxiij aprilis. Spectabilis vir Clemens olim Cipriani Sernigi civis et mercator florentinus ex parte una, et Vantes Ghabriellis Attavanti miniator, ex alia etc., omni modo etc., venerunt inter se ad infrascriptam conventionem infrascripti tenoris et continentie et sub infrascripto ulgari sermone descriptam, videlicet:

+ Yhus adi xxiij daprile 1494

Manifesto si fa per questa presente scripta a ciascheduna persona, come egli è vera cosa che conciosa che Chimenti di Cipriano di Sernigi fa scrivere la bibbia con le expositione di Nicholao de lira a diversi scriptori, diviso in septe volumi, et più el Maestro delle Sententie in uno volume; in tutto saranno otto volumi; e quali ditto Chimenti questo dì soprascripto ha allogati e alluogha per adornarli et miniarli a Vante di Gabriello Actavanti miniatore, con li patti e conditioni che apresso si dirà: et prima;

Il ditto Vante s'obriga sanza alcuna exceptione al dicto Chimenti miniare e adornare dicti libri in ogni loro parte nella perfectione delle figure e adornamenti e cholori, sechondo sono facte nel primo quinterno di dicta opera che lui medesimo ha miniato, anchora che non sia interamente fornito, perchè vi manca arme e liuree; ma debba fornirlo e debba essere el campione di tucto el resto di dicta opera. Et in quella perfectione o meglio debba lavorare et condure et fornire la dicta opera a piacimento del dicto Chimenti, o di chi lui deputassi: lo quale chosì diputato debba giudichare se saranno facti e mantenuti nella dicta perfetione o meglio. Et se fussi giudicato fussino peggio, allora et in tale caso dicto Vante sia tenuto et obligato pagare al dicto Chimenti a ogni sua richiesta et volontà ducati cento larghi d'oro in oro sanza alchuna exceptione, et più quello fussino giudicati essere peggio che in campione del primo quinterno di sopra nominato. E quali libri el dicto Vante s'obliga et promette sanza alchuna exceptione al dicto Chimenti darli forniti per quanto allui s'aspecta del miniarli et adornarli come di sopra, qualunche volume vno mese di poi che dagli scriptori harà hauto l'ultimo quinterno di tale volume; cioè se di qui a mesi viij havessi hauto 4 o 5 volumi, in capo di 9 mesi gli debba del tutto dare forniti; e chosì s'intenda prima o poi che gl'avessi, pure che l'effecto

sia che uno mese poi che l'abbi tempo haverli forniti o fornito quel tale volume. Et il dicto Chimenti sia tenuto giornalmente consegnare o fare consegnare al dicto Vante di quinterni di tali libri et volumi, secondo gl'arà dagli scriptori, poi che saranno rivisti et emendati dagl'errori, a chagione che il dicto Vante possa lavorare in sull'opera giornalmente. Et in caso che il dicto Vante non observassi di darli forniti al dicto tempo, s'intenda esso facto caduto nella pena di ducati 200 larghi d'oro in oro a pagare al decto Chimenti a ogni sua semplice richiesta sanza alchuna exceptione. Et non dimancho sia poi obligato a fornigli (sic) in tempo d'un altro mese o si veramente ch'el ditto Chimenti gli possa fare fornire a chi altri gli paressi a spese de detto Vante. Et il dicto Chimenti debba per tale opera pagare al dicto Vante a pregi in nel modo che appresso si dirà.

Et prima per ogni capo di volume ciò è uno principio colla rubrica a riscontro fatto chon quello adornamento o più, che ha facto nel sopradicto primo principio misso per campione et come di sopra è ditto; debba haver duchati XXV larghi d'oro in oro, et debba ogni dua mesi almeno dare fornito uno di dicti principij et lo resto chome di sopra si chontiene.

Et più debba fare generalmente a'prolaghi, pistole, prefatione, postille, proemii, in quella forma ha fatto nel primo quinterno deputato per campione, ciò è ornamento di sopra et pel mezo del cholonnello et da un lato et chon quella figura s'appartiene a ciascuno. Et debba havere tre quarti di ducato d'oro in oro dell'uno.

Et più debba fare alle additioni et arghumenti che sono in dicti volumi code alte quanto è il cholonnello chon figura come ha facto nel primo quinterno di sopra nominato, et hanno havere fogliami di sopra che adornino quanto sono le robriche di sopra nel libro; et debba havere uno quarto di ducato d'oro in oro dell'uno.

Et più debba fare ogni principio di libro, ciò è a capo di libro uno principio per 1/3 in quella forma ha facto alla pistola di San Girolamo nel primo quinterno, con quegli medesimi adornamenti et figure o meglio. Et debba havere ducati 3 larghi d'oro in oro dell'uno.

Et più debba fare in dicti libri a' chapitoli della bibbia lectere nel quadro, paliate et chon fogliami, secondo ha facto nel primo sopranominato quinterno: et debba havere sol. iiij picc:li dell'una.

Et più debba fare alle expositioni ne' chapitoli sua lettere paliate nel quadro, secondo ha facto nel ditto primo quinterno o meglio. Et debba havere sol. dua pic.li dell'uno.

Et più debba fare a ogni capo della expositione di Nicholò de Lira lettera et figura con tanti ornamenti che passino la valuta d'uno mezo ducato d'oro in oro dell'uno. Et debba avere 1/2 ducato d'oro in oro dell'uno.

Et più debba fare all'expositione de' prologhi, prefatii, pistole, proemij lettere chon figure et chon

ornamenti di fogliami alti quanto è il libro et di sopra in quella forma ha facto nel primo quinterno; et debba haverne 1/4 di ducato d'oro in oro dell'uno.

Et più debba fare a'chapoversi de'Salmi, lettere nel quadro, corpi d'oro macinato et debba haverne danari quactro picc:li dell'una, cioè uno quactrino.

Anchora debba fare al volume del Maestro delle Sententie vno principio chola robrica a riscontro, con quella medesima diligentia et copia et perfectione di figure et altre cose che ha facto nel primo principio di Nicholao de Lira, o meglio: et debba haverne ducati xvj d'oro in oro larghi.

Et più debba fare al dicto Maestro delle Sententie a ogni capo di libro uno principio per 1/3 con fogliami, figure et ornamenti in quella forma ha facto nel primo quinterno di Nicholao del Lira alla pistola di san girolamo: et debba averne ducato uno et mezo d'oro in oro dell'uno.

Et più debba fare a'chapitoli principali lectera nel quadro con fogliami nella medesima forma ha facto nel primo quinterno di Nicholao de Lira: et deba havere sol. 4 pic:li dell'una.

Et quale pagamento el dicto Chimenti debba fare al dicto Vante in questa forma, cioè; dargli ogni mese ducati XXV d'oro et per rata septimana per septimana et quello più o mancho che parrà a dicto Chimenti: perchè in caso gli scriptori non observassino di dare ogni mese la quantità de' quinterni hanno promesso, non harebbe bisogno di tanta copia di lavoranti el ditto Vante et però non si chonverebe darli tanti danari ogni mese. Di che, come è ditto, se ne rimecte alla discretione di decto Chimenti, il quale giornalmente habia a vedere o fare vedere quello harà lavorato dicto Vante in dicta opera, a chagione che non soprafacessi chol pigliare più danari non hauessi guadagnati. Et inoltre alfine di tutta la dicta opera, dicto Vante vuole restare havere almancho ducati cento d'oro, et quello che resterà havere, ditto Chimenti sia tenuto pagarglene tutti a un tratto.

G. Milanesi, *Nuovi documenti per la storia dell'arte toscana dal XII al XV secolo*, Florence, 1901 (repr. 1973), pp. 164–6 (no. 185). [Rogiti di Ser Giovanni Carsedoni da Firenze. Protocollo dal 1491 al 1500.]

7. On 5 February 1504 Frater Ludovicus de Canea, Carmelite of St Andrew's, diocese of Riez, charged by letter from the Prior and Convent of the Carmelites at Luc, diocese of Fréjus, has agreed a price for an Antiphonal containing all the antiphons and responses for the whole year, both Temporale and Sanctorale, to be made by Dom. Jacobus de Manso, priest, scribe, of the city of St-Flour. Frater Ludovicus has given him two folios of parchment of the required size as a model. The price is thirty-eight gold ducats to be paid on completion. But if Dom. Jacobus lacks the necessary money to finish the work, the Prior and Convent will give him ten ducats deducted from the total price. The Prior and Convent are

to pay for the parchment and also to provide a room, bed, food and a fire until the book is completed. Dom Jacobus is to provide colours for the illumination, viz azure and vermilion, and to pay for the colours.

Tradicio unius libri littere forme ad precium factum pro venerabilibus viris dominis priori, fratribus et conventu Carmelitarum loci Luci, Forojulien. diocesis.

Anno quo supra (1504) et die quinta mensis februarii, etc... venerabilis frater Ludovicus de Canea, baccalarius in theologia, conventus Carmelitarum S. Andree, diocesis Regensis, habens, ut dixit, onus infrascripta fieri faciendum a dictis dominis priore, fratribus et conventu Carmelitarum loci Luci, Forojulien. diocesis, prout de suo mandato constare dicebat quadam littera missoria eidem per eumdem dominum priorem dicti conventus missa, igitur dictus frater Ludovicus nomine dictorum procuratorio fratrum et conventus... tradidit ad precium factum... venerabili domino Jacobo de Manso, presbitero, civitatis S. Flori, scriptori, presenti etc. videlicet unum librum appellatum: lo responsorie alias lo ferial et centoral; in quo continentur omnes antiphone et responsoria tocius anni tam de tempore quam de sanctis, in pergameno bone littere forme, videlicet latitudinis et longitudinis duorum foliorum pergameni unius alterius libri eidem Jacobo de Manso per eumdem fratrem Ludovicum exhibitorum et traditorum pro forma dicti libri faciendi.

Et hoc precio et nomine precii triginta octo ducatorum auri solvendorum in fine operis, hoc est ipso libro patrato et finito per dictum dominum Jacobum de Manso; cum pactis sequentibus videlicet quod si ipse dominus Jacobus indigeat peccuniis pro necessariis emendis, quod ipsi domini prior et conventus debeant eidem tradere decem ducatos auri in deductionem dicti majoris precii.

Fuitque ulterius de pacto quod ipsi domini prior, fratres et conventus teneantur solvere pergamenos necessarios in dicto libro et eidem providere de camera, lecto, victu et igne donec ipse liber fuerit patratus.

Item amplius fuit de pacto quod ipse dominus Jacobus teneatur solvere colores et providere de coloribus ad illuminandum videlicet de asur vermelhono. Et ipse de Manso teneatur reddere dictum librum scriptum, illuminatum et ligatum in forma debita. Pro quibus ect.

Actum Avinione in domo Johannis Tornemalle blancherii....

P. Pansier, *Histoire du livre et de l'imprimerie à Avignon du XIV^e au XV^e siècle* (Avignon, 1922) pp. 97–8 [Doc. 77. Arch. de Vaucluse, notaires, fonds Pons, no. 1998, f. 60].

8. On 22 August 1455 Franciscus Bequati, clerk, eighteen years old, is contracted as apprentice to Master Henri Feynaud, illuminator of books, living in Avignon. He promises to serve his master well in the said art and to learn it well and to work with his hands, cook, make the beds, clean the house, draw and carry water, get wine from the tavern and do everything for his master's convenience and honour and not reveal his secrets to anyone. Master Henri promises in return to feed the young man and teach him how to illuminate and to give him a pair of boots and three pairs of sandals (?, sotularum) each year and to pay him at the end of his term of three years one gold écu.

Pro magistro Henrico Feynaudi, diocesis Corisopitensis, illuminatori librorum habitatori Avinionen. Conductio apprenticii.

1455, die XXII augusti, Franciscus Bequati, clericus ville Marelogii, diocesis Mimatensis, asserens... se esse in XVIII° sue etatis anno... locavit et dedicavit se ejusque operas manuales, fabriles et obsequiales prefato magistro Henrico, presenti, stipulanti, ad serviendum sibi in apprenticium seu discipulum dicte artis illuminationis ac aliis omnibus licitis et honestis per formam sequentem:

Ipse namque promisit sibi servire in dicta arte bene et fideliter, ac diligenter illam addiscere, et se affanare, cibaria domus decoquere, et lectos parere, domum mundare, aquam haurire et portare pro necessitate domus, et vinum querere ad tabernas quandocumque expedierit, sui magistri commodum et honorem procurare, ejus damnum aut injuriam avertere, sua secreta nemini revelare, resque suas prout ad ejus manus pervenerint fideliter custodire, et ab eo non recedere ante hujusmodi, terminum videlicet trium annorum in festo beate Marie proxime preterito hujus mensis inceptorum ac in omnibus agnoscere bonam fidem.

Et vice versa dictus magister Henricus promisit dictum juvenem per tempus predictum alimentare, et sibi monstrare et docere predictam artem illuminature librorum in singulis partibus et membris de quibus ipse magister utitur et se intromittit bene et fideliter ac caritative secundum cursus et gradus communes docendi in illa arte pro modo capacitatis ipsius juvenis, et sibi singulis annis unum par caligarum et tria paria sotularum quolibet anno, et in fine termini dictorum trium annorum unum scutum auri [dare].

... Actum Avinione....

P. Pansier, *Histoire du livre et de l'imprimerie à Avignon du XIV^e au XV^e siècle* (Avignon, 1922) pp. 48–9. [Doc. 26. Arch. de Vaucluse, fonds Martin, breves de Jhs. Morelli, fol 72. 22 August 1455]

Illuminators' Preliminary Marginal Drawings

This is a list of examples compiled mainly from printed sources noted below, supplemented by my own observations or the notifications of colleagues. It does not represent any kind of systematic search either into specific collections or into published catalogues. The latter cannot be relied on to record such drawings in any case, and it is to be hoped that future cataloguers will notice them more consistently. Admirable in this respect are the catalogues by F. Avril, P. Stirnemann, *Manuscrits enluminés d'origine Insulaire VIIe–XXe siècle* (Paris, 1987) and by L.M.C. Randall, *Medieval and Renaissance Manuscripts in the Walters Art Gallery, I. France, 875–1420* (Baltimore, London, 1989). It is certain that many more examples remain to be recorded and until we have a fuller listing it is hazardous to attempt generalisations from the evidence presented here. Nevertheless I hope this list can function as a basis for, and a stimulus to, further work. The main publications in which these drawings have been noted until now are listed in Ch. 3, n. 57, especially Martin (1904),[1] Meiss (1967), Branner (1977), Stirnemann (1982), Stones (1990), and Alexander (1990).

THIRTEENTH CENTURY

FRENCH

1. Liverpool, The National Museums and Galleries on Merseyside (Walker Art Gallery), Meyer 12038. Bible. Early thirteenth century. See Ch. 3, p. 65–6, figs 102–3.

2. Sotheby's, 20 June 1978, lot 2979 (Major J.R. Abbey). Bible. Early thirteenth century. Attributable to Magister Alexander, as is no. 1.

3. Amiens, Bib. mun., Ms. 23. Bible. Early thirteenth century. See Ch. 3, p. 65, fig. 99.

4. Paris, B.n., latin 11545. Glossed Bible. Second quarter thirteenth century. Branner, *Manuscript Painting*, pp. 218, 222, fig. 5. See Ch. 3, p. 63, fig. 93.

5. Baltimore, Walters Art Gallery, W. 108. Sens Breviary. Second and third quarter thirteenth century. Branner, *Manuscript Painting*, pp. 13, 211, 226, fig. 4. Randall, cat. 19.

6. Baltimore, Walters Art Gallery, W. 61. Bible. Second quarter thirteenth century. Randall, cat. 17.

7. Boulder, Colorado. University of Colorado, Bijoux Ms. 284–5. Bible (two leaves). Second quarter thirteenth century. Ex info. Ms. Lyn Bair.

8. Paris, B.n., latin 17907. Petrus Riga, *Aurora*. Second quarter thirteenth century. Branner, *Manuscript Painting*, pp. 15, 206, fig. 8. See Ch. 3, p. 66, fig. 105.

9. Paris, B.n., latin 108. Glossed Psalter. Second quarter thirteenth century. Stirnemann, 1982, pl.1. See Ch. 3, p. 64, fig. 97.

10. Paris, Bib. Mazarine, Ms. 15. Bible. Mid thirteenth century. Branner, *Manuscript Painting*, pp. 15, 209, 225, fig. 6.

11. Oxford, Magdalen College, latin 175. Isaac Judaeus. Mid thirteenth century. Alexander, Temple, no. 663.

12. Paris, Bib. de l'Arsenal, Ms. 5220. Guillaume de Tyr. Mid thirteenth century. Martin, p. 27.

13. Paris, B.n., latin 16082. Aristotle. Mid thirteenth century. Branner, *Manuscript Painting*, p. 21 n. 66, 220.

14. Erfurt, Wissenschaftliche Allgemeinbibliothek, Ampl. 2° 19, 31, 32. Aristotle. Mid thirteenth century. Ex info. Dr E. A. Peterson, University of Pittsburgh. See also Branner, *Manuscript Painting*, p. 209 for Ampl. 2° 31.

15. Vienna, O.N.B., Cod. 2424. Medical texts. Mid thirteenth century.

16. Assisi, Museo del Sacro Convento. Missal. *c.* 1255. Branner, *Manuscript Painting*, pp. 13, 236.

17. New York, Morgan, M. 111. Bible. *c.* 1260. See Ch. 3, p. 64, fig. 95.

18. Paris, B.n., latin 11538. Bible. Third quarter thirteenth century. Branner, *Manuscript Painting*, pp. 15, 237, fig. 7.

19. Oxford, Bodl., Ms. Lat. th. e. 40. Theological treatises. Third quarter thirteenth century. Pächt, Alexander, 1, no. 533.

20. Oxford, Merton College, Ms. 271 (O.1.3). Aristotle. Third quarter thirteenth century. Alexander, Temple, no. 684.

21. Paris, Bib. de l'Arsenal, Ms. 5056. Bible. *c.* 1280–

1300. Martin, p. 27.

22. San Marino, California, Huntington Library, H.M. 1073. Bible. Second half thirteenth century. C. Dutschke, *Guide to Medieval and Renaissance Manuscripts in the Huntington Library*, 1 (Berkeley, 1989), p. 358.

23. Toledo Cathedral, Ms. 56.18. Cambrai Pontifical. Late thirteenth century. Stones, *Artistes*, 3, 1990, p. 329, figs 10–11.

24. Oxford, Balliol College, Ms. 2. Bible. Late thirteenth century. Alexander, Temple, no. 700. See Ch. 3, p. 66, fig. 104.

25. Oxford, Bodl., Ms. Auct. D. 1 17. Bible. Late thirteenth century. Pächt, Alexander, 1, no. 543.

26. Baltimore, Walters Art Gallery, W. 131. Gerbert, Bernard of Clairvaux, etc. Late thirteenth century. Randall, cat. 46.

27. Paris, B.n., latin 12953. Aristotle. Late thirteenth century. Branner, *Manuscript Painting*, pp. 21 n. 66, 229, 236–7.

28. Vatican, B.A.V., Urb. lat. 376. Roman de la Rose. Late thirteenth century. E. König, *Der Rosenroman des Berthaud d'Achy. Kommentarband zur Faksimileausgabe des Codex Urb. lat. 376* (Zürich, 1987).

29. Paris, Bib. Mazarine, Ms. 3485. Aristotle. Thirteenth century. Branner, *Manuscript Painting*, p. 21 n. 66.

30. Reims, Bib. mun., Ms. 824. Thirteenth century. Branner, *Manuscript Painting*, p. 21 n. 66.

31. Nuremberg, Stadtbibliothek, Cent. V. 59. Aristotle. Thirteenth century. Branner, *Manuscript Painting*, p. 21 n. 66.

ENGLISH

32. Aberdeen, University Library, Ms.24. Bestiary. Early thirteenth century. See Ch. 5, p. 105, figs 172, 174.

33. Oxford, Merton College, Ms. 269 (F.1.4). Aristotle. *c.* 1260. Alexander, Temple, no. 241, pl. XIV.

34. London, B.L., Harley 3487. Aristotle. Third quarter thirteenth century. See Ch. 3, p. 68, figs 108–9.

35. Oxford, New College, Ms. 7. Bible. Third quarter thirteenth century. Alexander, Temple, no. 173, pl. IX. See Ch. 3, p. 59, fig. 85.

36. Oxford, New College, Ms. 20. Wisdom Books with gloss. Third quarter thirteenth century. Alexander, Temple, no. 205, pl. X. See Ch. 3, p. 65, figs 100–1.

37. Paris, B.n., latin 15211. Peter Lombard, Comm. on the Psalter. *c.* 1270–80. Avril, Stirnemann, no. 153.

38. Paris, B.n., latin 15472. Bible. *c.* 1270–80. Avril, Stirnemann, no. 154.

ITALIAN

39. Venice, Museo Correr, VI. 665. Romance of Alexander. Late thirteenth century.

FOURTEENTH CENTURY

FRENCH

40. Baltimore, Walters Art Gallery, W. 135. Gratian, *Decretum*. South (?). Thirteenth to fourteenth century. Randall, cat. 51.

41. Vatican, B.A.V., Reg. lat. 26. Bible. Thirteenth to fourteenth century. *Il libro della Bibbia, Biblioteca Apostolica Vaticana*, 1972, no. 86. Ex info. Professor A. Stones.

42. Paris, B.n., fr. 802. Roman de la Rose. *c.* 1300. A. Stones, *The Illustration of the French Prose Lancelot in Flanders, Belgium and Paris, 1250–1340*, Ph.D. (London University, 1970).

43. San Marino California, Huntington Library, HM. 3027. Jacobus de Voragine, *Legenda Aurea*. Early fourteenth century. See Ch. 3, p. 63, fig. 94.

44. Paris, Bib. de l'Arsenal, Ms. 2677. Brunetto Latini, *Livre du trésor*. Early fourteenth century. Martin, p. 28.

45. Paris, Bib. de l'Arsenal, Ms. 5201. Robert de Blois, Poems. Early fourteenth century. Martin, p. 27.

46. London, B.L., Harley 616. Bible, part 1. First quarter fourteenth century. Martin, p. 29.

47. Edinburgh, University Library, Ms. 19. *Bible historiale*. 1314. See Ch. 3, p. 64, fig. 96.

48. Paris, Bib. de l'Arsenal, Ms. 5059. Bible of Jean de Papeleu. 1317. Martin, pp. 28, 36.

49. Baltimore, Walters Art Gallery, W. 140. Vincent of Beauvais, *Speculum*. Second quarter fourteenth century. Randall, cat. 64.

50. Paris, B.N., latin 968. Avignon Pontifical. Second quarter fourteenth century. See Ch. 3, pp. 69, 70, figs 115–17.

51. London, B.L., Royal 18 D. VIII. *Bible historiale*. First half fourteenth century. Martin, pp. 29–30.

52. New Haven, Conn., Yale University Library, Ms. 227. Arthurian Romances. 1357. Meiss, *French Painting*, 1, p. 12.

53. London, B.L., Royal 19 D. I. Romances. Mid fourteenth century. See Ch. 3, p. 68, fig. 111.

54. Paris, Bib. de l'Arsenal, Ms. 5203. Guillaume de Machaut, Poems. Second half fourteenth century. Martin, p. 28.

55. Paris, Bib. de l'Arsenal, Ms. 588. Bible. Fourteenth century. Martin, pp. 28, 32–3, 35, 42, figs 3, 4, 7, 9, 10, 11.

56. Paris, B.n., fr. 2813. Grandes Chroniques de France. Before 1380. Hedeman (as in Ch. 6, n. 92), p. 109 n. 59, 110–15.

57. Paris, B.n., latin 18014. 'Petites Heures' of Jean de Berry. *c.* 1385. Avril (as in Ch. 3, n. 41), p. 63.

ENGLISH

58. Baltimore, Walters Art Gallery, W. 144. Aegidius Columna. Early fourteenth century. Ex info. Dr L.M.C. Randall.

59. Oxford, Exeter College, Ms. 42. First quarter fourteenth century. Alexander, Temple, no. 279, pl. XVIII.

60. Oxford, Oriel College, Ms. 46. *Liber custumarum*. *c.* 1320–30. Alexander, Temple, no. 280.

FIFTEENTH CENTURY

FRENCH

61. London, B.L., Cotton Nero E. II. *Chroniques de France*. Early fifteenth century. Meiss, *French Painting*, 1, pp. 11–13, figs 304–11, 314–15. See Ch. 3, p. 69, figs 112–13.

62. London, B.L., Royal 15 D. III. Bible. Early fifteenth century. Meiss, *French Painting*, 1, p. 11, fig. 317.

63. Paris, Bib. de l'Arsenal, Ms. 5077. Early fifteenth century. Martin, pp. 28, 31–2, 44–5, figs 1, 2, 8.

64. Paris, Bib. de l'Arsenal Ms. 664. Terence 'des Ducs'. Early fifteenth century. Martin, pp. 28, 44.

65. Paris, Bib. de l'Arsenal, Ms. 5193. Boccaccio, *Cas des nobles. c.* 1409–19. Martin, pp. 28, 32, 43, figs 5, 6.

66. London, B.L., Royal 19 D. III. *Bible historiale.* 1411. Meiss, *French Painting*, 1, p. 12, figs 312–13.

67. London, B.L., Royal 20 B. IV. *Meditationes vitae Christi. c.* 1420. Meiss, *French Painting*, 1, p. 13, fig. 316. See Ch. 3, pp. 66, 68–9, figs 106–7, 114.

68. Baltimore, Walters Art Gallery, W. 770. Augustine, *De Civitate Dei*. French translation of Raoul de Presles. First quarter fifteenth century. Randall, cat. 96.

69. Paris, B.n., fr. 182. Faits des Romains. Second quarter fifteenth century. *Le Livre*, no. 257. Alexander, *Artistes*, 3, p. 309, fig. 6.

OTHER

70. Formerly Private Collection, Germany. Book of Hours. German (?). Second quarter fifteenth century. Alexander, *Artistes*, 3, p. 309, fig. 5. See pp. 64–5.

71. London, B.L., Add. 38122. Bible. Dutch. *c.* 1430–50. Alexander, *Artistes*, 3, p. 309, fig. 5. See Ch. 3, p. 65, fig. 98.

72. San Marino, California, Huntington Library, HM 268. Lydgate, Fall of Princes. English. Mid fifteenth century. See Ch. 6, p. 145.

[1] Paris, Bib. de l'Arsenal, Ms. 3482, Arthurian Romance, is listed by Martin, but I was unable to find any marginal drawings on examining the manuscript.

Bibliography

Abbot Suger and Saint-Denis. A Symposium, ed. P.L. Gerson (Metropolitan Museum of Art, New York, 1986).

Abou-el-Haj, B., 'Consecration and Investiture in the Life of St Amand, Valenciennes Bibl. Mun. Ms. 502', *Art Bulletin*, 61 (1979), 342–58.

Abou-el-Haj, B., 'Bury St Edmunds Abbey Between 1070 and 1124: A History of Property, Privilege, and Monastic Art Production', *Art History*, 6 (1983), 1–29.

Adler, J., U. Ernst, *Text als Figur. Visuelle Poesie von der Antike bis zur Moderne*, exhibition catalogue (Wolfenbüttel, 1988).

Adomnán, *De locis sanctis*, ed. D. Meehan (Dublin, 1958).

Age of Chivalry. Art in Plantagenet England 1200–1400, eds J.J.G. Alexander, P. Binski (Royal Academy of Arts, London, 1987).

Alexander, J.J.G., 'A Little-known Gospel Book of the Later Eleventh Century from Exeter', *Burlington Magazine*, 108 (1966), 6–16.

Alexander, J.J.G., 'A Romanesque Copy from Mont St Michel of an Initial in the Corbie Psalter', *Millénaire monastique du Mont Saint-Michel*, 2, ed. R. Foreville (Paris, 1967), pp. 241–4.

Alexander, J.J.G., A.C. de la Mare, *The Italian Manuscripts in the Library of Major J.R. Abbey* (London, 1969).

Alexander, J.J.G., *Norman Illumination at Mont St Michel 966–1100* (Oxford, 1970).

Alexander, J.J.G., *Anglo-Saxon Illumination in Oxford Libraries* (Oxford, 1970).

Alexander, J.J.G., 'A Manuscript of Petrarch's Rime and Trionfi', *Victoria and Albert Museum Yearbook*, 2 (1970), 27–40.

Alexander, J.J.G., *The Master of Mary of Burgundy. A Book of Hours for Engelbert of Nassau* (New York, 1970).

Alexander, J.J.G., 'The Illustrated Manuscripts of the "Notitia Dignitatum"', *Aspects of the Notitia Dignitatum*, ed. R. Goodburn, P. Bartholomew (British Archaeological Reports. Supplementary Series, 15) (Oxford, 1976), 11–25.

Alexander, J.J.G., *The Decorated Letter* (New York, London, 1978).

Alexander, J.J.G., *Insular Manuscripts 6th to 9th Centuries* (A Survey of Manuscripts Illuminated in the British Isles, General editor J.J.G. Alexander, vol. 1) (London, 1978).

Alexander, J.J.G., 'Scribes as Artists: The Arabesque Initial in Twelfth-Century English Manuscripts', *Medieval Scribes, Manuscripts and Libraries. Essays Presented to N.R. Ker*, eds M.B. Parkes, A.G. Watson (London, 1978), pp. 87–116.

Alexander, J.J.G., *Wallace Collection. Catalogue of Illuminated Manuscript Cuttings* (London, 1980).

Alexander, J.J.G., 'Painting and Manuscript Illumination for Royal Patrons in the Later Middle Ages', *English Court Culture in the Later Middle Ages*, eds V.J. Scattergood, J.W. Sherborne (London, 1983), pp. 141–62.

Alexander, J.J.G., 'The Limbourg Brothers and Italian Art: A New Source', *Zeitschrift für Kunstgeschichte*, 46 (1983), 425–35.

Alexander, J.J.G., 'Italian Renaissance Illumination in British Collections', *Miniatura Italiana tra Gotico e Rinascimento* (Atti del II Congresso di Storia della Miniatura, Cortona, September, 1982), ed. E. Sesti (Florence, 1985), pp. 99–126.

Alexander, J.J.G., 'La résistance à la domination culturelle carolingienne dans l'art Breton du IXe siècle: le témoignage de l'enluminure des manuscrits', *Landévennec et le monachisme Breton dans le haut Moyen Age. Actes du colloque du XVe centenaire de l'abbaye de Landévennec 25–27 avril 1985*, ed. M. Simon (Landévennec, 1985), pp. 269–80.

Alexander, J.J.G., 'Constraints on Pictorial Invention in Renaissance Illumination. The Role of Copying North and South of the Alps in the Fifteenth and Early Sixteenth Centuries', *Miniatura*, 1 (1988), 123–35.

Alexander, J.J.G., 'Facsimiles, Copies and Variations; The Relationship to the Model in Medieval and Renaissance European Illuminated Manuscripts', *Retaining the Original. Multiple Originals, Copies and Reproductions* (Studies in the History of Art, volume 20), ed. K. Preciado (National Gallery of Art, Washington, 1989), pp. 61–72.

Alexander, J.J.G., 'Katherine Bray's Flemish Book of Hours', *The Ricardian*, 8 (1989), 308–17.

Alexander, J.J.G., '*Labeur* and *Paresse*: Ideological Images of Medieval Peasant Labour', *Art Bulletin*, 72 (1990), 436–52.

Alexander, J.J.G., 'Preliminary Marginal Drawings in Medieval Manuscripts', *Artistes, artisans et production artistique au Moyen Age. 3 Fabrication et consommation de l'oeuvre*, ed. X. Barral i Altet (Paris, 1990), pp. 307–19.

Alexander, J.J.G., 'Illuminations by Matteo da Milano in the Fitzwilliam Museum, Cambridge', *Burlington Magazine*, 133 (1991), 686–90.

Alexander, J.J.G., E. Temple, *Illuminated Manuscripts in Oxford College Libraries, the University Archives and the Taylor Institution* (Oxford, 1985).

Alexander, S.M., *Treatises Concerning the Use of Gold, Silver and Tin in Medieval Manuscripts*, M.A. (Institute of Fine Arts, New York University, 1963).

Alexander, S.M., 'Medieval Recipes Describing the Use of Metals in Manuscripts', *Marsyas*, 12 (1964–5), 34–51.

Apokalypse (Bodleian Library, Oxford, Ms. Douce 180) (Codices Selecti, LXII) (Graz, 1981).

Aratea. Kommentar zum Aratus des Germanicus Ms. Voss. Lat. Q. 79 Bibliotheek der Rijksuniversiteit Leiden, B. Bischoff, B.S. Eastwood, T.A.-P. Klein, F. Mütherich, P.F.J. Hobbema (Luzern, 1989).

Armstrong, L., 'The Illustration of Pliny's *Historia Naturalis* in Venetian Manuscripts and Early Printed Books', *Manuscripts in the Fifty Years After the Invention of Printing* (Papers read at a colloquium at the Warburg Institute 12–13 March 1982), ed. J.B. Trapp (London, 1983), pp. 97–106.

Armstrong, L., '*Opus Petri*: Renaissance Illuminated Books From Venice and Rome', *Viator*, 21 (1990), 385–412.

Armstrong, L., 'Il Maestro di Pico: un miniatore veneziano del tardo quattrocento', *Saggi e memorie di Storia del Arte*, 17 (1990), 7–39.

Armstrong, L., 'The Impact of Printing on Miniaturists in Venice After 1469', *Printing the Written Word: The Social History of Books* c. *1450–1520*, ed. S.L. Hindman (Ithaca, 1991), pp. 174–202.

Arnould, A., *The Art Historical Context of the Library of Raphael de Mercatellis*, Ph.D. (Ghent University, 1992).

Arns, E., *La technique du livre d'après Saint Jérôme* (Paris, 1953).

Art in the Making. Italian Painting Before 1400 (National Gallery of Art, London, 1990).

Artistes, artisans et production artistique au Moyen Age. 1 Les hommes. 2 Commande et travail. 3 Fabrication et consommation de l'oeuvre, ed. X. Barral i Altet (Paris, 1986, 1987, 1990).

Ashmole, B., 'Cyriaco of Ancona', *Proceedings of the British Academy*, 45 (1959), 25–41.

Avril, F., *La technique de l'enluminure d'après les textes médiévaux. Essai de bibliographie* (Réunion du Comité de l'Icom pour les laboratoires de Musées et du Sous-comité de l'Icom pour le traitement des peintures), 1967 (typescript).

Avril, F., 'Trois manuscrits napolitains des collections de Charles V et de Jean de Berry', *Bibliothèque de l'école de chartes*, 127 (1969), 291–328.

Avril, F., 'Une Bible historiale de Charles V', *Jahrbuch der Hamburger Kunstsammlungen*, 14–15 (1970), 45–76.

Avril, F., 'Un enlumineur ornemantiste parisien de la première moitié du XIVe siècle: Jacobus Mathey (Jaquet Maci ?)', *Bulletin Monumental*, 129 (1971), 249–64.

Avril, F., 'Un chef-d'oeuvre de l'enluminure sous le règne de Jean le Bon: La Bible moralisée manuscrit français 167 de la Bibliothèque nationale', *Fondation Eugène Piot. Monuments et mémoires publiés par l'Académie des Inscriptions et Belles Lettres*, 58 (1973), 91–125.

Avril, F., 'Autour du Bréviaire de Poissy (Chantilly, Musée Condé, ms. 804)', *Le Musée Condé*, 7 (1974), 1–6.

Avril, F., 'Un manuscrit d'auteurs classiques et ses illustrations', *The Year 1200: a Symposium* (Metropolitan Museum of Art, New York), ed. J. Hoffeld (New York, 1975), pp. 261–82.

Avril, F., 'Manuscrits à peintures d'origine française à la Bibliothèque nationale de Vienne', *Bulletin Monumental*, 134 (1976), 329–38.

Avril, F., 'A quand remontent les premiers ateliers d'enlumineurs laïcs à Paris ?', *Les Dossiers de l'Archéologie*, 16 (1976), 36–44.

Avril, F., 'Pour l'enluminure provençale. Enguerrand Quarton peintre de manuscrits ?', *Revue de l'Art*, 35 (1977), 9–40.

Avril, F., 'Les manuscrits enluminés de Guillaume de Machaut. Essai de chronologie', *Guillaume de Machaut. Colloque. Table Ronde organisé par l'Université de Reims* (Paris, 1982), pp. 117–33.

Avril, F., *Le livre des Tournois du Roi René de la Bibliothèque nationale (ms. français 2695)* (Paris, 1986).

Avril, F., J.-P. Aniel, M. Mentré, A. Saulnier, Y. Załuska, *Manuscrits enluminés de la péninsule ibérique* (Bibliothèque nationale, Paris, 1982).

Avril, F., M.-T. Gousset, C. Rabel, *Manuscrits enluminés d'origine italienne, 2. XIIIe siècle* (Bibliothèque nationale, Paris, 1984).

Avril, F., P. Stirnemann, *Manuscrits enluminés d'origine Insulaire VIIe–XXe siècle* (Paris, 1987).

Avril, F., L. Dunlop, B. Yapp, *Les Petites Heures de Jean duc de Berry. Introduction au manuscrit latin 18014 de la Bibliothèque nationale, Paris* (Luzern, 1989).

Ayres, L.M., 'Problems of Sources for the Iconography of the Lyre Drawings', *Speculum*, 49 (1974), 61–8.

Ayuso Marazuela, T., 'Un scriptorium español desconocido', *Scriptorium*, 2 (1948), 3–27.

Backhouse, J., *John Scottowe's Alphabet Books* (Roxburghe Club, 1974).

Backhouse, J., 'An Illuminator's Sketchbook', *British Library Journal*, 1 (1975), 3–14.

Backhouse, J., *The Illuminated Manuscript* (Oxford, 1979).

Backhouse, J., 'The Making of the Harley Psalter', *British Library Journal*, 10 (1984), 79–113.

Backhouse, J., 'Founders of the Royal Library: Edward IV and Henry VII as Collectors of Illuminated Manuscripts', *England in the Fifteenth Century* (Proceedings of the 1986 Harlaxton Symposium), ed. D.T. Williams (Woodbridge, 1987), pp. 23–41.

Backhouse, J., 'Illuminated Manuscripts and the Early Development of the Portrait Miniature', *Early Tudor England* (Proceedings of the 1987 Harlaxton Symposium), ed. D.T. Williams (Woodbridge, 1989), pp. 1–17.

Baker, M., 'Medieval Illustrations of Bede's *Life of St Cuthbert*', *Journal of the Warburg and Courtauld Institutes*, 41 (1978), 16–49.

Bange, E.F., *Eine Bayerische Malerschule des XI. und XII. Jahrhunderts* (Munich, 1923).

Barker, N., *Two East Anglian Picture Books. A Facsimile of the Helmingham Herbal and Bestiary and Bodleian Ms. Ashmole 1504* (Roxburghe Club, 1988).

Baron, F. 'Enlumineurs, peintres et sculpteurs parisiens des XIIIe et XIVe siècles d'après les rôles de la taille', *Bulletin archéologique du Comité des travaux historiques et scientifiques*, n.s. 4 (1969), 37–121.

Baron, F., 'Enlumineurs, peintres et sculpteurs parisiens des XIV et XV siècles, d'après les archives de l'hôpital Saint-Jacques aux Pèlerins', *Bulletin archéologique du Comité des travaux historiques et scientifiques*, n.s. 6 (1970–71), 77–115.

Barzon, A., *Codici Miniati. Biblioteca Capitolare della Cattedrale di Padua* (Padua, 1950).

Bauer, A., J. Strzygowski, 'Eine Alexandrinische Weltchronik', *Denkschriften der Kaiserlichen Akademie der Wissenschaften in Wien*, 51 (1905), 1–204.

Bauer-Eberhardt, U., 'Lauro Padovano und Leonardo Bellini als Maler, Miniatoren und Zeichner', *Pantheon*, 47 (1989), 49–82.

Bäuml, F.H., 'Varieties and Consequences of Medieval Literacy and Illiteracy', *Speculum*, 55 (1980), 237–65.

Beaurepaire, E. de, *Nouveaux mélanges historiques et archéologiques* (Rouen, 1904).

Beaurepaire, E. de, *Derniers mélanges historiques... concernant le département de la Seine-Inférieure* (Rouen, 1909).

Bell, H.E., 'The Price of Books in Medieval England', *The Library*, 17 (1936–7), 312–32.

Bellinati, C., 'La cappella di Giotto all'Arena'e le miniature dell'Antifonario Giottesco della cattedrale (1306)', *Da Giotto al Mantegna*, exhibition at the Palazzo della Ragione, Padua, 9 June–4 November 1974 (Milan, 1974), pp. 23–30.

Bénédictins du Bouveret, *Colophons de manuscrits occidentaux des origines au XVIe siècle* (Spicilegia Friburgensia Subsidia, 2–8), 7 vols (Fribourg, 1965–79).

Berg, K., *Studies in Tuscan Twelfth-Century Illumination* (Oslo, 1968).

Berger, S., *La Bible française au Moyen Age* (Paris, 1884; repr. 1967).

Berger, S., 'Les manuels pour l'illustration du Psautier au XIIIe siècle', *Mémoires de la Société nationale des Antiquaires de France*, 57 (1898), 95–134.

Berger, S., P. Durrieu, 'Les notes pour l'enlumineur dans les manuscrits du Moyen Age', *Mémoires de la Société nationale des Antiquaires de France*, 53 (1893), 1–30.

Bernasconi, M., L. dal Poz, *Codici miniati della Biblioteca Comunale di Trento* (Florence, 1985).

Bertoni, G., *Il maggior miniatore della Bibbia di Borso d'Este, Taddeo Crivelli* (Modena, 1925).

Besson, F.M., '"A armes égales": une représentation de la violence en France et en Espagne au XII siècle', *Gesta*, 26/2 (1987), 113–26.

Biemans, J.A.A.M., *Middelnederlandse Bijbelhandschriften: Verzameling van middelnederlandse bijbelteksten; catalogus* (Leiden, 1984).

Bierbrauer, K., *Die Ornamentik frühkarolingischer Handschriften aus Bayern* (Bayerische Akademie der Wissenschaften. Phil.-Hist. Kl. Abh. N.F. 84) (Munich, 1979).

Binski, P., *Medieval Craftsmen. Painters* (London, Toronto, 1991).

Bischoff, B., 'Über Einritzungen in Handschriften des frühen Mittelalters', *Zentralblatt für Bibliothekswesen*, 54 (1937), 173–77, reprinted 'erweitet' in *Mittelalterliche Studien. Ausgewählte Aufsätze zur Schriftkunde und Literaturgeschichte*, I (Stuttgart, 1966), pp. 88–92.

Bischoff, B., 'Elementarunterricht und "Probationes pennae" in der ersten Hälfte des Mittelalters', *Classical and Medieval Studies in Honor of Edward Kennard Rand* (New York, 1938), pp. 9–20, reprinted revised in *Mittelalterliche Studien. Ausgewählte Aufsätze zur Schriftkunde und Literaturgeschichte*, I (Stuttgart, 1966), pp. 74–87.

Bischoff, B., 'Scriptoria e manoscritti mediatori di Civiltà', *Settimane di studio del Centro italiano di studi sull' alto medioevo. II. Centri e vie di irradiazione della civiltà nell' alto medioevo* (Spoleto, 1963), pp. 479–504, reprinted *Mittelalterliche Studien. Ausgewählte Aufsätze zur Schriftkunde und Literaturgeschichte*, II (Stuttgart, 1967), pp. 312–27.

Bischoff, B., 'Die Überlieferung der technischen Literatur', *Artigianato e tecnica nella società dell' alto medioevo occidentale* (Settimane di studio del Centro italiano di studi sull' alto medioevo, XVIII) (Spoleto, 1971), pp. 267–96, reprinted in *Mittelalterliche Studien. Ausgewählte Aufsätze zur Schriftkunde und Literaturgeschichte*, III (Stuttgart, 1981), pp. 277–97.

Bischoff, B., transl. D. Ó'Cróinín, D. Ganz, *Latin Palaeography. Antiquity and the Middle Ages* (Cambridge, 1990).

Björnbo, A.A., 'Ein Beitrag zum Werdegang der mittelalterlichen Pergamenthandschriften', *Zeitschrift für Bücherfreunde*, 11 (1907), 329–335.

Black, A., *Guilds and Civil Society in European Political Thought from the Twelfth Century to the Present* (London, 1984).

Blanchard, A., *Les débuts du codex. Actes de la journée d'étude organisée à Paris les 3 et 4 Juillet 1985* (Paris, 1989).

Bloch, P., *Das Hornbacher Sakramentar und seine Stellung innerhalb der frühen Reichenauer Buchmalerei* (Basel, 1956).

Bloch, P., 'Zum Dedikationsbild im Lob des Kreuzes des Hrabanus Maurus', *Das erste Jahrtausend. Kultur und Kunst im werdenden Abendland an Rhein und Ruhr*, Textband I, ed. V.H. Elbern (Düsseldorf, 1962), pp. 471–94.

Bober, P.B., R.O. Rubinstein, *Renaissance Artists and Antique Sculpture. A Handbook of Sources* (London, 1986).

Boeckler, A., *Das goldene Evangelienbuch Heinrichs III* (Berlin, 1933).

Boeckler, A., *Der Codex Wittekindeus* (Leipzig, 1938).

Bommarito, D., 'Il ms. 25 della Newberry Library: la tradizione dei ricettari e trattati sui colori nel Medioevo e Rinascimento veneto e toscano', *La Bibliofilia*, 87 (1985), 1–38.

Borrodaile, V., R. Borrodaile, transl., *The Strassburg Manuscript. A Medieval Painter's Handbook* (London, 1966).

Borsook, E., *The Mural Painters of Tuscany from Cimabue to Andrea del Sarto* (2nd rev. edn, Oxford, 1980).

Boutemy, A., 'Enluminures d'Anchin au temps de l'abbé Gossuin (1131/3 à 1165)', *Scriptorium*, 11 (1957), 234–48.

Boyle, L.E., *Medieval Latin Palaeography. A Bibliographical Introduction* (Toronto, 1984).

Branner, R., 'Manuscript-Makers in Mid-Thirteenth Century Paris', *Art Bulletin*, 48 (1966), 65–7.

Branner, R., 'The Manerius Signatures', *Art Bulletin*, 50 (1968), 183–4.

Branner, R., *Manuscript Painting in Paris during the Reign of Saint Louis. A Study of Styles* (Berkeley, Los Angeles, 1977).

Braunfels, W., *The Lorsch Gospels* (New York, 1967).

Brieger, P.H., *The Trinity Apocalypse* (facsimile, London, 1967).

Briganti, A., *Le Corporazioni delle Arti nel Comune di Perugia (sec. XII–XIV)* (Perugia, 1910).

Brinkmann, B., 'The Hastings Hours and the Master of 1499', *British Library Journal*, 14 (1988), 90–106.

Brown, T.J., 'The Distribution and Significance of Membrane Prepared in the Insular Manner', *La paléographie hébraïque médiévale* (Colloques internationaux du Centre national de la recherche scientifique 547) (Paris, 1974), pp. 127–35.

Brownrigg, L., ed., *Medieval Book Production. Assessing the Evidence* (Los Altos Hills, 1990).

Bruce-Mitford, R.L.S., 'The Art of the *Codex Amiatinus*', *Journal of the British Archaeological Association*, 32 (1969), 1–25.

Bruce-Mitford, R.L.S., M. Bruce-Mitford, 'The Musical Instrument', *The Sutton Hoo Ship-burial, Volume 3*, ed. A.C. Evans (London, 1983), pp. 611–731.

Brunello, F., ed. and transl., *'De arte illuminandi' e altri trattati sulla tecnica della miniatura medievale* (Venice, 1975).

Buchthal, H., review of J. de Wit, *Die Miniaturen des Vergilius Vaticanus* (Amsterdam, 1959), in *Art Bulletin*, 45 (1963), 372–5.

Buchthal, H., *The 'Musterbuch' of Wolfenbüttel and Its Position in the Art of the Thirteenth Century* (Vienna, 1979).

Buettner, B., 'Jacques Raponde "marchand de manuscrits enluminés"', *Langue, texte, histoire médiévales (La culture sur le marché)*, 14 (1988), 23–32.

Burford, A., *Craftsmen in Greek and Roman Society* (London, 1972).

Butler, E.C., *Sancti Benedicti Regula Monachorum* (3rd edn, Freiburg-i-Breisgau, 1935).

Byrne, D., 'The Boucicaut Master and the Iconographical Tradition of the "Livre des propriétés des choses"', *Gazette des*

Beaux-Arts, 91 (1978), 149–64.

Byrne, D., *The Illustrated Manuscripts of Bartholomaeus Anglicus*, Ph.D. (Cambridge University, 1981).

Byrne, D., '*Rex imago Dei*: Charles V of France and the *Livre des propriétés des choses*', *Journal of Medieval History*, 7 (1981), 97–113.

Byrne, D., 'Manuscript Ruling and Pictorial Design in the Work of the Limbourgs, the Bedford Master, and the Boucicaut Master', *Art Bulletin*, 66 (1984), 118–36.

Byrne, D., 'An Early French Humanist and Sallust: Jean Lebègue and the Iconographical Programme for the *Catiline* and *Jugurtha*', *Journal of the Warburg and Courtauld Institutes*, 49 (1986), 41–65.

Cabelli, D.E., M.V. Orna, T.F. Mathews, 'Analysis of Medieval Pigments from Cilician Armenia', *Archaeological Chemistry*, 3 (1984), 243–54.

Cahn, A.S., 'A Note: The Missing Model of the Saint-Julien de Tours Frescoes and the *Ashburnham Pentateuch* Miniatures', *Cahiers archéologiques*, 16 (1966), 203–7.

Cahn, W., 'The Artist as Outlaw and Apparatchik: Freedom and Constraint in the Interpretation of Medieval Art', *The Renaissance of the Twelfth-century*, ed. S. Scher (Providence, 1969), pp. 10–14.

Cahn, W., 'St Albans and the Channel Style in England', *The Year 1200. A Symposium*, introd. J. Hoffeld (Metropolitan Museum of Art, New York, 1975), pp. 187–230.

Cahn, W., *Romanesque Bible Illumination* (Ithaca, 1982).

Cahn, W., 'The *Rule* and the Book. Cistercian Book Illumination in Burgundy and Champagne', *Monasticism and the Arts*, ed. T.G. Verdon (Syracuse, 1984), pp. 139–72.

Cahn, W., J. Marrow, 'Medieval and Renaissance Manuscripts at Yale: A Selection', *The Yale University Library Gazette*, 52 (1978), 173–283.

Cains, A., 'The Pigment and Organic Colours', *The Book of Kells Ms. 58 Trinity College Library, Dublin. Commentary*, ed. P. Fox (Luzern, 1990), pp. 211–31.

Calkins, R.G., 'The Brussels Hours Re-evaluated', *Scriptorium*, 24 (1970), 3–26.

Calkins, R.G., 'Stages of Execution: Procedures of Illumination as Revealed in an Unfinished Book of Hours', *Gesta*, 17 (1978), 61–70.

Calkins, R.G., 'Distribution of Labor: The Illuminators of the Hours of Catherine of Cleves and their Workshop', *Transactions of the American Philosophical Society*, 69 (1979), 3–83.

Calkins, R.G., 'An Italian in Paris: the Master of the Brussels Initials and his Participation in the French Book Industry', *Gesta*, 20/1 (1981), 223–32.

Calkins, R.G., *Illuminated Books of the Middle Ages* (Ithaca, New York, London, 1983).

Calkins, R.G., *Programs of Medieval Illumination* (Franklin D. Murphy Lectures, V) (Helen Foresman Spencer Museum of Art, University of Texas, 1984).

Camille, M., *The Illustrated Manuscripts of Guillaume de Deguileville's 'Pèlerinages' 1330–1426*, Ph.D. (Cambridge University, 1985).

Camille, M., 'Seeing and Reading: Some Visual Implications of Medieval Literacy and Illiteracy', *Art History*, 8 (1985), 26–49.

Camille, M., 'The Book of Signs: Writing and Visual Difference in Gothic Manuscript Illumination', *Word and Image*, 1 (1985), 133–48.

Camille, M., 'Illustrations in Harley Ms. 3487 and the Perception of Aristotle's *Libri naturales* in Thirteenth-Century England', *England in the Thirteenth Century* (Proceedings of the 1984 Harlaxton Symposium), ed. W.M. Ormrod (Harlaxton, 1985), pp. 31–44.

Camille, M., 'Labouring for the Lord: The Ploughman and the Social Order in the Luttrell Psalter', *Art History*, 10 (1987), 423–54.

Camille, M., 'Visual Signs of the Sacred Page: Books in the *Bible moralisée*', *Word and Image*, 5 (1989), 111–30.

Camille, M., *The Gothic Idol. Ideology and Image-Making in Medieval Art* (Cambridge, 1989).

Camón Aznar, J., *et al.*, *Beati in Apocalipsin Libri Duodecim: Codex Gerundensis* (facsimile, Madrid, 1975).

Campbell, L., 'The Early Netherlandish Painters and Their Workshops', *Le Dessin sous-jacent dans la peinture. Colloque III, 6–8 September 1979. Le problème Maître de Flémalle-van der Weyden*, eds D. Hollanders-Favart, R. van Schoute (Louvain, 1981), pp. 43–61.

Canivez, J.M., *Statuta capitulorum generalium ordinis Cisterciensis*, I (Louvain, 1933).

Cappel, C.B., *The Tradition of Pouncing Drawings in the Italian Renaissance Workshop: Innovation and Derivation*, Ph.D. (Yale University, 1988).

Carné, G. de, 'Contrat pour la copie d'un Missel au XVe siècle', *Artistes, artisans et production artistique en Bretagne au Moyen Age*, ed. X. Barral i Altet *et al.* (Rennes, 1983), p. 127.

Carrasco, M., 'Notes on the Iconography of the Romanesque Illustrated Manuscript of the Life of St Albinus of Angers', *Zeitschrift für Kunstgeschichte*, 47 (1984), 333–48.

Carrasco, M., 'An Early Illustrated MS of the Passion of St Agatha (Paris Bib. Nat. Lat. 5594)', *Gesta*, 24 (1985), 19–32.

Carrasco, M., 'Spirituality and Historicity in Pictorial Hagiography: Two Miracles by Saint Albinus of Angers', *Art History*, 12 (1989), 1–21.

Carrasco, M., 'Spirituality in Context: The Romanesque Illustrated Life of St Radegund of Poitiers (Poitiers, Bibl. Mun., Ms. 250)', *Art Bulletin*, 72 (1990), 414–35.

Carver, M., 'Contemporary Artefacts Illustrated in Late Saxon Manuscripts', *Archaeologia*, 108 (1986), 117–45.

Castelnuovo, E., C. Ginzburg, 'Centro e periferia', *Storia dell'arte Italiana. Parte Prima. Materiali e problemi. Volume 1, Questioni e metodi* (Turin, 1979).

Cazelles, R., 'Les étapes de l'élaboration des Très Riches Heures du duc de Berry', *Revue française d'histoire du livre*, 10 (1976), 4–30.

Cazelles, R., Commentary to *Les Très Riches Heures du Duc de Berry* (facsimile, Luzern, 1984).

Cazelles, R., *Illuminations of Heaven and Earth: the Glories of the Très Riches Heures* (New York, 1988).

Cecchelli, C., G. Furlani, M. Salmi, *The Rabbula Gospels* (Olten and Lausanne, 1959).

Cennino d'Andrea Cennini, Il libro d'Arte. The Craftsman's Handbook, ed. D.V. Thompson, 2 vols (New Haven, 1932–3).

Charavay, E., *Etude sur la chasse à l'oiseau au moyen âge* (Paris, 1873).

Chauvet, P., *Les ouvriers du livre en France des origines à la Révolution de 1789* (Paris, 1959).

Chevalier, U., *Sacramentaire et martyrologe de l'abbaye de Saint Remy* (Bibl. Liturg., VIII) (1900).

Chibnall, M., *The Ecclesiastical History of Ordericus Vitalis*, 2 (Oxford, 1969).

Christianson, C.P., 'A Century of the Manuscript-Book Trade in Late Medieval London', *Medievalia et Humanistica*, ns 12 (1984), 143–65.

Christianson, C.P., 'Early London Bookbinders and Parchmenters', *The Book Collector*, 34 (1985), 41–54.

Christianson, C.P., *Memorials of the Book Trade in Medieval London: The Archives of Old London Bridge* (Woodbridge, 1987).

Christianson, C.P., 'Evidence for the Study of London's Late Medieval Manuscript Book-Trade', *Book Production and Publishing in Britain 1375–1475*, eds J. Griffiths, D. Pearsall (Cambridge, 1989), pp. 87–108.

Christianson, C.P., *A Directory of London Stationers and Book Artisans 1300–1500* (New York, 1990).

Ciasca, R., *L'Arte dei medici e speziali nella storia e nel commercio Fiorentino dal secolo XII al XV* (Florence, 1927).

Clanchy, M., *From Memory to Written Record. England 1066–1307* (London, 1979).

Clark, J.W., ed., transl., *The Observances in Use at the Augustinian Priory of St Giles and St Andrew at Barnwell, Cambridgeshire* (Cambridge, 1897).

Clark, W.B., 'The Illustrated Medieval Aviary and the Lay-brotherhood', *Gesta*, 21 (1982), 63–74.

Clark, W.B., 'Three Manuscripts for Claimarais; A Cistercian Contribution to Early Gothic Figure Style', *Studies in Cistercian Art and Architecture. III*, ed. M.P. Lillich (Kalamazoo: Cistercian Publications, 1987), pp. 97–110.

Clark, W.B., 'The Aviary-Bestiary at the Houghton Library, Harvard', *Beasts and Birds of the Middle Ages. The Bestiary and Its Legacy*, eds W.B. Clark, M.T. McMunn (Philadelphia, 1989), pp. 26–52.

Clemoes, P., C.R. Dodwell, *The Old English Illustrated Hexateuch British Museum Cotton Claudius B.IV* (Early English Manuscripts in Facsimile, 18) (Copenhagen, 1974).

Clercq, C. de, 'Le rôle de l'image dans un manuscrit médiéval (Bodleian, Lyell 71), *Gutenberg-Jahrbuch* (1962), 23–30.

Clercq, C. de, 'Hugues de Fouilloy, imagier des ses propres oeuvres', *Revue du Nord*, 45 (1963), 31–41.

Cockshaw, P., 'Mentions d'auteurs, de copistes, d'enlumineurs et de libraires dans les comptes généraux de l'Etat bourguignon', *Scriptorium*, 23 (1969), 122–44.

Cohen-Mushlin, A., *The Making of a Manuscript. The Worms Bible of 1148 (British Library, Harley 2803–4)* (Wiesbaden, 1983).

Collon, M., *Catalogue général des bibliothèques publiques de France. Départements, t. xxxvii, Tours* (Paris, 1900).

Corsano, K., 'The First Quire of the *Codex Amiatinus* and the *Institutiones* of Cassiodorus', *Scriptorium*, 41 (1987), 3–34.

Cortesi, L., G. Mandel, *Jacopo da Balsemo miniatore (c. 1425–c. 1503)* (Monumenta Bergomensia, XXXIII) (Bergamo, 1972).

Couderc, C., 'Fragments relatifs à André le Mustier, libraire-juré de l'Université de Paris', *Bulletin de la société de l'histoire de Paris et de l'Ile de France*, 45 (1918), 90–107.

Dalton, O.M., *Catalogue of the Ivory Carvings of the Christian Era with Examples of Mohammedan Art and Carvings in Bone in the Department of British and Medieval Antiquities and Ethnography of the British Museum* (London, 1909).

D'Ancona, P., 'Nuove ricerche sulla Bibbia dos Jeronymos e dei suoi illustratori', *La Bibliofilia*, 15 (1913), 205–12.

D'Ancona, P., *La miniatura fiorentina (secoli XI–XVI)*, 2 vols (Florence, 1914).

D'Ancona, P., E. Aeschlimann, *Dictionnaire des miniaturistes du moyen âge et de la renaissance dans les différentes contrées de l'Europe* (Milan, 1949; repr. 1969).

Das Falkenbuch Kaiser Friedrichs II nach der Prachthandschrift in der Vatikanischen Bibliothek, Einführung und Erläuterung von C.A. Willemsen (Die bibliophilen Taschenbücher, Nr. 152) (Dortmund, 1980).

Davis-Weyer, C., *Early Medieval Art 300–1150* (Sources and Documents in the History of Art Series, ed. H.W. Janson) (Englewood Cliffs, New Jersey, 1971).

Dawson, C., ed., *The Mongol Mission (Narratives and Letters of the Franciscan Missionaries in Mongolia and China in the Thirteenth and Fourteenth Centuries)*, translated by a Nun of Stanbrook Abbey (London, 1955).

Degenhart, B., 'Autonome Zeichnungen bei mittelalterlichen Künstlern', *Münchner Jahrbuch der bildenden Kunst*, dritte Folge, 1 (1950), 93–158.

Degenhart, B., 'Das Marienwunder von Avignon. Simone Martini's Miniaturen für Kardinal Stefaneschi und Petrarca', *Pantheon*, 33 (1975), 191–203.

Degenhart, B., A. Schmitt, *Corpus der Italienischen Zeichnungen. Teil 1. Süd- und Mittelitalien*, 4 vols (Berlin, 1968).

Degenhart, B., A. Schmitt, 'Marino Sanudo und Paolino Veneto. Zwei Literaten des 14. Jahrhunderts in ihrer Wirkung auf Buchillustrierung und Kartographie in Venedig, Avignon und Neapel', *Römisches Jahrbuch für Kunstgeschichte*, 14 (1973), 3–137.

Degenhart, B., A. Schmitt, *Corpus der Italienischen Zeichnungen 1300–1450. Teil II. Venedig. Addenda zu Süd- und Mittelitalien*, 3 vols (Berlin, 1980).

De Hamel, C.F.R., *Glossed Books of the Bible and the Origins of the Paris Booktrade* (Woodbridge, 1984).

De Hamel, C.F.R., *A History of Illuminated Manuscripts* (Oxford, 1986).

De Hamel, C.F.R. 'Reflexions on the Trade in Books of Hours at Ghent and Bruges', *Manuscripts in the Fifty Years After the Invention of Printing* (Papers read at a colloquium at the Warburg Institute 12–13 March 1982), ed. J.B. Trapp (London, 1983), pp. 29–33.

Delaissé, L.M.J., *Le siècle d'or de la miniature flamande. Le mécenat de Philippe le Bon* (Brussels, Paris, Amsterdam, 1959).

Delaissé, L.M.J., *A Century of Dutch Manuscript Illumination* (Berkeley, 1968).

Delaissé, L.M.J., 'The Importance of Books of Hours for the History of the Medieval Book', *Gatherings in Honor of Dorothy E. Miner*, ed. U. McCracken, L.M.C. Randall, R.H. Randall jr (Baltimore, 1974), pp. 203–25.

Delalain, P., *Étude sur le libraire parisien du XIIIe au XVe siècle d'après les documents publiés dans le cartulaire d'Université de Paris* (Paris, 1891).

De la Mare, A.C., *Catalogue of the Collection of Medieval Manuscripts Bequeathed to the Bodleian Library, Oxford, by James P.R. Lyell* (Oxford, 1971).

De la Mare, A.C., 'The Shop of a Florentine "Cartolaio" in 1426', *Studi offerti a Roberto Ridolfi* (Florence, 1973), pp. 237–48.

De la Mare, A.C., 'Bartolomeo Scala's Dealings with Book-sellers, Scribes and Illuminators, 1459–63', *Journal of the Warburg and Courtauld Institutes*, 39 (1976), 237–45.

De la Mare, A.C., 'New Research on Humanistic Scribes in Florence' in A. Garzelli, *Miniatura fiorentina del rinascimento 1440–1525. Un primo censimento*, 1 (Florence, 1985), pp. 395–600.

Delisle, L., *Le cabinet des manuscrits de la Bibliothèque impériale (nationale)*, 3 vols (Paris, 1868–81).

Delisle, L., 'Les Livres d'Heures du duc de Berry', *Gazette des Beaux-Arts*, 2e pér. 29 (1884), 97–110, 281–92, 391–405.

Delisle, L., *Recherches sur la librairie de Charles V* (Paris, 1907).

Demus, O., *Byzantine Art and the West* (New York, 1970).

Demus, O., *The Mosaics of San Marco in Venice*, 2 vols (Chicago, 1984).

Denifle, H., A. Chatelain, *Chartularium Universitatis Parisiensis, 1, 1200–1286. 2, 1286–1350* (Paris, 1889, 1891).

Der kleine Pauly. Lexicon der Antike, ed. K. Ziegler *et al.*, 5 (Munich, 1975).

Derolez, A., *Codicologie des manuscrits en écriture humanistique sur parchemin*, 2 vols (Turnhout, 1984).

Deslandres, Y., 'Les manuscrits decorés au XIe siècle à Saint-Germain-des-Prés par Ingelard', *Scriptorium*, 9 (1955), 3–16.

Destrez, J., *La Pecia dans les manuscrits universitaires du XIIIe et du XIVe siècle* (Paris, 1935).

Deuchler, F., *Der Ingeborgpsalter* (Berlin, 1967).

Dewald, E.T., *The Illustrations of the Utrecht Psalter* (Princeton, 1932).

Diamond, J., 'Manufacture and Market in Parisian Book Illumination Around 1300', *Europäische Kunst um 1300* (Akten des XXV. internationalen Kongresses für Kunstgeschichte, 6.6) (Vienna, 1986), pp. 101–10.

Die Parler und der schöne Stil 1350–1400. Europäische Kunst unter den Luxemburgern, 5 vols, ed. A. Legner (Cologne, 1978–80).

Diringer, D., *The Illuminated Book: Its History and Production* (2nd edn, London, 1967).

Dix siècles de l'enluminure Italienne (VIe–XVIe siècles), catalogue by F. Avril *et al.* (Bibliothèque nationale, Paris, 1984).

Dodwell, C.R., 'Techniques of Manuscript Painting in Anglo-Saxon Manuscripts', *Settimane di studio del Centro italiano di studi sull'alto medioevo, 18 (1970)* (Spoleto, 1971), 643–62, 675–83.

Dodwell, C.R., *Painting in Europe 800–1200* (Pelican History of Art) (Harmondsworth, 1971).

Dodwell, C.R., *Anglo-Saxon Art. A New Perspective* (Manchester, 1982).

Dodwell, C.R., 'The Final Copy of the Utrecht Psalter and its Relationship with the Utrecht and Eadwine Psalters', *Scriptorium*, 44 (1990), 21–53.

Donovan, C., *The de Brailes Hours. Shaping the Book of Hours in Thirteenth-Century Oxford* (London, 1991).

Doutrepont, G., *Inventaire de la 'librairie' de Philippe le Bon (1420)* (Brussels, 1906).

Doyle, L.J., *St Benedict's Rule for Monasteries* (Collegeville, MN, 1948).

Dressler, F., *Scriptorum opus. Schreiber-Mönche am Werk. Prof. Dr Otto Meyer zum 65. Geburtstag* (Wiesbaden, 1971).

Duffey, J.E., *The Inventive Group of Illustrations in the Harley Psalter (British Museum Ms.Harley 603)*, Ph.D. (University of California at Berkeley, 1977).

Dumon, P., *L'alphabet Gothique dit de Marie de Bourgogne. Reproduction du codex Bruxellensis II.845* (Brussels, 1972).

Dunlop, L.J.V., *The Use of Colour in Parisian Manuscript Illumination c.1320–c.1420 with Special Reference to the Availability of Pigments and their Commerce at that Period*, Ph.D. (University of Manchester, 1988).

Dutschke, C.W., *Guide to Medieval and Renaissance Manuscripts in the Huntington Library*, 2 vols (Berkeley, 1989).

Ebel, F., A. Fijal, G. Kocher, *Römisches Rechtsleben im Mittelalter. Miniaturen aus den Handschriften des Corpus juris civilis* (Heidelberg, 1988).

Eder, C., *Die Schule des Klosters Tegernsee im frühen Mittelalter im Spiegel der Tegernseer Handschriften* (Munich, 1972).

Edmunds, S., 'The Kennicott Bible and the Use of Prints in Hebrew Manuscripts', *Atti del XXIV Congresso Internazionale di Storia dell'Arte* (Bologna 10–18 September 1979), 8 (Bologna, 1983), pp. 23–9.

Edwards, K., *The English Secular Cathedrals in the Middle Ages; A Constitutional Study with Special Reference to the Fourteenth Century* (Manchester, 1949; 2nd edn, Manchester, New York, 1967).

Egbert, V.W., *The Medieval Artist at Work* (Princeton, 1967).

Eggenberger, C., *Psalterium aureum Sancti Galli. Mittelalterliche Psalterillustration im Kloster St Gallen* (Sigmaringen, 1987).

Eleen, L., *The Illustration of the Pauline Epistles in French and English Bibles of the Twelfth and Thirteenth Centuries* (Oxford, 1982).

English Romanesque Art 1066–1200, catalogue by G. Zarnecki *et al.* (London, 1984).

Esposito, M., ed., *Itinerarium Symonis Simeonis ab Hybernia ad Terram Sanctam* (Scriptores Latini Hiberniae, 4) (Dublin, 1960).

Evans, A., *Francesco Balducci Pegolotti, La pratica della mercatura* (Cambridge, Mass., 1936).

Evans, M., *Medieval Drawings* (London, 1969).

Evans, M.L., 'Die Miniaturen des Medici-Gebetbuchs Clm 23639 und verwandte Handschriften', *Das Gebetbuch Lorenzos de' Medici Clm 23639 der Bayerischen Staatsbibliothek München* (facsimile) (Frankfurt am Main, 1991).

Farquhar, J.D., *Creation and Imitation. The Work of a Fifteenth-Century Manuscript Illuminator* (Fort Lauderdale, 1976).

Farquhar, J.D., 'Identity in an Anonymous Age: Bruges Manuscript Illuminators and their Signs', *Viator*, 11 (1980), 371–84.

Farquhar, J.D., 'Manuscript Production and Evidence for Localizing and Dating Fifteenth-Century Books of Hours: Walters Ms. 239', *Journal of the Walters Art Gallery*, 45 (1987), 44–57.

Felice Feliciano. Alphabetum Romanum Vat. lat. 6852 aus der Biblioteca Apostolica Vaticana (facsimile, text by G. Mardersteig, Zürich, 1985).

Fianu, G., 'L'histoire des métiers du livre Parisien aux XIVe et XVe siècles: presentation des sources', *Gazette du livre médiéval*, 15 (1989), 1–4.

Fichtenau, H., *Die Lehrbücher Maximilians I und die Anfänge der Frakturschrift* (Hamburg, 1961).

Filippini, F., G. Zucchini, *Miniatori e Pittori a Bologna. Documenti dei secoli XIII e XIV* (Raccolta di Fonti per la storia d'arte, dir. M. Salmi, VI) (Florence, 1947).

Fleming, J.V., *The 'Roman de la Rose'. A Study in Allegory and Iconography* (Princeton, 1969).

Forest, S.G., *The Aberdeen Bestiary* (Aberdeen University Library, 1978–9).

Friedman, L.J., *Text and Iconography for Joinville's Credo* (Cambridge, Mass., 1958).

Fritz, J.M., *Goldschmiedekunst der Gotik in Mitteleuropa* (Munich, 1982).

Frodl-Kraft, E., 'Das "Flechtwerk" der frühen Zisterzienserfenster', *Wiener Jahrbuch für Kunstgeschichte*, 20 (1965), 7–20.

Frühmorgen-Voss, H., *Text und Illustration im Mittelalter. Aufsätze zu den Wechselbeziehungen zwischen Literatur und bildender Kunst*, ed. with introd. N.H. Ott (Munich, 1975).

Gaborini, N., *Der Miniator Sawalo* (Cologne, 1978).

Gaborit Chopin, D., 'Les dessins d'Adémar de Chabannes', *Bulletin archéologique du comité des travaux historiques et scientifiques*, n.s. 3 (1967), 163–226.

Gameson, R., 'The Anglo-Saxon Artists of the Harley 603 Psalter' *Journal of the British Archaeological Association*, 143 (1990), 29–48.

Gasparri, F., 'Un contrat de copiste à Orange au XVe siècle' *Scriptorium*, 28 (1974), 285–6.

Gasparri, F., 'Godefroid de Saint-Victor: une personnalité peu connue du monde intellectuel et artistique Parisien au XIIe siècle' *Scriptorium*, 39 (1985), 57–69.

Géraud, P.H., *Paris sous Phillippe le Bel d'après des documents originaux, et notamment d'après un manuscrit contenant le rôle de la taille imposée sur les habitans de Paris en 1292* (Documents inédits sur l'histoire de France) (Paris, 1837).

Gerson, Jean, *Le Passion de Nostre Seigneur*, ed. G. Frénaud (Paris, 1947).

Gerstinger, H., Kommentarband to *Dioscorides, Codex Vindobonensis Med gr.1* (Codices Selecti, XII) (Graz, 1970).

Gilbert, C., 'The Archbishop on the Painters of Florence', *Art Bulletin*, 41 (1959), 75–87.

Gilbert, C., *Italian Art 1400–1500* (Sources and Documents in the History of Art Series, ed. H.W. Janson) (Englewood Cliffs, New Jersey, 1980).

Gilissen, L., 'Un élément codicologique trop peu exploité: la réglure', *Scriptorium*, 23 (1969), 150–62.

Gilissen, L., *Prolégomènes à la codicologie. Recherches sur la construction des cahiers et la mise en page des manuscrits médiévaux* (Ghent, 1977).

Gilissen, L., 'Un élément codicologique méconnu: l'indication des couleurs des lettrines joint aux "lettres d'attent", *Paläographie 1981. Colloquium des Comité international de Paléographie, München 15–18 September 1981* (Münchener Beiträge zur Mediävistik und Renaissance-Forschung, 32), ed. G. Silagi, pp. 185–91.

Giovannino de Grassi, Taccuino di disegni (Monumenta Bergomensia, V) (Bergamo, 1961).

Giraldi Cambrensis Opera, 5. Topographia Hibernica (Rolls Series 21), ed. J.F. Dimock (London, 1867).

Glasser, H., *Artists' Contracts of the Early Renaissance*, Ph.D. (Columbia University, 1965) (Garland Outstanding Dissertations in the Fine Arts, repr. 1977).

Glénisson, J., *Le livre au Moyen Age* (Turnhout, 1988).

Golub, J.S., *The Glossed Psalter of Robert de Lindsey*, Ph.D. (Cambridge University, 1981).

Gordon, D.R., *Art in Umbria c. 1250–c. 1350*, Ph.D. (London University, 1979).

Gould, K., 'Terms For Book Production in a Fifteenth-Century Latin-English Nominale (Harvard Law School Library Ms. 43)', *The Papers of the Bibliographical Society of America*, 79 (1985), 75–99.

Gousset, M.-T., P. Stirnemann, 'Indications de couleur dans les manuscrits médiévaux', *Pigments et colorants de l'Antiquité et du Moyen Age* (Colloque international du C.N.R.S., Orléans, 1988) (Paris, 1990), pp. 189–98.

Grabar, A., 'Fresques romanes copiées sur les miniatures du Pentateuque de Tours', *Cahiers archéologiques*, 9 (1957), 329–41.

Green, R., 'Marginal Drawings in an Ottonian Manuscript', *Gatherings in Honor of Dorothy E. Miner*, eds U. McCracken, L.M.C. Randall, R. H. Randall (Baltimore, 1974), pp. 129–38.

Guérard, B., *Polyptyche de l'abbé Irminon . . . ou denombrement des manses, des serfs et des revenus de l'abbé de Saint-Germain des Près sous la règne de Charlemagne*, 2 vols (Paris, 1844).

Guiffrey, J., *Inventaires de Jean duc de Berry (1401–1416)*, 2 vols (Paris, 1894–6).

Guiffrey, J., 'La communauté des peintres et sculpteurs parisiens, dite Académie de Saint-Luc (1391–1776)', *Journal des Savants*, 13 (1915), 145–56.

Guilmain, J., 'The Forgotten Early Medieval Artist', *Art Journal*, 25 (1965), 33–42.

Guineau, B., 'Microanalysis of Painted Manuscripts and of Coloured Archaeological Materials by Raman Lasar Microprobe', *Journal of Forensic Sciences*, 29 (1984), 471–85.

Guineau, B., 'Analyse non-destructive des pigments par microsand Raman laser: exemples de l'azurite et de la malachite', *Studies in Conservation*, 29 (1984), 35–41.

Guineau, B., C. Coupry, M.-T. Gousset, J.P. Forgerit, J. Vezin, 'Identification de bleu de lapis-lazuli dans six manuscrits à peintures du XIIe siècle provenant de l'abbaye de Corbie', *Scriptorium*, 40 (1986), 157–71.

Guineau, B., J. Vezin, 'Nouvelles méthodes d'analyse des pigments et des colorants employés pour la décoration des livres manuscrits; l'exemple des pigments bleus utilisés entre le IXe siècle et la fin du XIIe siècle, notamment à Corbie', *Actas del VIII Coloquio del Comité internacional de paleografía latina*, ed. M.C. Díaz y Díaz (Madrid, 1990), pp. 83–94.

Gullick, M., ed., *The Arte of Limming. A Reproduction of the 1573 Edition Newly Imprinted* (London, 1979).

Gullick, M., *A Working Alphabet of Initial Letters From Twelfth-Century Tuscany. A Facsimile of Cambridge, Fitzwilliam Museum Ms. 83.1972* (Hitchin, 1979).

Gullick, M., *List of Mediaeval Painting Treatises* (1979, additions 1983) (unpublished manuscript, kept in Palaeography Reading Room, London University Library).

Gullick, M., *Extracts from the Precentor's Accounts Concerning Books and Bookmaking of Ely Cathedral Priory* (Hitchin, 1985).

Gullick, M., *Working Alphabet of Initial Letters From Twelfth-Century Spain* (Hitchin, 1987).

Gullick, M., *Calligraphy* (London, 1990).

Gullick, M., 'From Parchmenter to Scribe: Some Observations on the Manufacture and Preparation of Medieval Parchment Based Upon the Literary Evidence', *Pergament: Geschichte, Struktur, Restaurierung, Herstellung heute*, ed. P. Rück (Marburger Kolloquium für Historische Hilfswissenschaften, 2) (Sigmaringen, 1991), pp. 145–57.

Gumbert, J.P., *The Dutch and their Books in the Manuscript Age* (Panizzi Lectures, 1989) (British Library, London, 1990).

Gyllene Böcker. Illuminerade medeltida handskrifter i dansk och svensk ägo (Nationalmuseum, Stockholm, 1952).

Hahn, C., Kommentarband to *Kilians und Margaretenvita. Passio Kiliani, Ps. Theotimus, Passio Margaretae, Orationes (Hannover, Niedersächsische Landesbibliothek, Ms. I 189)* (Codices Selecti, LXXXIII) (Graz, 1988).

Hahn, C., 'Purification, Sacred Action and the Vision of God: Viewing Medieval Narratives', *Word and Image*, 5 (1989), 71–84.

Hahn, C., 'Picturing the Text: Narrative in the *Life* of the Saints', *Art History*, 13 (1990), 1–33.

Hahnloser, H.R., *Villard de Honnecourt. Kritische Gesamtausgabe des Bauhüttenbuches ms. fr. 19093 der Pariser Nationalbibliothek* (2nd rev. edn, Graz, 1972).

Haney, K.E., *The Winchester Psalter: An Iconographic Study* (Leicester, 1986).

Harris, J., '"Thieves, Harlots and Stinking Goats": Fashionable Dress and Aesthetic Attitudes in Romanesque Art', *Costume*, 21 (1987), 4–15.

Harris, K., 'Patrons, Buyers and Owners: the Evidence for Ownership and the Rôle of Book Owners in Book Production

and the Book Trade', *Book Production and Publishing in Britain 1375–1475*, eds J. Griffiths, D. Pearsall (Cambridge, 1989), pp. 163–99.

Haseloff, G., *Die Psalterillustration im 13. Jahrhundert. Studien zur Geschichte der Buchmalerei in England, Frankreich und den Niederländen* (Kiel, 1938).

Hasler, R., 'Zu zwei Darstellungen aus der ältesten Kopie des Utrecht-Psalters, British Library, Codex Harleianus 603', *Zeitschrift für Kunstgeschichte*, 44 (1981), 317–39.

Hassall, A.G., W.O. Hassall, *The Douce Apocalypse* (London, 1961).

Hassall, W.O, *The Holkham Bible Picture Book* (London, 1954).

Hausherr, R., '*Arte nulli secundus*. Eine Notiz zum Künstlerlob im Mittelalter', *Ars auro prior. Studia Joanni Białostocki sexagenario dicata* (Warsaw, 1981), pp. 43–7.

Hedeman, A.D., *The Illustrations of the Grandes Chroniques de France from 1274 to 1422*, Ph.D. (Johns Hopkins University, 1984).

Hedeman, A., 'Valois Legitimacy: Editorial Changes in Charles V's *Grandes Chroniques de France*', *Art Bulletin*, 66 (1984), 97–117.

Hedeman, A.D., *The Royal Image. Illustrations of the Grandes Chroniques de France 1274–1422* (Berkeley, 1991).

Heilspiegel. Die Bilder des mittelalterlichen Erbauungsbuches 'Speculum humanae salvationis', mit Nachwort und Erläuterungen von Horst Appuhn (Die bibliophilen Taschenbücher, Nr. 267) (Dortmund, 1981).

Hermann, H.J., 'Zur Geschichte der Miniaturmalerei am Hofe der Este in Ferrara. Stilkritische Studien', *Jahrbuch der kunsthistorischen Sammlungen des Allerhochsten Kaiserhauses*, 21 (1900), 117–271.

Hermann, H.J., *Die deutschen Romanischen Handschriften* (Beschreibendes Verzeichnis der illuminierten Handschriften in Oesterreich. Neue Folge: Die illuminierten Handschriften und Inkunabeln der Nationalbibliothek in Wien, VIII Band. (II. Teil) (Leipzig, 1926).

Hermann, H.J., *Die italienischen Handschriften des Dugento und Trecento, 2. Oberitalienische Handschriften der zweiten Hälfte des XIV. Jahrhunderts* (Beschreibendes Verzeichnis der illuminierten Handschriften in Oesterreich. Neue Folge: Die illuminierten Handschriften und Inkunabeln der Nationalbibliothek in Wien, VIII Band. V Teil) (Leipzig, 1929).

Heslop, T.A., 'Romanesque Painting and Social Distinction: The Magi and the Shepherds', *England in the Twelfth Century (Proceedings of the 1988 Harlaxton Symposium)*, ed. D. Williams (Woodbridge, 1990), pp. 137–52.

Hetherington, P., *The 'Painter's Manual' of Dionysius of Fourna* (London, 1974).

Higgitt, J., 'Glastonbury, Dunstan, Monasticism and Manuscripts', *Art History*, 2 (1979), 275–90.

Hindman, S., 'The Case of Simon Marmion: Attributions and Documents', *Zeitschrift für Kunstgeschichte*, 40 (1977), 185–204.

Hindman, S., 'The Composition of the Manuscript of Christine de Pizan's Collected Works in the British Library: A Reassessment', *British Library Journal*, 9 (1983), 93–123.

Hindman, S., 'The Illustrated Book: An Addendum to the State of Research in Northern European Art', *Art Bulletin*, 68 (1986), 536–42.

Hindman, S., 'The Roles of Author and Artist in the Procedure of Illustrating Late Medieval Texts', *Text and Image, Acta*, vol. X, ed. D.W. Burchmore (Center for Medieval and Early Renaissance Studies, State University of New York at Binghamton, 1986), pp. 27–62.

Hindman, S., *Christine de Pizan's 'Epistre d'Othéa'. Painting and Politics At the Court of Charles VI* (Toronto, 1986).

Hindman S., J.D. Farquhar, *Pen to Press: Illustrated Manuscripts and Printed Books in the First Century of Printing* (University of Maryland, Johns Hopkins University, 1977).

Histoire de la Destruction de Troye le Grant. Reproduction du manuscrit Bibliothèque nationale nouvelles acquisitions françaises 24920, introd. M. Thomas (Paris, 1973).

Historia monasterii S. Augustini Cantuariensis by Thomas of Elmham (Rolls Series, 8), ed. C. Hardwick (London, 1858).

Hoffmann, H., *Buchkunst und Königtum im ottonischen und frühsalischen Reich* (M.G.H. Schriften, Bd. 30/1–2) (Stuttgart, 1986).

Holdsworth, C., 'The Chronology and Character of Early Cistercian Legislation on Art and Architecture', *Cistercian Art and Architecture in the British Isles*, eds C. Norton, D. Park (Cambridge, 1986), pp. 40–55.

Holter, K., Kommentarband to *Hrabanus Maurus, Liber de Laudibus sanctae crucis (Codex Vindobonensis 652)* (Codices Selecti, XXXIII) (Graz, 1973).

Homburger, O., *Die illustrierten Handschriften der Burgerbibliothek Bern. Die vorkarolingischen und karolingischen Handschriften* (Bern, 1962).

Horn, W., E. Born, 'The Medieval Monastery As a Setting for the Production of Manuscripts', *Journal of the Walters Art Gallery*, 44 (1986), 16–47.

Houghton, G.L., *Cassiodorus and Manuscript Illustration at Vivarium*, Ph.D. (State University of New York, Binghamton, 1975).

Huglo, M., 'Les Evangiles de Landévennec', *Landévennec et le monachisme Breton dans le haut Moyen Age. Actes du colloque du XVe centenaire de Landévennec 25–27 avril 1985*, ed. M. Simon (Landévennec, 1985), pp. 245–51.

Hunt, R.W., *Saint Dunstan's Classbook from Glastonbury* (Umbrae Codicum Occidentalium, IV) (Amsterdam, 1961).

Il libro della Bibbia (Bibliotheca Apostolica Vaticana, 1972).

Illuminated Manuscripts in Dutch Collections. Preliminary Precursor. Part I, A. Korteweg *et al.* (Koninklijke Bibliotheek, The Hague, 1989).

Ives, S.A., H. Lehmann-Haupt, *An English Thirteenth-Century Bestiary* (New York, 1942).

Jackson, D., *The Story of Writing* (London, 1981).

Jacoby, Z., 'The Beard Pullers in Romanesque Art: An Islamic Motif and its Evolution in the West', *Arte Medievale*, II serie, 1 (1987), 65–85.

Jahn, J., 'Die Stellung des Künstlers im Mittelalter', *Festgabe für Friedrich Bülow*, ed. O. Stamner (Berlin, 1960), 151–68.

James, M.R., 'On a Manuscript Psalter in the University Library Cambridge (Ee. IV. 24)', *Proceedings of the Cambridge Antiquarian Society*, 8/2 (1894), 146–67.

James, M.R., 'On the Paintings Formerly in the Choir at Peterborough', *Proceedings of the Cambridge Antiquarian Society*, 9/2 (1897), 178–94.

James, M.R., *A Descriptive Catalogue of the Manuscripts in the Library of Trinity Hall* (Cambridge, 1907).

James, M.R., *A Descriptive Catalogue of the McClean Collection of Manuscripts in the Fitzwilliam Museum, Cambridge* (Cambridge, 1912).

James, M.R., *A Descriptive Catalogue of the Latin Manuscripts in the John Rylands University Library* (London, 1921; repr. with introduction and notes by F. Taylor, Munich, 1980).

James, M.R., *The Bestiary Being a Reproduction in Full of the Manuscript Ms. Ii.4.26 in the University Library, Cambridge* (Roxburghe Club, 1928).

James, M.R., *The Apocalypse in Art* (London, 1931).

James, M.R., 'Pictor in Carmine', *Archaeologia*, 94 (1951), 141–66.

Jean Fouquet (Les dossiers du département des peintures), cat. by N. Reynaud (Paris, 1981).

Jenni, U., *Das Skizzenbuch der internationalen Gotik in den Uffizien. Der Übergang vom Musterbuch zum Skizzenbuch* (Vienna, 1976).

Jenni, U., 'Vom mittelalterlichen Musterbuch zum Skizzenbuch der Neuzeit', *Die Parler und der schöne Stil 1350–1400*, 3, ed. A. Legner (Cologne, 1978), pp. 139–50.

Jenni, U., U. Winter, *Das Skizzenbuch des Jaques Daliwe. Kommentar zur Faksimileausgabe des Liber picturatus A 74 der Deutschen Staatsbibliothek Berlin/DDR* (Berlin 1987).

John, J.C., 'A Note on the Origin of the Calligraphy Book of Lawrence Autenrieth', *Litterae Medii Aevi. Festschrift für Johanne Autenrieth zu ihrem 65 Geburtstag*, eds M. Borgholte, M. Spilling (Sigmaringen, 1988), pp. 309–14.

Jones, L.W., C.R. Morey, *The Miniatures of the Manuscripts of Terence Prior to the Thirteenth Century*, 2 vols (Princeton, 1931).

Kahsnitz, R., *Der Werdener Psalter in Berlin, Ms. theol. lat. fol. 358. Eine Untersuchung zu Problemen mittelalterlicher Psalter-illustration* (Düsseldorf, 1979).

Kahsnitz, R., 'Der christologische Zyklus im Otbert Psalter', *Zeitschrift für Kunstgeschichte*, 51 (1988), 33–125.

Karl der Grosse. Werk und Wirkung, (10th Council of Europe exhibition) (Aachen, 1965).

Kauffmann, C.M., *Romanesque Manuscripts 1066–1190* (A Survey of Manuscripts Illuminated in the British Isles, General editor J.J.G. Alexander, vol. 3) (London, 1975).

Kendrick, T.D., T.J. Brown, R.L.S. Bruce-Mitford, H. Roosen-Runge, A.S.C. Ross, E.G. Stanley, A.E.A. Werner, *Evangeliorum Quattuor Codex Lindisfarnensis*, vol. I, complete facsimile, vol. II commentary (Olten and Lausanne, 1956, 1960).

Ker, N.R., 'Medieval Manuscripts from Norwich Cathedral Priory', *Transactions of the Cambridge Bibliographical Society*, 1 (1949–53), 1–28. Reprinted *Books, Collectors and Libraries: Studies in the Medieval Heritage*, ed. A.G. Watson (London, 1985), pp. 243–72.

Ker, N.R., *English Manuscripts in the Century After the Norman Conquest* (Oxford, 1960).

Ker, N.R., *Medieval Manuscripts in British Libraries, 1. London* (Oxford, 1969).

Ker, N.R., 'The Beginnings of Salisbury Cathedral Library', *Medieval Learning and Literature. Essays Presented to Richard William Hunt*, ed. J.J.G. Alexander, M.T. Gibson (Oxford, 1976), pp. 23–49.

Kessler, H., 'Pictorial Narrative and Church Mission in Sixth-Century Gaul', *Pictorial Narrative in Antiquity and the Middle Ages. Studies in the History of Art*, 16 (National Gallery of Art, Washington DC, 1985), 75–91.

Kitzinger, E., 'Norman Sicily As a Source of Byzantine Influence on Western Art in the Twelfth Century', *Byzantine Art: An European Art* (Lectures given on the occasion of the Ninth Council of Europe Exhibition), ed. M. Chatzidakis (Athens, 1966), pp. 123–47.

Kitzinger, E., 'The Role of Miniature Painting in Mural Decoration', *The Place of Book Illumination in Byzantine Art* (Princeton, 1975), pp. 99–142.

Klein, P., *Endzeiterwartung und Ritterideologie. Die englische Bilderapokalypsen der Frühgotik und MS Douce 180* (Graz, 1983).

Klotz, H., 'Formen der Anonymität und des Individualismus des Mittelalters und der Renaissance', *Gesta*, 15 (1976), 303–12.

Knaus, H., 'Johann von Valkenburg und seine Nachfolger', *Archiv für Geschichte des Buchwesens*, 3 (1961), 57–76.

Koechlin, R., *Les ivoires gothiques français*, 2 vols (Paris 1924).

Koehler, W., *Die karolingischen Miniaturen, I. Die Schule von Tours* (Berlin, 1930; repr. 1963).

Koehler, W., *Die karolingischen Miniaturen, II. Die Hofschule Karls des Grossen* (Berlin, 1958).

Koehler, W., F. Mütherich, *Die karolingischen Miniaturen, IV. Die Hofschule Kaiser Lothars. Einzelhandschriften aus Lotharingien* (Berlin, 1971).

Koehler, W., F. Mütherich, *Die karolingischen Miniaturen, V. Die Hofschule Karls des Kahlen* (Berlin, 1982).

König, E., *Französische Buchmalerei um 1450* (Berlin, 1982).

König, E., *Der Rosenroman des Berthand d'Achy, Kommentarband zur Faksimileausgabe des Cod. Urb. Lat. 376* (Zürich, 1987).

Kosmer, E.V., *A Study of the Style and Iconography of a Thirteenth-Century Somme le Roi (British Museum, Ms. Add. 54180) with a Consideration of Other Illustrated Somme Manuscripts of the Thirteenth, Fourteenth and Fifteenth Centuries*, Ph.D. (Yale University, 1973).

Kosmer, E., 'Master Honoré: a Reconsideration of the Documents', *Gesta*, 14/1 (1975), 63–8.

Kraus, H.P., *Cimelia. Catalogue 165* (New York, 1983).

Kreuter-Eggemann, H., *Das Skizzenbuch des 'Jaques Daliwe'* (Munich, 1964).

Kristeller, P., *Andrea Mantegna* (Berlin, 1901; 2nd edn, 1902).

Kunert, S. de, 'Un padovano ignoto ed un suo memoriale de' primi anni del cinquecento (1505–1511)', *Bollettino del Museo Civico di Padova*, 10 (1907), 1–15, 64–73.

Kurth, B., 'Matthew Paris and Villard d'Honnecourt', *Burlington Magazine*, 81 (1942), 227–8.

Kurz, O., 'Ein insulares Musterbuchblatt und die byzantinische Psalterillustration', *Byzantinisch-neugriechische Jahrbücher*, 14 (1938), 84–93.

La Bibbia di Borso d'Este, ed. A. Venturi, 2 vols (complete facsimile, Milan, 1937).

Laborde, A. de, *Les manuscrits à peintures de la Cité de Dieu de Saint Augustin*, 2 vols (Paris, 1909).

Laborde, A. de, *La Bible moralisée illustrée conservée à Oxford, Paris et Londres*, 5 vols (Paris, 1911–27).

Lacaze, C., *The Vie de St Denis Manuscript (Paris, Bibliothèque nationale fr. 2090–92)*, Ph.D. (Institute of Fine Arts, New York University, 1978).

La corona de Aragón en el Mediterraneo, legado commún para Italia y Espana 1282–1492 (Barcelona, 1988).

La librairie de Philippe le Bon, cat. by G. Dogaer, M. Debae (Bibliothèque royale, Brussels, 1967).

Landsberger, F., *Der St Galler Folchart-Psalter* (St Gall, 1912).

L'art gothique Siennois. Enluminure, peinture, orfèverie, sculpture (Avignon, Musée du Petit Palais, 26 June–2 October 1983) (Florence, 1983).

Latin Psalter in the University Library of Utrecht (formerly Cotton Ms. Claudius C. vii) photographed and produced in facsimile by the permanent autotype process of Spencer, Sawyer, Bird and Co, London, n.d. [1875].

Laske-Fix, K., *Der Bildzyklus des Breviari D'Amor* (Münchner Kunsthistorische Abhandlungen, V) (Munich, 1973).

Lawrence, A., 'English Cistercian Manuscripts of the Twelfth Century', *Cistercian Art and Architecture in the British Isles*, eds. C. Norton, D. Park (Cambridge, 1986), pp. 284–98.

Lawton, L., 'The Illustration of Late Medieval Secular Texts With Special Reference to Lydgate's Troy-Book', *Manuscripts and Readers in Fifteenth-Century England: the Literary Implications of Manuscript Study* (Essays from the 1981 Conference at the University of York), ed. D. Pearsall (Cambridge, 1983), pp. 41–69.

Leclercq, J., *The Love of Learning and the Desire for God. A Study of Monastic Culture* (2nd revised edn, London, 1978).

Lehmann-Brockhaus, O., *Lateinische Schriftquellen zur Kunst in England, Wales und Schottland vom Jahre 901 bis zum Jahre 1307*, 5 vols (Munich, 1955–60).

Lehmann-Haupt, H., *An English Thirteenth-Century Bestiary* (New York, 1942).

Lehmann-Haupt, H., 'Gutenberg und der Meister des Spielkarten', *Gutenberg-Jahrbuch* (1962), 360–79.

Lehmann-Haupt, H., *Gutenberg and the Master of the Playing Cards* (New Haven, London, 1966).

Lehmann-Haupt, H., *The Göttingen Model Book* (rev. edn, Columbia, 1978).

Le Livre, exhibition catalogue (Bibliothèque nationale, Paris, 1982).

Le Livre au siècle des Rolin (Bibliothèque municipale, Autun, 1985).

Leroquais, V., *Les Livres d'heures manuscrits de la Bibliothèque nationale*, 3 vols (Paris, 1927); *Supplément* (Macon, 1943).

Leroquais, V., *Les Pontificaux manuscrits des bibliothèques publiques de France*, 4 vols (Paris, 1937).

Leroquais, V., *Les Psautiers manuscrits des bibliothèques publiques de France*, 3 vols (Macon, 1940–1).

Les Fastes du Gothique. Le siècle de Charles V, catalogue by F. Baron *et al.* (Paris, 1981).

Les manuscrites à peintures en France du VIIe au XII siècle, exhibition catalogue by J. Porcher (Bibliothèque nationale, Paris, 1954).

Les manuscrites à peintures en France du XIIIe au XVIe siècle, exhibition catalogue by J. Porcher (Bibliothèque nationale, Paris, 1955).

Lespinasse, R. de, F. Bonnardot, *Les métiers et corporations de ville de Paris. XIIIe siècle, le livre des métiers d'Étienne Boileau* (Histoire générale de Paris. Les métiers et corporations de la ville de Paris) (Paris, 1879).

Levi d'Ancona, M., *Miniatura e miniatori a Firenze dal XIV al XVI secolo. Documenti per la storia della miniatura* (Florence, 1962).

Levin, I., *The Quedlinburg Itala. The Oldest Illustrated Biblical Manuscript* (Leiden, 1985).

Lewis, S., 'Giles de Bridport and the Abingdon Apocalypse', *England in the Thirteenth Century* (Proceedings of the 1984 Harlaxton Symposium), ed. W.M. Ormrod (Harlaxton, 1985), 107–19.

Lewis, S., '*Tractatus adversus Judaeos* in the Gulbenkian Apocalypse', *Art Bulletin*, 68 (1986), 543–66.

Lewis, S., *The Art of Matthew Paris in the Chronica Majora* (California Studies in the History of Art, XXI), (Berkeley, 1987).

Light, L. 'Versions et révisions du texte biblique', *Bible de tous les temps, 4. Le Moyen Age et la Bible*, ed. P. Riché, G. Lobrichon (Paris, 1978), pp. 55–93.

Lightbown, R., *Mantegna* (Oxford, 1986).

Lippmann, F., *Le Chevalier délibéré by Olivier de la Marche. The Illustrations of the Edition of Schiedam Reproduced with a Preface* (London, Bibliographical Society, 1898).

Little, A.G., *Franciscan History and Legend in English Medieval Art* (Manchester, 1937).

Little, L.K., *Religious Poverty and the Profit Economy in Medieval Europe* (London, 1978).

Löffler, K., *Schwäbische Buchmalerei in Romanischer Zeit* (Augsburg, 1928).

Loerke, W., 'The Monumental Miniature', *The Place of Book Illumination in Byzantine Art* (Princeton, 1975), pp. 61–97.

Longnon, J., R. Cazelles, *The Très Riches Heures of Jean, Duke of Berry* (London, 1969).

Loomis, R.S., L.H. Loomis, *Arthurian Legends in Medieval Art* (London, New York, 1938).

Los Beatos exhibition catalogue, Europalia '85. España (Royal Library, Brussels, 1985).

Lowe, E.A., *Codices Latini Antiquiores, III. Italy. Ancona-Novara* (Oxford, 1938).

Lowe, E.A., *Codices Latini Antiquiores, V. France. Paris* (Oxford, 1950).

Lowe, W.R.L., E.F. Jacob, M.R. James, *Illustrations to the Life of St Alban in Trin. Coll. Dublin MS. E.i.40* (Oxford, 1924).

Manuscrits Normands XIe–XIIe siècles, catalogue by F. Avril (Bibliothèque municipale de Rouen, 1975).

Marchegay, P., 'Documents du XIe siècle sur les peintures de l'abbaye de Saint-Aubin', *Bulletin de la Société industrielle d'Angers*, 17 (1846), 218–23.

Mariani Canova, G., *La miniatura Veneta del Rinascimento 1450–1500* (Venice, 1969).

Marinis, T. de, *La Biblioteca napoletana dei re d'Aragona*, 4 vols (Milan, 1947, 1952); *Supplemento*, 2 vols (Verona, 1969).

Marrow, J., 'A Book of Hours From the Circle of the Master of the Berlin Passion: Notes on the Relationship Between Fifteenth-Century Manuscript Illumination and Printmaking in the Rhenish Lowlands', *Art Bulletin*, 60 (1978), 589–616.

Martin, H., 'Les esquisses des miniatures', *Revue archéologique*, 4 (1904), 17–45.

Martin, H., 'La Somme le Roi, Bibliothèque Mazarine, no. 870', *Trésors des Bibliothèques de France*, 1 (1926), 43–57.

Martindale, A., *The Rise of the Artist in the Middle Ages and Early Renaissance* (London, 1972).

Martindale, A., *Simone Martini* (Oxford, 1988).

Martini, G.S., 'La bottega di un cartolaio fiorentino della seconda metà del Quattrocento. Nuovi contributi biografici intorno al Gherardo e Monte di Giovanni', *La Bibliofilia*, 58 (1956), supplemento, 1–82.

Masai, F., 'De la condition des enlumineurs et de l'enluminure à l'époque romane', *Bulletino dell'archivio paleografico italiano*, 2–3 (1956–7), 135–44.

Master Drawings. The Woodner Collection (Royal Academy of Arts, London, 1987).

Mayr-Harting, H., *The Venerable Bede, the Rule of St Benedict and*

Social Class (Jarrow Lecture, 1976).

McCulloch, F., *Medieval Latin and French Bestiaries* (Chapel Hill, 1962).

Medieval and Early Renaissance Treasures in the North West, catalogue by J.J.G. Alexander, B.P. Crossley *et al.* (Whitworth Art Gallery, Manchester, 1976).

Medieval and Renaissance Miniatures from the National Gallery of Art, C. Nordenfalk, G. Vikan *et al.* (Washington, 1975).

Meiss, M., 'Italian Style in Catalonia and a Fourteenth-Century Catalan Workshop', *Journal of the Walters Art Gallery*, 4 (1941), 45–87.

Meiss, M., *Andrea Mantegna as Illuminator* (Hamburg, 1957).

Meiss, M., *French Painting in the Time of Jean de Berry. 1 The Late Fourteenth Century and the Patronage of the Duke* (London, 1967). *2 The Boucicaut Master* (London, 1968). *3 The Limbourgs and Their Contemporaries* (London, 1974).

Melnikas, A., *The Corpus of the Miniatures in the Manuscripts of Decretum Gratiani*, 3 vols (Rome, 1975).

Mély, F. de, *Les primitifs et leurs signatures. Les miniaturistes* (Paris, 1913).

Mentré, M., 'L'enlumineur et son travail selon les manuscrits hispaniques du Haut Moyen Age', *Artistes, artisans et production artistique au Moyen Age. 1 Les hommes*, ed. X. Barral i Altet (Paris, 1986), pp. 295–309.

Mérindol, C. de, *La production des livres peints à l'abbaye de Corbie au XIIe siècle. Etude historique et archéologique*, 3 vols (Université de Lille, 1976).

Mérindol, C. de, 'Les peintres de l'abbaye de Corbie au XII siècle', *Artistes, artisans et production artistique au Moyen Age. 1 Les hommes*, ed. X. Barral i Altet (Paris, 1986), pp. 311–37

Merrifield, M.P., *Original Treatises Dating from the XIIth to the XVIIIth Centuries on the Arts of Painting*, 2 vols (London, 1849; repr. New York, 1967).

Merten, J., 'Die Esra-Miniatur des Codex Amiatinus. Zu Autorenbild und Schreibgerät', *Trierer Zeitschrift*, 50 (1987), 301–19.

Merton, A., *Die Buchmalerei in St Gallen vom 9. bis 11. Jahrhundert* (Leipzig, 1912; 2nd edn 1923).

Meyvaert, P., 'Bede and the Church Paintings at Wearmouth-Jarrow', *Anglo-Saxon England*, 8 (1979), 63–77.

Meyvaert, P., ed. and commentary, *The Codex Benedictus: An Eleventh-Century Lectionary from Monte Cassino* (facsimile, New York, 1982).

Michael, M., 'Some Early Fourteenth-Century English Drawings at Christ's College, Cambridge', *Burlington Magazine*, 124 (1982), 230–32.

Michael, M., 'A Manuscript Wedding Gift from Philippa of Hainault to Edward III', *Burlington Magazine*, 127 (1985), 582–98.

Michael, M., 'Oxford, Cambridge and London: Towards a Theory for 'grouping' Gothic Manuscripts', *Burlington Magazine*, 130 (1988), 107–15.

Michaëlsson, K., 'Le Livre de la taille de Paris, l'an 1296', *Göteborg Universitets Årsskrift*, 44 (1958), no. 4. *id.*, 'Le Livre de la taille de Paris, l'an 1297', *ibid.*, 67 (1961), no. 3; 'Le Livre de la taille de Paris, l'an de grâce 1313', *Göteborgs Högskolas Årsskrift*, 57 (1951), no. 3.

Michon, L.-M., 'Un dessin inédit du XIV siècle', *Mélanges en homage à la mémoire de Fr. Martroye* (Paris, 1940), pp. 319–23.

Michon, S., *Le Grand Passionaire enluminé de Weissenau et son scriptorium autour de 1200* (Geneva 1990).

Milanesi, G., *Nuovi documenti per la storia dell'arte toscana dal XII al XV secolo* (Florence, 1901; repr. 1973).

Millar, E.G., *An Illuminated Manuscript of La Somme le Roy, attributed to the Parisian Miniaturist Honoré* (Roxburghe Club, 1953).

Millar, E.G., *The Parisian Miniaturist Honoré* (London, 1959).

Miner, D., review of S.A. Ives, H. Lehmann-Haupt, 'An English Thirteenth-Century Bestiary' in *Art Bulletin*, 25 (1943), 88–9.

Miner, D., 'More About Medieval Pouncing', *Homage to a Bookman. Essays on Manuscripts, Books and Printing Written for Hans P. Kraus on His Sixtieth Birthday October 12 1967*, ed. H. Lehmann-Haupt (Berlin, 1967), pp. 87–107.

Miner, D., 'Preparatory Sketches by the Master of Bodleian Douce Ms. 185', *Kunsthistorische Forschungen Otto Pächt zu ehren*, eds A. Rosenauer, G. Weber (Vienna, 1972), pp. 118–28.

Miner, D., *Anastaise and Her Sisters. Women Artists of the Middle Ages* (Baltimore, Walters Art Gallery, 1974).

Miniature Lombarde. Codici miniati dall' VIII al XIV secolo, introd. M.L. Gengaro, testo di L. Cogliati Arano (Milan, 1970).

Monget, C., *La Chartreuse de Dijon d'après les documents des Archives de Bourgogne*, 3 vols (Montreuil-sur-mer, 1898–1905).

Monks, P.R., 'Reading Fifteenth-Century Miniatures: The Example of the "Horloge de Sapience" in Brussels, B.R. IV. 111', *Scriptorium*, 40 (1986), 242–8.

Monks, P.R., *The Brussels 'Horloge de Sapience'. Iconography and Text of Brussels, Bibliothèque Royale, Ms. IV. III* (Leiden, 1990).

Moran, J., 'Stationers' Companies of the British Isles', *Gutenberg-Jahrbuch* (1962), 533–40.

Morand, K., *Jean Pucelle* (Oxford, 1962).

Morey, C.R., E.K. Rand, C.H. Kraeling, 'The Gospel-Book of Landévennec (the Harkness Gospels) in the New York Public Library', *Art Studies*, 8.2 (1931), 225–86.

Morgan, N.J., *Early Gothic Manuscripts (1) 1190–1250* (London, 1982). *Early Gothic Manuscripts (2) 1250–1285* (London, 1988) (A Survey of Manuscripts Illuminated in the British Isles, General editor J.J.G. Alexander, vol. 4).

Morgan, N., M. Brown, Commentary to *The Lambeth Apocalypse, Ms. 209 in the Collection of the Archbishop of Canterbury at Lambeth Palace* (facsimile, London, 1990).

Morison, S., ed. N. Barker, *Early Italian Writing-Books: Renaissance to Baroque* (London, 1990).

Mostra storica nazionale della miniatura, catalogue ed. G. Muzzioli (Rome, 1955).

Müller, H.G., *Hrabanus Maurus, De Laudibus Sanctae Crucis* (Beiheft der Mittellateinischen Jahrbuch, 11) (Cologne, 1973).

Muratova, X., 'Problèmes de l'origine et des sources des cycles d'illustrations des manuscrits des Bestiaires', *Epopée animale, fable, fabliau. Actes du IVe Colloque de la Société Internationale Renardienne (Evreux, 1981)*, eds G. Bianciotto, M. Salvat (Paris, 1984).

Muratova, X., 'Etude du manuscrit', *Bestiarium* (Club du livre, Paris, 1984), 13–55.

Muratova, X., '*Vir quidem fallax et falsidicus, sed artifex praeelectus*. Remarques sur l'image sociale et littéraire de l'artiste au Moyen Age', *Artistes, artisans et production artistique au Moyen Age. 1 Les hommes*, ed. X. Barral i Altet (Paris, 1986), pp. 53–72.

Muratova, X., 'Workshop Methods in English Late Twelfth-Century Illumination and the Production of Luxury Bestiaries', *Beasts and Birds of the Middle Ages. The Bestiary and its Legacy*, eds W.B. Clark, M.T. McMunn (Philadelphia, 1989), pp.53–68.

Muratova, X., 'Les manuscrits-frères: un aspect particulier de la production des Bestiaires enluminés en Angleterre à la fin du XIIe siècle', *Artistes, artisans et production artistique au Moyen Age.*

3 Fabrication et consommation de l'œuvre, ed. X. Barral i Altet (Paris, 1990), pp. 69–92.

Murdoch, J., J. Murrell, P.J. Noon, R. Strong, *The English Miniature* (New Haven, 1981).

Mütherich, F., 'Das Godelgaudus-Sakramentar, ein verlorenes Denkmal aus der Zeit Karls des Grossen', *Festschrift Wolfgang Braunfels*, eds F. Piel, J. Traeger (Tübingen, 1977), pp. 267–74.

Muzerelle, D., *Vocabulaire codicologique. Répertoire méthodique des termes français relatifs aux manuscrits*, edns CEMI (Paris, 1985).

Mynors, R.A.B., *Durham Cathedral Manuscripts to the End of the Twelfth Century* (Durham, 1939).

Mynors, R.A.B., *Catalogue of the Manuscripts of Balliol College, Oxford* (Oxford, 1963).

Neuss, W., *Die Apokalypse des Hl. Johannes in der altspanischen und altchristlichen Bibel-Illustration*, 2 vols (Münster in Westfalen, 1931).

Nordenfalk, C., *Die spätantiken Kanontafeln*, 2 vols (Göteborg, 1938).

Nordenfalk, C., 'A Travelling Milanese Artist in France at the Beginning of the XI Century', *Arte del Primo Millenio* (Atti del Convegno di Pavia, 1950) (ed. E. Arslan, 1954), pp. 374–80.

Nordenfalk, C, 'Book Illumination' in *Early Medieval Painting* (with A. Grabar) (Skira, 1957).

Nordenfalk, C., 'Book Illumination' in *Romanesque Painting* (with A. Grabar) (Skira, 1958).

Nordenfalk, C., 'Miniature ottonienne et ateliers capétiens', *Arts de France*, 4 (1964), 47–55.

Nordenfalk, C., *Die spätantiken Zierbuchstaben*, 2 vols (Stockholm, 1970).

Nordenfalk, C., *Codex Caesareus Upsaliensis. An Echternach Gospel-Book of the Eleventh Century* (Stockholm, 1971).

Nordenfalk, C., 'Corbie and Cassiodorus', *Pantheon*, 32 (1974), 225–31.

Nordenfalk, C., Kommentarband to *Vergilius Augusteus (Staatsbibliothek Preussischer Kulturbesitz, Berlin, Codex Lat. fol. 416 et Codex Vaticanus lat. 3256) (Codices Selecti, LVI)* (Graz, 1976).

Nordenfalk, C., 'Hatred, Hunting, Love: Three Themes Relative to Some Manuscripts of Jean Sans Peur', *Studies in Late Medieval and Renaissance Painting in Honor of Millard Meiss*, eds I. Lavin, J. Plummer (New York, 1978), pp. 324–41.

Nordenfalk, C., *Bokmålningar från Medeltid och Renässans i Nationalmusei Samlingar* (Stockholm, 1979).

Nordhagen, P.J., 'An Italo-Byzantine Painter at the Scriptorium of Coelfrith', *Studia Romana in Honorem Petri Krarup Septuagenarii* (Odense, 1976), 138–45.

O'Connor, D. E., J. Haselock, 'The Stained and Painted Glass' in G.E. Aylmer, R. Cant, *A History of York Minster* (Oxford, 1977).

O'Meadhra, U., *Early Christian, Viking and Romanesque Art: Motif-Pieces from Ireland* (Stockholm, 1979) with volume 2, *A Discussion* (Stockholm, 1987).

O'Meadhra, U., 'Irish, Insular and Scandinavian Elements in the Motif-Pieces from Ireland', *Ireland and Insular Art A.D. 500–1200*, ed. M. Ryan (Dublin, 1987), pp. 159–65.

O'Meara, J.J., *Giraldus Cambrensis. The History and Topography of Ireland* (Portlaoise, 1982).

Oakeshott, W., *The Artists of the Winchester Bible* (London, 1945).

Oakeshott, W., *Sigena: Romanesque Paintings in Spain and the Winchester Bible Artists* (London, 1972).

Oakeshott, W., *The Two Winchester Bibles* (Oxford, 1981).

Oliver, J., 'The Mosan Origins of Johannes von Valkenburg',

Wallraf-Richartz Jahrbuch, 40 (1978), 23–37.

Oltrogge, D., *Die Illustrationszyklen zur 'Histoire ancienne jusqu' à César' (1250–1400)* (Europäische Hochschulschriften, Ser. XXVIII, no. 94) (Frankfurt am Main., 1987).

Orlandelli, G., *Il libro a Bologna dal 1300 al 1330. Documenti con uno studio su il contratto di scrittura nella dottrina notarile Bolognese* (Studi e ricerche di storia e scienze ausiliarie, I) (Bologna, 1959).

Orna, M.V., M.J.D. Low, N. S. Baer, 'Synthetic Blue Pigments: Ninth to Sixteenth Centuries. 1. Literature', *Studies in Conservation*, 25 (1980), 53–63.

Orna, M.V., T.F. Mathews, 'Uncovering the Secrets of Medieval Artists', *Analytical Chemistry*, 60 (1988), 47A–50A.

Ornamenta Ecclesiae. Kunst und Künstler der Romanik, catalogue ed. A. Legner, 3 vols (Cologne, 1985).

Osley, A.S. *Luminario: An Introduction to the Italian Writing-books of the Sixteenth and Seventeenth Centuries* (Nieuwkoop, 1972).

Ouy, G., 'Une maquette de manuscrit à peintures', *Mélanges offerts à Frantz Calot* (Paris, 1960), 43–51.

Pächt, O., 'Two Manuscripts of Ellinger, Abbot of Tegernsee', *Bodleian Library Record*, 2 (1947), 184–5.

Pächt, O., *The Master of Mary of Burgundy* (London, 1948).

Pächt, O., 'Hugo Pictor', *Bodleian Library Record*, 3 (1950), 96–103.

Pächt, O., 'Early Italian Nature Studies and the Early Calendar Landscape', *Journal of the Warburg and Courtauld Institutes*, 13 (1950), 13–47.

Pächt, O., *The Rise of Pictorial Narrative in Twelfth-Century England* (Oxford, 1962).

Pächt, O., 'The Limbourgs and Pisanello', *Gazette des Beaux-Arts*, 6e pér. 62 (1963), 109–22.

Pächt, O., 'René d'Anjou Studien. 1, 2', *Jahrbuch der kunsthistorischen Sammlungen in Wien*, 69 (1973), 85–126, and 73 (1977), 7–106.

Pächt, O., *Book Illumination in the Middle Ages: An Introduction* (London, 1986).

Pächt, O., J.J.G. Alexander, *Illuminated Manuscripts in the Bodleian Library, Oxford 1 German, Dutch, Flemish, French and Spanish Schools* (Oxford, 1966). *2 Italian School* (Oxford, 1970). *3 British, Irish and Icelandic Schools* (Oxford, 1973).

Pächt, O., D. Thoss, *Französische Schule I (Fortsetzung des Beschreibenden Verzeichnisses der illuminierten Handschriften der Nationalbibliothek in Wien)* (Vienna, 1974).

Pächt, O., U. Jenni, *Holländische Schule (Fortsetzung des Beschreibenden Verzeichnisses der illuminierten Handschriften der Nationalbibliothek in Wien)* (Vienna, 1975).

Paget, H., 'Gerard and Lucas Hornebolt in England', *Burlington Magazine*, 101 (1959), 396–402.

Panofsky, E., *Early Netherlandish Painting. Its Origins and Character* (Cambridge, Mass., 1953).

Panofsky, E., *The Life and Art of Albrecht Dürer* (Princeton, 1955).

Panofsky, E., *Abbot Suger on the Abbey Church of St. -Denis and Its Art Treasures* (2nd edn by G. Panofsky-Soergel, Princeton, 1979).

Pansier, P., *Histoire du Livre et de l'imprimerie à Avignon du XIVe au XVe siècle*, 3 vols (Avignon, 1922).

Parassoglou, G.M., 'A Book Illuminator in Byzantine Egypt', *Byzantion*, 44 (1974), 362–6.

Paris, A.P., *Les manuscrits françois de la bibliothèque du roi*, I (Paris, 1836).

Park, D., 'The Wall-Paintings of the Holy Sepulchre Chapel',

Medieval Art and Architecture at Winchester (British Archaeological Association, 1983), 38–62.

Parkes, M.B., *The Scriptorium of Wearmouth-Jarrow* (Jarrow Lecture, 1982).

Partsch, S., *Profane Buchmalerei der bürgerlichen Gesellschaft im spätmittelalterlichen Florenz* (Worms, 1981).

Pellegrin, E., *La bibliothèque des Visconti et des Sforza, ducs de Milan, au XVe siècle* (Paris, 1955).

Pellegrin, E., *Manuscrits Latins de la Bodmeriana* (Cologny-Genève, 1982).

Peterson, E.A., 'Accidents and Adaptations in Transmission Among Fully-Illustrated French Psalters in the Thirteenth Century', *Zeitschrift für Kunstgeschichte*, 50 (1987), 375–84.

Petroski, H., *The Pencil: A History of Design and Circumstance* (London, Boston, 1989).

Petzold, A., 'Colour Notes in English Romanesque Manuscripts', *British Library Journal*, 16 (1990), 16–25.

Pickford, C.E., 'An Arthurian Manuscript in the John Rylands Library', *Bulletin of the John Rylands Library*, 31 (1948), 318–44.

Pinkernell, G., 'Die Handschrift B.N. fr. 331 von Raoul Lefèvre's "Histoire de Jason" und das Wirken des Miniaturisten Lievin van Lathem in Brügge', *Scriptorium*, 27 (1973), 295–301.

Pinson, Y., 'Les "Puys d'Amiens" 1518–1525. Problèmes d'attribution et d'évolution de la loi du genre', *Gazette des Beaux-Arts*, 6e sér. 109 (1987), 47–61.

Plummer, C., 'On the Colophons and Marginalia of Irish Scribes', *Proceedings of the British Academy*, 12 (1926), 11–44.

Pollard, G., 'The Company of Stationers before 1557', *The Library*, 4th series, 18 (1937), 1–38.

Pollard, G., 'William de Brailes', *Bodleian Library Record*, 5 (1954–6), 202–9.

Pollard, G., 'The University and the Book Trade in Medieval Oxford', *Miscellanea Mediaevalia* (Beiträge zum Berufsbewusstein des mittelalterlichen Menschen, ed. P. Wilpert), 3 (1964), 336–44.

Porcher, J., *French Miniatures from Illuminated Manuscripts*, transl. J. Brown (London, 1960).

Porcher, J., *Jean Lebègue, Les histoires que l'on peut raisonnablement faire sur les livres de Salluste* (Paris, 1962).

Porter, V.G., *The West Looks at the East in the Late Middle Ages: the 'Livre des merveilles du monde'*, Ph. D. (Johns Hopkins University, 1977).

Powitz, G., H. Buck, *Die Handschriften des Bartholomaeusstifts und des Karmeliterklosters in Frankfurt am Main* (Frankfurt am Main, 1974).

Prinet, M., 'Un manuscrit armorié du "Songe du vieux pèlerin"', *Bibliographe moderne* (Besançon, 1907), 32–8.

Prochno, J., *Das Schreiber- und Dedikationsbild in der deutschen Buchmalerei, 1 Teil. 800–1100* (Leipzig and Berlin, 1929).

Puncuh, D., *I manoscritti della raccolta Durazzo* (Genoa, 1979).

Ragusa, I, 'An Illustrated Psalter from Lyre Abbey', *Speculum*, 46 (1971), 267–81.

Raine, J., 'The York Fabric Rolls', *Surtees Society*, 35 (1858).

Randall, L.M.C., *Images in the Margins of Gothic Manuscripts* (Berkeley, 1966).

Rathe, K., *Die Ausdrucksfunction extrem verkürzter Figuren* (Studies of the Warburg Institute, 8) (London, 1938; repr. 1968).

Reed, R., *Ancient Skins, Parchments and Leathers* (London, New York, 1972).

Regensburger Buchmalerei. Von frühkarolingischer Zeit bis zum Ausgang des Mittelalters, F. Mütherich, K. Dachs, eds (Munich, 1987).

Remak-Honnef, E.M., *Text and Image in the 'Estoire del Saint Graal'. A Study of London British Library Ms. Royal 14 E.iii*, Ph.D. (University of North Carolina at Chapel Hill, 1987).

Renaissance Painting in Manuscripts. Treasures from the British Library, catalogue ed. T. Kren (New York, London, 1983).

Rickert, M., *The Reconstructed Carmelite Missal* (London, 1952).

Rickert, M., *Painting in Britain. The Middle Ages* (Pelican History of Art) (2nd edn, Harmondsworth, 1965).

Robert Goulet, Compendium on the Magnificence, Dignity and Excellence of the University of Paris in the Year of Grace 1517, lately done into English by Robert Belle Burke (Philadelphia, London, 1928).

Roberts, C.H., T.C. Skeat, *The Birth of the Codex* (British Academy, London, 1983).

Robinson, J.A., M.R. James, *The Manuscripts of Westminster Abbey* (Cambridge, 1909).

Rogers, N.J., *Books of Hours Produced in the Low Countries for the English Market in the Fifteenth Century*, M. Litt. (Cambridge University, 1982).

Roosen-Runge, H., A.E.A. Werner, 'The Pictorial Technique of the Lindisfarne Gospels', *Evangeliorum Quattuor Codex Lindisfarnensis*, T.D. Kendrick *et al.*, II (1960), pp. 261–77.

Roosen-Runge, H., *Farbgebung und Technik frühmittelalterlicher Buchmalerei*, 2 vols (Berlin, 1967).

Roosen-Runge, H., 'Zum Erhaltungszustand der Farben im Evangelistar Heinrichs III. der Universitätsbibliothek Bremen, Ms. 21b', *Von Farbe und Farben. Albert Knoepfli zum 70 Geburtstag*, ed. M. Hering-Mitgau (Zurich, 1980), pp. 13–20.

Roosen-Runge, M. and H., *Das spätgotische Musterbuch des Stephan Schriber in der Bayerischen Staatsbibliothek München, Cod. icon. 420*, 3 vols (Wiesbaden, 1981).

Rosenberg, C.M., 'The Influence of Northern Graphics on Painting in Renaissance Ferrara: Matteo da Milano', *Musei Ferraresi. Bollettino Annuale*, 15 (1985–7), 61–74.

Rosenthal, E., 'Dürer's Buchmalereien für Pirckheimers Bibliothek', *Jahrbuch der Preussischen Kunstsammlungen*, 49 (1928), Beiheft, 1–54 and *ibid.*, 51 (1930), 175–8.

Ross, D.J.A., 'Methods of Book-Production in a XIVth Century French Miscellany' *Scriptorium*, 6 (1952), 63–75.

Ross, D.J.A., 'A Later Twelfth-Century Artist's Pattern-Sheet', *Journal of the Warburg and Courtauld Institutes*, 25 (1962), 119–28.

Ross, D.J.A., 'An Illuminator's Labour-Saving Device', *Scriptorium*, 16 (1962), 94–5.

Rouse, R.H., M.A. Rouse, 'The Book Trade at the University of Paris, *c.* 1250–*c.* 1350', *La production du livre universitaire au Moyen Age. Exemplar et pecia* (Actes du Symposium tenu au Collegio San Bonaventura de Grottaferrata en Mai 1983), eds L.J. Bataillon, B.G. Guyot, R.H. Rouse (Paris, 1988), 41–123.

Rouse, R.H., M.A. Rouse, 'St Antoninus of Florence on Manuscript Production', *Litterae Medii Aevi. Festschrift für Johanne Autenrieth*, eds M. Borgolte, H. Spilling (Sigmaringen, 1988), 255–63.

Rouse, R., M.A. Rouse, *Cartolai, Illuminators and Printers in Fifteenth-Century Italy* (U.C.L.A. University Research Library. Department of Special Collections. Occasional Papers 1) (Los Angeles, 1988).

Rouse, R.H., M.A. Rouse, 'Wax Tablets', *Language and Communication*, 9 (1989), 175–91.

Rouse, R.H., M.A. Rouse, 'The Vocabulary of Wax Tablets',

Vocabulaire du livre et de l'écriture au moyen âge. Actes de la table ronde Paris 24–26 Septembre 1987, ed. O. Weijers (Turnhout, 1989), pp. 220–30.

Rouse, R.H. and M.A. Rouse, 'The Commercial Production of Manuscript Books in Late Thirteenth-Century and Early Fourteenth-Century Paris', *Medieval Book Production. Assessing the Evidence*, ed. L.L. Brownrigg (Los Altos Hills, 1990), pp. 103–115.

Rudolph, C., *Artistic Change at St-Denis: Abbot Suger's Program and the Early Twelfth-Century Controversy over Art* (Princeton, 1990).

Rudolph, C., *The 'Things of Greater Importance'. Bernard of Clairvaux's Apologia and the Medieval Attitude Toward Art* (Philadelphia, 1990).

Ruysschaert, J., 'Miniaturistes "Romains" sous Pie II', *Enea Silvio Piccolomini-Papa Pio II* (Atti del convegno per il quinto centenario della morte) (Siena, 1968), pp. 245–82.

Saint Bernard et l'art des Cisterciens, exhibition catalogue (Dijon, 1953).

Saenger, P., 'Books of Hours and the Reading Habits of the Later Middle Ages', *The Culture of Print: Power and the Uses of Print in Early Modern Europe*, ed. R. Chartier (Cambridge, 1989), pp. 141–73.

Salmi, M., *Italian Miniatures* (London, 1957).

Sandler, L.F., 'Peterborough Abbey and the Peterborough Psalter in Brussels', *Journal of the British Archaeological Association*, 33 (1970), 36–49.

Sandler, L.F., 'Jean Pucelle and the Lost Miniatures of the Belleville Breviary', *Art Bulletin*, 66 (1984), 73–96.

Sandler, L.F., 'A Note on the Illuminators of the Bohun Manuscripts', *Speculum*, 60 (1985), 364–72.

Sandler, L.F., *Gothic Manuscripts 1285–1385* (A Survey of Manuscripts Illuminated in the British Isles, General editor J.J.G. Alexander, vol. 5), 2 vols (London, 1986).

Sandler, L.F., 'Notes for the Illuminator: The Case of the *Omne Bonum*', *Art Bulletin*, 71 (1989), 551–64.

Sandler, L.F., '*Omne bonum: compilatio* and *ordinatio* in an English Illustrated Encyclopedia of the Fourteenth Century', *Medieval Book Production. Assessing the Evidence*, ed. L.L. Brownrigg (Los Altos Hills, 1990), 183–200.

Saxl, H., 'Histology of Parchment', *Technical Studies*, 8 (1939–40), 3–9.

Schaefer, C., 'Un Livre d'Heures illustré par Jean Colombe à la Bibliothèque Laurentienne à Florence', *Gazette des Beaux-Arts*, 6e pér. 82 (1973), 287–304.

Schapiro, M., 'From Mozarabic to Romanesque in Silos', *Art Bulletin*, 21 (1939), 312–74. Reprinted *Selected Papers. Romanesque Art* (New York, 1977), pp. 28–101.

Schapiro, M., 'On the Aesthetic Attitude in Romanesque Art', *Art and Thought: Issued in Honor of Dr Ananda Coomaraswamy on the Occasion of His 70th Birthday*, ed. K. Bharatha Iyer (London, 1947), pp. 130–50. Reprinted *Romanesque Art. Selected Papers* (New York, 1977), pp. 1–27.

Schapiro, M., *The Parma Ildefonsus. A Romanesque Illuminated Manuscript from Cluny and Related Works* (New York, 1964).

Schapiro, M., 'On the Relation of Patron and Artist. Comments on a Proposed Model for the Scientist', *The American Journal of Sociology*, 70 (1964–5), 363–9.

Schapiro, M., 'Diderot on the Artist and Society', *Diderot Studies*, 5 (1964), 5–11.

Schatzkunst Trier. Kunst und Kultur in der Diözese Trier, exh. cat. by F.J. Ronig (Trier, 1984).

Scheler, A., *Lexicographie Latine du XIIe et XIIIe siècle. Trois traités de J. de Garlande, A. Neckham et Adam du Petit-Pont* (Leipzig, 1867).

Scheller, R.W., *A Survey of Medieval Model Books* (Haarlem, 1963).

Scheller, R.W., 'Towards a Typology of Medieval Drawings', *Drawings Defined*, eds W. Strauss, T. Felker (New York, 1987), pp. 13–34.

Schilling, R., 'Two Unknown Flemish Miniatures of the Eleventh Century', *Burlington Magazine*, 90 (1948), 312–17.

Schlosser, J. von, 'Eine Fuldaer Miniaturhandschrift der K.K. Hofbibliothek', *Jahrbuch der kunsthistorischen Sammlungen des Allerhochsten Kaiserhauses*, 13 (1892), 30–36.

Schramm, P.E., F. Mütherich, *Denkmale der deutschen Könige und Kaiser. Ein Beitrag zur Herrschergeschichte von Karl dem Grosse bis Friedrich II. 768–1250* (Munich, 1962; 2nd edn, 1983).

Schryver, A. de, 'Prix de l'enluminure et codicologie. Le point comme unité de calcul de l'enlumineur dans "Le Songe du viel pellerin" et "Les faictz et gestes d'Alexandre" (Paris, B.n., fr. 9200–9201 et fr. 22547)', *Miscellanea Codicologica F. Masai dicata MCMLXXIX*, eds P. Cockshaw, M.-C. Garrand, P. Jodogne, 2 (Ghent, 1979), pp. 469–79.

Schulten, S., 'Die Buchmalerei des 11. Jahrhunderts im Kloster St Vaast in Arras', *Münchner Jahrbuch der bildenden Kunst*, 3 Folge 7 (1956), 49–90.

Schulz, H.C., *The Ellesmere Ms. of Chaucer's 'Canterbury Tales'* (San Marino, 1966).

Scillia, D.G., *Gerard David and Manuscript Illumination in the Low Countries, 1480–1509*, Ph.D. (Case Western Reserve University, 1975).

Scillia, D.G., 'The Jason Master and the Woodcut Designers in Holland 1480–5', *Dutch Crossing*, 39 (1989), 5–44.

Scillia, D.G., 'The Master of the London Passional: Johann Veldener's "Utrecht Cutter"', *The Early Illustrated Book: Essays in Honor of Lessing J. Rosenwald*, ed. S. Hindman (Washington, 1982), pp. 23–40.

Scott, K.L., 'A mid Fifteenth-Century English Illuminating Shop and Its Customers', *Journal of the Warburg and Courtauld Institutes*, 31 (1968), 170–96.

Scott, K.L., 'Lydgate's Lives of Saints Edmund and Fremund: A Newly-Located Manuscript in Arundel Castle', *Viator*, 13 (1982), 335–66.

Scott, K.L., 'Design, Decoration and Illustration', *Book Production and Publishing in Britain 1375–1475*, eds J. Griffiths, D. Pearsall (Cambridge, 1989), pp. 31–64.

Scott, K.L., '*Caveat lector*: Ownership and Standardization in the Illustration of Fifteenth-Century English Manuscripts', *English Manuscript Studies*, 1 (1989), 19–63.

Scott, K.L., *Later Gothic Manuscripts* c. *1385–1490* (A Survey of Manuscripts Illuminated in the British Isles, General editor J.J.G. Alexander, vol. 6) (London, forthcoming).

Scott-Fleming, S., *Pen Flourishing in Thirteenth-Century Manuscripts* (Litterae textuales) (Leiden, 1989).

Sears, E. 'Louis the Pious as *Miles Christi*. The Dedicatory Image in Hrabanus Maurus's *De laudibus sanctae crucis*', *Charlemagne's Heir: New Perspectives on the Reign of Louis the Pious (814–840)*, eds P. Godman, R. Collins (Oxford, 1990), pp. 605–28.

Shepperd, J.M., 'Notes on the Origin and Provenance of a French Romanesque Bible in the Bodleian', *Bodleian Library Record*, 11/5 (1984), 284–99.

Sherman, C.R., *The Portraits of Charles V of France (1338–80)* (New York, 1969).

Sherman, C.R., 'Representations of Charles V of France

(1338–1380) as Wise Ruler', *Medievalia et Humanistica*, n.s. 2 (1971), 83–96.

Sherman, C.R., 'Some Visual Definitions in the Illustrations of Aristotle's *Nicomachean Ethics* and *Politics* in the French Translations of Nicole Oresme', *Art Bulletin*, 59 (1977), 320–35.

Silber, E., 'The Reconstructed Toledo *Speculum humanae salvationis*: The Italian Connection in the Early Fourteenth Century', *Journal of the Warburg and Courtauld Institutes*, 43 (1980), 32–51.

Silvestre, H., 'Le Ms. Bruxellensis 10147–58 (s. XII–XIII) et son *compendium artis picturae*', *Bulletin de la Commission Royale d'Histoire*, 119 (1954), 95–140.

Simmons, T.F., ed., 'The Layfolks' Mass Book', *Early English Text Society*, 71 (1879).

Simonnet, J., *Documents inédits pour servir à l'histoire des institutions et de la vie privée en Bourgogne* (Dijon, 1867).

Smeyers, M., H. Cardon, 'Merktekens in de Brugse miniatuurkunst', *Merken opmerken. Typologie en methode*, ed. C. Van Vlierden, M. Smeyers (Leuven, 1990), pp. 45–70.

Smith, C.S., J.G. Hawthorne, 'Mappae clavicula: A Little Key to the World of Medieval Techniques', *Transactions of the American Philosophical Society*, n.s. 64 part 4 (1974), 1–128.

Smith, S.D., *Illustrations of Raoul de Praelles' Translation of St Augustine's City of God between 1375 and 1420*, Ph.D. (Institute of Fine Arts, New York University, 1974).

Smith, S.D., 'New Themes for the *City of God* around 1400: the Illustrations of Raoul de Presles' Translation', *Scriptorium*, 36 (1982), 68–82.

Soetermeer, F.P.W., 'La terminologie de la librairie à Bologne aux XIIe et XIVe siècles', *Actes du Colloque Terminologie de la vie intellectuelle au moyen âge. Leyde/La Haye 20–21 Septembre 1985*, ed. O. Weijers (Turnhout, 1988), pp. 88–95.

Soetermeer, F.P.W., *De 'pecia' in juridische Handschriften* (Utrecht, 1990).

Somerville, R., 'The Cowcher Books of the Duchy of Lancaster', *English Historical Review*, 51 (1936), 598–615.

Spencer, E., 'L'Horloge de Sapience (Bruxelles, Bibliothèque royale, ms. IV. 111)', *Scriptorium*, 17 (1963), 277–99.

Stähli, M., ed. H. Härtel, *Die Handschriften im Domschatz zu Hildesheim* (Wiesbaden, 1984).

Staley, J.E., *The Guilds of Florence* (London, 1906).

Stamm-Saurma, L.E., 'Zuht und wicze: zum Bildgehalt spätmittelalterlicher Epenhandschriften', *Zeitschrift des deutschen Vereins für Kunstwissenschaft*, 41 (1987), 42–70.

Stechow, W., *Northern Renaissance Art 1400–1600* (Sources and documents in the History of Art series), ed. H.W. Janson, (Englewood Cliffs, 1966).

Steenbock, F., 'Münzen, Blüten und Mannargen. Eine Motivstudie', *Festschrift für Peter Bloch zum 11. Juli 1990*, eds H. Krohm, C. Theuerkauff (Mainz, 1990), pp. 135–42.

Steinmann, M., 'Ein mittelalterliches Schriftmusterblatt', *Archiv für Diplomatik*, 21 (1975), 450–58.

Stern, H., *Le calendrier de 354. Étude de son texte et ses illustrations* (Paris, 1953).

Stevenson, T.B., *Miniature Decoration in the Vatican Virgil. A Study in Late Antique Iconography* (Tübingen, 1983).

Stevick, R.D., 'The 4 × 3 Crosses in the Lindisfarne and Lichfield Gospels', *Gesta*. 25/2 (1986), 171–84.

Stevick, R.D., 'The Shapes of the Book of Durrow Evangelist-Symbol Pages', *Art Bulletin*, 68 (1986), 182–94.

Stirnemann, P., 'Nouvelles pratiques en matière d'enluminure au temps de Philippe d'Auguste', *La France de Philippe Auguste. Le temps des mutations* (Colloques internationaux du Centre Nationale de la Recherche Scientifique, 1980, no. 602), ed. R.-H. Bautier (Paris, 1982), pp. 955–80.

Stirnemann, P., 'Quelques bibliothèques princières et la production hors scriptorium au XIIe siècle', *Bulletin archéologique du Comité des travaux historiques et scientifiques*, n.s. 17–8A (1984), 7–38.

Stirnemann, P., 'Réflexions sur des instructions non iconographiques dans les manuscrits gothiques', *Artistes, artisans et production artistique au Moyen Age. 3 Fabrication et consommation de l'œuvre*, ed. X. Barral i Altet (Paris, 1990), pp. 351–6.

Stirnemann, P., 'Fils de la Vierge: l'initiale à filigranes parisienne: 1140–1314', *Revue de l'Art*, 90 (1990), 58–73.

Stirnemann, P., M.-T. Gousset, 'Marques, mots, pratiques: leur signification et leurs liens dans le travail des enlumineurs', *Vocabulaire du livre et de l'écriture au moyen âge*, ed. O. Weijers (Turnhout, 1989), pp. 34–55.

Stock, B., *The Implications of Literacy: Written Language and Models of Interpretation in the Eleventh and Twelfth Centuries* (Princeton, 1983).

Stones, A., 'Short Note on Manuscripts Rylands French 1 and Douce 215', *Scriptorium*, 22 (1968), 42–5.

Stones, M.A., *The Illustration of the French Prose Lancelot in Flanders, Belgium and Paris, 1250–1340*, Ph.D. (London University, 1970).

Stones, A., 'Secular Manuscript Illustration in France', *Medieval Manuscripts and Textual Criticism*, ed. C. Kleinhenz (Chapel Hill, 1976), pp. 83–102.

Stones, A., 'Sacred and Profane Art: Secular and Liturgical Book-Illumination in the Thirteenth Century', *The Epic in Medieval Society. Aesthetic and Moral Values*, ed. H. Scholler (Tübingen, 1977), 100–12.

Stones, A., 'Four Illustrated Jacobus Manuscripts', *The Vanishing Past. Studies of Medieval Art, Liturgy and Metrology Presented to Christopher Hohler*, eds A. Borg, A. Martindale (British Archeological Reports, International Series, 111) (1981), 197–222.

Stones, A., 'Manuscripts, Arthurian Illuminated', *The Arthurian Encyclopedia*, ed. N.J. Lacy (New York, 1986), pp. 359–74.

Stones, A., 'Another Short Note on Rylands French 1', *Romanesque and Gothic: Essays for George Zarnecki*, ed. N. Stratford (Woodbridge, 1987), 185–92.

Stones, A., 'Indications écrites et modèles picturaux, guides aux peintres de manuscrits enluminés aux environs de 1300', *Artistes, artisans et production artistique au Moyen Age. 3 Fabrication et consommation de l'œuvre*, ed. X. Barral i Altet (Paris, 1990), pp. 321–49.

Stones, A., 'Arthurian Art since Loomis', *Arturus Rex, II* (Acta Conventus Lovaniensis 1987), eds W. van Hoecke, G. Tournoy, W. Verbeke (Leuven, 1991), 21–55.

Straub, R.E., 'Der Traktat "De clarea" in der Burgerbibliothek Berne. Eine Anleitung für Buchmalerei aus dem Hochmittelalter', *Schweizerisches Institut für Kunstwissenschaft. Jahresbericht 1964* (Zürich, 1965), pp. 89–114.

Strauss, W.L., ed., *The Book of Hours of the Emperor Maximilian the First* (New York, 1974).

Stuttgarter Zimelien, catalogue by W. Irtenkauf (Stuttgart, Württembergische Landesbibliothek, 1985).

Sullivan, L.E., *The Burgh of Ste Geneviève: Development of the University Quarter of Paris in the Thirteenth and Fourteenth Centuries*, Ph.D. (Johns Hopkins University, 1975).

Sutton, K., 'The Master of the "Modena Hours", Tomasino da Vimercate, and the Ambrosianae of Milan Cathedral', *Burlington*

Magazine, 133 (1991), 87–90.

Swartout, R.E., *The Monastic Craftsman* (Cambridge, 1932).

Swarzenski, H., 'The Role of Copies in the Formation of the Styles of the Eleventh Century', *Romanesque and Gothic Art: Studies in Western Art. Acts of the Twentieth International Congress of the History of Art*, 1, ed. M. Meiss *et al.* (Princeton, 1963), pp. 7–18.

Talbot, C.H., 'The Cistercian Attitude Towards Art: The Literary Evidence', *Cistercian Art and Architecture in the British Isles*, eds C. Norton, D. Park (Cambridge, 1986), pp. 56–64.

Temple, E., *Anglo-Saxon Manuscripts 900–1066* (A Survey of Manuscripts Illuminated in the British Isles, General editor J.J.G. Alexander, vol. 2) (London, 1976).

Text und Bild. Aspekte des Zusammenwirkens zweier Künste in Mittelalter und früher Neuzeit, eds C. Meier, U. Ruberg (Wiesbaden, 1980).

Texte et Image (Actes du colloque international de Chantilly, 13 au 15 octobre 1982) (Paris, 1984).

Teyssèdre, B. *Le sacramentaire de Gellone* (Toulouse, 1959).

The Glory of the Page. Medieval and Renaissance Manuscripts from Glasgow University Library, catalogue by N. Thorp (London, 1987).

The Golden Age of Dutch Manuscript Painting, catalogue by J.H. Marrow *et al.* (New York, 1990).

Theophilus, On divers arts, ed., transl. C.R. Dodwell (London, 1961; 2nd edn Oxford, 1986).

Thomas, M., *Le manuscrit de parchemin* (Faits de civilisation, 2) (Paris, 1967).

Thompson, D.V., ed. and transl., '*Liber de coloribus illuminatorum sive pictorum* from Sloane Ms. no. 1754', *Speculum*, 1 (1926), 280–307, 448–50.

Thompson, D.V., ed. and transl., 'The De Clarea of the so-called Anonymus Bernensis', *Technical Studies in the Field of the Fine Arts*, 1 (1932), 8–19, 70–81.

Thompson, D.V., '*De coloribus naturalia exscripta et collecta* from Erfurt, Stadtbücherei, Ms. Amplonianus Quarto 189 (XIII–XIV century)', *Technical Studies in the Field of the Fine Arts*, 3 (1934–5), 133–45.

Thompson, D.V., 'Medieval Parchment Making', *The Library*, 4th series 16 (1935), 113–17.

Thompson, D.V., 'Liber Magistri Petri de Sancto Audemaro De coloribus faciendis', *Technical Studies in the Field of the Fine Arts*, 4 (1935–6), 28–33.

Thompson, D.V., *The Materials and Techniques of Medieval Painting* (London, 1936; repr. New York, 1957) etc.

Thompson, D.V., 'More Medieval Color Making. *Tractatus de coloribus* from Munich Staatsbibliothek Ms. Lat. 444', *Isis*, 24 (1937), 382–96.

Thompson, D.V., G.H. Hamilton, ed. and transl., *An Anonymous Fourteenth-Century Treatise De arte Illuminandi. The Technique of Manuscript Illumination Translated from the Latin of Naples Ms. XII. E.27* (New Haven, 1933).

Tietze, H., *Die illuminierten Handschriften der Rossiana in Wien-Lainz* (Beschreibendes Verzeichnis der illuminierten Handschriften in Oesterreich, Band V) (Leipzig, 1911).

Tilander, G., 'Etude sur les traductions en vieux français du traité de fauconnerie de l'empereur Frédéric II', *Zeitschrift für Romanische Philologie*, 46 (1926), 211–90.

Tolley, T., *John Siferwas: The Study of an English Dominican Illuminator*, Ph.D. (University of East Anglia, 1984).

Torriti, P., *Le miniature degli antiphonari di Finalpia* (Genoa, 1953).

Tosatti, B.S., 'Le techniche pittoriche di Simone nell'

"Allegoria Virgiliana"', *Simone Martini. Atti del Convegno, Siena, 27–29 Marzo 1985*, ed. L. Bellosi (Florence, 1988), pp. 131–8.

Toubert, H., 'Illustration et mise en page', *Mise en page et mise en texte du livre manuscrit*, eds H.-J. Martin, J. Vezin (Paris, 1990), pp. 353–434.

Tout, T.F., *Chapters in the Administrative History of Mediaeval England*, 6 vols (Manchester, 1920–33).

Toynbee, J.M.C., 'Some Notes on Artists in the Roman World', *Collection Latomus*, 6 (1951).

Trost, V., 'Tinte und Farben – zum Erhaltungszustand der Manesseschen Liederhandschrift', *Codex Manesse. Die Grosse Heidelberger Liederhandschrift. Texte. Bilder. Sachen*, eds E. Mittler, W. Werner (Heidelberg, 1988), pp. 440–45.

Turcheck, J.P, 'A Neglected Manuscript of Peter Lombard's *Liber Sententiarum* and Parisian Illumination of the Late Twelfth Century', *Journal of the Walters Art Gallery*, 44 (1986), 48–69.

Turner, D.H., 'The Development of Maître Honoré', *The Eric George Millar Bequest of Manuscripts and Drawings, 1967. A Commemorative Volume* (London, 1968), pp. 53–65.

Turner, E.G., *The Typology of the Early Codex* (Philadelphia, 1977).

Two Thousand Years of Calligraphy (Walters Art Gallery, Baltimore Museum of Art, Peabody Institute, Baltimore, 1965; repr. 1976).

Ullmann, W., *The Individual and Society in the Middle Ages* (Baltimore, London, 1966).

Unterkircher, F., *Inventar der illuminerten Handschriften, Inkunabeln und Frühdrucke der Oesterreichischen Nationalbibliothek*, 2 vols (Vienna, 1957).

Unterkircher, F., Kommentarband to *Reiner Musterbuch* (Codices Selecti, LXIV) (Graz, 1979).

Unterkircher, F., *King René's Book of Love* (New York, 1975).

van Acker, L., ed., *Petri Pictoris Carmina necnon Petri de Sancto Audemaro Librum de coloribus faciendis* (Corpus Christianorum continuatio mediaevalis, XXV) (Turnhout, 1972).

van Buren, A., 'New Evidence for Jean Wauquelin's Activity in the Chroniques de Hainaut and for the Date of the Miniatures', *Scriptorium*, 26 (1972), 249–68 and 27 (1973), 318.

van Buren, A., 'The Master of Mary of Burgundy and His Colleagues: The State of Research and Questions of Method', *Zeitschrift für Kunstgeschichte*, 38 (1975), 286–309.

van Buren, A., 'The Model Roll of the Golden Fleece', *Art Bulletin*, 61 (1979), 359–76.

van Buren, A., 'Jean Wauquelin de Mons et la production du livre aux Pays-Bas', *Publication du centre Européen d'études Burgundo-Médianes* (Rencontres de Mons, 24–6 Septembre 1982), no. 23 (1983), pp. 53–66.

van Buren, A., 'Thoughts, Old and New, on the Sources of Early Netherlandish Painting', *Simiolus*, 16 (1986), 93–112.

van Buren, A., S. Edmunds, 'Playing Cards and Manuscripts: Some Widely Disseminated Fifteenth-Century Model Sheets', *Art Bulletin*, 56 (1971), 12–30.

van der Horst, K., J.H.A. Engelbregt, Kommentarband to *Utrecht-Psalter* (Codices Selecti, LXXV) (Graz, 1984).

Vandewalle, A., 'Het librariërsgild te Brugge in zijn vroege periode', *Vlaamse Kunst op Perkament* (Bruges, Gruuthuse-museum, 1981), pp. 39–43.

van Engen, J., 'Theophilus Presbiter and Rupert of Deutz: The Manual Arts and Benedictine Theology in the Early Twelfth Century', *Viator*, 11 (1980), 147–63.

van Gelder, J.G., 'Der Teufel stiehlt das Tintenfass', *Kunshistorische Forschungen Otto Pächt zu ehren*, eds A. Rosenauer, G. Weber (Salzburg, 1972), 173–89.

van Migroet, H.J., *Gerard David* (Antwerp, 1989).

Vasari, G., *Le vite de' piu eccellenti pittori, scultori ed architettori*, ed. G. Milanesi, vol. 7 (Florence, 1881).

Vaughan, R., *Matthew Paris* (Cambridge, 1958, repr. 1979).

Verey, C.D., T.J. Brown, E. Coatsworth, *The Durham Gospels* (Early English Manuscripts in Facsimile, 20) (Copenhagen, 1980).

Vergnolle, E., 'Un carnet de modèles de l'an mil originaire de Saint-Benôit-sur-Loire (Paris, B.n. lat. 8318 + Rome, Vat. Reg. lat. 596)', *Arte Medievale*, 2 (1984), 23–56.

Vezin, J., 'La réalisation matérielle des manuscrits latins pendant le haut Moyen Age', *Codicologica 2. Eléments pour une codicologie comparée*, ed. A. Gruys (Leiden, 1978), pp. 15–51.

Vocabulaire du livre et de l'écriture au moyen âge. Actes de la table ronde Paris 24–26 Septembre 1987, ed. O. Weijers (Turnhout, 1989).

Voeckle, W., 'Two New Drawings for the Boxwood Sketchbook in the Pierpont Morgan Library, *Gesta*, 20/1 (1981), 243–5.

von Euw, A., J.H. Plotzek, *Die Handschriften der Sammlung Ludwig*, 4 vols (Cologne, 1979–85).

Vor Stefan Lochner. Die Kölner Maler von 1300 bis 1430 (Wallraf-Richartz-Museum, Cologne, 1974).

Walliser, F., *Cistercienser Buchkunst. Heiligenkreuzer Skriptorium in seinem ersten Jarhrhundert 1133–1230* (Heiligenkreuz, Vienna, 1969).

Wardrop, J., *The Script of Humanism. Some Aspects of Humanistic Script 1460–1560* (Oxford, 1963).

Warner, G.F., J.P. Gilson, *Catalogue of Western Manuscripts in the Old Royal and King's Collections*, 4 vols (British Museum, London, 1921).

Watson, R., *The Playfair Hours. A Late Fifteenth-Century Illuminated Manuscript from Rouen (V. and A. L. 475–1918)* (London, 1984).

Wattenbach, W., *Das Schriftwesen im Mittelalter* (3rd edn, Leipzig, 1896).

Weale, W.H.J., 'Documents inédits sur les enlumineurs de Bruges', *Le Beffroi*, 2 (1864–5), 298–319; ibid., 4 (1872), 111–19, 238–337.

Weale, W.H.J., 'Simon Binnink Miniaturist', *Burlington Magazine*, 8 (1905–6), 355–6.

Weis, B., P. Bachoffner, *et al.*, Commentary to *Le Codex Guta-Sintram* (facsimile) (Luzern, Strasbourg, 1982, 1983).

Weitzmann, K., *Illustrations in Roll and Codex: A Study of the Origin and Method of Text Illustration* (Princeton, 1947; rev. edn 1970).

Weitzmann, K., *Ancient Book Illumination* (Cambridge, Mass., 1959).

Weitzmann, K., 'Book Illustration in the Fourth Century: Tradition and Innovation', *Studies in Classical and Byzantine Illumination*, ed. H.L. Kessler (Chicago, London, 1971), pp. 96–125.

Weitzmann, K., *Late Antique and Early Christian Book Illumination* (New York, 1977).

Weitzmann, K., H.L. Kessler, *The Cotton Genesis British Library Codex Otho B.VI* (Princeton, 1986).

Wellesz, E., *The Vienna Genesis* (London, 1960).

Werner, M., 'On the Origin of Zoanthropomorphic Evangelist Symbols: The Early Christian Background', *Studies in Iconography*, 10 (1984–6), 1–35.

Wieck, R., with L.R. Poos, V. Reinburg, J. Plummer, *Time Sanctified. The Book of Hours in Medieval Art and Life* (Walters Art Gallery, Baltimore, 1988).

Wilckens, L.V., 'Die Prophetien über die Päpste in deutschen Handschriften. Zu Illustrationen aus der Pariser Handschrift Lat. 10834 und aus anderen Manuskripten der ersten Hälfte des 15. Jahrhunderts', *Wiener Jahrbuch für Kunstgeschichte*, 28 (1975), 171–80.

Willelmi Malmesbiriensis monachi de Gestis Pontificum Anglorum (Rolls Series, 52), ed. N.E.S.A. Hamilton (London, 1870).

Willemsen, C.A., Kommentarband to *Fredericus II, De arte venandi cum avibus, Ms. Pal. Lat. 1071* (Codices Selecti, XXXI) (Graz, 1969).

Williams, J., 'A Contribution to the History of the Castilian Monastery of Valerancia and the Scribe Florentius', *Madrider Mitteilungen*, 11 (1970), 231–248.

Williams, J., *Early Spanish Manuscript Illumination* (New York, 1977).

Winter, P. de, 'Copistes, éditeurs et enlumineurs de la fin du XIVe siècle. La production à Paris de manuscrits à miniatures', *Actes du 100e Congrès national des Sociétés savantes (1975)* (Paris, 1978), 173–98.

Winter, P. de, 'Manuscrits à peintures produits pour le mécénat Lillois sous les règnes de Jean sans Peur et de Philippe le Bon', *Actes du 101e Congrès national des Sociétés savantes (1976)* (Paris, 1978), 233–56.

Winter, P. de, 'Christine de Pizan. Ses enlumineurs et ses rapports avec le milieu Bourguignon', *Actes du 104e Congrès national des Sociétés savantes (1979)* (Paris, 1982), pp. 335–75.

Winter, P. de, *La bibliothèque de Philippe le Hardi, duc de Bourgogne (1364–1404). Étude sur les manuscrits à peintures d'une collection princière à l'époque du 'Style gothique international'* (Paris, 1985).

Wirth, K.A., *Pictor in Carmine. Ein Handbuch der Typologie aus dem 12. Jahrhundert. Nach der Handschrift des Corpus Christi College in Cambridge, Ms. 300* (Berlin, 1989).

Wit, J. de, *Die Miniaturen des Vergilius Vaticanus* (Amsterdam, 1959).

Wolff, M., 'Some Manuscript Sources for the Playing-Card Master's Number Cards', *Art Bulletin*, 64 (1982), 587–600.

Wormald, F., 'Some Illustrated Manuscripts of the Lives of the Saints', *Bulletin of the John Rylands Library*, 35 (1952), 248–66; reprinted *Collected Writings, II*, eds J.J.G. Alexander, T.J. Brown, J. Gibbs, pp. 43–56.

Wormald, F., *English Drawings of the Tenth and Eleventh Centuries* (London, 1952).

Wormald, F., 'A Medieval Description of Two Illuminated Psalters', *Scriptorium*, 6 (1952), 18–25.

Wormald, F., 'The Monastic Library', *The English Library Before 1700*, eds F. Wormald, C.E. Wright (London, 1958), pp. 15–31; reprinted *Gatherings in Honor of Dorothy Miner*, eds U. McCracken, L.M.C. Randall, R.H. Randall (Baltimore, 1974), 93–9.

Wormald, F., *The Winchester Psalter* (London, 1973).

Wormald, F., *An Early Breton Gospel Book, A Ninth-Century Manuscript from the Collection of H.L. Bradfer-Lawrence*, ed. with 'Note on the Breton Gospel Books' by J.J.G. Alexander (Roxburghe Club, 1977).

Wormald, F., P.M. Giles, *A Descriptive Catalogue of the Additional Illuminated Manuscripts in the Fitzwilliam Museum*, 2 vols (Cambridge, 1982).

Wright, D.H., Kommentarband to *Vergilius Vaticanus (Vaticanus Latinus 3225)* (Codices Selecti, LXXI) (Graz, 1984).

Zacher, I., *Die Livius-Illustration in der Pariser Buchmalerei (1370–1420)*, unpubl. diss (Free University of Berlin, 1971).

Zimelien. Abendländische Handschriften des Mittelalters aus den Sammlungen der Stiftung Preussischer Kulturbesitz Berlin (1975–6).

Index of Manuscripts Cited

Note: Where a reference to a footnote is given, a manuscript is only mentioned in the footnote and not in the main text

Aberdeen, University Library, Ms. 24 45, 105, 162n.94, 185, figs 172, 174
Alba Julia, Romania. Batthyaneum Library. *Codex aureus* 79, fig. 124
Alnwick Castle, Northumberland. Library of the Duke of Northumberland, Sherborne Missal 156n.140
Amiens, Bibliothèque municipale,
 Ms. 18 90, fig. 147
 Ms. 23 65, 184, fig. 99
Amsterdam, Biblioteca Hermetica, BPH 1 172n.66
Angers, Bibliothèque municipale, Ms. 24 6
Arundel Castle, Sussex. Library of the Duke of Norfolk, Lydgate 145
Assisi, Museo del Sacro Convento, Missal 184
Autun, Bibliothèque municipale,
 Ms. 108A 163n.6
 Ms. 114A 163n.6
Avranches, Bibliothèque municipale, Ms. 159 160n.49

Baltimore, The Walters Art Gallery,
 W. 1 82, fig. 129
 W. 26 18, 20, fig. 31
 W. 61 184
 W. 108 184
 W. 131 185
 W. 135 185
 W. 140 185
 W. 141 165n.41
 W. 144 185
 W. 148 56–7, figs 79–80
 W. 200 175n.34
 W. 239 174n.30
 W. 770 186
Bamberg, Staatsbibliothek, Msc. Patr. 5 12, 20, 36, fig. 15
Basel, Öffentliche Bibliothek der Universität,
 Ms. 16 Nr. M. 175n.37
Bergamo, Biblioteca Civica, cod. VII.14 141, 145, 174n.33
Berlin, Staatliche Museen der Stiftung Preussischer Kulturbesitz, Kupferstichkabinett,
 Ms. 78 A.8 162n.87
 Ms. 78 A.22 126
 Inv. 14721 165n.41
Berlin, Staatsbibliothek Preussischer Kulturbesitz,
 A.74 130, fig. 220
 Cod. lat. fol. 384 175n.37
 Cod. lat. fol. 416 4
 Cod. theol. lat. fol. 485 4, fig. 1
 Cod. theol. lat. fol. 733 82, fig. 128
Bern, Burgerbibliothek,
 Cod. 264 84, 159n.35
 Cod. 318 105

Blackburn, Museum and Art Gallery, Lancashire,
 Hart 20865 129, fig. 218
 Hart 29060 172n.72
Bloomington, Indiana, Lilly Library, Ms. Ricketts 240 175n.34
Bologna, Biblioteca Universitaria, Ms. 1465 36, fig. 54
Bonn, Universitätsbibliothek, Cod. 384 29, fig. 44
Boston, Museum of Fine Arts, Leaves illuminated by Jacobus Muriolus 156n.142
Boulder, Colorado. University of Colorado, Bijoux Ms. 284–5 184
Boulogne-sur-mer, Bibliothèque municipale,
 Ms. 9 90, fig. 153
 Ms. 20 10
Bremen, Staats- und Universitätsbibliothek,
 Cod. b. 21 12, fig. 16
Brussels, Bibliothèque royale Albert Ie,
 8340 162n.94
 9018–9 50, 155n.125
 9020–23 50, 155n.125
 9242 165n.41
 9961–62 121
 11035–7 158n.12
 II. 845 175n.34
 IV. 111 54

Calci, Certosa, Cod. 1 36
Cambridge, England, Christ's College, Ms. 1 169n.52
Cambridge, England, Corpus Christi College,
 Ms. 2 35
 Ms. 4 18, 20, 95, fig. 26
 Ms. 16 109, 111, 158n.12, figs 180, 183, 185–6
 Ms. 26 109, 111, fig. 179
 Ms. 48 95, fig. 48
 Ms. 407 156n.139
Cambridge, England, Fitzwilliam Museum,
 McClean Ms. 123 68, fig. 110
 Ms. 330, leaf 3 25, fig. 38
 Ms. 379 162n.94
 Ms. 3-1954 158n.12
 Ms. 83. 1972 94, 126, fig. 154
 Ms. 86. 1972 131, 135, fig. 226
 Ms. 27-1991 174n.30
Cambridge, England, Magdalene College, Pepys Ms. 1916 177n.97
Cambridge, England, St John's College,
 Ms. 81 (D.6) 162n.87
 Ms. 183 (G.15) 95, fig. 156
 Ms. 262 (K.21) 60, fig. 90
Cambridge, England, Trinity College,
 Ms. B. 16.3 167n.13
 Ms. R. 16.2 107, fig. 176
 Ms. R. 17.1 101, 167n.14, fig. 166
Cambridge, England, Trinity Hall, Ms. 1 135
Cambridge, England, University Library,

Ms. Ee. 4. 24 54, 163–4nn.15–16, fig. 75
Ms. Ll. 1.10 77
Cambridge, Massachusetts, Harvard University, Houghton Library,
 Ms. Typ. 101 51, 168n.50, fig. 73
Chantilly, Musée Condé,
 Ms. 1695 169n.59
 Très Riches Heures of Jean de Berry 47, 139–43, figs 235, 240
Chicago, Illinois, Art Institute,
 no. 2.142B 156n.142
Chicago, Illinois, Newberry Library, Wing Ms. 7 175n.37
Cleveland, Ohio, Museum, Hours of Charles le Noble 174n.19
Cologne, Dombibliothek, Cod. 82 II 45
Cologne, Erzbischöfliche Diözesanbibliothek, Hs. 1b 156n.138
Cologne, Historisches Archiv der Stadt Köln, Handschriften Abteilung,
 Ms. W. 312 39
Copenhagen, Arnamagnean Institute, Ms. AM. 673a, 4° 175n.33
Copenhagen, Kongelige Bibliotek, Ms. 4. 2° 20, 36, 40, figs 30–32

Darmstadt, Hessische Landes- und Hochschulbibliothek,
 Cod. 746 7, fig. 7
 Cod. 1948 77, fig. 125
 Cod. 2505 177n.87
Douai, Bibliothèque municipale, Ms. 340 16, 168n.39, fig. 23
Dublin, Trinity College Library,
 Ms. 177 (E.I.40) 35, 107, 111, figs 177, 182
Durham, The Dean and Chapter Library,
 Ms. A.II.1 45, fig. 65
 Ms. A.II.17 36, 158n.15
 Ms. B.II.13 10, 89, 90, fig. 14

Edinburgh, University Library,
 Ms. 19 64, 185, fig. 96
 Ms. 44 163n.13
Erfurt, Wissenschafliche Allgemeinbibliothek,
 Ampl. 2° 19 184
 Ampl. 2° 31–2 184
Escorial, Real Biblioteca, Cod. Vitr. 17 161n.72
Evreux, Bibliothèque municipale, Ms. 4 97, fig. 159

Florence, Biblioteca Medicea-Laurenziana,
 Amiatinus 1 5, 72–3, fig. 118
 plut. 1,56 5
 plut. 53,2 178n.112
 plut. 56,1 6
Florence, Biblioteca Riccardiana, Ms. 2526 30, fig. 47
Florence, Uffizi, Gabinetto delle Stampe,
 Pattern book 145, 175n.33
Frankfurt a.M., Stadt- und Universitätsbibliothek, Ms. Barth. 42 18,
 fig. 29
Freiburg i. Br., Augustinermuseum,
 Inv. Nr. G 23/1a 98, fig. 160

Geneva, Bibliotheca Bodmeriana, Cod. 127 16, 40, fig. 25
Geneva, Bibliothèque publique et universitaire,
 Fr. 54 57–8, figs 82–3
Genoa, Biblioteca Civica Berio, Cf. 3.2 34, fig. 52
Genoa, Biblioteca Durazzo Giustiniani,
 Ms. 22 (A.III.3) 149, fig. 245
Girona Cathedral, Apocalypse 9
Glasgow, University Library and Hunterian Museum,
 SM 1161 175n.34
Göttingen, Niedersächsische Staats. und Landesbibliothek,
 Cod. Uffenbach 51 126

Hague, Koninklijke Bibliotheek,
 Ms. 76 D.45, IVA 175n.37
 Ms. 135 K.45 174n.30
Hague, Rijksmuseum Meermanno-Westreenianum, Ms. B.10.23 50
Hamburg, Kunsthalle, Ms. Fr.1 54
Hannover, Niedersächsische Landesbibliothek, Ms. I.189 84
Heiligenkreuz, Stiftsbibliothek, Cod. 226 100, fig. 163

Kassel, Landes- und Murhardsche Bibliothek,
 Ms. Astron. F.2 85, fig. 133

Leiden, Bibliotheek der Rijkuniversiteit,
 Voss. Lat. Oct. 15 87, fig. 136
 Voss. Lat. Q.79 167n.18
Leningrad *see* St Petersburg
León, Colegiata de San Isidoro,
 Cod. I.3 35
 Cod. 2 9
Lisbon, Arquivo Nacional da Torre do Tombo 53, 181–2
Liverpool, The National Museums and Galleries on Merseyside
 (Walker Art Gallery)
 Mayer 12009 125, fig. 213
 Mayer 12023 125, fig. 210
 Mayer 12038 65–6, 184, figs 102–3
London, British Library,
 Add. 5208 162n.78
 Add. 10043 162n.86
 Add. 10292–4 114, fig. 196
 Add. 11283 162n.94
 Add. 11612 143, fig. 243
 Add. 11695 9
 Add. 12531 34
 Add. 15248 165n.41
 Add. 16997 141, fig. 238
 Add. 17524 49, fig. 70
 Add. 18297 91, fig. 152
 Add. 19417 130, fig. 222
 Add. 28162 115
 Add. 31845 175n.34
 Add. 35254/R 130, fig. 223
 Add. 38119 162n.94
 Add. 38122 65, 186, fig. 98
 Add. 39943 35–6, fig. 53
 Add. 40618 168n.34
 Add. 47682 54, fig. 77
 Add. 49999 25, fig. 37
 Add. 54180 115, 117–18, figs 199, 202
 Cotton Claudius B. IV 41–2, 144, fig. 64
 Cotton Nero C.IV 95
 Cotton Nero D.I 29, 109, figs 43, 184
 Cotton Nero D.IV 6, 72–3, 77, fig. 119
 Cotton Nero D.VII 32, fig. 48
 Cotton Nero E.II 69, 186, figs 112–13
 Cotton Otho B.VI 121
 Cotton Titus D.XVI 101
 Cotton Titus D.XXVII 10
 Cotton Vespasian A.I 177n.95
 Harley 603 73, 76, 101, 144, fig. 121
 Harley 616 185
 Harley 1527 62, fig. 91
 Harley 2790 6, fig. 6
 Harley 2798 39, fig. 58
 Harley 3011 16, fig. 22
 Harley 3487 68, 185, figs 108–9
 Harley 3601 169n.61
 Harley 3885 175n.37
 Harley 4431 49
 Harley 6563 162n.94
 Harley 7026 30, fig. 45
 Lansdowne 420 162n.87
 Royal 2 A.XIV 162n.78
 Royal 2 A.XVIII 158n.12
 Royal 6 E.VI 40, fig. 59
 Royal 14 C.VII 25, 109, 172n.62, fig. 36
 Royal 14 E.III 114, fig. 195
 Royal 15 D.III 186
 Royal 18 D.VIII 185
 Royal 19 D.I 60, 68, 185, figs 87, 111
 Royal 19 D.II 161n.57, 165n.41
 Royal 19 D.III 186
 Royal 19 D.VI 166n.51
 Royal 20 B.IV 66, 68–9, 186, figs 106–7, 114
 Royal 20 D.I 50, 135, fig. 231
 Sloane 1448A 175n.34
 Yates Thompson 47 144

London, Public Record Office,
 Great Cowcher Book of the Duchy of Lancaster 158n.17
London, St Paul's Cathedral, Ms. 5 162n.78
London, University College London, Ms. 509 174n.30
London, University of London Library, Ms. 1 122, fig. 209
London, Victoria and Albert Museum, Library,
 L.475-1918 156n.147
 L.101-1947 138, fig. 233
 Reid Ms. 51 (AL 1682–1902) 49
 Department of Prints and Drawings,
 8122 163n.6
 P159-1910 (4677) 32, 34, fig. 51
London, Wallace Collection, M. 348 142, fig. 241
London, Westminster Abbey, Litlyngton Missal 36
Lyon, Bibliothèque municipale, Ms. 517 163n.6

Madrid, Archivio historico nacional, Ms. 1097B 9
Madrid, Biblioteca nacional, Ms. 611 138, fig. 234
Madrid, Real Academia de la Historia, Ms. 8 161n.57
Maeseyck, St Catherine, Trésor, Gospels 77
Malibu, California, J. Paul Getty Museum,
 Ms. Ludwig V.1 12
 Ms. Ludwig VI.1 30
 Ms. Ludwig IX.19 34
 Ms. Ludwig XIV.2 101, fig. 165
 Ms. Ludwig XV.3 171n.24
 Ms. Ludwig XV.4 45, 171n.24, fig. 66
 Ludwig Folia 1 85, fig. 132
Manchester, John Rylands University Library,
 Latin 8 162n.94
 Latin 14 129, fig. 217
 Latin 19 135, fig. 227
 Latin 22 54, 163–4nn.15–16
 English 1 177n.105
 French 1 112–15, figs 188–90, 192–4
Milan, Biblioteca Ambrosiana,
 Ms. A. 79 inf. (Sp. 10/27) 122
 Ms. E.24 inf. 30, fig. 46
Modena, Biblioteca Estense, VG. 12 53, 127, 140
Munich, Bayerische Staatsbibliothek,
 Cgm 254 163n.94
 Clm 146 142, fig. 239
 Clm 9511 153n.78
 Clm 10261 47
 Clm 10291 176n.52
 Clm 13031 167n.2
 Clm 14000 7, 49
 Clm 23639 176n.51
 Cod icon. 420 126
 2° L. impr. membr.64 122

New Haven, Connecticut, Yale University, Beinecke Rare Book and
 Manuscript Library,
 Ms. 227 185
 Ms. 425 49
 Ms. 439 175n.37
New York, Pierpont Morgan Library,
 M.81 171n.37
 M.87 178n.116
 M.90 158n.12
 M.111 64, 184, fig. 95
 M.240 54, fig. 76
 M.333 10, fig. 333
 M.346 124, fig. 207
 M.358 49, 126, fig. 69
 M.429 9, fig. 9
 M.524 105, 107, 135, fig. 169
 M.641 89
 M.644 9
 M.672 165n.41
 M.710 158n.15
 M.736 84, 162n.94
 M.791 35
 M.1044 138

 Glazier 37 23, fig. 34
New York, Metropolitan Museum of Art, Lehmann Collection,
 M. 191 32, 34
New York, The Cloisters Museum,
 Belles Heures of Jean de Berry 142, fig. 242
 Hours of Jeanne d'Evreux 122
New York, Public Library,
 Ms. 115 167n.23
 Spencer Ms. 26 158n.12
Nuremberg, Stadtbibliothek, Cent. V. 59 185

Oxford, England, Balliol College,
 Ms. 2 66, 155n.16, 162n.85, 185, fig. 104
Oxford, England, Bodleian Library,
 Ms. Ashmole 1504 175n.33
 Ms. Ashmole 1511 105, 162n.94, figs 173, 175
 Ms. Ashmole 1525 109, fig. 181
 Ms. Auct. D. 1.17 185
 Ms. Auct. D. 2.1 105, fig. 170
 Ms. Auct. D. 2.16 77, figs 123, 126
 Ms. Auct. D. 2.19 6
 Ms. Auct. D. 4.17 105, 107, 135, fig. 168
 Ms. Auct. E. inf. 1–2 92, 170n.2, fig. 150
 Ms. Auct. F. 2.13 109, fig. 178
 Ms. Auct. F. 4.32 9, 26, 76, 109, fig. 10
 Ms. Bodley 147 168n.30
 Ms. Bodley 188 100, fig. 164
 Ms. Bodley 717 10, fig. 13
 Ms. Canon. Ital. 196 175n.37
 Ms. Canon. Misc. 378 130–31, 135, figs 224–5
 Ms. Douce 180 41–2, 107, figs 62–3
 Ms. Douce 185 165n.33
 Ms. Douce 192 101
 Ms. Douce 215 172n.67
 Ms. Douce 219–220 149, fig. 247
 Ms. Douce f. 2 175n.34
 Ms. D'Orville 141 165n.36
 Ms. Lyell 71 171n.23
 Ms. Lat. th. e. 40 184
 Ms. Laud Misc. 409 158n.17
 Ms. Laud Misc. 752 95, fig. 157
 Ms. Rawl. C. 781 162n.78
 Ms. Rawl. D. 403 162n.78
Oxford, England, Exeter College, Ms. 42 185
Oxford, England, Lincoln College, Lat. 26 49, 161n.75
Oxford, England, Magdalen College,
 lat. 100 158n.12
 lat. 175 185
Oxford, England, Merton College,
 Ms. 269 (F.1.4) 166n.71, 185
 Ms. 271 (O.1.3) 185
Oxford, England, New College,
 Ms. 7 59, 185, fig. 85
 Ms. 20 65, 185, figs 100–101
 Ms. 322 158n.12
Oxford, England, Oriel College, Ms. 46 185
Oxford, England, St John's College,
 Ms. 111 39, fig. 56
 Ms. 167 162n.78
Oxford, England, Trinity College, Ms. 58 105, fig. 171
Oxford, England, University College,
 Ms. 165 85, 87, 89, 111–12, figs 131, 137–40
Oxford, England, Wadham College, Ms. 2 38–9, fig. 55

Padua, Biblioteca Capitulare,
 Isidore Gospels 18, fig. 27
 A.15 121, fig. 205
Paris, Bibliothèque de l'Arsenal,
 Ms. 588 162n.94, 185
 Ms. 664 176n.66, 186
 Ms. 940 122
 Ms. 2677 185
 Ms. 3482 186n.1
 Ms. 5056 184–5

Ms. 5059 185
Ms. 5077 186
Ms. 5193 186
Ms. 5201 185
Ms. 5203 185
Ms. 5212 54
Ms. 5220 184
Ms. 6329 117, fig. 200
Paris, Bibliothèque Mazarine,
Ms. 15 184
Ms. 473 163n.13
Ms. 870 115
Ms. 1002 170n.8
Ms. 3485 185
Paris, Bibliothèque nationale,
fr. 91 63, fig. 92
fr. 145 36–8
fr. 166 163n.7, 164n.18
fr. 167 49
fr. 182 186
fr. 301 135, fig. 230
fr. 308–10 165n.41
fr. 598 138
fr. 616 138
fr. 619 138
fr. 802 185
fr. 823 62
fr. 829 59, fig. 84
fr. 938 115, 117, fig. 198
fr. 958 117–18, fig. 197
fr. 2813 161n.57, 185
fr. 9342 158n.12
fr. 12201 138
fr. 12400 135, fig. 229
fr. 12420 138
fr. 12465 54
fr. 12562 60, fig. 88
fr. 13091 139
fr. 14939 117–18, fig. 201
fr. 19093 65, 112, fig. 187
fr. 22542 54
fr. 25526 120, fig. 204
fr. 25532 165n.48
n. acq. fr. 24920 47, 63, fig. 68
latin 1 6, 7, 50, fig. 8
latin 6 66n.51
latin 108 64, 184, fig. 97
latin 323 159n.35
latin 919 139
latin 946 90, fig. 146
latin 968 26–7, 69, 70, 185, figs 39, 40, 115–17
latin 1023 118, fig. 203
latin 1087 85, fig. 135
latin 1160 163n.13
latin 1169 155n.106
latin 1152 7
latin 3893 154n.102
latin 4884 164n.28
latin 4915 32, 40, fig. 49
latin 5762 165n.36
latin 5931 173n.9
latin 6069G 162n.94
latin 7907A 138
latin 8055 90, fig. 148
latin 8193 138
latin 8318 85, fig. 134
latin 8504 60, 158n.12, 165n.41, fig. 89
latin 8685 175n.37
latin 8824 172n.57
latin 8846 101, 162n.69, 167n.14, fig. 167
latin 9684 165n.36
latin 10157 135, fig. 232
latin 10435 164n.15
latin 10483–4 27, 53–4, fig. 74

latin 10532 149, 158n.12, fig. 246
latin 10834 165n.42
latin 11282 159n.31
latin 11538 184
latin 11545 63, 184, fig. 93
latin 11575 12, 34, fig. 17
latin 11751 51, 169n.62, fig. 72
latin 11907 57, 168n.50, fig. 81
latin 11930–1 23
latin 11935 27, fig. 41
latin 12048 6, fig. 5
latin 12054 91, fig. 151
latin 12190 5, fig. 2

latin 12610 51, fig. 71
latin 12953 185
latin 13392 90, fig. 149
latin 14643 54–5, fig. 78
latin 14782 77, 82, fig. 127
latin 15176 158n.12
latin 15211 185
latin 15472 185
latin 16082 184
latin 17907 66, 184, fig. 105
latin 18014 165n.41, 185
n. acq. lat. 1297 157n.9
n. acq. lat. 1390 12, 85
n. acq. lat. 2334 162n.89
n. acq. lat. 3189 26
Paris, Bibliothèque Ste Geneviève,
Ms. 1273 161n.74
Ms. 1624 45, 47, 54, fig. 67
Paris, Ecole des Beaux-Arts, Ms. Masson 98 126, fig. 214
Paris, Musée du Louvre,
Codex Vallardi 175n.33
Alphabet of Mary of Burgundy 175n.34
Inv. 1222 141, fig. 237
Perugia, Collegio del Cambio, Ms. 1 16
Philadelphia, Free Library,
Ms. Lewis 22 170n.80
Ms. Lewis 185 164n.15
Prague, Metropolitan Library, A XXI/1 15, 47, fig. 19
Princeton, New Jersey, Princeton University Library,
Ms. 83/1 154n.102

Reims, Bibliothèque municipale,
Ms. 40 23, fig. 35
Ms. 824 185
Rome, Gabinetto nazionale delle Stampe, Inv. 3727–56 175n.33
Rome, San Paolo fuori le Mure, Bible 35
Rouen, Bibliothèque municipale, Ms. 1044 165n.41

St Gall, Stiftsbibliothek, Cod. 53 7
St Petersburg, M.E. Saltykov-Shchedrin State and Public Library,
Ms. lat. Q.v.III.1 163n.97
Ms. lat. Q.v.V.1 171n.37
Ms. lat. Q.v.XIV.1 168n.52
San Marino, California, Huntington Library,
Ms. 26 C 9 50
HM 268 59, 186
HM 1073 185
HM 3027 63, 185, fig. 94
Siena, Biblioteca Comunale, Ms. X.V.3 129
Solothurn, St Ursen Kathedrale,
Hornbach Sacramentary 89, figs 142–5
Stockholm, Kungliga Biblioteket,
A.144 15, 34, 120, fig. 18
B. 1578 156n.142
Stonyhurst College, Lancashire, Ms. 33 130, fig. 221
Strasbourg, Bibliothèque du Grand Séminaire,
Cod. 37 18, fig. 28
Stuttgart, Württembergische Landesbibliothek,
Cod. hist. fol. 420 15, fig. 20
Cod. mus. I fol. 65 32, fig. 50

Toledo Cathedral,
 Bible moralisée 54
 Ms. 56.18 185
Tours, Bibliothèque municipale, Ms. 558 23
Trento, Biblioteca Comunale, Ms. 3568 153n.78
Trier, Stadtbibliothek, Cod. 261/1140 2° 16, fig. 21
Troyes, Bibliothèque municipale, Ms. 2273 89

Upholland College, Lancashire (formerly), see below under *Untraced*
 (Christie's)
Upperville, Virginia, Paul Mellon Collection,
 Pattern book 175n.33
Utrecht, Bibliotheek der Rijksuniversiteit,
 Ms. 32 (Script. eccl. 484) 73, 76, figs 120, 122

Valenciennes, Bibliothèque municipale,
 Ms. 99 121
 Ms. 500 84, 158n.12
 Ms. 502 84, 89, fig. 141
Vatican, Biblioteca Apostolica Vaticana
 Archivio San Pietro C. 128 138
 Barberini lat. 570 77, 82
 Pal. lat. 50 77
 Pal. lat. 1071 135, fig. 228
 Reg. lat. 12 10, fig. 12
 Reg. lat. 26 185
 Reg. lat. 124 83, fig. 130
 Reg. lat. 596 85, 161n.58
 Rossiana 181 16, fig. 24
 Rossiana 259 27, fig. 42
 Urb. lat. 376 185
 Vat. gr. 1626 138, 178n.111
 Vat. lat. 1202 85, 89
 Vat. lat. 1976 98
 Vat. lat. 3225 50, 121
 Vat. lat. 3256 4
 Vat. lat. 3868 6, 77, fig. 4
 Vat. lat. 6852 175n.34
Venice, Museo Correr, VI. 665 185
Vercelli, Biblioteca Capitolare,
 Vercelli Roll 57, 165n.34, 168n.50
 Cod. 148 168n.38

Vienna, Kunsthistorisches Museum, Inv. no. 5003–4 124
Vienna, Oesterreichische Nationalbibliothek,
 Cod. Med. Gr. 1 6, fig. 3
 Cod. Th. Gr. 31 160n.50
 Cod. 507 99, 174n.33, fig. 162
 Cod. 1226 153n.60
 Cod. 1861 152n.37
 Cod. 2424 184
 Cod. 2597 145, 148, fig. 244
 Cod. 2617 148
 Cod. 2771 59, fig. 86
 Cod. 2828 40, 50, figs 60–61
 Cod. 4943 126, figs 215–16

Washington, D.C., Library of Congress, Lessing J. Rosenwald
 Collection, Gradual leaf 156n.142
Winchester Cathedral, Bible 39, 40, 47, 95, fig. 57
Wolfenbüttel, Herzog August Bibliothek,
 Cod. Guelf. 74.3 Aug. 2° 153n.78
 Cod. Guelf. 61.2 Aug. 8° 98, fig. 161

UNTRACED AND SALES

Christie's, 2 December 1987, lot 35 (formerly Upholland College,
 Lancs., Ms. 105) 129, fig. 219
Christie's, 2 December 1987, lot 36 (formerly Upholland College,
 Lancs., Ms. 106) 125, fig. 212
Private Collection, Germany 64–5, 185
Sotheby's, 7 December 1953, lot 42 174n.30
Sotheby's, 24 June 1969, lot 71 (Chester Beatty Collection, Western
 Ms. 85) 178n.114
Sotheby's, 20 June 1978, lot 2979 (Major J.R. Abbey) 184
Sotheby's, 5 December 1978, lot 15 156n.142
Sotheby's, 11 December 1979, lot 62 178n.114
Sotheby's, 22 June 1982, lot 12 156n.142
Sotheby's, 21 June 1982, lot 15 174n.30
Sotheby's, 25 April 1983, lot 99 49
Sotheby's, 23 June 1987, lot 121 174n.30
Sotheby's, 20 June 1989, lot 67 174n.30
Sotheby's, 29 November 1990, lot 126 162n.77
Sotheby's, 18 June 1991, lot 33 174n.30

Subject Index

Alphabet pattern books 94, 126, figs 154, 214–16
Antiquarian copies 77, 130–31, 135, 138
Apprentices 27, 127
Artists' treatises 39
Atelier *see* Workshop

Binders 23, 38
Bone trial pieces 92
Byzantine art 97–8

Cartolai 52
Champs ('champide', 'champs') 53
Codex 35
Collaboration of illuminators 47, 49, 50, 127, 139
Colour directions 41, 45–6, 105, 163n.94, figs 65–7
Colours 39, 40
Contracts 52–5
Copies 72–3, 76–7, 82, 100–101, 105–7, 109, 121–2, 125–6,
 130–31, 135, 138

Drawings 38–41, 47, 56–7, 62, 73, 109, figs 10, 15, 43, 55–8,
 60–63, 67–9, 71–2, 80–81, 92–4, 96–9, 101, 103–5, 109–14,
 120–22, 132–6, 151–2, 154, 159, 160–64, 168–9, 177–80, 182–7,
 207, 215–16, 220, 237, 239
Drawings, preliminary marginal 56–7, 63–71, 76, figs 93–4, 96–8,
 101, 103–5, 107, 109, 113–14, 122

English Royal Chancery 36
Engravings 49, 125
Exemplaria 22

Flourished penwork ('fleuronée') 49

Gold 7, 42, 45, 53
Graphite 38–9, 76
Grisaille 39
Guilds and Confraternities 30–31, 126–7

'Histoire' 59

'Illuminator' 10, 155n.108
Initials, re-use of 49
Ink seller 23
Instructions to illuminators:
 Verbal 4, 53–63, 69, 71, 112–18, 161n.57, 162n.85, 178n.116,
 figs 1, 65–7, 85–6, 88, 91–2, 115–17
 Visual *see* Drawings, preliminary marginal
 See also Colour directions

Journeymen 127

Lapis lazuli 40

'Letters d'attent' 47
'Librarius' ('libraires') 6, 22–3, 52, 113, 115
'Limners' 31

Maquette 56–7
Marginal scenes 118–19
Minium 40
Models (*see also* Copies) 53
'Moduli' 87, 114

'Notours' 31
Numbered miniatures 59, 161n.57, figs 84, 89

Palette 23, fig. 35
Paper 35
Papyrus 35
Parchment 35
Parchment pasted in 35–6
Parchmenter 20, 23, 36, fig. 30
Paris tax rolls 4, 22–3
Pattern books (*see also* Alphabet pattern books) 5, 57, 76, 85, 94, 98,
 109, 111–12, 121, 124, 126, 130, 141, 145, figs 2, 132–5, 160–62,
 179, 187, 207
Payment of illuminators *see* Prices
'Pecia' 22
Pen trials (*probationes pennae*) 76
Pencil 38
'Penellum' 38
'Pictor' 9, 10, 15–16
Pigments 39–40
'Plummet' 38
Pouncing 50
Preliminary marginal drawings *see* Drawings
Preliminary marginal written instructions *see* Instructions
Prices 23, 26–7, 32, 36, 165n.48
Pricking for transfer (*see also* Tracing) 50, figs 71, 73
Production and/or pricing marks 26
Programmes for illumination *see* Instructions, Verbal

Repainting of miniatures 49
Restoration of manuscripts 49
Roll 35
Rule of St Benedict 4, 72, 89
Ruling 40

Scriptorium 9, 12, figs 9, 16
Silk, as protection for miniatures 164n.18
Single leaves 30, 36, 125–6
Stages of execution 40–42, 47, figs 60–64, 68–9
Stamps, of artists 126
Stylus 38

Tools 38
Tracing 50–51, 126–7
'Turnours' 31
'Twin' manuscripts 105, 138

Unfinished miniatures 38–41, 47, figs 57, 60–64, 68

Vellum 35

Wax tablets 35
Woodcuts 49, 125
Workshop 127, 129
Writing masters 23, 126

Index of Names

Adalbert, Abbot of Hornbach 89, fig. 143
Adomnán of Iona 35
Aelheah, Archbishop of Canterbury 73
Aethelnoth, Archbishop of Canterbury 73
Aidan, St 72
Albrecht, Cardinal of Brandenburg 34
Amadeus, Duke of Savoy 131
Amiens 36
Angers, Benedictine Abbey of St Aubin 12
Antoninus, St, Archbishop of Florence 156n.151
Arculf 35
Arnhem 49
Arnstein, Premonstratensian Abbey 39
Artists (see also Illuminators):
 Cennino Cennini 38, 47
 Duccio di Buoninsegna 122
 Fulk 12
 Giotto di Bondone 121
 Hugo van der Goes 31, 123
 Jacques Plastel 38
 Justus van Ghent 31, 123
 Lucas Horenbout 124
 Martin Schongauer 125
 Master of the Playing Cards 125
 Taddeo Gaddi 141
 Suzanne Horenbout 124
 Villard d'Honnecourt 65, 112, 114
Aulne, Cistercian Abbey 100
Aumale, Duc d' 139
Avignon 26, 52–3, 69, 122, 180–81, 183

Bamberg, Benedictine Abbey of St Michael 12, 20, 36, fig. 15
Barnwell, Augustinian Priory 89
Benedict XIII, Antipope 26, 69
Benedict, St, of Nursia 4, 5, 92
Benedict Biscop, Abbot of Wearmouth/Jarrow 121
Bernard, St, of Clairvaux 99
Bertoldus, Dean of Hamburg Cathedral 20
Blanche, Queen of France 54
Bologna University 23, 26, 101
Borso d'Este, Duke of Ferrara 53, 127, 140
Brittany 77, 82
Brno 40
Bruges, Confraternity of St John 31
 Painters' Guild 30–31, 126
Bury St Edmunds, Benedictine Abbey 10, 12, 35

Canterbury, Benedictine Cathedral Priory of Christ Church 18, 41, 73
Canterbury, Benedictine Abbey of St Augustine 60, 73, 135
Cassiodorus 5, 72
Ceolfrid, Abbot of Wearmouth/Jarrow 72
Champmol, Dijon, Charterhouse 154n.85

Charlemagne, Emperor 77
Charles the Bald, Emperor 6, 49, 82, fig. 8
Charles V, King of France 22, 50, 54, 143, 150n.5, fig. 243
Charles VI, King of France 23
Charles VIII, King of France 154n.92
Chimenti di Cipriano di Sernigi, merchant of Florence 53, 181
Christian, Archbishop of Mainz 90, fig. 146
Christine de Pisan 49
Cistercian Order 99–100
 Statutes 47
Cîteaux, Cistercian Abbey 99
Clairvaux, Cistercian Abbey 100
Claricia 20, fig. 31
Cluny, Benedictine Abbey 95
Cnut, King of England 12
Cologne 39
Constance, Council of 130
Corbie, Benedictine Abbey 4, 12, 65, 90
Corvey, Benedictine Abbey 6

Dante Alighieri 4, 22
Dijon 52–3, 179–80
Donato, Pietro, Bishop of Padua 130–31, 138, 149
Dover, Benedictine Priory 18, 20, 95
Dunstan, St, Abbot of Glastonbury, Archbishop of Canterbury (see also Illuminators) 76
Durham, Benedictine Cathedral Priory 11, 35, 85, 87, 89
Duvart, Jean, physician 163n.7

Echternach, Benedictine Abbey 12, fig. 16
Edward III, King of England 27
Edward of Woodstock, the Black Prince 122
Ekkehard, monk of St Gall 7
Ely, Benedictine Cathedral Priory 36
Emma, Queen of England 12
Engelbert of Nassau 149
Estienne de Chaumont, Master of the University of Paris 54
Etienne Marcel 143
Etienne Boileau, Prévôt of Paris 30
Eusebius, Bishop of Caesarea 4
Evesham, Benedictine Abbey 9
Exeter Cathedral 77, 82

Felix V, Antipope 131
Fernando, Infante of Portugal 34
Fleury, Benedictine Abbey 12
Florence 53, 181–2
 Confraternity of St Luke 30
 Guild of Medici e Speciali 30
Florence, Santa Croce, Baroncelli Chapel 141
Florence, Santa Maria Novella 50
Forbor, John 179

Frederick II, Emperor 135
Fulda, Benedictine Abbey 9, 83–4

Gaudiosus, 'librarius' 6
Gellone, Benedictine Abbey 6
Geoffroy de St-Léger, *librarius* 154n.97
Gerald of Wales 35
Gero, Archbishop of Cologne 77
Girona Cathedral 9
Gerson, Jean, Chancellor of the University of Paris 54, 143
Ghent, Painters' Guild 31
Godelgaudus, monk of Saint-Rémy, Reims 9
Gregory IV, Pope 83, fig. 130
Guillaume le Chamois, bourgeois of Dijon 180

Hamburg Cathedral 20
Heiligenkreuz, Cistercian Abbey 100
Henry II, King of England 95
Hrabanus Maurus, Abbot of Fulda and Archbishop of Mainz 83
Hugh, St, of Lincoln 95
Hugo de Folieto 100
Humphrey de Bohun, 7th Earl of Hereford 29

Illuminators:
 Adelricus 6, 77, fig. 4
 Adalpertus, monk of St Emmeram, Regensburg 49
 Adémar de Chabannes, monk of S Martial, Limoges 87
 Alan Strayler 33, fig. 48
 Albrecht Dürer 122, 125
 Alexander, Magister 23, 65, 184
 Alexander Bening 31, 122
 Amandus, monk of Saint Martin, Tours (Illuminator and/or
 Scribe ?) 6, 7
 André Beauneveu 139
 Andrea Mantegna 122, 149
 Aripo, monk of St Emmeram, Regensburg 49
 Attavante degli Attavanti 53, 124, 129, 181–2
 Bartolomeo Neroni of Siena, called il Riccio 34, fig. 52
 Chunibert, monk of St Gall 9
 Claes Brouwer 50
 Cornelie van Wulfschkercke 155n.106
 Cristoforo di Predis 122
 David 6, fig. 5
 Dunstan, St, Abbot of Glastonbury 9, 10, 26, 76, fig. 10
 Eadfrith, Bishop of Lindisfarne (also Scribe) 6, 9
 Emeterius 9, 12, fig. 9
 Ende, 'pinctrix' 9
 Engilbertus, 'pictor' and 'scriptor' 16, fig. 21
 Enguerrand Quarton 49
 Everwinus 15, 47, figs 18–19
 Ervenius, monk of Petersborough 4, 12
 Felix 12, 34, fig. 17
 Franciscus Bequati, apprentice 183
 Franco Bolognese 4
 Franco dei Russi 53, 127, 138
 Fructuosus, 'pictor' 9
 Galterus, 'illuminator' 155n.108
 Gautier Lebaube 23, fig. 34
 Gedeon 6, 7, fig. 6
 Gerard Horenbout 124
 Gerarduccius, priest of Padua (also Scribe) 121
 Gioacchino di Giovanni 'de Gigantibus' (also Scribe) 16
 Giovanni dei Grassi 141, 145
 Girolamo da Cremona 122, 125
 Giulio Clovio 124
 Guta, nun 18, figs 28, 29
 Guy-le-Flameng 38
 Haregarius, monk of Saint Martin, Tours (Illuminator and/or
 Scribe ?) 7
 Henri Feynaud 183
 Herman Scheerre 124, 159n.28
 Hervardus, monk of Mont St Michel (also Scribe) 90
 Hildebertus, 'pictor' 15, 34, figs 18–19
 Honoré, master 23

Hugo, master, of Bury St Edmunds 12, 35, 95
Hugo, O.F.M. 29
Hugo, 'pictor' (also Scribe) 10, 15, 82, fig. 13
Ingelrannus, monk of Corbie (also Scribe) 90
Isidorus 'doctor bonus' (also Scribe) 18, fig. 27
Jacobus Muriolus of Salerno, O.P. 30
Jacopo 26
Jacopo da Balsemo 53
Jacquemart d'Hesdin 29, 124, 130, 139–40
Jacques Daliwe 130
Jaquet Maci 27, fig. 42
Jean Bourdichon 158n.12, 178n.114
Jean Colombe 47, 63
Jean Demolin (also Scribe) 53, 180
Jean Fouquet 122, 157n.170
Jean Pinchon 38
Jean Pucelle 27, 53, 122, 124, fig. 41
Jean de Montmartre 27
Jean de Planis 53, 180–81
Jeanne, widow of Richard de Montbaston 23
Johannes de Valkenburg, O.P. 29, fig. 44
John of Holland 130
John Siferwas, O.P. 30, fig. 45
John Teye, O.P. 29
Lantbertus, priest in Reims (also Scribe) 9
Laurentius 27, fig. 42
Lieven van Lathem 32
Limburg Brothers, Paul, Jean, Hermann 29, 47, 122, 124,
 139–43
Lippo Vanni 122
Littifredo Corbizzi 129, fig. 217
Liuthardus, priest (also Scribe) 7, fig. 7
Lucas Cranach 122
Mannius, Abbot of Evesham (also Scribe) 9
Marco Zoppo 122
MacRegol, Abbot of Birr (also Scribe) 6, 9
Magius, 'archipictor' 9, 12
Margriete Sceppers 155n.106
Master of the Aix Annunciation 49
Master of the Bedford Hours 127, 130, 141
Master of the Boucicaut Hours 69, 127, 129–30, 139, 141
Master of the Egerton Hours 130
Master of the Harvard Hannibal 130
Master of Mary of Burgundy 149
Master of the Vatican Homer 138
Matthew Paris, monk of St Albans 4, 25, 29, 35, 107–12, fig. 36
Matteo di Ser Cambio of Perugia (also Scribe) 16
Michelino da Besozzo 122
Monte and Gherardo del Fora 122
Nevelo, monk of Corbie (also Scribe) 153n.67
Nicolaus Bertschi 32, fig. 50
Nivardus 12
Notker, monk of St Gall 7
Oderisi of Gubbio 4
Oliverus, 'pictor' 16, fig. 23
Otbert, Abbot of St Bertin 9, 10, fig. 11
Oveco 9
Pacino da Bonaguida 122
Peronet Lamy 131, 149
Petrus, Prior of Silos 9
Petrus de Pavia, frater 30, fig. 46
Petrus de Villola (also Scribe) 26
Pseudo-Jacquemart 140
Remiet 62
René of Anjou 148
Robert, master 27
Robert Benjamin, monk of Durham 10, 89, fig. 14
Rufillus, Canon of Weissenau 16, fig. 25
Sancius Gonter 26, 69, 71
Sigvaldus, monk of Saint Martin, Tours (Illuminator and/or
 Scribe ?) 7
Simon d'Orleans 135
Simon Bening of Bruges 32, 35, 124, fig. 51
Simon Marmion 32

Simon Master 95
Simone Martini 122
Sintram, Canon of Marbach 18, fig. 28
Stephan Schriber 126
Taddeo Crivelli 53, 127
Teodericus 16, fig. 22
Thomas Rolf 36
Tuotilo, monk of St Gall 9
Willem Vrelant 127
Wernherus, 'pictor' 15, 16, fig. 20
William de Brailes 25, figs 37–8
William the Englishman, O.F.M. 29, 109
Wulfstan, Bishop of Worcester 12
Zebo da Firenze 124
Isabeau de Bavière, Queen of France 49
Innocent III, Pope 22
Iona, Abbey of 72

Jacques Raponde (Rapondi) 138
Jean II, le Bon, King of France 27, 49
Jean, Duke of Berry 29, 127, 135, 138
Jean sans Peur, Duke of Burgundy 138
Jean II, Seigneur de Dampierre 135
Jean Jouvenel des Ursins, Chancellor of France 32
Jean Lebègue 57
Jean de Vaudetar 50
Jeanne, d'Evreux, Queen of France 122
Jehan Adam, Master of the University of Paris 54
Jerome, St 4
John, 5th Lord Lovell 30, fig. 45
Juliot, Philippe, merchant of Dijon 180
Jumièges, Benedictine Abbey 10

Landévennec, Benedictine Abbey 77, 82
Leobertus 97
Leofric, Bishop of Exeter 77, 82
León, S. Isidoro 35
Limoges, S Martial, Benedictine Abbey 87
Lindisfarne, Benedictine Priory 6, 72–3, 77
Litlington, Nicholas, Abbot of Westminster 36
London, Lymners' Guild 31
 Stationers Guild 31
Lorens, Friar 115, 118
Lorsch, Benedictine Abbey 77
Louis the Pious, Emperor 83
Louis IX, King of France 54
Louis XII, King of France 154n.92
Louise de Savoie 38
Luc 182–3
Ludovicus de Canea, Carmelite friar 183
Lyfing, Archbishop of Canterbury 73
Lyre, Benedictine Abbey 82, 97

Mainz 83, 90, 126
Manfred of Hohenstaufen 135
Marbach, Augustinian Priory 18
Marcanova, Giovanni 149
Marcello, Jacopo 122
Margaret of Provence, Queen of France 54
Marienthal, Cistercian Abbey 100
Marino Sanudo 105
Maximilian I, Emperor 122
Milan 36
Monreale, Benedictine Abbey 97–8
Mont St Michel, Benedictine Abbey 89, 90
Monte Cassino, Benedictine Abbey 85, 89

Naples, Kings of 32, 135, 151n.5
Nicholas de la Motte 38
Norwich, Benedictine Cathedral Priory 36

Oldcastle, Sir John 31
Orsini, Giordano, Cardinal 131
Osbern Fitz Osbern, Bishop of Exeter 82

Otto I, Emperor 77
Oxford University 23, 25

Padua 135
Padua Cathedral 18, 121
Palermo, Cappella Palatina 97
Paolino Veneto 105
Paris 22–3, 54
 Burgh of Ste Geneviève 23
 Painters' Confraternity of St Luke 30
 Scribes' Confraternity of St John 30
 University 22–3, 52, 101
Paris, St Germain-des-Prés, Benedictine Abbey 51
Paris, St Maur-des-Fossés, Benedictine Abbey 91, 169n.60
Perugia 16
 Arte degli Miniatori 30
Peterborough, Benedictine Abbey 121
Petrarca, Francesco 122
Philip III, King of France 115
Philip IV, le Bel, King of France 22–3, 118
Philip the Bold, Duke of Burgundy 29, 150n.5, 154n.85
Philip the Good, Duke of Burgundy 32, 151n.85
Philippa of Hainault, Queen of Edward III 27
Pierre Faveryn, binder 38
Pirckheimer, Willibald 122
Porphyrius, court poet of Emperor Constantine 83
Prüfening, Benedictine Abbey 167n.2
Puiset, Hugh, Bishop of Durham 45

Ramwold, Abbot of St Emmeram, Regensburg 49
Regensburg, Benedictine Abbey of St Emmeram 7, 49
Rein, Cistercian Abbey 99
Reinhard von Munderkingen, Abbot of Zwiefalten 15, fig. 20
René of Anjou, King of Naples 122, 145, 148
Reims 9, 73
Richard II, King of England 31
Richard de Montbaston, librarius 154n.97
Roger, monk of Helmarshausen 92
Roger II, King of Sicily 97
Rolin, Jean, Bishop of Autun 53, 180
Rome, Sts Cosmas and Damian 83
Rome, St Peter's 72
Rome, Santa Maria Maggiore 121

St Albans, Benedictine Abbey 35, 109
St Amand, Benedictine Abbey 84, 89
St Bertin, Benedictine Abbey 9, 10
St Denis, Benedictine Abbey 99
St Evroul, Benedictine Abbey 167n.2
St Gall, Benedictine Abbey 7
St Vaast, Benedictine Abbey 90
Salisbury Cathedral 30
Salomon III, Abbot of St Gall 7
Salomon, Duke of Brittany 77, 82
Schwarzenthann, Convent 18
Scribes (see also Illuminators for Scribe/Illuminators):
 Alanus 155n.106
 Alberto di Ugolino da Firenze 26
 Anno 77
 Bartolomeo Sanvito of Padua 138, 149
 Berengar, priest 7
 Carolus 20
 Dominique Cousserii 180–81
 Eburnant 89, fig. 142
 Ellinger, Abbot of Tegernsee 152n.39, 169n.68
 Felice Feliciano 149
 Fridericus, monk 90
 Furius Dionysius Filocalus 4
 Guntfridus, monk of St Vaast 90, fig. 153
 Guta, nun 18, figs 28, 29
 Heriveus, monk of St Bertin 10
 Hrodegarius, monk of Corvey 6
 Jacobus de Manso, priest 182–3
 Jean de Beguines, priest 38

Johannes, monk of Corbie 12
Guta, nun 18, fig. 28
Leonhard Wagner 32, fig. 50
Lorenzo di Stefano, notary 26
Osmund, Bishop of Salisbury 9
Rabula 5
Rainaldus, monk of Anchin 16, fig. 23
Raoulet d'Orleans 50, 54
Raulinus of Fremington 26
Richard Flint, priest 31
Robert, maistre 179
Robert Brekeling 179
Robert de Billyng 27, fig. 41
Senior 9, fig. 9
Thomas Preston 36
Thomas of Wymondswold 154n.102
William of Kirkeby 154n.102
Siena Cathedral 122
Sigbertus 97
Sigena, Nunnery 121
Silos, Benedictine Abbey 9, 95
Simon, Abbot of St Albans 95
Speyer Cathedral 130
Suger, Abbot of St Denis 99
Syon, Bridgettine Abbey 49

Talbot, Prior of Bury St Edmunds Abbey 35
Tavara, Benedictine Abbey 9
Theophilus 92
Thiébaut de Besançon, monk of Champmol 154n.85

Thomas de Maubeuge, *librarius* 154n.97
Tiro, freedman of Cicero 4
Tours, Benedictine Abbey of St Martin 6, 50
Trier, Benedictine Abbey of St Paulinus 135
Tubre (Taufers), Sankt Johann 153n.78

Utrecht 30, 126

Venice, San Marco 121
Vespasiano da Bisticci, *cartolaio* 145
Viliaric, Magister 6
Vivarium, Monastery 72

Wearmouth/Jarrow, Benedictine Abbey 5, 72, 121
Weissenau, Premonstratensian Abbey 16
Westminster, St Stephen's Chapel 122
Whitby, Benedictine Nunnery 72
William I, King of Sicily 97
William II, King of Sicily 97
William of Rubruck, O.F.M. 54
William of St Calais, Bishop of Durham 11, 90, fig. 14
Winchester, Benedictine Cathedral Priory 39, 40, 95
Winchester, New Minster, Benedictine Abbey 10

York, Guild of Stationers 31
York Minster 85

Zwettl, Cistercian Abbey 100
Zwiefalten, Benedictine Abbey 15